THE PAN ART DICTIONARY

VOLUME ONE
1300–1800

ERIKA LANGMUIR is Head of Education at the Nati█████ry, London. Born in Poland, she lived in France and the U████es – where she received a BA from Sarah Lawrence and an M/████ ford – before coming on a Kress Fellowship to the War█████ute in London. Her Stanford PhD was awarded in 1972, bu█████ned in Britain, first as a Lecturer, then Reader, at the University████x. From 1982 to 1988 she was Professor of Art History at the Open University. She has published art-historical articles and reviews in the *Journal of the Warburg and Courtauld Institutes*, the *Art Bulletin*, *Storia dell'Arte*, the *Burlington Magazine*, *The British Journal of Aesthetics* and elsewhere. Her main interest is Italian Renaissance art and she has travelled widely in Italy.

THE PAN
ART
DICTIONARY

VOLUME ONE

1300–1800

ERIKA LANGMUIR

PAN ORIGINAL

PAN BOOKS
LONDON, SYDNEY AND AUCKLAND

First published in Great Britain 1989 by Pan Books Ltd
Cavaye Place, London SW10 9PG

9 8 7 6 5 4 3 2 1

Copyright © Erika Langmuir 1989

ISBN 0 330 30923 4

Designed by Peter Ward
Photoset by Parker Typesetting, Leicester
Printed and bound in Great Britain by
Richard Clay Ltd, Bungay, Suffolk

To C.P. McK.
L.S.B. and V.C.L.

THE PURPOSE of this dictionary is twofold: to act as a reference book for travellers and gallery visitors, but also to provide at-home information to students of Western art history and general readers interested in the subject. To these ends, entries vary between the cursory and the encyclopaedic: major artists and artists whose careers or talents have recently been reassessed, or who seem to the authors to merit reassessment, are given the fuller treatment. Examples in *Volume One* are Dutch 17th-century history painters, whose work, highly praised by contemporaries, has only recently come to be studied again after two centuries of neglect (see, e.g. Sandrart). The longer entries have been written so as to provide a quick overall evaluation of the character and significance of the artist's work in the first paragraph, and to trace his or her career in greater detail in the following ones.

Entries include painters, sculptors, printmakers, etc. but not architects, except those who also practised as one or more of the above, and provide coverage of Western Europe and the Americas. The very specialized field of Byzantine art has not been included, although some Western-influenced Eastern European artists are mentioned. It has been decided to make value judgements explicit but, at the same time, to try to differentiate clearly between the judgements of contemporaries, posterity, the general public and specialists, and to alert readers to differences of opinion where these exist and seem to matter. Finally, I have not shied from recording my own opinions in longer entries, thinking it better to allow these open expression rather than have them creeping in by the back door of supposed objectivity.

Stylistic, technical and other art-historical terms are included where standard dictionary entries were felt to be inadequate. The aim has been to provide a glossary to more specialized art-historical literature, such as exhibition catalogues or scholarly monographs, rather than to be exhaustive. The choice of terms defined has been dictated mainly by my experience as a university teacher of art history, explaining to students the past meaning of such terms as 'decorum' or 'Fancy Picture', the significance of style labels such as 'Gothic' or '*mudéjar*' or the finer points of difference between 'Classical' and 'classicizing', as well as the more obvious technical aspects of, say, 'fresco' or 'grisaille' painting.

Cross-referencing between entries, indicated by asterisks (*) or (*see also* . . .) has been copious, partly to encourage browsing but mainly from a desire to demonstrate the intricate web of relationships which make up the history of art. It is a fact that professional artists in the centuries *c.* 1300–*c.* 1800 actively sought out the influence of other artists as well as passively absorbing the influence of their teachers or local schools. The names most frequently referred to, such as Leonardo da

Vinci, Michelangelo, Raphael, Rubens, Poussin and a few others really do identify the lodestars of Western art. Cross-references to 'See Smith, John' mean that the artist is listed under 'Smith' and not, say, 'John Smith'; those to 'See under Smith, John' indicate that mention of an artist or topic is made within an entry devoted mainly to someone else (in this case John Smith).

Museum, church and other institutional references are normally listed not in alphabetical order but, depending on the entry, according to the importance of their holdings of works by the artist or in chronological order as this applies to their holdings of works by the artist under whose name they appear. Anonymous private collections are only mentioned where a major, or important, portion of the artist's work is held in such collections. References have been abbreviated only slightly, either by dropping such words as 'Museum' or 'Gallery' – as in 'New York, Metropolitan' for 'New York, Metropolitan Museum of Art' – or the name, where only one museum or gallery exists in the locality listed: 'Bergamo, Accademia' for 'Bergamo, Accademia Carrara'. 'Collection' is shortened to 'Coll.'. Churches are normally listed only under the short name of their titular saint; 'Rome, S. Ignazio', not 'Rome, church of S. Ignazio Loyola'. The local name of the saint or church is usually given, except where familiarity with the English name makes such consistency undesirable for the English-speaking reader. Thus, references are to 'Vatican, St Peter's' or 'Rome, St John Lateran' rather than 'Vatican, S. Pietro' or 'Rome, S. Giovanni in Laterano'. By extension, I have referred to 'Venice, Doge's Palace', 'Pavia, Charterhouse', 'Dijon, Charterhouse' rather then 'Venice, Palazzo Ducale' or 'Pavia, Certosa', 'Dijon, Chartreuse'.

Any work such as this relies on the primary research and survey compilations of others. To all these I give humble and grateful thanks. Every effort has been made to seek out up-to-date sources and to eliminate errors where these have crept into the literature, but anyone who has undertaken a similar task will know that such efforts can never wholly succeed. The users for whom this dictionary is mainly intended should find it adequately reliable; any specialists who may come upon it are asked for tolerance – and to communicate errors of fact, new findings or differences of opinion to the author. Discrepancies in dates between this volume and other publications reflect either scholarly debate in the face of inadequate documentation, or new certitudes recently published. Differences in the spelling of names normally reflect contemporary variations in orthography. The currently preferred form has generally been adopted; occasionally, however, the most familiar English form of a foreign name has been used. Thus, while Jan van Eyck is listed as 'Eyck, Jan van', the reader will find Charles I's favoured painter under 'Van Dyck, Sir Anthony'. In the case of many compound names cross-references are given, but readers are asked to look under possible variants. To have listed, for example, all

the forms of Dutch names beginning with 'van' and 'ter' would have taken up an unacceptable amount of space.

Artists' dates are normally given in the form '1450–1527', where '1450' is the date of birth and '1527' of death. The form '*c.*1450–1527' indicates a date of birth of *around* 1450; '1450/51–1527' greater precision. An entry such as 'active (or recorded) 1480–1527' means that the artist was working in 1480 at an age not now known and died in 1527, whilst 'active (or recorded) 1480 to 1527' means that neither the year of birth nor death is now known. A variation might be '1450–after 1527', indicating that the artist was not necessarily active until 1527 but is recorded in some form of documentation until that date.

ERIKA LANGMUIR
London, September 1988

ABATE, Nicolò dell' (1512–71) Painter from Modena, now chiefly remembered as the third Italian founder of the School of Fontainebleau (*see* Rosso; Primaticcio; *also* Cellini). Nicolò's career before his voyage to France in 1552 is also of interest, however. A specialist in decorative *fresco cycles throughout the Modenese and in Bologna (from *c*.1548), he executed the fullest 16th-century pictorial recensions of Virgil's *Aeneid* (*c*.1540, now Modena, Galleria; *Story of Camilla*, *Aeneid* book xi, *c*.1550–52, Bologna, Palazzo Poggi), of the *Roman Histories* of Appian (1546, Modena, Palazzo Comunale), of Livy (*Tarquin* cycle, *c*.1548–50, Bologna, Palazzo Torfanini, destroyed), and of Ariosto's *Orlando Furioso* (*c*.1548–50, now Bologna, Pinacoteca), which were based whenever possible on book illustrations and prints after, for example, *Giulio Romano and *Raphael. His decorative friezes influenced the early work of the *Carracci in Bolognese palaces, and although he worked largely as an executant of Primaticcio's designs at Fontainebleau, his taste for Northern Italian *illusionism (*see* Mantegna, Correggio) helped to transform the latter's designs for the Galerie d'Ulysse. His eclectic style, formed on Correggio and *Parmigianino, but on Netherlandish landscape (*see* Patinir) and *Dosso as well, also helped to soften and enliven the colder *Mannerism of Primaticcio (e.g. *Salle de Bal*). His predilection for narratives set in landscape found an independent outlet at the French court (*Aristeus and Eurydice*, London, National, and *Rape of Proserpine*, Paris, Louvre) and anticipates the French *Rococo. The same may be said for his depictions of aristocratic pastimes – in which he is also an unrivalled recorder of fashionable dress (*Sala dei Concerti*, Bologna, Palazzo Poggi; drawings, Düsseldorf, Kunstmuseum; Florence, Uffizi; Paris, Louvre; Cambridge, Fitzwilliam). The canon of his portraits has never been fully established, and some of his work in this genre has been attributed to Parmigianino. A great deal of his work in France, for the court and other patrons, has been lost, although much is recorded in drawings. He was assisted in his last project, the decorations for the festive entry of Charles IX to Paris, 1571, by his son Giulio-Camillo dell'Abate.

ACADEMY By the late 18th century, many European artists perfected their training in specialized art schools – academies – the majority of which were subsidized by governments and held a monopoly of public exhibitions of art (the London Royal Academy was a notable exception). The academies superseded, but did not entirely replace, the earlier system of craft training through apprenticeship to a master licensed by a guild.

Typically, academic art training was founded on *classicizing theories of art. Perhaps the clearest exposition of these are the *Discourses* of Sir Joshua *Reynolds, the first President of the London Royal

Academy (1769–90). In practice, students began with drawing: first from prints or drawings after ancient Graeco–Roman sculpture or the works of Italian *Renaissance masters such as *Michelangelo and *Raphael; later, after plaster casts or originals of antique statuary, and finally from specially posed nude life models. Only after several years' training in drawing were students allowed to paint, that is, to use colour. The academies enforced a rigid hierarchy of the *genres, allotting prizes, such as scholarships for study in Italy, only to those who proved themselves in the 'highest' genre, history painting. These provisions caused much discontent among practising artists, and are basic to the revolts which undermined the academies almost from their inception.

The first academies, however, were not of this kind. So-called after the original location of Plato's school of philosophy in ancient Athens, the earliest modern academies date from the revival of Platonism in 15th-century Italy. They consisted of small debating societies meeting to discuss philosophical topics. The most influential of them was sponsored by Lorenzo de'Medici in the 1470s. By 1600, academies of various disciplines had proliferated throughout Italy and even north of the Alps. The word 'academy' was also used as a Latin synonym for the vernacular 'university'.

Despite several engravings, by or after *Leonardo da Vinci, bearing the inscription Academia Leonardi Vinci, there is no evidence that Leonardo founded an academy of art – although he may have given his name to a scientific academy. It is difficult to date or place precisely the first art academies (Florence in the 1490s? Rome c.1530?), but it is probable that they, too, began as informal discussion and drawing groups, whether in connection with Lorenzo de'Medici's collection of ancient sculpture, in the studio of the sculptor Baccio *Bandinelli, or elsewhere.

The first modern art academy – one which was both sponsored by a ruler and undertook to educate young artists – was the Accademia del *Disegno founded in Florence in 1562 by the artist-courtier Giorgio *Vasari under the aegis of the Grand Duke Cosimo I de'Medici. Its foundation was facilitated by the fact that in Florence sculptors and painters did not belong to the same guilds, and were not in the majority within the guilds to which they belonged. A benevolent society or confraternity of artists, the Company of St Luke, already existed, probably since the 14th century.

By claiming for painting and sculpture a common source in theory (*disegno), the Florence academy strove to gain for the visual arts the standing of a liberal art such as poetry, to differentiate artists from craftsmen, and to enlist them in the ranks of the professions. All later art academies have been motivated by a similar desire to raise the status of artists. For his part, the newly invested Grand Duke Cosimo sought to harness artistic production in Florence to legitimize and publicize his dynastic aspirations.

Similar factors played a part in the foundation of the second important

Italian art academy, the Academy of St Luke in Rome, sponsored by the pope. After abortive beginnings, it was effectively initiated in 1593, under the presidency of the painter Federico *Zuccaro.

Because of opposition by more powerful local painters' guilds, the spread of art academies throughout Italy was slow. Throughout the 17th century, in centres outside Florence and Rome, they retained the character of private study groups, admitting both professional artists and connoisseurs. A crucial development, however, was the importance accorded to drawing from life (including from unposed models), notably in the academy at Bologna instituted by the *Carracci.

Art academies of this unofficial type also migrated north of the Alps through artists returning home from Italy. The first seems to have been established in Haarlem by Karel van *Mander, 1583; the earliest in Germany by Joachim von *Sandrart, in 1674/5 at Nuremberg. The guilds, however, continued to legislate for the arts in the Netherlands until the second half of the 17th century, and in German states until the early 18th century.

The first official art academy in northern Europe was founded in Paris in 1648, through the efforts of the painter *Lebrun. Although its rules depended on those of the academies of Florence and Rome, the French Royal Academy, under the protection of Colbert, the minister of Louis XIV, far outstripped its Italian models in efficacy. It held a monopoly of hiring models for life-drawings, as well as of public exhibitions. It opened branches in provincial cities. It disbursed scholarships for study at the French Academy in Rome, and became the model for all the other royal and imperial academies of northern Europe, with the exception of the London Royal Academy, founded in 1768. Through its profitable exhibitions, this English institution, despite its royal charter, maintained both economic and political independence. A Polish academy was projected in the 1690s; the Berlin Academy was established in 1697; the Vienna Academy in 1705 (re-established 1726); that of St Petersburg in 1724; of Stockholm in 1735; at Copenhagen, 1738; at Madrid, 1752. Lesser academies were also founded in the 18th century throughout the German principalities, Italian and Swiss cities, and the municipalities of the Netherlands. The Royal Academy of Mexico was opened in 1785; the first official American Academy of the Fine Arts in Philadelphia in 1805.

For the history of the academies and academic art in the 19th century, see Volume Two.

ADAM, Lambert-Sigisbert (1700–59) and his brother Nicolas-Sébastien (1705–78) French neo-*Baroque sculptors, much influenced by the work of *Bernini which they studied whilst at the French *Academy in Rome, where Lambert-Sigisbert defeated *Bouchardon in the competition for the Trevi fountain. Although this commission eventually went to an Italian architect, the elder Adam gained many others, including a relief for the Corsini chapel, St John Lateran.

After their return to France the brothers mainly practised as a team employed by the court on large-scale decorative sculpture, of which the best-known is the *Neptune and Amphitrite* on the Bassin de Neptune, Versailles (other works St Cloud; Paris, Louvre; Versailles, chapel; Leningrad, Hermitage). Less successful in portraiture, Lambert-Sigisbert executed a bust of *Louis XIV as Apollo* on speculation, but the work was rejected (terracotta version, London, Victoria and Albert). Nicolas-Sébastien's outstanding independent work is the tomb of Queen Catharina Opalinska, 1749, Nancy, Notre-Dame de Bon Secours.

Natives of the Lorraine, the Adams came from a long line of sculptors and bronze founders in Nancy. A third brother, François-Gérard (1710–61) became court sculptor to Frederick the Great at Potsdam. They were the maternal uncles of *Clodion.

AELST, Willem van (1627–*c*.83) Much-travelled, influential Dutch painter of flower pieces, whose asymmetric compositions and novel colour range anticipate *Rococo design. Born in Delft, he spent 1645–9 in France and later became court painter to Ferdinand II de'Medici in Florence, returning to settle in Amsterdam in 1657. Two of his best-known followers are Rachel *Ruysch and Jan van *Huysum. There are works by him in The Hague, Mauritshuis; Karlsruhe, Kunstsammlungen; Oxford, Ashmolean; etc.

AERTS, Hendrick *See under* Steenwijk, Hendrick van.

AERTSEN, Pieter (1508–75) Amsterdam painter, a member of the guild in Antwerp from 1535 to before 1557. He was a pioneer of independent *still-life and *genre (e.g. *Farmer's Wife*, 1543, Lille, Musée; *Peasants' Feast*, 1550, Vienna, Kunsthistorisches; *Farmer's Table*, Antwerp, Mayer van den Bergh; *Egg-Dance*, 1557, Amsterdam, Rijksmuseum; *Peasant's Kitchen*, Copenhagen, Museum; *Pancake Bakery*, *c*.1560, Rotterdam, Boymans-Van Beuningen). These paintings are the direct forerunners of the 17th-century kitchen and market scenes of the Flemish artists *Snyders and *Fyt, and the northern Italian Vincenzo *Campi and Bartolomeo *Passarotti. The pictures for which Aertsen is best remembered today, however, are works which are symbolic inversions of religious scenes. In these, monumental yet naturalistic (*see under* realism) secular elements are featured in the foreground, and the religious motif is relegated to a small area in the background. Thus the famous *Butcher's Shop* (1551, Uppsala, University) virtually occludes the Flight into Egypt; the biblical story of *Jesus in the House of Martha and Mary* justifies the lavish display of foodstuffs and kitchen implements (Rotterdam, Boymans-Van Beuningen; Vienna, Kunsthistorisches). This 'inversion' of religious theme and *genre* through engraved versions – the youthful *bodegónes* of *Velázquez.

Aertsen's numerous altarpieces were largely destroyed in Iconoclastic Riots (*see under* icon). Only fragments and smaller devotional

panels have survived (e.g. Antwerp, Musée). Portraits by him are recorded, but none is known. His son, Pieter Pietersz (c.1543–1603) continued to paint portraits and *history pictures.

Aertsen's Italianate modelling and brushwork, as well as his dramatic monumentality and sense of movement, even in still-life, anticipate the work of *Rubens. His nephew-in-law, Joachim Beuckelaer (c.1535–c.75) was trained by him and painted the same themes in much the same technique; some problems of attribution remain between the two artists. The best-known works attributable to Beuckelaer are in Cologne, Wallraf-Richartz; Brussels, Musées; Antwerp, Musée.

AFFETTI *See* expression.

AGOSTINO di Duccio (1418–81) Sculptor who left Florence as a mercenary soldier on his father's death in 1433 and was trained elsewhere. He worked mainly in Modena; Venice; Perugia; Bologna, and, above all, Rimini, where he executed some of the reliefs in the Tempio Malatestiano (*see* Matteo de'Pasti; Alberti; Piero della Francesca). In 1463 he returned to Florence, where he began to work on the gigantic block of marble later used by *Michelangelo for the *David*.

AIKMAN, William (1682–1731) Distinguished, albeit monotonous, Scottish portrait painter. He was the son of the laird of Cairney, but he sold the family estate to travel abroad. He studied under *Medina, but later spent several years in Rome and visited Constantinople. After *Kneller's death in 1723 he migrated from Scotland to London, where he had connections in literary circles. He is reckoned, with *Richardson, to be the best portraitist of the generation following Kneller's. There are works by him in Edinburgh, National Portrait, and in many Scottish collections.

ALBANI, Francesco (1578–1660) Bolognese painter, a pupil first of *Calvaert, then of the *Carracci. He followed Annibale Carracci to Rome shortly after 1600, carrying out his designs for frescoes in S. Giacomo degli Spagnuoli, 1602–07. In 1609 he painted decorative frescoes in the Palazzo Giustiniani (now Odescalchi) and c.1616 in the Palazzo Verospi (now Credito Italiano) where his growing fascination with *Raphael is noticeable. In 1616 he returned to Bologna, where his lyrical and rather slight talent was at its best in representations of myth and allegory in landscape, of which the most notable is the series of the *Four Elements* (1626–8, Turin, Pinacoteca). In his later years he became increasingly involved in the theoretical defence of *Classicism.

ALBERTI, Leon Battista (1404–72) Italian humanist; professional papal secretary, amateur antiquarian, architect and artist. His importance for the history of art resides primarily in his authorship of the influential treatise *On Painting* (Latin version, *De Pictura*, 1435; Italian version, *Della Pittura*, 1436), circulated in manuscript until the 16th century when it was first printed.

The illegitimate scion of a Florentine family in exile from their native city state, Alberti first entered Florence in 1434. *On Painting* prescribes artistic ideals which in effect record those of the Florentine New Style as evolved by *Donatello, *Masaccio, *Ghiberti and *Brunelleschi, to whom the Italian version is dedicated. Alberti describes *istoria* (*see under* genres) as the greatest work of the painter, and advocates a method of constructing single-vanishing-point *perspective. The treatise was almost certainly directly influential on *Leonardo da Vinci, and on certain non-Florentine artists, notably *Mantegna. The author was also acquainted with *Piero della Francesca, whose architectural backgrounds reflect Alberti's views on this subject, as advocated in the treatise *On Architecture* (*De re aedificatoria*, 1452), and demonstrated in a few buildings erected or restructured to Alberti's designs in Rimini and Mantua. A treatise in the Tuscan vernacular, *On the Family*, 1433–4, continued to be plagiarized until the mid-18th century and still makes excellent reading for anyone interested in the social thought of Renaissance Florence.

ALBERTINELLI, Mariotto (1474–1515) Florentine painter, long-time associate of Fra *Bartolommeo and his business partner from 1509–12. They had both studied under Cosimo *Rosselli. Although generally influenced by Bartolommeo (e.g. *Visitation*, 1503, Florence, Uffizi), Albertinelli clung longer to a 15th-century style (*Crucifixion*, 1506, Val d'Ema, Charterhouse). Occasionally, however, he surpassed his friend in dramatic power (*Annunciation*, 1510, Florence, Accademia). Weary, according to *Vasari, of the 'sophistry and brain-rackings' of painting, Albertinelli 'retired for many months' in 1513 (not, as is often asserted, permanently) to run an inn. There are works by him in Rome, Borghese; Harewood House; London, Courtauld; Florence, private coll.

ALGARDI, Alessandro (1598–1654) Sculptor born and trained in Bologna, mainly known for his activity in Rome (from 1625) where he became the only rival of Gian Lorenzo *Bernini. A more reticent, less *expressive sculptor than Bernini, he also lacked the latter's gifts as courtier and salesman. Nonetheless he was a highly original artist, combining lyricism, vitality and an unaffected naturalism (*see under* realism) in his portraits with elegance and fantasy in his decorative work; younger contemporaries preferred him to Bernini as a teacher. Overshadowed after his premature death by the long-lived *Baroque master, he regained influence with the Neo-*Classical sculptors of the 18th century (e.g. Edmé *Bouchardon).

Since Bologna lacked natural sculpting stone, he spent his formative years modelling clay. This, and the influence on him of his first teacher, the painter Lodovico *Carracci, were responsible for his highly developed pictorial sense: he created the relief altarpiece, a pictorial sculptural type which was to become a major art form for the next hundred years. His immense relief of the *Encounter of St Leo the Great*

and Attila the Hun for the altar of St Leo in St Peter's, Vatican (1643–53) was unprecedented in scale and prominence of location, and, despite lacking dramatic tension, it remained for centuries the exemplar of a sculpted *istoria* (*see under* genres). His portrait busts, which span almost the length of Algardi's Roman career (e.g. Rome, various churches, Palazzo Odescalchi; Doria; Milan, Poldi Pezzoli; Berlin, Museen; Manchester, Gallery; Leningrad, Hermitage; London, Victoria and Albert; etc.) focus on individual physiognomy and personality rather than on social status. In contrast to Bernini's mature and late portraits, they are undemonstratively meditative. Yet Algardi, too, pioneered new bust types: one, unprecedented in a secular context, in which both hands are shown as the sitter turns the pages of a book (London, Victoria and Albert); another, in which the sitter interrupts his reading of a prayer book to turn, hand on heart, to the altar of his funerary chapel (Rome, S. Maria del Popolo), inspired Bernini's more flamboyant bust of Gabriele Fonseca. And perhaps no contemporary sculptor rivalled Algardi's delicate touch in the carving of certain textural effects, such as the gauzy material of a widow's veil (e.g. Rome, Doria).

After the death of Lodovico Carracci in 1619 Algardi left Bologna and was employed by the Duke of Mantua to carve ivory and produce small models for metalwork. It is with such work, and with the restoration of antiques, that Algardi first earned his living in Rome (e.g. *Urn of St Ignatius Loyola*, 1629, Rome, Gesù; drawing, Leningrad, Hermitage; supports for the Borghese Table, 1634, private coll.). In Mantua, Algardi also studied the decorative stucco work of *Primaticcio, which influenced his later ornamental stuccoes in the Villa Doria Pamphilj, constructed under Algardi's direction largely as a showcase for decorative sculpture encasing antique reliefs and sarcophagus fronts (1645–6). Its owner, Prince Camillo Pamphilj, nephew of Pope Innocent X, was Algardi's most important patron after his uncle's accession in 1644.

Algardi's first public commission in Rome, obtained for him by *Domenichino, was for large stucco statues of saints for the Bandini chapel, S. Silvestro al Quirinale (1629). From the mid-1630s he received commissions also for large-scale sculpture in marble: the tomb of Pope Leo XI (1634–40, Vatican, St Peter's); the altar group of the *Beheading of St Paul* (1634–44, Bologna, S. Paolo Maggiore) and a statue of *St Philip Neri with an Angel* (1635–8, Rome, S. Maria in Valicella, sacristy). But his position as the second foremost sculptor in Rome was not assured until the accession of Pope Innocent X and the temporary fall from favour of Bernini.

Algardi also executed the bronze statue of *Pope Innocent X* (1647–50, Rome, Palazzo dei Conservatori) which, despite an accident in the casting, rivals the painted portrait by *Velázquez; the fountain of St Damasus (1645–7, Vatican, courtyard of S. Damaso) now much damaged; and the high relief altar for Camillo Pamphilj's church of S. Nicola da Tolentino (1651), which constitutes a critique of Bernini's

altar of St Teresa in the Cornaro chapel. He probably also provided designs for the stucco reliefs in St John Lateran (*c.*1648).

Many small bronze and silver objects, figurated or purely ornamental, by or after Algardi may also be found in private and public collections. His moulds and models continued to be used after his death, and innumerable copies in gesso were made, as well as casts in wax for study by other sculptors.

ALL'ANTICA (Italian, in the ancient mode) A term used most often with reference to works of *Renaissance art, to signify dependence on motifs or stylistic elements derived from the art of Graeco–Roman antiquity: '*all'antica* ornament', 'nudity *all'antica*', etc. It is not precisely synonymous with *classical or classicizing: it does not differentiate between periods of ancient art and aesthetic ideals; an image *all'antica* may depict archaeological motifs in a non-classical style. Alternatively, a classicizing image may include few, or no, *all'antica* motifs.

ALLA PRIMA (Italian, from *prima*, first, early) A method, practicable only in oils, of painting directly on the support without elaborate preliminary studies to establish composition, pose, tonality. Changes are incorporated into the paint layers, and are revealed through X-rays. As the top layers become translucent with age, such changes may become visible to the naked eye (*pentimenti*). Painting *alla prima* tends to preclude learned perspective representations or other sophisticated compositions; it generally implies dependence on the model, and relies for its effects on subtle adjustments of colour areas and/or spontaneity of colour application.

ALLEGRI, Antonio *See* Correggio, Antonio Allegri.

ALLORI, Alessandro (1535–1607) and his son Cristofano (1577–1621) – also called *Bronzino after his father's uncle and teacher – were Florentine painters. Alessandro was a *Mannerist who combined the influence of Bronzino with that of *Michelangelo, whose work he studied in Rome in the late 1550s (Florence, Palazzo Vecchio; S. Maria Novella; SS. Annunziata; Rome, Doria; Cortona, S. Maria Nuova; etc.). Cristofano reacted against his father's style, siding with the 'reformist' painters *Santi di Tito and Cigoli to evolve a more painterly and *naturalistic idiom. He was a striking portraitist (e.g. Oxford, Ashmolean) and his ability to represent subtle and complex emotional states is exemplified in his celebrated *Judith with the Head of Holofernes* (1613, Coll. HM the Queen; later version, Florence, Pitti), long considered to be the major masterpiece of Florentine 17th-century art. There are other works by him in Florence, Pitti; Casa Buonarotti; Pistoia, S. Domenico; Belfast, Museum; etc.

ALTDORFER, Albrecht (*c.*1480–1538) Painter and printmaker, perhaps trained as an illuminator by his (probable) father Ulrich Altdorfer. He was the most consistent exponent of the *'Danube school' style, whose main characteristics are the importance of

landscape as an *expressive element even in religious scenes, and a poetic feeling for nature (see also Jörg Breu, Lucas Cranach, Wolf Huber).

His work is rooted in the calligraphic ornament of Late *Gothic, and in its *naturalism and emotionality. Although he borrowed motifs from Venetian and other Italian art, he remained indifferent to the *classicism of the Italian *Renaissance and to the new pictorial problems of *perspective, proportion and anatomical correctness (in contrast to his contemporary, *Dürer). The drawings, prints and paintings of the Danube school, and of Altdorfer in particular, provided German-speaking humanists with an attractive alternative to Italianate rationality: a supposed revival of the pantheistic native sensibilities of ancient Germanic tribes.

Most of Altdorfer's life was spent in Regensburg, where he achieved both financial success and influence. He was on the town council in 1519 when the entire Jewish community of nearly 600 was expelled within four days, and the synagogue demolished – an event which Altdorfer celebrated (as the inscriptions make plain) with two etchings of the building's porch and interior. He was also a prime mover of the profitable cult of an image of the Virgin which was promoted on the site, designing the cult badge, painting the banner, and making several woodcuts relating to the pilgrimage. He was still a council member – having refused an invitation to become mayor – when the city adopted Lutheranism in 1533.

His earliest known works are drawings and prints, and the early paintings, such as the first dated picture, the Satyr Family of 1507 (Berlin-Dahlem, Museen), are small in scale. Natural forms provide the dramatic content, the human figure virtually submerged in luxuriant northern forest vegetation (e.g. St George in a Wood, 1510, Munich, Alte Pinakothek) or dramatic light effects (Nativity, c.1515, Berlin-Dahlem, Museen). At this time Altdorfer also produced independent drawings, intended for collectors.

From c.1510 he began to receive commissions for altarpieces, adopting a somewhat larger scale and more monumental figure style, although natural forms still dominate. The major works of this type were executed from c.1518 for the monastery of St Florian near Linz; there are also panels from a dismembered altarpiece of c.1520 in Florence, Uffizi, and Nuremberg, Museum. He continued, however, to paint *cabinet pictures, including pure landscapes with no human figures, and landscapes with architectural fantasies, of which details were derived from engravings after the Italian architect Bramante (Danube Landscape, c.1522–5; Susannah in the Bath, 1526; both Munich, Alte Pinakothek). Altdorfer's most celebrated painting, the Victory of Alexander over Darius (1529, Munich, Alte Pinakothek), was a commission from Duke Wilhelm IV of Bavaria, one of a series of famous battles which also comprised pictures by Hans *Burgkmair and Jörg *Breu the

Elder. On a panel less than 1.5m tall, it is one of the most grandiose compositions in Western art. The impossibly high and distant viewpoint suggests that the battle is seen as only God and eternity could view it.

Erhard Altdorfer (recorded 1506–61) was his brother's pupil but may also have been influenced by the other masters of the Danube style *c.*1500, Lucas Cranach and Jörg Breu. Although he never achieved Albrecht's greatness, he became, in 1512, court painter and architect to the Duke of Mecklenburg at Schwerin, where he is documented until 1561. He made 85 woodcuts for the Lower German Bible printed at Lübeck in 1533.

AMADEO, Giovanni Antonio (1447–1522) The leading Lombard sculptor, architect and engineer of the second half of the 15th century. The architectural and sculptural style for which he is best known, relying on brilliant *polychromy, a profusion of decorative carving, and formed through contact with the International *Gothic sculpture of Milan and his native Pavia, is best exemplified on the façade and the tombs of the Colleoni chapel, Bergamo, executed between 1470–76. Here he introduced *classical motifs within a mannered Gothic whole. He worked originally as a modeller of terracotta, later as a marble carver in the cloisters of the Charterhouse at Pavia (1466–70). In 1474 he undertook joint responsibility for the façade of the charterhouse, and for a series of tombs for Cremona cathedral (1481–4). Around 1500 his style underwent yet a further change under the impact of Gian Cristoforo *Romano's classicism. The new manner is evident in Amadeo's harmonious *Tomb of S. Lanfranco* (S. Lanfranco outside Pavia) and in a relief for the Carmine, Pavia. In the last 20 years of his life Amadeo was mainly active as an architect and engineer on the cathedrals of Pavia and Milan, having resigned his directorship of the Charterhouse façade sculpture in 1499, in favour of Benedetto *Briosco.

AMBERGER, Christoph (*c.*1505–61/2) A pupil of Hans *Burgkmair, Amberger was an outstanding portrait painter in Augsburg, the most cosmopolitan German city of the Renaissance and a dissemination point for Italianate artistic ideals. Even before his meeting with *Titian in 1548, his works demonstrate Venetian influences (Birmingham, Barber; Berlin-Dahlem, Museen; Brunswick, Anton Ulrich-Museum; Stuttgart, Staatsgalerie; Vienna, Kunsthistorisches).

AMIGONI, Jacopo (1682–1752) Born in Naples and already schooled in the manner of *Solimena upon his arrival in Venice, Amigoni is nonetheless classed as a Venetian painter. The main influences on him are Luca *Giordano and Sebastiano *Ricci. Like them, he became a peripatetic artist, spending 10 years in Bavaria (1717–27), where his fresco cycles at Schleissheim, Nymphenburg and Ottobeuren influenced Bavarian *Rococo, and the next 10 (1729–39) in England; his best surviving decorative work is at Moor Park, where he succeeded *Thornhill. In England he was forced to diversify into

portraiture, which he enlivened through luminous colour schemes and the introduction of playful *putti*. Between 1740–7 he was once again in Venice, painting mainly mythological scenes for the private market. In 1747 he left Italy for ever, to become Court Painter in Madrid. His late style degenerated into a rather lifeless, *classicizing form of *Rococo.

AMMANATI, Bartolomeo (1511–92) Outstanding Tuscan-born *Mannerist sculptor and architect, active in Florence, Urbino, Venice – where he was strongly influenced by Jacopo *Sansovino – Padua and Rome. At the end of his life he was much affected by the Counter-Reformatory ideas of the Jesuits, and in two famous letters, one to the Florentine *Academy (1582) and one to the Grand-Duke Ferdinand I de'Medici (c.1590), he pleaded against the representation of the nude and begged that those already extant in Florence, whether by himself or others, be covered up or removed. His best-known works as a sculptor are the *Del Monte monuments* in Rome, S. Pietro in Montorio (1550–3), begun originally under the direction of *Vasari and with the advice of *Michelangelo, and the *Fountain of Neptune* on the Piazza della Signoria, Florence (1560–75; *see also* Montorsoli).

AMORINO, pl. *amorini See under putto.*

ANAMORPHIC, ANAMORPHOSIS A type of *perspective in which the viewpoint is placed far outside the image to the side. Viewed from the front in the normal way, the motif is so elongated as to be unrecognizable; it is visible only when viewed from the side of the image or through a glass tube. The principle of anamorphic design was first exemplified in a woodcut of c.1531–4 by Erhard Schön. It was used by Hans *Holbein the Younger for a distorted skull in his portrait of *The Ambassadors* (1533, London, National). The anonymous portrait of *Edward VI* (1546, London, National Portrait) is also an anamorphosis.

ANDACHTSBILD (pl. *andachtsbilder*; German, devotional image) A small-scale religious image for private devotion, intended to arouse meditation. The term is most frequently applied to the intimate and *expressive half-length portrait *icons produced in northern Europe in the late Middle Ages, sometimes as symbolic representations of mysteries of the Christian faith. Thus the figure of Christ as the Man of Sorrows, abstracted from the narrative of the Passion, symbolizes the mystery of the Eucharist.

ANDREA del Castagno (c.1419–57) Precocious and influential Florentine painter from the mountain village of Castagno. An outstanding draughtsman, he was praised by contemporaries and also *Vasari for his *expressive line and his mastery of relief and *perspective, specifically *foreshortenings of human figures rather than the depiction of deep space. Vasari's accusation that Castagno murdered his friend *Domenico Veneziano has been disproved: the latter survived him by some years.

Possibly trained by an itinerant follower of *Masaccio, Andrea moved to Florence c.1437–8. His first metropolitan commission

(destroyed) was to paint the conspirators in the Albizzi rebellion hanging by one leg on the façade of the Bargello – a work which earned him the unwelcome nickname of *Andrea* (or *Andreino*, 'little Andrew') *degli Impicchati*, 'of the hanged men'. He executed his first surviving dated work 1442–4, the *frescoes of the apse vault, Venice, S. Zaccaria, S. Tarasio chapel, whose standing saints show his study of *Donatello's prophets on the bell tower of Florence cathedral. By 1444 he had also furnished designs for the mosaic of the *Death of the Virgin* for the Mascoli chapel, S. Marco, which was to influence *Mantegna. Back in Florence in the same year, he designed one of the circular stained-glass windows in the drum of the cathedral dome (*Lamentation*); his only *sacra conversazione*, *The Madonna di Casa Pazzi*, (Florence, Pitti) also dates from *c*.1444. Its colour is indebted to Domenico Veneziano, working at about this time on the important, now lost, fresco cycle of the *Life of the Virgin* in S. Egidio at the hospital of S. Maria Nuova, which was completed by Andrea in 1451–3 with the scene of the *Death of the Virgin* (also lost). Andrea's most mature surviving ensemble, *The Last Supper*, with, above, the *Resurrection*, *Crucifixion* and *Entombment*, was executed in 1447 in the then-refectory of the convent of S. Apollonia, Florence. In 1449–51 Andrea decorated a room in the Villa Carducci outside Florence with a series of *Famous Men and Women* (detached frescoes, now Florence, Uffizi), single figures from Florentine and world history, painted as if standing in shallow niches seen from below. The *Assumption* of 1449–50 for the Florentine church of S. Miniato fra le Torri is now in Berlin-Dahlem, Museen. Two chapels in SS. Annunziata, newly remodelled by *Michelozzo, were furnished with *fresco altarpieces by Andrea *c*.1453: *St Julian with the Saviour* (Da Gagliani chapel) and the famous *Trinity with Sts Jerome, Paula and Eustochium* (Corboli chapel) with its drastically foreshortened crucified Christ, whose awkward lower limbs were later concealed by the artist with flaming seraphim painted *a secco* (*see* secco). In 1454 Andrea was probably in Rome, designing and perhaps executing some of the illusionistic architectonic decoration of the Bibliotheca Graeca in the Vatican. His last work, the equestrian monument in fresco of Nicolò da Tolentino, emulating that of Hawkwood by *Uccello, was painted in Florence cathedral in 1456; the wiry and energetic figure in fictive marble demonstrates the abiding influence of Donatello. In addition to newly uncovered *sinopie* (*see under* fresco) there are drawings by Andrea in, e.g. Düsseldorf, Kunstmuseum; Vienna, Albertina; Cambridge, Mass., Fogg.

ANDREA del Sarto (1486–1530) The leading painter in Florence from *c*.1510. Influenced by Fra *Bartolommeo (whom he displaced in importance both as executant and teacher), *Leonardo, *Michelangelo, *Raphael, contemporary Northern prints (*Dürer, Lucas van *Leyden), and by 15th-century Florentine tradition, he evolved a complex but harmonious individual style combining firm

draughtsmanship with energetic and *expressive colour, naturalism (*see under* realism) with *idealization, spontaneity and sketchiness of brush-work side by side with a high finish. He rethought the work of Leon-ardo, adapting the latter's *sfumato* and complexities of pose whilst rejecting his monochrome *chiaroscuro for a form of chromatic modelling (*see under* colour). Just as his colour range is warmer and more varied than Leonardo's, so the address of his painted figures to the viewer is more direct and less enigmatic, albeit almost equally poetic. A measure of Andrea's success is that he was both a principal source of the development of Florentine *Mannerism (*see* Pontormo, Rosso) and an inspiration to the anti-Mannerist reformers at the end of the century (*see* e.g. Cristofano Allori, Santi di Tito). He is amongst the most copied of Tuscan artists.

The son of a tailor, he was first apprenticed to a goldsmith, then trained as a painter under *Piero di Cosimo and Raffaellino del Garbo (1466-1524). His earliest important independent works were *frescoes painted in the entrance cloister of SS. Annunziata, four scenes from the *Life of S. Filippo Benizzi*, 1509–10; *Procession of the Magi*, 1511; *Birth of the Virgin*, 1513–14. This last, Andrea's first mature statement, is a critique in 16th-century idiom of *Ghirlandaio's treatment of the subject in S. Maria Novella (*c.*1485–90).

Also begun in 1514 but worked on at intervals until 1526 was a series of frescoes in *grisaille in the Chiostro dello Scalzo. Two scenes were painted during Andrea's absence in 1518–19 by *Franciabigio. The subject of the series is the life of St John. Despite their pale mono-chrome, which varies from a golden warmth to cooler greener hues, the scenes are vibrant with light and colour, and are amongst the most important High *Renaissance works in Florence.

Other outstanding frescoes by Andrea are the unfinished *Tribute to Caesar* (*c.*1521), completed in 1582 by Alessandro Allori, which is part of the propagandistic Medicean decoration of the salone in the villa at Poggio a Cajano (*see also* Pontormo, Franciabigio); the *Madonna del Sacco* above a door of the Great Cloister of SS. Annunziata (1525), a famous composition which inspired a painting by *Poussin; and the less well-known, because for a long time inaccessible, *Last Supper* in the refectory of the ex-convent of S. Salvi (1526–7).

His most famous easel painting is the altarpiece of the *Madonna of the Harpies* (1517, Florence, Uffizi). Other altarpieces and smaller devo-tional works in oils on panel are found in Florence, Pitti, Uffizi; Lenin-grad, Hermitage; London, National, Wallace; Madrid, Prado; Paris, Louvre; Rome, Borghese; Vienna, Kunsthistorisches; Washington, National. Although he mainly painted religious subjects, a few portraits are also known (Berlin-Dahlem, Museen; London, National; Edin-burgh, National; Chicago, Institute). In 1513 Andrea, along with the younger Pontormo and Rosso, designed the decorations for the car-nival floats of the Medicean confraternities (allegorical scenes, Florence,

Uffizi), and in 1515, in tandem with his friend and associate the sculptor Jacopo *Sansovino, he executed decorations for the festival entry into Florence of Pope Leo X de'Medici. A more unusual commission (1515) was the furniture and panelling decoration for the nuptial chamber of Pier Francesco Borgherini, illustrating the Old Testament story of Joseph, in which Andrea and *Granacci were the senior painters and the younger Pontormo and Francesco Bacchiacca (1494–1577) also participated (decoration dispersed; panels by these artists respectively Florence, Pitti, Uffizi, Palazzo Davanzati; Rome, Borghese and London, National).

Andrea worked in France 1518/19 in the service of King Francis I. He broke his contract, according to *Vasari, because he missed his wife. Whether the story is true or not, it points to a quality in the man which is consonant with his work. Vasari discerned in him 'a certain timidity of spirit' and the lack 'of ornaments, grandeur, and copiousness' which prevented him from achieving in painting something 'truly divine'. And it is true that, despite his Medicean commissions, Andrea the tailor's son worked mostly for the Florentine bourgeoisie, for confraternities of small merchants and artisans, religious communities, and a few art-loving merchant collectors.

ANGELICO, Fra or Beato (1395/1400–55) Influential and much loved Tuscan painter; the nickname 'Angelic' was given to him posthumously. Born Guido di Pietro, he took the name Giovanni upon entering the Dominican order in Fiesole c.1418–21; *Vasari calls him Fra Giovanni da Fiesole. Already trained as a painter and miniaturist before becoming a friar, he continued to practise his art mainly in the service of his order. After the mid-1430s his work shows mastery of the new style initiated by *Masaccio, translated, however, into a different *expressive idiom: tender, meditative, delicately luminous. Depending on the function and location for which they were executed, his paintings range from the austere (e.g. *frescoes of S. Marco, *see below*) to the richly decorative (e.g. frescoes of Chapel of Pope Nicolas V, *see below*). In the latter he continued to use gold-leaf ornament and complex colour harmonies in the manner of *Gentile da Fabriano, active in Florence in 1422–5.

Fra Angelico's earliest known works, the triptychs (*see under* polyptych) for S. Domenico, Fiesole (c.1424/5, reworked c.1505 by Lorenzo di Credi to form a single-field, *Renaissance *sacra conversazione*) and for Florence, S. Pietro Martire (1428–9, now Florence, S. Marco) show the influence both of Gentile and *Ghiberti. Soon after (c.1430), his study of Masaccio becomes evident in greater spatial clarity and simplification of volume (e.g. *Madonna and Child*, S. Marco; *Madonna and Child with Twelve Angels*, Frankfurt, Kunstinstitut). His first mature painting, which gave rise to innumerable variants and adaptations, was the altarpiece of the *Annunciation* of c.1432/3 now at Cortona, Museo. The panels of the *predella include some of the most magical evocations of the Tuscan landscape ever painted.

[14]

Fra Angelico's artistic status was confirmed with the commission in 1432 from the Linendrapers' Guild for an enormous image of the Virgin and Child on panel in a shuttered tabernacle, with Sts John the Baptist and John the Evangelist on the inside of the shutters, and Sts Peter and Mark on the outside (1433–5, S. Marco). The marble tabernacle was furnished by Ghiberti's workshop, and the sculptor may have aided the painter-friar with designs for the over-life-size figures, which are analogous to his own statues for the Or San Michele, and larger than any contemporary Florentine works on panel.

From c.1437–45 and 1450–c.2 Fra Angelico was occupied with the altarpiece and frescoes for S. Marco in Florence, one of the most extensive Dominican pictorial ensembles ever executed. Sadly, the condition of the altarpiece, and the dispersal of its predella (Munich, Alte Pinakothek; Paris, Louvre) make it difficult to appreciate either its original splendour or novelty (1438–40, S. Marco). Features of it were imitated by *Ghirlandaio, *Baldovinetti, and others. Of the remaining frescoes, the mystical *Crucifixion with Saints* of the chapter room of the priory (1441–2) is undoubtedly the most solemn painting by Fra Angelico. In addition to this and other frescoes on the ground floor he designed all the paintings in the upstairs corridor and in the friars' individual cells. They represent scenes from the life of Christ and the Virgin, not as realistic narratives, but as subjects for meditation.

Something of the style of the S. Marco altarpiece may be seen in the other great panel painting of c.1440–5, the *Deposition* for the Strozzi chapel in S. Trinità (now S. Marco, pinnacles of *Gothic frame by *Lorenzo Monaco).

In 1445 Fra Angelico was summoned to Rome by Pope Eugene IV. His only surviving work in the Vatican was painted, however, for Eugene's successor, Nicolas V, in 1447–8; after a brief period at Orvieto, 1447, he was back in Florence in 1450. The frescoes of Nicolas' small chapel, representing six scenes from the *Life of St Stephen* and five from the *Life of St Lawrence*, are the most complex of his works, showing his study of Roman architecture and his fruitful experiments with various methods of dividing up the narrative fields. Benozzo *Gozzoli was the chief assistant on this and the Orvieto project.

On his death in 1455, Fra Angelico was the most prized painter in Florence. Both *Piero della Francesca and *Domenico Veneziano probably spent time in his studio in the 1430s; Ghirlandaio, Baldovinetti profited from his example; *Verrocchio came under his spell. No other artist, however, achieved quite the same blend of new science with popular appeal, spirituality with charm – the qualities which make him even today one of the most widely reproduced, if not well-understood, Italian artists.

ANGUISSOLA, Sofonisba (1527–1625) The most celebrated of a family of 'lady painters' – the others being her sisters Elena, Lucia, Europa and Anna Maria. Born in Cremona, she was taught first

by Bernardino *Campi, then by Sojaro (c. 1495–1575). In 1559 she was invited by Philip II to the court of Spain, where she was a maid of honour to the Queen and executed many portraits in the *realistic north Italian mode of *Moroni. Most were destroyed in the fire of 1604 at the Pardo palace. There are a number of self-portraits by her (e.g. Naples, Capodimonte) and she may have invented an early form of *Conversation Piece, consisting of half-length portrait figures relating to each other in a *genre situation, such as playing chess (e.g. 1555, Poznán, Museum). She returned to Italy in 1580, settling in Genoa in 1584 and then moving to Palermo with her second husband. *Van Dyck drew her on his Italian visit (1624, 'Italian Sketchbook', London, British), recording her conversation and advice; his painting of her is now lost.

ANTEPENDIUM A low rectangular panel used to decorate the front of the altar table. Antependia are amongst the earliest (12th century) post-antique panel paintings in the Latin West.

ANTONELLO da Messina (c. 1430–79) Outstanding, if ill-documented, painter from Messina in Sicily. His mature works combine an Italian sense of volumetric structure with Netherlandish technique, notably in the treatment of light, and *iconography (e.g. bust-length Ecce Homo, New York, Metropolitan; Genoa, Spinola; Salvator Mundi, 1475, and St Jerome in his Study, both London, National). He was prized as a master of the small bust-length portrait in the Netherlandish mode (New York, Metropolitan; Philadelphia, Museum; Berlin, Museen; Washington, National; Paris, Louvre; Lugano, Thyssen-Bornemisza Coll; London, National; Rome, Borghese; Turin, Museo). Exceptionally, he was able to work both on the monumental scale of large altarpieces (*Polyptych of St Gregory, 1473, Messina, Museo; S. Cassiano altarpiece, see below) and, for private collectors on a minute scale approaching that of miniatures (e.g. St Jerome, London National). Although his portraits have the finesse of surface texture associated with Netherlandish art, certain small-scale works (e.g. Crucifixion, London, National) have such breadth of form that they appear grandly monumental; all, even the Ecce Homo, avoid the extremes of pathos characteristic of much northern art for a meditative, *classical restraint.

An independent master in Messina by 1457, Antonello is said to have been apprenticed in Naples to Colantonio, an able imitator of Netherlandish painting (e.g. St Jerome in his Study, Naples, Capodimonte). Since original works by Jan van *Eyck and Rogier van der *Weyden, as well as by their Burgundian, Provençal and Spanish followers, were available for study in Naples, scholars have abandoned earlier hypotheses of a trip to the Netherlands, although a voyage to central and northern Italy between 1465–71, when Antonello could have absorbed the influence of *Piero della Francesca and *Mantegna, is still thought likely. A stay in Venice 1475–6 is well documented. Of his major Venetian commission, an altarpiece for S. Cassiano, only fragments remain (Vienna,

Kunsthistorisches). Other works from this period are the *St Sebastian*, now in Dresden, Gemäldegalerie, once the wing of a triptych (*see under* polyptych) and the small *Crucifixion* now in Antwerp, Musée. A close interaction between Antonello and Giovanni *Bellini is universally acknowledged, although scholars disagree as to which artist most influenced the other.

Antonello's son Jacobello da Messina, first recorded in his father's will in 1479, was his chief assistant and completed works left unfinished at his death. His only secure independent work is the *Madonna and Child*, 1480, Bergamo, Accademia.

ANTONIO and Giovanni d'Enrico *See* Tanzio da Varallo.

ANTONIO Lombardo *See under* Pietro Solari.

AQUATINT A specialized form of etching (*see under* intaglio prints), developed in the 18th century. Rosin dissolved in spirits of wine was poured over a clean metal plate. In drying, the rosin collected into little lumps with the plate exposed in a fine system of irregular lines between them. These lines could then be etched or 'stopped out', providing a soft tone, which could then be accented with line etching.

ARCIMBOLDO, Giuseppe (1527–93) Milanese painter, designer of stained glass and tapestries. From 1562 until 1587 he served as court painter at the Habsburg imperial court in Prague. He is now remembered almost exclusively for his grotesque allegorical or symbolic figures, some of them are personifications of, e.g. *The Elements* or *The Seasons* (Vienna, Kunsthistorisches), others actual portraits, all ingeniously composed from still-life elements: e.g. *The Cook*, portrayed in frying pans, roast meats and sausages; *Rudolph II as Vertumnus*, the god of horticulture, assembled out of fruit, flowers and corn (both Stockholm, Museum).

ARNOLFO di Cambio (recorded from 1265–*c.*1302) One of the three leading sculptors of late 13th-century Italy. Like his one-time master Nicola *Pisano, he combined a knowledge of antique models with that of contemporary *Gothic developments. Some of his sculptural works rely primarily on architectural forms (altar canopies, 1285, Rome, S. Paolo fuori le mura; 1293, S. Cecilia in Trastevere), and he is thought also to have been the architect of the churches of the Badia and S. Croce in Florence, and the first chief architect of Florence Cathedral, for the façade of which he executed a sculptural complex of figures and reliefs (*c.*1300, Florence, Opera del Duomo). From *c.*1277, Arnolfo was working for the Angevin court in Rome (*Charles of Anjou*, Rome, Palazzo dei Conservatori) and probably through connections at court he won commissions for the tombs of Cardinal de Braye (*d.*1282, Orvieto, S. Domenico) and Cardinal Annibaldi della Molara (*d.* 1276, Rome, St John Lateran). The de Braye wall tomb is the key monument for our understanding of Arnolfo as a sculptor; much altered, it is nonetheless remarkable both for the naturalism (*see under* realism) of the effigy and for its influential *iconography of Death and Salvation.

ARPINO, Giuseppe Cesari (usually called by his papal title, Cavaliere d'Arpino) (1568–1640) The favourite painter of Pope Clement VIII, he specialized in decorative cycles for high-ranking ecclesiastics and Roman princes (1589–91, Naples, S. Martino; 1589, Rome, Loggia Orsini; 1591/2, S. Luigi de'Francesi, Contarelli chapel, vault; 1592, S. Prassede, Capella Olgiati; 1591–1636, Palazzo dei Conservatori). He also designed the mosaics for the dome of St Peter's 1603–12. His style is usually classed as Late *Mannerism, and is marked by clarity and sobriety; his recollections of *Raphael are unrefreshed by studies from nature. Around 1590 he employed *Caravaggio as a fruit and flower specialist.

ARRICCIO See under fresco.

ASAM, Cosmas Damian (1686–1739) and his brother Egid Quirin (1692–1750) Influential Bavarian *Rococo artists specializing in ecclesiastical buildings. Cosmas Damian was primarily a *fresco painter, Egid Quirin a sculptor in stucco and wood. Both practised as architects, to create spectacular *illusionistic church interiors akin to stage designs and popular miracle plays, in which all the arts contributed equally to the dramatic total effect. Sons of the painter Hans Georg Asam of Tegernsee, they were sent by a patron to Rome in 1711. Having absorbed the ideals of the Roman *Baroque (see especially Bernini, Gaulli, Pozzo) they reinterpreted them in a lighter and even more vivid way throughout the German principalities and in Switzerland and Bohemia. Their greatest achievement is the church of St John Nepomuk, Munich (1733–46) endowed by Egid Quirin and built, together with a priest's house, next to his own residence. The brothers designed the entire building as a symbol of artistic creation in the service of God, but included also figures from *classical mythology. Cosmas Damian also executed secular frescoes at Mannheim (1729–30; destroyed in World War Two) and Alteglofsheim (1730), drawing together the Italian tradition of *Correggio and *Pietro da Cortona and the Flemish manner of *Rubens for his own version of mythological subjects.

ASPERTINI, Amico (1474–1552) Eccentric Bolognese painter and sculptor, now best known for his eclectic *fresco cycle in Lucca, S. Frediano, 1507–09. He was in Rome in 1500–03 and again in 1532–4 and 1535–40, when he produced two important sketch-books of drawings after the antique, which are amongst the fullest records of ancient works of art known in the *Renaissance (London, British).

ASSELIJN or ASSELYN, Jan (c.1615–52) Dutch painter, best known today for his heroic painting of the Threatened Swan defending its nest against a dog (Amsterdam, Rijksmuseum), which at a later date was transformed, with the aid of an inscription, into a political allegory. Asselijn began as a painter of battle scenes; he painted a few exquisite Dutch winter landscapes (e.g. Paris, Coll. F. Lugt) but the majority of his work consists of Italianate harbour scenes and landscapes

(Amsterdam, Rijksmuseum; Barnsley, Museum; Woburn Abbey; etc.). Of these, the most remarkable are his panoramic views (Vienna, Akademie). He was in Rome between 1635 and 1644; he married in Lyon in 1644, and worked in the Hotel Lambert in Paris in 1646. He was back in Amsterdam in 1647; in 1648, *Rembrandt executed a portrait etching of him.

AUDRAN, Claude III *See under* Watteau, Jean-Antoine.

AVED, Jacques-André-Joseph-Camelot (1702–66) French portraitist, who trained under a French engraver in Amsterdam and went on to paint with the sober naturalism (*see under* realism) associated with the Dutch school. He came to Paris in 1721, and his best-known work is the portrait of *Mme Crozat* (1741, Montpellier, Musée; others, Cleveland, Ohio, Museum; Versailles). A friend of *Chardin, he is thought to have provoked the latter to begin painting *genre* pictures in the 1730s.

AVERCAMP, Hendrick (1585–1634) A pioneer of the *realistic Dutch landscape, who was called 'the Mute of Kampen' because of his disability. He specialized in winter scenes of outdoor sport and leisure (Bergen, Museum; London, National; Toledo, Ohio, Museum; etc.). His nephew, Barent Avercamp (1621/3–79), closely imitated his manner in the early years of his career.

AVERLINO, Antonio *See* Filarete.

B

BABUREN, Dirck van (c.1590/5–1624) One of the group of painters known as the Utrecht Caravaggisti (see also Honthorst; Terbrugghen). He left for Rome probably in 1612, returning to Utrecht in 1621. His most important Roman commission was the decoration, with another Dutch painter, David de Haen (d. 1622), of a chapel in S. Pietro in Montorio. Back home, he was more at ease with *genre subjects; like Terbrugghen, he combined earlier Netherlandish motifs with *Caravaggesque effects of illumination. *Vermeer may have owned his picture of The Procuress (1622, Boston, Mass., Museum), which appears in the background of two of his own paintings, and his yellow, sky-blue and white colour harmonies may have influenced the Delft artist. There are paintings by Baburen in Utrecht, Museum.

BACCHIACCA; Francesco Ubertini, called See under Andrea del Sarto.

BACICCIA or BACICCIO See Gaulli, Giovan Battista.

BACKER, Jacob Adriaensz (1608–51) Dutch portraitist and *history painter, influenced by *Rembrandt but almost certainly not his pupil; later works show him turning to the new, Italianate *classical style. There are civic and militia group portraits, as well as individual likenesses, in Amsterdam, Historisch and Rijksmuseum; The Hague, Mauritshuis. His nephew and probable pupil, Adriaen Backer (1630/2–84) was also a successful portraitist.

BACON, John (1740–99) English sculptor, self-trained after going to work at the age of 14 in a porcelain factory. Technically very efficient, he invented a superior *pointing machine, by means of which a block of marble could be rough-hewn in half the time previously taken; it was used not only in his studio but by many others in England and abroad, particularly in France. His largest work was the Chatham monument, Westminster Abbey (1779–83).

BAILLY, David (1584–1657) Leiden portrait painter, credited, on insufficient evidence, with the invention of the vanitas* still-life, of which his pupil Harmen van *Steenwijck was the leading exponent. His 1651 Portrait of a Young Painter (which may be a disguised self-portrait in youth and middle age) presents, however, a virtually complete catalogue of vanitas motifs (Leiden, De Lakenhal).

BALDOVINETTI, Alesso (c.1425–99) Florentine painter, designer of stained-glass windows, mosaics and tarsias. His style was formed on that of *Domenico Veneziano, whose now lost frescoes in Florence, S. Egidio, he completed in 1461. His best-known independent work is the fresco of the Nativity, 1460–2, in the entrance courtyard of SS. Annunziata, with an expansive and detailed landscape studied, at least in part, after nature (see also Andrea del Sarto; Franciabigio; Pontormo; Rosso). He also collaborated on the chapel of the Cardinal of Portugal in S. Miniato (1466–73; see also Antonio Rossellino; Pollaiuolo; Luca

della Robbia) for which he painted the *Annunciation*. In 1483 he was appointed curator and restorer of the mosaics in Florence Baptistry. There are panel paintings by him in Paris, Louvre; London, National; Florence, Uffizi; etc.

BALDUNG, Hans (called Grien) (1484/5–1545) Draughtsman, print-maker, book illustrator, designer of stained glass and painter, trained in *Dürer's workshop in Nuremberg *c.*1503–05. Born into an academic family in Schwäbisch Gmünd, Baldung spent most of his working life in Strasbourg, although he lived also in Halle, where in 1507 he painted two altarpieces – now in Berlin-Dahlem, Museen and Nuremberg, Museum – and in Freiburg, 1512–17. The most outstanding and influential follower of Dürer, he nonetheless did not share the latter's rational humanism and is the German artist most closely identified with northern mysticism. Many of his prints and paintings express to an extraordinary degree the period's ambivalence towards sensuality: woodcuts of witches and witches' sabbaths, with their emphasis on the female nude, and small *cabinet pictures on the theme of Death and the Woman, of which the most famous and arresting is the panel of *c.*1517 in Basel, Kunstmuseum, depicting a fully *classical nude horribly embraced by a half skeletal, half-cadaverous Death (other paintings on this subject, from 1509 onwards, Vienna, Kunsthistorisches; Florence, Uffizi). Three woodcuts of wild horses in the forest (1534) are almost certainly meant to allude to man's bestial passions, and Baldung's most famous print, the woodcut of *The Bewitched Groom* (1544) combines the themes of horse and witchcraft to mysteriously powerful effect, aided by Italianate *perspective.

In addition to altarpieces (the most important of which, based on Dürer's *Heller Altarpiece*, was painted in 1512–16 for the cathedral of Freiburg im Breisgau) and collectors' pictures, Baldung also painted masterly portraits, notably during his stay in Freiburg (e.g. Munich, Alte Pinakothek; Berlin-Dahlem, Museen; Vienna, Kunsthistorisches). In his later years, he was increasingly influenced by *Grünewald (e.g. *Magdalen*, 1539, Darmstadt, Landesmuseum).

BALEN, Hendrick van (1575–1632) *See under* Van Dyck, Sir Anthony.

BALTEN, Pieter *See under* Bruegel.

BAMBOCCIATE, BAMBOCCIANTI, BAMBOCCIO *See under* Laer, Pieter van.

BANCO, Nanni di *See* Nanni di Banco.

BANDINELLI, Baccio (1493–1560) Ambitious but neurotic and technically deficient Florentine sculptor, who was an early (1530s) proponent of *academic training. A protégé of the Medici from their return to power in 1512, he became, in all but name, court sculptor to Cosimo I after *Michelangelo's final departure from Florence in 1534. His monumental *Hercules and Cacus* of the same year (Florence, Piazza della Signoria) designed as a pendant to Michelangelo's *David* was deservedly criticized, not least by Bandinelli's bitter rival *Cellini.

Trained by his father as a goldsmith and inlay expert, Bandinelli was apprenticed to *Rustici, but, despite his ability to attract major monumental sculpture commissions (e.g. *tombs of Popes Leo X and Clement VII de'Medici*, 1536, Rome, S. Maria sopra Minerva; *monument of Giovanni dalle Bande Nere*, 1540, for Florence, S. Lorenzo, now Piazza S. Lorenzo) remained most successful working on a small scale (Florence, Bargello) and as a draughtsman and carver in relief. The latter skill was acquired during his stay at Loreto under Andrea *Sansovino (1517–19); although he abandoned the reliefs he had been working on before they were finished – as he was to abandon many statues – his later reliefs for the balustrade of the choir of Florence cathedral (1547–55) are generally adjudged to be his best work. Others in the same series were executed by his pupil Giovanni *Bandini. Temperamentally and technically ill-equipped to produce naturalistic (*see under* realism) and *expressive statues in the Florentine tradition, Bandinelli was able, however, to copy well from the antique (*Orpheus*, dependent on the *Apollo Belvedere*, 1519, Florence, Palazzo Medici; copy of *Laocöon*, 1520–5, Florence, Uffizi). His *Dead Christ supported by Nicodemus*, 1554–9, for his tomb in SS. Annunziata in Florence (begun after his model by his son Clemente Bandinelli (1534–54) before the latter's departure for Rome) was the sculptor's final act of rivalry with Michelangelo, who was then carving a Pietà for his own funerary monument. Socially as ambitious as he was artistically, Bandinelli forged a noble pedigree for himself and successfully negotiated to be made a Knight of St James, *c*.1529; he describes his intrigues in his *Memoriale*, along with Cellini's autobiography and *Vasari's *Lives* an important document for the history of 16th-century art.

BANDINI, Giovanni (1540–99) Florentine sculptor, a pupil of Baccio *Bandinelli, after whose death he completed the choir screen for Florence cathedral, 1572, for which work he became known as Giovanni dell'Opera ('Opera del Duomo', cathedral workshop). Ironically, in view of his master's long rivalry with *Michelangelo, he participated in the decorations for the latter's funeral, and was entrusted with the figure of *Architecture* on Michelangelo's tomb in S. Croce (set in place 1574; terracotta model, London, Soane). He also contributed a bronze figure to the decoration of Francesco de'Medici's *Studiolo* in the Palazzo Vecchio, under the overall direction of *Vasari (1573). From 1582 he worked for the Duke of Urbino (*Pietà*, 1585–6, Urbino, cathedral; portrait statue, 1587, now Venice, Doge's Palace courtyard). In 1595 he returned to Tuscany to execute Ferdinand I de'Medici's statue for the monument at Leghorn (*see also* Pietro Tacca). There are also reliefs by Bandini in the Gaddi chapel, Florence, S. Maria Novella (1576–7); in these as in his portrait sculpture he followed the rather tight, generalized style of Bandinelli.

BANKS, Thomas (1735–1805) British sculptor, amongst the first to work in the Neo-*Classical style (*see* Volume Two). The son of a

steward to the Duke of Beaufort, he was first influenced by William
*Kent. Although ill-educated and inarticulate, he aimed 'to bring
poetry to the aid of all his compositions'. During the 1760s he won
prizes for classical reliefs, and in 1772 he went to Italy on a Royal
*Academy travelling studentship. In his seven years in Rome he became
friends with *Sergel and Fuseli (see Volume Two), and came under the
influence of J. J. Winckelmann, celebrated author of *Reflections on the
Imitation of Greek Art in Painting and Sculpture*. Upon his return to
England in 1779 Banks could find little patronage; he attempted to
settle in St Petersburg (1781–2) where the Empress Catherine bought
his much-admired *Cupid*, now lost. In 1786 he was elected to the Royal
Academy, and continued working mainly on funerary monuments and
busts; little of his 'poetic' sculpture remains. There are works in
London, (Westminster Abbey, Victoria and Albert, St Paul's, National
Portrait, Soane, Royal Academy), in Stowe Park, Stratford-on-Avon,
and elsewhere. His best-known monument, to *Penelope Boothby* (1793), is
in Ashbourne, Derbyshire.

BARBARI, Jacopo de' (c.1440–before 1516). Printmaker and painter
from Venice; after 1500 he worked at courts in Germany and the
Netherlands, although he may have revisited Venice in 1508/9. Little is
known of his background or training; it has been suggested that he was
a well-born amateur who entered Alvise *Vivarini's studio in the 1490s.
The first dated work attributed to him is the famous large *woodcut in
six blocks, the *Bird's-eye View of Venice*, 1497–1500. Early *engravings
show the influence of Vivarini and *Mantegna; some were copied by
*Dürer. Later prints adopt German techniques evolved by *Schongauer
and Dürer. Amongst the few painting by Jacopo known today is the
famous *trompe l'oeil* *still-life, one of the earliest known, of the *Dead
Bird* (Munich, Alte Pinakothek). Other works in paint are in Berlin-
Dahlem, Museen; Dresden, Gemäldegalerie; London, National; Paris,
Louvre; Philadelphia, Johnson Coll.

BARNA da Siena (active early 1350s) A follower of *Duccio, only
slightly influenced by the intervening generation of painters,
primarily *Simone Martini. His *fresco cycle of the *Life of Christ* (San
Gimignano, Collegiata) is notable for the intellectual rigour of its
arrangement and its transcendental emotionality. There are panel
paintings in New York, Frick and Boston, Mass., Fine Arts.

BAROCCI, Federico (c.1535–1612) Eclectic but highly individual
painter of Urbino. His refined and emotional fusion of Venetian
colore with Central Italian *disegno*, most dependent on the earlier
example of *Correggio, anticipated and influenced the *Carracci and
led the transition from Late *Mannerism to the *Baroque. Through his
many altarpieces, commissioned from as far afield as Genoa, Tuscany,
Umbria and Rome, he affected many artists throughout Italy. The
sincerity and lyrical pathos of his idiom perfectly expressed Counter-
Reformation sensibility; his altarpiece of *The Visitation* (1583–6; Rome,

S. Maria in Valicella) is the only painting known to have been admired
by St Philip Neri, founder of the Oratorians, who was once found in
mystical ecstasy in front of it.

Formative influences on Barocci were his study of High *Renais-
sance works in the collection of the Duke of Urbino, notably those by
*Titian and *Raphael, and his visit to Rome in the mid-1550s, where he
became friends with Taddeo *Zuccaro and studied the *frescoes of the
Vatican. A subsequent visit, 1560–3, ended tragically with his being
allegedly poisoned by a rival. After his return to Urbino he virtually
ceased to paint for four years, and remained an invalid for the rest of
his life. By c.1567, however, with the *Madonna of S. Simone* (Urbino,
Galleria) he had somehow found his Corregesque idiom – by what
precise means is not known, since he apparently never visited Parma.
His subsequent series of great altarpieces includes the *Deposition*
(1567–9, Perugia, cathedral); *Il Perdono* (early 1570s, Urbino, S.
Francesco); the *Madonna del Popolo*, painted in 1575–9 for the Miseri-
cordia of Arezzo (now Florence, Uffizi); the *Entombment* (1580–82,
Sinigallia, S. Croce); the *Martyrdom of S. Vitale* (1580–3, Milan, Brera);
the *Calling of St Andrew* (1580–3, Brussels, Musée); the *Annunciation*
(1582–4, Vatican, Pinacoteca); the *Circumcision* (1590, Paris, Louvre);
the *Presentation of the Virgin* (1593–4, Rome, S. Maria in Valicella); the
Last Supper (late 1590s, Urbino, cathedral); the *Madonna del Rosario*
(1593, Sinigallia, Palazzo Vescovile); *Crucifixion* (1596, Genoa, cathe-
dral). Other works are dispersed in many public collections, as are
Barocci's wonderfully colouristic chalk drawings, part of his meticulous
preparation after the life for his painted works. The subtle diversity of
colour, the linear rhythms and the exquisite sentiment – sometimes
falling into sentimentality – of his late paintings, such as the *Beata
Michelina* (1606, Vatican, Pinacoteca) anticipate the *Rococo as much as
the earlier works pointed the way to the *Baroque.

BAROQUE, baroque A stylistic term employed in its neutral sense for
art, architecture, music and even literature of the 17th century. It
may derive from *barocco*, as used for irregular or misshapen pearls.
Originally a derogatory term, meaning a departure from the norms of
*classicism, in its lower-case form it may still be used, not only in the
arts, to denote something exaggerated, overblown, capricious. In art,
Baroque is associated with a large scale; sweeping diagonal movement;
a tendency to break away from the picture plane both in depth and
towards the viewer; forms flowing or swirling one into the other (as
opposed to the clearly delimited forms of classicizing art); colourism (*see
under* disegno) and, in fresco, *illusionism. Its best-known exponents
are, in painting, *Rubens and *Pietro da Cortona, and in sculpture,
*Bernini. It is characteristic of the Roman High Baroque, as exemp-
lified particularly in the work of Bernini, to abolish the traditional
boundaries between the arts, and between art and reality, in order to
create unified environments which stimulate in the viewer a heightened

emotional state analogous to ecstasy. These effects are particularly associated with the militant and triumphant phase of Counter-Reformation Catholicism. Confusingly, art historians also speak of Baroque Classicism, meaning 17th-century classicizing art of e.g. *Poussin, and even of Early Baroque Classicism (*see* Domenichino).

BARRA, Didier (*c.*1590–after 1652) Born in Metz, he is recorded in Naples from 1631, painting poetical yet accurate panoramic views of the city based on contemporary maps. Under the name Monsù (a corruption of Monsieur) Desiderio, his identity has until recently been merged with that of another painter from Metz, François de *Nomé.

BARRY, James (1741–1806) Irish-born painter of huge talent, a fiery and unbalanced temperament, and the overwhelming ambition to succeed as a painter of heroic subjects. Brought by Edmund Burke to London in 1764, he was introduced to *Reynolds, who encouraged him. Still financed by Burke, he studied in Italy from 1766 to 1771, schooling himself in the manner of *Michelangelo. He was made Associate to the Ròyal *Academy in 1772, and Academician in 1773; after a disagreement in 1776 over his *Death of Wolfe*, a critique of *West's famous picture of 1771, he never exhibited at the Academy again. His major works are the enormous canvases representing *The Progress of Human Culture* painted in 1777–83 to decorate the Great Room of the Society of Arts; but his portraits in the elevated style advocated by Reynolds are more consistently successful (e.g. *Hugh, Duke of Northumberland*, *c.*1784, Syon House). Embittered by lack of patronage for his narrative extravaganzas, Barry, who in 1782 became Professor of Painting at the Academy, took to abusing his fellow Academicians from the lecture podium. He was turned out of the Academy in 1799, and died deranged and in poverty. There are works by him in Dublin, National; London, Tate; Manchester, City; Bologna, Pinacoteca; Sheffield, Galleries; etc.

BARTOLOMMEO or BACCIO DELLA PORTA; called Fra Bartolommeo (1472–1517) Florentine painter, a Dominican friar from 1500. A pupil of Cosimo *Rosselli, later associated with the workshop of *Ghirlandaio, he gradually freed himself from their pedestrian *realism, adopting, *c.*1499, the pictorial principles of *Leonardo da Vinci (*Last Judgement*, now Florence, S. Marco), and becoming the chief protagonist in Florence of the transition to the High *Renaissance style. More accessible than Leonardo or *Michelangelo, and more attuned to local traditions than *Raphael, he had a decisive influence on younger Florentine artists, notably *Andrea del Sarto who displaced him as 'head' of the Florentine school after *c.*1514.

A supporter of Savonarola, Bartolommeo entered the Dominican order as a consequence of a vow made during the storming of San Marco in 1498, when Savonarola was taken prisoner. He resumed painting (*c.*1503–04), only at his superiors' insistence and in the service of the order, running the San Marco workshop as Fra *Angelico had

before him. From 1509–12 he was in official partnership with his former fellow pupil, Mariotto *Albertinelli. By 1503–4, with Leonardo's temporary return to Florence, he had recent examples of his manner to hand. In 1508 he spent April-November in a Dominican house in Venice, where he studied the work of Giovanni *Bellini. Three important paintings of 1509 attempt to reconcile Leonardesque and Venetian modes: *Madonna with Six Saints* (Florence, S. Marco); *God the Father with the Magdalen and St Catherine of Siena* (Lucca, Pinacoteca); *Madonna with Sts Stephen and John the Baptist* (Lucca, cathedral). This last also demonstrates the influence of Raphael's *Madonna del Baldacchino*, although earlier Raphael had, in some lesser details, been indebted to him. The mature altarpieces, and the most *classicizing, date from 1511–12: *Marriage of St Catherine* (Paris, Louvre); the unfinished *St Anne* (Florence, S. Marco); a second *Marriage of St Catherine* (Florence, Accademia); *Virgin in Glory* (Besançon, cathedral).

In 1514, concerned to see the latest developments of the art of Michelangelo and Raphael, Fra Bartolommeo visited Rome. What he saw there discouraged him, according to *Vasari, and he returned to Florence, troubled by his own inability to paint 'nudes', or, more accurately, figures in dramatic action. Ill-digested Roman borrowings can be found in the *Madonna of Misericord* (1515, Lucca, Pinacoteca) and *St Mark Evangelist* (c.1514, Florence, Pitti). A more successful synthesis is achieved in his last great altar, the *Salvator Mundi* (1516, Florence, Pitti).

BASAITI, Marco (c.1470–1530) Venetian painter, probably of Greek origin. From the mid-1490s he was an assistant in the studio of Alvise *Vivarini, whose altarpiece in Venice, S. Maria Gloriosa dei Frari, he completed in 1503–05. He became a weak imitator of Giovanni *Bellini. His best-known work is the large and picturesque *Calling of the Sons of Zebedee* (1510, Venice, Accademia); other works London, National; Vaduz, Liechtenstein Coll.

BASCHENIS, Evaristo (1617–77) One of the most original *still-life painters of the 17th century. Ordained as a priest at an early age, he lived all his life in his native Lombard town of Bergamo; by 1675, however, his works had entered princely collections in Rome, Florence, Venice and Turin. Although stylistically dependent on *Caravaggio, Baschenis invented a new type of still-life, composed almost entirely of musical instruments. Without any overt *vanitas* (*see under* still-life) symbolism, these images conjure up melancholy associations. Perhaps late in life he also executed a few 'kitchen pieces' of poultry and fruit. Repetitions and variants of Baschenis' prototypes were produced in quantity by his studio; his manner was also closely imitated by his pupil Bartolomeo Bettera (c.1639–after 1687) and by the latter's son, Bonaventura Bettera (c.1663-after 1718) and by many other, anonymous, local painters, with increasing loss of quality.

BASSA, Ferrer (recorded 1324–48) Catalan painter and manuscript illuminator, the first Spanish artist known to have worked in the

Italian style derived from contemporary Florentine and Sienese art (*see* e.g. Giotto, Duccio, Simone Martini). He had probably studied in Italy. He received commissions from Alfonso IV, King of Aragon, and his successor Pedro IV, but his only secure extant works are the *frescoes in the Chapel of San Miguel in the Franciscan convent of Pedralbes, near Barcelona, 1345–6. He died while working on an altar for the Franciscan priory, Valencia.

BASSANO or BASSANI A family of painters of the Venetian school, so-called after their native town of Bassano; their family name was dal Ponte. The best-known is Jacopo Bassano (*c*.1510–92), who between 1545-60 was one of the most influential painters in the Veneto, apart from *Titian, combining a highly elaborate *Mannerist style with *realistic details, some of them adapted from northern prints by, e.g. *Dürer, and others observed directly from nature. First trained by his father, Francesco dal Ponte the Elder (*c*.1470/80–*c*.1540), he was then taught by Bonifazio de'Pitati in Venice. Jacopo's sons – Francesco the Younger (1549–92), Giovanni Battista (1553–1613), Leandro (1557–1622) and Gerolamo (1556–1621) – staffed the workshop which came to specialize in the bucolic *genre paintings, often with biblical subjects, evolved by him in the 1550s. In 1579 Francesco, the most talented, moved to Venice where he received state commissions for the Doge's Palace as well as specializing in *genre* nocturnes in a style more realistic than his father's.

Jacopo evolved an especially sumptuous colour range (*see also* Tintoretto), although later works show a falling-off in quality, partly because of the substantial contribution of his shop, and partly on his gradual loss of sight. There are important works by him in Bassano, Museo and in galleries in Italy and abroad.

BASTIANI, Lazzaro *See under* Carpaccio, Vittore.

BATONI, Pompeo Girolamo (1708–87) Italian painter who drew from the antique and copied *Raphael, and whose *classicizing style influenced *Mengs and Gavin *Hamilton. Born at Lucca, he settled in 1728 in Rome, where he painted altarpieces for churches and grand decorative schemes (notably in the Villa Borghese, Palazzo Colonna and the Casino Benedict XIV). He is chiefly known today for his portraits of European nobles and Englishmen on the Grand Tour, usually posed in front of architectural ruins or with other examples of ancient art (Brunswick, Museum; Florence, Moderna, Uffizi, Pitti; London, National Portrait, Victoria and Albert; Milan, Brera; etc.).

BEALE, Mary (née Cradock) (1632–99). The daughter of a Suffolk clergyman, Mrs Beale became known in London as a prolific portrait painter in the manner of *Lely; many of her sitters were clerics. Transcripts of her husband's diaries (1671–81) record about 140 portraits completed in six years, of which a number have been identified; of her work before 1671 we know nothing. She often painted heads framed in fictive stone ovals adorned with fruit in stone.

BEATO Angelico *See* Angelico, Fra or Beato.

BEAUNEVEU, André (active *c.*1360–1401) Flemish sculptor and illuminator, probably from Valenciennes. He was one of the most innovative and influential *Gothic artists working in France, active in Paris as sculptor to King Charles V (St Denis, royal tombs) and from *c.*1380 at the court of the Duke of Berry in Bourges. Here he painted 24 pioneering illuminations of prophets and apostles, naturalistic (*see under* realism) and sculptural, for the duke's famous *Psalter*, *c.*1380–5 (Paris, Bibliothèque Nationale). From 1392 he was at work as a sculptor on the Sainte Chapelle at Bourges, which was to contain the duke's funerary monument. Only fragments remain of this once-brilliant enterprise (now Bourges, Cathedral, Musée). Although not as monumental as the work of *Sluter, Beauneveu's sculpture demonstrates the penetrating individualism of facial features characteristic of late 14th-century Flemish art. His assistant and successor at the court of Bourges, Jean de Cambrai (*d.*1438), continued this tradition in his effigies of the Duke of Berry and his wife (now Bourges, Cathedral; also a *Virgin and Child*, Marcoussis, Célestins).

BECCAFUMI, Domenico (*c.*1486–1551) With *Sodoma, the leading Sienese painter of the late 16th century, although a more intelligent, sensitive and consistent artist. Labelled a *Mannerist, he can now be seen to have assimilated Florentine, Umbrian and Roman influences into a Sienese idiom traceable back to the *Gothic art of *Duccio. All of Beccafumi's work, despite internal evolution and change, combines calligraphic line and rhythmic contours with intense colourism (*see under* disegno). Probably more than any other artist of his time he exploits *contre-jour* and lighting effects, as in the great nocturnal *Birth of the Virgin* altarpiece, *c.*1543, now in Siena Pinacoteca. Bare-limbed trees, as if in filigree against the sky, are almost a trademark (e.g. *Stigmatization of St Catherine*, *c.*1514–15, Siena, Pinacoteca; *St Paul* altarpiece, *c.*1515, Siena, Opera del Duomo; *Nativity*, *c.*1524, Siena, S. Martino; etc.).

An early trip to Rome, *c.*1511, has been postulated, followed by another and more decisive visit *c.*1519, when he was able to study virtually all of *Raphael's Roman paintings, and a third in 1541. From 1519–24, and intermittently throughout the rest of his life, he was employed designing episodes of biblical history inlaid in the pavement of Siena cathedral. These were to be his most *classicizing works. A number of major altarpieces remain in Siena. Between 1538–9 he executed large panels for the apse of Pisa cathedral. His important Sienese *frescoes maintain the intensity of colour of his panel pictures, most notably the ceiling in the Sala del Concistoro of the Palazzo Publico, commissioned in 1529 but executed mainly *c.*1535. It demonstrates also Beccafumi's ability to improvise on *all'antica* motifs, especially in architecture, and his grasp of the principles of *perspective. Eight bronze angels on *Peruzzi's high altar in Siena

cathedral were modelled by Beccafumi in the last three years of his life.

BEHAM, Hans Sebald (1500–50) and Barthel or Bartel (1502–40) Nuremberg painters and printmakers. Both brothers trained under *Dürer, and both were expelled from Nuremberg in 1525, along with Georg *Pencz, for anarchism and atheism – although the sentence was revoked in the same year.

Bartel is the more major artist, notable for portraits, many of which employ Italianate formats, such as the half-length or knee-length (e.g. New York, Metropolitan; Liechtenstein, Schloss Vaduz; Lugano, Thyssen-Bornemisza Coll.; Vienna, Kunsthistorisches; Munich, Alte Pinakothek; Ottawa, National). His best-known print was an allegory of the equality of all humankind in death. He died on a trip to Italy, having been court artist to the Duke of Bavaria at Munich and Landshut from 1530.

The elder brother, usually called Sebald, was an etcher, engraver (see under intaglio prints), designer for stained glass and woodcuts and a painter of miniatures. No easel pictures are known to have been painted by him, although he executed a table top, now in Paris, Louvre. He was one of the most prolific graphic artists of the time, producing popular prints, often tiny in size, in huge editions. He specialized in *genre subjects and topical events, but borrowed also from Italian engravings by *Mantegna, *Pollaiuolo, Marcantonio Raimondi (see under Raphael). After relinquishing his Nuremberg citizenship in 1535, he settled in Frankfurt, where he continued his association with book production.

BELLA, Stefano della (1610–64) One of the greatest Italian etchers (see under intaglio prints), influenced first by *Callot, later by *Rembrandt and the Dutch landscapists. Born in Florence, he was a pupil of Callot's teacher Remigio Cantagallina (c.1582–?1635) and became a protégé of the Medici. Around 1638 he went to Rome, and between 1639–50 worked for French publishers in Paris. In 1650 he returned to Florence. A prolific artist, he made over a thousand etchings, many concerned with various aspects of popular life, and influenced Italian *genre painting as well as other printmakers.

BELLANGE, Jacques (recorded 1600–17) Painter, etcher (see under intaglio prints) and designer of stage scenery and theatrical machinery, active with Jacques *Callot and the painter Claude Deruet (d.1660), at the court of the Duke of Lorraine at Nancy. An internationally famous Lorraine Late *Mannerist artist . His highly individual style, now known mainly through prints, was formed on the etchings of *Parmigianino and the *engravings (see under intaglio prints) of German masters such as *Schongauer and *Dürer, and Flemish masters such as *Goltzius. These disparate sources were welded into a sophisticated idiom in which extreme figure elongation, complex poses, unusual viewpoints and spatial ambiguity serve the

end of religious mystical *expressivity (e.g. etchings of *The Three Maries*, *The Annunciation, Carrying of the Cross*, etc.; drawings, various museums including Leningrad, Hermitage; paintings of the *Virgin Annunciate* and the *Archangel Gabriel*, Karlsruhe, Kunsthalle). In addition to his major works on religious subjects, Bellange also executed a number of *genre* compositions (e.g. etching of the *Hurdy-Gurdy Player*) which stress ugliness and deformity as intensely as the religious works stress elegance and beauty.

BELLINI, Jacopo (before 1400–70/1) and his sons Gentile (1429–1507) and Giovanni (*c*.1431/2–1516) The leading dynasty of Venetian painters (*see also* Vivarini), they exemplify the transition from *Gothic to High *Renaissance styles in Venetian art. The most important was Giovanni; *see below*.

Jacopo Bellini was a pupil of *Gentile da Fabriano, whom he may have followed to Florence in 1422. Virtually nothing of his painted work remains; we may assume that, at least early on, it shared Gentile's International Gothic style. Jacopo was the author, however, of two important volumes of drawings, the largest extant collection by any single Italian artist of the period and by any Venetian artist (London, British, on paper; Paris, Louvre, on vellum). Gentile was to present the notebook now in Paris to Sultan Mehmet II in 1479 (*see below*). The drawings demonstrate Jacopo's interest in narrative and in *perspective, including the single-vanishing-point type developed in Florence (*see under* Alberti). It is difficult to assess either the originality or the degree of influence of these drawings in the absence of secure dating. If compiled early in Jacopo's career their emphasis on landscape or architectural settings and on imaginative motifs *all'antica* might be assumed to have influenced Jacopo's son-in-law from 1453, Andrea *Mantegna. If, however, as some scholars believe, the notebooks date from the 1450s, they must reflect the younger man's influence on Jacopo. In either case, they prefigure later Venetian developments.

Gentile Bellini's career, like that of his brother, began in their father's workshop. A solid, meticulous, if prosaic draughtsman, he continued to head the family firm, specializing in official portraiture, large-scale commissions from the Venetian state and from the *scuole* – the charitable confraternities of Venice. In 1474 he was appointed to the team refurbishing the Greater Council Hall in the Doge's Palace (this series of paintings, to which Giovanni later also contributed, were lost in the fire of 1577; *see also* Carpaccio). His *teleri* – large narrative paintings on canvas – for the Scuole di S. Giovanni Evangelista, 1496–1500, and di S. Marco are now in Venice, Accademia and in Milan, Brera, respectively. (The latter painting was finished by Giovanni.) In 1479–81 Gentile was despatched by the Venetian government to Istanbul, where he worked as an artist in the service of Sultan Mehmet II, whose portrait, a badly damaged original by Gentile or a variant or copy, is now in London, National. (Other portraits, mainly bust-length

profiles in the older Venetian tradition, are in Venice, Accademia; Boston, Mass., Museum; etc.). In 1469 Gentile was knighted by the German Emperor Frederick III; a portrait has been postulated, although none is known or recorded.

The most gifted and the most influential of the family was Giovanni Bellini. Although the greater part of his work was conservative in content – altarpieces and Madonna and Child pictures for private devotion, a few portraits – it is he who inaugurated the High Renaissance in Venetian art. This he achieved through a highly personal synthesis of Tuscan and Tuscan-influenced pictorial construction, based on geometric calculation, with Netherlandish optical empiricism (*see* Jan van Eyck). When, *c.*1475, and perhaps through the agency of *Antonello da Messina, he mastered the Netherlandish technique of oil painting in glazes (*see under* colour) he was able to represent mathematically measurable space and volumes as if suffused with light (*Coronation of the Virgin*, *c.*1475, Pesaro, Museo. This is Bellini's first painting in oils, in which the influence of *Piero della Francesca has also been discerned). Even in Bellini's earlier works in tempera (e.g. *St Vincent Ferrer Polyptych*, 1464, Venice, SS. Giovanni e Paolo; *Pietà with the Virgin and St John*, *c.*1470, Milan, Brera) light served as a unifying principle – not only through its optical effects, but also *expressively and symbolically. The clearest expression of Bellini's symbolism of light may be found in his *St Francis* (after 1475, New York, Frick), where sunlight recalls both Francis' hymn to 'Brother Sun' and his receiving the stigmata of Christ.

Giovanni's paintings are distinguished also by a new method of colour perspective. He eschews the aerial perspective of *Leonardo da Vinci, by which colours lose their separate identity and intensity with distance, fading to a pale blue at the horizon. Instead, he suggests recession by alternating 'wedges' of light and dark colour from foreground to background – a development of great importance for later painters of landscape (e.g. *Poussin) as it has the virtue of preserving the colouristic unity of the picture without sacrificing three-dimensionality (*see especially* the *Baptism of Christ*, 1501, Vicenza, S. Corona).

Giovanni Bellini transmitted his mature achievements to his pupils, *Giorgione and *Titian, and they in turn affected him. Although a sincerely pious Christian, late in life he painted a few pagan subjects. The *Feast of the Gods* for Alfonso d'Este (1514, Washington, National) was later partly modified by Titian, to harmonize with his own more unbuttoned mythologies for the same room. But the *Venus, or Lady at her Toilet* (1515, Vienna, Kunsthistorisches), one of Bellini's very rare nudes, is sensuous without a hint of eroticism.

Giovanni's early works demonstrate the influence on him both of his father and of his brother-in-law Mantegna, although his derivations from the latter may be seen also to be 'arguments'. This dialogue is

especially noticeable in the two *Agony in the Garden* paintings, one by
each artist, now in London, National. Mantegna's influence is notice-
able in the linear outlines, hard-edged drapery folds and glossy tight
curls, as well as in the figure canon and foreshortenings. After his
assimilation of Antonello's more atmospheric manner, Bellini
returned briefly to Mantegna. It has been suggested, plausibly, that he
wished to recapture the crisp detail of his early work, and combine it
with his new-found monumentality. Such a synthesis is indeed visible
in many of his finest paintings, e.g. the great altarpieces and votive
pictures of the 1480s (*Doge Agostino Barbarigo before the Virgin*, 1488,
Murano, S. Pietro Martire; the first extant work by him painted on
canvas).

Giovanni's many Madonna and Child pictures adapt Byzantine
*icon conventions. Some of the most beautiful may be found in Ven-
ice, Accademia; Bergamo, Accademia; London, National; Milan,
Brera.

Of his altarpieces, many of the most famous remain *in situ* in Vene-
tian churches; others may be found in the Accademia.

BELLOTTO, Bernardo (he signed himself also Bellotto de Canaletto,
and is still known in Poland as Canaletto) (1720–80) Nephew
and one-time assistant of Antonio *Canaletto, from whom he learned
the use of the *camera obscura. He soon abandoned the 'sunlit' palette
of his uncle's studio for a colder, more intense colour key, culminating
in the famous 'moonlight' colours of his Warsaw paintings. Unable to
break Canaletto's monopoly of Venetian *vedute, Bellotto, after some
years' activity in various centres of central and northern Italy, left the
peninsula to become court painter in Dresden (1747–56). Later he
worked also in Vienna and Munich. The final 13 years of his life saw
him employed at the court of the last King of Poland, Stanislas Poni-
atowski. His most interesting works are his *vedute* of Warsaw. The
topographical precision of these enabled them to be used in the exact
reconstruction of the city after World War Two. The greater part of
Bellotto's work is to be found in the museums of Dresden and War-
saw, but there are examples in many collections in Europe, Britain and
the United States.

BENEDETTO da Majano or Maiano (1442–97) Florentine sculptor
closely associated throughout his career with his architect and
sculptor brother Giuliano (1432–90) and with the painter Domenico
*Ghirlandaio. His own fastidious carving style is highly pictorial, and
he is the first *Renaissance sculptor known to have relied extensively
on terracotta models, a number of which survive. His masterpiece is
the pulpit in S. Croce, Florence, with its poetic invocation of land-
scape in the scenes from the *Life of St Francis*. He also carved a bust of
the rich merchant who commissioned the pulpit, Pietro Mellini (1474,
Florence, Bargello). Another authenticated bust is that of Filippo
Strozzi (before 1491, Paris, Louvre). His free-standing statue of *St*

Sebastian in the Misericordia, Florence, has been said to look forward to the tensions of 16th-century *Mannerist sculpture.

BENTAME *See* Schildersbent.

BENTVUEGHELS *See* Schildersbent.

BERCHEM, Nicolaes or Claes (1620–83) Prolific Dutch Italianate painter and etcher, born in Haarlem, the son of the great *still-life painter Pieter *Claesz. He popularized pictures of Italian pastoral and arcadian scenes, and is one of the precursors of the *Rococo style (Amsterdam, Rijksmuseum; Hannover, Landesgalerie; Leningrad, Hermitage; London, National, Wallace; Munich, Gemälde-sammlungen; etc.). He also executed mythological and biblical scenes (The Hague, Mauritshuis; Bristol, Museum; Paris, Louvre; etc.) and an *Allegory of Amsterdam* (Amsterdam, Historisch); views of harbours (Leipzig, Museum); winter scenes (Haarlem, Hals); in fact, nearly every genre with the exception of still-life. He also painted figures in other artists' landscapes, especially for his friend Jacob van *Ruisdael and for *Hobbema, and collaborated on a painting with *Dou (Amsterdam, Rijksmuseum). He is said to have been in Italy from 1642 to *c*.1645, but it is unlikely that he actually made the journey at this time, although he probably travelled there in 1653/4. Recorded in Amsterdam in 1660 and 1667, he had settled there permanently by 1680. A popular and highly paid artist, he left some 800 paintings, 500 drawings, and over 50 etchings (*see under* intaglio prints).

BERCKHEYDE, Gerrit (1638–98) and Job (1630–93) Amongst the earliest Dutch specialists of townscape. Gerrit, probably a pupil of his elder brother Job, is the better known of the two, although Job was more versatile. After travelling in Germany in their youth, they returned to their native Haarlem, painting small pictures of the city's streets, squares and canals, as well as a few landscapes and church and shop interiors (e.g. London, National; Haarlem, Hals; Douai, Musée; The Hague, Mauritshuis).

BERMEJO, Bartolomé (active 1474–after 1498) A native of Córdoba, he has been called the best artist in Spain before 1500. Unlike most of the other Hispano-Flemish painters (*see* Luis Dalmau) he may actually have trained in the Netherlands, although his greatest work, the dramatic *Pietà* in Barcelona Cathedral, also shows signs of northern Italian influence. There are other paintings by him in Madrid, Prado; Boston, Mass., Gardner; Luton Hoo.

BERNINI, Pietro (1562–1629) and his celebrated son Gian Lorenzo (1598–1680) Sculptors, active mainly in Rome. Gian Lorenzo Bernini, important also as an architect (e.g. Rome, S. Andrea al Quirinale; Vatican colonnade), playwright and stage designer, is virtually synonymous with the High *Baroque style (*see also* Rubens). Pietro Bernini, best known to contemporaries for his exceptional technical facility, has been variously categorized as a Late *Mannerist, an *expressive Mannerist, and a proto-Baroque sculptor. Born near, and

trained in, Florence, he sought advancement first in Rome, then, in 1584, in Naples, where Gian Lorenzo was born. The family moved to Rome in 1605/6. Pietro is the author of one of the city's best-loved landmarks, the *Fontana della Barcaccia* (1637–9) – a fountain in the form of one of the barges which then navigated the Tiber – at the foot of the Spanish steps. It has been said that Pietro handed on to Gian Lorenzo his technical facility, an empirical approach to style, and an 'emotive attitude to sculpture' best demonstrated in the remarkable range of transient emotions portrayed in his marble relief of the *Assumption of the Virgin* (1606–10, Rome, S. Maria Maggiore) inspired by the painter Lodovico *Carracci.

Gian Lorenzo Bernini, a child prodigy, continued to grow in artistic stature throughout his life and to work into extreme old age. Not an introspective or intellectual genius like his great predecessors *Donatello, *Leonardo and *Michelangelo, he must be identified with those orthodox beliefs and aspirations of triumphant Catholicism and of secular absolutism for which he found such compelling visual embodiments. For this reason, his reputation – as he himself predicted – waned after his death, and has never been high in non-Catholic countries. Recent scholarship, however, has restored him to his rightful place as one of the 'great image-makers of all time'. His work sometimes reaches out to crowds but more typically seeks to affect the individual viewer. In the most famous example, the Cornaro chapel (1645–52, Rome, S. Maria della Vittoria), architecture, painting, sculpture – in variously coloured marbles and gilt wood – and carefully adjusted natural light are combined so as to reveal, as in a vision, the ecstatic vision of St Teresa of Avila. Art historians have termed this Baroque effect the 'double vision': the saint's mystical experience of the divine is made the subject of the viewer's mystical experience of the work of art. Where *Renaissance artists expended their skills – notably in *perspective – to make of the spectator an 'eye-witness' of objectively 'real' events, Bernini draws the viewer into an enlarged sphere of subjectivity.

Trained in his father's workshop, Gian Lorenzo was early put to the study of the antique, profiting from Pietro Bernini's access to the Vatican collections. His earliest surviving work, variously dated 1609, 1612 or 1615, the *Goat Amalthea nursing the Infant Jupiter* (Rome, Borghese) evokes Hellenistic sculpture. At the same time he executed portraits (Rome, S. Giovanni dei Fiorentini, S. Prassede, S. Maria sopra Minerva) and religious statuary (Florence, Contini-Bonacossi Coll.; Lugano, Thyssen-Bornemisza Coll.). Drawn through his father into the circle of papal patronage (portrait bust of *Pope Paul V*, c.1618, Rome, Borghese) the youthful prodigy attracted above all the patronage of a great collector, the pope's nephew, Cardinal Scipione Borghese (portrait bust, two versions, 1632, Borghese). It was for Scipione that he carved the three great works which crown his early development: *Pluto and Persephone* (1621–2), *Apollo and Daphne* (1622–5) and *David* (1623;

all Borghese), which were influenced by contemporary painting, especially that of the recently deceased Annibale Carracci, his rival *Caravaggio, and Guido *Reni.

In 1623 the elevation to the papacy of another early patron, Cardinal Maffeo Barberini (Urban VIII, 1623–44) ended Bernini's career as a purveyor of collectors' sculpture. The new pope employed him extensively on the decoration of St Peter's. The great bronze baldacchino, a canopy over the site of St Peter's grave under the dome (1624–33) is a hybrid of sculpture and architecture and mediates between the human scale and the gigantic proportions of St Peter's. Bernini's plans for the piers supporting the dome included four colossal statues; he himself carved the Longinus (1632–8; see also Mochi; Quesnoy). He executed the marble and bronze tomb of Urban VIII in 1628–47; like his other mature works, it is a sculpted theatrical event, in which even the allegorical figures play a lively part, and a skeletal Death draws our fearful attention to the sarcophagus below. The concept is recast more dramatically and sombrely in the much later tomb of Pope Alexander VII in St Peter's (1671–8). Of Bernini's several other monuments for the Vatican church, mention must be made of the Cathedra Petri, 1657–66, the throne of St Peter as Vicar of Christ, which completes the symbolic and visual task of the baldacchino by closing off our view of the apse.

Bernini's portraits of the 1630s revolutionized sculptural practice in their pictorial representation of transient attitudes; when working from life, he sketched his sitter carrying on his daily routine. From this period date the busts of Scipione Borghese already mentioned; the likeness of Bernini's mistress, Costanza Buonarelli (c.1636, Florence, Bargello), which in intimacy and immediacy anticipates *Rococo sculpture; a bust of King Charles I, now lost, after the triple portrait by *Van Dyck, and the flamboyant portrait of the young Englishman who brought it to Rome, Thomas Baker, completed by an assistant (c.1637, London, Victoria and Albert).

In the 1640s Bernini worked more as a designer than an executant. In this decade began the great series of figurative fountains which changed the face of Rome, notably the Triton fountain for Urban VIII (1642-3, Piazza Barberini) and the strikingly theatrical Four Rivers fountain (1648–51, Piazza Navone) for Innocent X. Innocent X's successor, Pope Alexander VII (1655–67) proved to be one of Bernini's most generous patrons; amongst his commissions were the Cathedra Petri discussed above and the Scala Regia, the 'royal staircase' of the Vatican palace (1663-6) down which the pope was carried in his ceremonial chair and which provided Bernini with the occasion to execute one of his only two equestrian statues, the Constantine (compl. 1670). In 1665 Bernini visited France, but his grandiose plans for the façade of the Louvre palace were not accepted. Although his bust of King Louis XIV (1665, Versailles) was appreciated, the equestrian statue of

the King (completed 1677), a masterpiece of absolutist propaganda, was recarved to represent a Roman hero.

In the last phase of Bernini's career he designed, for Pope Clement IX, the *Angels* on the bridge over the Tiber leading to the papal fortress of Sant'Angelo (autograph *Angel with the Superscription*, 1670, Rome, S. Andrea delle Fratte). The visionary bust of *Gabriele Fonseca*, Pope Innocent X's physician, in his funerary chapel in S. Lorenzo in Lucina (*c*.1668) marks the apogee of Bernini's expressive portraiture, almost to the point of caricature (but *see* Algardi) and the altar monument of the *Blessed Lodovica Albertoni* (1671-4, Rome, S. Francesco a Ripa) takes up again themes of the Cornaro chapel in an even more vehemently emotional form. Where the youthful Bernini had revelled in the virtuoso carving of varying textures – as in the Scipione Borghese commissions – the old sculptor put his formidable technique entirely in the service of fervent spirituality. In an age of increasing doubt, he died affirming, in his art as, paradoxically for so accomplished a courtier, in his private life, the certainty of individual salvation to the point of mysticism.

Bernini's son, Domenico, wrote a life of his father published in 1713. His most outstanding follower was not a relation, however, but Antonio Raggi, originally a pupil of Algardi.

BERRETTINI, Pietro *See* Pietro da Cortona.

BERRUGUETE, Pedro (*d*.1504) and Alonso (*c*.1488–1561) Pedro Berruguete has been identified with 'Pietro Spagnuolo', Peter the Spaniard, who was the assistant of *Joos van Ghent in the ducal palace of Urbino, 1477. First-hand experience of both Netherlandish and Italian art is indeed suggested by the works he completed after his return to Spain by 1483, when he settled in Toledo to engage on a series of *retables.

Pedro's eldest son, Alonso, was the most important sculptor in 16th-century Spain. In Florence by *c*.1504, he studied the early work of *Michelangelo and participated in a contest of wax models after the ancient group of the *Laocoön*, discovered in 1506. He returned to Spain *c*.1517 (*Resurrection*, *c*.1517, alabaster relief, Valencia, cathedral). In 1518 he became court painter at Valladolid but was prevented by illness from following Charles V to Germany in 1520. Henceforth, although receiving benefices and eventually ennoblement, he worked only for royal ministers and high-ranking churchmen. Through his activity, the centre of Spanish sculpture shifted from Burgos to Vallodolid. He executed a number of complex sculpted altars (now Vallodolid, Museum; Santiago; Cáceres, Santiago; Salamanca, Irish college; etc.) and carved 36 walnut choir stalls, surmounted by 35 alabaster figures, for Toledo Cathedral (1539–43). Even when *polychromed, Berruguete's work is never naturalistic (*see under* realism). His is an *expressive form of *Mannerism, animated by recollections of Florentine sculpture – not only by the youthful Michelangelo, but also by *Donatello – unrefreshed by study from the life, but made more strident by a Spanish form of

religious intensity. His carving in relief can be refined and delicate, but his figure style is characterized by dislocated, angular outlines and elongated proportions. Although he had many pupils, notably Francisco Giralte and Isidro de Villoldo, his style never really became popular in Spain.

BERTOLDO di Giovanni (c.1420–91) Bronze sculptor, trained by *Donatello and employed on the latter's unfinished pulpits in S. Lorenzo, Florence; possibly responsible for the design as well as the casting of the *Entombment* relief and parts of the frieze. In his last years he was in charge of the collection of antiquities of Lorenzo the Magnificent de'Medici, and is reputed to have been *Michelangelo's master from c.1489. For the Medici he also made bronze statuettes (Florence, Bargello; Vienna, Kunsthistorisches) and a bronze relief (Florence, Bargello) reconstructing, or improvising upon, antique prototypes.

BETTERA, Bartolomeo and Bonaventura See under Baschenis, Evaristo.

BEUCKELAER, Joachim See under Aertsen, Pieter.

BIBIENA Influential family of Italian *quadratura* (see illusionism) specialists, stage designers, inventors, theatre architects and draughtsmen of scenographic fantasies, whose real name was Galli; they were called Bibiena after their place of origin in Tuscany. The most important were the brothers Ferdinando (1657-1743) and Francesco (1659-1739), pupils of Cignani in Bologna, and Ferdinando's sons Giuseppe (1696–1757) and Antonio (1700–74). Ferdinando spent 28 years in Parma as painter and architect before transferring in the same capacity to the imperial court at Vienna, 1708. His important treatise, *L'architettura civile . . .*, 1711, introduced the new device of two-vanishing-point or diagonal *perspective, which revolutionized the *Baroque stage and decisively influenced the draughtsmanship of *Piranesi. Francesco is known primarily as a theatre architect. Giuseppe, famed for opera sets, also published a collection of designs, the *Architetture e Prospettive*, 1740, which was the model for Piranesi's first publication and was influential on the great visionary artist in other ways (e.g. drawing, London, British, formerly attributed to Piranesi). Antonio practised both as a theatre architect and as a painter of *illusionist frescoes (Vienna; Pressburg; etc.).

BIRD, Francis (1667–1731) English sculptor, the first to receive extensive training in Flanders and Rome, between c.1678–c.1689, during a second journey to Rome c.1695, and probably a third in 1711. He worked for *Gibbons, then for *Cibber; his reputation as an independent sculptor dates only from after 1700. There are funerary monuments by him in London, at Westminster Abbey and St Paul's; and a *Conversion of St. Paul* on the west pediment of St Paul's, as well as monuments in the provinces (Isleworth, Middlesex; Tissington, Derbyshire; Oxford; etc.). He became one of the directors of *Kneller's *Academy; in the last decade of his life, when he had virtually ceased to

practise sculpture, he ran a business as an importer of Italian marbles.

BLES, Herri or Hendrick met de (known in Italy as Enrico da Dinant or Civetta) (1480?/c.1510?–50?) Ill-documented Flemish follower of *Patinir. He may be identical with the latter's nephew Henry Patenier, who became a master in Antwerp in 1535. He travelled in Italy, and probably spent some time in Ferrara, where his landscapes, more complex and more crowded with detail than those of Patinir, influenced local artists, notably *Dosso Dossi. His best-known picture, *The Copper Mine*, has been in Florence, Uffizi, since 1603. There are works also in Vienna, Kunsthistorisches; Piacenza, Galleria; Pisa, Museo; etc.

BLOCKLANDT; Anthonie van Montfoort, called (1534–83) Dutch painter, the founder of Utrecht *Mannerism. A student of Frans *Floris in Antwerp, he travelled to Rome in 1572. By 1577 he had returned to Utrecht, where he specialized in altarpieces, most of which were destroyed by Calvinist iconoclasts (*see under* icon). He was the teacher of *Bloemaert, *Wtewael and others. His compositions, disseminated through engravings (*see under* intaglio prints), influenced some of the greatest Spanish painters, including *El Greco, Morales (*see under* Valdés Leal) and even *Velázquez.

BLOEMAERT, Abraham (1564–1651) Utrecht *Mannerist painter. Like his compatriot *Wtewael, he must have absorbed elements of this artificial style during a voyage to France, 1580-83; from 1591–93 he was in Amsterdam, where he encountered the work of Haarlem Mannerists (*see* Goltzius, van Mander, Cornelis van Haarlem). Unlike Wtewael, he abandoned Mannerist complexity c.1600, when he adopted a more 'sober', *classicizing mode. His importance derives in great part from his having taught virtually all the Utrecht painters of his day, including *Honthorst and *Terbrugghen. After 1620 he was himself influenced by Honthorst's adaptation of the style of *Caravaggio. His son, Frederick Bloemaert (after 1610–after 1669), engraved his father's *Foundations of the Art of Drawing*, which continued to be used in the training of Dutch artists until the 19th century. There are works by Bloemaert in most continental collections; in London, Ham House, and in some collections in the USA (Toledo, Ohio). Another son, Hendrick Bloemaert (1601–72) painted mainly history pictures (*see under* genres) in small format (Utrecht, Museum).

BODEGÓN *See under* still-life.

BODY-COLOUR A colour which has 'body', as opposed to a tint or wash; that is, watercolour made opaque by the addition of white. *See also* gouache.

BOL, Ferdinand (1616–80) One of *Rembrandt's most productive pupils, probably the teacher of Godfrey *Kneller. Early in his career he imitated Rembrandt's *chiaroscuro, but from the 1640s he turned to the lighter, brighter manner derived from *Van Dyck. He became a fashionable portraitist (e.g. *Admiral de Ruyter*, 1667, The

Hague, Mauritshuis) and was also in demand as a painter of allegories and history pictures (*see under* genres) for public buildings (e.g. *The Intrepidity of Fabritius in the Camp of King Pyrrhus*, 1656, Amsterdam Town Hall, now Royal Palace). After his second marriage in 1669 to the widow of a wealthy merchant, Bol ceased painting, and lived as a patrician.

BOLOGNA, Giovanni; also called Giambologna (1529–1608) Born in Douai as Jean Boulogne, he trained from *c.*1544 in the workshop of the Italianate Flemish sculptor Jacques Dubroeucq, and became the most influential Italian sculptor of the second half of the century, the historical link between *Michelangelo and *Bernini. His characteristic style, *Mannerist in its sinuous and complex elegance, became widely available throughout Europe with the bronze or silver statuettes sent by his Medici patrons as diplomatic gifts to courts in Italy and across the Alps, and was propagated also through his many transalpine students and assistants (*see* e.g. Adriaen de Vries). It is perhaps less well known that the same artist executed sober and unmannered portraits (e.g. *bust of Cosimo I*, late 1550s, Florence, Uffizi) and religious works (e.g. Genoa, S. Francesco di Castelleto, now university chapel and Aula Magna), and naturalistic (*see under* realism) sculptures of animals and birds (Florence, Bargello; Berlin-Dahlem, Museen).

Having set out, *c.*1550, on a study trip to Rome, where he met the aged Michelangelo, Giambologna was induced on his way home to settle in Florence. By 1560 he had attracted the favour of Francesco de'Medici and was competing for the commission of a statue of *Neptune* as centrepiece to a fountain for the Piazza della Signoria. Although he lost the commission to *Ammanati, his full-scale clay model won him renown. A series of large multi-figured marble groups was commissioned from him by Francesco: *Samson and Philistine*, *c.*1560–2 (London, Victoria and Albert), *Florence Triumphant over Pisa*, *c.*1564 (Florence, Bargello) and the *Rape of a Sabine Woman*, 1580s (Florence, Loggia dei Lanzi). These address a problem perennial in Florentine sculpture since *Donatello: how to unite several figures in a single-action group, successful from different viewpoints. The *Rape of a Sabine* realizes an obsession long held by Michelangelo but never executed by him in stone: uniting three figures in a single spiral composition. The sculptural problem had preceded the choice of a specific narrative subject, which was identified subsequently by a bronze relief added to the base.

Between working on the first two marble groups for Francesco, Giambologna received the commission (1563) for the bronze figures of a *Fountain of Neptune* for Bologna. During his stay there he produced the earliest version of the famous bronze *Flying Mercury* (Bologna, Museo). A slightly later version was sent as a diplomatic gift by Cosimo I de'Medici to the Emperor Maximilian II in 1565 (Vienna, Kunsthistorisches). A third variant, *c.*1578, is in Naples, Capodimonte; it established the form in which the *Mercury* was later reproduced on a

small scale in the workshop. Finally, the nearly life-size version now in Florence, Bargello, was cast in the 1590s.

Giambologna's monument to Cosimo I (1587–99, Florence, Piazza della Signoria), the first equestrian statue in Florence, was the fruit of studies for a sculpture of a pacing horse begun early in the sculptor's career; this work (and the base relief showing the rider on a rearing horse) demonstrates his interest in *Leonardo's studies for the never-cast Sforza and Trivulzio monuments. The *Cosimo I on horseback* itself spawned a series of commissions completed by assistants largely after Giambologna's models (*Ferdinando I de'Medici*, 1601–07/8, Florence, Piazza SS. Annunziata; *Henry IV of France*, c.1600-10/14, formerly Paris, Pont-Neuf, destroyed 1792, fragments in Louvre; *Philip III of Spain*, 1606–16, Madrid, Plaza de Oriente). The chief assistants associated with these workshop projects were Pietro *Tacca, who succeeded Giambologna as granducal sculptor, Antonio *Susini and Pietro *Francavilla. The shop also produced many statuettes of horses and mounted riders (e.g. Dijon, Musée; Kassell, Schlöss), which became archetypal symbols of monarchic authority throughout Europe, and were widely imitated.

With the succession in 1587 of Ferdinando I de'Medici, the proto-industrial organization of the workshop was completed through the provision of a foundry, extensive storage space and even dormitory rooms for assistants, technicians and labourers, all geared to the manufacture of granducal monuments and small-scale diplomatic gifts. Division of labour increasingly pertained, and the master's models were reused for many cast examples of variable quality. From the 1590s, Giambologna's participation was virtually limited to the creation of wax sketches and clay models, and, in his last years, to an advisory role only – as in the project of the three pairs of bronze doors for the west façade of Pisa Cathedral, c.1600.

In addition to the works already mentioned, the best-known statuette types originating in Giambologna's workshop include the *Woman bathing* and the *Venus Urania* (signed versions Vienna, Kunsthistorisches); *Apollo* (best version Florence, Palazzo Vecchio *studiolo*); *Mars*; various figures in mythological guise of *Morgante*, the court dwarf of Cosimo I, (Florence, Bargello; Paris, Louvre; London, Victoria and Albert); *Nessus and Deianira*; the *Labours of Hercules*; and the *genre* subjects of the *Bird-catcher*, *Bag-piper* and *Peasant resting on his staff*, which wittily combine rustic northern European themes with poses drawn from antique Roman sculpture.

BOOKS OF HOURS In the Late Middle Ages, the most important religious books in use by the laity, especially popular in northern Europe. They included the Psalms, prayers to the Virgin, and a church calendar, and were written partly in the vernacular and partly in Latin. Because manuscript Books of Hours were richly illuminated, they were extremely important in the evolution of northern European painting, especially in the development of certain *genre* subjects included in the

Labours of the Months (see e.g. Bruegel, Pieter the Elder). Particularly famous for their illustrations are the five Books of Hours executed for the Duke of Berry in the late 14th century (now Paris, Bibliothèque Nationale and Louvre; Brussels, Bibliothèque Royale; Turin, Museo; Chantilly, Musée Condé; see also Limbourg Brothers; Jan van Eyck).

BOR, Paulus (c.1660–69) Italianate Dutch painter of religious and mythological subjects and portraits; a founder member of the *Schildersbent, the Netherlandish artists' fraternal association, during his stay in Rome 1623–6. After his return to Holland he worked in his native Amersfoort, near Utrecht (Utrecht, Centraal) participating also in the decoration of the royal palaces at Honselaersdijk and Rijkswick (destroyed) and the Huis ten Bosch. He was profoundly influenced by *Caravaggio's Italian follower Orazio *Gentileschi and the Utrecht Caravaggesque painters, *Terbrugghen, *Honthorst, *Baburen.

BORCH, Gerard Ter See Ter Borch.

BORDONE, Paris (1500–71). Painter from Treviso; a pupil of *Titian from c.1518. He died one of the most famous artists in Venice; before then, however, he had travelled widely – to Crema in Lombardy 1525–6; to France in 1538 or 1559 or both; to Augsberg c.1540 and Milan soon after; and to his native Treviso 1557–8. Around 1533–5 he painted a telero for the Scuolo di S. Marco in Venice (see under Carpaccio) now in Venice, Accademia, which shows his preference for architectural settings. He was an accomplished portraitist (e.g. London, National; Vienna, Kunsthistorisches; Chatsworth), but was perhaps best-known for his mythological, biblical and allegorical *cabinet pictures (e.g. Berlin-Dahlem, Museen; Cologne, Wallraf-Richartz; Hamburg, Kunsthalle; Leningrad, Hermitage). His mature style was influenced by the *Mannerism of the School of Fontainebleau (see e.g. Primaticcio).

BOSCH, Hieronymus (first recorded 1474–1516) His family name was van Aken, suggesting origins in the German town of Aachen; the name by which he is known refers to the Dutch town of 's-Hertogenbosch, where he was born (presumably c.1450), lived and worked. Bosch is celebrated for panel pictures, both large and small, fantastically peopled with a nightmare world of shifting forms and inconsistent scale, elegantly painted with sometimes lurid colour effects. The effects of metamorphosis – beings changing from one order of existence to another – recall those of *Gothic manuscript decorations or Italian *grotesques, but are far more gruesome and threatening. The meticulous techniques of oil painting in translucent layers or glazes (see under colour) evolved by Jan van Eyck are utilized by Bosch to give a semblance of reality to his creations, deployed within landscapes that stretch as far as the eye can see, or across night scenes fitfully illuminated by the fires of Hell or Armaggedon.

Fanciful theories have grown up around these paintings in the 20th century, from psychoanalytical explanations to hypotheses of Bosch's

allegiance to magic, alchemy or a secret heretical sect. But it can be demonstrated that these pictures were designed to impart quite orthodox moral and spiritual truths, and that their monstrous visual imagery often simply translates into pictorial form verbal puns and metaphors, the linguistic imagery of proverbs, sermons and popular devotional literature. It is probable that Bosch's most dreamlike allegories (such as the large *triptychs of the *Garden of Earthly Delights* and the *Haywain*, both Madrid, Prado, the latter in another version in the Escorial) were painted for lay patrons – Burgundian nobles at the courts of Brussels and Malines – who delighted in intricately crafted and refined works of art and craft, but required also a moralizing message. His equally nightmarish, but more conventional *Last Judgement* triptych, now in Vienna, Akademie, may have been an actual altarpiece, or intended for an institution such as a hospital, like Rogier van der *Weyden's *Last Judgement* in Beaune, Hôtel-Dieu.

Bosch's pictorial inventions spawned innumerable successors, amongst them Pieter *Brueghel's painted allegories and the prints after them; his influence can be traced through the 17th century.

We should be aware, however, that these paintings do not represent Bosch's entire *oeuvre*, which included striking but less enigmatic representations of human folly (e.g. the early *Tabletop of the Seven Deadly Sins and the Last Four Things*, Madrid, Prado) and, in well over half of his extant pictures, traditional Christian subjects, especially episodes of the Passion of Christ (e.g. Brussels, Musées; Ghent, Musée; Berlin-Dahlem, Museen; etc.).

BOSSCHAERT, Ambrosius the Elder (1573–1621) Antwerp-born founder of a dynasty of Dutch fruit and flower painters. He specialized in bright, evenly lit, symmetrical bouquets of individually-portrayed blooms, assembled from independent studies made at different times of year, set in arched windows opening on distant landscapes, and flanked by insects and sea shells (The Hague, Mauritshuis; etc.). His three sons, Ambrosius the Younger (1609–45), Johannes (1610/11–?) and Abraham (1612/13–43) continued in the same tradition.

BOTH, Andries (c.1612–41) and his better-known brother Jan (1615/18–52) Italianate Dutch painters; Jan was the most gifted member of the second generation of landscape specialists in this mode, and Andries executed outdoor *genre* subjects in the manner of Pieter van *Laer. He is supposed also to have painted the figures in his brother's landscapes, but no collaborative painting has been identified with any certainty, except possibly the *Capriccio with Figures in the Forum Romanum* (Amsterdam, Rijksmuseum). Born in Utrecht, both brothers studied with *Bloemaert before leaving for Rome, where Andries arrived c.1632 and was joined by Jan in c.1637. During his stay in Italy (to 1641) Jan evolved an original and extremely influential vision of the Roman Campagna as a setting for modern idylls: artists sketching

(Amsterdam, Rijksmuseum), peasants on the road (Indianapolis, Museum) or watering their flocks (London, National) etc. His landscape style combines realistic detail with a refined sense of composition and an all-pervading golden sunlight akin to that of *Claude. After Andries' accidental death by drowning in Venice, Jan returned to Utrecht where he inspired even artists who had not been to Italy to paint Italianate landscapes and Dutch landscapes bathed in the atmosphere of the Campagna (*see especially* Cuyp). There are drawings by Andries Both in Leiden, University; London, Witt.

BOTTICELLI, Sandro (1444/5–1510) Florentine painter, probably a pupil of Filippo *Lippi, and teacher of the latter's son Filippino Lippi. Between the departure from Florence of *Leonardo da Vinci, then *Pollaiuolo and *Verrocchio (c.1482, 1484 and 1485 respectively) and the death of Lorenzo de'Medici in 1492, he was the most sought after and widely imitated artist in the city, especially for the Madonna and Child pictures which he and his workshop turned out in great numbers (e.g. Florence, Uffizi; Berlin-Dahlem, Museen; London, National). Like other successful Florentine painters of the time he also executed altarpieces and church *frescoes (*see below*); portraits (e.g. London, National, Victoria and Albert; Washington, National; Florence, Pitti, Uffizi) a few *cassone* and wall-panelling paintings (Madrid, Prado; Bergamo, Accademia; Boston, Gardner; London, National; Dresden, Kunstsammlungen; New York, Metropolitan). His first documented work was an allegorical figure for the Mercanzia, a guild commercial court (*Fortitude*, 1470, Florence, Uffizi). His fame today, however, rests largely on his authorship of a very few pictures of an unprecedented kind: the first post-antique mythological paintings on the scale of life. The *Primavera*, c.1478; *Pallas and the Centaur*, c.1482 and the *Birth of Venus*, c.1485–6 (all Florence, Uffizi) adopt the large size and moral seriousness of altar paintings, albeit their pictorial treatment betrays their private and decorative nature. Both the *Primavera* and the *Birth of Venus* resemble, especially in the backgrounds and in the relationship of figures to backgrounds, the late medieval Flemish tapestries so popular in Florence at the time. And although Botticelli based some of his mythological personages on *classical sources, he did not disguise his preference for the sinuous International *Gothic ideal of feminine beauty.

The erotic painting called *Mars and Venus* (after 1485, London, National) may not, in fact, represent a mythological theme. Probably part of the decoration of a bed, it must, however, have some nuptial relevance.

Less well known are the fresco fragments from the Villa Lemmi near Florence (c.1483, now Paris, Louvre) probably representing a newly married couple being introduced to the Arts and Sciences and welcomed by the Graces.

However interesting to the modern viewer, these exceptional private

commissions would not have been viewed at the time as important in comparison with Botticelli's participation in 1481-2 in the mural decoration of the Sistine chapel in Rome (*see also* *Perugino, *Ghirlandaio, Cosimo *Roselli). Botticelli executed three large narrative frescoes; two depicting stories of the *Life of Moses* from the Old Testament and one representing both an Old Testament blood sacrifice and the *Temptation of Christ* from the New Testament. Here he demonstrates his particular gift for the clear visual exposition of narrative and of theological subtleties, evident in the major altarpieces produced on his return to Florence. In the earliest of these, the *S. Barnaba* altar (Uffizi), the emaciated figure of St John the Baptist recalls *Donatello. By the end of the decade, and through the 1490s, this harsh angularity, reminiscent also of Netherlandish and German art, spread to all of Botticelli's painted protagonists (e.g. two versions of the *Lamentation*, Munich, Alte Pinakothek; Milan, Poldi Pezzoli). In no other picture is this archaicizing mode more evident than in the small so-called *Mystic Nativity* (1501, London, National), where, as in medieval art, the scale of the figures varies in accordance with their religious significance. We know that Botticelli's brother was a follower of Savonarola, the Dominican friar who ruled Florence as a theocracy after the death of Lorenzo de'Medici until his execution in 1498. Although there is no evidence that Botticelli himself was a champion of the friar, the Greek inscription on this personal work, and the deeply felt fervour of all the late paintings, bespeak his increasing involvement in the secular and religious perturbations of the time.

Botticelli, in some ways so responsive to Florentine tradition, was in other ways untypical. He never shared the Early *Renaissance interest in *perspective, the study of anatomy, or even, paradoxically, classical antiquity. Although capable of *realism in details, he was more interested in decorative or expressive values, and he eschewed tonal painting and *chiaroscuro to the end of his life. Whilst continuing to be respected in Florence, he fell out of favour as a painter, to be rediscovered by the general public only after 1850, partly through the interest of the English Pre-Raphaelite Brotherhood (*see* Volume Two).

BOUCHARDON, Edmé (1698–1762) French sculptor, internationally famous in his day for reacting against the pictorial and *expressive idiom of *Baroque and *Rococo sculpture (*see* especially Jean-Baptiste Lemoyne, the brothers Adam and Guillaume Coustou the Elder, briefly Bouchardon's teacher). Trained by his father, the provincial sculptor and architect Jean-Baptiste Bouchardon (1667–1742), he was highly proficient technically, imposing an icy high finish on his works. Always based on intensive study from life, these sometimes imitate closely the sculpture of *Classical antiquity (bust of *Philipp Stosch*, 1727, Berlin-Dahlem, Museen), and at other times strive for a calmly dignified naturalism (*see under* realism) (bust of *Pope Clement XII*, 1730, Florence, Corsini Coll.). Bouchardon's attempt to ally realism

with classicism within a single work (*Cupid making himself a bow from the club of Hercules*, *c.*1750, Paris, Louvre) not only did not find favour at the French court, where the statue was criticized for 'turning Cupid into a street-porter', but proved an embarrassment in the making: when the eminently respectable Bouchardon sought an adolescent model amongst youths bathing in the Seine, he was reported to the police for soliciting.

Bouchardon spent 1723–32 in Rome as a pensioner of the French *Academy. Already famous and much in demand, he reluctantly obeyed a summons to return to France, where, despite the enthusiasm of an influential group of connoisseurs, he would not receive a major commission for five years. Finally, in 1739, he was able to design for the city of Paris a work of the type which had eluded him in Rome, where his project for the Trevi fountain had been rejected (*see also* Lambert-Sigisbert Adam). The fountain of the Rue de Grenelle, combining sculpture with architecture, is his one extant public monument. His huge equestrian statue of Louis XV, commissioned by the city authorities for the Place Louis Quinze in Paris in 1749, was completed only after the sculptor's death by his nominee *Pigalle (destroyed in the French Revolution).

BOUCHER, François (1703–70) Protégé of Mme de Pompadour and the leading French painter of the early–mid-18th century. In contrast to his contemporary *Chardin, he was the consummate *Rococo decorator, and the greatest exponent of fashionable *mythologie galante* – a decorative composition devoid of drama in which the mythological theme is an excuse for erotic display of the female nude, a type of painting which Boucher executed with wit and charm (outstanding examples, Stockholm, Museum; Paris, Louvre, Cognac Jay). But he practised all the *genres with the exception of serious history painting and the lowly still-life: altarpieces (e.g. Lyons, Musée); modern *Conversation Pieces (Louvre); portraits, quasi-official such as those of Mme de Pompadour (e.g. Munich, Alte Pinakothek; London, Victoria and Albert) or the affectionately ironic, intimate one of his wife (New York, Frick) or the vigorously realistic one of the baby Duke of Montpensier (Waddesdon Manor); decorative pastoral or rustic *genre* and landscape (e.g. Barnard Castle; London, Kenwood); hunting scenes inspired by *Rubens (Amiens, Musée); stage designs for the Opera; tapestry designs for the factories of Beauvais and the Gobelins (one of the two large mythologies now in London, Wallace, was begun as a *grisaille* tapestry cartoon (*see under* fresco) for the Gobelins; *see also* Oudry).

A brilliant draughtsman, the son of a minor painter who apprenticed him briefly to François *Lemoyne, Boucher early practised as a book illustrator and by *c.*1722 was one of the engravers (*see under* intaglio prints) reproducing *Watteau's *oeuvre* for publication. He has been called Watteau's greatest posthumous pupil. Other major influences – besides Rubens and, at second-hand, *Correggio – were

the so-called 'little masters' of the Dutch and Flemish school, such as the
Italo-Dutch *Berchem, by whom he owned a painting. From 1727–31
he was in Italy with *Natoire and Carle van *Loo, but not a full
pensioner of the French *Academy in Rome. It is often said that he
admired *Tiepolo, although it is uncertain what paintings by him he
could have seen; in any case, his style owes little to large-scale Italian
decoration with its *illusionistic *perspectival effects. In 1765, he was
made Director of the Academy and *Premier Peintre du Roi*, although he
was already ill and his powers failing. By the 1760s royal taste, to which
Boucher remained faithful, was being challenged, and the artist was
publicly criticized for not painting works capable of elevating private
morality and public virtue. He was the teacher of *Fragonard.

BOULOGNE, Jean *See* Bologna, Giovanni.

BOURDICHON, Jean *See under* Fouquet, Jean.

BOURDON, Sébastien (1616–71) Eclectic and derivative, albeit
highly successful French painter, whose best and most personal
works, executed in Paris after 1663, translate the *classicism of *Poussin
into a more elegant and cooler idiom (e.g. *Holy Family*, before 1670,
Kent, Saltwood). Born at Montpellier, he moved in 1623 to Paris and in
1630 to Bordeaux. From 1634–7 he worked in Rome, imitating the
work of the *bamboccianti* (*see under* Laer) and of *Castiglione. In 1637 he
returned to Paris via Venice; his major works of the 1640s adopt
Venetian colourism (*see under disegno*) and *Baroque compositions (e.g.
Louvre). In 1652 he was invited by Queen Christina to be court painter
in Sweden; in this capacity he executed only portraits (e.g. Stockholm,
Museum; Madrid, Prado) and after Christina's abdication and his
return to Paris in 1654 he continued successfully to practise as a port-
raitist. Simultaneously, however, he also painted altarpieces chastened
by the growing influence on him of *Poussin (e.g. Montpellier, Musée;
Madrid, Prado; Paris, Louvre). Around 1659 he went to Montpellier,
where he painted a large *Fall of Simon Magus* for the cathedral in the
same style, a series of tapestry cartoons (*see under* fresco) and seven
increasingly Poussinesque canvases of the *Acts of Mercy* (Sarasota, Flor-
ida, Museum). He was driven back to Paris in 1663 by the violent
jealousy of local painters.

BOUTS, Dieric, Dirk or Thierry (1420s–75) Haarlem-born Nether-
landish painter, active mainly in Louvain, where he became offi-
cial town painter in 1468. Influenced by Rogier van der *Weyden and
Jan van *Eyck, perhaps through the agency of Petrus *Christus, he ran
a large and active workshop whose output in turn influenced many
northern European, especially German, artists. His sons Dieric Bouts
the Younger (1448-91) and Aelbrecht Bouts *c.*1455/60–1549) assis-
ted him in the shop, and problems of attribution have arisen in relation
to their output and to documentary records. His mature work is
characterized by rationally organized space, whether landscape or
architecture, depicted from a high viewpoint and with single-vanishing-

point *perspective. Against such backgrounds, increasingly elongated figures are deployed in stiff and solemn poses. His best-known work is the *Last Supper Altarpiece*, 1464–7, Louvain, St Pierre; in 1468 he was commissioned for four panels on the subject of justice for the Town Hall of Louvain, of which only one was fully completed before his death, and the second finished by an unknown painter (now Brussels, Musées). These narratives of the *Justice of Emperor Otto III*, 1470-5, are perhaps the most important large-scale, secular narrative works of the period in northern Europe. Bouts also painted striking portraits (e.g. New York, Metropolitan; London, National) and is the author of a rare work on linen, the *Entombment*, *c*.1455–60 (London, National). There are other devotional works by him in Granada, Capilla Real; Madrid, Prado; Lille, Musée; etc.

BRAIJ or BRAY, Salomon (1596–1664) and Jan de (*c*.1627–97) Dutch artists, father and son. Salomon was born in Amsterdam, moving whilst young to Haarlem, where he studied with *Cornelis van Haarlem and *Goltzius. He practised both as an architect and a painter. In the 1630s he painted a number of Old Testament narrative composi- tions with half-length figures (e.g. Malibu, Calif., Getty) influenced by, amongst others, *Lievens; after *c*.1640 he turned to *classicizing com- positions with full-length figures (e.g. his contributions to the decora- tion of the Huis ten Bosch). He died of the plague, preceded by his wife and four of their children. One of the surviving sons, Jan, is well known as a history (*see under* genres) painter (e.g. Haarlem, Town Hall) and portraitist, especially of *portraits historiés* (e.g. Louisville, Kentucky; Rotterdam, Boymans-Van Beuningen).

BRAMANTINO; Bartolommeo Suardi, called (*c*.1465–1530) Milan- ese painter, probably trained by the architect Bramante who also practised as a painter in Milan. From his native Urbino, Bramante imparted to his pupil the tradition of *Piero della Francesca, of highly structured but immobile compositions. This mode Bramantino infused with Lombard *realism and *expressivity (e.g. Milan, Ambrosiana; Lugano, Thyssen-Bornemisza Coll.; London, National). After a visit to Rome, 1508–9, Bramantino was ready to accept the influence of *Leon- ardo da Vinci, evident in the greater monumentality of his best works from *c*.1510–20 (e.g. Milan, Brera).

BRAY, Salomon and Jan de *See* Braij, Salomon and Jan de.

'BREAKFAST PIECE' *See under* Heda, Willem Claesz., and Claes, Pieter.

BREENBERGH, Bartholomeus (*c*.1599–1655/9) A leading member of the first generation of Italianate Dutch painters. A native of Deventer, he was in Amsterdam before 1619 and lived in Italy from 1619 to 1629. His pen-and-wash drawings of the Roman Campagna anticipate those by *Claude (Oxford, Christ Church); his painting style was much influenced by *Elsheimer, and, to a lesser extent, Paul *Brill. After his return to Amsterdam his work becomes extremely eclectic. He also etched (*see under* intaglio prints). There are works by him in

Amsterdam, Rijksmuseum; Berlin-Dahlem, Museen; Dulwich, Gallery; London, National; Malibu, Cal., Getty; etc.

BREGNO, Andrea (1418–1506) Lombard-born sculptor. Arriving in Rome in the 1460s, he became the most popular sculptor in the city, through the precision of his decorative carving, inspired by *classical motifs. Many Roman churches contain altars and wall monuments by him and his shop. He sometimes worked in collaboration, for example with *Mino da Fiesole at SS. Apostoli. As his fame spread, he was commissioned to execute the Piccolomini altar for Siena cathedral (1481–5), to which *Michelangelo later contributed four statuettes (1501–4). His style was carried back to northern Italy by his pupil Gian Cristoforo, called Romano, the son of *Isaia da Pisa.

BREGNO, Antonio (recorded from 1425–after 1457) Ill-documented Lombard sculptor from Como active in Venice. He was the principal sculptor of the transitional period between Bartolommeo *Buon and Antonio *Rizzo and Pietro Lombardo (*see* Pietro Solari). He probably worked as a member of Buon's studio on the Porta della Carta of the Doge's palace, and in collaboration with Rizzo on the Arco Foscari. His work on these projects has been identified on the basis of the attribution to him of the monument of Francesco Foscari in S. Maria dei Frari, influenced by Florentine sculptors active in Venice, notably Pietro di Niccolo *Lamberti.

BREKELENKAM, Quiringh (*c.*1620–67/8) Dutch painter, active in Leiden from 1648. He specialized in scenes from the lives of artisans and small shopkeepers and their families, emphasizing the virtues of parental instruction, diligent labour and domesticity. Thirteen variations on the theme of a tailor's shop are recorded (e.g. Amsterdam, Rijksmuseum; London, National; Philadelphia, Museum; Bonn, Museum; Worcester, Mass., Museum) and half a dozen of men or women spinning (notably Philadelphia, Museum; New York, Metropolitan; Amsterdam, Rijksmuseum). There are also paintings by Brekelenkam in Leiden, Museum.

BREU, Jörg the Elder (*c.*1475/6–1537) Painter and designer of stained glass and woodcuts. He is best-known as the founder of the so-called 'Danube school' (*see also* Lucas Cranach the Elder, Albrecht Altdorfer, Wolf Huber). During his *Wanderjahre* in Austria, *c.*1500–02, he evolved a type of altarpiece in which directly observed landscape and landscape motifs were a major, and emotionally *expressive, adjunct to narrative, even in scenes of the Passion (Zwettl, parish church; Herzogenburg, collegiate buildings; Nuremberg, Museum; Melk, abbey). From 1502 until his death, Breu worked at Augsburg, where he increasingly made use of Italianate *Renaissance motifs, some derived directly from Italian masters of the 15th century, others adopted after *Dürer, and others still from the Augsburg artist *Burgkmair.

In addition to the works cited, there are paintings by Jörg Breu in

Augsburg, St Anna; Munich, Alte Pinakothek; Dresden, Gemälde-galerie; Aufhausen, parish church. He contributed to the drawings for the Emperor Maximilian I's prayer book (see Dürer), and made 18 woodcuts (see under relief prints) of the investiture of Ferdinand I in 1530.

Breu's son, Jörg Breu the Younger (after 1510–47) was his pupil. After Wanderjahre which took him as far abroad as Venice, he was registered as a master painter in Augsburg in 1534. He seems to have specialized in large-scale, *classicizing decoration (New York, Metro-politan).

Nicolas Breu (recorded in Austria 1524–33) was the younger brother of Jörg Breu the Elder and his pupil at Augsburg. He has been tentatively identified with the so-called Historia Master, also known as the Master of Pulkau, active from c.1508, and included in the 'Danube School' through his mastery of, and emphasis on, land-scape. He is the author of the altarpiece in the parish church, Pulkau (c.1518–22), and of the illustrations to Grünpeck's text of the Historia Friderici et Maximiliani, c.1514–15 (Vienna, Staatsarchiv). There is a Nativity by this artist in Chicago, Institute.

BRIL(L), Paul (1554–1626) and his older brother Matthew (1550–83) Born in Antwerp, they played a key role in the evolution of landscape painting in Italy, assimilating Flemish modes to the new *classicizing style of the *Carracci school. This development cul-minated in the grand landscapes of *Poussin and *Claude, whose teacher, Tassi, may have been taught by Paul Bril.

Matthew was already an established landscape specialist, working in the Vatican, when his brother joined him in the mid-1570s. Paul is first recorded in the *Academy of St Luke in 1582. At Matthew's premature death he succeeded him in papal service (*frescoes, 1589, Vatican, Scala Santa). It is generally accepted that he was active in Naples as well as Rome, leaving many easel paintings in the city; a leading share of the influential landscape and *grotesque frescoes in the Ospedale degli Incurabili can be attributed to him. There are easel landscape paintings and paintings on copper by him in most of the main galleries in Europe.

BRIOSCO, Andrea See Riccio.

BRIOSCO, Benedetto (active 1483–1506) Lombard sculptor, prob-ably trained in the workshops of Milan cathedral (St Agnes, com-pleted 1491, Milan, Museo del Duomo). He collaborated with Gian Cristoforo Romano (see under Isaia da Pisa), adopting his Neo-*Classical style, on the Visconti monument in the Charterhouse of Pavia in the 1490s, and with *Amadeo, whom he converted to the new manner, at Pavia, S. Lanfranco, c.1498. When Amadeo left his directorship of the façade sculpture at the Charterhouse to become chief architect of Milan cathedral, Briosco was left in charge, being confirmed as sculptor-in-chief in 1501 (reliefs of the portal).

BRONZINO, Agnolo (1503–72) Florentine painter, one of the greatest portraitists of the 16th century and an outstanding exponent of *Mannerism in religious art. After training with Raffaellino del Garbo (d.1527) he became the pupil and quasi-adoptive son of *Pontormo. Although he modelled his style on Pontormo's, the resemblance is superficial. Pontormo distorts the human form for the sake of emotional communicativeness and for him, as for *Michelangelo, aesthetic beauty is symbolic of spiritual values. For Bronzino, style itself is a value: the poignancy of his best work is due to an abnegation of feeling. This is nowhere more apparent than in the *Allegory of Illicit Love* (c.1545, London, National) in which erotic passion and its consequences (including, as recent research has shown, syphilis) are elaborated into patterns of crystalline grace. This tendency of Bronzino's work predates, but must have been reinforced by, his service at the autocratic court of Cosimo I de'Medici.

Bronzino's independent career began with a period in Pesaro, 1530–2, where he executed his earliest known portrait (*Guidobaldo, Duke of Urbino*, Florence, Uffizi). From then on he was to remain mainly in Florence, with trips to Rome recorded between 1546–8. His portraits vary with functional requirements. Where the sitters seem to demand it, their icy refinement is very great (e.g. *Ugolino Martelli*, c.1536, Berlin-Dahlem, Museen; *Bartolommeo Panciatichi* and his wife *Lucrezia*, pendants, both c.1540, Florence, Uffizi; *Laura Battiferri Ammanati*, 1555–60, Palazzo Vecchio). On the other hand, the dynastic portrait of Cosimo's wife and his heir – from which copies and variants were to be produced – is boldly direct (*Eleonora di Toledo and her son*, c.1545, Florence, Uffizi). In the images of the Medici children, notably of the teething two-year-old *Giovanni* (1545, Uffizi) a sympathetic *realism seems to exclude style altogether. In 1541 Bronzino began the *fresco decoration of Eleonora's private chapel in Florence, Palazzo Vecchio, his first large-scale religious work, in which naturalistic proportions and *classical features are conjoined with decorative pattern and colour. An even more extreme example of Mannerist composition is provided in the 1565–9 fresco of the *Martyrdom of St Lawrence* in the side aisle of S. Lorenzo (where Pontormo had been painting the choir before his death in 1557). Here the figures strike poses, Michelangelesque but flattened to rhyme with the wall surface and robbed of tragic import, in an *all'antica architectural setting complementing and extending Brunelleschi's architecture. Large altarpieces were painted by Bronzino for Eleonora's chapel (1545, now Besançon, Musée; replica *in situ*, 1553); for SS. Annunziata (1552); S. Croce (1552, now Museo di S. Croce), the latter in a style whose rhetorical clarity announces the Catholic Reformation. An analogous sentiment may be found in certain late portraits, such as the *Widow with a statuette of Michelangelo's Rachel* (c.1555–60, Florence, Uffizi).

Bronzino died in the house of the family of his favourite pupil, *Allori, who adopted his name.

BROUWER, Adriaen (*c.*1605–38) The most pictorially refined painter of low-life subjects (*see under* genres), many of them rowdy peasant tavern scenes. According to literary sources, he himself frequented port houses, paying his bills with sketches, and despised the hypocrisy and pretensions of 'respectable' society. Brouwer reconciled the sense of drama and the strictly geometric compositions of the art of his native Flanders with the painterly, tonal treatment characteristic of Dutch art, having worked from *c.*1624 to *c.*1631 in Holland, mainly in Haarlem where he came into contact with Frans *Hals.

Brouwer's first teacher was his father, a specialist in tapestry cartoons, but his earliest known work is indebted to Pieter *Bruegel the Elder, founder of the category of peasant subjects. After his return to Flanders (he became master of the Antwerp Painters' Guild in 1631/2) the vivid local colours and rigidly planar compositions of his first manner gave way to a subtler, more atmospheric treatment. Continuous space is suggested through a predominant use of translucent greys and browns, with a focal accent in a single colour: red or green, gold or blue. In the last years of his life he painted some landscapes, idyllic in mood albeit realistic in subject (Berlin-Dahlem, Museen). Both *Rembrandt and *Rubens avidly collected Brouwer's work, and he influenced Adriaen van *Ostade and Jan *Steen, amongst others (Frankfurt, Kunstinstitut; Munich, Gemäldesammlungen; Philadelphia, Museum; etc.).

BRUEGEL, BRUEGHEL A dynasty of Flemish artists, of whom the most original and influential was Pieter Bruegel the Elder (*c.*1524/30–69), followed by his younger son, Jan Brueghel, nicknamed Velvet Brueghel (1568–1625). Pieter's elder son, Pieter Bruegel the Younger, nicknamed Hell Bruegel (1564–1638), mostly produced innumerable variations on his father's *genre* scenes and landscapes. This tradition was continued by his son and pupil Pieter Bruegel III. The son of Jan Brueghel, Jan Brueghel II (1601-78) was, in his turn, a careful imitator of his father's work.

Pieter Bruegel the Elder is chiefly remembered for his landscapes and his scenes of peasant life. It was formerly thought that he had been a peasant himself, catering to the coarse humour of other rustics. This was emphatically not the case. Between 1555 and 1563, the prints issued after his drawings by the publisher and engraver Hieronymus Cock must have been popular with the general public. When, *c.*1560, Bruegel began to paint the pictures for which he was to become famous, however, he found his patrons amongst the leading intellectuals and rich bankers of Antwerp and shortly after amongst members of the court in Brussels. At least 10 of Bruegel's paintings entered the collection of the Emperor Rudolph II (now Vienna, Kunsthistorisches). What little we know of the artist suggests that he was an educated man well able to associate with his distinguished clients, perhaps in the *rederijker kamers*, or chambers of rhetoric, central to festive and literary life in

Netherlandish cities. The farces and allegorical plays and processions presented by these societies are reflected in many of Bruegel's paintings. The humour in his work was like the humour of *rederijker* performances: that of a townsman laughing at, not with, the antics of peasants, but also that of a moralist showing up the follies of humankind in general. At the same time, like any educated townsman of his day, he would have viewed the land and those who tilled it as the source of his country's wealth and the index of its well-being, not only in economic terms but also in relation to the forces of nature. It is the richness of all these references, as well as Bruegel's visual mastery, which made him so influential on later northern artists, for example *Rubens in the 17th century.

Bruegel drew heavily both on the traditions of early Netherlandish art and, in his mature works, on Italian *Renaissance masters. Although we now view these two modes as separate and antithetical, they were not seen as such in the Habsburg dominions which looked in two directions at once: inwards to the heyday of the native art of Burgundy, and across the Alps, to the new Italian art.

Bruegel was probably trained by Pieter Coeck van Aelst, although he may have been a landscape specialist in Coeck's workshop. After a brief spell in Malines following Coeck's death in 1550, he moved to Antwerp, leaving almost immediately for southern Europe. His itinerary can be reconstructed through a painting (*View of the Bay of Naples*, c.1552, Rome, Doria) and many drawings made on his travels, which included Rome and Sicily. Unlike other northern artists, he recorded no works of art while in Italy, only views of cities and landscapes. Perhaps the most important immediate result of his travel sketches are the views of Alpine scenery published as a set of 12 prints, the *Large Landscapes*, after Bruegel's return to Antwerp in 1555. The high viewpoint of these panoramic scenes was to recur in subsequent paintings (e.g. *Parable of the Sower*, 1557, San Diego, Cal.; *Hunters in the Snow*, 1565, Vienna, Kunsthistorisches).

Bruegel was now retained by Cock to produce designs for engravings in the style of Hieronymus *Bosch. Nearly 40 drawings were produced by Bruegel between 1555–1563: moralizing allegories, such as the series of the *Seven Deadly Sins*; illustrations of Netherlandish proverbs, such as *Big Fish Eat the Little Fish*. In the *Seven Virtues* series, c.1559/60, Bruegel freed himself from dependence on Bosch's demonic imagery to draw more heavily on examples from daily life.

The earliest known independent paintings by Bruegel also date from 1559/60 and bear a close relationship to the popular engravings designed for Cock: *Netherlandish Proverbs* or *The Blue Cloak* (1559, Berlin-Dahlem, Museen); *The Battle between Carnival and Lent* (1559, Vienna, Kunsthistorisches); *Children's Games* (1560, Vienna, as above).

Three original paintings recreating Bosch's nightmarish vision were executed shortly after: the *Fall of the Rebel Angels* (1562, Brussels,

Musées); *Dulle Griet* (*c*.1562–4, Antwerp, van der Bergh) and *The Triumph of Death* (*c*.1562–4, Madrid, Prado).

In 1563 Bruegel moved to Brussels. Presumably in response to aristocratic collector patrons, he now began to paint religious subjects, incorporating both archaic motifs derived from Rogier van der *Weyden and Italian Renaissance models (e.g. *Christ carrying the Cross*, 1564, Vienna, Kunsthistorisches; *Adoration of the Magi*, 1564, London, National; *Christ and the Woman taken in Adultery*, 1565, London, Courtauld). Two important Italian sources were *Michelangelo's *Bruges Madonna*, in Bruges since 1506, and *Raphael's tapestry cartoons, in Brussels since 1517.

Bruegel's study of Raphael now helped to unify the structure of his small biblical narratives of many figures in landscape (*Massacre of the Innocents*, *c*.1566, Vienna, Kunsthistorisches; *Census at Bethlehem*, 1566, Brussels, Musées; *Sermon of St John the Baptist*, 1566, Budapest, Museum). It also underpins the large-scale compositions of his last years, paradoxically some of his most Flemish in content (*Peasant Kermis* and *Peasant Wedding Feast*, both *c*.1567/8, Vienna, Kunsthistorisches; *Parable of the Blind*, 1568, Naples, Capodimonte; the *Peasant and the Nest Robber*, 1568, Vienna, as above.

Mention must also be made of the cycle of the months which Bruegel painted in 1565 as domestic decoration for the wealthy Antwerp banker and royal official, Niclaes Jonghelinck. Only five panels are known, and it is not certain that a full 12 were painted (three panels, Vienna, Kunsthistorisches; one, Prague, Museum and one New York, Metropolitan). The decoration is ultimately dependent on early Burgundian and Netherlandish calendar illuminations in *Books of Hours. But in several of the panels Bruegel has combined the homely details of Flemish peasant life with the mountain panoramas of his Alpine sketches. The paintings subordinate the world of humankind to the majestic cycles of nature.

Few of Bruegel's immediate followers appreciated the monumentality of his late works. Pieter Bruegel the Younger was born only five years before his father's death, long after Bruegel's large-scale compositions had been sold. His knowledge of his father's work was thus drawn mainly from prints and from imitators, such as Pieter Balten (1525–98), Hendrick and Maerten van Cleef (*d*.1589 and 1581 respectively), Gillis Mostaert (*d*.1598) and Jacob Grimmer (*d*.1590), naturally attracted to the most popular *genre* scenes. Throughout his life he painted variations on his father's work as reflected in these derivations; his nickname 'Hell' refers to his pictures of the underworld with Bosch-like devils and torments. He was the master of Frans *Snyders.

Jan Brueghel became a major artist in his own right, albeit very much a painter of *cabinet pictures. His earliest work, like his elder brother's, repeats variations on his father's paintings, although in a

delicate miniaturist technique, said to have been taught him by his maternal grandmother, Marie Verhulst. About 1589 Jan Brueghel went to Italy; in Rome 1593–5 he met Cardinal Federigo Borromini, Archbishop of Milan from 1595, who became his great patron. Jan painted for him small, even tiny pictures, combining exquisitely painted naturalistic (*see under* realism) details in highly decorative and artificial compositions, such as the four allegorical pictures of the *Elements* (after 1608, Milan, Ambrosiana and Paris, Louvre) and the *Five Senses* (Madrid, Prado). Jan's small landscapes, too, were magical vistas of woodlands and open glades, like miniature versions of the woodland scenes of Gillis van *Conixloo, who may have taught him (e.g. 1607, Leningrad, Hermitage). His masterpiece in this genre is considered to be the *Continence of Scipio* (1609, Munich, Gemäldesammlungen). Finally, Brueghel became a specialist also of flower pieces, sometimes combined with precious jewels and other manufactured accessories. His ability to reproduce the varieties of texture earned him the nickname 'Velvet'. Working from nature, he collected flowering plants from spring through summer, and painted landscapes the rest of the year.

Brueghel often collaborated with other artists. His most famous collaboration was with the youthful *Rubens, who also looked after his Italian correspondence. Rubens provided the figures of Adam and Eve in Brueghel's *Garden of Eden* (The Hague, Mauritshuis) and the 'pictures' in the *'Madonna and Child' wreathed with garlands of flowers* of which Brueghel painted several versions (e.g. Madrid, Prado).

Devalued in our day, partly through the many imitations by his son, Jan Brueghel II and other pupils, Jan Brueghel's work was immensely prized by many aristocratic collectors throughout Europe. They admired his meticulous technique; the subtle interplay between naturalism and artifice, the copiousness within a small compass of his precious little pictures, executed, as Cardinal Borromeo wrote, 'with extreme strength and care', an art simultaneously 'great and delicate'.

BRUGGHEN, Henrick Ter *See* Terbrugghen.

BRUNELLESCHI, Filippo (1377–1446) Best-known as the greatest architect of the Early *Renaissance, this Florentine artist matriculated as a goldsmith and practised also as a sculptor in silver, bronze and wood, designing for marble and perhaps terracotta. He is important, too, in the history of figurative art for his studies in *perspective, and for inspiring, and perhaps designing, the perspectivized architectural framework of *Masaccio's *fresco of the *Trinity*. This entry is limited to outlining Brunelleschi's figurative work, although the reader should recall his most important and famous achievement, the huge cupola of Florence cathedral.

The most significant figurative work by Brunelleschi is the bronze relief of the *Sacrifice of Isaac* now in Florence, Bargello, made in 1401–02 for the competition, won by *Ghiberti, for the second set of doors of Florence baptistry. The relief demonstrates Brunelleschi's absorption

of the antique, his bias towards *realism, and the way both are combined in a composition dominated by clear geometric forms. It is technically less accomplished than Ghiberti's competition panel, which was lighter, cast in a single piece, whereas Brunelleschi's consists of a base with soldered relief sections. The technique relates it to the silver altar of St James in the cathedral at Pistoia, for which Brunelleschi had executed reliefs and statuettes, 1399–1400.

The other important sculpture, not documented but generally attributed to Brunelleschi, is the wooden figure of the crucified Christ, Florence, S. Maria Novella. Whether or not inspired by rivalry with *Donatello, as the sources report, the work recalls Brunelleschi's relationship with the younger sculptor – with whom he may have visited Rome to study antique remains sometime after 1402, or, as is more probable, who came to visit Brunelleschi during the latter's stay in Rome c.1413–15.

Brunelleschi did not carve in stone but several works – a lavabo in the sacristy of Florence cathedral, the pulpit in S. Maria Novella, the tomb and altar in the Old Sacristy, S. Lorenzo – were executed by his disciple, adopted son and 'sculptural amanuensis', Buggiano (1412–62), after designs and wooden models by Brunelleschi.

BUGGIANO *See under* Brunelleschi.

BUON, Giovanni (*c*.1355–*c*.1443) and his son, Bartolommeo (*c*.1374–1464/7) The leading Venetian sculptors from 1392 until Bartolommeo's death. They were employed jointly on the Ca d'Oro (1422–34); the tympanum lunette over the entrance to the Scuola di San Marco (1437), and the Porta della Carta of the Doge's Palace (1438–42). A relief by Bartolommeo for the Guild of the Misericordia in Venice (1441-5) is in London, Victoria and Albert.

BURGKMAIR, Hans (1473–1531) Outstanding German painter, engraver (*see under* intaglio prints) and designer of woodcuts (*see under* relief prints), active in Augsburg, where he occupied a position analogous to that of *Dürer in Nuremberg, acting as a conduit of Italian *Renaissance developments. The son of the painter, Thoman Burgkmair (*d*.1523), he may also have worked under *Schongauer in Colmar in the 1490s. A trip to northern Italy is probable before 1498, when he returned to Augsburg and married the sister of Hans *Holbein the Elder, and he almost certainly visited Milan and Venice c.1505 and the Netherlands before 1510. His paintings after 1505 show increasingly his study of Venetian colour and monumental figure types indebted to *Leonardo and *Michelangelo. In addition to altarpieces (e.g. *St John Altarpiece*, 1518; *Crucifixion Triptych*, 1519, both Munich, Alte Pinakothek) and smaller devotional paintings (e.g. *Madonna and Child*, 1509; 1510, both Nuremberg, Museum; *Mystic Marriage of St Catherine*, Hannover, Landesgalerie), he executed many portraits (e.g. Karlsruhe, Kunsthalle; Augsburg, Museum; Cologne, Wallraf-Richartz; Vienna, Kunsthistorisches). In 1529 he was commissioned to

paint one of a series of ancient battle scenes for Duke William IV of Bavaria (*Battle of Cannae*, Munich, Alte Pinakothek; *see also* Altdorfer). From 1510 he was employed on woodcuts for the Emperor Maximilian, including some for the *Triumphal Arch*, when he came into contact with Dürer, who made a portrait drawing of him. He was the teacher of Christoph *Amberger.

BUSHNELL, John (*c*.1630–1701) English sculptor who spent 10 years on the Continent – he is recorded working on a funerary monument in Venice in 1663 – returning to England in the late 1660s. The first English artist to show first-hand knowledge of *Baroque sculpture, he executed several important public commissions, for Temple Bar and the Royal Exchange (London, Old Bailey) and some funerary monuments (London, Fulham Parish Church; Sussex, Ashburnham) but his mental instability prevented further commissions; he died insane.

BUYS, Cornelis *See under* Jan van Scorel.

BUYSTER, Philippe van *See under* Sarrrazin, Jacques.

BUYTEWECH, Willem (*c*.1591–1624) Nicknamed 'Geestige Willem' ('witty Willem'). Dutch draughtsman and etcher (*see under* intaglio prints) as well as painter. He is credited with having established an important *genre category: the banquet scene in an interior, usually called the 'Merry Company'. Its origins can be traced to biblical illustrations of the *Parable of The Prodigal Son, Mankind before the Flood, Mankind awaiting the Last Judgement*, as well as representations of the pagan *Feast of the Gods* (e.g. *Merry Company*, *c*.1617–20, Rotterdam, Boymans-Van Beuningen). Buytewech was a decisive influence on the work of Frans *Hals' brother Dirck, as well as that of Hendrick Gerritsz *Pot (*c*.1585–1657) and Isack Elyas (active *c*.1620–30).

C

CABINET PICTURES From 'cabinet', a small room, private apartment or boudoir. Small-scale highly finished paintings designed to appeal to private collectors.

CALIARI, Paolo *See* Veronese.

CALLOT, Jacques (1592–1635) One of the greatest and most influential etchers (*see under* intaglio prints); a pioneer both in technique and in subject matter in which he combined Italian and northern European traditions. His prints are notable for the marshalling of innumerable small figures into coherent patterns. Until *c.* 1621 his love for the grotesque was expressed with wit and fantasy; after that time his tone became increasingly serious, and his last great work, the series of the *Grandes Misères de la Guerre*, 1633, foreshadows the grim horrors of Goya's *Disasters of War* (*see* Volume Two).

Born in Nancy, Callot was apprenticed to a goldsmith. Between 1608–11 he went to Rome, where he learnt line engraving and copied compositions by *Mannerist painters. In 1611 he moved to Florence, becoming a pupil of Remigio Cantagallina (*c.* 1582–1635?) and a protégé of Cosimo II de'Medici. He achieved great success with prints of public festivities, grotesque beggars, hunchbacks and characters from the *commedia dell'arte*. After the death of Cosimo Callot returned to Nancy, where he became one of the leading figures in the artistic life of Lorraine. Probably under the impact of the religious revival current there (*see also* Bellange, Georges de la Tour) his work became more serious and deeply felt, notably in religious works such as the series of the *Great Passion*, 1625. He also turned to pure landscape, in the manner of *Bruegel. In 1625 he was called to Brussels to collect material for his huge *Siege of Breda* – later to be drawn upon by *Velázquez for the background to his painting of the same name – and in 1629 to Paris to illustrate the captures of La Rochelle and the island of Ré by the royal forces. Details from these siege compositions were to be reused in the *Grandes Misères de la Guerre* already mentioned, alluding to the invasion of Lorraine by the French in 1633.

CALVAERT, Denijs or Denys (*c.* 1540–1619) Antwerp-born *Mannerist painter. He went to Italy *c.* 1562, settling in Bologna *c.* 1574. A comparatively mediocre follower of *Parmigianino, he became none-theless an important influence in his own right, as the first teacher of *Reni, *Albani and *Domenichino, who, together with the *Carracci, founded the famous school of Bologna and, through their later activity in Rome, 'reformed' Italian art by counteracting the naturalism (*see under* realism) and *tenebrism of *Caravaggio and his followers. There are paintings by Calvaert in Bolognese churches (e.g. Sta Maria della Vita) in Parma, Pinacoteca, and Rome, Pallavicini.

CAMBIASO, Luca (1527–85) The only outstanding native Genoese painter of the 16th century. Eclectic and prolific, he was trained

by his father Giovanni Cambiaso (c.1495–c.1579), but formed through study of the Genoese works of Perino del *Vaga, *Giulio Romano and *Pordenone, and perhaps also through a visit to Rome before 1544. He executed extensive *fresco decorations in and around Genoa (Doria Palace, now Prefettura, 1544; S. Matteo, before 1559; Genoa-Turalba, Villa Imperiale, c.1565; Palazzo Meridiana, 1565; S. Lorenzo, 1569) and numerous altarpieces (S. Bartolommeo degli Armeni; Montalto Ligure, S. Giovanni Battista). By 1570 he abandoned his earlier ingenious *Mannerist style for a sober, pious Counter-Reformation naturalism (see under realism; e.g. S. Giorgio), which became an almost affected folk-like simplicity in his work at the Escorial for King Philip II of Spain from 1583 (see also Federico Zuccaro, Bartolomé Carducho, Pellegrino Tibaldi). In addition to large- and small-scale religious works, however, he executed some quasi-erotic mythological pictures (e.g. Venus and Amor, Chicago, Institute) and, like his Cremonese contemporary Antonio *Campi, produced some striking nocturnes.

CAMERA OBSCURA, CAMERA OTTICA A mechanical device developed in the 16th century as a short-cut to two-dimensional representation of three-dimensional reality. A series of adjustable lenses and mirrors in a darkened space or box project on to a screen, canvas or piece of paper the scene in front of the lens. *Canaletto is known to have used a portable device of this type for his panoramic views, and it was employed, although to different ends, by Dutch artists of the Delft school, notably Carel *Fabritius and *Vermeer.

CAMPI Dynasty of painters from Cremona, mainly active there and in Milan. The best known are the three sons of Galeazzo Campi: Giulio (after 1500–72) and his younger (half?) brothers and pupils, Antonio (1520/5–87) and Vincenzo (1530/5–91). A distant relation, Bernardino Campi (1522–91) also studied under Giulio and became the first teacher of Sofonisba *Anguissola.

Giulio Campi was an eclectic painter of altarpieces and church *frescoes (Cremona, S. Abbondio, S. Agata, S. Sigismondo, S. Margherita, cathedral; Milan, Brera). Antonio Campi, like Giulio a painter of religious subjects, began, as early as 1567 (Cremona, Museo), to specialize in nocturnal scenes (notably Milan, S. Paolo, 1581; S. Angelo, 1584). Painted for Milanese churches just before and during *Caravaggio's apprenticeship in Milan, they are thought to have influenced the younger man's *tenebrist manner, first apparent in Caravaggio's paintings for chapels rather than in his earlier *genre pictures.

Vincenzo Campi is best remembered for his large *still-life with *genre paintings, which are amongst the earliest of their type in Italy (Milan, Brera). Painted in the mid-1570s, they were influenced by the works of *Aertsen and Beuckelaer in the Farnese collection in Parma, where Vincenzo was active at the time. Vincenzo's market scenes are the immediate antecedents of similar paintings by *Passarotti and Annibale *Carracci.

CAMPIN, Robert (c.1375–1444) One of the great pioneers of Netherlandish art, now frequently identified with the *Master of Flémalle. He was the leading painter in Tournai from c.1410 until his death; Rogier van der *Weyden was one of his many pupils. Despite biographical data, none of his paintings is documented and the work discussed below has been attributed to him by deductions from style and by comparison with other artists as well as from the scant recorded information. Campin/the Master of Flémalle introduced to panel painting the monumentality of form and dramatic intensity already achieved in Netherlandish/Burgundian sculpture (see Claus Sluter). In addition, he is credited with originating that system of 'disguised symbolism' which came to characterize Netherlandish art (see Jan van Eyck) and its successors, notably Dutch 17th-century painting. By portraying religious events as taking place in the convincingly represented actual environment of the Netherlandish bourgeoisie, Campin/Flémalle fostered a deliberate ambiguity. A round form silhouetting the Virgin's head simultaneously represents a firescreen and a halo (Virgin and Child before a Firescreen, c.1428, London, National). The well-appointed room in which the Annunciation is enacted in a famous *triptych (Mérode Altarpiece, c.1426, New York, Metropolitan, Cloisters) contains a water basin and towel against the wall, and a white lily in a jug on the table. Previous knowledge of Marian symbolism, as formulated in theological and mystical texts and in church liturgy, and pictured in earlier paintings, enables us to 'read' at least one of these objects, the lily, as a precise reference to the purity of the Virgin, and to infer a similar significance for the others. In other words, the viewer is invited to scan the whole painting for religious significance, and by extension the entire world of appearances, so cunningly imitated here in the new technique of oil painting. This is a precise pictorial parallel to contemporary Netherlandish religious mysticism, increasingly propounded amongst the laity.

Campin may have been born in Valenciennes, but his career is entirely documented in the city of Tournai, where he held administrative posts devolving from his deanship of the painters' guild from 1423. His prestige as an artist may be gauged from the fact that when, in 1432, he was charged with leading a dissolute life, and sentenced to a year's exile and a penitential pilgrimage, the sentence was commuted to a fine through the intervention of Jacqueline of Bavaria, daughter of the Count of Holland. The earliest extant painting attributed to him (as the Master of Flémalle) is the Entombment Triptych of c.1415–20 (London, Courtauld), where a new, forthright bourgeois *realism makes its first appearance. A slightly later fragment from an altarpiece depicting the Life of St Joseph (c.1420, Madrid, Prado) shows the beginnings of the use of 'disguised symbolism'.

The artistic identity of the 'Master of Flémalle' has been reconstructed around three large panels, c.1430–4, now in Frankfurt, Kunstinstitut, wrongly said to have been painted for an abbey or castle of

Flémalle. A stylistically related fragment of an altarwing representing either the *Repentant* or the *Unrepentant Thief*, *c*.1428–30, is in the same museum. All are monumental, individually characterized and dramatic. Two portraits in London, National, are widely attributed to the same artist and his shop.

The reader should be aware that although a wide consensus has been reached about the attributions and identification proposed in this entry, there is still a large measure of uncertainty about the relationship between Flémalle/Campin/the young Rogier van der Weyden and the *oeuvre* here described.

CANALETTO; Giovanni Antonio Canal, called (1697–1768) Venetian *vedute* painter working largely for the English market and mainly resident in England 1746–55. He trained first as a scene painter under his father, Bernardo Canal, and worked with his father and brother Cristoforo in theatres in Venice and Rome, 1719–20. Little is known of his training in easel painting, although he must have studied the work of older *vedutisti* such as *Van Wittel (Vanvittelli) and *Carlevaris. Canaletto's early pictures for local patrons are carefully, but freely, painted and based on individual studies. They include his masterpiece, *The Stone Mason's Yard* (1725/6, London, National). He soon discovered, however, that the mass production of pictures of celebrated sights for tourists paid better than the painting of individual masterpieces. He therefore streamlined his technique, trained a studio of assistants, one of whom was his nephew Bernardo *Bellotto, and turned out a steady stream of formulaic, brightly-lit pictures, based on a repertoire of drawings (many of them now in the Accademia, Venice) from panoramas projected in a *camera obscura*. His connections with English tourists, strengthened by an association with the famous collector, later British Consul to Venice, Joseph Smith, led him to follow his clients to England when the 1741 War of the Austrian Succession made travel on the Continent hazardous. But, after a promising start, his English paintings disappointed, and they, and his later Venetian works, show a marked decline from his former achievements. Nonetheless, in 1763, after two unsuccessful earlier attempts, Canaletto was finally elected to the Venetian *Academy. Whilst few major paintings remain in Italy, there are innumerable pictures by him in England (Royal Coll. and private colls.; London, National, Wallace) and many in collections in the USA and on the Continent. Canaletto's luminous etchings (*see under* intaglio prints) are also to be found in many collections and printrooms, including Venice, Correr.

CANO, Alonso (1610–67) Outstanding Spanish painter, draughtsman, sculptor and architect active at Granada, Seville, Madrid, Valencia and Malaga; the son of a joiner and *retable designer who taught him the rudiments of architecture and sculpture. Born in Granada he lived from 1614–38 in Seville, where he was apprenticed for a time to *Pacheco and perhaps also to *Montañés, whose close follower

he became. Cano's art belies his violent character and the melodramatic events of his life (*see below*). His paintings from the mid-1620s–*c*.1635 follow *Zurbarán in severity and *tenebrism (e.g. Seville, Museo), but after this early period he began to employ lighter colours and a looser brush (e.g. London, Wallace) culminating in the luminous and serene *classicizing works executed in Madrid from *c*.1640–51, and in Granada in 1652–67 (e.g. *St Isidore's Miracle of the Well*, 1645–6, now Madrid, Prado, seven *Mysteries of the Virgin*, 1652–3, Granada, cathedral; *Virgin and Child*, *c*.1659/64, Guadalajara, Museo; other late works, Madrid, Prado, Academy; and Granada, Museo). His major sculptural work dates from his periods in Seville (high altar at Lebrija, S. María, 1629–31) and Granada, where he established the fashion for small *polychrome wood statuettes. Nothing remains of his sculpture from the Madrid period.

Quarrelsome and jealous, Cano left Seville under a cloud, having spent part of 1636 in jail for debt, and having wounded a colleague in a duel in 1637. Possibly through the intervention of *Velázquez, who had also been in Pacheco's studio, he received an invitation to the court at Madrid. But in 1644 his young wife, whom he had married in 1631 when she was 12, was found dead with 15 stab wounds, and the artist was arrested and tortured – although, by royal command, his right arm and hand were spared. Set free, he fled to Valencia, before returning secretly to Madrid. He was finally ordained a sub-deacon and appointed a canon of Granada cathedral.

CANOVA, Antonio *See* Volume Two.

CANTAGALLINA, Remigio *See under* Bella, Stefano della, and Callot, Jacques.

CAPPELLE, Jan van de (*c*.1624–79) Marine painter of the *classic phase of Dutch art (*see also* Aelbert Cuyp). He specialized in early morning or evening scenes in harbours or the mouths of rivers with ships at anchor. He also painted winter landscapes. Van de Cappelle ran his family's prosperous dye-works and his fortune enabled him to accumulate one of the greatest art collections of the time, including more than 500 drawings by *Rembrandt, as well as quantities of works by other seascape painters. There are works by him in most important collections.

CAPRICCIO (Italian, whim, fancy) The Italian 18th-century imaginary, fantastical landscape, pioneered by *Magnasco and Marco *Ricci. Its greatest exponent was *Guardi. But the genre has clear affinities also with Salvator *Rosa's scenes of brigands and witchcraft, Francois de *Nomé's ('Monsù Desiderio') architectural fantasies, the imaginary compilations of actual ruins by *Pannini, and *Piranesi's romanticized archaeological etchings. The term is sometimes used for any or all of these.

CARAVAGGESQUE *See* Caravaggio.

CARAVAGGIO, Michelangelo Merisi da (1571/2–1610) Called Caravaggio after his birthplace near Milan, he is the prototype of the turbulent Bohemian artist, his explosive personality helping to obscure

the traditional elements of his painting. It is now obvious, however, that from *c.*1599 he drew on High *Renaissance and even antique models, and that his *decorum-defying naturalism (*see under* realism) derived from Flemish art mediated through Veneto-Lombard painting of the early 16th century (*see* Lotto, Moretto, Romanino, Savoldo). Caravaggio's influence was indeed greatest on artists in areas of Flemish artistic ascendancy, notably Naples, Spain and the Netherlands. Except, perhaps, in Naples, *caravaggismo* characteristically combines subjects and compositions of Caravaggio's youthful works (half-length figures set in shallow space, prominent *still-life elements) with the *tenebrism of his later production.

Caravaggio was apprenticed in 1584 to Simone Peterzano, a Milanese painter in oils and fresco. Whether from inadequate training or aesthetic preference Caravaggio confined himself to painting in oils, in a narrow range of earth colours, even in his large-scale Roman chapel decorations (S. Luigi dei Francesi, Contarelli chapel, 1598/9; S. Maria del Popolo, Cerasi chapel, 1601). These works, despite being in oils on canvas, require to be viewed *in situ* and not as portable easel paintings.

His earliest years in Rome, from *c.*1588, are shrouded in uncertainty but were undoubtedly difficult. He was employed for a time in the workshop of Giuseppe d'*Arpino as a fruit and flower specialist, although it is not clear whether he ever produced independent *still-lifes without accompanying figures. The only one known, a *Basket of Fruit* (Milan, Ambrosiana) may have been painted as a trial piece, since the background was added later.

In the 1590s Caravaggio found patrons amongst art-collecting high-ranking ecclesiastics. For Monsignor Petrignani he painted a lyrical *Rest on the Flight to Egypt* indebted to Lotto, and a full-length *Repentant Magdalen* (both Rome, Doria). But most of the pictures painted before 1598, including those executed in the household of Caravaggio's important patron, Cardinal del Monte, are of secular subjects. They combine half-length figures of androgynous youths (many of them Caravaggio himself reflected in a mirror) with *illusionistic still-lifes (*Boy with fruit*, Rome, Borghese; *Lute-Player*, Leningrad, Hermitage). Some allude playfully to the antique (*Bacchus*, Florence, Uffizi). All may embody poetical, emblematic and allegorical conceits (as is obviously true of the *Concert of Youths*, or *Musica*, New York, Metropolitan). There are some low-life subjects (*The fortune-teller*, Paris, Louvre) and some studies of expression (*Boy bitten by a Lizard*, London, National).

Probably through the intervention of Cardinal del Monte, Caravaggio received his first monumental commission for the altarpiece and lateral paintings of the Contarelli chapel (*Calling of St Matthew, Martyrdom of St Matthew*, 1598/9; *St Matthew writing his Gospel*, first version formerly Berlin, Kaiser Friedrich, destroyed, second version *in situ*). Working directly on the canvas (*see alla prima*) Caravaggio had to make

many, and radical, changes to the composition of the *Martyrdom*. The first altarpiece was rejected; the second one was completed in 1602. In these works we find Caravaggio's earliest use of tenebrism; strong contrasts of dark and light are employed to render relief, to harmonize with the restricted source of light in the chapel and to illustrate the spiritual significance of the scenes. A second monumental commission followed for the Cerasi chapel (lateral paintings, *Martyrdom of St Peter*, *Conversion of St Paul*, 1601). The low-life naturalism of these scenes dismayed lower clergy, the general public, and some theoreticians of art, but found favour with upper clergy and connoisseurs. Despite controversy, Caravaggio was awarded commissions for altarpieces (*Deposition*, 1602, Vatican, Pinacoteca; *Madonna di Loreto*, 1604, S. Agostino; *Madonna del Serpe*, 1605, Borghese; *Madonna of the Rosary*, 1605?, Vienna, Kunsthistorisches; *Death of the Virgin*, 1605/6, Paris, Louvre).

In May 1606 Caravaggio killed his opponent in a duel following a brawl over a game of tennis. Severely wounded himself, he fled Rome, and after some months resumed his career as a painter of monumental devotional works in Naples (*Flagellation of Christ*, S. Domenico Maggiore; *Seven Works of Mercy*, 1607, S. Maria della Misericordia). In 1608 he went to Malta (portrait of *Alof de Wignacourt, Grand Master of the Order of St John*, Paris, Louvre; *Beheading of St John*, Valletta, cathedral) where he was received into the Order of St John. Imprudently quarrelling with a superior, he was imprisoned. His escape was followed by a year (1608–09) of itinerant painting in Sicily (Syracuse, Messina, Palermo). These late pictures, hastily executed, are now in poor condition. They show increased pathos: light now flickers over figures reduced in scale, revealing and suggesting expression more than form.

Returning to Naples, Caravaggio was set upon by hired thugs and disfigured. He continued to paint after his convalescence (*Crucifixion of St Andrew*, Cleveland, Ohio, Museum). Expecting a papal pardon for the homicide of 1606, he set sail from Naples in June 1610, only to be arrested, mistakenly, at Port Ercole. Released, he set out after the boat which was carrying all his belongings, and died, at Port Ercole, of a malignant fever. Ironically his pardon had been granted shortly before.

Caravaggio's *oeuvre*, from the suave homoerotic paintings of the 1580s through the tragic visions of 1606–10, is distinguished by its directness of address to the viewer, accomplished in his youth through mastery of close-range illusionism (*Supper at Emmaus*, London, National), later through selective social realism and the expressive manipulation of light. These qualities may compensate for his shortcomings in the composition of large-scale narrative, but do not disguise them. Caravaggio's dependence on the model, his method of painting *alla prima*, caused him to be classified as a *colourist, despite the restricted range of colours he employed (*see also disegno*).

CARDUCHO, Bartolomé (*c*.1560–1608) and his brother Vincencio or Vicente (1576–1638) Florentine-born painters working in

Spain from 1585, when Bartolommeo Carducci (as he was known) accompanied his master Federico *Zuccaro to the Escorial, bringing with him his nine-year-old brother. After Federico's abrupt dismissal in 1588, Bartolomé remained in Spain and in 1598 was appointed court painter to Philip III. With Vincencio's assistance he worked, in oils and *fresco, on the decoration of royal residences at Segovia, Valladolid, the Escorial and the Prado, evolving further the simple, *realistic style employed at the Escorial in the 1580s and 1590s by *Tibaldi and Luca *Cambiaso. There are works by Bartolomé in Madrid, Prado, Colegio de S. Marca; Lisbon, Museu, Escorial.

Vincencio became one of the most prolific Spanish painters and draughtsmen, the bitter but unsuccessful rival at court of *Velázquez. In addition to the innumerable works he executed for religious foundations all over Spain he wrote a famous treatise, *Diálogos de la pintura, su defensa, origen, essensia, definición, modos y diferencias*, Madrid, 1633. These *Dialogues on Painting* castigated the 'disregard of beauty' and naturalism (*see under* realism) of *Caravaggio and his followers, thus indirectly indicting Velázquez, and defended the moral purpose of art and the *decorum required of religious painting. As a painter, Vincencio Carducho is probably best appreciated through his vivid oil sketches, 22 of which survive, for a series of Carthusian scenes for El Paular near Segovia (20 in Florence, Coll. Contini-Bonacossi; one in Edinburgh, National; one in London, private coll.).

CARICATURE (Italian *caricatura* or *ritratto caricato*, loaded – that is, exaggerated – portrait, from *caricare*, to load) Strictly speaking, not any comical, grotesque or satirical figure drawing or representation (such as the 'grotesque heads' of *Leonardo or the satirical tax collectors and money changers painted by *Marinus van Reymerswaele), but a likeness which deliberately brings to light and exaggerates the faults and weaknesses of an individual for purposes of mockery. The caricature portrait was invented at the end of the 16th century in the studio of the *Carracci. The sculptor *Bernini was a famous early practitioner, and the genre had a great vogue in 18th-century England, where not only *Hogarth but even *Reynolds painted caricature *Conversation Pieces (the latter, it is true, only during his study trip in Italy). *Rowlandson is perhaps the best-known English caricaturist. Theoreticians of art took the genre very seriously, as the 'low' counterpart to 'high' academic portraiture. Where the *classicizing academic portraitist stripped off all 'accidental' features to reveal the noble essence of the sitter (*see also* Academy; idealization), the caricaturist unmasked the petty self concealed by social conventions and pretensions.

CARLEVARIJS or CARLEVARIS, Luca (1663–1730) Painter, etcher and mathematician, born at Udine but active in Venice; the first recorder of Venetian scenes as advertisements of the Serene Republic's splendours. This aim was expressly announced on the title page of his series of *vedute* etchings (*see under* intaglio prints), 1703 (preparatory

drawings, London, British). A number of his paintings depict receptions or regattas in honour of foreign kings and ambassadors, and were produced for foreign participants in these events (e.g. Leningrad, Hermitage; Copenhagen, Fredericksborg; Birmingham, Gallery; Dresden, Gemäldegalerie). *Canaletto was to re-use his compositions in similar scenes. Carlevarijs' paintings are few; a sketch-book, in oils, of studies of figures – more lively than his finished works – is in London, Victoria and Albert.

CARON, Antoine (early 1520s–c.1600) French *Mannerist painter and draughtsman, first recorded working under *Primaticcio before 1500, later painter to Queen Catherine de'Medici and closely connected with the Catholic League. Only one painting by him is known to represent a traditional religious subject (Resurrection, Beauvais, Musée); the remaining works – easel paintings, drawings for tapestries and engravings – fall into three main categories: allegorical subjects, recalling the famous festivities of the Valois court (e.g. Histoire d'Artémise, drawings); massacres, alluding to the contemporary Wars of Religion (e.g. Massacres under the Triumvirate, 1566, Paris, Louvre) and fantastical or occult subjects (e.g. Augustus and the Sibyl, Paris, Louvre).

CARPACCIO, Vittore (1460/5–1525/6) Venetian painter, a specialist in teleri, the large narrative paintings on canvas which adorned the scuole – charitable confraternities characteristic of Venice (Scuole di S. Giovanni Evangelista, 1494; di S. Orsola, 1495–1500, both now Venice, Accademia; di S. Giorgio degli Schiavoni, 1502, in the scuola building but not in the room for which they were painted; degli Albanesi, c.1504, now Venice, Ca d'Oro, Galleria Giorgio Franchetti, and Museo Correr; di S. Stefano, c.1511–20, dispersed amongst many museums including Milan, Brera). He was also employed in the Doge's Palace. Whilst Carpaccio may have trained under the teleri specialist Lazzaro Bastiani (c.1425–1512), he was more indebted to Gentile and Giovanni *Bellini.

Although he was unable to come to terms with the innovations of *Giorgione and *Titian after c.1507, Carpaccio's colourful, detailed 'inventory style' is superior to that of the other teleri painters, not only because of his response to light but also through his unerring feeling for interval and his fertile invention. He also executed a few altarpieces (Venice, Accademia, S. Domenico) and some portraits (Venice, Correr). Many of his drawings have been preserved (e.g. London, British; Paris, Lugt Coll.; Oxford, Christ Church).

Carpaccio's workshop included his son Benedetto (recorded 1530–45). The family name in Venetian dialect was Scarpazza; Carpaccio is the Italian form of the Latin Carpathius with which Vittore signed several of his works, and only came into use in the 17th century.

CARRACCI, Agostino (1557–1602), his brother Annibale (1560–1609) and their cousin Lodovico (1555–1619) Bolognese artists, because of whom Bologna assumed a leading role in Italian art in the

1590s. This was due not only to their individual and collaborative efforts as painters and (Agostino) engraver (*see under* intaglio prints). They became famous teachers (of, e.g. *Reni; *Albani; *Lanfranco; *Domenichino) and, *c.*1582, founders of an art *Academy where artists met to draw after the live model – an important feature of the Carraccis' own practice – and discuss theoretical problems. In a lighter vein, they investigated problems of visual representation through pictorial guessing games and *caricature. The questions debated in the Carracci Academy echoed wider concerns: in 1582 the Archbishop of Bologna, Gabriele Palleotti, published a treatise calling for the reform of religious painting in accordance with the exhortations of the Council of Trent. In many respects these Counter-Reformatory precepts were a return to *Renaissance artistic ideals. The Carracci, and more specifically Annibale in his Roman works, 1595–1605, discussed below, came to be seen as having rescued the great traditions of Italian art, from *Giotto to *Raphael, from the twin evils of, on the one hand, *Mannerism and, on the other, unbridled *realism (*see* Caravaggio).

The Carraccis' much debated eclecticism was in some measure, however, less a deliberate programme than made possible by Bologna's situation within the artistic map of Italy. A northern city, it looked simultaneously to Lombardy, the Veneto, across the Alps and to central Italy. In nearby Parma, the great *Correggio (*d.*1534) had already integrated the legacy of *Leonardo's Lombard sojourn (Milan, 1482–1500) with Venetian colourism (*see under disegno*). Before seeking out Correggio's own works, *c.*1585, *see below*, Annibale had come under his indirect influence through the Urbino painter *Barocci (*d.*1612), after whom Agostino executed reproductive engravings, 1582. But the warm and sensuous Venetian Renaissance idiom also survived undiluted and at first hand in the work of *Veronese (*d.*1588). It was again Agostino, as a result of a trip to Venice in 1582 to make prints after Veronese's paintings, who first awakened the other Carracci's interest in this master (*Madonna and Child*, 1586, Parma, Galleria). Netherlandish *genre* painting was collected throughout the region; the Farnese collection in Parma had an important group of pictures by Beuckelaer (*see under* Aertsen), and these works had, from *c.*1575, inspired local imitators, notably Vincenzo *Campi in Cremona and Bartolomeo *Passarotti (*d.*1592), a leading painter in Bologna in whose studio Agostino and Annibale spent some time *c.*1577–8. Annibale followed Passarotti in the painting of *genre* (*Butcher's Shop*, *c.*1582/3, Oxford, Christ Church; *Bean Eater*, *c.*1583/4, Rome, Colonna). Unlike Passarotti's coarsely comical low-life pictures, however, his works in this mode treat their subjects with dignity. When, however, Annibale employed a similarly forthright manner in his earliest known dated religious painting, the altarpiece of the *Crucifixion* (1583, Bologna, S. Maria della Carità), Passarotti and other artists of the older generation were shocked. For such public paintings, Passarotti and his contemporaries employed a

different style: the more highly *idealizing and artificial central Italian *Mannerism absorbed through study in Rome or Florence. The antagonism caused by his breach of stylistic *decorum may have alerted Annibale to the originality of this approach to the painting of *istoria* (*see under* genres); nevertheless, he henceforth tempered his naturalistic style through adopting a Correggesque mode (e.g. *Baptism of Christ*, 1585, Bologna, S. Gregorio).

Lodovico's painting in these early years was very different, more Mannerist and elegant, the brushwork more polished (e.g. *Annunciation, c.*1585, Bologna, Pinacoteca), perhaps contradicting the assertion of early biographers that he trained his cousins. Agostino, as has been said, practised mainly as an engraver, and as such was in the 1580s the most successful of the three Carracci. By 1580, however, the young artists had opened a joint workshop, albeit continuing also to work independently. They received their first collaborative commission *c.*1583: two mythological *fresco friezes for the newly constructed Palazzo Fava, Bologna (*Jason and the Argonauts*; *Europa*) followed in 1586 by a third (episodes from the *Aeneid*). Narrative friezes had been popularized in Bologna a generation earlier by *Nicolò dell'Abate and Pellegrino *Tibaldi. Borrowing motifs from the former, and the latter's Michelangelesque monumentality, the Carracci succeeded in improving on their predecessors. In 1589/90 they executed their collaborative masterpiece: the frieze of the *Founding of Rome* in the Palazzo Magnani, which in many details anticipates Annibale's Roman frescoes. There followed the less extensive collaborative decoration of three rooms in the Palazzo Sampieri, *c.*1593/4, after which, in 1594/5, with Annibale's departure for Rome, the joint Bologna workshop split up. Agostino was to follow his brother in 1597.

During these formative years Lodovico's independent production began to diverge even more markedly from Annibale's. Like his younger cousin, he too looked to Correggio and the Venetians. But *Tintoretto (*d.*1594) proved to be a more lasting influence on him than Veronese. From *c.*1587 he began to employ brushstrokes and light and shade more *expressively, to convey emotion and a sense of mystery rather than to clarify form. The important paintings of these years are a series of five great *Baroque altarpieces, 1587–94/5, now in Bologna, Pinacoteca, including his masterpiece, the *Preaching of St John* (1592); a *Holy Family with St Francis* of 1591 (Cento, Museo) and the *St Hyacinth* of 1594 (Paris, Louvre). After his cousins' departure from Bologna, Lodovico continued to teach, and greatly influenced many younger artists, notably Lanfranco and *Guercino; *see also* Algardi. After *c.*1600, however, his own work deteriorated, although the better pictures of this period still demonstrate his power to represent mystical and ecstatic experience (e.g. 1608–10, Bologna, Pinacoteca; S. Domenico).

Agostino, whilst predominantly a graphic artist and the moving spirit in the Carracci Academy, also executed several independent easel

paintings between 1584–93. In addition to the Dresden altarpiece already mentioned, there are pictures by him in Bologna, S. Maria della Pioggia; Vienna, Kunsthistorisches; Parma, Pinacoteca. His masterpiece is the much admired *Last Communion of St Jerome* (c.1592/3, Bologna, Pinacoteca), which marries Venetian colourism to a rigorously stable architectonic structure. Agostino, an intelligent man of wide culture, was through his work as a reproductive engraver familiar with a wide range of Renaissance paintings. It may have been he who first influenced Annibale to take a stand in opposition to Lodovico's emotionalism, opening Annibale's eyes to Raphael as he had done to Correggio and the Venetians. Annibale's *Sacra conversazione (1593, Bologna, Pinacoteca) echoes the structure of Agostino's St Jerome. In Rome, Agostino assisted Annibale in the Farnese palace gallery; after difficulties in collaboration, he left c.1599. From 1600 until his death he worked for the Farnese in Parma, where he left incompleted frescoes in the Palazzo del Giardino. His son and assistant Antonio (c.1589–1618) then joined Annibale in Rome, where he remained more or less continuously, assisting Reni in the Chapel of the Quirinale, 1610; there are frescoes by him in several Roman churches.

I have briefly sketched Annibale's development from the *genre* and *genre*-like paintings of the early 1580s through Correggesque and Venetianizing altarpieces and a more classicizing synthesis of 1593. Through such works Annibale's reputation grew, but it was almost certainly the Carracci workshop's success in the Palazzo Magnani which impelled Odoardo Farnese of Parma to invite all or some of the family to help decorate the new Farnese palace in Rome. In the event, Agostino and Annibale arrived on a preliminary visit but only Annibale remained. The first task brought to completion by him was the ceiling decoration of the small *Camerino* used by Odoardo as his study (original centrepiece, *Choice of Hercules*, now Naples, Capodimonte). Although influenced by Central Italian Renaissance forms, the *Camerino* decoration relates more closely to Annibale's recent Bolognese work than to his Roman environment, unlike his major work for the Farnese, and the culmination of his career: the fresco decoration of the vault of the Farnese palace gallery, c.1597–1600. This key document in the history of European art is today little known by the wider public, due to its virtual inaccessibility in what is now the French embassy in Rome. Annibale's solution brilliantly resolved the *iconographic challenge: the gallery was to house the great Farnese collection of ancient sculpture; he created on the vault a 'picture gallery' of mythological scenes. More importantly, he revived on the gallery ceiling Michelangelo's architectonic scheme for the Sistine chapel ceiling, ridding it of its illogical shifts in scale and viewpoint and its spatial ambiguities. In so doing Annibale provided the 17th century with the major alternative to the *illusionistic 'open' ceiling – the two traditions being merged in *Pietro da Cortona's great fresco in the Palazzo Barberini. Furthermore, in executing the

Gallery decoration, Annibale once more adjusted his pictorial style: modelling himself on Michelangelo, on Raphael's Villa Farnesina *Psyche* paintings and on ancient sculpture, but without losing either his northern naturalism or his vibrant Venetian colourism, he forged a new style which underpins all of the classical revival of the 17th century. Basing every figure on studies after the live model, he reformulated in vigorous and convincing form an ideal vision of humankind.

Whilst the gallery, true to the overall theme of its mythological scenes, 'Love conquers all', is joyous in feeling, Annibale also created deeply felt, tragic religious paintings. Perhaps the most important is the *Pietà* (*c.*1599/1600, Naples, Capodimonte), but other such works, all influential, are now in Leningrad, Hermitage; London, National; Paris, Louvre; Vienna, Kunsthistorisches. In 1600–01 he competed directly with his 'rival', the 'arch-naturalist' Caravaggio, in the altarpiece of the *Assumption of the Virgin* for the Cerasi chapel, S. Maria del Popolo, for which Caravaggio executed the side paintings.

Landscape painting, whilst a small part of Annibale's output, was another of his fundamental contributions to the history of Western art. He created the 'ideal landscape' (between 1598–1601; Rome, Doria; Grenoble, Musée), in which a monumental, classical vision of nature, on the moderate scale of the landscapes of northern artists such as Paul *Brill, provides the setting for mythological or religious narrative. His pupils Albani and Domenichino carried on this genre of painting, which in turn directly influenced the ideal or heroic landscapes of *Poussin and *Claude.

Annibale's last years were darkened by depressive mental illness, precipitated by Cardinal Farnese's miserly payment for his labours in the Farnese gallery, and his sense of humiliation as a retainer in the Cardinal's household. Despite the affectionate concern and care of his devoted pupils, he painted little after 1605, although he executed some etchings *c.*1606.

CARRIERA, Rosalba (1675–1757) Internationally celebrated Venetian pastellist, specializing in bust-length, single-figure *Fancy Pictures and portraits. Although her work now appears insipid and flimsy, its historical interest is considerable. The earliest *Rococo portraitist, Carriera initiated a new type of likeness, seemingly intimate yet flattering. The Fancy Pictures of girls impersonating the *Arts*, the *Seasons* or the *Elements* (e.g. Washington, National) anticipate *Greuze. She was also capable, as in her self-portraits, of objective observation (e.g. Windsor Castle). Her popularity was greatest amongst foreign tourists to Venice, notably the English, who first discovered her, and the French, whose admiration for her work was tinged with gallantry. She spent a triumphant year in Paris, 1720–1, executing, amongst innumerable others, two pastels of the young King Louis XV and being made a member of the Royal *Academy. In 1730 she travelled also to Vienna. The rest of her working life was spent in Venice, although she catered

to a large mail-order clientele: Augustus III, Elector of Saxony and King of Poland, assembled the greatest collection of her work in Dresden (Gemäldegalerie). *Pellegrini, married to one of her sisters, acted virtually as her agent in England. Her influence was formative on Maurice-Quentin de *Latour and *Liotard and she had a number of Italian imitators, including her sister Giovanna.

Carriera's career was cut short by blindness in 1745 and she died in isolation, but not forgotten by her foreign admirers. There are works by her in many public and private collections beside the ones already mentioned, including Venice, Accademia, Ca'Rezzonico; Wolterton Hall.

CARTOON *See under* fresco.

CARUCCI, Jacopo *See* Pontormo.

CASSONE (pl. *cassoni*; Italian, large chest) In the Renaissance these were used for storing household items and clothes, and in the 15th century were often decorated with painted scenes from ancient history and mythology, the Old Testament, and contemporary writers such as Boccaccio. Especially elaborate were marriage *cassoni*. The only fully preserved *cassone* from the 15th century is the *Trebizond cassone* (c.1475, New York, Metropolitan) but *cassone* panels or reconstituted chests can be found in many museums. Since the same painters who decorated *cassoni* were also responsible for the decoration of bed-heads and footboards, the tops of benchbacks and wainscoting (*spalliere*) it is not always possible to tell the original location of a detached panel exhibited as an easel painting – especially since many such panels share an elongated format. The word *cassone* has thus come to signify this type of decorative domestic painting in general.

Whilst specialist workshops were responsible for the greater part of the production of *cassoni* and *deschi da parto* (*see under desco da parto*), they could also be commissioned from well-known artists; *Uccello, *Botticelli, *Piero di Cosimo are amongst those known to have engaged in such work. Painted *cassoni* tended to be replaced, from the last decade of the 15th century, by unpainted elaborately carved chests, and the importance of painted *spalliere* seems to date from that time. *See also* the Borgherini decoration *under* Andrea del Sárto, Granacci, Pontormo.

CASTAGNO, Andrea del *See* Andrea del Castagno.

CASTIGLIONE, Giovanni Benedetto (called Grechetto) (1609–63/5) Versatile artist, born and trained in Genoa, equally at home on an intimate scale and in monumental works, in rustic *genre* and in the grand manner. He completed his training with Sinibaldo Scorza (1589–1631), an Italian specialist of the Flemish animal and *still-life genre, at the same time passionately studying the Genoese work of *Rubens and *Van Dyck. He was also the first Italian to discover the etchings (*see under* intaglio prints) of *Rembrandt (c.1630), which remained an inspiration for the rest of his life. Documented in Rome from 1632–4,

Castiglione came there under the influence of *Poussin – translating the latter's *classical landscapes into a more *realistic form – as well as of the great exponents of *Baroque decoration, *Bernini and *Pietro da Cortona. From 1634 he spent some time in Naples, in turn influencing indigenous painters. In the 1630s he invented the monotype technique – a single print made from an unincised copper plate painted in oils or printer's ink – and began to execute fluid brush drawings in oils on paper. Back in Genoa in 1645 he completed monumental Baroque works (S. Maria della Cella, S. Giacomo della Marina); slightly later he treated allegorical and philosophical subjects (etching, *The Genius of Castiglione*, 1648). In 1648 he was appointed court painter in Mantua, where his work continued to evolve in new directions; at the end of his life he painted ecstatic compositions reminiscent of Bernini's. There are drawings, etchings and monotypes in the Royal Collection (Windsor) and paintings in various galleries, including Birmingham.

CAVALIERE D'ARPINO *See* Arpino, Giuseppe Cesari.

CAVALLINI, Pietro (Pietro dei Cerroni) (recorded Rome 1273, Naples 1308) Founder of a Roman school of painting which fused antique, Early Christian, Byzantine and, to a lesser extent, *Gothic elements to create a new style notable for its soft modelling and relative naturalism (*see under* realism). Like the sculptor *Arnolfo di Cambio, Cavallini was employed by Charles of Anjou in Rome; he may have worked alongside Arnolfo, restoring and repainting the Early Christian cycle in S. Paolo fuori le mura (*c.*1285, destroyed 1823) and painting the *frescoes of S. Cecilia in Trastevere (*c.*1293, partially destroyed) whilst Arnolfo was erecting the altar canopies of these churches. Cavallini also designed the mosaics in S. Maria in Trastevere, and he, or members of his workshop, may have painted the frescoes in Naples, S. Maria Donna Regina. Through the Florentine painter *Cimabue, recorded in Rome in 1272, the influence of Cavallini was transmitted to *Giotto.

CELLINI, Benvenuto (1500–71) Florentine goldsmith and sculptor. Thanks to his candid, if not always literally truthful, autobiography (1558–62, published only in the 18th century) he is now one of the best-understood personalities of his time; his two technical treatises, 1565, provide invaluable information about the ideals and procedures of Italian *Mannerist sculpture. He was the implacable critic and rival of the more *academic *Bandinelli. Although his first piece of large-scale sculpture was not executed until 1543–4 (bronze relief of the *Nymph of Fontainebleau*, now Paris, Louvre) and all of his work is characterized by a goldsmith's striving for refined decorative effects, he sought always, in both small objects and large statues, that liveliness which had been a feature of the Florentine sculptural tradition since *Donatello. Cellini moved to Rome in 1519 and until 1540 was mostly active in that city as a coin designer and medallist, jeweller and seal-maker (Florence, Bargello; Milan, Gabinetto Numismatico;

Mantua, Curia Vescovile; Turin, Gabinetto Numismatico; Vienna, Kupferstichkabinett; London, Victoria and Albert; etc.). According to his memoirs, he participated as a gunner in the defence of the papal fortress of Castel Sant'Angelo during the Sack of Rome, 1527; he also spent some agonized time as a prisoner in the fortress dungeons, 1539. From 1540–5 he worked in France for King Francis I, for whom he completed the celebrated gold-and-enamel salt cellar begun for Ippolito d'Este (Vienna, Kunsthistoriches). It combines, in miniature, the elegance of the School of Fontainebleau (*see* Primaticcio) with the monumentality of figural poses derived from *Michelangelo. Returning to Florence in 1545, he received the commission from Cosimo I de'Medici for the bronze *Perseus*, as a pendant to Donatello's *Judith and Holofernes* and in full view of Michelangelo's *David* and Bandinelli's despised *Hercules and Cacus* (Florence, Loggia dei Lanzi; wax and bronze models, Florence, Bargello). He also executed the boldly *expressive over-life-size bust of Cosimo (Florence, Bargello). His talent for capturing a 'speaking likeness' in the precious and durable medium of bronze is shown to even better advantage in the bust of Bindo Altoviti (*c.*1550, Boston, Gardner). But he was able also to carve marble with sensitivity (*Apollo and Hyacinth*, 1546, *Narcissus*, 1547–8, both Florence, Bargello); his most technically accomplished work in that medium is the white-and-black marble *Crucifix*, 1556–62, originally intended for his own tomb (now Spain, Escorial), and derived from a vision of 16 years before in the dungeons of the Castel Sant'Angelo.

There is a tragic element in Cellini's life and art: although dependent throughout most of his career on princely patrons, he lacked a courtier's servile instincts and was several times imprisoned; at the same time, his sincere artistic aspirations, and his most personal creative impulses, were shaped – as they are in the *Crucifix* – into coldly elegant, courtly forms. It is these tensions that make the *Autobiography* such compelling reading even for non-art historians.

CENNINI, Cennino *See under* Gaddi, Agnolo.

CERACCHI, or CIRACHI, Giuseppe (1751–1801) Peripatetic sculptor, born in Rome. He specialized in portraits and in decorative sculpture. In England *c.*1773, he executed decorations for Robert Adam and William Chambers; between 1776–9 he exhibited at the Royal *Academy. After travels to Vienna, and in Italy and Prussia, he went to America, where between 1790–5 he made many portrait busts, including those of Jefferson and Washington. Returning to Europe imbued with revolutionary ardour, he made his way to Paris hoping for great commissions. In 1800 he was implicated in a plot to assassinate Napoleon, then First Consul, and went to the guillotine – dressed as a Roman Emperor, in a chariot of his own design. There are works by him in London (Somerset House; British; Royal Academy) and elsewhere.

CERANO; Giovanni Battista Crespi, called (c.1575–1632) With Giulio Cesare *Procaccini and *Morazzone, one of the three foremost painters in Milan in the early 1600s; a protégé of Cardinal Federico Borromeo and one of the leading artists of the Italian Counter-Reformation. He was also a sculptor, architect, engraver (see under intaglio prints) and writer. His eclectic but always *expressive style had local roots – notably the *realism of the Lombard Sacri Monti (see Sacro Monte) – but was affected also by *Barocci and Roman *Mannerism, with which Cerano became acquainted during a visit to Rome in the late 1590s. After his return to Milan, he participated in the city's two most important artistic commissions of 1601–10: the decoration of the side aisles of S. Maria presso S. Celso and the so-called Quadroni of S. Carlo Borromeo. For the former he executed both vault *frescoes and stucco sculptures. The Quadroni are huge paintings, nearly 5m×6m in glue size on canvas, illustrating the life and miracles of Carlo Borromeo, and part of a propaganda campaign mounted in Milan to obtain his canonization (1610). Cerano completed two Quadroni in 1602, a further two in 1603, and six in 1610 – more than any other artist working on this project (Milan, cathedral). Where the earlier scenes still employ Mannerist conventions, the latter are remarkably direct and intensely dramatic.

In 1621 Federico Borromeo appointed Cerano director of the painting section of the new *Academy he founded in Milan according to the regulations of the *Carracci Academy in Bologna. From 1629–31 Cerano served as master of works on Milan cathedral, with special responsibility for the sculptural decoration. His designs, executed in marble by others, are in the cathedral museum. Other works by Cerano are in churches throughout Milan, and galleries in Italy and elsewhere. The Brera in Milan also has a Martyrdom of SS. Ruffina and Seconda executed jointly in the early 1620s by Cerano, Morazzone and Giulio Cesare Procaccini – whence its more usual name of the 'Tre Mani', 'the three-hander'.

CERQUOZZI, Michelangelo See under Laer, Pieter van.

CERUTI, Giacomo (1698–1767) Milanese-born painter active in Brescia c.1721–35, and from c.1736 commuting between Venice, Padua and Piacenza. A prolific portraitist of the local aristocracy in the Bergamasque tradition of *Moroni (Bergamo, Accademia; see also Ghislandi), he came to specialize in stark, dark-hued representations of beggars and vagabonds, poor peasants and the urban proletariat, which earned him the nickname of Pitocchetto, 'Little Beggar' (e.g. Brescia, Pinacoteca). They have been compared with analogous paintings by *Le Nain and Georges de *La Tour, although no direct relationship has been established. Ceruti borrowed figures, poses and whole background settings from the prints of Jacques *Callot and, especially after 1740, from engravings after pastoral scenes by Abraham *Bloemaert.

CESARI, Giuseppe See Arpino.

CHAMPAIGNE, Philippe de (1602–74) Born in Brussels, he became one of the leading painters of portraits and religious subjects in Paris, where he settled in 1621 and was appointed Painter to the Queen Mother Marie de'Medici in 1628 (paintings for Carmelite convent, Rue St Jacques, now Dijon, Musée; Grenoble, Musée) whilst simultaneously gaining the favour of Louis XIII (*Portrait of Louis XIII as Victor over La Rochelle*, 1628, Paris, Louvre). By 1635 he had also attracted the attention of Cardinal Richelieu (decoration of gallery at Palais Royal, now lost; series of portraits of famous men, in collaboration with *Vouet; known mainly through engravings, one portrait, Versailles; *frescoes, dome of Sorbonne; *Portrait of Richelieu*, 1635–40, London, National). The official portraits of this period, such as those mentioned above, show Champaigne's links with his fellow-Flemings *Rubens and *Van Dyck, although the handling of the draperies is more *classical, resembling that of Roman statuary. Religious works of the same years (e.g. *Adoration of the Shepherds*, c.1630, London, Wallace) also show the influence of the early Rubens, translated, however, into a more static, colder and naturalistic (*see under* realism) idiom.

The *Baroque influences, however, were rejected by Champaigne after his conversion, c.1645, to the Jansenist doctrines practised at the convent of Port Royal – a particularly severe and rational form of Catholicism. The religious paintings from the 1650s until the year of his death are increasingly static, and intense in their restrained simplicity (e.g. Paris, Louvre; Lyons, Musée; Toulouse, Musée des Augustins). The portraits of these years are even more effective and original, especially the sober half-lengths, usually depicting sitters dressed in black against a grey background and behind a stone-coloured parapet (e.g. Paris, Louvre). Champaigne's mature portrait mode also well suited the official group portraits he was three times called upon to execute (*Echevins of Paris*, e.g. version of 1648, Paris, Louvre). The masterpiece of his last period combines both portraiture and a religious theme: it is the votive picture for the cure of his daughter, a nun at Port Royal (1662, Paris, Louvre), in which the painter's daughter and the prioress who prays for her are shown full-length on the scale of life, almost at right angles to each other and nearly parallel to the picture plane, in subtlest tones of grey, cream and blacks relieved only by the red crosses on their habits. It has been called as typical of the Jansenist approach to a miraculous event as *Bernini's ecstatic *St Theresa* is of the Jesuit.

CHARDIN, Jean-Siméon (1699–1779) French *still-life painter, who very early in his career, and again in c.1730–55, turned also to *genre scenes. From 1771, failing in health and eyesight, he executed masterly portrait heads in pastel (e.g. *Self-portrait*, 1755, Paris, Louvre). Although he did not practise the *academically sanctioned 'higher *genres', he was acclaimed by critics, collectors and the wider public of his own time. He fell into disfavour with the Neo-*Classicist critics of

the late 18th and early 19th centuries, but was rescued from oblivion by the Realist artists and critics of the 1840s–60s (*see* Volume Two), when his works were acquired for the Louvre. He is now acknowledged to be one of the greatest French painters and one of the finest painters of the 18th century.

The son of a master-carpenter, he was apprenticed to the painter Cazes in 1718. Then, *c*.1720, he became an assistant to Noël-Nicolas *Coypel, and matriculated in the Académie de Saint-Luc, which was mainly an artisanal organization. In 1728, however, he was received at the Royal Academy as a painter 'of animals and fruits' and although, because of this lowly classification, he could not rise to the higher posts, he did hold the treasurership of the Academy and was for a long time responsible for the hanging of the pictures at its annual Salon or public exhibition. In 1757 he was granted living quarters in the Louvre.

Although in the 1720s Chardin tried to compete with the brilliant large-scale ornamental still-lifes of *Oudry, he lacked Oudry's facility, especially in the painting of live animals (e.g. *Cat Stalking a Partridge and Hare left near a Tureen*, late 1720s, New York, Metropolitan; *see also* his Academy reception pieces, *The Buffet*, and *The Skate*, both 1728, Louvre). He then turned to smaller, more unified and static compositions, for which he is best known. These can broadly be grouped as dead game; the kitchen table with copper and earthenware pots and utensils, fish, meat, vegetables and eggs, and the more refined dessert table, with fruits, wine, porcelain, glass, silver and pewter (e.g. Paris, Musée de la Chasse et la Nature; Springfield, Mass., Museum; and, of course, Louvre). Unlike most Flemish and Dutch still-life painters he did not depict prepared, and abandoned, meals, rather a still moment before the preparation or the consumption of food. Working laboriously from direct observation, he evolved a complex technique involving – unusually for a still-life specialist of his period or earlier – the use of impasto. By the 1750s he had extended this to include subtle glazes, scumbling and dragging (*see under* colour). But the 'magic of his technique', as an 18th-century critic called it, which envelops forms in air and makes surfaces at once opaque, reflective and translucent, is not the only factor which makes his work so affecting. The long-meditated geometric arrangement of simple shapes, as well as the modest objects depicted, give these still-lifes a grave, even austere, moral compulsion. And when in the 1730s, perhaps in response to a friendly gibe by the portraitist *Aved, Chardin began to exhibit *genre* scenes, it was their moral climate, which reflected the domestic values of order, industriousness, education and affection, that probably ensured their wider popularity (e.g. Stockholm, Museum; London, National; Paris, Louvre; Ottawa, National). When these paintings were engraved, they were furnished with moralizing captions which highlight, or perhaps exaggerate, their kinship with Dutch 17th-century moralizing *genre*.

By the 1750s Chardin, his limited invention exhausted, was showing

only replicas of his earlier figure paintings; the popularity of *Greuze's more anecdotal and more melodramatic *genre* may have persuaded him to cease this type of production. During the 1760s, however, after the death of Oudry, he was commissioned to return to a larger, more decorative type of still-life: *Attributes of the Arts and Sciences*, designed as overdoors for royal palaces (now Paris, Louvre; Jacquemart-André; private coll.). A variant was acquired by Catherine the Great of Russia (Leningrad, Hermitage). This painting and a replica in Minneapolis, Institute, include the plaster model of the famous statue of *Mercury* by *Pigalle, one of the many artist-admirers of Chardin who owned examples of his work. Of Chardin's several emulators the one who came nearest to him was Henri-Horace Roland de la Porte (1725–93) whose work was for a long while confused with Chardin's. *See also* Anne Vallayer-Coster.

CHIAROSCURO (Italian, light-dark) In painting, and by extension in other media, extreme contrasts of light and dark, i.e. highlight and shadow. *Leonardo da Vinci pioneered the use of chiaroscuro to create the illusion of relief on a two-dimensional surface. He exploited the predominant dark tonality of his late paintings, however, largely for *expressive ends, and this use of chiaroscuro assumes great importance from the end of the 16th century with the work of *Caravaggio and his followers (*see also* tenebrism).

CHIAROSCURO PRINTS *See* relief prints.

CHODOWIECKI, Daniel Nikolaus (1726–80) Draughtsman, painter and engraver (*see under* intaglio prints) from Danzig, active in Berlin. Trained as a shop assistant, he turned to miniature portraits *c.*1743, then to literary and scientific illustration and the depiction of the life of the bourgeoisie. Influenced by French *Rococo prints, notably those after *Watteau and *Chardin's *genre* pieces, he became one of the first German artists to work for the middle classes, independent of court employment. He championed 'natural' German bourgeois manners against the affectations of French-inspired aristocrats and parvenus. His work as a whole is a valuable source for social historians. There are drawings by him in East Berlin, Kupferstichkabinett; Leipzig, Museum; Weimar, Schlossmuseum.

CHRISTUS, or CRISTUS, Petrus (active from *c.*1442–72/3) After the death of Jan van *Eyck in 1441 he became the leading painter in Bruges. His work is slavishly dependent on van Eyck's, except in the *Lamentation over the Dead Christ* (Brussels, Musées; New York, Metropolitan) which are indebted to Rogier van der *Weyden and Dieric *Bouts. There are paintings ascribed to him in London, National; Madrid, Prado; etc., and some signed pictures, Frankfurt, Städel. He is unlikely to have travelled to Italy, as has been suggested.

CIAMPELLI, Agostino *See under* Santi di Tito.

CIBBER, Caius Gabriel (1630–1700) Danish-born sculptor, probably trained in Rome, practising in England during the Restoration. He

[76]

executed several public commissions, including the two figures of *Raving and Melancholy Madness* for the gate of Bedlam Hospital (London, Victoria and Albert). He was the father of the dramatist Colley Cibber.

CIMA DA CONEGLIANO, Giovanni Battista (*c.*1459/60–1517/18) Venetian painter from Conegliano, established in Venice from before 1492–1516. He may have studied under Alvise *Vivarini, but was mainly influenced by *Antonello da Messina and Giovanni *Bellini. His style changed little during his career and he not only repeated entire compositions but actually re-used the same cartoons (*see under* fresco) for several works; he also ran a large studio, so that many works attributable to him are not to any great extent autograph. His first known painting, a *sacra conversazione* for Vicenza, 1489, is now in Feltre, Museo; other altarpieces and paintings of religious subjects Conegliano, cathedral; Venice, many churches and Accademia; Milan, Brera; London, National; Berlin-Dahlem, Museen; Washington, National; Paris, Louvre. There are also roundels painted by Cima *c.*1500 on mythological themes, Parma, Estense, Farnese; Copenhagen, Museum; Milan, Poldi-Pezzoli; Philadelphia, Johnson coll.

CIMABUE (Cenni di Pepi) (first recorded 1272–after 1302) Designated 'Florentine painter' in a Roman document of 1272, he is traditionally regarded as the teacher of *Giotto, to whom he probably transmitted the new modes of *fresco painting evolved in Rome by *Cavallini. His own sources are antique Roman and Byzantine. Cimabue's only securely attributable and datable work is the figure of St John in the mosaic of *Christ Enthroned with the Virgin and St John* (Pisa, cathedral, 1301–02). On the basis of this documented work, he is credited also with the *Madonna of St Francis* in the lower church of S. Francesco, Assissi; the much deteriorated fresco cycle in the choir and transepts of the upper church (*c.*1280); and the grandiose panel of the *S. Trinita Madonna* (Florence, Uffizi, early 1280s), which narrowly anticipates *Duccio's *Rucellai Madonna*. Some authorities also attribute to Cimabue the design of the enormous round stained glass window of the choir of Siena Cathedral (*c.*1287), and painted crucifixes (Arezzo, S. Domenico; Florence, S. Croce). He may in addition have participated in the mosaics for the Baptistry, Florence; his influence at any rate appears in some of the latest scenes (*c.*1325).

CIONE, Jacopo and Nardo di *See* Orcagna, Andrea.

CIVETTA *See* Bles, Henri met de.

CLAESZ., Pieter (1597/8–1661) Dutch *still-life specialist, born in Westphalia but working in Haarlem. Along with Willem Claesz. *Heda he is an originator of the tonal 'breakfast piece': a simple meal painted more or less at eye level in monochromatic harmonies, usually in silver tones (e.g. Rotterdam, Boymans-Van Beuningen). He was the father of Nicolaes *Berchem.

CLASSIC, CLASSICAL, Classical, CLASSICISM and CLASSICIZING The confusion surrounding the usage of these terms stems from the fact that their distinct normative, historical and descriptive connotations are combined or used interchangeably.

Classic or classical in its normative sense means 'that which sets a norm, standard or canon'. In art theory from the Middle Ages until the 19th century, this normative usage tended to be conflated with the historical usage, referring to Graeco-Roman antiquity. The conflation expresses the canonic role of ancient civilization in the history of Western culture. The value-free, purely historical use of the term is generally indicated by the capitalization of the first letter, as in Classical.

The descriptive use of these terms points to features thought to have originated in ancient monuments of art and architecture, notably Greek 5th-century BC works and their derivations. It denotes rationality, the clear articulation of separate parts subsumed to the monumental effect of the whole, and an emphasis on stable vertical and horizontal axes – albeit not to the point of noticeably distorting organic forms. The presentation of a somewhat generalized physical beauty is characteristic of classical etc. art, as is lucid narrative. The term Neo-Classicism is applied to those styles, recurrent from the 18th century, which exaggerate some or all of these features and combine them with Classical motifs, as for example heroic nudity or antique dress. Neo-Classicism is sometimes used pejoratively, to imply lack of spontaneity and the pedantic application of outworn rules and stereotypic forms (see also Volume Two).

A functional definition of classical has been proposed by the art historian E. H. Gombrich. In this definition, the classical or classic solution to an artistic problem reconciles the conflicting demands of representational accuracy and of compositional order, both being equally esteemed by the artist. Representational accuracy here means fidelity to appearances as defined by a single viewpoint, a particular lighting scheme, and, by implication, a single moment of viewing. Compositional order, on the other hand, signifies a pattern governed by a shaped and bounded pictorial or sculptural field. Another formulation defines classicism or the classical in art as the point of equipoise between *illusion, *expression and *idealization. All definitions include the notions of balance, harmony and closure.

CLAUDE GELÉE (called Lorraine or Le Lorrain) (1600–82) Painter born in the Lorraine but active for most of his life in Rome; landscape specialist who raised the *genre from a low standing in the *academic hierarchy to a major means of artistic expression. Rooted in the landscape tradition of the northerners established in Rome, the brothers *Brill and *Elsheimer, he succeeded in giving pictorial form to the nostalgia for a lost Golden Age articulated by the Roman poet Virgil, often illustrating themes from the latter's *Aeneid* or the *Georgics*.

His poetic *classicism, founded on masterly control of subtle grad-
ations of all-enveloping light and harmonious geometric structure,
became the lens through which successive generations of artists and
art-lovers viewed his preferred subjects, the landscape of the Roman
Campagna and the Bay of Naples or, like Richard *Wilson, the land-
scape of their own countries (see also 'Claude glass').

Claude left the Lorraine c.1612, first for Germany and thence to
Rome, where he worked, like many Lorrainers, as a pastry cook.
Employed as such in the household of Agostino Tassi (c.1580–1644), a
landscape and quadratura (see illusionism) painter and probable pupil
of Paul Brill, Claude became his apprentice. Around 1623 he visited
Naples, studying there under the little-known Flemish landscapist
Goffredo Wals. In 1625–7 he was again in Nancy, but by 1628 had
settled for good in Rome. Within a decade he had established his
reputation as a purveyor of landscape paintings to ambassadors, cardi-
nals and the pope. In later life he would record his compositions in
drawings, compiling the Liber Veritatis, or 'Book of Truth' (London,
British) to guard against forgeries and imitations, the earliest of which
can be traced to c.1634. These drawings were engraved in 1777 by the
English print-maker Richard Earlom.

Claude's oil paintings, composed and executed in the studio, are
based on the sketches in pen-and-wash which he executed during
constant excursions into the Roman countryside (e.g. London,
British); he may also have been directly inspired by ancient Roman
wall paintings. To Elsheimer's dramatic light effects he preferred
more typical and serene conditions: cool early-morning light, warm
evening glow or hot noonday. It is the depiction of light which gives
significance and poetic *expression to his paintings, in most of which
the eye is led to infinity through an atmosphere-filled space whose
continuity and extent are established more by subtle changes of
*colour and tone than by means of linear *perspective. In the earlier
harbour scenes (e.g. The Embarkation of St Ursula, 1641, London,
National) the sun, lying low on the horizon and by definition the
lightest area of the painting, coincides with the vanishing-point.
Shadows reinforce the receding lines of orthogonals, and dark tree
and architectural forms in the foreground act as *repoussoirs. In later
pictures Claude abandons these devices. The disc of the sun is no
longer visible and the lightest portion of the painting lies parallel with
the horizon; other objects are often also disposed horizontally. Light
penetrates the flickering trees, dissolves architectural forms and is
reflected from rippling water.

These tendencies are reinforced in the style of the last 15 or 20
years of Claude's life, when the emphasis on open space and the view
to infinity is intensified through bold compositional asymmetry and
transparency of form (e.g. Perseus and Medusa, 1674, Norfolk,
Holkham Hall). Colours become so cool as to be almost uniformly

chalky or silvery, and all the pictorial elements seem reduced to the immateriality of dream (e.g. *Ascanius and the Stag*, 1682, Oxford, Ashmolean).

Claude's very large output found its way to most important aristocratic and princely collections. He is now particularly well represented in England, having become especially prized by 18th-century Grand Tourists.

CLAUDE GLASS A slightly convex blackened mirror, an 18th-century device used to view landscape. By turning his back on the reflected scene, and looking at it in his Claude glass, the *Picturesque tourist or landscape artist saw a framed, 'composed' image in finely graduated harmonizing tones, reminiscent – at least in theory – of the landscape paintings of *Claude.

CLEEF, Hendrick and Maerten van *See under* Bruegel.

CLEVE, Joos van (also known as Joos Van Cleef) (active by 1511–1540/1) Formerly known as the Master of the Death of Mary (after two paintings on this theme, 1515, Cologne, Museum; Munich, Alte Pinakothek) his real name was Joos van der Beke, but he was called after his native town of Cleves. Active in Antwerp from 1511, he was dean of the guild in 1515 and 1525, and one of the most prolific and eclectic of the city's painters. He was influenced by earlier Flemish art (e.g. *Gossart, *Patinir, *Metsys), by *Dürer, by *Raphael – whose tapestry cartoons had arrived in Brussels in 1517 – and by *Leonardo. The latter's influence was probably transmitted to Joos during his stay at the court of France, where he was invited by Francis I to paint portraits of the king and his entourage (Philadelphia, Johnson Coll.; Hampton Court). There are also works by Joos and his workshop in New York, Metropolitan; Brussels, Musées; Vienna, Kunsthistorisches; etc.

CLEYN, Francis (1582–1657/8) Painter, born in Rostock and trained in Rome and Venice. He became court painter to Christian IV of Denmark; a number of history paintings (*see under* genres) survive in Danish royal palaces. In 1625 he settled in England, becoming chief designer for the Mortlake tapestry works, and executing also the three canvases of the *Story of Perseus* let (after 1654) into the ceiling of the Double Cube Room at Wilton. He was the master of William *Dobson.

CLODION; Claude Michel called (1738–1814) French sculptor, best known for his inventive, delicate yet energetic terracotta statuettes of Bacchic subjects – nymphs, satyrs, playful *putti* – which were inspired as much by antique vase paintings as by Graeco-Roman statuary and domestic figurines (e.g. Waddesdon Manor; Nancy, Musée; London, Wallace, Victoria and Albert). From *c.*1771–*c.*89 he was assisted, especially in turning out bronze and porcelain replicas of his terracottas, by his brothers Sigisbert-François (1728–1811), Sigisbert-Martial (1727–after 85), Nicolas (*b.*1733) and Pierre-Joseph (*b.*1737). The first of his only two commissions from the crown,

a group of *Music and Poetry* in the guise of children (comm. 1773, Washington, National) was in the same style, albeit on a larger scale. With the second, however, the life-size seated *Montesquieu*, he demonstrated his capacity to carve marble in a severe monumental style (1783, Versailles). His one religious commission, a *St Cecilia* for Rouen cathedral (1775–7), shows that he had studied *Bernini and *Algardi. Associated through his earlier work mainly with *ancien régime* private collectors, who included the painter *Boucher, he astonished everyone at the post-Revolutionary Salon of 1800 by his ability to adapt to Revolutionary artistic ideals with his grimly heroic group of *The Deluge*. He was later (1805) to contribute to the decoration of the Vendôme column honouring the Napoleonic Great Army.

Born at Nancy, Clodion was the nephew of the brothers *Adam, and received his first training in Paris under his mother's eldest brother Lambert-Sigisbert Adam, 1755–9. After the latter's death he briefly entered the studio of *Pigalle, winning first prize for sculpture at the *Academy in the same year. From 1762–71 he was in Rome, first as a pensioner at the French Academy, later as a successful independent sculptor, sought after by collectors from all over Europe. Sometimes seen as the last great *Rococo sculptor, he is – like the painter *Fragonard – an artist celebrating the forces of nature. His virtual alienation from the Academy and his reliance on private clients anticipate later developments in the status and conditions of art production.

CLOUET, Jean or Janet (*c*.1475/80–*c*.1541) and his son, François (also called Janet) (*c*.1516/20–72) Both held the post of chief court painter to the King of France, Jean under Francis I (*Francis I of France*, *c*.1525, Paris, Louvre; *Francis I on Horseback*, *c*.1525–30, Florence, Uffizi) and François under Henry II, Francis II and Charles IX.

Jean Clouet's origins are obscure, but he was certainly trained in Flanders or by a Flemish artist. First recorded at court in 1516, he became *Premier Peintre du Roi* in 1531. His famous portrait of the King now in the Louvre (see above) shows an affinity to *Gossart in the treatment of the body and drapery, but is closer to the cooler French tradition of *Fouquet in the representation of the face.

About 130 portrait drawings in red, white and black chalk or crayon are attributed to Jean Clouet, most of them at Chantilly, Musée. Only a few painted portraits are now known; in addition to those already cited, the most remarkable is that of the humanist *Guillaume Budé* (*c*.1535, New York, Metropolitan).

François Clouet, born at Tours, was active by 1536 and succeeded his father as *Premier Peintre* upon the latter's death. He designed the funerary decorations for the obsequies of Francis I and in 1552 executed the death mask of Henry II. He continued his father's practice of chalk-drawn portraits, but his only signed painted portrait (*Pierre*

Quthe, 1562, Paris, Louvre) shows the influence on him of the new international portrait style (*see*, e.g. Anthonis Mor). The only other signed painting, the enigmatic *Lady in her Bath* (*c*.1550, Washington, National) demonstrates his interest in both the new Flemish painting (e.g. *Heemskerck, *Aertsen) and Italian motifs. On the strength of this signed work, a mythological painting, the *Bath of Diana* (or *Diana and Acteon*) has been attributed to him (Rouen, Musée).

CODDE, Pieter (1599–1678) Dutch painter, resident of Amsterdam. A specialist of guardroom scenes (*see also* Willem Duyster) he also painted portraits and *Merry Company pictures (London, National; etc.). He was the painter commissioned to finish Frans *Hals' group portrait, the *Meagre Company* (1637, Amsterdam, Rijksmuseum).

COELLO, Alonso Sánchez *See* Sánchez Coello, Alonso.

COELLO, Claudio (1642–93) Spanish Late *Baroque painter of Portuguese descent, a protégé of the dowager Queen Mariana and her son Charles II, and the last great painter of the school of Madrid. His works are festive, colourful and crowded; the best known is the vast *Sagrada Forma*, or *Mass of Charles II* (1685–90), which is conceived as an *illusionistic extension of the sacristy of the Escorial – at once a devotional picture, a historical scene and a portrait gallery. He was displaced from royal favour by Luca *Giordano.

COLANTONIO *See under* Antonello da Messina.

COLLOT, Marie-Anne *See under* Falconet.

COLOMBE, Michel (*c*.1430–1512) Celebrated French sculptor, viewed by some historians as the last great *Gothic master working in France, and by others as a pioneer of a new indigenous style influenced by the Italian *Renaissance but not directly dependent on Italian models. A native of Bourges, where his father Philippe Colombe worked as a sculptor, he was active at Tours from 1473. His only surviving works, however, date from the beginning of the 16th century: the double *Tomb of François II of Brittany and his wife Marguerite de Foix*, 1502–07, originally Nantes, Carmelite church, now Nantes cathedral; and the altar relief of *St George and the Dragon*, 1508–09, for the chapel of the château of Gaillon, now Paris, Louvre.

COLONNA, Angelo Michele (1600–87) In collaboration with Agostino Mitelli (1609–60), the leading specialist in *quadratura* (*see* illusionism) painting. Trained in Bologna, they virtually monopolized such commissions throughout Italy and even worked for a while in Madrid, where Mitelli died. Colonna then collaborated with Mitelli's pupil, Giacomo Alboresi (1632–77). There are decorations by Colonna and Mitelli in Florence, Palazzo Pitti, and other palaces in Parma, Genoa, Rome, etc., and they trained a large school in their decorative style, thus laying the foundation for its extensive 18th-century development.

COLORITO (Italian, colouring) *See under* disegno.

COLOUR There are three main properties of colour as it is employed by painters: *hue*, *tone* and *temperature*. *Hue* is that attribute by which

colours are classed as red, blue, yellow, etc. *Tone* is the degree of lightness or darkness on a scale from white to black (*see also* chiaroscuro). Some colours have a wider tonal range than others: yellow, for example, is restricted to a narrow range near the white end of the scale; blue, on the other hand, ranges from the near-white of sky-blue to near black. Artists have two standard means of ascertaining, and employing, the maximum tonal range of any given pigment. The first is by a process of dilution and saturation. A blue pigment, for example, highly diluted in water, a drying oil or varnish, will leave a lighter brushmark on paper, plaster or panel than the same pigment held in suspension at the point where no more can be absorbed by the medium – that is, a saturated or fully saturated colour. The full tonal range of a colour can also be obtained, at any desired stage of dilution, through the addition of white or black pigment, the limiting factor being the point at which the original colour changes hue. *Temperature* is relative: colours, when compared with each other, can be seen to be 'cold' or 'warm' – as in the case of a steely-blue side by side with orange. Effects of three-dimensional relief can be obtained by colouristic means (as opposed to linear means, as in linear *perspective) by contrasting all or some of these attributes of colour in adjacent areas. When tonal contrasts are introduced within a single contour, for example, we speak of 'shading'. But similar optical effects can be produced through contrasting hues, and especially by placing cold against warm colours. Colour 'harmonies' are created by careful juxtapositions of colours taking into account hue, tone and temperature. An artist's *palette* is not only the surface on which he lays out his paints prior to applying them; the word is also used to mean either his customary choice of colours and colour harmonies, or all the colours utilized in a particular painting.

In painters' pigments, as opposed to the colours of the spectrum, of printers' ink or photographic emulsions, there are three so-called *primary* colours: red, blue and yellow. These may occur naturally in vegetable or animal dyes or in minerals, or be synthesized chemically; they cannot, however, be obtained by mixing pigments before or after application, that is, on the palette or by successive translucent layers superimposed on the support (*glazes*). *Secondary* colours are those which may be obtained by mixing pigments of the primary colours, regardless of the fact that all, or some, may also be obtained directly from minerals or through chemical processes. Thus, as most school children know, red and blue mixed yield violet or purple; blue and yellow, green; yellow and red, orange. These relationships may be shown diagrammatically on a colour wheel or by two triangles superimposed in a star shape. It will then be seen that primary colours are placed directly opposite secondary colours: yellow is opposite violet, blue faces orange, and red, green. These colours are then described as being *complementary*: red is complementary to green, etc. (This relationship has a physiological basis in the after-image on the retina when the eye has stared at a single

colour for a considerable time.) Although the colour wheel is a modern invention, relationships of complementary colours have often been exploited in the colour harmonies of the art of the past, and are particularly associated with the painting of *Renaissance Venice and its tributaries (e.g. *Giorgione, *Veronese).

CONCA, Sebastiano *See under* Giaquinto, Corrado.

CONEGLIANO, Cima da *See* Cima da Conegliano, Giovanni Battista.

CONINXLOO, Gillis van (1544–1606) The most important landscape painter to have worked in Holland in the first decade of the 17th century. A Fleming, he escaped the Spanish wars first to Frankenthal, near Frankfurt, then, in 1595, to Amsterdam. He broke with the panoramic landscape of *Patinir and *Bruegel and his late landscapes represent luxuriant forests seén close to at eye level, in which foreground, middleground and background are interwoven and interrelated through dramatic distribution of light and shade (Vaduz, Liechtenstein Coll.; Vienna, Kunsthistorisches; etc.). His principal followers were David *Vinckboons and Roelant *Savery (but *see also* Jan Brueghel).

CONTRAPPOSTO Italian for a pose evolved originally in *Classical Greek sculpture and revived in the *Renaissance (*Donatello's *St Mark*, 1411, is an early example). It is designed to lend the illusion of potential movement to a static figure, through a system of changing axes and alternating contraction and relaxation. By the 16th century the term also came to mean 'variety through contrast', and is applicable not only to a single figure but to entire compositions or even groups of works of art.

CONTRE-JOUR, À (French, against daylight) In painting, the device of silhouetting figures, or other motifs, against a light background. It is an effect exploited particularly in the work of Mattia *Preti.

CONVERSATION PIECE Small-scale informal portrait group, usually of a family or a gathering of friends. It may be set indoors or out. The term is modern, but is applied to a *genre of portraiture which became especially popular in 18th-century England. *Mercier and *Devis are particularly well-known specialists, as was *Hogarth early in his career. *See also* Fancy Picture; *fête galante.*

COOPER, Samuel (1609–72) English miniature painter, the last distinguished practitioner of this technique in Britain. His international reputation, and his prices, rivalled those of his contemporary at the Restoration court, *Lely, many of whose sitters he also painted. Until *c.*1634 Cooper trained with his uncle, the miniaturist John Hoskins; from *c.*1634 until 1642 he travelled widely on the Continent. In the 1640s he was in demand in England for portraits both of Royalists and Parliamentarians. His miniature of Cromwell is the Protector's best-known and most distinguished likeness. Despite Cooper's service to the Commonwealth, he was appointed 'limner' or miniature painter to

Charles II. Like Isaac *Oliver, and unlike *Hilliard, Cooper treated the miniature as a fully modelled painting; Evelyn records (1662) holding the candle for him, '. . . for the better finding out the shadows . . .' as he drew the King. His elder brother, Alexander, also trained by Hoskins, worked as a miniaturist in Holland and Scandinavia. He died in 1660. There are paintings by both in the Royal Collections and in London, Victoria and Albert.

COPLEY, John Singleton (1738–1815) The most distinguished of the New England portraitists (Boston, Museum; Cambridge, Mass., Fogg; New Haven, Yale; New York, Metropolitan). He is now chiefly remembered for his contributions to the English school: pioneering modern-dress narratives in the Grand Manner.

Taught only by his step-father, the engraver Peter Pelham, Copley quickly surpassed the Colonial painters who influenced him: *Smibert, *Feke, *Greenwood. In 1774 he emigrated to London, via a study tour of Italy. There he discovered 'composition' and first undertook a traditional narrative subject, The Ascension (1774, Boston, Museum). His hopes of receiving a commission for an altarpiece version were never realized; upon settling in London, his bid for membership in the Royal *Academy was made with a double portrait painted in Italy. This, like his following year's entry, The Copley Family (1776–7, Washington, National), which celebrated his reunion with his wife and children, was coolly received. Success came with the commission from a prominent merchant and sometime Lord Mayor of London, Brook Watson, to record an accident which befell him some three decades earlier. Watson and the Shark (1778, Washington, National), is the earliest painting to employ the full panoply of history painting (see under genres), albeit in modern dress, in order to depict a private event of no historical or moral import. Copley, however, probably did not differentiate between this and the following series of paintings, in which he turned to direct competition with the Death of Wolfe by his benefactor, Benjamin *West: Death of Chatham (1779/8, London, Tate); Death of Major Peirson (1783, London, Tate); The Repulse of the Floating Batteries at Gibraltar (1791, London, Guildhall); Admiral Duncan's Victory at Camperdown (1799, Dundee, Camperdown House). These form the greatest series of modern history paintings executed in England in the 18th century; the Death of Chatham, furthermore, combines meticulous individual portraiture with dramatic narrative. Copley, having painted the picture on speculation, sold advance subscriptions to the engraving. In addition, he exhibited the work privately, in rented quarters, charging admission. By thus competing with the Academy's exhibition, he made enemies and compromised the critical reception of his later works for the next 25 years, including his only royal commission: The three Youngest Daughters of King George III (1785, Buckingham Palace on loan, National), a *Rococo composition of considerable charm. The finest of the historical works, The Death of Major Peirson, commissioned by Boydell, was likewise

exhibited independently and for a fee, further alienating the Academicians; the *Siege of Gibraltar*, exhibited in a huge tent in a London park, shows a real falling off of Copley's powers and, despite its popular success, marks the beginning of his decline. His later years were marred by pathological enmity against West, by quarrels with patrons as well as with the Academy, and by the failure of his last royal portrait, an uncommissioned equestrian portrait of the Prince of Wales, later George IV (Boston, Museum).

COQUES, Gonzales (1614/18–84) The outstanding Flemish specialist in small-scale fashionable **genre* and portraiture; his *Conversation Pieces were influential on later artists. He probably lived abroad after his apprenticeship with Pieter *Bruegel III and David *Rijckaert the Younger, perhaps in Holland and England, where he would have come into contact with the work of *Van Dyck. The arrival of *Ter Borch at Antwerp *c.*1640 was also an influence. Coques was patronized by the Dutch House of Orange, and his work was admired by successive Governors General of the Netherlands. There are examples of his meticulously finished pictures at Kassel, Gemäldegalerie; Budapest, Museum; London, National; Antwerp, Musée. Some of his paintings were executed on copper and even silver plates, and some of the individual portraits form series of the Five Senses, in which each sitter exemplifies Taste, Hearing, Sight, Smell or Touch.

CORNEILLE DE LYON (*c.*1500/15–74) Netherlandish portraitist, a native of The Hague, he settled in Lyons in France before 1534, becoming court painter to the future Henry II in 1541. His speciality of small-scale, thinly painted bust-length portraits was widely imitated, creating problems of attribution (e.g. Paris, Louvre; Versailles, Musée; Blois, Musée; Dijon, Musée).

CORNEJO, Pedro Duque *See* Duque Cornejo, Pedro.

CORNELIS CORNELISZ. van Haarlem (1562–1638) One of the so-called Haarlem *Mannerist painters. He was a portraitist who became friends *c.*1584 with the Italianate theoretician of art van *Mander and the engraver *Goltzius; under their influence he produced, 1588–90, spectacular history paintings (*see under* genres) with *Michelangelesque nudes in exaggerated foreshortening (*The Dragon Devouring Cadmus' Companions*, 1588, London, National). In 1590 he was commissioned by the city to decorate the Prinsenhof, the residence of the Stadtholder (1590–2; Haarlem, Hals; Amsterdam, Rijksmuseum). From 1599 he carried out several other civic commissions. Following Goltzius' example, he tempered his Mannerist exuberance after *c.*1591 to work in a blander, more *classical style.

CORREGGIO; Antonio Allegri called (*c.*1494–1534) One of the most eclectic yet innovative High *Renaissance painters; a precursor of the *Baroque and even anticipating *Rococo developments. Born in Correggio in northern Italy he was active mainly in Parma, albeit almost certainly trained at Mantua in the workshop of either

*Mantegna or Lorenzo *Costa. He is renowned chiefly for his *illusionis-
tic vault and dome *frescoes (c.1519, Parma, Camera di S. Paolo; 1520–3,
S. Giovanni Evangelista; c.1525–30, cathedral; but see also Pordenone)
and his dramatic yet suave altarpieces and smaller devotional works
(many in Parma, Galleria, see also below). Equally important, however, is
the small group of mythological and allegorical paintings for the Gon-
zaga (see below).

Around 1513–14 various other influences become discernible in his
work. The small panel of Christ Taking Leave of His Mother (c.1515,
London, National) is especially significant. The composition is based on a
print by *Dürer, but the pictorial treatment owes its use of *sfumato to
*Leonardo da Vinci – arguing perhaps for a visit by Correggio to Milan.
Leonardo's facial types are especially noticeable in major later altarpieces
such as the Madonna of St Jerome (1528, Parma, Galleria). The presence in
Northern Italy by c.1514 of two famous works by *Raphael, the Sistine
Madonna and the St Cecilia (Piacenza and Bologna respectively) may be
reflected in Correggio's earliest altarpieces, the Madonna of St Francis
(1515, Dresden, Gemäldegalerie) and Four Saints (c.1515, New York,
Metropolitan). At some point in the same period he must have looked to
Venice, *Giorgione in particular (Nativity, c.1514, Milan, Brera).

Whilst the overall design of the vault of the Camera di S. Paolo,
c.1519, painted for the mundane abbess of the convent, is indebted to
Mantegna, its details are fresh. Frolicking *putti look down through
openings in a leafy pergola. Lunettes in *grisaille of mythological sub-
jects demonstrate the availability to the artist of ancient coins and medals.
Although individually their mythological content is perfectly legible, the
overall *iconography has never been satisfactorily explained. Attracting
less notice from scholars is the life-like illusionism of the painted swags of
linen cloths holding plates, jugs and bowls, referring presumably to the
Camera's function as a dining room.

A greater challenge was met in the Vision of St John of the cupola of S.
Giovanni Evangelista, 1520–3. No domal surface of such size had been
painted before, and no decoration of a dome had previously omitted any
allusion to the actual architecture. Correggio has depicted heavenly light
which compensates for the dome's lack of a lantern or other illumination,
notionally opening up the church crossing to the miraculous vision – the
steeply *foreshortened body of Christ, viewed from below by the spec-
tator and from the cupola's rim by St John.

The much larger octagonal cupola of the cathedral amplifies and
transforms this concept. Taking advantage of the natural light provided
by windows in the drum, Correggio has created three zones, in keeping
with the subject, the Assumption of the Virgin Mary. Around the cornice,
which represents also the parapet of the Virgin's tomb, the Apostles
gesture upward. Above them the Virgin ascends to the open heavens
within a continuous spiral, which seems to depict at one and the same
time cloud, angels, the Saints and Blessed. To her right Eve holds

the apple of Paradise. In the dark below, on the floor of the church, the viewer stands as if within the Virgin's tomb.

These domes are the artistic time-bombs which were exploded in Rome, a century later, by *Lanfranco – the source of Baroque cupola and vault decoration. Although the *Assumption* has fared very badly in a recent restoration, its visionary impact can hardly be overstressed. Detailed figure drawings testify to Correggio's meticulous preparation from the life for the orchestration of his soaring, foreshortened figures and cloud masses.

Altarpieces, the painting of which punctuates the continuous work on the cupolas, attest to Correggio's response to *Mannerist painting of the day. Bold asymmetries and diagonals – not only across the picture surface but also in depth – enliven even the traditional formula of the *sacra conversazione* (e.g. *Madonna of St Jerome*, as above; *Madonna of St George*, c.1530, Dresden, Gemäldegalerie).

To this compositional drama may be added the complexity of nocturnal lighting (*Adoration of the Shepherds*, '*La Notte*', c.1527–30, Dresden, Gemäldegalerie), a further example of Correggio's interest in northern European art (*see* Geertgen Tot Sint Jans).

Where in Correggio's religious works these effects express spiritual beauty, they give unsurpassed sensuality to his mythological paintings. The earliest, c.1525–5, are the *Celestial Venus or the Education of Cupid* (London, National) and *Terrestrial Venus or Jupiter and Antiope* (Paris, Louvre). Around 1530 Federico Gonzaga commissioned four pictures for a *Loves of Jupiter* series: *Danaë* (Rome, Borghese); *Leda* (Berlin-Dahlem, Museen); *Io* and *Ganymede* (both Vienna, Kunsthistorisches). Io's abandoned pose is derived from a famous *classical relief, the *Bed of Policretes* once owned by *Ghiberti, and later also copied by *Giulio Romano. An equally sensuous, if in the context discordant, note is struck in the two allegories painted in tempera c.1531 for Federico's mother, Isabella d'Este, to hang in her *studiolo* alongside *all'antica* works by Mantegna, *Perugino and Costa (*Vice, Virtue*, Paris, Louvre).

Besides Lanfranco, the chief artists directly influenced by Correggio, and who in turn spread his influence, include *Parmigianino, *Barocci and the *Carracci.

COSSA, Francesco (1436–78) Ferrarese painter, best known for his *frescoes in the *salone* of the palazzo Schifanoia at Ferrara, depicting, like mural-sized calendar pages, the activities and zodiacal signs of the months of March, April and May, in a style indebted mainly to *Mantegna. Disappointed at the low valuation and payment for this work, Cossa abandoned the decoration in 1470 to settle in Bologna, where he executed major altarpieces (now Dresden, Gemäldegalerie; Bologna, Pinacoteca; Madonna del Baraccano), frescoes (now destroyed) and designs for stained-glass windows. There are panels by him – fragments from altarpieces – in London, National; Lugano, Thyssen-Bornemisza Coll.; etc.

COSTA, Lorenzo (c.1460–1535) Painter from Ferrara, probably trained by Ercole Roberti (recorded from 1479–96) (but see also Tura, Cossa). From 1483–1506 he worked for the Bentivoglio court in Bologna, where his style was affected by the softer, more luminous manner of *Francia, himself influenced by *Perugino. From 1507 he succeeded *Mantegna as court painter for the Gonzaga at Mantua (but see Giulio Romano). He was prized by his contemporaries for the gracefulness and 'cosmetic softness' of his work, although in portrait busts he tried to emulate the meticulous *realism of Netherlandish artists. He has the distinction of having influenced the incomparably greater *Correggio. (London, National; Coll. HM the Queen; Paris, Louvre; Bologna, S. Giacomo Maggiore; Milan, Brera, etc.)

COSTRUZIONE LEGITTIMA See perspective.

COTÁN, Juan Sánchez See Sánchez Cotán, Juan.

COTES, Francis (1726–70) Apart from *Reynolds and *Gainsborough, the most fashionable English portraitist in the 1760s. He trained in pastels under Knapton (1698–1778) and began to work in oils only from c.1753. There are pictures by Cotes in private collections and in Edinburgh, Portrait; London, National Portrait, Tate, Royal Academy, Foundling Hospital; Oxford, Christ Church; etc.

COUSIN, Jean the Elder (recorded from 1526–60/1) and his son Jean Cousin the Younger (c.1522–c.94) Leading French painters and designers from Sens, both active mainly in Paris. Jean the Elder was one of the few important painters of his day working independently of the School of Fontainebleau (see Primaticcio, Nicolò dell'Abate). In Paris from c.1538, he gained renown – and accumulated considerable property – as a painter and designer of stained glass. Only a few extant works can now be securely attributed to him: the design of the tapestries of the life of St Mammès (1543, Langres, cathedral) and the painting Eva Prima Pandora (before 1538, Paris, Louvre) which show his debt to *Rosso, his knowledge of Italian engravings as well as those by *Dürer, and of *Leonardo da Vinci's use of light. Two windows in Sens cathedral are traditionally attributed to him (1530). Jean Cousin the Younger was even better known to contemporaries than his father; surviving works (Livre de Fortune, 1568, series of emblem drawings; engravings after his designs, notably Brazen Serpent, Conversion of St Paul; engraved illustrations to Ovid's Metamorphoses, 1570, and Epistles, 1571; stained glass windows, St Gervais; Last Judgement, Paris, Louvre) demonstrate his debt to Florentine *Mannerism and a Flemish figure style.

COUSTOU, Nicolas (1658–1733) and his brother Guillaume the Elder (1677–1746) French sculptors, nephews and pupils of *Coysevox, with whom they collaborated on the Lamentation Group with Kings Louis XIII and Louis XIV on the high altar of Notre-Dame in Paris, one of their few works still in situ. Like their uncle, they were active mainly for the court in decorative large-scale sculpture (e.g. Seine and

Marne, 1712, by Nicolas, Paris, Tuileries; *Apollo*, 1713–14, by Nicolas, and *Daphne*, 1713, by Guillaume, for Marly, now Paris, Tuileries; *Pediment*, 1716, by Nicolas, Rouen, Customs House) and portraiture (e.g. *Marie Leczinska as Juno*, 1726–33, by Guillaume; *Louis XV as Jupiter*, 1726–33, by Nicolas, Paris, Louvre; *Nicolas Coustou* by Guillaume, Louvre, marble version Liverpool, Walker). Both brothers spent time at the French *Academy in Rome (Nicolas from 1683–7, Guillaume at some point before 1703) where they learned as much from the *Baroque of *Bernini as from antiquity. Guillaume, however, continued to evolve from the Grand Manner to *realism (e.g. *Cardinal Dubois*, Paris, Saint-Roch) and to a proto-romantic notion of nature (*see* Volume Two), as in his masterpiece, the *Horses*, originally for the horse pond in the garden of Marly, now Paris, Place de la Concorde (models ready 1740, marble groups set up 1745).

His son, Guillaume Coustou the Younger (1716–77) was also a sculptor, much patronized by Louis XV's mistress Mme de Pompadour and by the king himself (e.g. Paris, Louvre; his most important work, *Monument to the Dauphin*, designed before 1767, set up posthumously, Sens, cathedral).

COYPEL Dynasty of French painters successful within the Royal *Academy and in court circles during the 17th and 18th centuries.

Noël Coypel (1628–1707), a protégé of *Lebrun, under whom he worked at Versailles and for the Gobelins, painted in a *classicizing style modelled on that of *Poussin. He was Director of the French Academy in Rome 1673–5 and of the Academy in Paris 1695. From c.1700 he was employed on the decoration of the Invalides in Paris.

His son Antoine Coypel (1661–1722) derives his art-historical importance from his role as one of the leading champions of the *Baroque style in the later years of the reign of Louis XIV and during the Regency (*see also* Jouvenet). He is the author of the two most completely Baroque pictorial ensembles in French art of this period: the decoration of the gallery in the Palais-Royal (1702–18; destroyed 1780s; some wall panels, sketch for ceiling, Angers, Arras, Montpellier, Musées) and the ceiling of the royal chapel at Versailles (1707–10) based on *Gaulli's scheme for the ceiling in the Gesù, Rome. A child prodigy, Antoine accompanied his father to Rome, where he was praised by *Bernini. Before returning to Paris in 1676, he spent an additional year in northern Italy, studying *Correggio, the Bolognese followers of the *Carraci, notably *Albani and his school, and the Venetians (*see*, e.g. Veronese, Titian). Received in the Academy as a history (*see under* genres) painter in 1681 (diploma piece, *The Peace of Nijmegen*, 1681, Montpellier, Musée) Antoine Coypel first oscillated between proto-*Rococo lightness derived from Albani and a more severe classicism. By the early 1690s, however, he was converted to wholehearted admiration of *Rubens (e.g. *Democritus*, 1692, Paris,

Louvre) and continued to work in an explicitly Baroque manner. He became director of the Academy in 1714; *Premier Peintre du Roi* 1716, and was ennobled in 1717.

Antoine's half-brother Noël-Nicolas Coypel (1690–1734), a more naturally gifted painter but a timid personality, rose more slowly in the academic hierarchy. He never went to Italy, but was influenced by Rosalba *Carriera during her visit to Paris in 1720–1 and practised sometime as a pastellist. His best surviving work is a group of mythological pictures whose translucent colour and curving rhythms prefigure the work of *Boucher (e.g. Philadelphia, Museum; Geneva, Musée). His most important work, the cupola of a chapel at St Sauveur, Paris, executed *c.*1730 in collaboration with the sculptor Jean-Baptiste *Lemoyne, was destroyed later in the century. Distracted by disputes with his patrons over the expense of the scheme, the painter accidentally injured his head passing through a doorway, and died as a result.

Antoine's son Charles-Antoine Coypel (1694–1752) was but four years younger than his uncle; he was, however, received at the Academy as early as 1715. In 1747, three years after becoming *Premier Peintre du Roi*, he was made director; under his directorship, the Academy became the scene of discussions and lectures, and he initiated a scheme of 'pre-Academic' training. In addition to the decorative history paintings (*see under* genres) in which he specialized (e.g. Paris, Louvre) Charles-Antoine also executed portraits, some in pastels; *Fancy Pictures, tapestry cartoons (*see* fresco). He wrote a good deal of art theory – including a pamphlet explaining the aims of his huge *Ecce Homo* painted in 1729 for the Oratory in Paris (destroyed) and was also a poet and a dramatist.

COYSEVOX, Antoine (1640–1720) French sculptor, the chief rival of *Girardon, whom he eclipsed in royal favour in the 1690s, when Louis XIV began to favour the *Baroque style over strict *classicism. Although his most original works were the portrait busts in which he specialized late in life, and which earned him at his death the epithet of 'the *Van Dyck of sculpture' (see below), he first achieved great success with his stucco decorations at Versailles, notably the equestrian relief of Louis XIV, *c.*1679, Salon de la Guerre. Equally spirited were his tomb monuments at Serrant, 1680–1; Paris, St Eustache, 1685–7 and Louvre, 1689–93. He was less successful in the forecourt and garden sculpture at Versailles, where he attempted to follow the manner of Girardon and *Sarrazin.

Born at Lyons, Coysevox came to Paris in 1675 to study at the *Academy. His earliest surviving work dates from 1676 (Lyons, Musée). As early as 1680 he executed a bronze bust of Louis XIV (London, Wallace) inspired by *Bernini's bust of the king at Versailles. He continued to use the same Baroque formula for later portraits of the King and court dignitaries, but evolved a more naturalistic, intimate manner

for busts of his friends and colleagues (London, Wallace; Paris, Louvre; Bibliothèque St Geneviève). The spontaneity of some of his late portraits foreshadows the work of *Houdon, and certain of his full-length statues look forward to the lightness and delicacy of the *Rococo (e.g. *Duchesse de Bourgogne as Diana*, 1710, Versailles). He was the teacher of his nephews, Nicolas and Guillaume *Coustou the Elder, with whom he collaborated on a *Lamentation Group with Kings Louis XIII and Louis XIV*, 1715, for the high altar of Notre-Dame, Paris.

COZENS, Alexander (c.1717–86) and his son John Robert (1752–97) English watercolourists, founders of the 'Southern School' of watercolour painting, specializing in the poetically atmospheric representation of Italian and Swiss scenery. Born in Russia, Alexander Cozens only settled in England in 1746, presumably after a stay in Rome. Through his position as drawing master at Eton, he became associated with the notable patrons Sir George Beaumont and William Beckford. He is chiefly remembered now for his *A New Method of Assisting the Invention in Drawing original compositions of Landscape*, 1785, in which he advocates the use of inkblots to suggest landscape motifs to the amateur painter. His classification of cloud formations published in the same volume influenced John Constable (*see* Volume Two). The latter was also to praise the Swiss and Italian watercolours of John Robert Cozens, recording transient phenomena of light and atmosphere and compiled during two visits to the Continent (1776–9, with Richard Payne Knight; 1781–3, with Beckford). John Robert ceased painting in 1792, due to progressive paralysis. During his last years of insanity, 1794–7, he was nursed by the amateur painter Dr Thomas Munro, who set a number of young watercolourists, amongst them Girtin and Turner, to copying his works (*see* Volume Two).

CRANACH, Lucas the Elder (1472–1553) Painter, etcher and inventor of the chiaroscuro woodcut in 1507 (*see* intaglio and relief prints); in his later years also a bookseller and printer. As court painter to the Elector of Saxony, the protector of Luther, he has been called the chief artist of the Reformation. He collaborated on woodcuts in Melanchthon's *Commentary on the Lord's Prayer*, 1527; designed Lutheran altars, and several times painted Luther's portrait. Luther stood godfather to one of his children.

Although his family name was Sunder or Muller, he is called after his birthplace, Kronach, near Bamberg, where he was probably trained by his father Hans. Around 1498 he began his *Wanderjahre*, which took him to Vienna c.1500 and may have included a visit to Venice.

Cranach's early works, c.1500–04, are formative examples of the *'Danube school'– *see also* Albrecht Altdorfer, Jörg Breu the Elder, Wolf Huber. That is, Cranach employed landscape and landscape elements (inspired by *Dürer's prints but also observed from nature) as major formal and *expressive elements in portraits (e.g. *Dr Johannes Cuspinian, Frau Anna Cuspinian*, c.1502, Winterthur, Reinhart Coll.), in

biblical scenes (e.g. *Crucifixion*, 1503, Munich, Alte Pinakothek) and in episodes from the lives of saints (e.g. *Stigmatization of St Francis, c.*1500–05, Vienna, Akademie). The naturalism (*see under* realism) and romantic intensity of these works gave way, however, to a more ornamental and calligraphic style, which was to prove better suited to the demands made on Cranach after his appointment in 1505 as court painter to Friedrich the Wise, Elector of Saxony, at Wittenberg. A trip to the Netherlands in 1509 stimulated him into adopting Flemish pictorial modes (*Holy Kinship Altarpiece*, 1509, Frankfurt, Kunstinstitut), but this stage in his working life was very brief.

As court painter, Cranach was called upon to produce innumerable portraits in many copies and variants. He seems to have been the first to evolve a new portrait type, the full-length life-size figure against a monochromatic ground, evenly lit – a secular version of full-length portrait figures in the wings of altarpieces (*Duke Henry the Pious, Duchess Catherine*, 1514, Dresden, Gemäldegalerie). In these figures the proportions of the body are elongated, the silhouette of the bulky costumes, and their elaborate inner patternings, stressed, and only the heads realistically modelled in light and shade. The same heraldic style was applied to half-length portraits (e.g. *Johann Friedrich the Magnanimous*, 1529, formerly Haarlem, Gutman) and persisted throughout Cranach's career in his effigies of princely and other public figures. Yet Cranach remained entirely capable of naturalistic and fully modelled portraiture, which he continued to employ for likenesses of private persons (e.g. *Dr Johannes Scheüring*, 1529, Brussels, Musées; *Self-Portrait*, 1550, Florence, Uffizi). The reasons for this dual stylistic modality were neither purely aesthetic preference nor a matter of *decorum – although both must have played a part. To furnish, for example, over 60 copies of portraits of the Electors required by Cranach's third princely patron at Wittenberg, Johann Friedrich, Cranach had had to organize a large and quasi-industrial workshop. Avoiding the more personal approach characteristic of such contemporaries as Dürer, he evolved a court style readily reproducible by many hands under his supervision, without loss of quality or even visible distinction between a single 'original' and its 'copies' or 'variants'. His two sons, Hans Cranach (*d.*1537) and Lucas Cranach the Younger (1515–86) were among those painters who submerged their individual artistic personalities in this enterprise. Cranach himself drew penetrating brush sketches from the life, in *gouache on tinted paper, and these were available for use in the workshop (Rheims, Museum).

In addition to portraits the Cranach shop specialized in a new kind of figure composition geared to the taste of the court. *Classical myth provided an excuse for depicting the female nude in *cabinet pictures (e.g. *Judgement of Paris*, 1530, Karlsruhe, Kunsthalle; *Three Graces*, 1535, Kansas City, Gallery; *Venus*, 1532, Frankfurt, Kunstinstitut; many variants also of *Lucretia*, etc.). Despite their ostensibly antique origins, these

figures are Late *Gothic in their proportions and bearing, and their beauty is more fashionable than *idealized. Cranach was not attempting, like Dürer, to discover the secret harmonies of human proportion, but appealing to the erotic fantasy of his patrons. Certain Old Testament subjects were treated in the same spirit (*Bathsheba in her bath*, 1526, Berlin-Dahlem, Museen; *Judith and Holofernes*, c.1530, New York, Metropolitan). Larger compositions reflect another preoccupation of the court: hunting (Vienna, Kunsthistorisches; Madrid, Prado).

Simultaneously, however, Cranach continued to paint devotional images and religious scenes, and altarpieces reflecting Lutheran theology (Gotha, Schlossmuseum; Prague, Galerie; Naumburg, St Wenzel; Hamburg, Kunsthalle). His last work, finished after Cranach's death by his son Lucas the Younger, was the *Allegory of Redemption* (1553–5, Weimar, Stadtkirche). In the central panel the artist is depicted at the foot of the cross, flanked by John the Baptist and Luther, the blood of Christ spurting directly on to his forehead – no priestly intercessor between him and Salvation. There is no artist of the 16th century in whose work the tensions and contradictions of the time are more clearly demonstrated.

CREDI, Lorenzo di (1456/7–1536) Florentine painter, pupil, then assistant of *Verrocchio, whose heir and executor he became in 1488. After 1482–3, when Verrocchio left for Venice and *Leonardo da Vinci for Milan, Lorenzo remained alone in charge of Verrocchio's Florentine workshop. Around 1485 he completed a *sacra conversazione* for Pistoia cathedral probably commissioned from Verrocchio; otherwise, he is mainly known for the many domestic Madonnas, *Adorations* and images of saints which he painted in a slick and highly coloured variant of Leonardo's style (e.g. Dresden, Kunstsammlungen; London, National; Oxford, Ashmolean; Turin, Sabauda). There are also portraits by him, including one of *Perugino, in Florence, Uffizi. Because of his technical excellence, Lorenzo was much in demand as a restorer: in 1501 he restored – i.e. modernized – an altarpiece by Fra *Angelico in Fiesole, S. Domenico; in 1524, whilst restoring the *condottieri* *frescoes by *Uccello and *Andrea del Castagno in Florence cathedral, he added decorative borders which compromised the *illusionism of both works.

CRESPI, Daniele (c.1597–1630) Prolific and precocious Milanese painter; his rapid development was cut short by the plague. Crespi's style underwent many changes during his short working life – from the *Michelangelo-influenced pendentives in the dome of S. Vittore al Corpo, and the Giulio Cesare *Procaccini-derived pendentives in a chapel at S. Eustorgio, 1621, to the rugged *realism of his work from S. Protaso ad Monachos, now in Busto Arsizio, S. Giovanni, 1623, and of his organ shutters for the Church of the Passion, c.1623. His knowledge of central Italian *Renaissance painting, and his indebtedness to the Genoese works of *Rubens and *Van Dyck, are evident in his main

work, the two great cycles of *frescoes in the nave of the Charterhouse of Garegnano outside Milan, 1629. He is best remembered, however, for his celebrated *Fast – or Lenten Meal – of San Carlo Borromeo* (c.1628, Milan, Church of the Passion) an austere testimony to Counter-Reformation piety, and the best-known work of 17th-century Lombard art.

CRESPI, Giovanni Battista *See* Cerano.

CRESPI, Giuseppe Maria (called Spagnoletto) (1664–1747) The most original and distinguished Bolognese painter of his day, Crespi achieved international fame, turning down invitations to settle as a court artist in Rome, Vienna and Savoy, and maintaining a mail-order practice in intimate representations of religious scenes, contemporary *genre*, portraiture and *still-life. He deliberately rejected *academic teaching, instructing himself instead through the *genre* pictures of the *Carracci, the early work of *Guercino, and through direct contact with Sebastiano Mazzoni, to whom he owed the intense *chiaroscuro and free brushwork characteristic of his style. Supported by a sympathetic Bolognese merchant collector, he went on study trips to Modena, Parma, Pesaro, Urbino, spending considerable time in Venice; influences from most of these are evident in his work. His local reputation was fully established c.1693 with *frescoes painted for the Palazzo Pepoli Campogrande, Bologna. From 1708, he enjoyed the enlightened patronage of Ferdinando de'Medici for whom he executed some of his most notable works, including the autobiographical *Painter's Family* and the *Fair at Poggio a Cajano* (both, with other *genre* works, Florence, Uffizi). Visits to Florence in 1708 and 1709 cemented the rapport between patron and painter, but with Ferdinando's death in 1713 Crespi retreated to Bologna. His treatment of low-life subjects (e.g. *The Hamlet*, after 1710, Bologna, Pinacoteca) remains exceptional in Italian art for its sympathy towards the poor and simple; a similar approach marks his contemporary religious scenes (e.g. the series of *Seven Sacraments*, c.1712, Dresden, Gemäldegalerie). Mention should be made also of his famous *trompe-l'oeil* (*see* illusionism) library cupboard doors in Bologna, Conservatorio Musicale, representing *Shelves with Music Books* (c.1710).

Although his influence in Bologna was limited, Crespi's contribution to Venetian art was considerable. His son, Luigi Crespi (1709–79) is better known as a biographer of contemporary Bolognese artists than as a painter; *Piazzetta and Pietro *Longhi were his pupils.

CRITZ, John de *See under* Gheeraerts, Marcus the Younger.

CRIVELLI, Carlo (c.1430–95) Venetian-born painter, probably trained in Padua under *Squarcione (*see under* Mantegna), and active mainly in the Marche, where he was the main competitor of the *Vivarini in church *polyptychs. He is notable for his decorative, yet intensely *expressive use of line, his daring application of linear *perspective to architectural settings and of *foreshortening to individual

figures, the inventiveness of detail and pose which enlivens his versions of traditional religious themes, and his brilliant, metallic colour. After centuries in provincial obscurity, he was rediscovered by 19th-century English admirers of William Morris and the Pre-Raphaelites (*see* Volume Two); as a consequence the National Gallery in London now has the most extensive holdings of his work.

Crivelli's life is scantily documented. In 1457, in Venice, he was fined and imprisoned for six months for an adulterous liaison with the wife of a sailor, subsequently leaving the city never to return. Around 1461 he established residence in Zara, Dalmatia, becoming a citizen in 1465; by 1468, however, he was working in the Marche where he remained, mainly in Ascoli and Camerino, for the rest of his life. Possible trips to Ferrara or Tuscany have been postulated to account for his evident familiarity with Flemish art (especially Rogier van der *Weyden), but these are undocumented. In 1490 he was knighted by the *condottiere* Ferdinand of Aragon, future king of Naples, operating in the area against papal armies. Crivelli's last known work was the altar for Fabriano, S. Francesco, 1494 (now in Milan, Brera). Other works are in galleries in Italy and abroad.

His brother, Vittore Crivelli (recorded *c.*1481–1501/02), was also a painter, working in the Marche in a similar style (S. Elpidio a Mare, Residenza Municipale).

CUYP, Aelbert (1620–91) Dutch painter, the famous son of the portrait specialist Jacob Gerritsz. Cuyp (1594–1652). He is best known for the landscape paintings of his mature style, combining the 'heroic' motifs of the *classical phase of Dutch landscape (*see* Jacob van Ruisdael) with an all-pervading Italianate light (*see* Poelenburgh, Breenbergh, Jan Both). Cuyp's grandeur of composition and warmth of colour characterize both the countryside scenes with sturdy cattle, and the river scenes, whether near his native Dordrecht or on other Dutch rivers. He is particularly well-represented in English collections (e.g. London, National) and in many Continental museums, as well as in galleries in the US, including Cleveland, Museum; Indianapolis, Museum; Toledo, Ohio, Museum; Washington, National.

DADDI, Bernardo (recorded 1327–49/51) Florentine painter whose work fuses Florentine and Sienese traditions (*see also* Giotto, Duccio, Simone Martini, the Lorenzetti). An indifferent large-scale painter, he is notable mainly for his small portable tabernacles, a form pioneered by Duccio but popularized by Daddi to cater for the growing needs of personal devotion by the urban middle classes. The earliest known example (1335) is in the Bigallo, Florence, and one of the finest is in London (1338, Courtauld), but there are others in museums in Europe and America. All show workshop participation. *Orcagna's tabernacle in the guild church Or San Michele, Florence, enshrines a *Virgin and Child* by Daddi (*c.*1346).

DAHL, Michael (1659–1743) Swedish portrait painter, and *Kneller's only serious rival in England. He came to London in 1682 and may have worked as an assistant in Kneller's studio. From 1685–8 he travelled on the Continent, mainly in Italy; in Rome, he painted *Queen Christina of Sweden* (1687, Grimsthorpe Castle). After his return to England he secured aristocratic and court patronage; although the latter ceased with Queen Anne's death in 1714, Dahl continued to be employed by private individuals until his retirement *c.*1740. His style was carried on for another decade by his pupil Hans Hysing (Huyssing), a fellow Swede (active after 1691–*d.*1753) who entered Dahl's studio *c.*1700.

DALLE MASEGNE, Jacobello (*d. c.*1409) and Pierpaolo (*d.*1403?) Venetian sculptors, brothers, active also in Emilia (Bologna, S. Petronio; S. Francesco). The figures of saints on their choir screen for St Mark's, Venice (1394) are executed in a northern *Gothic style which had great influence on subsequent Italian sculpture.

DALMATA, Giovanni *See* Giovanni Dalmata.

DALMAU, Luis (recorded 1426–45) Catalonian painter. His *Virgin of the Councillors*, 1445, now in Barcelona, Museo de Arte de Cataluña, but painted for the chapel of the town hall, is the earliest documented work in the Hispano–Flemish style. Reflecting the manner of Jan van *Eyck, this style replaced the older, Italian-based *Gothic mode of Barcelona and, although short-lived in Catalonia, became the dominant style in Castile and the interior of Spain in the second half of the 15th century. Dalmau's contact with van Eyck dated from 1431–6, when he and a tapestry weaver were sent by the king to Flanders to study the techniques of Flemish tapestry.

DANCE, Nathaniel (1735–1811) English painter, one of the youngest founder members of the Royal *Academy. He was a pupil of *Hayman in 1753–4, after which he spent 12 years in Rome (1754–65) with his architect brother, George, working hard to become a *history (*see under* genres) painter (*Timon of Athens*, Hampton Court; *Death of*

Mark Antony, Knole). He is now chiefly known for his *Conversation Pieces of English tourists in Rome – which combine the manner of Hayman with the more elegant influence of *Batoni – and the theatrical picture of *Garrick as Richard III* (Stratford-on-Avon, Corporation). He retired from painting after inheriting a fortune in 1776, and in 1790 he resigned from the Academy to become a Member of Parliament. In 1800 he was created a baronet as Sir Nathaniel Dance-Holland.

DANIELE da Volterra; Daniele Riciarelli called (*c.*1509–66) One of the most gifted of the Roman painters closely influenced by *Michelangelo. After the death of *Sebastiano Veneziano in 1547, he became Michelangelo's 'surrogate', not only transcribing the aged master's sculptural manner in paint (e.g. *Madonna with Sts John and Barbara*, *c.*1552, Siena, d'Elci Coll.) but actually working from sketches supplied by Michelangelo (e.g. *David and Goliath*, *c.*1555/6, Paris, Louvre). After 1556 he turned, with Michelangelo's help, to sculpture (e.g. bronze equestrian monument for King Henry II of France, 1560–6; only horse cast, used in 1639 for a monument to King Louis XIII, melted down in French Revolution; portrait of Michelangelo in bronze relief, Florence, Casa Buonarotti), although continuing to direct the painting activities of his workshop (1555/6–62/3, S. Pietro in Montorio, Cappella Ricci). After 1559 he accepted the task of 'veiling' in paint some of the nude figures in Michelangelo's *Last Judgement* – work which earned him the nickname of '*Il Brachettone*' (Big Britches).

Born in Volterra but probably trained under *Sodoma in Siena, Daniele came to Rome *c.*1536, soon finding employment as an executant for *Perino del Vaga (*c.*1538–40, SS. Trinità, Capella Massimo, destroyed; *c.*1540/1–3, S. Marcello, Cappella del Crocefisso). Perino helped him to secure the commission for the *Fabius Maximus* frieze of the main salone of the Palazzo Massimi alle Colonne, the work which established his reputation. Michelangelo's influence is clearly visible in the powerful *Deposition* of *c.*1545, in *fresco now transferred to canvas, all that survives of the decoration of the Cappella Orsini in SS. Trinità, 1541–8. At Perino's death in 1547 Daniele became one of the foremost decorative artists in Rome (*see also* Salviati), succeeding Perino from 1547–50 in the Sala Regia of the Vatican (*see also* the Zuccaro brothers). Other important decorative schemes in the Palazzo Farnese; 1548–53, SS. Trinità, Cappella Rovere; Vatican, Apartments of Pope Julius III; Stanza di Cleopatra; 1545, an altarpiece, now Volterra, Pinacoteca. Daniele's style, always poised between *classicism and *Mannerism, became increasingly tinged with Counter-Reformation gravity and austerity.

DANTI, Vincenzo (1530–76) Perugian goldsmith and sculptor, the author of the seated bronze statue of Pope Julius III outside Perugia cathedral (1553–6). Between 1557–73 he worked mainly at the court of Cosimo I de'Medici in Florence, publishing a celebrated treatise on human proportions, dedicated to Cosimo in 1567. His main

works in Florence are the bronze group of the *Beheading of St John the Baptist* over the south door of Florence Baptistry (1569–70; *see also* Rustici, Andrea Sansovino); the marble two-figure group of *Honour Triumphant over Falsehood*, his first work in that medium (after 1561, now Florence, Bargello) and a bronze statuette of *Venus Anadyomene* for the Studiolo of Francesco de'Medici in the Palazzo Vecchio.

DANUBE SCHOOL Not a school or movement in the modern sense. The term is applied to the work, or some of the work, of certain painters who early in the 16th century having travelled along the Danube and become fascinated by its scenery, employed landscape and landscape motifs as major formal and *expressive components of their pictures. There are some affinities between their paintings and those of the Venetian *Giorgione, although their vision became available to German-speaking humanists as a nationalistic alternative to Italianate *classicism; in this sense it is a direct antecedent of German Romanticism of the 19th century (*see* Volume Two). *See* Albrecht Altdorfer, Jörg Breu the Elder, Lucas Cranach the Elder, Wolf Huber.

DAVID, Gerard (*c.*1460–1523) Netherlandish painter, the leading artist in Bruges after the death of Hans *Memlinc. His work was eclectically based on the traditions of Jan van *Eyck and Rogier van der *Weyden, and he was the last major painter to practise this native idiom, as opposed to the new Italianate art being forged in Antwerp (*see* Quentin Metsys, probably an exact contemporary). Forgotten for centuries, David was rediscovered only in the second half of the 19th century. There are works by him in London, National; Bruges, Musée; Paris, Louvre; Amsterdam, Rijksmuseum; Rouen, Musée; etc.

DAVID, Jacques-Louis (1783–1825) Great and complex French painter. He oscillated between *Baroque *Rubénisme* and *classicizing *Poussinisme* (*see under* Rubens, Poussin; *disegno*) and may be said to have at last reconciled these tendencies in French art. We can think of him as the last major 18th-century painter or as the originator of 19th-century art (*see* Volume Two). His working life fell into quite distinct phases: *ancien régime* artist making a career in the Royal *Academy and with official commissions from the crown; ardent revolutionary and republican supremo of the arts; hero-worshipper of, and court artist to, Napoleon; exile and archaicizing aesthete. Throughout – and this is sometimes forgotten with attention focused, as David himself wished, on the 'higher' *genre of history painting – he remained a brilliant portraitist. In this field David's continuing allegiance to colourism (*see under disegno*) may be perceived even in his sparest and most classical compositions (outstanding portraits in Paris, Louvre; Warsaw, National; Buffalo, New York; Montpellier, Musée; New York, Metropolitan; London, National; Cambridge, Mass, Fogg; Washington, National; self-portraits, Florence, Uffizi; Louvre).

David's widowed mother took the drawing-mad boy to her relation *Boucher, who recommended *Vien as a teacher. From 1769–74 David

competed for prizes at the Academy, and it is instructive to look at these early works: the *Combat of Mars and Minerva* (1771, Louvre) which resembles Boucher at his most vigorous; the *Death of Seneca* (1773, Paris, Petit Palais), whose Boucher-like passages are modified with Baroque drama in the handling of light and dark; *Antiochus and Stratonice* (1774, Paris, École des Beaux-Arts), which finally won him first prize and whose Baroque handling is tempered with *Le Sueur-like classicism of composition.

In 1775 Vien was appointed Director of the French Academy in Rome and took David there with him, 1775–80. Here, it has rightly been said, David sought a style: drawing constantly from the antique, studying anatomy, but also studying *Ribera, *Caravaggio, *Veronese and others. He was influenced also by Gavin *Hamilton. All these influences are apparent, in various admixtures, in the works he exhibited after his return at the Salon of 1781, and which included a Rubensian equestrian portrait, the *Count Potocki* in Warsaw, and an eclectic altarpiece, *St Roch interceding with the Virgin* (1780, Marseilles, Musée) in which Caravaggio, Poussin, *Guercino and even *Lebrun are recalled in various details. The most prophetic of his famous later works, however, was the *Belisarius* (Lille, Musée), deeply serious, emotionally compelling, warm in colouring, but returning to the readable clarity of Poussin and to his recreation of the world of antiquity. Its success led directly to the royal commission which consolidated 'David's revolution' of painting and prefigured political Revolution – although it is true that its programme was a patriotic one rather than anti-monarchic: the *Oath of the Horatii* (compl. 1784, Paris, Louvre). Believing that he could not paint a true tribute to Roman virtue in Paris, David returned for a year to work in Rome, where he finished the painting, and where his studio was stormed with admirers. Exhibited in Paris in 1785, the *Horatii* passed for 'the most beautiful picture of the century', the history painting which at last restored the French school to its 17th-century grandeur. A very model of Poussinesque rigour, the painting is also disturbingly *realistic. Its success was followed up by that of *Socrates Drinking the Hemlock* (1787, New York, Metropolitan) which sealed David's reputation as head of a new school of art spreading far beyond the borders of France.

He was, however, still far from consistent in style or temper: the *Death of Ugolino* (1786, Valence, Musée) is already Romantic both in its subject and 'gothick' style (the theme had previously been treated by *Reynolds), and *Paris and Helen* (1788, Louvre), painted for an aristocratic private collector, comes close to the closet *Rococo neo-classicism of Vien. The famous *Lictors Bringing Brutus the Bodies of his Sons* (1789, Louvre), however, resembles the *Horatii* in its tragic furor, its recreation of ancient patriotic virtue at the cost of personal happiness. A commission from the crown, whose subject had been modified by David, it was exhibited six weeks after the storming of the Bastille and became closely identified with the Republican cause.

David's political activism, however, was first realized within the sphere of the Academy, when he led younger artists in demanding an exhibition for the works of his talented pupil, Jean-Germain *Drouais, who had died in Rome before receiving academic recognition. This demand for equality in accord with the Declaration of the Rights of Man led finally to the setting up of the more egalitarian *Commune des Arts* and, in 1793 at the urging of David, to the abolition of the Academy, so closely identified with the monarchy.

David's role as artistic dictator and impresario of the pageantry and rites of the Revolution is beyond the scope of this entry. As a painter, he was charged in 1790 with recording the political opening act of the Revolution, the *Tennis Court Oath* of 1789. The project was never completed, but the preliminary sketches, combining 100 protagonists in a composition of tremendous breadth, demonstrate (yet again) David's ability to combine exact observation with monumentality (Cambridge, Mass., Fogg; Versailles; Paris, Louvre). Of three paintings of 'martyrs' of the Revolution only one has achieved fame: *Marat assassiné* (1793, Brussels, Musée), at once portrait and *icon, borrowing the pose of a Christ in the *Pietà* – which itself goes back to ancient pagan prototypes – and combining generalized space with naturalism of detail. The *Death of Lepeletier*, destroyed, is only known through an engraving; the *Death of Bara* was never finished (Avignon, Musée).

After the execution of Robespierre, whom he had supported, and his own imprisonment during the Directory (*View of the Luxembourg*, 1794, Louvre, his only landscape, painted whilst in prison) David turned once again to mainly artistic problems, notably to purifying his work further in the direction of greater refinement and abstraction 'in the Greek style'. The resulting painting, emulating Hellenistic statues such as the *Apollo Belvedere* looted from Italy by Napoleon, can be called Neo-Classical in its aestheticism (*Rape of the Sabines*, 1799, Paris, Louvre), although it is surpassed in frigid archaicism by a similarly motivated later canvas (*Leonidas at Thermopylae*, 1800–14, Paris, Louvre).

Under Napoleon, however, David regained both his extra-artistic motivation and his social and artistic position. An oil sketch resulting from a short sitting granted by the victorious Bonaparte was worked up into the heroic *Napoleon crossing the Alps*, 'calm on a fiery steed' (1800, Versailles). Named *Premier Peintre* under the Empire, David executed two out of four great commissions rivalling the projected *Tennis Court Oath* in scale, scope and genre. *Napoleon Crowning Josephine* or *Le Sacre* (1805–08, Paris, Louvre) takes as its point of departure a scene by Rubens in the *Marie de'Medici* cycle. *Napoleon Distributing the Eagles* (1810, Versailles) controls its crowded scene with similar recall from earlier art, including *Raphael's Stanze.

After 1816 David remained in exile in Brussels, working for private patrons. Although a few late portraits continue to demonstrate his powers, the subject paintings from this period return to the erotic

Neo-Classicism of his *Paris and Helen* of 1788 (e.g. *Cupid and Psyche*, 1817, Cleveland, Ohio, Museum).

David was the generous teacher of many pupils, amongst them the leading French painters of the first half of the 19th century (*see* Volume Two for, e.g. Ingres).

DECORUM Suitability, fitness, propriety. These normal usages of the word are extended, in art theory modelling itself on ancient Graeco-Roman literary theory, and are elevated to a fundamental principle. Decorum governs the entire work of art, taking into account its intended location and function as well as its subject matter – from its scale, format and composition, down to details of the dress and deportment of painted or sculpted figures. In the 17th century *Poussin, in his theory of the *modes* of painting (derived from music theory) argued for the need to adjust the colour range of paintings in accord with their subject and mood; this, too, is an example of decorum.

DELEN, Dirck van *See* Steenwijck, Hendrick van.

DELVAUX, Laurent (1696–1778) Flemish sculptor. Recorded in England from 1721, he worked in partnership with Peter *Scheemakers from *c.*1726–8 when he left for Rome. Returning briefly to England in 1733, he then settled in Brussels, where he received a Court appointment and continued to work largely in a style inspired by *Classical antiquity (Ghent Cathedral; Brussels, Musée).

DERUET, Claude *See under* Bellange, Jacques.

DESCO DA PARTO (pl *deschi*; Italian, birth tray) In *Renaissance Italy, 12-sided or circular trays decorated with appropriate narrative or symbolic scenes, or patterns, were given as presents to new mothers, or in anticipation of a birth. They were often the product of the same workshops which specialized in *cassone* painting, although like *cassone* or other furniture decoration, they could also be commissioned from better-known artists. Many of these trays now hang as easel paintings in museums.

DESHAYS, Jean-Baptiste Henri *See under* Restout, Jean the Younger.

DESIDERIO da Settignano (*c.*1430–64) Florentine sculptor from the neighbouring commune of Settignano, the native town also of his teacher, Bernardo *Rossellino. Son of a stone cutter, he set up a studio in Florence with his sculptor brother Geri (*b.*1424) whose work remains unidentified. Desiderio enjoyed great fame in his lifetime and after his premature death for his uniquely sensitive handling of *schiacciato*, or shallow, relief in *Donatello's 'sweet' mode (as exemplified in the latter's *Pazzi Madonna*). His major works are the *Monument of Carlo Marsuppini*, former Chancellor of Florence (after 1453, Florence, S. Croce), which reinterprets Bernardo Rossellino's monument to Marsuppini's predecessor, Bruni, in the same church, with greater emphasis on the ornament and figure sculpture, and the *Altar of the Sacrament* (*c.*1461–2, Florence, S. Lorenzo). Desiderio carved a number of Virgin and Child reliefs (Philadelphia, Museum; Turin, Pinacoteca;

Florence, Bargello); stuccos after these became very popular through-
out Tuscany. A number of other works, mainly reliefs, some of the
young St John the Baptist and Christ Child, and portrait busts of
women, have been attributed to the artist on the basis of references by
*Vasari and resemblance to the major monuments (Paris, Louvre;
Washington, National; Berlin-Dahlem, Museen).

DETROY *See* Troy, de.

DEUTSCH, Nikolaus Manuel *See* Manuel Deutsch, Nikolaus.

DEVIS, Arthur (1711–87) Minor English painter rediscovered in
the 20th century, the first to specialize entirely in small-scale
*Conversation Pieces and equally small single full-length portraits. A
pupil of *Tillemans, he may have begun as a landscape artist. By 1764
he was eclipsed by *Zoffany, and turned to painting on glass and
restoring. Even in his heyday, from 1742, he was disdained by the
aristocracy, but found favour with the middle classes, in whose mod-
erately sized rooms his pictures neatly fitted, and whose belongings and
pretensions he inventoried with naïve charm. There are pictures by him
in London, Tate, Victoria and Albert; Manchester, City Art Gallery, etc.

DISEGNO (Italian, drawing, design) In Renaissance art theory, the
term means far more than its literal translation. *Disegno* or draw-
ing is the principle underlying and unifying the arts of sculpture,
painting and architecture. Drawing the outline of a man's shadow cast
by the sun of ancient Egypt, or, in other accounts, ancient Corinth, was
said in legend to have been the first artistic act. Most important, *disegno*
is the intellectual component of the visual arts, which justifies their
elevation from crafts to liberal arts, on a par with poetry, theology, etc.

In the more particular context of 16th- and 17th-century painting,
disegno (identified in the first instance with Florentine art and later, in its
French translation, *dessein* or *dessin*, with the Franco-Roman painter
*Poussin and his emulators, the *Poussinistes*) was opposed to *colorito*
(identified first with the Venetian school, notably *Giorgione and
*Titian, and later, as *coloris*, with the Italianate Flemish painter *Rubens
and his followers the *Rubénistes*). *Disegno* involved using drawings as the
basic building blocks of a finished composition; *colorito*, by contrast,
implied the direct application of colour, that is paint, to the canvas or
panel. (*See also* colour.) The distinction has a philosophical dimension.
An artist wedded to *disegno* (the archetypal example would be *Michel-
angelo), after long training in drawing from life and from artistic
exemplars such as ancient sculpture, devises complex figure poses and
combines them into a telling composition, not through direct observa-
tion of a model but through invention, the exercise of his imagination.
Disegno is both the ability to draw, which facilitates invention, and the
capacity for designing the whole, which is identified with invention. It is
the imaginative and intellectual end of this process which justifies both
*academic practice and the academic hierarchy of the *genres. In the
latter, history painting – the genre most dependent on *disegno* – is

elevated to pride of place. The revival of Platonism in the 15th century identified artistic inventions – the products of *disegno* – with Platonic Ideas, the perfect prototypes of earthly things, dwelling in the mind of God. In this view, the artist, through *disegno*, found direct access to the Divine Intellect, and his activity paralleled the creative aspect of divinity. An Aristotelian, however, would have stressed the artist's ability to generalize, to arrive at a composition through familiarity with, and a memory of, many individual examples. *Colorito*, on the other hand, entails encoding in paint the tonal and colour relationships of objects seen under particular light conditions. The composition of a picture thus cannot precede its 'adornment' with colour (as in *disegno*-led painting). It grows out of the adjustments made by the artist to the tonal and colour relationships on the canvas or panel. In theory, therefore, the *colorito* specialist remains dependent on the model throughout the process of creating a painting, constantly checking the painted relationships against those of the model. (It is this fact which accounts for 17th-century writers labelling as a champion of *colorito* an artist such as *Caravaggio, who used an extremely limited and sombre range of colours. The term, coined for the more genuinely colourful Venetian school, had become synonymous with painting **alla prima*, without preliminary drawings, and with *naturalism, which depends closely on the model.) In practice, *colorito* specialists too must have relied on their memory of visual effects; this almost certainly accounts for the anatomical inaccuracies of many figures painted by *Titian, and the relative simplicity of his compositions. In general, the subtle or brilliant effects of *colorito*, such as the depiction of light at different times of day or under different atmospheric conditions, of reflections, of textures, of mood – these effects are produced to the detriment of those complexities of structure which are the province of *disegno*. On a Platonic scale of values, *colorito* depicts transient, accidental aspects of things: the momentary effects of light, shade, colour, lustre, with their immediate appeal to the senses. *Disegno*, on the other hand, reveals the permanent, invariable qualities of matter: volume, form and hidden order. The latter are, in this view, of greater appeal to the intellect, and thus 'higher'. Certain 20th-century artists and artistic movements have revived these old quarrels under new rubrics (*see* Volume Two, e.g. Mondrian).

The concept of *disegno* as the origin and foundation of the visual arts can be traced back to between 1354–60. In these years the Florentine humanist and poet Petrarch wrote the dialogue *Remedies Against Fortune*, in which he states that *graphis* (Latin for *disegno* or drawing) is the one common source of sculpture and painting. The idea is elaborated by many later writers on art, of whom probably the most important are *Alberti, *Ghiberti, *Vasari and Federico *Zuccaro.

'DISGUISED SYMBOLISM' *See under* Campin, Robert.

DOBSON, William (1610/11–46) English painter, pupil of Francis *Cleyn, from whom he acquired a knowledge of Italian High *Renaissance, and especially Venetian, traditions of portraiture. Nothing is known of his work before 1642, when he painted the royal entourage at Oxford. Dobson is the great portraitist of the royal cause in the Civil War (although never of the King); ironically his style owes nothing to that of *Van Dyck (d. 1641), the foremost interpreter of the ideals of absolutist monarchy. Dobson is a master of the half-length or three-quarter-length portrait, and excels particularly in his few group arrangements (e.g. *Prince Rupert, Colonel William Murray and Colonel John Russell*, private collection; Dobson, *Sir Charles Cotterell and Nicholas Lanier*, Alnwick Castle). His handling of paint is more vigorous and impasted than Van Dyck's, and his interpretation of his sitters' personalities more robust and direct. Unlike Van Dyck's, his portraits incorporate learned symbolic allusions to the qualities and interests of his sitters (e.g. *Endymion Porter*, London, Tate).

Dobson is the only purely British painter before *Hogarth of a comparable artistic and intellectual stature to his Continental contemporaries, if we except *Hilliard, who worked in the totally different idiom of miniature painting.

DOLCI, Carlo or Carlino (1616–86) Morbidly religious Florentine painter; a child prodigy whose superb, if painfully slow, technique evolved, from its initial fresh and charming naturalism (*see under* realism) (1640s), into an enamelled 'hyper-realism' (1670s). This later manner, if distasteful to most 20th-century viewers, was well-suited to the pietistic *cabinet pictures of Christ or ecstatic saints to which Dolci increasingly devoted himself and which were popular at the bigoted court of Cosimo III de'Medici and his mother Vittoria della Rovere, as well as with English collectors. Through such single bust-length figures he exercised what has been called a 'baneful influence' on later artists such as *Greuze. Yet he remained, as he had begun at the age of 15, a superb portraitist, even on the scale of life (Florence, Pitti; Cambridge, Fitzwilliam) and in this capacity was sent, instead of the aged portrait specialist *Sustermans, to Innsbruck in 1675 to paint Claudia Felice de'Medici. His slowness of execution, mocked by Luca *Giordano upon his arrival in Florence in 1682, prevented Dolci from personally completing his many commissions, and he was assisted by his daughter Agnese (d. 1689) and pupil Onorio Marinari (1627–1715). Dolci executed a number of large altarpieces (e.g. Florence, Pitti) and not all of his collectors' paintings are small (London, National; Munich, Alte Pinakothek; etc).

DOMENICHINO; Domenico Zampieri called (1581–1641) One of the Bolognese pupils of the *Carracci, Domenichino became, after Annibale Carracci's death in 1609, a leading painter in Rome. His frescoes of the *Scourging of St Andrew* (S. Gregorio al Celio, Oratory of St Andrew, 1608) and the *Scenes from the Life of St Cecilia* (S.

Luigi de'Francesi, 1613–14) are foremost examples of the style known as Early *Baroque *Classicism which was influenced by *Raphael and the Antique. *Poussin was to be deeply impressed with these works in the 1620s, and he was also influenced by Domenichino's small landscape paintings, as was *Claude.

From 1622–8 Domenichino painted the choir and pendentives of S. Andrea della Valle, whilst his arch-rival, *Lanfranco, received the commission for the dome. Responding to the demands of scale and location as much as to Lanfranco's *illusionism (derived from *Correggio's Parma domes) Domenichino here modified his former manner. The new tendency to *Baroque was further accentuated in the pendentives and dome of the Chapel of S. Gennaro of the Cathedral in Naples, for which he was commissioned in 1630. The jealous intrigues of Neapolitan painters drove him from the city back to Rome in 1634; his wife having had to remain in Naples, however, he was forced to return in 1635. In Naples, in addition to the S. Gennaro frescoes, Domenichino also executed altarpieces (Naples, Cathedral; New York, Metropolitan) and the *Exequies of a Roman Emperor*, one of a series of paintings illustrating scenes from Roman antiquity, commissioned from several artists for the Palace of Buen Retiro (Madrid, Prado). A few smaller easel paintings are also known (Madrid, Academia).

DOMENICO VENEZIANO (c.1410–61) Venetian-born Florentine painter, celebrated in his day. With the loss of most of his influential *fresco decorations in Florence and Perugia, however (*see below*), he is now known mainly for his *St Lucy* altarpiece, a *sacra conversazione* executed 1445–7 for Florence, S. Lucia de'Magnoli (now Florence, Uffizi). He has accurately been described as combining a Florentine grasp of *disegno* with a Netherlandish feeling for light (*see*, e.g. Jan van Eyck, Rogier van der Weyden) and a north Italian sensitivity to naturalism (*see under* realism) and ornament (*see also under* International *Gothic). The master of *Piero della Francesca in 1439 and associated with him again in 1447, he is thought to have been the determining influence on Piero's light and luminous palette (*see under* colour) and his *perspectival researches. He himself most probably trained under *Gentile da Fabriano in Florence and Rome 1422–7, remaining with Gentile's heir *Pisanello at St John Lateran, Rome, until c.1432. His earliest independent Florentine works, the so-called *Carnesecchi Tabernacle*, an outdoor fresco of which fragments now survive in London, National, and a *Madonna and Child* now in Settignano, I Tatti, were painted c.1432–7. In the latter year he went to Perugia to paint extensive fresco decorations for the Baglioni palace (razed 1540). Between 1439–45 he was active mainly on frescoes for S. Egidio, the chapel of the hospital of S. Maria Nuova, Florence, now destroyed (*see also* Andrea del Castagno, Alesso Baldovinetti). After the completion of the *St Lucy* altar, in 1447, he and Piero della Francesca began to paint frescoes in the sacristy of S. Maria at Loreto, but left soon after for fear

of the plague. Two luxurious *cassoni* executed for a Florentine patron in 1447–8 are also lost. From *c.*1450–3 he was working on frescoes for the Cavalcanti Chapel in Florence, S. Croce (fragments now S. Croce, Museo; detached and transferred to a portable support during *Vasari's remodelling of this church in 1560, amongst the earliest frescoes to be so treated). Few other works are recorded in the last decade of his life, and he is documented as having died destitute. It is not, however, true that he was, as Vasari claims, assassinated by Andrea del Castagno, whom he survived by several years.

DONATELLO (*c.*1386–1466) Florentine sculptor. His full name was Donato di Niccolò di Betto Bardi; Donatello is the nickname he used when signing his works. He was famous throughout Italy and in his native town where he received numerous illustrious public commissions from guilds and governing bodies, and, especially late in life, private commissions from Cosimo de'Medici. His reputation as the greatest sculptor of the Early *Renaissance has never been challenged; *Vasari calls him 'superior not only to his contemporaries but even to the artists of our own times'. No later Florentine artist, including especially *Michelangelo, escaped his influence. Probably trained as a goldsmith, he was uniquely versatile in that he worked not only in metal, that is, bronze, often with silvered and gilt surfaces (beginning as an assistant in *Ghiberti's first Florence baptistry doors workshop) but also in stone (starting on *Nanni di Banco's Porta della Mandorla on Florence cathedral) and later also in wood, terracotta, stucco, perhaps even glass. His versatility in media was matched by his versatility of *genres. He became an innovator in relief sculpture, carved or cast, for domestic devotional purposes as well as for public emplacements on altars, pulpits, baptismal fonts, organ lofts, in architectural ornament, on doors and tomb slabs; of the seated and standing niche statue; of the free-standing statue; of the antique-emulating nude; of multiple-figure sculptural groups; of the equestrian monument; perhaps also of the portrait bust and the bronze statuette. He was prominent in the revival of antique figurative and decorative motifs. He pioneered both single-vanishing point *perspective and *schiacciato, or shallow, carving in the relief originally beneath the statue of *St George* on the guild church of Or San Michele (*c.*1417, now Florence, Bargello). Sculptural *illusionism, in the sense of allowing for the actual viewpoint of the spectator, had engaged him as early as 1408–15 in the seated *St John the Evangelist* for the façade of Florence cathedral (now Florence, Museo dell'Opera del Duomo). Looking back at the *Gothic masters Nicola and Giovanni *Pisano, he outdid them in dramatic *expressivity. His unprecedented emotional range varied from the contemplative dignity of *S. Mark* for Or San Michele, *c.*1411–*c.*15, through the virile alertness of *St George*, to the grave tenderness of the *Pazzi Madonna* relief (1420s–30s, now Berlin-Dahlem, Museen), the prophet's despair of the *Zuccone* from the bell tower of Florence cathedral (*c.*1427–36, now Florence, Opera del

Duomo), the bacchic abandon of the *putti on the organ gallery from the cathedral (1433–9, now Florence, Opera del Duomo) and the playfulness of the so-called *Atys-Amorino* (1430s–50s, Florence, Bargello), the penitential fervour of the wooden *Magdalen* (1430s–50s, Florence, Opera del Duomo), the sensuous self-absorption of the bronze *David* (*c*.1446–*c*.60, Bargello), to the fierce severity of the equestrian *Gattamelata* (*c*.1445–53, Padua, Piazza Sant'Antonio), the traumatized solemnity of *Judith* poised between the two blows which decapitate Holofernes (*c*.1446–*c*.60, now Florence, Palazzo Vecchio), the tragic hysteria of the mourners in the *Lamentation* relief from the pulpits in S. Lorenzo, 1460s – one of the several pulpit reliefs which, completed after Donatello's death, offer a compendium of varied extreme emotional states depicted with the greatest penetration and realism, even when dependent on antique prototypes. Donatello's expressivity is intimately linked with his unrivalled story-telling powers, naturally most evident in his narrative reliefs (e.g. *Herod's Feast*, 1423–7, Siena Baptistry, font; *Altar*, Padua, Sant'Antonio). But even single statues, *Madonna and Child* reliefs, accessory or decorative figures – such as the putti on the pediment of the *Cavalcanti Annunciation*, who have no head for heights (1430s, Florence, S. Croce), or the paired saints on the bronze doors of the Old Sacristy, S. Lorenzo (after 1428–*c*.40), who debate with varying degrees of acrimony – seem to be enacting complex and absorbing tales. The sense thus imparted of the autonomous capacity for thought and action of his sculpted figures, of statues projecting a force-field of psychic energy which goes out to the viewer, rather than waiting passively to be looked at, differentiates Donatello from earlier, and most later, sculptors and gives his work its endless fascination. His technical innovations serve these dramatic ends: not only the *schiacciato* carving, perspective and illusionism already mentioned, but also his re-invention of *contrapposto*, which frees the standing figure from immobile frontality.

Donatello is so quintessentially a Florentine artist that it is easy to forget how peripatetic he really was. His main periods of residence outside Florence were: 1444–54, Padua (*Altar* for Sant'Antonio; *Gattamelata*); 1457–9, Siena. He and his long-time partner the architect and sculptor *Michelozzo had a studio in Pisa, 1426–9, where they executed the tomb of Cardinal Brancaccio for shipment to Naples (Sant'Angelo a Nilo). He visited Rome with *Brunelleschi to study antique ruins (possibly *c*.1402–04, more probably 1413–15) and worked there from before 1432–3 (*Tomb of Giovanni Crivelli*, S. Maria in Aracoeli; *Tabernacle*, sacristy of St Peter's). He travelled throughout Tuscany, and was in Mantua in 1450, in Modena in 1451 in connection with never completed commissions. Other commissions came from cities even further afield and which he did not visit. In addition to works in Florence, and the other works already cited, there are sculptures by Donatello in Venice, S. Maria dei Frari; Lille, Musée; London, Victoria and Albert;

Pisa, Museo; Prato, Opera del Duomo; attributed works are to be found in a few other museums, notably Paris, Louvre.

DONNER, George Raphael (1693–1741) Innovative and influential Austrian sculptor. Apprenticed first to a goldsmith, later to the Venetian Giovanni Giuliani (1663–1744) during the latter's employment at Heiligenkreuz, Donner avoided the typical Austrian media of wood or stucco and worked exclusively in stone or metal. His preferred medium was lead, in which he executed both reliefs and free-standing figures. His graceful *classicizing Italianate style marked a turning- point in Viennese art from the hitherto predominant Late *Baroque or *Rococo. He worked at Salzburg, Schloss Mirabell, 1726–7; Linz, parish church, 1727; Bratislava, cathedral, c.1729–35; Gurk, cathedral, 1741. His greatest project was the Mehlmarkt fountain for Vienna, 1737–9 (original lead figures now Vienna, Museum der Stadt, replaced by bronze copies, 1873). Despite his tendency to planar compositions, he employed, for this monument in the round, the spiralling figure patterns of Giovanni *Bologna.

His brother Matthäus Donner (1704–56) continued to transmit the elements of his art to younger Viennese artists at the *Academy school which he ran.

DOSSAL or RETABLE A vertically proportioned altar panel set above and behind the altar table, evolved by the late 13th century from the *antependium.

DOSSO or DOSSO DOSSI; Giovanni Luteri called (c.1489–1542) Ferrarese court artist, influenced by *Giorgione and the young *Titian; a probable trip to Rome before 1514 has been deduced from the reminiscences of *Raphael, and to some extent *Michelangelo, present in his work from that date. He is first recorded working for Federico Gonzaga at Mantua in 1512, but from 1514 was in the service of the d'Este at Ferrara, for whom he executed religious paintings, portraits, but above all allegorical and mythological subjects and others derived from contemporary poets, especially Ariosto. It is not always easy to distinguish between these latter types, especially in his many single-figure compositions (e.g. *Melissa* or *Circe*, Rome, Borghese). Landscape settings play an important part in virtually all his works, painted with great freedom both of the brush and of colour, in rich and unexpected textures and tonalities which produce a poetic, even romantic, effect (e.g. *Adoration of the Kings*, London, National). The *Bacchanal* probably from the Camerino of Alfonso d'Este (now London, National) demonstrates his shortcomings in figure painting, but these are more easily overlooked in his small-scale *cabinet pictures or his more purely decorative work (c.1530, Pesaro, Villa Imperiale, Sala delle Cariatidi; 1531–2, Trento, Castel Buonconsiglio; *see also* Romanino). He was assisted by his younger brother, Battista Dosso (recorded from 1517–48).

DOU, Gerrit (1613–75) Leiden painter, the son of a glass-maker and engraver. He was *Rembrandt's first pupil (1628–31). After

Rembrandt's departure for Amsterdam, he remained in Leiden, initiating the school of Fijnschilders ('fine, or miniature, painters'), which continued into the 19th century, specializing in minutely finished small pictures crammed with *genre and *still-life accessories. He adopted many of the subjects and compositions of Rembrandt's early period (e.g. *Portrait of Rembrandt's Mother*, Amsterdam, Rijksmuseum) reducing Rembrandt's expressive *chiaroscuro to a decorative device, as in the nocturnal scenes which he popularized. Many of his pictures should be read as emblematic metaphors of the human condition (e.g. *The Quack*, 1652, Rotterdam, Boymans-van Beuningen).

DROUAIS, François-Hubert (1727–75) Successful French court portraitist, son of the painter Hubert Drouais (1699–1767). He studied also with Carle van *Loo and *Boucher, evolving a hard, porcelain-like style, recording faithfully details of his sitters' costume and surroundings (e.g. *Mme de Pompadour*, 1764, London, National). He inherited *Nattier's aristocratic clientele, becoming especially fashionable for his portraits of noble children dressed as gardeners or Savoyard beggars to emphasize their 'natural' or 'filial' characters (e.g. Paris, Louvre; New York, Frick). His son, Jean-Germain Drouais (1763–1788), became a pupil of *David and in 1784 went with him to Rome, where he died of smallpox. A brilliant artist, who copied a *Caravaggio painting as early as 1758, he became a history painter (*see under* genres) of great power; his death removed from David his greatest potential rival (Paris, St Roch, Louvre).

DRYPOINT *See under* intaglio prints.

DUBOIS, Ambroise (1542/3–1614) French *Mannerist painter of the so-called second school of Fontainebleau, in the service of Henry IV as the artists of the first school of Fontainebleau, *Rosso, *Primaticcio, Nicolò dell'*Abate, had been of Francis I and Henry II (*see also* Toussaint Dubreuil, Martin Fréminet). Born in Antwerp, Dubois came to France as a youth; his style is a mixture of Flemish and Italian styles largely derived from engravings (*see* intaglio prints). His most important work, the Gallery of Diana at Fontainebleau, was pulled down in the 19th century, (fragments, Fontainebleau, Galerie des Assiettes) but paintings survive from other cycles he executed in the palace (Fontainebleau, Salle Ovale; Paris, Louvre).

DUBREUIL, Toussaint (1561–1602) French *Mannerist painter of the so-called second school of Fontainebleau, in the service of Henry IV as the artists of the first school of Fontainebleau, *Rosso, *Primaticcio, Nicolò dell'*Abate, had been of Francis I and Henry II (*see also* Ambroise Dubois, Martin Fréminet). Although Dubreuil's decorations at Fontainebleau have disappeared, and his paintings in the Petite Galerie of the Louvre were destroyed by fire in 1661, many are known through copies, drawings and tapestries after his designs (painting, *A Sacrifice*, Paris, Louvre). Dubreuil's style is generally based on that of Primaticcio, but he is more restrained, and forms an important link

between Fontainebleau Mannerism and the later *classicism of *Poussin.

DUCCIO, Agostino di See Agostino di Duccio.

DUCCIO DI BUONINSEGNA (first recorded 1278–c.1318) Sienese painter, who was one of the great innovators in Italian art, although his reputation has been overshadowed by that of his younger Florentine contemporary, *Giotto. There are two factors mainly responsible: the early development of art-historical writings in Florence, and the survival of great *fresco cycles by Giotto in their architectural settings. Duccio's masterpiece, on the other hand, the *Maestà *polyptych for the high altar of Siena cathedral (1308–11), in tempera and gold leaf on panel, was dismembered in 1771. Although most of its fragments have been restored and assembled in the cathedral museum, others are scattered throughout galleries in America and Europe (New York, Frick; Washington, National; Fort Worth, Museum; Lugano, Thyssen-Bornemisza Coll.; London, National). Some fragments are lost. The original effect of this most ambitious and complex of Italian altarpieces can now be reconstructed only through an effort of the imagination.

Contracts survive for three major commissions. Of these, the 1302 Maestà for a chapel in Siena Town Hall is lost. It was the second altarpiece known to have incorporated a *predella. The contract of 1285 with a confraternity of S. Maria Novella, Florence, is generally accepted as relating to the so-called Rucellai Madonna (Florence, Uffizi). This is the largest panel with a unified pictorial field to have survived from the 13th and 14th centuries. The painting combines a monumental scale with jewel-like precision and delicacy, and grandeur with emotional intimacy. Duccio has forged a new idiom merging traditional Byzantine schemata with a new naturalism (see under realism), colour with linear pattern, and surface decoration with description of form and volume.

But the achievements of the Rucellai Madonna are surpassed in the great Siena Maestà (contract of 1308). The Virgin enthroned amongst angels, saints and apostles figures on the main panel on the front, originally facing the lay congregation in the nave. The front predella comprised narrative scenes of the Infancy of Christ, and the front pinnacles, scenes of the Last Days of the Virgin. On the back, originally visible only to the clergy in the choir, the predella illustrated Christ's Ministry; the main panel, the fullest depiction of Christ's Passion in Italian art; the pinnacles, his miraculous Apparitions. With its 58 narrative scenes and 30 single figures in addition to the main front scene, the Maestà rivals any mural cycle or sculptural programme in formal and *iconographic inventiveness. It may be thought to surpass Giotto's Arena Chapel cycle not only in colouristic effects (as might be expected of a panel painting) but also in descriptive realism.

Duccio trained and influenced a notable school of Sienese painters,

amongst them Simone *Martini and Ambrogio and Pietro *Lorenzetti, who continued and extended his researches into combining visual description with expressive subtlety and decorative splendour.

DUCK, Jacob (1600–60) Dutch painter, resident in Utrecht. He specialized in guardroom scenes (Utrecht, Museum). *See also* Willem Duyster, Pieter Codde.

DUGHET, Gaspar (1615–75) He is also known as Gaspar Poussin, after his celebrated brother-in-law Nicolas *Poussin, in whose studio he trained 1630–5. From *c*.1647 he was acknowledged as the leading landscape specialist in Rome. Whilst basing his finished paintings on intensive study from nature in the Roman Campagna, he combined in them the *picturesque style of Salvator *Rosa with the *classical ideal of landscape of Poussin and *Claude. Avidly collected by English travellers, his works influenced English 18th-century painters such as Richard *Wilson and were taken up by supporters of the Picturesque Movement as models for actual landscape gardens and parks; his style continued to be imitated by painters in Rome until well after 1700. There are many easel paintings by him in English collections, including the National, London; he also painted landscapes in *fresco (Rome, S. Martino ai Monti, Colonna, Palazzo Costaguti, Doria).

DUJARDIN, Karel (*c*.1622–78) Versatile Dutch painter and etcher, born in Amsterdam, where he studied with Nicolas *Berchem before leaving for Rome sometime in the 1640s. By 1650 he was again in Amsterdam, preparing to visit France; he returned to Holland in 1652–75. He died in Venice after a trip to Tangiers. Best known for his small bucolic Italianate landscapes (e.g. Cambridge, Fitzwilliam; The Hague, Mauritshuis; Paris, Coll. F. Lugt), in the years 1654–6 Dujardin also painted Dutch landscapes with animals in the manner of Paulus *Potter (Amsterdam, Rijksmuseum; London, National). In the 1660s he became fashionable with the ruling classes of Amsterdam, executing portraits in the elegant style of van der *Helst (Amsterdam, Rijksmuseum) and highly finished religious and mythological pictures (London, National; Mainz, Museum; Potsdam, Sanssouci; Sarasota, Fla, Museum).

DUPONT, Gainsborough (*c*.1754–97) The nephew and assistant of Thomas *Gainsborough. He engraved his uncle's *Fancy Pictures, and probably himself painted the small-scale 'engraver's copies' which exist of some of them. He also completed, in the elder Gainsborough's style, the series of portraits of members of Whitbread's brewery begun by his uncle. In 1790 he began to exhibit at the Royal *Academy.

DUQUESNOY, François *See* Quesnoy, François du.

DÜRER, Albrecht (1471–1528) The first self-conscious artistic genius in northern European art; painter, draughtsman, printmaker in both *relief and *intaglio, theoretician and would-be reformer of art. Through his woodcuts and engravings, most of them

published by himself, he became an international figure, supplying
*iconographic models to artists throughout Europe and as far away as
Persia, and setting new standards of technical mastery. From within his
own German/Netherlandish *Gothic heritage, with its interest in the
particular, he sought to learn the general laws enshrined in Italian art:
the laws of optics, the 'rules' of ideal beauty and harmony (*see also
disegno*). His own work ultimately succeeded in synthesizing these two
traditions, so that some of his most detailed and 'northern' images
demonstrate his conquest of, for example, single-vanishing point *perspective (*Nativity*, engraving 1504, with its picturesque setting of a
ruined German farmhouse) or of the canonic proportions of man,
horse, hounds and stag (*St Eustace*, engraving *c.*1501), or the *classical
female nude (*The Dream of the Doctor*, engraving, *c.*1497/8). Other works
translate Italianate imagery into Gothic idiom; thus the winged, nude
Fortuna (engraving 1501/02), holds a perfect example of a German
goldsmith's chalice, and hovers over a minutely portrayed northern
landscape; the *Centaur's Family* (engraving, 1505) lives in a German
forest, and a northern lake is the setting of a rape modelled on such
*Classical scenes as the *Rape of Europa*, but performed by a marine
monster with elk antlers (engraving, *c.*1498).

Dürer was born in Nuremberg, the second son of Albrecht Dürer
the Elder, a goldsmith from Hungary who had trained in the Netherlands. From his father he must have learnt draughtsmanship, the use of
the burin in copper engraving, and admiration for the great Netherlandish artists (*see* Jan van Eyck, Rogier van der Weyden). Until the age
of five he lived in a house behind that of the rich patrician Pirckheimer.
Here were laid the foundations of Dürer's lifelong friendship with
Willibald Pirckheimer (two portrait drawings, 1503, Berlin, Kupferstichkabinett). Pirckheimer was later to study law and the humanities at
the universities of Padua and Pavia. It is he, the improbable humanist
intimate of a Nuremberg craftsman, who was to prompt Dürer's
interest in visiting Italy; who would initiate him in the classics, assist him
with his treatises and suggest the iconography of his unusual secular
prints, and, above all, foster and encourage his ambitions, not as a
craftsman but as a creative and erudite artist in the Italian mode.

A famous drawing in silver-point, the *Self-Portrait of 1484 at the Age of
Thirteen* (Vienna, Albertina) testifies as much to the efficacy of the elder
Dürer's training as to young Albrecht's precocious talent and unusual
self-consciousness. It was to be the first in a series of drawn and painted
self-portraits, unique in the history of art before *Rembrandt (drawing,
1491/2, Erlangen, University Library; drawing, 1493, New York, Lehman Coll.; painting on parchment, 1493, Paris, Louvre; painting on
panel, 1498, Madrid, Prado; painting on panel, 1500, Munich, Alte
Pinakothek; drawing, *c.*1503, Weimar, Schlossmuseum; drawing
*c.*1512/13, and drawing, 1522, Bremen, Kunsthalle).

In 1486 Dürer was apprenticed to Michael *Wolgemut, in whose

workshop he learned painting in oils and watercolours, designing woodcuts for book illustration, and the rudiments of marketing works of art.

In the spring of 1490 began the four-year period of Dürer's *Wanderjahre*, only part of which are accounted for. He was supposed to go to Colmar to work under Martin *Schongauer; when he arrived early in 1492, Schongauer had been dead for nearly a year, and his three brothers recommended Dürer to another brother, the goldsmith Georg Schongauer who practised in Basel, one of the great centres of European book production. Here Dürer produced designs for woodcuts which transformed Basel book illustrations (e.g. frontispiece to the *Letters of St Jerome*, 1492) introducing greater spatial *realism and descriptive notation of surfaces.

In 1494 Dürer was back in Nuremberg where a marriage had been arranged for him by his father. Agnes Frey, Dürer's wife, was to sell prints for him at book fairs. The marriage, which was to remain childless, was unhappy. Dürer left his wife almost immediately on his first trip to Venice (summer 1494–spring 1495), the first German artist to seek artistic instruction in Italy rather than in the Netherlands, and one of the earliest northern European artists to encounter the Italian *Renaissance on its native soil. It is probable that at this time he also stopped at Padua, Mantua, Cremona, and visited Pirckheimer in Pavia. The main evidence for the trip consists of drawings and watercolours (Vienna, Albertina; Berlin, Kupferstichkabinett; Basel, Kunstsammlungen; Frankfurt, Kunstinstitut).

After his return from Italy Dürer settled down in Nuremberg to consolidate his new-found synthesis between northern love of detail and Italianate generalization. There followed a decade of extraordinary productivity, during which he carried out numerous commissions for paintings (*Dresden Altarpiece*, Dresden, Gemäldegalerie; the *Mater Dolorosa Altarpiece*, now divided up between Dresden, Gemäldegalerie and Munich, Alte Pinakothek; the *Paumgärtner Altarpiece*, Munich, Alte Pinakothek; the *Adoration of the Magi*, Florence, Uffizi; the *Jabach Altarpiece*, Frankfurt, Kunstinstitut; Cologne, Museum; the portrait of *Frederick the Wise*, Berlin, Deutsches; three portraits of members of the Tucher family, Weimar, Schlossmuseum; Kassel, Gemäldegalerie; etc.), began to print and publish his own woodcuts and engravings (of which over 60 were produced between 1495 and 1500, including the *Apocalypse* and the *Large Passion*) and continued to draw and paint in watercolours for his own delight and instruction (e.g. the *Parrot*, Milan, Ambrosiana, the *Little Hare* and *Great Piece of Turf*, Vienna, Albertina).

Dürer's prints of these years established his international fame. On his second trip to Italy, 1505–07, he was no longer an unknown young northerner but the most celebrated German artist of the age. Thus upon his arrival in Venice he secured the commission for an altarpiece

in the national church of the German community, S. Bartolommeo (*The Feast of the Rose Garlands* now Prague, Rudolphinum). The *Christ among the Doctors* (Lugano, Thyssen-Bornemisza Coll.) is a painting also undertaken in Venice, probably for an Italian patron. While the S. Bartolommeo altarpiece paid tribute to Giovanni *Bellini, who received Dürer with friendship, the *Christ among the Doctors* reveals the influence of *Leonardo da Vinci. Several portraits were also produced during Dürer's stay in Venice (e.g. Hampton Court; Berlin-Dahlem, Museen).

Dürer relished the social position attainable by artists in Italy. In a famous letter to Pirckheimer he writes, 'How shall I long for the sun in the cold; here I am a gentleman, at home I am a parasite.'

His return to Nuremberg saw him trying to attain a similarly elevated position even in this more hostile climate. He bought a large house, wrote verse, studied languages and mathematics, and began to draft an elaborate treatise on the theory of art. He succeeded in bringing out three books: on geometry, on fortifications, and on the theory of human proportions, this last appearing posthumously. He collaborated with Pirckheimer, illustrating the latter's translation – from Greek into Latin – of a treatise on Egyptian hieroglyphics. At the same time, however, his Venetian experiences revived his gusto for painting (*Adam and Eve*, now Madrid, Prado; and three major altarpieces: *Martyrdom of the Ten Thousand*, now Vienna, Gemäldegalerie; *Heller Altarpiece*, central panel by Dürer destroyed 1729, copy by Jobst Harrich, Frankfurt, Museum; *Adoration of the Trinity* or *Landauer Altarpiece*, Vienna, Gemäldegalerie).

From about 1511 he returned also with increased energy to his graphic works, experimenting with tonal effects more than he had before the Venetian trip (woodcut *Small Passion*, 1511; *Engraved Passion*, 1513). He produced three 'master engravings' in 1513 and 1514 which are exceptionally large in size, meticulous in technique and unprecedented in their representation, by linear means alone, of pictorial effects of lustre and tonal variations (*Knight, Death and the Devil*; *St Jerome in his Study*; *Melencolia I*).

In 1512 Dürer was involved in designing the gigantic woodcut of the *Triumphal Arch*, printed from 192 blocks, for the Emperor Maximilian I, and in other projects for the Emperor, the *Triumphal Procession* and the *Prayer-Book*. These mark the so-called 'decorative' phase of his *oeuvre*, on which he turned his back after Maximilian's death in 1519 and his own conversion to Lutheranism *c*.1520. His religious beliefs did not, however, prevent him from seeking out the Emperor's successor, the ultra-Catholic Charles V, at his coronation, in order to secure the renewal of the pension granted him by Maximilian. This was the occasion of Dürer's final long excursion from Nuremberg, this time accompanied by his wife – the year-long trip through the Netherlands, as much the artist's triumphal tour, sightseeing and sketching expedition (*Silver-point sketchbook*, dispersed among print cabinets of major museums), sales round and shopping trip, as a voyage to petition a prince.

After his return from the Netherlands, already weakened by a malarial fever contracted there, Dürer resumed the production of small-scale engravings, many of them portraits in profile. His last important paintings were the monumental over-life-size panels of the *Four Apostles*, perhaps originally conceived as wings of an altarpiece which was never carried out and executed instead as independent works. They were donated by the artist to the city of Nuremberg, 1526, inscribed with texts meant to castigate both Papists and the more radical Protestants falsifying – in Dürer's view – Luther's teachings (Munich, Alte Pinakothek).

Dürer may be said to have truly brought the Italian Renaissance to northern Europe, not only in its pictorial motifs (as others were also beginning to do) but in its artistic theories and conceptions of art and the artist's role. Simultaneously, he influenced Italy, directly and through followers such as *Altdorfer – fuelling the narrative imagination even of such great masters as *Raphael – and elevated the print to a great expressive medium, unsurpassed until Rembrandt. His stress on originality of invention – made possible in this marketable commodity which required no previous commission – marks him out as perhaps the first truly 'modern' artist.

DUSART, Cornelis *See under* Ostade, Adriaen and Isaack van.

DUYSTER, Willem (*c.*1599–1635) Dutch painter resident in Amsterdam, a specialist of small-scale guardroom scenes (Philadelphia, Museum; Leningrad, Hermitage; London, National; Stockholm, Museum; etc.

ÉCORCHÉ (French, flayed) A type of figure drawn or sculpted as an aid to the study of anatomy, in which muscles and tendons are shown as if the covering skin had been removed.

EHRENSTRAHL, David Klöcker (1629–98) German-born Swedish painter. In Sweden from 1652, he moved in 1661 to Stockholm, where he became court painter, earning the art-historical title of 'father of Swedish painting'. In addition to official portraits and allegorical compositions, he executed large hunting and animal scenes in landscape, in which both landscape and animals are studied from nature. These subjects were commissioned from Ehrenstrahl by King Charles XI of Sweden, and form the most original aspect of the artist's work (Stockholm, Museum).

ELLE, Ferdinand *See under* Poussin, Nicolas.

ELSHEIMER, Adam (1578–1610) Short-lived but immeasurably influential painter on copper of small-scale religious works and, later in his career, poetic landscapes peopled with biblical or mythological figures. Born in Frankfurt, Germany, he trained as a figure painter but was deeply affected by the landscape style initiated by *Coninxloo. From 1598–1600 he was in Venice, where he was influenced by Hans *Rottenhammer and the works of *Titian, *Giorgione, *Tintoretto. From 1600 until his death he lived in Rome, where the landscape backgrounds in his paintings came to dominate the figures. Elsheimer's painstakingly and delicately executed works are notable for the way in which light is used to model form and express mood. He often experimented with different sources of illumination within a single scene: moonlight, firelight, the light of torches. Within its tiny compass his world is surprisingly monumental, and he is the great interpreter of a characteristically northern European nostalgia for the *Classical south, a tradition carried on subsequently by the Italianate Dutch painters (*see* e.g. Both). Working very slowly, he contracted debts which led him to be imprisoned for a time shortly before his death. From about 1604 he had rented rooms in his house to a Dutch artist, Hendrick Goudt (1580/1–1648) who may also have been his pupil, and who bought his work. Goudt's engravings after his paintings made Elsheimer's compositions available to artists in the Netherlands from as early as 1608; the dark tones, particularly of the night-time scenes, influenced *Rembrandt amongst others. *Rubens, who knew Elsheimer in Rome, is another of the great artists affected by him, as is *Claude. There are paintings by Elsheimer in Kassel, Gemäldegalerie; Cambridge, Fitzwilliam; Edinburgh, National; Florence, Uffizi; Frankfurt, Kunstinstitut; The Hague, Mauritshuis; London, National, Apsley House; Munich, Alte Pinakothek; Paris, Louvre; Vienna, Kunsthistorisches; etc.

ELYAS, Isack *See under* Buytewech, Willem.

EMBLEM BOOK An emblem is made up of three parts: picture, motto and explanatory text. Emblem books originated in Italy (*Emblemata*, 1531, Alciati) but their importance for art history largely derives from their wide currency in the Low Countries in the 17th century. Many Dutch *genre* pictures derive, not from direct observation of everyday scenes, but from the illustrations in emblem books. Their contemporary significance, therefore, can best be recovered through familiarity with these publications. Heraldic emblems, often highly sophisticated, associated with noble Italian families and individuals, are called *imprese* (sing. *impresa*).

ENGRAVING *See under* intaglio prints.

ERHART, Michael (recorded 1469–after 1522) and his son Gregor (recorded 1494–1540) German sculptors, active in Ulm (high altar, Blaubeuren Abbey near Ulm, 1493–4). Only fragments of Michael Erhart's sandstone *Mount of Olives*, erected in front of Ulm Minster, survive (1516–18, Ulm, Museum). Sometime between 1500–10 Gregor Erhart became the most prominent carver in Augsburg, associated with the painters Hans *Holbein and Hans *Burgkmair, but all the documented works are lost, and his career after 1510 has not been convincingly reconstructed.

ETCHING *See under* intaglio prints.

EVERDINGEN, Caesar Boëtius van (1606–78) and his now-better-known younger brother, Allart (1621–75) Dutch painters. Atypically, Caesar Boëtius specialized in *classicizing allegorical and history paintings (*see under* genres). He was one of the nine Dutch painters active, alongside Flemish artists, in the courtly decoration of the Oranjezaal in the palace of Huis ten Bosch outside The Hague (*see also*, e.g. Jan Lievens, Honthorst, Jordaens). Allart was a landscape painter, influenced by his probable teachers, Roelant *Savery and Pieter *Molijn, and, after 1644–5, by his voyage in Scandinavia. On his return to Haarlem he began to specialize in scenes of rocky mountains, fir forests, log cabins and waterfalls. After his move to Amsterdam in the 1650s this romantic repertoire affected the greater painter Jacob van *Ruisdael. There are works by the younger Everdingen in London, National; Leningrad, Hermitage; as well as in galleries in Holland, Germany and Denmark.

EWORTH, Hans (active 1540–73) A native of Antwerp, he is recorded in London between 1549–73, painting mainly portraits but also mythological figures and allegories. His style progressed from a robust *realism to ornate Elizabethan stylization. Eworth was employed by Mary Tudor (portrait, *c.*1553, Cambridge, Fitzwilliam) and later by her successor, Elizabeth I, of whom he painted the allegorical *Queen Elizabeth confounding Juno, Minerva and Venus* in 1569 (Windsor Castle). One of his best-known pictures is the allegorical portrait of Sir John Luttrell (1550, London, Courtauld).

EXPRESSION, EXPRESSIONISM, EXPRESSIVITY (for Expressionism as a 20th-century style, *see* Volume Two) A complex topic in art,

expression always aims to arouse emotion in the viewer. It may do so by depicting emotion, that is, by portraying figures displaying emotions appropriate to a given situation or narrative. In Italian *Renaissance art theory, the 'motions of the soul as shown through the motions of the body' are called *affetti*. The viewer is intended to react to the portrayed *affetti* as he would to the attitudes of actors in the theatre. Then again, artists may strive to arouse emotions in the viewer not through the depiction of emotional states, but through a representation of e.g. natural phenomena which normally evoke an emotional response, such as a storm, a moonlit night, etc. Such responses are generally culturally conditioned (a sunny sky may not evoke similar emotional states in a desert Bedu and a Laplander) and the viewer's emotional response may, or may not, accord with the artist's expectations, depending on whether they share the same cultural set. Given cultural precon-ditioning, emotional arousal may be effected, as in music, by less con-crete representational means. Thus certain ranges or combinations of colours may, or may be thought to, evoke certain ranges of emotions: 'cool' colours such as blues, greys, greens, may calm or sadden, whilst 'hot' colours such as reds, oranges, yellows, may evoke joy or rage. Analogous effects may result from lines or shapes independent of colour. Even more problematic is the question of the artist's state of mind. A Romantic definition of art (*see* Volume Two) supposes that the work of art allows direct access to the artist's emotions. It is improbable, however, that a painting or sculpture requiring months, even years, of work, and perhaps the intervention of assistants, should in this sense express a single predominant emotion, such as tenderness or anguish etc. A modified and more acceptable version of the Romantic theory of art describes the artist as his own first, and ideal, audience. He seeks, through various artistic strategies, to arouse *in himself* a given emotional response.

EYCK, Jan van (active 1422–41) Netherlandish painter, inter-nationally celebrated in his own lifetime and since as the 'inventor of oil painting'. This is not literally true, but there is no doubt that Jan – and perhaps his shadowy elder brother Hubrecht (*see below*) – brought oil painting to a dazzling degree of proficiency in the depiction of optical phenomena. Working on panel with glazes (*see under* colour), van Eyck was able to portray a seemingly infinite variety of textures and light effects. Although he never mastered convincing linear *perspect-ive, he evolved aerial or colour perspective, and was precocious also in achieving unity of lighting, whether in an interior (*Arnolfini Marriage*, 1434, London, National) or in an expansive landscape (*polyptych of the *Adoration of the Lamb*, 1432, Ghent, St Bavo). Despite the fact that he painted with the meticulous precision of a miniaturist, and may have begun his career as an illuminator of manuscripts (pages of *Turin Book of Hours*, *c*.1417, Turin, Museo) van Eyck did not invariably paint small: some of the figures in the Ghent polyptych are represented on the scale

of life. On whatever scale, however, it is to the convincing portrayal of the natural world, rather than to decorative or *expressive ends, that the art of van Eyck was directed – albeit within a system of symbolism and a scale of values dictated by the church and the courtly circles who were his main employers (e.g. *The Virgin in the Church*, Berlin-Dahlem, Museen; *The Annunciation*, Washington, National; *Virgin and Child with the Chancellor Rolin*, Paris, Louvre; *Virgin and Child with Saints and a Carthusian*, New York, Frick; *Virgin and Child with Saints and Canon van der Paele*, Bruges, Musée).

Jan van Eyck's career as a painter and courtier is well documented. From 1422–4 he served John of Bavaria at The Hague. At the end of his employment he went to Bruges, but in 1425 moved to Lille, to take up his appointment as court painter and *valet de chambre* to Philip the Good, Duke of Burgundy, for whom he was also to undertake several secret diplomatic missions. Around 1430, however, he was allowed to continue as court painter – a post he was to hold in all for 16 years – whilst residing at Bruges and working as an ordinary master painter. It is then that he was able to paint the double portrait of the Italian merchant from Lucca, Arnolfini, and his bride (*see above*), signing his name beside the mirror which reflects them and him, a witness to their contract of marriage. Quite probably, this device inspired the construction of *Velázquez's *Las Meninas* (1656), in which a mirror plays a similar role, since van Eyck's picture was then in the Spanish royal collection. Also from the 1430s are the inscribed and dated portraits in the National, London (*Leal Souvenir*, 1432; *Man in a Turban*, perhaps a self-portrait, 1433).

. Matters are quite otherwise with regard to Hubrecht, or Hubert, van Eyck. An inscription, which may be a later addition, on the frame of the Ghent polyptych identifies it as the work of Hubrecht, completed after his death by his brother Jan. If there was such a person, he is thought – from a now lost epitaph – to have died in 1426. Attempts to differentiate the brothers' hands, and establish a body of work for Hubrecht, have not proved convincing.

Although van Eyck's influence was incalculable, and he is in a sense the very fountainhead of all naturalism (*see under* realism) in European art, his direct influence was not widespread. Petrus *Christus was his immediate follower in Bruges and may have completed a picture of his. Dieric *Bouts borrowed certain decorative elements of his style. In general, however, his example proved both too difficult and too dispassionate, and Netherlandish art moved into a more linear and more overtly emotional mode with the work of Rogier van der *Weyden.

F

FABRIANO, Gentile da *See* Gentile da Fabriano.

FABRITIUS, Carel (1622–54) *Rembrandt's most gifted and original pupil, *c*.1641–*c*.3, the initiator of the Delft school of painting *c*.1650, and the major link between Rembrandt and the greatest Delft painter, *Vermeer. He was killed in the explosion of the Delft gunpowder magazine which destroyed a large part of the city. Fewer than a dozen paintings can be attributed securely to him. After one essay in dramatic narrative (*The Raising of Lazarus*, 1643/5, Warsaw, Muzeum) he devoted the rest of his life to portraits and figure studies (*Self-Portrait*, *c*.1645/50, Rotterdam, Boymans-Van Beuningen); *genre (*The Goldfinch*, 1654, The Hague, Mauritshuis) and *perspective scenes (*View of Delft*, 1652, London, National). Fabritius favoured Rembrandt's use of heavy, pasty paint juxtaposed with thin glazes, but he replaced his teacher's warm brown tonality with cool daylight hues, and reversed Rembrandt's use of *chiaroscuro, preferring to silhouette a dark figure against a light ground.

His younger brother, Barent or Barend Fabritius (1624–73), may have studied with Rembrandt *c*.1650. His best-known work, *Self-Portrait as a Shepherd*, 1658 (Vienna, Akademie) employs his brother's style.

FALCONET, Etienne-Maurice (1716–91) Individualistic, temperamental French sculptor and writer on art, a pupil of Jean-Baptiste *Lemoyne (*see also* Pigalle). Like his teacher, Falconet never went to Italy, arguing for the superiority of modern over ancient sculpture, and modelling himself on *Puget – whose *Milo of Crotona* he was accused of plagiarizing in his first Salon piece, a plaster of the same subject (1745; marble version, 1754, both Paris, Louvre). Slow to make his mark at the *Academy, and never receiving a major French crown commission, Falconet was first patronized by Mme de Pompadour (e.g. *Music*; *Cupid*, 1757, both Louvre), then other rich bourgeois, for whom he evolved a type of highly-finished small-scale statuary, usually of the female nude, comparable in its erotic charm to the paintings of *Boucher (e.g. *Baigneuse* 1757, plaster, Leningrad, Hermitage; marble, Louvre). Such work gained him, from 1757, the effective directorship of the Sèvres factory, where his figures were adapted for duplication in porcelain. More to his inclination were the large-scale sculptures he executed for Parisian churches (St Roch, Invalides) of which little survives. Finally, in 1766 he unexpectedly gained the chance of working on a statue commensurate with his talent and ambition: an equestrian *Monument to Peter the Great* (unveiled 1782, Leningrad). The rearing bronze horse, with its calm rider in 'timeless' clothes stretching out his hand to protect his city, rises on a great jagged granite outcrop. Peter's head was the work of Falconet's devoted pupil, assistant and daughter-in-law, Marie-Anne Collot, a portrait sculptor whose bust of Falconet, *c*.1768, is now in Nancy,

Musée. Falconet left Russia in 1778, after which he executed no more sculpture, perhaps through encroaching blindness. In 1783 he suffered a paralytic stroke. Whilst the monument to Peter the Great exercised no direct influence in France, where Falconet continued to be known as the author of *Rococo figurines (e.g. London, Wallace), it remains one of the greatest sculptural works of the century, at once the culmination of *Baroque equestrian monuments and, in its naturalism (*see under* realism) and its characterization of Peter as a beneficent prince-philosopher, an embodiment of the Enlightenment and a precursor of Romanticism (*see* Volume Two).

FANCY PICTURE A term first given in 18th-century England to a new type of painting inspired by 17th-century *genre* and the more recent French *fête galante*. They may have been designed originally to make money by the engraving rather than as paintings. 'Fancy Pictures' may have something in common with the *Conversation Piece – that is, they may represent informal groupings of figures as well as a single figure picturesquely dressed and posed – but they are not portraits. Unlike the *fête galante* and the Conversation Piece, 'Fancy Pictures' may be either large or small in scale. Some of the most famous were painted by *Gainsborough (*Girl with Pigs*, Castle Howard; *Girl with Faggots*, Manchester, Gallery) but credit for creating the genre in Britain is usually given to *Mercier.

FEINMALEREI German for Fijuschilder. *See under* Dou, Gerrit.

FEKE, Robert (*c*.1705–*c*.50) Portrait painter, recorded in Boston, Newport and Philadelphia. He may have been born on Long Island, which would make him the first native American artist of major significance. His *Royall Family* group (1741; Cambridge, Mass.; Harvard Law School) paraphrases *Smibert's *Bermuda Group*; his later works, however, although indebted to engravings of English portraits, achieve an elegant and monumental style of his own.

FERRARI, Gaudenzio (*c*.1475/80–1546) Northern Italian painter, born in an Alpine valley on the border between Piedmont and Lombardy. Like all the artists of these regions, he was much affected by late *Gothic German art. His important work at the *Sacro Monte of Varallo (*c*.1517–30, *see also* Morazzone, Tanzio da Varallo) is in his most Germanic and vernacular mode: the *realism of his painted backdrops and of the terracotta sculptures which he designed gives way to *expressive near-*caricature. Like *Pordenone, however, he was master also of a more polished style, influenced by *Leonardo da Vinci (e.g. *Madonna degli Aranci*, 1529, Vercelli, S. Cristoforo). In 1534 he was called to Saranno to complete a decorative project left unfinished at the death of *Luini: the *illusionistic dome of S. Maria dei Miracoli, which seems to owe nothing to the domes of either Pordenone or *Correggio. After 1535 he settled in Milan, where his style lapsed into a pedestrian Lombard version of Roman *classicism (e.g. Milan, Brera). He was very influential on younger Piedmontese and Milanese artists.

FÊTE GALANTE Untranslatable French term, roughly equivalent to 'outing of polite company'. A new type of painting created in 18th-century France by *Watteau, inspired by Flemish and Italian precedents (notably *Rubens and *Giorgione) and contemporary theatre, the *fête galante* is specifically associated with the *Rococo style. It represents elegant men and women at play in an idealized landscape or park-like setting. They are always depicted in full length and on a small scale, although the actual painting need not be small. Whilst Watteau's followers (*see* Pater, Lancret) trivialized the genre, his own *fêtes galantes* always carry a sense of melancholy, of the transience of love and happiness. Formally, albeit not in spirit, the English 18th-century *Conversation Piece, when set outdoors, may be related to the *fête galante*, and was indeed influenced by engravings after Watteau and his followers. *See also* Fancy Picture.

FETTI, Domenico (*c.*1588/9–1623) Roman-born painter mainly active at the court of Mantua (1613–21/2). Despite having studied in Rome with a Florentine painter, he was most of all influenced by Venetian art. As court painter, he was forced to execute some large-scale public commissions (e.g. Mantua, cathedral; Palazzo Ducale) but he was most successful and happiest in small *cabinet pictures, to which he devoted himself after his removal to Venice in 1622. He is best known for his paintings in this manner of 12 of the 30 New Testament parables and two of the sayings of Christ; 10 of these pictures exist in more than one version (e.g. Rome, Capitoline; Florence, Pitti; Bologna, Pinacoteca; Alnwick Castle; Burghley House: Birmingham, Barber; York, Gallery; Dublin, National; New York, Metropolitan). Fetti's warm humanity, lyrical colour and vibrating light transformed the pictorial traditions of Venice into a recognizably 17th-century idiom. He influenced Johann *Liss, and through him, as well as directly, subsequent Venetian painting.

FIJNSCHILDER *See* Dou, Gerrit.

FILARETE (*c.*1400–69?) Florentine-born architect and sculptor, active mainly in Rome and Milan. His real name was Antonio Averlino. His most important work of sculpture is the bronze door of the main portal of St Peter's, Rome, 1433–45. Although probably trained in *Ghiberti's studio, Filarete modelled his relief style on Early Christian ivories and late antique sculpture, thus executing the first *Renaissance work in which an 'indigenous' Roman style is evident. The only other surviving works of sculpture certainly by Filarete are the equestrian bronze statuette, based on the *classical monument of Marcus Aurelius and cast in Rome, now in Dresden, Albertinum; a signed Processional Cross in Bassano, Cathedral, and a bronze medal self-portrait (London, Victoria and Albert).

FLINCK, Govert (1615–60) German-born Dutch painter, a pupil of *Rembrandt *c.*1633–6. His early work closely imitates Rembrandt's manner (*Samuel Manasseh ben Israel*, 1637, Stichting, Kunstbezit; *Isaac*

blessing Jacob, 1638, Amsterdam, Rijksmuseum), but in the 1640s he abandoned his master's *chiaroscuro for the lighter and brighter style of *Van Dyck. He became not only a fashionable portraitist but also the most successful Dutch painter of allegorical and historical decorations for palaces and public buildings. He was patronized by Amalia van Solms, the widow of Prince Frederick Hendrick of Orange (*Allegory in memory of the Prince of Orange, with the portrait of his widow Amalia van Solms*, 1654, Amsterdam, Rijksmuseum). After successfully completing two history paintings (*see under* genre) for Amsterdam town hall, Flinck received the most important public commission given to any 17th-century Dutch artist: 12 paintings for the building's great civic hall. Flinck died, however, and the commission was redistributed amongst a group of artists, including Jan *Lievens, Jacob *Jordaens, and *Rembrandt.

FLORIS or DE VRIENDT, Cornelis (1514?–75) and Frans (1516/20–70) Brothers, the elder a sculptor and architect and the younger a painter, who between them dominated art not only in their native Antwerp but throughout the Netherlands and as far abroad as Northern Germany and Scandinavia.

Cornelis' busy workshop raised Antwerp *c*.1550 into the leading sculptural centre of the Netherlands. In addition to church furnishings and tombs, he specialized in the design of ornamental motifs. Although *grotesque ornament had been introduced to Flanders by Pieter Coeck – perhaps Cornelis Floris' teacher – it was the publication in Antwerp of Cornelis' series of engraved ornamental designs, 1548–77, which really popularized in the north the taste for this form of Italianate decoration. It also introduced to the Netherlands the *strap-work designs evolved at Fontainebleau (*see* Rosso).

Paradoxically, Cornelis' sculpted monuments do not display an abundance of decoration; their austerity demonstrates his grasp of *classical principles, learned from his close study of the antique, of *Raphael and of the sculpture of Andrea and Jacopo *Sansovino, during his stay in Rome in 1538. His shop concentrated on the working of black and red marble, with alabaster for the figures. Their most important monuments, in which it is difficult to distinguish individual hands, are the *memorial to Duchess Dorothea*, 1549, Köningsberg (now Kaliningrad) cathedral; tabernacle, 1550–2, Zoutleeuw (Léau) St Leonard; *tomb of King Frederick I of Denmark*, 1550–after 1553; Schleswig, cathedral; *tomb of Jan III van Merode*, 1554, Gheel, St Dymphna; *tomb of Duke Albrecht I of Prussia*, 1568–74, Köningsberg, cathedral; *tomb of King Christian III of Denmark*, 1568–after 1576, Roskilde, cathedral; rood-screen, *c*.1570–3, Tournai, cathedral.

Frans Floris has been called the most important Flemish painter of the 16th century. According to Karel van *Mander, he had over 100 pupils; the best-known of them is Maerten de *Vos. His workshop in Antwerp continued to influence Flemish painting until the return of

*Rubens from Italy in 1608, and echoes of his manner may be discerned even in the work of later Dutch painters such as *Rembrandt.

An eclectic artist, Frans Floris combined the earthy *realism of his native tradition with Italianate forms and ideals – sometimes within the same picture (e.g. *Holy Family*, *c.*1556, Brussels, Musées). He painted religious and mythological themes, and may be considered to have anticipated the expressive *Baroque portrait of the 17th century (*Portrait of a woman*, 1558, Caen, Musée). Having studied with the Italianate painter *Lambert Lombard, 1538–40, around 1541 he followed his brother Cornelis to Rome, where he much admired *Michelangelo's *Last Judgement.* He was directly influenced too by *Giulio Romano, *Tintoretto and ancient Graeco–Roman sculpture. Late in life he was affected also by the *Mannerism of the School of Fontainebleau, where some of his pupils had worked *c.*1566 (e.g. *Athena visiting the Muses*, Condé-sur-Escaut, Town Hall). Other works Antwerp, Musées; Amsterdam, Rijksmuseum; Florence, Uffizi; Kremsier, Archiepiscopal; Brunswick, Museum; etc.

FLÖTNER, Peter (*c.*1490–1546) Versatile Swiss-born sculptor, architect and designer of woodcuts, goldsmith's work, furniture, stove tiles, etc., working in Nuremberg. He has been called the greatest artist in that city after the death of *Dürer, and a poet of sculpture. Two visits to Italy, *c.*1520 and after 1530, reinforced the feeling for *classical form derived from Dürer. His greatest work is the bronze *Apollo Fountain* (1532, Nuremberg, Germanisches) in which the figure is based on an engraving by *Jacopo de'Barbari. He also executed the chimney piece in the Hirschvogelsaal in Nuremberg, 1534; both are considered masterpieces of the German *Renaissance. There are many smaller works in bronze (Stuttgart, Landesmuseum) in wood (Vienna, Kunsthistorisches), in stone and above all many plaques in lead, in which his poetic imagination is given free rein.

FOPPA, Vincenzo (*c.*1430–*c.*1516) The leading painter in Lombardy until the arrival of *Leonardo da Vinci, he may have studied under Squarcione (*see under* Mantegna) and was certainly influenced also by Jacopo *Bellini and *Gentile da Fabriano (London, National, Wallace; Bergamo, Accademia, Carmine; Milan, Brera, Poldi-Pezzoli, Castello; Washington, National).

FORESHORTENING A method of representation in which objects are depicted according to the laws of *perspective as if receding in space. Extreme foreshortening, best demonstrated through elongated forms of which the width is parallel to the picture plane and the length at right angles to it, is typically used for dramatic effect: e.g. a pointing or blessing hand seeming to jut out of the picture, as in *Caravaggio's *Supper at Emmaus*, London, National. Steep foreshortening of objects and figures painted on a ceiling, as if they were descending or ascending directly overhead, is called *di sotto en su* (Italian, 'from below upwards'), and such effects are often combined with *quadratura* painting of architecture.

FOUQUET, Jean (c.1420–in or before 1481) The foremost French artist of the 15th century, best known today for the panel paintings attributed to him (*Charles VII*, c.1445; *Guillaume Jouvenal des Ursins*, c.1455, both Paris, Louvre; *Melun Diptych*, c.1450, Berlin-Dahlem, Museen, and Antwerp, Musée; *Lamentation*, c.1470–5, Nouans, parish church) but active also as an illuminator of luxurious manuscripts (*Book of Hours of Etienne Chevalier, 1452–60, Chantilly, Musée; Boccaccio's *Des Cas des Nobles Hommes et Femmes Malheureuses*, c.1458, Munich, Staatsbibliothek; *Grandes Chroniques de France*, c.1458, and Josephus' *Antiquités Judaïques*, c.1470–5, both Paris, Bibliothèque Nationale), designer of decorations for festivals and triumphal entries, and of sculpted tombs and altars. The *Antiquités Judaïques* is his only documented work; the rest of his *oeuvre* rests on attribution. For over 30 years he ran a large and active workshop which executed many commissions for members of the French court, although Fouquet was officially appointed court painter only in 1474. He may have executed a portrait of the Pope Eugene IV and his two nephews in Rome between 1443–7, perhaps whilst accompanying a French mission in 1446.

Fouquet's painting style assimilates certain elements of Italian art, notably central vanishing point *perspective (not consistently used by him) and generalized handling of form. It is distinguished by sober restraint, as in the small enamel *Self-Portrait* (c.1450, Paris, Louvre). Despite the absence of naturalistic (*see under* realism) surface detail the portrait of *Charles VII* is strikingly unidealized, so that the king's unprepossessing features and melancholy expression jar painfully with the pompous contemporary inscription, 'the most victorious King of France', on the frame.

FRA ANGELICO *See* Angelico, Fra or Beato.

FRA BARTOLOMMEO *See* Bartolommeo or Baccio della Porta.

FRA GALGARIO *See* Ghislandi, Giuseppe.

FRAGONARD, Jean-Honoré (1732–1806) Ostensibly the last French painter of *Rococo frivolity, he was – like the sculptor *Clodion – an individualist celebrating nature, impulse and instinct. His style, whether in his many chalk, pen or wash drawings, in pastels, gouache or oils, in his engravings and etchings (*see* intaglio prints), was always energetic, spontaneous and painterly. Although, especially late in life, he could produce highly finished surfaces he is particularly renowned for the sketchiness of many of his pictures. In the same way that he often effaced the distinctions between the *genres – notably between landscape and *genre* or **fête galante*, or between portrait and *Fancy Picture – so he seems to have abolished the boundaries between drawing and painting, sketch and finished picture. Equally, he conflated in his work the influence of Italy (notably *Tiepolo, *Giordano, *Solimena, *Castiglione) with that of the north, not only *Rubens (in part directly, in part through *Watteau) but also *Ruisdael and *Rembrandt (e.g. several variants of a copy of Rembrandt's *Holy Family* now in

Leningrad, Hermitage; San Francisco, de Young Museum; taken up later in the painting now in Amiens, Musée). With a few exceptions where a commission is dated, Fragonard's work is difficult to date; there are many variants of the same or similar compositions and his style varies rather than evolving.

Born in Grasse in south-east France, Fragonard was brought to Paris as a child. After a brief, unhappy apprenticeship under *Chardin he became a pupil of *Boucher in 1751, then worked under Carle van *Loo at the *Academy school. Certain presumed early decorations now in private collections and Chicago, Fowler McCormick, follow Boucher's subject matter and tonality, although Fragonard seems to have quickly abandoned Boucher's characteristically blue and rose harmonies for a palette organized around shades of yellow (see also under colour).

After winning first prize at the Academy Fragonard was sent to the French Academy in Rome in 1756; his last few months in Italy were spent in the company of a collector and patron at the gardens of the Villa d'Este at Tivoli and in a long return voyage home, 1761. Whilst the impact of Italy was decisive, he experienced it in the first place through landscape – the Academy's Director, *Natoire, encouraged him to go on sketching expeditions into the countryside, (sometimes with Hubert *Robert) – and only secondly through the contemporary or near-contemporary artists listed above. Neither the antique nor the *Renaissance seems to have left any mark on his work. Above all, the sparkling Italian light and the Tivoli gardens continued to haunt him, in the gigantic cypresses and other trees which surge above the minuscule protagonists of such pictures as the Blind Man's Buff and Swing now in Washington, National, and the fountains, cascades and statues which animate these and others of his decorative fêtes galantes. A more direct record of Tivoli is found in a small group of paintings executed either in Italy or soon after (Paris, Louvre; Amiens, Musée; London, Wallace) and, above all, in a large number of wonderfully poetic drawings (e.g. Besançon, Musée).

Fragonard's large, melodramatic Corésus and Callirhoé appeared at the Salon in 1765 (Paris, Louvre), a bid for recognition as a history painter (see under genres). But after showing again at the Salon of 1767 he virtually disappeared from official artistic life under the monarchy, working almost entirely for private patrons, many of whom became his friends. A commission for a *fresco for a ceiling at the Louvre, given him in 1766, was at his insistence exchanged for an oil of smaller size in 1776. The most important semi-official commission he ever received was from Louis XV's mistress Mme du Barry, for a set of four decorative paintings on the Progress of Love for her Neo-*Classical pavilion at Louveciennes (1771–3, New York, Frick). These works, generally now acknowledged as Fragonard's masterpieces, were rejected by du Barry for Neo-Classical paintings by *Vien. They were to be used by the artist

to decorate his own reception rooms at Grasse where he retreated in 1790 during the Revolution.

After the disaster of this commission Fragonard, with his wife and at the expense of yet another patron who accompanied them, undertook a second trip to Italy, 1773–4 (e.g. drawing, Amsterdam, Rijksmuseum; paintings, private coll.; New York, Metropolitan). A rarely seen, very large painting of a fair in a mysteriously wooded park, generally called *La Fête à Saint-Cloud* (now Paris, Banque de France) may date from either just before the voyage in 1773 or from 1775–80.

In addition to erotic small paintings and larger decorative works Fragonard painted a number of fantasy portraits – that is, portraits of mainly real people in fancy dress. What the purpose or destination of these dashingly painted works were has never been elucidated (Paris, Louvre, Petit Palais; Williamstown, Clark Institute; Liverpool, Walker). From the late 1770s he seems also to have turned to more domestic subjects, 'happy families', mothers and children, saved from *Greuze-like sentimentality by the brio of their pictorial technique (e.g. Amiens, Musée; London, Wallace). The following decade saw him essaying either proto-Romantic themes (*see* Volume Two; e.g. Buenos Aires, Museo) or even Neo-Classical compositions. Some of the more tightly painted pictures were probably executed in collaboration with Marguerite Gérard, his sister-in-law and pupil, with whom Fragonard and his wife lived from 1775 in what was almost certainly a *ménage-à-trois*.

Although he was of republican sympathies and a Freemason, with the collapse of the art market during the Revolution Fragonard left Paris for Grasse, 1790–1. Under the patronage of *David, the teacher of his son Alexandre-Evariste Fragonard (1780–1850), he was drawn into Revolutionary art politics and administration, eventually becoming charged with the creation of a new national museum.

FRANCESCO DI GIORGIO MARTINI (1439–1501/02) Celebrated Sienese-born architect, military engineer, painter and sculptor, trained under *Vecchietta. His early wooden statue of St John the Baptist also shows the influence of *Donatello (1464, now Siena, Pinacoteca; two painted altarpieces, 1471, 1475, also in the same gallery). In 1475–7 he entered the service of Federigo da Montefeltro in Urbino, maintaining his connection with the Montefeltro court even after Federigo's death in 1481. He is thought to have designed the *perspectivized intarsia decorations of the Duke's studios in the castles of Urbino and Gubbio (the latter now New York, Metropolitan). A bronze medal of Federigo was cast during his years at Urbino, and three major bronze reliefs (now in Venice, Carmine; Perugia, Pinacoteca; stucco casts only after lost bronze original, London, Victoria and Albert). In 1497 he completed two bronze angels for the high altar of Siena Cathedral, in which the influence of *Leonardo da Vinci, whom he had met in Milan in 1490, has been discerned.

FRANCIA; Francesco Raibolini, called (c.1450–1517/18) Bolognese goldsmith, first recorded as a painter in 1486; his soft and graceful style, much imitated in and around Bologna, was formed first on that of *Costa, later increasingly on *Perugino (e.g. Bologna, Pinacoteca). There are works by him also in many other Italian and foreign collections, including London, National; New York, Metropolitan; Paris, Louvre; Washington, National; Milan, Brera; Rome, Capitoline, Borghese; etc.

FRANCIABIGIO, Francesco (1482/3–1525) Florentine painter, active until c.1506 in *Albertinelli's workshop and recurrently associated with *Andrea del Sarto (entrance cloister of SS Annunziata, 1513; two scenes in the Chiostro dello Scalzo, 1518–19; decoration of the Salone in the Medicean villa at Poggio a Cajano, 1521). His work, less sophisticated than Andrea's, is frequently more dramatically forceful (e.g. Florence, Uffizi; Vaduz, Liechtenstein Coll.). He is now best remembered for his portraits (e.g. Berlin-Dahlem, Museen; London, National).

FRANCKEN Prolific dynasty of Flemish painters. Hieronymus Francken (1540–1610) was an Italianate Antwerp painter who studied with Frans *Floris before going to work at Fontainebleau in 1566. In France, he became painter to the king, largely on his reputation as a portraitist, although only two small portraits by him are known today (Pommersfelden, Museum; Self-Portrait, Aix-en-Provence, Musée). He specialized also in pictures of masquerades and ballroom scenes. Finally, he was also a painter of large-scale altarpieces, and in this capacity he returned occasionally to his native city, once, in 1571, to complete an Adoration of the Magi left unfinished by Floris. There are altarpieces by him in Paris, Notre-Dame; Antwerp, St Charles Borromeo and Musées. The eclecticism he had learned from Floris, with its admixture of Flemish *realism, Central Italian figure design and Venetian colourism (see under disequo), was tempered by a cold *classicism under the influence of his sojourn at Fontainebleau. He died in Paris. His younger brother Frans I Francken (1542–1616) was a somewhat less intensely classicizing artist, influenced by Maerten de *Vos (altarpiece, 1587, Antwerp, cathedral). Their brother Ambrosius I Francken (1544–1618) was also a pupil of Floris. He occasionally collaborated on altarpieces with de Vos (Antwerp, St Jacobskerk) and he is known to have painted figures in landscapes by other artists.

Frans II Francken (or Frans Francken the Younger) (1581–1642) is now the best-known member of the family. A son of Frans I Francken, he produced some large altarpieces (Antwerp, Musées; Amiens, cathedral). But his main speciality was in countless small *cabinet pictures, on religious and mythological themes as well as *genre and fantastical scenes such as the Witches' Sabbath (1607, Vienna, Kunsthistorisches). There are pictures by him also in Paris, Service de Récuperation; Sarasota, Fla., Museum; etc. His work is comparable to

that of Jan and Pieter II *Brueghel, and, like theirs, it gave rise to a
school of minor painters of *genre*: Christian Jansz van der Laemen
(1606?–52?); his pupil, Hieronymus Janssen, called 'The Dancer'
(1642–93), and Frans' own son, Frans III Francken, who made numer-
ous copies of his father's pictures, as well as painting the figures in the
works of other artists, notably the church interiors by Peter I and Peter
II Neefs (*see under* Steenwijck). Other, less well-documented members
of the Francken family were also painters, including a daughter,
Isabella Francken.

FRANKENTHAL STYLE A mode of landscape painting indebted to
*Coninxloo, who took refuge in this German locality in 1587.

FRÉMINET, Martin (1567–1619) French *Mannerist painter and
architect, the last artist active in the so-called Second School of
Fontainebleau (*see also* Ambroise Dubois and Toussaint Dubreuil), in
the service of Henry IV as their predecessors, *Rosso, *Primaticcio,
Nicolò dell'*Abate had been in that of Francis I and Henry II. After
spending some 15 years in Italy, mainly in Rome where he was much
influenced by the Cavaliere *d'Arpino, Fréminet was summoned to
Paris upon the death of Dubreuil in 1602. His most important surviving
work is the ceiling, 1608, of the Chapel of The Trinity at Fontainebleau,
for which he also designed the high altar.

FRESCO (Italian, fresh) A method of wall painting with water-soluble
pigments over damp plaster, one of the most durable forms of wall
decoration as long as the supporting wall is protected from damp.
Probably for this reason the method gained currency mainly in central
Italy, with its suitably dry climate. There vast numbers of frescoes were
painted, in churches and public buildings but also in private houses,
where fewer have survived, from the 13th through the 18th centuries.
In the 16th century the fashion for frescoing exterior façades became
widespread, but little of this type of decoration remains. Ceiling fres-
coes are an important feature of the 17th-century Italian *Baroque
style.

Buon fresco is applied through several stages. The wall having been
rough-plastered, a finer coat of plaster, the *arriccio*, is then applied. On
this the entire composition is drawn, whether free-hand as from the
13th to the 15th centuries, or by tracing a full-scale drawing on paper,
the cartoon (16th century). The reddish-brown pigment utilized in the
underdrawing is called sinopia, and this term is now applied to the
drawing on the *arriccio* itself. Many sinopie have been revealed through
the process of detaching frescoes from their original support in the
course of restoration and conservation. Over the *arriccio*, a still finer
coat of plaster, the *intonaco*, is applied only to that area which can be
painted whilst damp, that is, in one day. For this reason, that area is
called a *giornata*, a day's work, from the Italian word for day. The
covered portion of the sinopia is drawn, or incised, in the *intonaco* to
join up with the portion still visible on the *arriccio*, then painted with

pigments dissolved in water or lime-water. As the *intonaco* dries the pigments are chemically bonded with the plaster, becoming part of the structure of the wall. The unpainted edges of *intonaco* are chiselled off, to be joined by the following day's *giornata*. These joins being faintly visible, the working speeds of fresco artists can be judged: *giornate*, the work of a single day, vary widely in size, from a single head to large tracts of drapery or landscape. Fresco proceeds from the top of the wall downward, to avoid splashing, and for this reason the normal narrative flow of early fresco cycles, such as that in *Giotto's Arena Chapel, is in tiers from the top of the wall to the socle. In time, the tier system was replaced by a more *illusionistic, less narratively copious, form of decoration: the walls seem to dissolve as large-scale figures pose within fictitious architectural or landscape settings. *Raphael's frescoes in the Vatican *Stanze are of this type.

FUSELI, Henry *See* Volume Two.

FYT, Jan or Joannes (1611–61) Outstanding and influential Flemish painter of monumental *still-lifes, famous especially for his depiction of trophies of the hunt; also the most important apprentice and assistant of Frans *Snyders. In 1633–4 he was in Paris; he then travelled in Italy, returning to Antwerp by 1641. He may have visited the northern Netherlands in 1642. Under Dutch influence he turned from the extrovert *Baroque manner of Snyders to a more contemplative mode, combining large-scale decorative arrangement with meticulous depiction of different surfaces (Stockholm, Museum; London, National; Frankfurt, Kunstinstitut; Amiens, Musée; Madrid, Prado; The Hague, Mauritshuis; Copenhagen, Museum; New York, Metropolitan; Leningrad, Hermitage; etc.).

GADDI, Taddeo (recorded 1332–66) and his son Agnolo (recorded 1369–96) Florentine painters; Taddeo was the best-known pupil of *Giotto, Agnolo is the most important of his three painter sons. The earliest dated works by Taddeo, the 1332–8 *frescoes of the *Life of the Virgin* in Florence, S. Croce, Baroncelli chapel, demonstrate, through their descriptive and *expressive complexity, his dependence on the Sienese *Lorenzetti brothers as well as on his teacher. The famous scene of the *Annunciation to the Shepherds* pioneers nocturnal light effects. On the socle of the east wall is painted the earliest known example of post-antique independent *still-life: a fictive niche enclosing liturgical vessels.

Even more strikingly *illusionistic, and on a much larger scale, are the c.1340–50 frescoes in the former refectory of S. Croce depicting *The Last Supper* as taking place in the viewer's own space in front of a wall painting of *The Tree of Life* – a mystical Crucifixion illustrating the *Meditations* of St Bonaventure – and scenes from the *Lives of Sts Benedict, Louis, Francis* and *Mary Magdalen*. His 1342 frescoes in Pisa, S. Francesco, have largely disappeared, but there are panel paintings by him in Florence, Uffizi; Berlin-Dahlem, Museen (indebted to Bernardo *Daddi); Pistoia, S. Giovanni Fuorcivitas.

In the best known of his works, the frescoes of *The Legend of the True Cross*, c.1380, S. Croce, choir, Agnolo Gaddi abandoned almost totally the sober realism of Giotto, already diluted in his father's Baroncelli frescoes, in favour of a fantastical and decorative style based on abrupt transitions of scale and complex colour harmonies. (Other frescoes Chapel of the Holy Girdle, 1392–5, Prato, cathedral.) Several panel paintings have been attributed to him, and he was recorded as working in the Vatican, 1369.

Agnolo Gaddi trained Cennino Cennini, author of *The Craftsman's Handbook* (*Il Libro dell'Arte*) c.1390, our best source of information on the painting techniques of Giotto and his followers, and on many procedures followed by artist-craftsmen of the fourteenth and even fifteenth centuries.

GAINSBOROUGH, Thomas (1727–88) Portraitist, painter of landscapes and of *Fancy Pictures. Unlike his great rival, *Reynolds, he was not a learned artist, being musical, not literary; he did not aspire to the Italian Grand Manner, and his antecedents are rather to be found in Dutch, Flemish and French *Rococo art. Equally unlike Reynolds and other fashionable portraitists, he did not rely on drapery painters to assist him in the production of over 700 portraits. The beauty of his mature and late works depends in large measure on the charm of his flickering, spirited, autograph touch. All the parts of the picture have been worked on together, so that no area of the canvas is

lifeless; form dissolves into texture, colour and air. Although the term 'impressionism' has been used to describe Gainsborough's style, his aims should not be confused with those of 19th-century Impressionism (*see* Volume Two). His goal was not the transcription of optical reality, but the evocation of sensibility, and it should not surprise that his late landscapes were composed from little models he made from pebbles, dried weeds, etc., and that his Fancy Pictures romanticize the lot of the rural poor.

Born in Sudbury, Suffolk, the youngest son of a cloth merchant, he showed a precocious talent for painting. Around 1740 he was sent to London. He had no academic training, but worked with the French engraver *Gravelot, and restored Dutch landscapes, notably *Ruisdael, whom he also copied. On periodic visits back to Sudbury he painted Suffolk landscapes in this style (e.g. *Cornard Wood*, finished 1748, London, National). Late in the 1740s or in the early 1750s, he met, and was influenced by, *Hayman. After his marriage in 1746 he seems to have lived mainly in Sudbury, where he tried to combine the landscape painting he loved with the portraiture he needed to do to earn a living. These fresh *Conversation Pieces, or small full-length single portraits in landscape are amongst the first paintings in which equal attention is lavished on the landscape and the figures, often gauche and ill-proportioned (e.g. *Mr and Mrs Andrews*, c.1749, London, National). In these years he must have continued to visit London, as his city-scape in the Foundling Hospital testifies (*The Charterhouse*, 1748). Between c.1752 and 1759 he was settled in Ipswich, where he turned to the more lucrative portraiture on the scale of life (e.g. *William Wollaston*, c.1759, Ipswich, Christchurch Mansion). Artistically, the most successful portraits of these years are the informal, unfinished, pictures of his daughters (... *chasing a Butterfly*, 1755/6; ... *with a Cat*, 1757/8; London, National). In 1759 he moved to Bath, where two important factors caused him radically to remodel his style: for the first time, he attracted a fashionable metropolitan clientele, and he encountered the works of *Van Dyck (e.g. copy after *Lords John and Bernard Stuart*, St Louis, Mo.). The full impact of Van Dyck is best judged in Gainsborough's female full-length portraits, which now combine elegance with ease of manner, a new, more tender, colour range and a loosening of paint texture (*Mrs Philip Thicknesse*, 1760, Cincinnatti, Museum; *Mrs William Henry Portman*, c.1767/8, Viscount Portman). Simultaneously, however, his landscape backgrounds become no more than artificial backdrops. His reputation spread to London; in 1768 he was invited to become a founder-member of the Royal *Academy. In 1774 he moved permanently to London, acquired a great practice, including, in 1780, the Royal Family (*King George III, Queen Charlotte*, Windsor Castle). After a quarrel with the Academy in 1784, he ceased to exhibit there, holding private exhibitions in his house.

From the time he had settled in Bath, he had painted landscapes,

mainly for his own pleasure (Birmingham, University, Barber Institute; Egham, Holloway College). In London, falling back on earlier landscape studies, and relying increasingly on his artificial models, he began to explore certain idealized rural themes, notably that of *The Cottage Door* (*c*.1780; Cincinnatti, Museum; California, Huntington). After seeing a version of one of *Murillo's pastoral *Child St John* pictures in the late 1770s, he started to paint the pictures by which he himself set most store, the 'Fancy Pictures' of rural beggar children, gypsies and child labourers. Ragged and melancholy, but well-fed and meltingly pretty, these figures found a ready response (Castle Howard; Manchester, Gallery, etc.).

There are paintings – especially portraits – by Gainsborough in almost all major museums in Britain and the USA.

GALGARIO, Fra *See* Ghislandi, Giuseppe.

GALLI *See* Bibiena.

GALLOCHE, Louis *See under* Lemoyne, François.

GAMBARA, Lattanzio *See under* Romanino, Girolamo.

GAULLI, Giovan Battista; called Baciccio or Baccia (1639–1709) Genoese painter best-known for his *illusionistic ceiling *frescoes in the Gesù, Rome, executed between 1672–85 under the influence of *Bernini. This type of church decoration, fusing together painted areas, three-dimensional decorations and the actual architecture, was to reach its final expression in Germany and Austria (*see also* Andrea Pozzo). Before settling in Rome in 1657 Gaulli had based his style on the Genoese works of *Van Dyck and *Strozzi; perhaps on Bernini's advice he visited Parma in 1669 and was much affected by *Correggio, whose *sfumato* handling is evident at the Gesù. His first frescoes were the pendentives for S. Agnese in Piazza Navona, 1668–71. After Bernini's death his colour range became paler and he turned to more *classical compositions, such as the one of his last ceiling fresco, SS. Apostoli, 1707. Gaulli was also one of the prime portraitists of his time; he painted likenesses of all seven popes from Alexander VII to Clement XI as well as most of the cardinals (e.g. Rome, Nazionale.)

GEERTGEN tot Sint Jans (Little Gerard of the Brethren of St John) (1460/5–90/5) The best-known Dutch painter of the 15th century. Born at Leyden, he is presumed to have been the pupil in Haarlem of Albert Ouwater (active from 1450 to 1480), from whom he would have learned the new naturalistic (*see under* realism) idiom of van *Eyck; he may, however, have been an apprentice in Bruges in 1475/6. *The Holy Kindred* (*c*.1485; Amsterdam, Rijksmuseum), attributed to him, shows an indebtedness to Ouwater's only known work. His best-attested pictures are two panels from a triptych painted for the Knights of St John in Haarlem (1490/5; Vienna, Kunsthistorisches). These, and other pictures grouped around his name, demonstrate an interest in landscape and in the nocturnal light effects

with which he is now particularly associated (*Nativity, at Night*, London, National; other paintings, Berlin Museen; Rotterdam, Boymans-Van Beuningen).

GELDER, Aert or Arent de (1645–1727) *Rembrandt's last and best pupil, *c*.1661–*c*.1663, was also his closest follower, and the only Dutch artist to continue working in Rembrandt's manner during the 18th century, albeit he brightened Rembrandt's limited colour range to include blue, green and violet. In addition to portraits (e.g. *The Family of Herman Boerhave, c*.1722, Paris, Louvre) Gelder painted basically two types of history pictures (*see under* genres), mainly from Scriptural sources: those, derived from Rembrandt paintings, which focused on the interaction of a few life-size half-length figures (e.g. *Abraham Entertaining the Angels*, Rotterdam, Boymans-Van Beuningen; *The Feast of Belshazzar*(?), 1682–5, Malibu, Calif., Getty) and those, frequently related to Rembrandt's etchings, in which many small-scale figures appear at a distance (e.g. *Scenes from the Passion, c*.1715, Aschaffenburg, Museum; Amsterdam, Rijksmuseum).

GENRES (French for varieties, types, categories) There is no comprehensive system of categorization universally employed in art theory or in the study of the visual arts. It could be argued, however, that classifying art by genres – that is, according to subject matter and function, supplemented by medium – might be more useful than categorizing it by styles, as is normally done in art history (*see* Gothic, Renaissance, Mannerism, Baroque, Rococo, classicizing). Genres play an important role in determining scale, format, cost and even style in the production of works or art. Generic aptness and coherence are key components of the art-theoretical notion of *decorum.

A ranked ordering of pictorical genres was evolved in the Italian Renaissance by analogy with ancient Graeco–Roman theories of literary genres, to accommodate the growing number of uses to which painting was put, and the growing differentiation between the arts of *disegno* and manual crafts. This system of categorization applies only very partially to sculpture, although it has been very influential on Western art as a whole. It was given its definitive expression in the Preface written by Félibien to the 1669 publication of lectures delivered at the French *Academy in 1667. In the academic hierarchy of the genres the highest category is *history painting* (from the Italian *istoria*), large-scale narrative in the grand manner, comparable to the literary genres of tragedy or epic which represent the actions of people 'better than ourselves'. Thus history painting may depict episodes from the lives of saints, Christ and the Virgin; from ancient mythology, literature and history, and, by extension, from more recent literary texts and historical events, provided that the actions represented are 'noble' and worthy of serious consideration. This type of painting is particularly suited to the decoration of princely palaces or of public buildings and public spaces, where it can both express, and help to form, communal ideals. The

painter who specializes in this category of art is to be ranked on a par with the ancient tragic poet and public orator, since he not only requires comparable gifts of intellect and imagination, but may be thought to wield comparable influence.

The second-highest pictorial category in the academic hierarchy of the genres is *portraiture*. Although it lends itself also to small-scale private forms, portraiture concerns itself with the depiction of heroic personages for public viewing.

Third in the academic hierarchy of the genres is the representation of everyday life, comparable with the ancient literary category of comedy, depicting the actions of people 'like ourselves or worse than ourselves'. Since the 19th century this category has been confusingly called *genre*: thus *genre* is one of the genres. Before the 19th century people spoke of 'everyday subjects', 'market scenes', 'banquet scenes', 'brothel scenes', etc. If, in its pure form, history painting is associated with public venues and a large scale, pure *genre* is associated with domestic settings and a small scale.

The fourth and fifth categories are not primarily concerned with the depiction of human actions. They are *landscape* and *still-life* respectively.

From the very beginning, genres could be conflated or subdivided. Thus landscape comprises seascape, mountain scenery, townscape, harbour or river scenes, etc. It is only a matter of emphasis which determines whether a painting representing peasants labouring in the fields is classified under landscape or *genre*. Even today the Spanish recognize two categories of what we might call still-life: the *florero* or flower-piece, and the *bodegón*, or representation of foodstuffs, which has always admitted the human presence. Still-life, always a popular genre, has admitted such specialities as still-lifes with shells, with fish, with trophies of the hunt, with musical instruments, with books. Moralizing intentions could be expressed almost as easily in the 'lower' genres as in the highest, and Dutch 17th-century painting, which evolved so many forms of *genre*, landscape and still-life, must be read with this in mind. Thus a 'merry company' of young people enjoying a banquet may have been intended to remind the viewer of human society before the Flood, and a still-life, of the Preacher's words in Ecclesiastes, 'vanity of vanities, all is vanity' (*see Still-life*).

Although, as has been said, the academic hierarchy of the genres was evolved primarily for pictorial art, it is possible to speak of the genres of sculpture: funerary monuments, for example, or equestrian statuary, portrait busts, etc. The term may thus be applied loosely to mean any type of art which has a format, function or subject which distinguish it from any other type. Even within painting, it is thus possible to consider, e.g. the altarpiece, or illusionistic ceiling paintings, as forming discrete genres with their own characteristic problems and traditions.

GENTILE da Fabriano (*c.*1385–1427) Italian painter from Fabriano in the Marche. Celebrated in his day for his technical perfection

and his novel pictorial language, at once elegant and naturalistic (*see under* realism), he has been categorized in modern scholarship as a leading exponent of the International *Gothic style. This pigeon-holing obscures his innovations – notably in the use of light to create unity of space – which were indeed quickly eclipsed by those of *Masaccio. Yet Gentile's influence, preponderant in Florence *c.*1420–3 even over Masaccio himself, continued to affect artists throughout the 15th century. *Masolino, Fra *Angelico, Benozzo *Gozzoli, *Domenico Veneziano and *Piero della Francesca are amongst those most indebted to him, as were all those painters required by conservative patrons to paint *polyptychs on a gold background. Gentile, in turn, remained receptive to novelty. Originally influenced by Lombard miniatures, subsequently by developments in Venice, by contact with Franco-Flemish panels and perhaps miniatures in Brescia, by Florentine 14th-century painting and 15th-century sculpture, he adopted those innovations of Masaccio which he could have seen by the time he left Tuscany for Rome in 1427.

First recorded in 1408 in Venice, Gentile achieved fame and prosperity in that city. Unfortunately, all his Venetian works have been lost, including the illustrious commission of a naval battle painted in *fresco 1411–14 in the Great Council Hall of the Doge's Palace, one of the scenes destroyed by fire in 1577 (*see also*, e.g. Bellini, Titian). From 1414–19 he was in Brescia, where he decorated the chapel of the Broletto, or municipal palace, for the city's ruler, Pandolfo Malatesta (destroyed, 16th century). In Brescia, Gentile met Pope Martin V, on his way back to Rome from the Council of Constance, and was invited to work for him. In 1419/20 he followed the pope to Florence. By 1422 Gentile had been enrolled in the Florentine painters' guild. His earliest surviving documented work, the *Adoration of the Magi* (1423, now Florence, Uffizi) was painted for the sacristy of S. Trinita for Palla Strozzi. A key document of Italian 15th-century art, this work represents the acme of medieval panel-painting technique as recorded in Cennino's (*see under* Gaddi) treatise, whilst firmly embracing the notion of painting as an extension of visual experience. The narratives of the *predella demonstrate most clearly Gentile's interest in complex lighting schemes, as in the nocturnal *Nativity*; in problems of picturing action in panoramic landscape, as in the *Flight to Egypt*, and in continuous townscape, as in the *Presentation in the Temple*. The whole is expressed with Gentile's characteristically humane warmth: splendour contrasts with simplicity, religious solemnity with intimacy.

In the following two years Gentile ran a busy workshop in Florence, employing at least two assistants, of whom one may have been Jacopo *Bellini (e.g. panels now in Pisa, Museo; New York, Frick; Florence, I Tatti; New Haven, Conn, Yale). The major work following the *Adoration* was the Quaratesi polyptych for S. Nicolo Sopr'Arno of 1425, now dismembered (central panel, *Madonna and Child*, Coll. HM the Queen, on loan London, National; four flanking *Saints* with four roundels of

saints, Florence, Uffizi; four predella scenes, Vatican, Pinacoteca; one predella scene, Washington, National). In unified spatial planning and colour harmonies this work extends the experience of the *Adoration*. The predella scenes were especially praised by *Vasari.

In 1425 Gentile repaired to Siena to paint a (lost) polyptych for the city notaries; the work was interrupted to paint a fresco of the *Madonna and Child* for the cathedral of Orvieto, Gentile's second documented work to survive, albeit in poor condition and with a figure of St Catherine added in the 16th century. Finally, in 1427, Gentile reached Rome to begin working for Martin V at St John Lateran, on a decoration which influenced the *iconography and disposition of the later wall paintings in the Sistine chapel. The narrative scenes were completed after Gentile's death by *Pisanello (in 1431–2), but the whole decoration was destroyed in the remodelling of the basilica in 1647.

In addition to the works above, Gentile's most important extant work is the signed but undocumented Valle Romita polyptych painted for a Franciscan church near Fabriano, *c*.1410–12, and reassembled in a modern frame in Milan, Brera.

GENTILESCHI, Orazio (1563–1639) and his daughter Artemisia (1593–1652/3) *Caravaggesque painters. Born in Pisa, Orazio came to Rome in 1576, and in the early 1600s was drawn to *Caravaggio's manner albeit remaining loyal to his Tuscan heritage, apparent especially in his range of colours which included blues, yellows and violets. After a stay in Paris, 1623–5, he became court painter to Charles I in England, where he shed the remnants of his Caravaggesque *tenebrism. In addition to his principal English works (nine ceiling paintings for Greenwich, Queen's House, after 1635, now London, Marlborough House) there are paintings by him in Milan, Brera; Fabriano, cathedral; Malibu, Cal., Getty; Vienna, Kunsthistorisches; etc.

Unlike her father, Artemisia continued to paint sensational Caravaggesque subjects, notably of Old Testament heroines, catering to private collectors throughout Europe (e.g. *Judith and Holofernes*, versions in Naples, Capodimonte; Florence, Pitti, Uffizi). She was also sought after as a portraitist, although few works in this genre have survived (*Self-Portrait as the Personification of Painting, 'La Pittura'*, Coll. HM The Queen). She became notorious at 19, through the trial of the art entrepreneur Agostino Tassi, whom her father accused of raping her 'many times'. After Tassi's imprisonment, Artemisia married a Florentine and although the marriage broke down, she lived in Florence 1612–21. Her clients there included the Grand Duke Cosimo II. In 1621 she followed her father to Genoa, then spent some time in Venice. Around 1630 she settled permanently in Naples, leaving the city in 1638–40 to visit the dying Orazio in London. Her public commissions, like three large altarpieces in Pozzuoli (late 1630s) show the influence of the new Bolognese *classicism.

GERHAERT, Nikolaus (active 1462–73) Sculptor influential throughout southern Germany. His figure style is marked by a new physical expansiveness and highly individualized physiognomies and poses; it is indebted to Claus *Sluter. Signing himself as *von Leyden*, he may have been a native of Holland or trained there. His earliest known work is the *tomb of Archbishop von Sieck* in Trier (1462, Diocesan Museum), but throughout the 1460s he was based in Strasburg (portal for New Chancellery, fragments in the Musée de l'Oeuvre Notre-Dame; Frankfurt, Liebieghaus), travelling also to Constance (cathedral high altar, destroyed). From 1469 until his death he was employed in Vienna, mainly on the *Tomb of Emperor Friedrich III* (St Stephen's Cathedral).

GERHARD, Hubert (1540/50–1620) Dutch-born sculptor, a pupil in Florence of Giovanni *Bologna. He was the first sculptor active in Germany to employ the monumental style of the Italian *Renaissance, as opposed to the ornamental *Mannerism of, e.g. the *Jamnitzer workshop. From 1581, he worked for members of the Fugger family in the castle at Kirchheim (e.g. fountain, 1584–94, surviving bronze group, 1590, now Munich, National); from 1589, for the city of Augsburg (*Augustus Fountain*, compl. 1594; *see also* Adrian de Vries). After 1584 Gerhard also worked for Duke Wilhelm V in Munich, mainly on the ducal palace (e.g. *Perseus Fountain*; fountain figures, now Residenz-Museum) and the new Jesuit church of St Michael (e.g. façade figures; *see also* Hans Reichle). With the Duke's abdication in 1597, he found employment with the Archduke Maximilian at Innsbruck, probably returning again to Munich in 1613.

GHEERAERTS, Marcus the Younger (c.1561–1635) Leading painter of the late Elizabethan period and under James I. Brought to England in 1568 by his father, the painter and engraver Marcus Gheeraerts the Elder (c.1520–c.90) who returned to his native Bruges in 1577, he was one of a group of Protestant refugee artists whose influence at court was only displaced c.1615–20 with the arrival of, e.g. *Mytens. His father's second wife was a sister of the painter John de Critz (1555–1642); he himself married their younger sister, thus becoming his step-mother's brother-in-law. His own sister married Isaac *Oliver. Whilst no works can be attributed with certainty to de Critz (although *see*, e.g. London, National Portrait) a large number of the formal, heraldic 'costume pieces' of Elizabethan and Jacobean portraiture can be ascribed to Marcus Gheeraerts whether through a signature (e.g. Oxford, Bodleian, Trinity College; Penshurst; Coll. HM the Queen; Duke of Bedford) or on the basis of inscriptions in his style. Amongst the latter works are the famous 'Ditchling' portrait of *Elizabeth I* (1592?, London, National Portrait) and of *Thomas Lee as a Hibernian Knight* (1594, London, Tate).

GHEYN, Jacob I de (c.1530–82) Jacob II de (1565–1629) and Jacob III de (c.1596–1641) Dynasty of Dutch draughtsmen and

painters, of whom the best known is Jacob II de Gheyn. Like his father, Jacob I de Gheyn, Jacob II de Gheyn designed stained-glass windows, but he was also a pioneer of drawings of domestic subjects, of the painted *vanitas still-life (New York, Metropolitan; New Haven, Conn., Yale) and of flower pictures (The Hague, Gemeentenmuseum). He studied in Haarlem with *Goltzius, worked in Amsterdam 1591-5 and Leiden 1595-8, after which he settled in The Hague, where he was employed at the court of Prince Maurits of Orange. He began to paint only c.1600. His son, Jacob III de Gheyn, also worked for the court, and is known for still-lifes featuring books, a novelty introduced by his father.

GHIBERTI, Lorenzo (1378-1455) Florentine goldsmith, painter and bronze sculptor, famous for his authorship of two of the three bronze doors of Florence baptistry (1403-24; 1425-52). His workshop became the training ground of many exponents of the Florentine *Renaissance: *Donatello, *Michelozzo, Paolo *Uccello amongst others. Despite a restrictive contract for the first doors, Ghiberti also accepted commissions for the monumental bronze statues for the Florentine Guild Hall Church, Or San Michele: St John the Baptist, compl. 1414; St Matthew, compl. 1422. A third, St Stephen, dates from 1427-8. In addition, he participated in the design of the Siena baptismal font, and executed two of its narrative bronze reliefs: The Baptism of Christ and St John Preaching before Herod (compl. 1427). From 1403-43 he furnished cartoons (see under fresco) for stained-glass windows in Florence cathedral, and throughout his career he continued to practise as a goldsmith.

He also gained a reputation as an architect, but his design for the dome of Florence cathedral was rejected in favour of that by *Brunelleschi, his unsuccessful rival in the 1401 competition for the Baptistry doors. Ghiberti's trial panel for this competition (Florence, Bargello) already demonstrates the abiding character of his art, transitional between *Gothic and Renaissance. His dual allegiance, to antiquity on the one hand and to northern European Gothic on the other, is demonstrated also in his Commentari (c.1447) a treatise on the fine arts which contains an account of his own life. Ghiberti was on friendly terms with leading Florentine humanists; the rise in status of the Florentine artist in the Renaissance, from craftsman to professional man, is dramatically illustrated in his career and through the Commentari. His sons Tommaso and Vittorio (1416-97) inherited his workshop, and Vittorio supervised the execution of the bronze surrounds of the baptistry doors.

GHIRLANDAIO, Domenico Bigordi, called (c.1448-94) Florentine painter. With his painter-mosaicist brother Davide (1451-1525; Orvieto, cathedral façade mosaics) he ran one of the leading workshops in Florence, c.1480-94, specializing in *frescoes but also producing mosaics and works in tempera on panel; the young *Michelangelo was apprenticed to him 1488-9. His son Ridolfo Ghirlandaio (1483-

1561) was trained after Domenico's death by Davide, later by Fra *Bartolommeo, and was deeply influenced by *Leonardo da Vinci. Ridolfo is best remembered for his portraits (e.g. Florence, Pitti; London, National; Washington, National) but was the author also of numerous religious paintings (e.g. Florence, Uffizi) and festival decorations.

Although to 20th-century eyes Domenico Ghirlandaio's work is apt to look prosaic, it exemplifies the concerns of the most advanced Florentine artists in the last days of the Medicean Republic. Deeply rooted in Florentine traditions, he looked to *Giotto and *Masaccio (via Filippo *Lippi) for patterns of narrative and *perspectival construction, and used almost entirely the tried-and-true techniques advocated by *Cennino. From his visits to Rome (*see below*), he imported to Florence the latest *all'antica* models: details from reliefs on the Arch of Constantine and on sarcophagi; *grotesque decoration. Finally, he was, like his patrons, deeply responsive to the newest Netherlandish art, borrowing its motifs and emulating its effects of surface naturalism (*see under* realism).

A pupil of *Baldovinetti after training by his goldsmith father, Ghirlandaio executed his first significant Florentine work c.1472: a *Madonna of Misericord* for the Vespucci family, Florence, Ognissanti. In 1475, Ghirlandaio's workshop was in Rome, decorating the Sistine library in the Vatican (destroyed). Around 1475–6 he painted the chapel of S. Fina at the Collegiata in San Gimignano, assisted by his favourite pupil and future brother-in-law, the San Gimignese Sebastiano Mainardi (c.1455–1513; active in Pisa 1493–5). In 1480 Ghirlandaio was working once more in Florence, Ognissanti, on the *Last Supper* in the refectory, and, in the church, on a fresco of *St Jerome in his study* which was closely influenced by a panel of the same subject by van *Eyck and *Christus Petrus, then in the possession of the Medici. This work, dignified but stolid, may be contrasted with a similarly derived but more *expressive *St Augustine* by *Botticelli in the same church.

In 1480–1 Ghirlandaio was one of the team working on mural frescoes in the Sistine Chapel in the Vatican (*see also* Perugino, Botticelli, Cosimo Rosselli). Here for the first time in his work we find the mixture of historical narrative and contemporary portraiture which characterizes his best-known and most accomplished projects: the decorations of the Sassetti chapel in Florence, S. Trinita, 1485, and of the Tornabuoni chapel, now choir, Florence, S. Maria Novella, c.1486–90. The former, the best preserved 15th-century family chapel in Florence, houses also the tempera-on-panel altarpiece by Ghirlandaio. In addition to motifs *all'antica*, this *Adoration of the Shepherds*, 1485, depicts a group of shepherds inspired by an analogous group in the *Portinari altarpiece* by Hugo van der *Goes, which reached Florence only in 1483.

As elaborate as the narratives of the *Life of St Francis* in the Sassetti

chapel, but larger and more extensive, are the tiered *Lives of the Virgin and of St John the Baptist* in the much larger Tornabuoni chapel. Although still relying on Florentine recensions of the legends, these frescoes include more *all'antica* elements than the Sassetti. Both cycles have been avidly studied by historians, since Ghirlandaio transposes, in the earlier cycle, all events in the life of the saint to contemporary Florence, and, in both cycles, includes life-like 'witnesses' from amongst the families and connections of the patrons.

In addition to these key works, Ghirlandaio executed the fresco decoration in the Sala dei Gigli in the Palazzo della Signoria, Florence, 1481–4. This room, an outstanding monument to the ethos of the Florentine Republic, has an important marble portal sculpted by *Benedetto da Majano. (Since 1988, it also contains Donatello's bronze *Judith and Holofernes*, originally an outdoor sculpture.) An important altarpiece by Ghirlandaio still stands in *Brunelleschi's Hospital of the Innocenti for which it was painted, 1488. A badly-restored mosaic over *Nanni di Banco's north portal of Florence cathedral was designed by Domenico in 1489. There are other works in Paris, Louvre; London, National, and many drawings in various museum print rooms, including Florence, Uffizi; London, British; Vienna, Albertina.

GHISLANDI; Giuseppe, called Fra Galgario (1655–1743) The most distinguished Italian Late *Baroque portraitist. His comparative obscurity in our time can only be explained by the fact that most of his works remain in his native city, Bergamo. Although many are in private collections, the Accademia Carrara has excellent examples on view: from the touchingly fresh likeness of his youthful assistant, to the grandiloquent double portrait of *Count Giovanni Secco-Suardo with his servant*. He studied in Venice and spent some years there and in Milan, before returning to Bergamo to live and work in the friary of Galgario. His portraits combine Venetian colourism (*see under disegno*), although always against a dark ground, with Lombard *realism, and his mastery of character rivals that of *Moroni. Single examples also in Venice, Accademia; Milan, Brera; Minneapolis, Institute; Hartford, Conn., Atheneum.

GHISOLFI, Giovanni (1623–83) Milan-born painter active in Rome from 1640. He was the first Italian artist to specialize in imaginary topographical views of Roman ruins, scenically arranged. These *vedute ideate* (*see veduta*) anticipate, and inspired, the more famous works in the same genre by *Panini (e.g. Rome, Spada).

GIAMBOLOGNA *See* Bologna, Giovanni.

GIAN Cristoforo Romano *See under* Isaia da Pisa.

GIAQUINTO, Corrado (1703–65) Painter educated in the Neapolitan *Academy of Francesco *Solimena; he specialized in large-scale *Rococo decoration in *fresco and on canvas. From 1723–53 he worked mainly in Rome, having joined the studio of Sebastiano Conca (1679–1764) with whom he collaborated on frescoes in Rome

and Turin (1732, Rome, S. Nicola dei Lorenesi; 1733, Turin, Villa della Regina; 1740–2, Turin, S. Teresa). Elected to the Roman Academy of St Luke in 1740, he became its president in 1750. In 1753 he succeeded *Amigoni as court painter in Madrid, where he also became Director of the Academy of S. Fernando (Madrid, Royal Palace; palaces of the Escorial; Aranjuez). Upon the arrival of *Mengs in 1761/2, Giaquinto returned to Italy. Other works London, National; Oporto, Museo; etc.

GIBBONS, Grinling (1648–1721) English wood carver and sculptor, born at Rotterdam. He may have been trained in the *Quellin workshop at Amsterdam Town Hall and came to England at about the age of 19. He is best remembered for his naturalistic (see under realism) decorative festoons of fruit, flowers, etc. carved in wood (London, Victoria and Albert, St Paul's, Hampton Court, Blenheim, etc.), but he was also a monumental sculptor, who may, however, have relied heavily on studio assistants, notably Arnold *Quellin, for this branch of his production (London, Trafalgar Square, Chelsea Hospital, etc.). In 1684 he was made Master Sculptor to the Crown. His late work shows an increasing interest in the antique.

GILLOT, Claude See under Watteau, Jean-Antoine.

GILPIN, Sawrey (1733–1807) Apprenticed to a landscape and marine painter, Gilpin later specialized in animal, especially horse, painting. Although lacking *Stubbs's knowledge of anatomy, he shared Stubbs's frustration at the lowly status of the 'sporting painter' and at being excluded from the Royal *Academy at its foundation. In reaction, he executed some literary and history pictures (see under genres) with horse protagonists: three episodes of Gulliver and the Houyhnhnms (1768–72; Southill; York, Gallery; New Haven, Conn., Yale); The Election of Darius (1769; York, Gallery). In 1795, he became Associate of the Royal Academy, and an Academician in 1797. He was the younger brother of the Rev. William Gilpin, the exponent of the *Picturesque.

GIORDANO, Luca (1634–1705) The leading Neapolitan painter of the second half of the 17th century, so prolific that he was nicknamed Luca fa presto, 'paint-fast Luke'. The son of a painter, Antonio Giordano, Luca trained in his native city in the circle of *Ribera; his early work reflects Ribera's *Caravaggesque style, as well as some of his pictorial themes, such as the half-length pictures of philosophers (Hamburg, Kunsthalle; Rome, Nazionale; Vienna, Kunsthistorisches; Buenos Aires, Museo). After Ribera's death in 1652, Luca left Naples to study in Rome, Florence and Venice, where he attended particularly to the painting of *Pietro da Cortona, one of the founders of the Roman High *Baroque, and to the great 16th-century masters of colourism (see under disequo), *Titian and *Veronese. Luca evolved a personal synthesis of *realism and Baroque painterliness, which was modified throughout his career as he came into contact with, for example, the *classicizing paintings of *Maratta. In turn, Luca's innumerable altarpieces, collectors'

pictures and decorative cycles influenced many Italian and foreign painters. He received important *fresco commissions in Florence (Palazzo Medici-Riccardi, 1682–5; Carmine, 1682) in Naples (Montecassino, 1677–8, destroyed in World War Two; S. Brigida, cupola, 1678, and Sacristy, completed posthumously by pupils after Luca's designs of 1702; S. Gregorio Armeno, 1678–9). Between 1692–1702 he worked at the court of Charles II of Spain, where he carried out grandiose decorative schemes in royal palaces (Escorial, Buen Retiro, Madrid) and churches (Toledo, cathedral) as well as altarpieces and other easel paintings. His late works anticipate 18th-century *Rococo, and were greatly esteemed by, amongst others, *Fragonard. There is now a large, narrative canvas in London, National.

GIORGIONE; Giorgio da'Castelfranco, called (1476/8–1510) Venetian painter from Castelfranco; the nickname by which he is known means 'Big George'. Despite the brevity of his career, the scarcity of facts concerning his life and work, and the small number of pictures securely attributed to him, he is one of the most celebrated and influential of artists, credited with laying the foundations of the Venetian High *Renaissance. Basing himself on the style of Giovanni *Bellini, his probable master, he lent it greater monumentality, sensuousness and lyricism. Like Bellini from the 1490s onwards, he adopted colour as the basic constituent of pictorial representation (*see under disegno*; *also* colour). His paintings were built up through harmonies of complementary colours, with relatively few hues, generally in their most saturated state. Forms are enveloped in a dense atmosphere, like light passing through haze; this *sfumato*, unlike *Leonardo da Vinci's, was based primarily not on graduations from dark to light but from hue to hue. One of the first Venetian artists to work predominantly for private collectors, he extended the narrow range of traditional subject matter – virtually all religious – to include landscape, reclining nudes, pseudo-portraits of beautiful youths and young women. In these paintings, the suggestion of a poetic mood, dreamlike and introspective, takes precedence over narrative. Such 'Giorgionesque' imagery was widely imitated, perhaps even in his lifetime.

Of the many paintings associated with Giorgione only a handful is universally agreed to be by him. A ruined fragment is all that remains (Venice, Ca' d'Oro) of the one documented work, the 1508 frescoes on the canalside façade of the Fondaco dei Tedeschi – the warehouse of the German merchants' in Venice. The young *Titian worked on the side façade. Of the remaining secure attributions the *Castelfranco Madonna* (c.1504) in the cathedral of his home town is Giorgione's only known altarpiece. The enigmatic little picture known as the *Tempesta*, described in a 16th-century source as 'a landscape with a storm, a soldier and a gypsy', is usually assigned to about the same date (Venice, Accademia). The portrait of an unknown woman, called *Laura* after the emblematic laurel leaves behind the figure and attributed on the basis

of a contemporary inscription on the back, dates from 1506 (Vienna, Kunsthistorisches). The *Three Magi*, also called *Three Philosophers*, is given to Giorgione by the same source as the *Tempesta* (*c*.1508, Vienna, Kunsthistorisches). It is said to have been completed by Giorgione's disciple *Sebastiano Veneziano. Finally, the *Sleeping Venus* (1509–10, Dresden, Gemäldegalerie) was completed by Titian, to whom are owed the rustic landscape and the incongruous bedding. A group of disputed Giorgionesque works of *c*.1510 are now also usually attributed to the young Titian (e.g. *Fête Champêtre*, Paris, Louvre). Various museums own works accepted by some scholars to be by Giorgione. Of these, the Leningrad *Judith*, the San Diego *Terris* portrait and the *Giustiniani* portrait in Berlin-Dahlem have won the greatest consensus.

GIORNATA (pl. giornate) *See under* fresco.

GIOTTO (first recorded 1301–37) Florentine painter, uniquely celebrated in early Italian literature, as in later art-historical writings, for creating a new *realistic and dramatic pictorial style. Influenced by recent developments in sculpture (*see* Giovanni Pisano) and painting (*see* Cavallini, Cimabue) Giotto evolved an individual manner, less lyrical and descriptive than that of his older contemporary *Duccio, but more focused on the telling moments of narrative. He stands at the beginning of the tendency in Italian art to dissolve the picture or relief surface and involve the viewer as a witness to the event depicted. His *iconographic inventiveness is accompanied by increasing mastery of the human form, human movement and facial expression, as of *expressive groupings.

Giotto is recorded working in Rome, Avignon and in Naples at the court of Robert of Anjou (1328–32). In 1334 he was made chief architect of the cathedral, Florence. But the mosaic of the *Navicella* in St Peter's, Rome (*c*.1300 or after 1313) has not survived in its original form, and the Avignon and Neapolitan works have been destroyed. Not one of his surviving works is documented. On the basis of secondary sources, however, the touchstone of Giotto's *oeuvre* is the Scrovegni, or Arena, Chapel in Padua (*c*.1304–13) of which he may have been the architect. Under a starry vault, and within a fictive architectural enframement, window-like pictorial fields arranged in tiers across the walls of the nave recount the *Lives of the Virgin's parents*, the *Life of the Virgin*, the *Infancy*, *Ministry*, *Passion* and *Apparitions of Christ*. The undivided west wall carries a large fresco of the *Last Judgement*. The socles of the side walls are painted with fictive marble reliefs of the *Virtues* and *Vices*. The arrangement is designed to make apparent thematic and symbolic relationships, but the allegorical programme is overshadowed by the emotional and spiritual profundity of individual scenes. Giotto's last surviving *frescoes are the cycles in the Bardi and Peruzzi chapels (Florence, S Croce, *c*.1315–*c*.25). As late as the end of the 15th century they still provided Florentine artists with compositional models and a repertoire of individual gestures.

A famous cycle of paintings in the upper church of S. Francesco,

Assissi, is sometimes attributed to Giotto, but its authorship and dating are in doubt. (*See* Master of the St Francis cycle.)

Of the panel paintings (Paris, Louvre; Bologna; London, National; etc.), only the *Ognissanti Madonna* (Florence, Uffizi) reflects the quality of Giotto's fresco paintings. It is in the tradition of the great enthroned madonna panels of the 13th century and can be compared with Cimabue's *S. Trinita* and Duccio's *Rucellai* Madonnas in the same gallery. Less stylized than either of these, it compensates for a certain loss of drama with increased rationality of space and volume.

Giotto's influence continued in Florence through most of the first half of the 14th century (*see* Taddeo Gaddi) but by the Black Death of 1348 and after, his humane and realistic art had been superseded by more stylized and hieratic forms (*see* Orcagna). He becomes a major inspiration once more from the first quarter of the 15th century (*see* Masaccio).

GIOVANE, Palma *See* Palma Giovane.

GIOVANNI D'ALEMAGNA *See under* Vivarini, Antonio.

GIRARDON, François (1628–1715) *Classicizing French sculptor, a close collaborator of *Lebrun, trained in the Royal *Academy and in Rome, 1645–50. His early works show his dependence on *Sarrazin, but his famous groups for Versailles, *Apollo and the Nymphs of Thetis* (1666) and *The Rape of Persephone* (1677–99), both moved from their originally planned emplacement, demonstrate his study of the paintings of *Poussin as much as of ancient sculpture. The same principles of composition emphasizing parallel planes can be observed in his many other commissions (e.g. tomb of Richelieu, 1675–7, Paris, Sorbonne). After *c.*1690 he began to be displaced in royal favour by his more *Baroque rival, *Coysevox.

GIULIO ROMANO; Giulio Pippi called (1499–1546) Roman-born painter, architect and designer of brilliantly fertile invention. He was the favoured pupil and one of the heirs of *Raphael, whose workshop he joined as a boy. From 1524 he lived in Mantua as court artist to the Gonzaga, dominating the artistic life of the city and gaining celebrity throughout Italy. Since virtually all his projects in these years were carried out hurriedly and by assistants, he must be judged through their conception and design rather than their execution. Classified as a *Mannerist artist, Giulio shared and extended Raphael's interest in archeology, becoming not only a master of motifs *all'antica* but also applying to painting certain principles of Roman art, notably relief sculpture as known through sarcophagi, triumphal columns and arches. Paradoxically, when compared to Raphael's High *Renaissance mode (as in the Stanza d'Eliodoro), the effect appears unclassical (*see* classicism). This can already be observed in the *frescoes of the Sala di Costantino in the Vatican completed after Raphael's death under Giulio's direction (1521; 1524). An equally stylized effect is evident in Giulio's altarpieces, the *Stoning of St Stephen* (*c.*1521, Genoa, S. Stefano),

*Madonna della Gatta (c.*1523, Naples, Capodimonte) and *Holy Family with Sts Mark and James (c.*1524, Rome, S. Maria dell'Anima).

Of his projects in and around Mantua, the main surviving ones are the Palazzo del Tè – a lavish villa contiguous to Federico Gonzaga's famous stables and conceived as a pleasure palace – and the Appartamento di Troia in the old ducal palace, designed as an armoury. Both are lavishly decorated with frescoes, the themes of which are predominantly taken from ancient mythology, although the Tè also contains a large room decorated with portraits of Federico's favourite horses. The most elaborate decorations in the Tè depart in contrasting ways from the High Renaissance ideal of harmony. The explicitly erotic Sala di Psiche elaborates *all'antica* motifs and styles – the latter now also related to painted ceiling decorations in the Golden House of the Roman emperor Nero, albeit with naturalistic *foreshortenings. It is thus blatantly a work of artifice. The famous Sala dei Giganti, on the other hand, based on the mythological tale of the defeat of the Titans by the gods of Olympus, deviates from classical balance through a surfeit of naturalism (*see under* realism). The visitor thrust into the room risks, at first sight, being crushed to death by falling masonry along with the brutish giants, succumbing to the thunderbolt of Jove on the ceiling.

Many drawings by Giulio survive in various collections and print cabinets, a large number recording his designs for silversmiths. The reader should be aware that this entry does not discuss Giulio's works of architecture and civil engineering.

GLAZE, GLAZES *See under* colour.

GOUDT, Hendrick *See under* Elsheimer, Adam.

GNADENBILD (pl. *gnadenbilder*, German, image of grace) A miraculous image. The German term is normally used for images produced, or copied, in northern Europe in the Late Middle Ages, when private devotion to images was particularly important. *See also Andachtsbild.*

GNADENSTUHL (German, throne of mercy/grace) *Iconographic motif imported sometime in the early 15th century into German and Austrian art from France, via manuscript illuminations. The enthroned God the Father, from whom the Dove of the Holy Ghost emanates, holds out the crucified Christ.

GOES, Hugo van der (active 1467–82) Important but ill-documented Netherlandish painter, probably born in Ghent. His *oeuvre* has been reconstructed by comparison with the *Portinari Altarpiece*, attributed to him by *Vasari, and commissioned by Tommaso Portinari, an agent of the Medici bank in the Netherlands, for his family chapel in the Florentine church of S. Egidio, where it was installed in 1483 (now Florence, Uffizi). Conceived to Italian specifications, the Portinari triptych (*see under* polyptych) includes a central panel larger than any hitherto painted by a northerner. It weds the minutely descriptive naturalism of Jan van *Eyck to a new monumentality. But what

most impressed Florentines (and was to be imitated by *Ghirlandaio in the altarpiece of the Sassetti chapel, 1485) was the social and psychological *realism of Hugo's painting. The *Portinari Altarpiece*, since it was immediately despatched to Florence, had no impact in the Netherlands, but we can trace its effects on Florentine art through the 16th century, counteracting the tendency to *idealization endemic in Italian *Renaissance art.

The Adoration of the Kings, also called the Monforte altarpiece (Berlin-Dahlem, Museen) has been attributed to van der Goes. The two votive panels (or organ shutters?) executed on behalf of Sir Edward Bonkil for the church of the Holy Trinity, Edinburgh (now on loan from HM the Queen, Edinburgh, National) have also been ascribed to the artist, possibly with studio assistance and some contemporary repainting.

Hugo's originality in relation to Netherlandish painting of his time is amply demonstrated also in *The death of the Virgin* (Bruges, Musée). The composition is exceptional in setting the bed at a near right angle to the picture plane, so that the face of the Virgin is foreshortened, and the surrounding apostles deployed in an ellipse from foreground to background.

We know from a contemporary monastic chronicle that Hugo spent the last five or six years of his life in a monastery near Brussels, although he continued painting and receiving distinguished visitors, amongst them the future Emperor Maximilian. He seems to have suffered bouts of melancolia and delirium, and may have entered the monastery both from religious scruples and for a measure of care and protection during his periods of mental illness. The account has tempted art historians to read signs of mental instability into the artist's paintings – a tendency that should be resisted. Although deeply affecting, Hugo van der Goes' painting is as fully controlled and rational as that of any artist of his day.

GOLTZIUS, Hendrick (1558–1616) Versatile and prolific Haarlem graphic artist and painter, one of the most influential northern European artists of his day. Despite his crippled right hand, he was an unsurpassed draughtsman and engraver (*see under* intaglio prints), able to reconstruct the style and technique of earlier masters such as *Dürer and *Lucas van Leyden. He is one of the most important means of transmission of Italianate themes and motifs to northern Europe, first, through his engravings after the *Mannerist *Spranger, 1585–90; and, following his trip to Rome in 1590, through his drawings and prints of mythological subjects and after antique statuary, in the style of *Raphael and *Parmigianino. Paradoxically, he also specialized in *realistic engraved portraits of the leading personalities of the day and in minute studies of animal and plant life. He is the first printmaker to make *chiaroscuro prints of landscape, and the first Dutch artist to produce open-air drawings of the Dutch countryside (Rotterdam, Boymans-Van Beuningen; Amsterdam, Rijksprentenkabinet; Paris,

Coll. F. Lugt). These anticipate, and may have directly influenced, the landscape paintings of the 17th-century Dutch school.

Goltzius began also to paint c.1600, frequently allegorical or mythological works as eclectic as his prints (Amsterdam, Rijksmuseum).

He had become friends with Karel van *Mander shortly after the latter's arrival in Haarlem in 1583; it was van Mander who introduced him to the work of Spranger, and who stimulated his interest in Italian art, occasioning both his *Mannerist and his *classical phases.

GOSSART or GOSSAERT, Jan; also called Mabuse (c.1478–1532) Flemish painter, the earliest of the so-called 'Romanists', a pioneering and influential artist who was the first Fleming to travel to Rome with a patron in order to record ancient works of art. A native of Maubeuge in Hainault, and trained probably in Bruges, he became a master in Antwerp in 1503. Around 1507 he entered the service of Philip of Burgundy, accompanying him on his mission to the Vatican in 1508. After Philip's death he worked for other members of the ducal family, finally settling in Middleburg, where he died.

Gossart's early work is based entirely on Flemish examples, Hugo van der *Goes in particular (Adoration of the Magi, c.1507, London, National). After his trip to Rome he combined Flemish elements with motifs borrowed directly from ancient art or from intermediaries such as Marcantonio Raimondi (see under Raphael), Jacopo de'*Barbari and *Dürer (e.g. Palermo, Galleria; Prague, Gallery; Vienna, Kunsthistorisches). In 1515 he began a series of mythological paintings for Philip of Burgundy at the castle of Suytborg, completing them alone after the death in 1516 of his collaborator, Jacopo de'Barbari. The surviving panel of Neptune and Amphitrite (now East Berlin, Museen) is the first example of *classicizing nudes in Flemish painting (see also Venus and Cupid, 1521, Brussels, Musées).

In addition to his altarpieces and the decorative mythological works, Gossart remains well-known for his portraits, combining Flemish naturalism (see under realism) and psychological penetration with Italianate monumentality (e.g. Munich, Alte Pinakothek; Paris, Louvre; Berlin-Dahlem, Museen; London, National).

GOTHIC A style label applied to the art and architecture of northern Europe from the 12th to the 16th centuries. Although primarily associated with a type of architecture developed on the Ile-de-France, the term is applied also to decorative and figurative art. Typical Gothic *genres are manuscript illumination, stained glass, tapestry and other textiles, goldsmith's work and ivory carvings. Sculpture other than miniature is almost entirely conjoined with architecture, where it can serve both ornamental and symbolic ends. The word Gothic derives from Goth – the Germanic people who, with the Lombards, destroyed the Roman Empire – and was first used by Italian writers (see Vasari) to indicate the non-*Classical styles of northern European art. Because of this extremely broad application, it is difficult to summarize the

characteristics of Gothic art. In general, however, Gothic (and its derivatives, Late Gothic, International Gothic – a courtly type associated also with such Italian artists as *Gentile da Fabriano and *Pisanello) is distinguished by the primacy of pattern and rhythm, decorative line and decorative colour. Striking *realism of detail is unrelated to any rationally organized total system of representation, and natural forms tend to be subsumed to ornamental ends. Despite its derivation, Gothic does not necessarily connote the *anti*-Classical; some Gothic sculpture – as for example at Rheims and Amiens – emulates antique prototypes.

GOUACHE (French, from Italian *guazzo*, from Latin *aquatio*, fetching of water, watering place) Opaque watercolour paint; pigments are ground in water and mixed with gum. *See also* body-colour.

GOUJON, Jean (*c.*1510–68) The leading French sculptor of the mid-16th century, admired chiefly for his reliefs, which form the greater part of his known *oeuvre*. He also practised as an architect. Both the early and late years of his career are ill-understood. His mature style, as exemplified principally in the decorative panels of the *Nymphs* and *Naiad* from the *Fontaine des Innocents*, (1547–9, now Paris, Louvre) shows the influence of *Primaticcio and *Cellini, but is more *classical.

Goujon's first recorded work, the 1540 organ loft columns at St Maclou, Rouen, argues for first-hand experience of Roman architecture. He is generally credited with the sculpture of the *tomb of Louis de Brézé*, albeit not the design of the whole (*c.*1540, Rouen, cathedral). Possibly in 1544, after carving the reliefs for the chapel at Ecouen (now Chantilly, Musée), Goujon transferred to Paris (St Germain l'Auxerrois; Paris, Louvre; *Fontaine des Innocents*, as above; Hôtel Carnavalet, *c.*1547–9; Louvre palace, relief and free-standing sculpture, 1549–53, heavily restored in the 19th century). His name appears in the royal accounts until 1562, when he is thought to have left France for Bologna. His place in the French capital was taken by Germain *Pilon.

GOWER, George (active from 1573–96) Leading Elizabethan portrait painter, an Englishman of noble birth whose self-portrait (1579, Milton Park) justifies, through an inscription, his earning a living by painting. There are pictures by him in London, Tate, and some of the surviving portraits of Queen Elizabeth have been attributed to him, notably the Woburn Abbey version of the 'Armada' portrait. He seems to have been associated with *Hilliard, although the patent giving them exclusive rights to represent the Queen seems never to have been executed.

GOYA, Francisco de G. y Lucientes *See* Volume Two.

GOYEN, Jan van (1596–1656) Prolific painter and draughtsman, the leading master of the 'tonal' phase of Dutch landscape, in which the topography and humid atmosphere of the Dutch coast

dominate over the representation of human activities (*see also* Salomon van Ruysdael, Pieter de Molijn). Born in Leiden, he studied with six different masters, of whom only Esaias van de *Velde of Haarlem seems to have influenced him. He settled in The Hague in 1631, but travelled frequently, not only as a painter but also as a valuer, auctioneer and art dealer, and speculator in real estate and tulip bulbs. In the 1650s he was influenced by the new *classical trend of Dutch art (*see also* Jacob van Ruisdael) and introduced more forceful accents into his landscapes, and stronger contrasts between light and dark. Most major galleries on the Continent and in the US have examples of his work, as well as London, National.

Gozzoli; Benozzo di Lese, called (*c*.1422–97) Florentine painter, the prolific author of narrative *fresco cycles in provincial centres in Umbria, Lazio and Tuscany. These were painted in a manner both 'modern' – in their use of *perspective, for example – and archaicizing, linear yet colourful, ornate and full of incident, recalling the International *Gothic style. His best-known work is the decoration of the chapel in the Medici palace, Florence, depicting the *Adoration of the Magi* (1459–*c*.63). Benozzo was a pupil of, then an assistant to, Fra *Angelico at the friary of S. Marco in the late 1430s and early 1440s. From 1445–7 he worked with the sculptor *Ghiberti on the east doors of Florence baptistry, but from 1447–9 rejoined Fra Angelico as his principal assistant at the Vatican and in Orvieto cathedral. From 1450–3 he painted independently in Montefalco in Umbria (1450, S. Fortunato, frescoes; 1451, altarpiece now in Vatican, Pinacoteca; *c*.1451–2, S. Francesco, his first extensive fresco cycle of the *Life of St Francis*; S. Francesco, chapel of S. Jerome, frescoes and *illusionistic fresco *'polyptych') and in Viterbo, north of Rome (1453, S. Rosa, frescoes destroyed 1632). From 1454–8 he worked once more in Rome (e.g. frescoes, S. Maria in Aracoeli). Back in his native city, he executed the chapel decoration already mentioned, before moving out again to the provinces: 1464–5, S. Gimignano, choir frescoes of the *Life of S. Augustine* in S. Agostino, more *classicizing than the Montefalco cycle. Simultaneously, he furnished the cartoon (*see under* fresco) for the *Martyrdom of St Sebastian* for the Collegiata, executed by assistants, and various other works in or near S. Gimignano. From 1467–83 he was employed on his most extensive commission, a cycle of 26 frescoes complementing the 14th century series at Pisa, Camposanto; all nearly completely destroyed in World War Two. Also lost are the 1484–95 frescoes for Pisa, S. Michele in Borgo. From 1495–7 Benozzo was in Florence, but he died in Pistoia, where he had taken refuge from the plague.

There are panels by him in Washington, National; Ottawa, National; London, National; Paris, Louvre; etc. Disdained by modern art historians for his archaicism and relative lack of *expressivity, Benozzo was in demand amongst contemporaries: religious orders in provincial centres, and the luxury-loving Piero di Cosimo de'Medici in Florence.

His art reflects not only the influence of his master Fra Angelico, but also that of *Domenico Veneziano, *Piero della Francesca, Filippo *Lippi and his contemporary *Andrea del Castagno.

GRAF, Urs (c.1485–1527) Swiss goldsmith, designer for stained glass, experimental printmaker, best known for his pen-and-ink drawings of which about 100 – more than half the extant total – are in the Print Room of the Basel Kunstsammlung. Graf was a brawler and on several occasions enlisted as a mercenary soldier in foreign campaigns on the Italian peninsula and in France. From c.1511 his prints and drawings chronicle the swaggering, lustful and bloody life of soldiers of fortune and their camp followers, whilst some mythological figures and a few religious scenes stress the lascivious or sadistic aspects of the subject. *Genre scenes of Basel street life hint at parody and *caricature; perhaps only the Alpine landscapes are recorded in a neutral manner. Although stylistically conservative, Graf was technically as audacious as he was in his subject matter; in 1513 he made the first dated etching (see under intaglio prints).

GRANACCI, Francesco (1477–1543) Florentine painter, a pupil of Domenico *Ghirlandaio at the same time as *Michelangelo. He was later (1508) to advise the latter on the technical problems of *fresco painting in the Sistine Chapel. Like *Pontormo, who influenced him, he painted scenes for festivals (e.g. 1515, entry of Pope Leo X de'Medici into Florence) and also stage scenery, specializing in painting on stuffs. Around 1515 he executed two scenes for the decoration on panel of the famous Borgherini bedroom (now Florence, Uffizi, Palazzo Davanzati), on which Pontormo, *Andrea del Sarto and Bachiacca (1495–1557) also collaborated.

GRASSER, Erasmus (c.1450–1518) Sculptor active in Munich, author of emphatically posed figures, most notably the 10 (originally 16) Morris-dancers for the Tanzsaal of the Alte Rathaus, 1480 (Munich, Stadtmuseum).

GRAVELOT, Hubert F. B. (1699–1773) French engraver (see under intaglio prints) and book illustrator, trained in the studio of *Boucher. He is the main purveyor of the French *Rococo style to the British School (but see also *Mercier). During two extended visits to England from 1733 to 1755 he illustrated most of the important books published in London, influencing *Hogarth, *Hayman (with whom he collaborated on Hanmer's Shakespeare) and *Gainsborough, who probably worked with him.

GRECO, El; Domenico Theotocopulos, called (1541–1614) Greek painter and architectural theorist, born on the Venetian-ruled island of Crete, best known for his work in Toledo, Spain, where he settled in 1576/7. Out of his training as a painter of *icons in Crete, his experiences in Venice (1558–70, 1572–6) and Rome (1570–2), El Greco wrought an idiosyncratic *Mannerist style combining Western and Byzantine elements. In his mature works we can distinguish the

flame-like *figura serpentinata* of *Michelangelo and his central Italian followers; the free handling of the brush, the *alla prima* application of paint and the colourism (*see under disegno*) of *Titian, motifs from whose works of the 1560s appear in El Greco's pictures until 1600; the dramatic movement and *chiaroscuro of *Tintoretto; compositions, motifs and the elongated figure canon of prints by *Parmigianino and *Schiavone. From the Byzantine East he inherited a preference for breaking up large curvilinear patterns into smaller jagged-edged areas of sharply differentiated colour, whose spatial relationship is often left unclear, as in mosaic; reducing landscape backgrounds to symbolic shapes and at times violating, for symbolic reasons, the rules of Western *Renaissance *perspective. Above all, both in the religious paintings which form the greater part of his production and in his portraits, El Greco employed painting as a vehicle for intensely *expressive spirituality.

After initial success with Philip II (*Adoration of the Holy Name of Jesus*; small-scale version London, National; full-scale canvas, 1578, Madrid, Escorial), El Greco's visionary style displeased the king (*Martyrdom of St Maurice* and the *Theban Legion*, 1582, Madrid, Escorial) and the Greek artist, deprived of a post at court or any further royal commissions, continued to work for the churches, convents and hospitals of Toledo amongst whom he had found enthusiastic patronage immediately after his arrival in the city (*c.*1577, *retable of S. Domingo el Antiguo, for which he designed the architectural/sculptural frame as well as painting eight large pictures). Amongst his other works for Toledo the most important are: the *Disrobing of Christ (El Espolio)* (1577–8, cathedral); *Agony in the Garden* (1580–6, now Toledo, Ohio, Museum); his masterpiece and the largest single work he ever painted, the *Burial of the Count of Orgaz*, which includes amongst its many portraits one of his young son Jorge Manuel Thetocopulos (*b.*1578, later painter and architect) (1586, S. Tomé); three great altarpieces for S. José (1598–9, one *in situ*, two in Washington, National); a mystical scene from the Apocalypse for the Hospital of St John (*Clothing of Martyrs*, 1610–14, now New York, private coll.). Other works were commissioned for e.g. a royally endowed convent in Madrid (1596, now Madrid, Prado; Rumanian State Coll.; Villanueva y Geltrú, near Barcelona, Museo Balaguer); and the Hospital of Charity at Illescas (1603–4). From *c.*1603 his paintings are characterized by ever-greater luminosity and restlessness. He began also to base religious compositions on northern European, mainly Flemish, prints (e.g. *Resurrection*, 1608–10, Madrid, Prado, from an engraving after *Blocklandt).

El Greco's earliest extant portraits date from his stay in Rome, 1570–2 (Naples, Capodimonte) and he continued to execute vigorous likenesses virtually throughout his career. One of the most attractive is the untypical female portrait, *A Lady in a Fur Wrap*, perhaps representing El Greco's mistress and the mother of his son, Jerónima de las

Cuevas (c.1577–9, Glasgow, Pollok House; in the same collection, *Portrait of a Man*, 1590s; also New York, Frick).

Several variants are known of an *Allegorical Night Scene* showing a boy lighting a candle, sometimes including a monkey and a grinning youth (e.g. Earl of Harewood Coll.; Edinburgh, National). Stylistically, this group of pictures resembles the nocturnal scenes of Jacopo *Bassano.

Finally, two landscape paintings by El Greco are known, one being the famous turbulent and ghostly *View of Toledo* (c.1604–10, New York, Metropolitan).

Of the artist's complex personality the best-known trait is his arrogance. When he was in Rome, the 'problem' of nudity in Michelangelo's *Last Judgement* was being debated at the Papal court (*see* Daniele da Volterra). El Greco antagonized other artists by volunteering that if the fresco were demolished he would paint a better as well as a more decorous one (*see* decorum). As late as 1611 he was to say to *Pacheco that 'Michelangelo was a good man – alas, he did not know how to paint!'

GREUZE, Jean-Baptiste (1725–1805) From 1755 or, most especially, 1761 to c.1780 one of the most popular French painters, celebrated for his 'elevated' *genre* pictures, analogous to popular contemporary bourgeois novels and sentimental drama and ostensibly preaching the virtues of family harmony and the simple life. The best-known is *L'Accordée du Village* or the *Village Bethrothal*, which caused a sensation at the Salon of 1761 (Paris, Louvre; others also Louvre; Leningrad, Hermitage; Moscow, Pushkin; Portland, Oregon, Museum; London, Wallace; etc.). To modern eyes these tableaux, engraved, and described at length by the artist in exhibition catalogues, seem sentimental and melodramatic, with erotic undertones that look unwholesome when allied to their sometimes slick and glossy handling of paint. More unwholesome still are Greuze's morally ambiguous Fancy Pictures of voluptuously pretty girls, often mourning their loss of virginity with the aid of allegorical props (e.g. *Girl Pining over a Dead Bird*, c.1765, Edinburgh, National; *The Broken Jug*, Louvre; *Girl with Broken Mirror*, London, Wallace). Apparently affiliated to 17th century Dutch *genre*, Greuze's works have as their true forerunners respectively *Poussin (both compositionally and in their insistence on a variety of emotional reactions being read sequentially by the viewer) and the swooning or suiciding late female figure compositions of *Reni.

That Greuze had looked closely at Poussin may be demonstrated by his *Academy reception piece: *Septimus Severus and Caracalla* (1769, Paris, Louvre). The painting, modelled after Poussin's *Death of Germanicus*, was turned down by the Academy for reasons that are not now clear, and Greuze was refused a classification as a history (*see under* genres) painter. At this unexpected slight, the artist broke with the Academy and never exhibited again at its annual Salon until after the fall of the monarchy.

Born at Tournus, Greuze trained at Lyons and first made his mark at the Salon of 1755 with *The Father of the family expounding the Bible*; he then left for Italy, returning to Paris in 1757. Italy proved to be of little significance in his art. Perhaps surprisingly, in view of his best-known production, he was not only an excellent draughtsman but a strongly *realistic portraitist (e.g. Paris, Jacquemart-André). For a while after his return to France he took up the more painterly, impasto technique of *Chardin, and in this mode executed some affecting likenesses of children (e.g. *Schoolboy memorizing his lesson*, 1757, Edinburgh, National). With the advent of Neo-*Classicism and the rise of *David, he lost his popularity, although, welcoming the Revolution, he continued to execute portraits of its leaders. Favoured by the Bonaparte family he was commissioned in 1804 for a portrait of *Napoleon as First Consul* (1804-5, Versailles). For this his last work, he shared the single posing session with the young Ingres (*see* Volume Two).

GRIEN, Hans Baldung *See* Baldung, Hans.

GRIMMER, Jacob *See under* Bruegel.

GRISAILLE A painting executed entirely in tones of grey; often used decoratively to imitate stone relief. By extension, the term is sometimes applied to monochrome paintings in other colours, imitating, for example, bronze reliefs.

GROTESQUE (from the Italian *grottesche*, of a grotto or crypt) In the history of art, the term has a significance quite distinct from that of its everyday usage. It denotes a type of decoration used in antiquity and revived by *Renaissance artists excavating 'grottoes' – i.e. buried ruins, such as those of the Golden House of Nero in Rome. Grotesque decoration is essentially representational, and made up largely of natural forms. But it subverts the natural order by depicting these forms as metamorphosing one into the other: thus plant forms change into human shapes, or half-animal, half-human beings such as harpies or sphinxes. The organizing principle of antique grotesque decoration and its Renaissance imitations, which differentiates them from either *Gothic or *Rococo imagery on the same theme, is bilateral symmetry. Forms do not interlace, as in arabesque, but 'grow' one out of the other on either side of, or along, a central axis, or 'stem'. *Perugino and *Ghirlandaio were amongst the first artists to revive true grotesque decoration; *Raphael supervised the painting of the *logge* of the Vatican palace with grotesques.

GRÜNEWALD, Matthias (*c.*1470–1528) German painter whose real name was Mathis Gothart Neithart; he was called Grünewald by his 17th-century biographer Joachim *Sandrart, in the *Teutsche Akademie*, where Sandrart confuses him with Hans *Baldung Grien. His identity and the facts of his biography were not established until the 20th century

'Master Mathis the Painter' was court artist to the archbishops of Mainz, for whom he also designed waterworks and fountains, from

*c.*1508–25. He is best known today for the complex folding *polyptych called the *Isenheim Altarpiece*, completed in 1515 for the Hospital Order of St Anthony at Isenheim (now Colmar, Musée). The sculpted portions are attributed to Nikolaus *Hagnower. The altarpiece would have been seen daily by the sick treated by the Order and the original destination accounts in some measure for the work's gruesome *iconography, with its stress on the physical wounds of Christ in the *Crucifixion* (central panel, exterior) and *Lamentation* (*predella, exterior and first opening), the prominent syphilitic demon in the *Temptation of St Anthony* (right wing, second opening), and the inclusion of St Sebastian, one of the 'plague saints' (right wing, exterior) in addition to St Anthony, who reappears in every arrangement of the polyptych. But the *expressive intensity of this work results less from its imagery than from its pictorial treatment. In this as in his other paintings Grünewald distorts proportions and exaggerates the play of light and shade for symbolic and emotional ends.

Grünewald ranks second only to his contemporary, *Dürer, in the history of German *Renaissance art. But their aims and gifts were very different. Like Dürer, Grünewald was a great draughtsman, but he relied on drawing only as a preliminary to painting; his true medium is not graphic but pictorial (there are over 30 drawings, however, executed in mixed technique with chalk, in Berlin, Kupferstichkabinett). His use of colour is at once rich and sombre, relying on dramatic contrasts. More importantly still, where Dürer sought to reconcile Italianate *idealization with northern European naturalism (*see under* realism), Grünewald stresses the conflict inherent between those two types of representation.

In 1525 Grünewald left the service of Albrecht von Brandenburg, former Archbishop of Mainz and, since 1518, cardinal, because of his sympathies with the Peasants' Revolt. Although forgiven by Albrecht, he did not return to Mainz but settled in Frankfurt, departing in 1528 for Halle, where he died. A list of books left behind him in Frankfurt suggests that, like Dürer, he had become a Lutheran.

In addition to the *Isenheim Altarpiece*, Grünewald painted panels for other *retables, including additional *grisaille wings for the *Heller Altarpiece* (*see* Dürer), now in Frankfurt, Kunstinstitut, and Donaueschingen, Sammlungen. Three altarpieces in Mainz are known to have been lost through Swedish looting. Other works are to be found in Washington, National; Freiburg im Breisgau, Augustinermuseum; Stuppach, parish church; Karlsruhe, Kunsthalle, and Munich, Alte Pinakothek.

GRUPPELLO, Gabriel (1644–1730) Versatile and prolific Flemish sculptor, celebrated as the chief sculptor of the Elector Palatine Johann Wilhelm in Dusseldorf (from 1695; *see also* Adriaen van der Werff, Godfried Schalcken, Rachel Ruysch).

A pupil of Artus II *Quellin from 1658, Gruppello participated in the decoration of Amsterdam Town Hall (now Royal Palace) in 1663.

After working in Versailles, Brussels, Apeldoorn and Potsdam, on sculptures ranging from fountain figures through portraits in full- and bust-length and medals, he settled in Düsseldorf, producing Italianate mythological sculpture on the scale of life and in collectable small format, an equestrian statue of the Elector (c.1703–13, Market Place) and many religious sculptures both for churches and personal use (e.g. St Maximilian; Theresienhospital; St Cecilia). His most famous work, however, and surely one of the most extraordinary pieces of public sculpture of all time, is the 7m-high Bronze Pyramid (compl. 1716) set on a 5m-high stone base (1743) on the Paradeplatz, Mannheim, and made up of innumerable figures sculpted in the round in complex interlacing poses, personifying virtues and vices in allegorical actions glorifying the Elector, whose seated portrait is included near the base of the pyramid.

GUARDI, Francesco (1712–93) and his brother Giovanni Antonio (1698–1760) Members of a family of painters from the Trentino active in Venice. The work of their father Domenico (1678–1716) and brother Nicolo (1715–86) has either not survived or not been identified. Francesco is now celebrated for his *vedute and *capricci (see below) but began his career collaborating with Giovanni Antonio in a family 'firm' of which the latter was the dominant partner, and which turned out uneven and derivative paintings in many *genres: altarpieces (Berlin-Dahlem, Museen); scenes from mythology (e.g. Liverpool, Walker); battle pieces; flower pieces; genre scenes in the manner of Pietro *Longhi; *frescoes (1750s, Venice, Cà Rezzonico). An unresolved problem of attribution between the two brothers is presented by the sparkling figurative decorations of the organ parapet at Angelo Raffaele, Venice (after 1753? after 1773?). A newly discovered altarpiece by Francesco, dating from after his brother's death, that is, c.1777, in the parish church of Roncegno, proves that the artist continued to paint some large-scale figure pieces after the dissolution of the Guardi 'firm'. But from c.1760 his main work consisted of the famous views of Venice, at first influenced by *Canaletto whose designs he often copied (e.g. Waddesdon Manor). Soon, however, Guardi freed himself both from Canaletto's more prosaic manner and from literal topography, to concentrate on poetic capricci. Whilst his *Rococo colours and airy touch have affinities with the work of his sister's husband, *Tiepolo, their careers could hardly have differed more. Guardi's pictures became smaller, some barely larger than matchboxes, and ever more allusive, painted in rapid shorthand in oils diluted nearly to water-colour thinness. His clientele is almost totally unknown to us, the main exception being the Englishmen who patronized him. He seems to have had no studio, although his son Giacomo (1764–1835) possibly assisted him and often copied his work, later specializing in *gouache views of Venice which, however, lack the freshness of those by Francesco. The industry in fake and pastiche Guardis began early; the artist himself

painted many versions of his own works. His drawings (e.g. Venice, Correr; Vienna, Albertina; London, Victoria and Albert) show even greater spontaneity than the paintings.

Most large public collections – including London, National; Milan, Poldi-Pezzoli; Paris, Louvre – have works by Guardi.

GUERCINO; Giovanni Francesco Barbieri, called (1591–1666) Precocious and largely self-taught painter from Cento, a small town in the Duchy of Ferrara, near Bologna. He became one of the most famous Italian artists of the 17th century, author of notable *frescoes, altarpieces and collectors' pictures. He also executed some small-scale pictures on copper. Having forged a highly personal, emotionally charged pioneering *Baroque style notable for its *chiaroscuro, he retreated, under pressure from the prevailing climate of critical opinion in Rome during his stay there, 1621–3, into a lighter hued, more *classical manner, marrying Venetian *colorito* with *disegno* but maintaining his earlier romantic outlook.

Trained in the technical rudiments of his art by local artists, Guercino was influenced by *Caravaggio, but even more by Lodovico *Carracci, one of whose finest altarpieces was in Cento; he also studied the Carracci workshop frescoes in Bologna. He emerges as an independent artist by 1613, executing portraits, decorative friezes and altarpieces for patrons in Cento and Bologna (Cento, Pinacoteca; Villa Giovanina; Casa Provenzali, now Benazzi; Brussels, Musées). By 1618 he had gained considerable success and undertook a study trip to Venice. His early style may best be assessed in his masterpiece of 1620, *St William of Aquitaine receiving the Cowl* (Bologna, Pinacoteca).

Summoned to Rome in 1621 by his chief Bolognese patron, Cardinal Ludovisi, recently elevated to the papacy as Gregory XV, Guercino seemed set to vanquish the current classicizing style, exemplified in *Domenichino's *St Cecilia* frescoes of 1613–14. His main work in Rome, the frescoes of the Casino Ludovisi, challenged, through the *illusionism of the *Aurora* on the ceiling of the entrance hall, Guido *Reni's *Aurora*, 1613–14, Casino Rospigliosi. Where Reni had planned his ceiling decoration like an easel painting hung over the viewer's head, Guercino's personification of Dawn seems to charge in her horse-drawn chariot across the open sky. The *quadratura* framework (*see* illusionism) was executed by Agostino Tassi (*c.*1580–1644).

By 1623 the artist seemed to have lost confidence in his earlier manner. With Gregory XV's death of the same year, he must have lost faith in his ability to compete for commissions in Rome. He returned to Cento, where he conducted an extremely successful international mail-order business in large altarpieces and collectors' paintings. He refused invitations to the royal courts of England and France. After Guido Reni's death in 1642, he moved to Bologna and assumed his rival's position as the city's leading artist. In addition to the works cited above, there are paintings by Guercino in many churches throughout Italy,

including naturally Cento and Bologna. In Cento he may have designed the façade of a new church for the Confraternity of the Rosary, of which he became Prior, and for which he endowed and decorated a chapel, 1641.

In addition to paintings in many collections, there are splendid drawings by Guercino, including landscape drawings, in, e.g., Oxford, Christ Church and Windsor, Library.

GUÉRIN, Giles *See under* Sarrazin, Jacques.

HAEN, David de *See under* Baburen.

HAGNOWER, Nikolaus or Niclas (*c.*1445–after 1526) Leading sculptor in Strasburg. He is known principally for the (undocumented) wood sculpture of the Isenheim altar (Colmar, Musée, *c.*1500–15; *see also* Grünewald), executed in his characteristically coarse, assertive style. He was probably the father of Friedrich Hagenauer, a Strasburg-trained sculptor who became the greatest of the portrait medallists of the 1520s.

HALS, Frans (1581/5–1666) Dutch portrait specialist, famous since the mid-19th century for his bravura handling of paint and his vigorous evocation of character.

Although probably born in Antwerp of Flemish parents, he was raised in Haarlem, studied there with Karl van *Mander, and remained in practice in the city throughout his life. With the exception of his first dated portrait (*Jacobus Zaffius*, 1611, Haarlem, Hals) his earliest known work consists of earthy *genre* scenes (*Merry Company* or *Shrove Tuesday Revellers*, *c.*1615–17; *Yonker Ramp and his Sweetheart*, 1623, New York, Metropolitan). Some of the vivid spontaneity achieved in his *genre* pictures was transferred by him to commissioned portraits (e.g. *The Laughing Cavalier*, 1634, London, Wallace). Between 1616–64, Hals painted nine group portraits on the scale of life, more than any other leading painter of the day (*Officers of the Haarlem Militia of St George*, 1616, *c.*1627, *c.*1639; *Officers of the Haarlem Militia of St Hadrian*, *c.*1627, *c.*1633; *Regents of St Elizabeth's Hospital*, *c.*1641; *Regents of the Old Men's Home*, *c.*1664; *Regentesses of the Old Men's Home*, *c.*1664; all in Haarlem, Hals; the so-called *Meagre Company*, 1633, finished by Pieter *Codde, 1637, Amsterdam, Rijksmuseum). He began the transformation of the group portrait from stilted assemblage of individual faces, like a class photograph, to the sweeping, unified *Baroque composition, brought to its apogee in *Rembrandt's *Night Watch*.

In the 1640s and 1650s he executed a number of companion pictures of husbands and wives (e.g. *Stephanus Geraerdts*, Antwerp, Musée; *Isabella Coymans*, Paris, private coll.; both *c.*1650–2) and some life-size family group portraits (e.g. London, National). His clientele now included civic leaders and professional men, theologians, university professors, his most illustrious sitter being *Descartes* (*c.*1649, Copenhagen, Museum). Despite his continuing success, Hals is documented as being in financial difficulties throughout his career. The legend that he was a drunkard and a wife-beater, however, rests on a case of mistaken identity in the documents of the period.

From the bright colours of the 1620s, Hals shifted to more monochromatic effects in the 1630s, the earlier blond tonality giving place to subtle distinctions between predominantly black hues, of which the

painter Vincent Van Gogh (*see* Volume Two) was to write: 'Frans Hals had no fewer than 27 blacks'. In the same way, the boisterous mood of the early pictures was replaced after 1650 by austere and even tragic dignity.

Several of Hals's sons became painters: Harmen Hals (1611–69); Frans Hals II (1618–69); Reynier Hals (1627–71); Claes Hals (1628–50) whose work is sometimes confused with his father's. Frans' brother and pupil Dirck Hals (1591–1656), influenced primarily by *Buytewech, became a specialist of small-scale, elegant Merry Companies (e.g. Vienna, Akademie) and small pictures of one or two figures in an interior (e.g. Philadelphia, Museum) anticipating the *genre* paintings of the next generation. In addition, Frans Hals was the teacher of Adriaen van *Ostade and Philips *Wouwerman, and the probable teacher of Judith *Leyster.

HAMILTON, Gavin (1723–98) Scottish gentleman-painter, antiquary and art-dealer, resident mainly in Rome (1740s; 1756–98). A leading member of the *classicizing coterie around J. J. Winckelmann, author of *Reflections on the Imitation of Greek Art in Painting and Sculpture*, he was, along with *Mengs, a precursor of *David and indeed a direct influence on the French artist. Unable to fulfil his ambition as a history (*see under* genres) painter in London, where, at the end of his training in Rome he painted a few portraits (*c*.1752), he returned to Italy and in the 1760s began his cycle of illustrations to the *Iliad*. Commissioned individually by different patrons, sometimes at the artist's insistence as part payment on works of art in which he traded, the *Poussinesque paintings were never hung together, but the effect of a cycle could be imagined through the engravings which Hamilton had executed and which made his reputation throughout Europe and as far as Russia. There are paintings by Hamilton in Edinburgh, National; Glasgow, University; Rome, Borghese, and in a few private collections.

HAYMAN, Francis (*c*.1708–76) English painter and engraver, one of the most versatile British artists in *genre if not in style (he was criticized for 'the large noses and shambling legs of his figures'). Having started out as a stage painter, he went on to paint monumental scenes on ceilings. As an engraver (*see under* intaglio prints) he illustrated Shakespeare, Congreve, Milton, Pope and Cervantes. Between *c*.1744–55 he painted religious narratives (*The Finding of Moses*, 1746, London, Foundling Hospital; *see also* Hogarth); illustrations to Shakespeare (*Wrestling Scene from As You Like It*, *c*.1744, London, Tate) and theatre pieces; *Fancy Pictures; scenes from popular life (*Sliding on the Ice*, *The Dance of the Milkmaids on Mayday*, London, Victoria and Albert); sporting pictures; *Conversation Pieces (*Conversation in the Painter's Studio*, London, National Portrait) and portraits.

A pivotal figure in British art, he was associated with the influential French engraver *Gravelot, with *Hogarth (at the Vauxhall Gardens; in the Foundling Hospital; on a trip to Paris, when they were both

imprisoned; in promoting the St Martin's Lane Academy), and with
*Gainsborough, who was probably working with him and with Gravelot
in the 1740s. Having been President of the Society of Artists, 1766–8,
he seceded to become a founder member of the Royal *Academy, and,
in 1771, its first Librarian.

HEDA, Willem Claesz. (1599–1680) Dutch *still-life specialist
active in Haarlem. Along with Pieter *Claesz, he is an originator
of the tonal 'Breakfast Piece': a simple meal, painted more or less at eye
level, usually in silvery tones. After 1640 Heda's compositions became
larger and more decorative, introducing touches of colour and a more
dramatic *chiaroscuro, and assuming a new vertical format (e.g. Lenin-
grad, Hermitage). The paintings of his son and pupil Gerrit (c.1620–
before 1702) are so similar that they are often hard to distinguish,
especially since both father and son usually signed simply 'Heda'
(Amsterdam, Rijksmuseum).

HEEM, Jan Davidsz. de (1606–83/4) Son of the Utrecht painter
David de Heem (1570–1632), he was trained by Balthasar van der
Ast and became one of the greatest European *still-life specialists. From
c.1625-29 he worked in Leiden, where his favourite theme was a
*vanitas still-life of scholarly books executed in subtle tones of grey and
ochre. In 1636 he moved permanently to Antwerp. Here he developed
the speciality which won him international fame: lavish displays of
expensive foodstuffs and flowers and precious metal vessels and glass-
ware. De Heem's 'Banquet Pieces' combine Flemish *Baroque
exuberance and colouristic splendour with the compositional and tonal
control of the modest Dutch 'Breakfast Pieces' (see Claesz and Heda).
His son, Cornelis de Heem (1631–95), followed in his footsteps, and
his works were frequently copied in succeeding centuries (Amsterdam,
Rijksmuseum; Edinburgh, National; London, National, Wallace; Paris,
Louvre; etc.).

HEEMSKERCK, Maerten van (1498-1574) Dutch painter and
draughtsman. A pupil or assistant of van *Scorel 1527-9, he had
already absorbed the latter's Italianate manner before his own trip to
Rome, 1532–6. His sketch-books recording Roman views and
antiquities became – and remain – a most valuable record (Berlin-
Dahlem, Kupferstichkabinett), the drawings of ancient sculpture ser-
ving at various times as a source for engravings (see under intaglio prints)
and the views providing our best information on, e.g. the appearance of
the Capitoline Hill, or the history of the rebuilding of St Peter's, before
the interventions of *Michelangelo.

Heemskerck's early paintings include vigorous portraits (e.g. Amster-
dam, Rijksmuseum; Kassel, Kunstsammlungen; New York, Metropoli-
tan) and the famous St Luke Painting the Virgin, dedicated to the
Haarlem painters' guild before his departure for Rome in 1532 (now
Haarlem, Hals). Upon his return from Italy he began also to paint
mythological scenes (Prague, Nostiz Coll.; Vienna, Kunsthistorisches;

Amsterdam, Rijksmuseum), altarpieces (now Linköping, cathedral; The Hague, Mauritshuis; Brussels, Musées) and more portraits (Rotterdam, Boymans-Van Beuningen; Amsterdam, Rijksmuseum). His *Self-Portrait with a view of the Colosseum* (1553, Cambridge, Fitzwilliam) is unparalleled in its dramatic impact.

Although deeply affected by Michelangelo, Heemskerck seems to have been more directly influenced by younger artists such as *Pontormo, *Salviati and *Giulio Romano. Having settled in Haarlem, he left the city only once, during the Spanish siege of 1572, when he went to Amsterdam. In 1540 he became dean of the Haarlem painters' guild. Engravings after his paintings as well as his many drawings influenced many northern European artists.

HELST, Bartholomeus van der (1613–70) Dutch portraitist, born in Haarlem, established in Amsterdam from *c.*1627. He replaced *Rembrandt as the city's leading portrait painter in the mid-1640s, catering to the governing classes with brightly coloured portraits influenced by *Van Dyck. He continued to be admired throughout the 18th century, and his group portrait of *Captain Bicker's Company* (Amsterdam, Rijksmuseum) was praised by *Reynolds above Rembrandt's *Nightwatch*. Other works are in The Hague, Mauritshuis; London, National, Wallace; Rotterdam, Boymans-Van Beuningen; etc.

HERRERA, Francisco the Elder (*c.*1590–1657) and his son Francisco the Younger (1622–85) Spanish painters, active in Seville and Madrid; Francisco the Younger also practised as an architect. Unusually for a Spaniard, Francisco the Elder also worked as an engraver (*see under* intaglio prints), a miniaturist and a draughtsman with the pen. A pupil of *Pacheco, he worked in Seville *c.*1610–*c.*40, at first in a derivative *Mannerist style (e.g. *Pentecost*, 1617, Toledo, Museo). Under the influence mainly of *Roelas, he began to apply pigment more freely, finally arriving at a boldly dramatic colouristic manner in the mid-1630s (e.g. Rouen, Musée; Bilbao, Museum; Paris, Louvre). Around 1640 he settled in Madrid (e.g. Lazaro Galdiano). His liquid brushwork foreshadows the 'vaporous style' of *Murillo.

Francisco Herrera the Younger studied architecture and painting in Rome, and *still-life painting in Naples. Returning to Seville at about the time of his father's death, he was named co-president with Murillo of the new *Academy of Painting, leaving almost immediately, however, for Madrid. He was appointed court painter in 1672, but worked almost exclusively as an architect from 1679. His sketchy technique and luminous colours anticipate the *Rococo (e.g. Madrid, Prado; Seville, cathedral).

HEYDEN, Jan van der (1637–1712) The first Dutch artist to devote himself almost exclusively to townscape. Mainly active in Amsterdam, he painted over 100 identifiable views of towns in Holland, and of Brussels and Cologne, as well as architectural fantasies, some *still-lifes and landscapes. His illustrated work on the fire-hose, which he is said to

have invented, was published in Amsterdam in 1690. There are paintings by him in most important European galleries including London, National, and Washington, National.

HIGHMORE, Joseph (1692–1780) English painter, older contemporary of *Hogarth. He was amongst the earliest artists in Britain to illustrate literary themes (Richardson's *Pamela*, London, Tate, Victoria and Albert; Cambridge, Fitzwilliam; Melbourne Hall), to paint religious history paintings (*see under* genres) (London, Foundling Hospital) and portraits of personality more than of status, including a splendid *Conversation Piece on the scale of life, *Mr Oldham and his friends* (London, Tate).

HILLIARD, Nicholas (*c*.1547–1618/19) English goldsmith and miniature painter, the greatest visual artist at the court of Elizabeth I, whose portrait he painted several times from 1572 (London, National Portrait; other miniatures of the Queen, e.g. *The Drake Jewel*, 1575, private coll.; locket, after 1600, London, Victoria and Albert). He combined ornamental virtuosity – it must be remembered that most of his miniatures were meant to be worn as jewels and were set accordingly – with psychological penetration. In his treatise on miniature painting, the *Arte of Limning, c.*1600, he wrote of striving to catch 'these lovely graces, witty smilings, and these stolen glances which suddenly, like lightning, pass and another countenance taketh place', extending his private portraits' emotional range through emblems such as flames, hearts, roses, etc. The refined, poetic yet trenchant imagery of his miniatures has been compared with the world of Shakespeare's earlier plays and sonnets. Whilst his theory of art was Italianate, his practice related to the art of the French court, which he visited in 1576–8. Unlike his pupil and rival, Isaac *Oliver, he modelled his sitters' likenesses through delicate line and sunlit colours alone, without the use of shadows. Although some portraits of Elizabeth on the scale of life have at times been attributed to him, they are inferior to his miniatures. His son, Lawrence Hilliard (1582–after 1640) was also a miniature painter. Other works, Coll. H.M. the Queen; Greenwich, Maritime; New York, Metropolitan; Cambridge, Fitzwilliam; Oxford, Bodleian Library. *See also* Gower, George.

HISPANO-FLEMISH STYLE *See under* Dalmau, Luis.

HISTORY PAINTING *See under* genres.

HOBBEMA, Meyndert (1638–1709) Dutch landscape painter, the best-known pupil and follower of Jacob van *Ruisdael. His work is lighter in tonality and mood than that of his master, but also more repetitive in subject matter and treatment. A favourite motif is a watermill in a woodland clearing. In 1668 Hobbema married the kitchen maid of an Amsterdam burgomaster and acquired the lucrative position of wine gauger to the Amsterdam octroi. After this he painted little. His best, and most famous picture, however, dates from as late as 1689: *The Avenue, Middleharnis* (London, National), called the swan-song of Dutch landscape painting.

HOEFNAGEL, Georg or Joris (1542–1600) Much-travelled and highly original artist, born in Antwerp. He was a book illuminator (Vienna, Kunsthistorisches) and a miniaturist, specializing in decorative but scientifically accurate flower and insect pictures (Lille, Musée). He also composed an *emblem book (1569). Between 1561–7 he travelled throughout France and Spain; in 1569 he visited England; in all these countries he executed topographical views of cities. It is to him that we owe the best visual record of Henry VIII's vanished Nonsuch Palace. Hoefnagel also left behind him in England the first oil painting showing an English *genre scene (Wedding at Horsleydown in Bermondsey, Hatfield). In 1591 he entered the service of the Emperor Rudolph II in Prague, and died at the Imperial court in Vienna. Many of his works, including the views of cities, were engraved by his son, Jacob Hoefnagel (b. 1575).

HOGARTH, William (1697–1764) English painter and engraver (see under intaglio prints), a controversial and quarrelsome figure in his own day, now recognized as probably the most innovative and interesting of British artists. Despite having been appointed Serjeant Painter to the King in 1757, Hogarth died an embittered and disappointed man, frustrated in his ambition to succeed Thornhill (his father-in-law from 1729) as a famous English painter of monumental histories (see under genres). Hogarth's essays in the genre, notably the huge Pool of Bethesda and Good Samaritan painted gratis for the staircase of St Bartholomew's Hospital, London, in 1736 and 1737, earned him neither renown nor commissions, and he remains best known for his small-scale 'modern moral subjects' and satires, and his theatre pieces. Almost as notable as the narrative subjects are Hogarth's portraits, which are forthright and painterly. A vociferous patriot, who fulminated against the fashion for Old Masters and contemporary Continental artists, Hogarth was himself heavily indebted to French art and the Old Masters, transmitted mainly through engravings. He was one of the first English artists to adopt the new *Rococo aesthetic, and despite his professed contempt for things French (e.g. The Roast Beef of Old England, &c., 1748, London, Tate) he relied at times on Parisian engravers for his own editions of engravings after his paintings (Marriage à la Mode, c.1743; paintings, London, National).

Hogarth's paradoxical career began with an apprenticeship, never completed, under an engraver of silver plate. His technical training in painting he owed to *Vanderbank's 1720 *Academy, although his sparkling fresh paint surface seems to have been self-taught. It is best seen in his late oil sketches (e.g. The Shrimp Girl, London, National; Hogarth's Servants, London, Tate). Having set up shop as a copper-plate engraver, Hogarth soon turned from shop cards, book illustrations and single satirical prints to the painting of small portrait *Conversation Pieces in the manner of *Mercier, and a new genre which Hogarth himself may have initiated, the theatre picture. Six versions of a scene

from John Gay's *Beggar's Opera* (private coll.; London, Tate; drawing, Windsor, Royal Library) are the first securely attributable pictures by him. His first financial success came with yet another new venture: *The Harlot's Progress* (1732), a series of paintings, now lost, of which Hogarth executed and published, on subscription, the engravings. *Harlot* brought in its wake many piracies, causing Hogarth to take up the cause of an Engraver's Copyright Act, finally passed in 1735. *The Rake's Progress* series followed immediately (paintings, London, Soane). These new 'modern moral subjects' or 'comic history paintings' not only provided Hogarth with a means of livelihood independent of commissions: they enabled him to find, as he wrote, 'an intermediate species of subjects between the sublime and the grotesque'. *Marriage à la Mode* (*c.*1743) was the first of the series to deal with high life and to attack a specifically modern vice. Hogarth's difficulty in selling the paintings of this series caused him to concentrate solely on engravings in the following years: *The Effects of Industry and Idleness* (1747); *Beer Street and Gin Lane* (1750/1); *The Four Stages of Cruelty* (1750/1), drawn and cut in a purposely coarse vernacular style. His last ambitious series, *The Election* (*c.*1754, London, Soane) finally conflated his popular manner and his pictorial ideal, as enunciated in his treatise, *The Analysis of Beauty*, 1753.

Hogarth's first excursion into portraiture on the scale of life, like that into large-scale history painting at St Bartholomew's, was occasioned by rivalry from a foreign artist. Again combining his philanthropic and his artistic interest, he donated a full-length seated portrait (1740) of his friend Captain Thomas Coram, founder of the Foundling Hospital, to the institution, of which he was himself a founding governor. By organizing also the donation of four biblical histories (including his own *Moses Brought to Pharoah's Daughter*, 1746), Hogarth created in the hospital the first permanent public gallery of English art. The hospital was later to win the lottery for his *March to Finchley* (1750).

Hogarth's last years were increasingly darkened by polemic. Having himself founded St Martin's Academy (1735) along the lines of Vanderbank's, he now opposed the growing agitation by younger artists for a real state Academy of art on the Continental model. The failure of his *Sigismunda* (1758/9) marks the failure of his last attempt to assert the supremacy of the English artist over the foreign import. Becoming involved in political polemic, he executed several prints attacking Wilkes (*The Times*, Plates I and II, 1762/3; *John Wilkes*, 1763; *The Bruiser*, 1763) and Wilkes' retaliation hastened the onset of an illness, followed by a paralytic stroke, from which he never really recovered.

HOLBEIN, Hans the Elder (*c.*1460/5–1524), his brother Sigmund (after 1477–1540) and his sons Ambrosius (*c.*1494–1519) and Hans the Younger (1497/8–1543) Family of painters from Augsberg, the most cosmopolitan German city of the *Renaissance and a

dissemination point for Italianate artistic ideas. The best known is Hans Holbein the Younger, the last great German painter of the century (see below).

Hans Holbein the Elder was an important artist, influenced by the art of the Netherlands, which he may have visited during his long *Wanderjahre*. He is at his best in the 200 or more independent drawings, mainly portrait heads, executed in the Netherlandish technique of silver-point (Berlin-Dahlem, Museen; Copenhagen, Museum). From *c.*1515 he tried, less successfully, to assimilate Italian influences in his work (*St Sebastian Altarpiece*, 1515–17, Munich, Alte Pinakothek). His most important commissions were executed from 1499–*c.*1510; the Roman Basilicas of *Sta Maria Maggiore* (1499) and of *St Paul* (*c.*1504) for the convent of St Catherine, Augsburg (now Augsburg, Museum); high altar for the Dominican church, Frankfurt (1500–01, now Frankfurt, Kunstinstitut); the design for the high altar for Kaisheim (1502, now Munich, Alte Pinakothek); a votive table for Ulrich Schwarz (*c.*1508, now Augsburg, Museum). In addition to the works already listed, there are *realistic painted portraits in Basel, Kunstmuseum; a series of *Madonnas* (e.g. Munich, Böhler Coll.) and the last known work, *The Fountain of Life* (1519?) an altarpiece now in Lisbon, Museu.

Hans Holbein was the head of a busy workshop in Augsburg and the teacher of both his sons. Hans Holbein the Younger, after leaving his father's shop, made his brilliant solo debut in Basel in 1515–16, with the obverse of a signboard painted by his brother Ambrosius, the marginal drawings of Erasmus' *Praise of Folly*, woodcuts for book illustrations (*see* relief prints), and the paired portraits of the Burgomaster of Basel, *Jakob Meyer* and his wife *Dorothea Kannengiesser* (Basel, Kunstmuseum). In their clarity and precision of line these works already surpass those of his father, and anticipate Holbein's later success as portraitist to the Tudor court. Around 1517 Holbein set out via Lucerne on travels in northern Italy, returning to Basel in 1519. Many works of the 1520s owe a debt to Italian models, notably to the murals by *Bramantino and *Leonardo in Milan: *frescoes for interiors and façades of houses in Basel and Lucerne, now largely destroyed (e.g. Great Council Chamber, Basel Town Hall, 1521–2; façade, 'House of the Dance', Basel, design in Berlin-Dahlem, Museen); religious works (*The Man of Sorrows* and the *Mater Dolorosa*, *c.*1519/20; *Last Supper*, *Scenes from the Passion*, *c.*1520–3; *Dead Christ*, 1521, Basel, Kunstmuseum; *Virgin*, 1522, Solothun, Museum; *Oberreid Altarpiece*, 1521–2, Freiburg, cathedral) and even portraits (Magdalena Offenburg as *Laïs of Corinth*, 1526, Basel, Kunstmuseum). Simultaneously, however, Holbein looked to German and Netherlandish art: to *Baldung and *Metsys (e.g. portraits of *Erasmus* London, Basel, Kunstmuseum; *c.*1523, Paris, Louvre).

He continued also to create designs for woodcuts and metal-cuts; the most famous is the text-less *Dance of Death*, designed 1523–6,

published 1538. In 1524 Holbein went to France, where he acquired the three-colour (red, white, black) pastel technique of portrait drawing (see also Jean Clouet) which he was often to use later. Recommended by Erasmus to Sir Thomas More, Holbein travelled to England in 1526. A number of portraits resulted from this first visit, notably the Group portrait of More and his family, the first non-devotional group portrait in northern Europe, now known only through an old copy (London, National Portrait) and a drawing (Basel, Kupferstichkabinett), and William Warham, Archbishop of Canterbury (London, Lambeth Palace; another version, Paris, Louvre). He was back at Basel in 1528. Despite the efforts of the town council to keep him in the city, however, the increasing violence of reformatory iconoclasm (see under icon) and narrowing opportunities for painters drove him once again to abandon his wife and children and return, in 1532, to England, where he was compelled virtually to abandon religious painting. More being now in disgrace, Holbein found his patrons amongst the German merchants of the Steelyard. His portrait of Georg Giesze (1532, Berlin-Dahlem, Museen) reintroduces the format and *iconography of a work by Jan van *Eyck. A still-life with *vanitas connotations is depicted with equal precision in the full-length life-size double portrait of the French Ambassadors (1533, London, National), in which, however, a large skull in *anamorphic perspective intrudes into the foreground space. Later portraits employed a simpler and less time-consuming formula, setting the figure against a neutral background, often a cool blue, enlivened, as on a medal, by an identifying inscription. In 1537 Holbein entered the service of Henry VIII, having already portrayed many members of the court and Parliament (e.g. Robert Cheseman, 1533, The Hague, Mauritshuis; Sir Richard Southwell, 1533, Florence, Uffizi). In addition to easel portraits of the king (e.g. Rome, Nazionale), of his wives (e.g. Vienna, Kunsthistorisches) and prospective brides (e.g. London, National; Paris, Louvre), Holbein was called upon to execute mural decorations of Tudor dynastic pretensions (e.g. 1537, London, Whitehall Privy Chamber, now lost; cartoon (see fresco), London, National Portrait) and to design state robes, jewellery, silver plate, bookbindings, pageant accessories, etc. More than 250 designs for craftsmen are known. The easel court portraits – most of them under-life-size half-lengths – became more and more formalized and frontal, only the hands and face fully modelled, spatial depth reduced to surface pattern. Holbein's late, *iconic style was the source for *Hilliard's Elizabethan miniatures.

Hans Holbein the Younger's older brother, Ambrosius, left their father's workshop in 1514. After painting decorative murals at Stein am Rhein, 1515–16, he joined his brother in Basel, where he specialized in book illustrations in woodcut. In addition, he left excellent portraits (Basel, Kunstmuseum; Leningrad, Hermitage). The brothers' paternal uncle, Sigmund Holbein, spent many years in the

Augsburg workshop, but died in Bern. Works attributed to him are in Schweinfurt, Schäfer Coll.; The Hague, Mauritshuis; Nuremberg, Museum.

HONTHORST, Gerrit van (1590–1656) Called 'Gherardo della Notte' or 'delle Notti' (Gerard of the Night, or Nights) in Italy, where he established his reputation as a painter of nocturnal scenes, he was one of the so-called Utrecht *Caravaggisti (*see also* Terbrugghen; Baburen), the only one to establish an international reputation. A pupil of *Bloemaert, he is said to have been in Rome by 1610–12; he returned to Utrecht in 1628. He enjoyed the patronage in Italy of the most aristocratic collectors, and continued to find favour in court circles all his life: at the invitation of Charles I he came to London for six months in 1628 (*Mercury presenting the Liberal Arts to Apollo and Diana*, Hampton Court); in 1635 he produced a long series of history pictures (*see under* genres) for the Danish King Christian IV; from *c*.1635 until 1652 he was painter to the Stadtholder at The Hague, executing allegorical decorations and a large number of court portraits. In Rome he had painted many religious works (*Christ before the High Priest*, London, National), some of them for churches (S. Maria della Scala, etc.) but such themes found little favour outside Italy. Of greater importance for the evolution of Dutch painting were his *genre* pictures (*Supper Party*, 1620, Florence, Uffizi). His modification of Caravaggio's illumination by depicting artificial light, its source sometimes hidden by a silhouetted motif, influenced the young *Rembrandt and perhaps Georges de *La Tour.

HOOCH, Pieter de (1629–after 1684) Dutch painter, best-known for his pictures of the domestic life of women and children executed at Delft *c*.1655–*c*.62. These seem to have influenced the greater Delft artist, *Vermeer; they may owe something to the *perspectival studies of Carel *Fabritius. From *c*.1647–*c*.1655 de Hooch specialized in guardroom and barracks scenes. After his move to Amsterdam in the early 1660s his homely interiors gave way to highly decorated salons, fashionable musical parties, etc., and the gentle daylight of the Delft pictures to a harsh *chiaroscuro derived from *Rembrandt's pupil Nicolas *Maes. There are paintings by de Hooch in most major collections in the US and on the Continent, and in London (National, Wallace, Wellington). His work influenced many lesser Dutch artists.

HOOGSTRAETEN, Samuel van (1627–78) A pupil of *Rembrandt at the same time as Carel *Fabritius, probably in the 1640s. He visited Vienna, 1651, Rome, 1652, and London, 1662–6, but worked also in The Hague, where he is mentioned in documents in 1658 and again in 1671. He finally settled in his native town of Dordrecht. A poet and essayist as well as a painter, he was appointed provost of the Holland mint. As an artist he is best remembered for his *perspective peep boxes (London, National; Detroit, Institute) and perspectivized

architectural paintings (The Hague, Mauritshuis). He also executed *trompe l'oeil* (*see under* illusionism) *still-lifes (Vienna, Akademie) which anticipate 19th-century American rack pictures (*see* Volume Two: Haberle, Peto). His portraits are less innovative (Amsterdam, Rijksmuseum; Dordrecht, Museum). But perhaps his greatest contribution to the history of art is his treatise, *Introduction to the Advanced School of Painting: or, The Visible World* (1678), a much-expanded version of van *Mander's preface to the *Schilder-Boeck*. Although written long after the death of Rembrandt in 1669, the treatise purports to record a disputation among the master and three of his pupils (Carel Fabritius, Abraham Furnerius, and Hoogstraeten himself) and certainly reflects Rembrandt's views on painting.

HOUDON, Jean-Antoine (1741–1828) Whilst not particularly celebrated in his day, he has become the most famous 18th-century French sculptor, especially for his portrait busts and the statue of the *Écorché* (1767, Gotha, Institut) – the 'flayed' figure of a man originally executed as a model for *St John the Baptist* (1767, Rome, S. Maria degli Angeli) – casts and replicas of which have been used at the French *Academy and elsewhere for teaching anatomy to artists. Although Houdon experimented with various styles, from the *Mannerism of *Primaticcio (*Diana*, 1780, Lisbon, Gulbenkian) through *Rococo (*Shivering Girl*, 1785, Montepellier, Musée) and Neo-*Classicism (1781, *d'Ennery Tomb*, Paris, Louvre), his most characteristic mode is a sober, even scientific, *realism. It is this quality which disturbed contemporaries, who accused him of a lack of imagination and *decorum.

Born the son of a concierge '. . . at the feet of the Academy', Houdon began to sculpt at an early age and was later the pupil of Michel-Ange *Slodtz, and influenced by both Jean-Baptiste *Lemoyne and *Pigalle. Having won first prize at the Academy school in 1761 he spent 1764–8 in Rome, where he executed the *Écorché* at the French hospital, the *St John the Baptist* and its more famous companion in S. Maria degli Angeli, the *St Bruno* (1767). He first revealed his ability as a sculptor of portrait busts with *Diderot* (1771, New Haven, Seymour Coll.; Paris, Louvre); amongst his many other famous sitters were the American ambassador to Paris, *Benjamin Franklin* (e.g. 1778, New York, Metropolitan), *Voltaire* (full-length seated statue, 1781, Paris, Comédie Française; busts, marble, London, Victoria and Albert; terracotta, Cambridge, Fitzwilliam; Baltimore, Maryland, Walters), *Gluck* (terracotta, 1775, London, Royal College of Music), *Thomas Jefferson* (1789, Boston, Mass., Museum), *Napoleon as Emperor* (1806, Dijon, Musée). Houdon's busts of children are especially notable for their freshness and intimacy (mainly private collections).

In 1785 Houdon went to America to press for a commission, which never materialized, for an equestrian statue of Washington. To this end, he executed an *écorché* model of a horse (compare with the anatomy studies of *Stubbs). His standing statue of *Washington*, dated 1788

but completed only 1792, is in the State Capitol, Richmond, Virginia; a bronze copy stands outside the National Gallery, London.

HOUSEBOOK MASTER (also known as the Master of the Amsterdam Cabinet) (c.1447/52–after 1505?) Important print-maker and painter working in the Middle Rhine area. German or Dutch origins have both been claimed for him. He is called after a book of secular subjects, now in Schloss Wolfeg, Germany. His other name derives from the fact that 80 of his prints, 63 in unique copies, are in the collection of the Amsterdam Rijksmuseum Print-room or cabinet. Only 89 prints by him are known in all, 69 of them in a single copy.

A few paintings by him and his workshop are known, notably the dismembered *Passion altarpiece* (Freiburg im Breisgau, Augustiner-museum; Berlin-Dahlem, Museen). But he is far more interesting as a maker of prints, many of them drypoints on lead plates (*see under* intaglio prints), a technique only rarely used again until *Rembrandt, since it does not permit many copies to be run off the press. It has the advantage, however, of allowing far more spontaneous working of the plate than copper engraving, and of producing a rich velvety tonality.

The Housebook Master's secular prints introduced such motifs as the naked *putto* into German art. Even many of his religious subjects are characterized by humour and an individualistic approach to nature. Where playfulness is not appropriate, he evokes pathos and dramatic tension. The prints must have been made for a small circle of sophisticated collectors and friends, who appreciated their pictorial qualities and the Master's original interpretation of traditional subjects. Albrecht *Dürer, although he made only three drypoints in his entire career, was much influenced by him.

HUBER, Wolf or Wolfgang (c.1485/90–1553) The youngest of the major exponents of the *'Danube school' style (*see also* Albrecht Altdorfer, Jörg Breu the Elder, Lucas Cranach the Elder). Born at Feldkirch in Austria, he set out on his *Wanderjahre c.1505*, drawing the picturesque scenery on his way to Innsbruck and Salzburg (e.g. *Mondsee*, drawing 1510, Nuremberg, Museum) and along the Danube. By 1515 he had become court painter and architect to the Bishop at Passau, where he remained, with occasional visits to Austria, for the rest of his life. More dependent on nature than Altdorfer, whom he may have met c.1510, but more romantic than *Dürer, whose work he knew well, Huber remained a master of the landscape pen-and-ink drawing as an independent work of art (e.g. London, British; Berlin-Dahlem, Museen). He is, however, also the author of altarpieces (Feldkirch, parish church; Munich, Museum; Vienna, Kunsthistorisches; St Florian; Berlin-Dahlem, Museen) and of portraits, in several of which landscape plays an important part (Merion, Pa., Barnes Foundation; Dublin, National; Philadelphia, Museum).

HUDSON, Thomas (1701–79) English painter, son-in-law of *Richardson. From c.1746–55 he was the most fashionable

portraitist in London, but he relied on standard patterns and much of the execution of his paintings was left to specialized studio assistants. His fame today rests almost totally on the fact that he was the teacher of *Reynolds (London, Foundling Hospital, Royal College of Physicians; Greenwich, Maritime; Edinburgh, National; etc.).

Huysum or Huijsum, Jan van (1682–1749) Vastly acclaimed Amsterdam flower painter of international reputation (London, National, Wallace; Dulwich, Gallery; Hamburg, Kunsthalle; etc.). A pupil of his father, the flower painter Justus van Huysum (1659–1716), he worked in the tradition established by Willem van *Aelst: asymmetrically composed ornamental bouquets, painted with an enamel-smooth finish, in cool light tones, with vivid blues and greens. They were intended to instruct as well as delight; inscriptions occasionally point the moral (e.g. Amsterdam, Rijksmuseum). He is the author also of some fruit *still-lifes and a few decorative Italianate landscapes (e.g. Amsterdam, Historisch). Van Huysum is exceptional in painting from nature, rather than relying on a collection of drawn or painted studies. Since his bouquets contain flowers from different seasons, double dates appear on some of his pictures.

He attracted many imitators – amongst them his younger brother, Jacobus van Huysum (c.1687/9–c.1740) – well into the 19th century, and was an influence on porcelain decoration.

ICON (from the Greek *eikon*, image) In Byzantine art, an icon is a Christian cult image. It is conceived as a proxy: veneration passes through the image to the Imaged. The struggle between Iconoclasts (image-destroyers) who opposed the veneration of images, and Iconodules, who supported it, divided Byzantine Christianity from 730 to 843. By extension to other art, an icon is an image stressing the timeless and hieratic aspect of the subject and allowing maximum eye contact of the viewer with the image. 'Iconic' thus tends to denote static, frontal figures, sometimes with exaggeratedly prominent eyes. In the semiology of art, however, an icon means merely a sign which shares some of the characteristics of that which it signifies – i.e. a representation, such as a portrait.

ICONOGRAPHY (from the Greek, *eikonographia*, a sketch or description) In art history, the term broadly signifies 'imagery' and to study iconography means to study works of art in terms of their imagery rather than their style or technique. This obviously involves analysing the symbolic connotations of images. 'Iconology' is a word coined to describe the total system of symbols, or social myths, enshrined in the visual imagery of a given culture. It is sometimes used to mean uncovering hidden, perhaps unconscious, significances, and presupposes a link, or underlying unifying principle, between or behind all manifestations of a culture. In this way, iconology is akin to stylistics, in the sense that style labels such as *Gothic are meant to link diverse works of art, and may be thought to reveal some underlying aesthetic predisposition. Whereas the study of iconography is an essential part of the study of all art, required to recover the intended original significance of a work of art, the study of iconology is a philosophically loaded activity; the two words should not be used, as they sometimes are, as synonymous.

The term 'iconography' has the other function of denoting a range of representations of a particular thing. We might speak, for example, of studying the iconography of Justice: such a study would catalogue all the different ways in which Justice has been represented, and trace the evolution of the dominant representation. The iconography of Charles I would list all the known portraits and portrait types of that ill-fated king. In the 16th and 17th centuries, the term simply meant a collection of portraits, and it occasionally is still so used.

IDEALIZATION In theory, idealization in art is a means of elevating representation from the particular to the general, from relative to absolute significance. Its justification derives from the Platonic theory of Ideas. Plato asserts that only Ideas (perfect forms existing in the Divine Intellect and apprehended through the human intellect) are real; phenomena which are evident to the senses are shadows or distortions of the Ideas. Idealization is an integral part of academic theory and practice

in Western art. Sir Joshua *Reynolds' Third Discourse to the Royal *Academy (1770) sets out the clearest academic prescription for idealization: 'His [the painter's] eye being enabled to distinguish the accidental deficiencies, excrescences and deformities of things, from their general figures, he makes out an abstract idea of their forms more perfect than any one original; and what may seem a paradox, he learns to design naturally by drawing his figures unlike to any one object. This idea of the perfect state of nature, which the Artist calls the Ideal Beauty, is the great leading principle, by which works of genius are conducted.' In practice, as Reynolds goes on to say, the laborious task of abstracting ideal form from a comparison of actual forms may be shortened 'by a careful study of the works of the ancient sculptors'. Because it is founded upon intellectual principle, and is thought most nearly to approximate timeless perfection, the *Classical ideal thus gains its canonical value in academic art.

The ability of the artist to idealize has been closely related to his claims for high social status. Mere craftsmanlike dexterity is not enough. Reynolds concludes: '. . . it is not the eye, it is the mind, which the painter of genius wishes to address . . . [it] is that one great idea, which gives to painting its true dignity, which entitles it to the name of a Liberal Art, and ranks it as a sister of poetry.'

ILLUSIONISM A special kind of *realism, which is intended to deceive the viewer either into believing that a pictorial or sculptural representation is the actual thing represented, or into misjudging his real environment. The former type of illusionism is often termed *trompe l'oeil* (French, deceive the eye). The latter type may consist of painted 'extensions' of actual architecture, which rely on a highly technical use of *perspective and *foreshortening. Although *trompe l'oeil* is most often used for objects represented at close range, the distinction is not rigid, and both types of illusionism may coexist. A striking example is the 'cupola' designed by *Pozzo for the Church of S. Ignazio in Rome (c.1685). A flat painting on canvas, it gives, viewed at an angle from the nave, the illusion of a hemispherical cupola complete with articulated and windowed drum, coffering and lantern. The illusion only breaks down when the viewer stands directly under the painting. The pictorial 'extension' of the wall architecture on ceilings and vaults is termed *quadratura*; a specialist in this field of decoration is a *quadraturista*. The original centre for this type of painting was Bologna, northern Italy; *see also* Colonna and Mitelli.

IMPRESA (pl. *imprese*) *See under* emblem books.

INTAGLIO PRINTS These are made by tearing, cutting or eroding the surface of a highly polished plate of metal, usually copper. The marks thus made can hold printer's ink and can be printed on paper in a press (compare with relief prints). The three basic processes of intaglio printing are drypoint, engraving, etching. *See also* mezzotint, aquatint.

In *drypoint* a sharp round point is used to tear the surface of the plate by being thrust into the metal and dragged along through it. It creates a rut or trench and a ridge, or burr, of displaced metal standing up on either side of the rut. The burr gives a velvety quality to the printed line but wears away very quickly during printing.

In *engraving* a trench is cut in the surface of the plate by a graver or burin which gouges or scoops out a shaving of the metal as it travels along the surface. Even the sharpest burin will still leave a minute burr along either side of the rut. In early 15th-century engravings this burr was left to wear away in the course of printing; later engravers scraped the burr away before printing, ensuring greater uniformity between impressions.

In *etching* the lines to be printed are eroded in the surface of the plate by chemical means. The plate is covered with a ground, composed principally of wax; this ground may be coloured, or blackened with smoke after it is laid. The etcher uses a point to draw his design on the ground, just hard enough to wear through the ground but not to dig into the metal. Acid is then applied to the surface; it bites into the exposed metal of the drawn lines, but does not attack the metal covered by the ground. The length of exposure to the acid determines the depth of the lines, and thus the amount of ink they will carry. Parts of the design can be covered with ground, or 'stopped out', and the rest of the plate bitten again thus providing variations of tone in the finished print.

Intaglio plates are printed by having tacky printer's ink spread over the warm plate and worked down into the lines. The surface of the place is then wiped, more or less cleaned at will and the inked plate is laid face up upon the bed of the press. Damp paper is then laid on the plate; protected by blankets or felts; and the bed is rolled through the press, so that the soft paper is pushed into the inked trenches of the plate and takes up the ink. The lines in an intaglio print will stand up above the surface of the paper.

In the mid-18th century Thomas Bewick (1753–1828) developed an intaglio printing process using 'end wood', or blocks of wood cut across the grain. Wood engraving became a standard 19th-century method of book illustration.

INTONACO *See under* fresco.

ISAIA DA PISA (active 1447–64) Ill-documented sculptor from Pisa, active mainly in Rome, where he adopted *Filarete's *classical style (St John Lateran; S. Salvatore in Lauro; S. Agostino; St Peter's; Grotte Vaticane). He worked also in Orvieto (1450–1) and on the Aragonese Triumphal Arch in Naples (1456–9; *see also* Francesco Laurana). His son Gian Cristoforo (*c*.1470–1512) trained originally as a metalworker but later practised also as an architect and marble carver. Taught by Andrea *Bregno, he brought his classicizing sculptural style and decorative repertory back to Bregno's native Lombardy where, as Gian

Cristoforo Romano, he worked from 1491–1501 on the Visconti monument in the Charterhouse in Pavia, influencing Benedetto *Briosco and *Amadeo amongst others. Charged with the reliefs of the Holy House at Loreto, he died before he could execute any of them, and was succeeded by Andrea *Sansovino.

ISIDRO de Villoldo *See under* Berruguete, Alonso.

ISTORIA *See under* genres.

J

JACOBELLO da Messina *See under* Antonello da Messina.

JAMNITZER, Wenzel (1508–85) Viennese-born goldsmith and sculptor working in Nuremberg from before 1534, the eldest member of a large dynasty and founder of a long-lived workshop. He specialized in small figures, reliefs on caskets and ornamental tableware in an Italianate *Mannerist style. The small scale of his work belies its lasting and widespread influence (Munich, Residenz; Amsterdam, Rijksmuseum; Vienna, Kunsthistorisches; Berlin-Dahlem, Museen; New York, Morgan Library; etc.). Christoph Jamnitzer (1563–1618) is, after Wenzel, the best-known member of the family.

JANSSEN, Hieronymous (called 'The Dancer') *See under* Francken.

JANSSENS, Abraham (1573/4–1632) Italianate Flemish painter, one of the leading artists in Antwerp before the arrival of *Rubens in 1608. He made at least one trip to Rome, in 1598 (a second trip *c.*1604, in which he would have seen the work of *Caravaggio, has been postulated but is not documented). His early work is in a complex *Mannerist idiom indebted to *Spranger (*Diana and Callisto*, 1601, Budapest, Museum), but he later came to paint in a powerful, monumental, *classicizing style (Antwerp, Musées; Malines, St Janskerk; Valenciennes, Musée). Towards the end of his life, however, he fell under the spell of Rubens, loosening his brushwork and the clear architectonic structure of his previous figure design (1626, Ghent, St Michael).

JARDIN, Karel du *See* Dujardin, Karel.

JOANINE STYLE A Portuguese form of *Rococo associated with King John V and flourishing *c.*1715–35, which was evolved by Italian and French artists attracted to Portugal by the new wealth created through the discovery of gold and diamonds in Brazil. One of its main exponents was the French sculptor Claude Laprade (active from 1699–1730; e.g. clay figures, altar, 1727, Oporto, cathedral).

JOOS van Ghent (also Justus of Ghent; and in Italian, Giusto da Guanto) (active 1460–*c.*80) Netherlandish painter, Joos van Wassenhove, best known for his work at the court of Urbino in Italy. His documented altarpiece of the *Communion of the Apostles* (*Institution of the Eucharist*), 1472/4, which has a *predella by *Uccello, is still in Urbino (ducal palace, now Galleria). Much of the decoration he designed, and executed in collaboration with his assistant, 'Pietro Spagnuolo' (identified as Pedro *Berruguete) for the Duke of Urbino's private study or *studiolo*, however, has been dispersed. Fourteen mainly imaginary portraits of illustrious men (1476) are still in the *studiolo* (Urbino, ducal palace) but another 14 are in Paris, Louvre. A portrait of *Duke Federico da Montefeltro with his son* is in Urbino; another of the *Duke with courtiers listening to a lecture* is in the English Royal Collection.

Two allegorical figures of *Liberal Arts*, perhaps from the *studiolo* of the Montefeltro palace at Gubbio, are now in London, National Gallery; a further two from the original set of seven were in the Berlin Museum, but were destroyed in World War Two.

Joos's birthplace and training are unknown. He matriculated in the painters' guild in Antwerp in 1460; was in Ghent from 1464 to 1468/9, and in contact with Hugo van der *Goes, for whom he stood guarantor with the painters' guild, in 1465 and 1467. Some time after 1468 he left for Rome, to spend the rest of his life in Italy. In addition to the works listed above he has been generally credited with the authorship of a painting in tempera on linen (New York, Metropolitan) and a triptych (*see under* polyptych) in the Cathedral of St Bavo, Ghent.

JORDAENS, Jacob (1593–1678) The leading painter in Antwerp after the death of *Rubens. He was apprenticed to Adam van *Noort, who later became his father-in-law, becoming a Master of the Antwerp painters' guild, specializing in fictitious tapestries in water-colour, in 1615, and Dean of the guild in 1620–1. His early works show the influence of *Van Dyck, of the *classicizing style of Rubens *c*.1610, and of *Caravaggio, although he himself never went to Italy. From *c*.1620 many of his paintings were completed with the help of his pupils. Although he continued to borrow motifs from Rubens, his work from 1620–35 is marked by greater *realism, a tendency to crowd the surface of his pictures, a preference for burlesque even in lofty themes and on a large scale (e.g. *St Peter finding the Stater*, also called *The Ferry at Antwerp*, Copenhagen, Museum). In these years he also painted illustrations of Flemish proverbs and boisterous depictions of Flemish festivals and feasts. Between 1635–40, when Rubens was ill with gout, and after his death in 1640, Jordaens was called upon to work from Rubens' sketches (e.g. Madrid, Prado) and to complete large-scale decorations originally commissioned from Rubens (e.g. for the Queen's House, Greenwich; now lost). These works show a falling-off of his exuberance, which was fully recovered, however, *c*.1645, most notably in his huge decorative canvas of 1652, the *Baroque *Triumph of Prince Frederick Hendrik of Orange* (Huis ten Bosch). In his later years Jordaens joined a Calvinist community tolerated in Catholic Antwerp. The restrained classicism and cooler colour of his late paintings, many of them on moralizing subjects, fit well both with a new general artistic trend imported from France and with his religious convictions (e.g. Kassel, Gemäldegalerie). He never ceased, however, to carry out commissions for Catholics. In addition to the works mentioned above, there are paintings by Jordaens in churches and museums in Antwerp, and in many galleries through-out Europe and the USA.

JOURNEYMAN (from French *journée*, a day's duration) Under the guild system governing the professional activities of artists in most northern European cities (and, less thoroughly, in Italy) in the Middle Ages and the *Renaissance, a journeyman was someone who

had completed his apprenticeship but had not, or not yet, become a master allowed to set up his own establishment. The term implies that a journeyman is hired by the day, but this was in fact rarely the case; various city statutes specify that he might be hired by the week, the month or the year, and others lay down a minimum period of notice. A young artist on his *Wanderjahre might work as a journeyman, (see e.g. Dürer), although little is known of the mobility of journeymen as a group.

JOUVENET, Jean See under Restout, Jean the Younger.

JUEL, Jens (1745–1802) Danish painter, trained in Hamburg, the most successful portraitist and a pioneer of landscape painting in Denmark. In 1772, subsidized by some of his titled lady clients, he travelled to Rome, where he worked from 1774–6, returning to Denmark in 1780 via Paris and a three-year stay in Geneva. Juel adapted his style to his clients, painting sober and intimate likenesses of townspeople and professional men in a manner derived from Dutch 17th-century *realism and influenced by *Chardin, and borrowing *Rococo formulae for his many likenesses of royalty and aristocrats. He taught at the *Academy in Copenhagen from 1784, his two most important students being the German painters Caspar David Friedrich and Philip Otto Runge (see Volume Two). Towards the end of his life he modified his style once again in accord with the prevailing *classicism of French and English portraiture of the time, probably transmitted through prints and drawings. There are works by Juel in Copenhagen, Museum.

JUSTUS of Ghent See Joos van Ghent.

KALF, Willem (1619–93) Probably the greatest Dutch painter of *still-life. He is famous as an exponent of *pronkstilleven*, or 'still-lifes of ostentation', although his mature works are monumental in effect, and suggestive of philosophical meditation rather than luxury and ostentation. Many of the expensive objects in these still-lifes reappear in several paintings: a blue and white Ming porcelain bowl in no fewer than 16 pictures, an Augsberg goldsmith's chalice in 13, etc. Such borrowed objects may have been re-utilized by Kalf from drawings, yet the final effect is never that of mechanical or monotonous repetition.

Kalf was the son of a wealthy and civic-minded Rotterdam cloth merchant. Little is known of his education. In 1642–6 he is known to have lived in Paris; from this period date peasant or 'stable' interiors (and a few exteriors) with prominent kitchen still-lifes of copper and brass vessels and utensils to one side in the foreground (e.g. Dresden, Kunstsammlungen). These were to prove influential on French painters of the 18th century (*see* Chardin) and later. At the same time Kalf developed a type of true still-life, with costly vessels grouped together in profusion, some lying on their sides (e.g. Cologne, Wallraf-Richartz).

Sometime after 1651 Kalf moved to Amsterdam, where, *c.*1653-63, he created the still-lifes for which he is best known. The objects are now fewer in number, and no longer in seeming disarray. They are often arranged in a vertical format, on a richly patterned Oriental carpet against a dark background. Colour harmonies are equally restrained, but, in conjunction with the broad brush stroke, sumptuous (Berlin-Dahlem, Museen; London, National; etc.). These works are classed in the heroic or *classic phase of Dutch 17th-century art, like the monumental landscapes of *Ruisdael.

KÄNDLER, Johann Joachim (1706–75) German *Rococo sculptor, celebrated for his designs for the Meissen porcelain factory, to which he was appointed in 1731. Amongst his best-known works are the decoration in porcelain of the Japanese palace in Dresden, and the 2,200 pieces of the dinner service called the Swan Set (1737–41; Dresden, Porzellansammlung).

KAUFMANN, Angelica Catherina Maria Anna (1741–1807) Tyrolese painter of portraits and *Classical narrative, probably most successful in her decorative pictures for the interiors of Adam's London houses. She was trained in painting by her father, with whom she worked throughout Italy, making her reputation originally as a copyist of Old Master pictures. Her international fame dates from her 1764 portrait of J.J. Winckelmann, the celebrated author of *Reflections on the Imitation of Greek Art in Painting and Sculpture* and the *History of Ancient Art*, painted in Rome (Zürich, Kunsthaus; five replicas exist, and the

artist also produced an etching after the painting). In 1765 or 1766 she travelled to England with the wife of the English Resident in Venice; a royal portrait commission caused her to be sought after as a society portraitist. She became a founder member of the Royal *Academy, exhibiting there between 1769–97. In 1781 she married (after the failure of a first marriage) the Italian decorative painter Antonio Zucchi with whom she returned to Italy, continuing to paint for monied travellers and the leading European nobility. There are works by her in London, Kenwood, National Portrait, Royal Academy, Nostell Priory; New York, Metropolitan; etc.

KENT, William (1685–1748) A protégé of Lord Burlington, known primarily as an architect and landscape gardener. He had, however, studied painting in Rome in 1714/15, and his work for Burlington began in London in 1719 when Kent completed the paintings at Burlington House which Sebastiano *Ricci had left unfinished.

KEYSER, Hendrick de (1565–1621) and his son Thomas (1596/7–1667) Hendrick was an architect and the most important Dutch sculptor of the first half of the 17th century, specializing in portraiture (Amsterdam, Rijksmuseum) and in decorative sculpture. Both are combined in his masterpiece, the *Tomb of Prince William I* in the Nieuwe Kerk, Delft; there are also works by him in Rotterdam and in London, Victoria and Albert. His son, Thomas, was the leading portrait painter in Amsterdam until the arrival of the young *Rembrandt in 1631/2. He executed important group portraits and militia pieces on the scale of life (Amsterdam, Rijksmuseum), which emphasize individual likeness at the expense of compositional unity. More artistically successful were his small full-length portraits of one or two figures (London, National) and the small equestrian portraits he popularized. After 1640, he virtually stopped painting, becoming active as a stone merchant and mason.

KNELLER, Sir Godfrey (1646/9–1723) Born in Lübeck, trained in Amsterdam under *Bol, and perhaps in contact with the aged *Rembrandt, Kneller became the dominant artistic personality of his time in England, where he settled in 1676 (*but see* Lely). After the Revolution of 1688 he shared the office of Principal Painter with *Riley, assuming the whole office on Riley's death in 1691. He was knighted in 1691/2, and created a baronet in 1715. He was the first painter to rise to such eminence in Britain; his social status reflects both the stature of his sitters, drawn from the leading figures of the period, and the quality of his work. Despite an immense output, made possible only by extensive use of specialized assistants and a studio run as an assembly line, Kneller at his autograph best demonstrates psychological acuity and technical brilliance (*see* e.g. *Philip, Earl of Leicester*, 1685, Kent, Penshurst Place; *The Chinese Convert*, 1687, London, Kensington Palace; *Kit Cat* series, 1702–17, London, National Portrait). His notorious personal vanity, and a certain cynicism attendant upon his enormous practice and studio methods, did not prevent him from showing concern with

the training of young artists. He became the first Governor of the first
*Academy of Painting to be set up in London, and continued active in
the post until he was replaced in 1716 by *Thornhill.

KREMSER-SCHMIDT *See* Schmidt, Martin Johann.

KUNSTKAMMER (German, art-room) A word applied to the often
highly decorated small chambers in which 16th-century collec-
tors kept examples of natural wonders and exotica as well as small-scale
works of art such as medals, coins and statuettes.

Labille-Guiard, Adélaïde (1749–1803) French portraitist in pastels and oils. She was praised by contemporaries for painting with 'masculine vigour', and her work is both sober in its naturalistic (*see under* realism) portrayal of character and rich in its depiction of costume and setting – in contrast with that of her rival, Mme *Vigée-Lebrun, which is more 'feminine' in its exploitation of sentiment. Both were received in the French *Academy on the same day in 1783. Labille-Guiard became *Premier Peintre* to the daughters of Louis XV (Versailles) and shortly before his execution Louis XVI commissioned a portrait of himself from her, which was never painted. Because of her revolutionary sympathies, she was able to remain in Paris throughout the 1790s.

Lacroix, Charles de *See under* Vernet, Claude-Joseph.

Laemen, Christian Jansz van der *See under* Francken.

Laer, Pieter van (*c.*1592–1642) Haarlem painter, possibly trained by Esaias van de *Velde, resident in Rome *c.*1625–38. He was the first artist to specialize in small-scale pictures of Roman street life, adapting *Caravaggio's *chiaroscuro and naturalism (*see under* realism) to outdoor scenes with numerous full-length figures (Rome, Nazionale; Spada; Hartford, Conn., Atheneum; etc.). Despite being held in low esteem by art critics, his paintings were much prized and lastingly influential. Van Laer's physical deformity and small stature earned him the nickname Bamboccio (poppet); his pictures gave the name *bambocciate* (trifles) to the whole genre, and his numerous followers are termed *Bamboccianti*. He was a prominent member of the Netherlandish artists' fraternal organization in Rome, the *Schilderbent, and an associate of *Poussin and *Claude Lorrain; his influence extended even to the great Spanish painter *Velázquez. His Italian followers included Michelangelo Cerquozzi (1602–60) and Viviano Codazzi (1611–72); amongst the northerners the most prominent were the Flemings Jan Miel (1599–1663) and Michiel *Sweerts.

Laguerre, Louis (1663–1721) Learned French painter of allegorical mural decorations, he worked for a while with *Lebrun before arriving in England in 1683/4, as an assistant to the architectural painter Ricard. Both men worked for *Verrio at Christ's Hospital in 1684, and with him at Chatsworth from 1689–94. Whilst most of the royal commissions before 1688 and after 1699 went to Verrio, Laguerre painted many of the most important wall and ceiling decorations in great houses (Burghley; Devonshire House; Marlborough House; Blenheim). He is generally considered far superior to Verrio in both invention and execution. From *c.*1711 his rival *Thornhill, who had learned much from him, tended to supplant him in public esteem, and in his later years Laguerre devoted himself increasingly to portraiture

and history painting (*see under* genres). Little of his easel painting is known to have survived.

L AIRESSE, Gerard de (1640–1711) Influential Flemish-born Dutch painter, etcher (*see* intaglio prints) and theoretician of art. Both through his practice and his treatises and lectures, he single-handedly revitalized decorative and large-scale painting in Holland.

The precocious son of a painter father, de Lairesse studied also with a *classicizing painter who had worked for many years in Paris. Fleeing from a broken engagement, he settled in Amsterdam, where he acquired citizenship in 1667. Despite his training, he initially admired *Rembrandt, but was soon won over to the artistic tenets of the French *Academy through a circle of intellectuals promoting French fashions. Most of his energies as a painter were devoted to easel paintings of mythological scenes (e.g. Brunswick, Museum; Antwerp, van den Bergh; Amsterdam, Rijksmuseum) and to vast classicizing decorative schemes in public buildings, palaces (e.g. The Hague) and the houses of rich merchants. He was the first Dutch artist to paint *illusionistic ceiling pictures on canvas (Amsterdam, Rijksmuseum).

De Lairesse went blind *c*.1690. He supported himself by lecturing on art theory; the lectures were collected and published in two volumes: *Fundamentals of Drawing*, 1701, and the famous *Groot Schilderboek* (*Great Book on Painting*) 1707, which became one of the most widely read and used handbooks on art in the Dutch Republic (reprinted 1712, 1714, 1716, 1740, 1836) and translated into German, English and French.

L AMBERTI, Niccolò di Pietro (*c*.1370–1451) Florentine sculptor, employed on the Porta della Mandorla, Florence cathedral, in 1393 and on a *Virgin and Child* for a niche on the Guild Hall Church, Or San Michele. In 1415 he executed, for the cathedral façade, a *St Mark* (Florence, Opera del Duomo) which makes a poor showing beside its companion figures, *Nanni di Banco's *St Luke* and *Donatello's *St John*. In 1416, he moved to Venice with his son, Pietro di Niccolo Lamberti (*c*.1393–1435); there he played a leading part in the sculpture for the façade of S. Marco. He is recorded in Bologna 1428–39.

LANCRET, Nicholas *See under* Watteau, Jean-Antoine.

LANDSCAPE PAINTING *See under* genres.

L ANFRANCO, Giovanni (1582–1647) Painter from Parma, he introduced to Rome the *illusionism of *Correggio's domes, initiating a new phase of *Baroque decoration (1625–7, S. Andrea della Valle). From 1634–46 he was the most successful *fresco painter in Naples, influencing later Neapolitan decorative painters, notably Luca *Giordano (Gesù Nuovo, cupola, 1634–6; S. Martino, 1637–9; SS. Apostoli, 1638–44; Cathedral, Capella del Tesoro, 1643 – originally commissioned from his rival, *Domenichino).

A pupil of Agostino *Carracci, after his master's death in 1602 he joined his brother Annibale Carracci in the service of the Farnese in Rome. Despite rivalry with Annibale's pupils and followers, notably

*Guercino, *Reni and Domenichino – which caused him to retire back to Emilia, 1609–11 – Lanfranco was able to establish himself as one of the leading painters of successive papal courts and powerful aristocratic patrons, modifying the *classicizing style of the Carracci school through an admixture of *Caravaggesque *chiaroscuro and the freer, more painterly mode of Correggio. The prelude to his great dome painting at S. Andrea was the loggia vault of the Villa Borghese, 1624–5, a more dynamic and freer critique of Annibale's Farnese Gallery ceiling. His move to Naples was motivated, however, by his eclipse in the 1630s by the artists of the Barberini court, *Bernini and *Pietro da Cortona.

LAPRADE, Claude *See under* Joanine style.

LARGILLIERRE or LARGILLIÈRE, Nicolas de (1656–1746) French painter known primarily for his portraits and votive works (only surviving example of the latter, 1696, Paris, St Etienne-du-Mont) but the author also of *still-lifes (e.g. Grenoble, Musée). Born in Paris, he was trained in Antwerp under a painter of still-lifes and peasant scenes; between *c.*1674–80 he worked in London as a drapery and accessory assistant to *Lely. In 1682 he settled in Paris and was received as a member in the *Academy in 1686, rising to Director in 1738–42. By the end of the 1680s he had become the favoured portraitist of the rich Parisian bourgeoisie – as his friendly rival *Rigaud was of the court aristocracy – adapting for them English variants of naturalistic (*see under* realism) Flemish and Dutch portrait formulae (e.g. Paris, Louvre; Strasbourg, Musée; Washington, National). He was the teacher of *Oudry and welcomed *Chardin into the Academy.

LASTMAN, Pieter (1583–1633) Amsterdam painter. From *c.*1603–*c.*1606 he was in Rome, where he was deeply influenced by *Elsheimer and, through him, *Caravaggio. On his return to Amsterdam he specialized in vigorous, albeit small, history paintings (*see under* genres), narratively clearer, more *realistic and more *expressive, than those of the earlier generation of Dutch Italianate painters (*see* especially Cornelis van Haarlem; Bloemaert). Like Elsheimer he used landscape to set the dominant mood of a scene, and a mixture of *Classical and Orientalizing accessories (such as turbans) to locate the story in pagan or Biblical antiquity. Around 1610 he began to introduce crowds of figures, which act as a chorus to intensify and comment upon the dramatic action. In 1623–4 the young *Rembrandt spent six months in Lastman's studio, and was deeply marked by his teaching, as was his colleague Jan *Lievens. There are pictures by Lastman in Rotterdam, Boymans-Van Beuningen; Munich, Alte Pinakothek; London, National; etc. He, and a group of Amsterdam artists closely related through common interests and also by marriage, etc. are frequently known as the 'Pre-Rembrandtists'.

LA TOUR, Georges de (1593–1652) Important Lorrain *Caravaggesque painter, active in Lunéville from *c.*1620. Although he received two commissions from the Duke of Lorraine in 1623–4, he

worked mainly for the local bourgeoisie and the French administration; Louis XIII of France owned a painting by him, and in 1639 he is mentioned as having the title of King's Painter. By the 1630s he seems to have given up entirely his earlier low-life *genre subjects, to concentrate on religious themes executed in a highly individual, simplified manner which, together with the apparently humble settings and social origins of the painted protagonists, reflects the ideals of the religious revival led in the Lorraine by the Franciscans.

La Tour's earliest known paintings (e.g. Fortune Teller, New York, Metropolitan) continue the manner practised in Nancy by *Callot. Sometime c.1621, and again c.1639–42, perhaps during trips to the Netherlands, he seems to have come into contact with *Caravaggio's Dutch followers in Utrecht, *Terbrugghen and *Honthorst. Paintings from c.1620–5 employ *chiaroscuro and a minute surface naturalism (see under realism), stressing the texture of hair and the wrinkles of aged skin (e.g. two versions of St Jerome, Stockholm, Museum; Grenoble, Musée; Hurdy Gurdy Player, Nantes, Musée). In the next phase of his work, beginning with Job and his Wife (Epinal, Musée) La Tour introduces an unshaded candle: the chiaroscuro is now based on warm coppery red tones suggesting candlelit night scenes (e.g. Penitence of St Peter, 1645, Cleveland, Ohio, Museum; Jesus and St Joseph in the Carpenter's Shop, c.1645, Paris, Louvre). In the last, and greatest group of paintings, the motif of an unshaded, or sometimes shaded, flame is kept but surface description is reduced to a minimum. Although forms are pressed close to the viewer, sometimes cut off by the frame, they are represented in paradoxically distant, generalized terms. The compositions are correspondingly simplified; movement is eliminated. A mysterious stillness is produced, and these paintings are at once both monumental and intimate (Denial of St Peter, 1650, Nantes, Musée; St Sebastian, c.1650, Berlin-Dahlem, Museen; Nativity, c.1650, Rennes, Musée). La Tour, more than any of Caravaggio's followers, converts the Italian master's *tenebrism and low-life naturalism into a noble *classicism.

LATOUR, Maurice-Quentin de (1704–88) The best-known French portraitist of the mid-18th century. His pastel portraits are vivid and vivacious almost to the point of *caricature. Born in Saint-Quentin, he arrived, after an early stay in London, in Paris probably during Rosalba *Carriera's visit in 1620–1; her success prompted him to adopt the pastel medium (see also Liotard). His sitters ranged widely through society; he charged high fees and presented himself as a 'character', capricious, vain, opinionated and often rude. There are works by him in Geneva, Musée; Paris, Louvre; Saint-Quentin, Musée; etc.

LAURANA, Francesco (c.1430–1501/02) Dalmatian-born sculptor probably trained in a Venetian studio operating in Dalmatia, perhaps that of a disciple of Bartolommeo *Buon. He worked in Naples on the Aragonese Triumphal Arch, 1454–8, and again in the early

1470s (*Virgin and Child*, Chapel of St Barbara, Castelnuovo, 1474; *Virgin and Child*, S. Maria Materdomini); in France at the court of René of Anjou in 1461–6, when he was employed as a medallist and again in 1477–83 and c.1498–1501/02; and in Sicily, 1467–after 1471. He is best known, however, for a series of nine female portrait busts usually ascribed to his second Neapolitan period, c.1472–4, but probably executed in two separate periods, 1472–5 and 1487–8. These busts, (now in Florence, Bargello; New York, Rockefeller Coll., Frick; Vienna, Kunsthistorisches; Washington, National; Paris, Louvre, Jacquemart-André; Palermo, Museo; and formerly in Berlin, Kaiser Friedrich), are to a great degree abstract images, a subtle type of court art in which the representational demands of portraiture are restricted in favour of geometrical approximation. Laurana's inexpressive manner is nearly as successful in his statues of the *Virgin and Child*, but his narrative scenes demonstrate his rudimentary grasp of spatial construction and *expressive movement. In France, his work turned to Late *Gothic pathos and grotesque, especially marked in the relief at Avignon which depicts *Christ carrying the Cross*.

LAZZARINI, Gregorio *See under* Tiepolo, Giovanni Battista.

LEBRUN, Charles (1619–90) French painter and designer; from 1663 until the death in 1683 of his patron, Colbert, the powerful minister of King Louis XIV, he was the virtual dictator of the visual arts in France. Director of the Gobelins, the royal factory which produced all the furnishings, including tapestries, for Versailles, and the re-organized Royal *Academy of Painting and Sculpture, he channelled all the great commissions of the crown and controlled the training of artists and artisans, outside all guild restrictions. He himself was responsible, in 1663, for the decoration of the Galerie d'Apollon, Paris, Louvre, and, from 1671–81, for designing every aspect of the interior decoration of the great royal apartments at Versailles. He executed, with assistants, the series of ceiling paintings of the *Life of Louis XIV* in the Galerie des Glaces and the Salons de la Guerre and de la Paix begun in 1678, and completed in 1684 and 1686 respectively.

Although, in theory and in his academic teaching, Lebrun championed the rational *classicism of *Poussin, in practice, when designing vast decorative ensembles, he relied on a classically tempered *Baroque which owed much to the example of *Pietro da Cortona. Despite condemning the Flemish school, he was indebted to *Van Dyck for the naturalism (*see under* realism) and warm colouring of his own very accomplished portraits (e.g. *The Chancellor Séguier*, 1661, Paris, Louvre). And when, after 1683, he was gradually displaced from royal commissions by *Mignard, he continued to paint, on a smaller scale, intimate and luminous works reminiscent of Dutch *Caravaggesque painters (e.g. *The Nativity*, c.1689, Louvre).

First trained by François Perrier (1590–1650), a collaborator of *Vouet who had studied in Rome under *Lanfranco, and by Vouet

himself, Lebrun was sent to Rome, 1642–6, by his first protector, Ségur, studying part of the time with Poussin. Although he obtained commissions for decorative and religious works immediately upon his return to France, his reputation was made *c.*1650 with his *illusionistic Baroque ceiling for the Hotel Lambert, Paris. In 1661 he received his first commission from the king, the *Family of Darius before Alexander* (Paris, Louvre) – the first instance of the mature style, reminiscent of Poussin but freer, more picturesque and less severely heroic, which Lebrun was to impose on all of France (*see*, e.g. Sarrazin).

In addition to the decorative schemes and administrative duties undertaken by Lebrun for the crown, he executed a few easel paintings for corporate clients (e.g. Lyons, Muśee). Earlier smaller scale works are in Nottingham, Gallery; Dulwich, Gallery; London, Victoria and Albert; etc. Tapestries woven to his designs are in Paris, Gobelins; and an enormous collection of his drawings can be found in the Louvre. As a theoretician and teacher he is mainly remembered for his influential treatise on the representation of the emotions, *Méthode pour apprendre à dessiner les passions*.

Under Lebrun's leadership and with the active financial and institutional protection of Colbert, Paris became the artistic capital of Europe, reversing the historical supremacy of Italy. The change, and Lebrun's influence, may be gauged from his election in 1675 to the post of President of the Academy of St Luke in Rome.

LE CLERC, Jean *see under* Saraceni, Carlo.

LEGROS Family of French artists, of whom the best known is the sculptor Pierre Legros the Younger (1666–1719). He won first prize for sculpture at the *Academy in 1686. From 1690–5 he was a pensioner at the French Academy in Rome, finally dismissed for accepting private commissions (statues for altar, S. Ignazio). He remained in the city as an independent artist, the principal sculptor for the Jesuits. There are works by him in S. Ignazio; Gesù; St Peter's. Perhaps the best known is the gruesomely *realistic *polychrome marble statue of *St Stanislaus Kostka on his death-bed*, in the Novitiate annexe of S. Andrea al Quirinale. Other works are in Paris, Louvre; Turin, cathedral. Late in life he also worked for the Olivetans at the monastery of Montecassino.

His father, Pierre Legros the Elder (1629–1714), was the King's Sculptor in Paris, and from 1702 professor of sculpture at the French Academy. There are works by him on various façades of the palace at Versailles; Paris, Invalides, Louvre; Chartres, cathedral. Jean Legros (1671–1745), Pierre the Younger's brother, specialized in portrait painting, having studied at the Academy under *Rigaud.

LELY, Sir Peter (1618–80) The most important painter working in England in the second half of the 17th century. Although extremely successful as a painter of landscapes, *genre* and narrative as well as portraits during the Commonwealth and Protectorate, Lely is mainly identified with court portraiture after the Restoration in 1660.

His most famous series, the *Windsor Beauties* (Hampton Court), demonstrates best the animated, voluptuous, but flatteringly generalized portrait style which he evolved at this time, although (as in the series of the *Admirals* 1666/7, Greenwich, Maritime, or *Van Helmont* c.1671, London, Tate) he could, at will, return to a more sharply individuated and penetrating mode.

Lely was born in Westphalia of a Dutch family named Van der Faes, trained in Haarlem under Pieter de Grebber and arrived in London between 1641 and 1645. His early portraits echoed the style of *Dobson (Althorp; Syon House). Under the influence of a work by *Van Dyck, Lely evolved the 'portrait in a landscape', which became a dominant British type until the end of the 18th century (e.g. *The Young Children of Charles I*, 1646/7, Petworth). In the 1650s, he painted mythological pictures (*Europa*, Chatsworth; *Sleeping Nymphs*, Dulwich, Gallery) and anecdotal scenes in the Dutch manner (*The Duet*, 1654, Batsford Park). With the Restoration, Lely was appointed Principal Painter in Ordinary to the King. He was knighted in the year before his death. Investing his considerable fortune in works of art, Lely accumulated one of the finest private collections in Europe, making his studio virtually an *academy for the training of younger artists. Its sale after his death has been called 'the first of the spectacular picture auctions of the modern world'.

LEMOYNE, François (1688–1737) Leading French painter from c.1725 until his suicide; the more successful rival of Jean-François de *Troy. Unlike the latter, he specialized almost entirely in decorative mythological pictures in outdoor settings (e.g. London, Wallace; Leningrad, Hermitage; Nancy, Musée; Paris, Louvre). Trained by a leading 'Rubéniste' (*see under disegno*), Louis Galloche (1670–1761), Lemoyne modelled his work especially after *Rubens, *Correggio and *Veronese, responding directly also to observed landscape. In 1724 he travelled in Italy with a patron, but his acquaintance with Italian *Renaissance art had already been made through Parisian collections. Ambitious to carry out large decorative schemes, he lost the 1719 commission for the ceiling of the Banque Royale to *Pellegrini, but received major commissions for vaults in Paris, St Thomas d'Aquin and St Sulpice (sketch, Paris, Louvre); the culmination of these *illusionistic ceiling decorations was the *Apotheosis of Hercules* (comp. 1736, Versailles, Salon d'Hercule), the last *Baroque large-scale decoration in France, which won him the post of *Premier Peintre* to the King. The death of his wife, and of his great protector at court, the Duc d'Antin, may have precipitated the fit of madness in which he hacked himself to death. He was the teacher of *Natoire and *Boucher.

LEMOYNE, Jean-Baptiste (1704–78) Best-known member of a dynasty of French sculptors, not to be confused with his uncle, Jean-Baptiste Lemoyne the Elder (1679–1731), a minor and short-lived artist influenced by his study of *Rubens (*Death of Hippolytus*, Paris, Louvre).

Jean-Baptiste Lemoyne was the son of the sculptor Jean-Louis Lemoyne (1665–1755), trained under *Coysevox and himself an accomplished portraitist (e.g. busts of *Mansart*, 1703, Paris, Louvre; *Coysevox*, Paris, Ecole des Beaux-Arts) as well as the author of decorative *Rococo groups such as the *Crainte de l'amour* (1742, Paris, Rothschild Coll.). Stricken by blindness, Jean-Louis increasingly relied on his gifted son from the 1720s; like his father, Jean-Baptiste never went to Italy, although he was offered a place at the French *Academy in Rome in 1728. He was trained by his father and the latter's friend Robert Le Lorrain, and sought the help and advice of 'Rubéniste' (*see under disegno*) painters such as François de *Troy and François *Lemoyne. He was most at ease as a modeller in terracotta, and his work stresses fleeting movement and surface texture in a way more pictorial than sculptural, for which some of his contemporaries criticized him (e.g. *Baptism of Christ*, 1731, Paris, St Roch). His vivacious and *expressive portrait mode, however (busts, e.g. Paris, Louvre, Arts Décoratifs, Jacquemart-André, Comédie Française; Rouen, Musée; Vienna, Kunsthistorisches), earned him the favour of Louis XV, of whom he executed a series of portraits over 40 years (e.g. 1757, New York, Metropolitan), beginning with the bronze equestrian monument for Bordeaux commissioned from his father and himself (1734, Place Royale; destroyed in the French Revolution). His pupil *Falconet was in the studio when the statue was being executed and recalls it in his own bravura *Peter the Great*.

Most of Jean-Baptiste Lemoyne's church decorations – some of them in *polychrome – and funerary monuments have been destroyed or mutilated (fragments, Paris, St Roch; Ecole des Beaux-Arts; Dijon, Musée). His attachment to a pictorial mode of sculpture, his relative indifference to the antique and his neglect of the nude made him the virtual contrary of his arch-rival, *Bouchardon. In addition to Falconet, he was the much-loved teacher of *Pigalle and *Pajou.

LE NAIN, Antoine (*c*.1600/10–48), Louis (*c*.1600/10–48) and Mathieu (*c*.1600/10–77) French painters, brothers born at Laon and working in Paris by 1629. Their beginnings are ill-documented, but their birthdates of *c*.1588, *c*.1593 and *c*.1607 respectively, long recorded in the literature, have been shown to be erroneous at least in the case of Antoine and Louis: all three, the youngest of five children, belong to the same artistic generation, which may explain their professional closeness until the deaths of Antoine and Louis, their habit of signing works only with a surname, and the subsequent difficulties of attributing individual works to one or the other. Best remembered for their striking small *genre* paintings of peasants and to a lesser extent those of artisans, gaming soldiers and children – all low-life subjects known in France as *bambochades*, after the Italian *bambocciate* (*see under* Pieter van Laer) – they are known also to have painted portraits in miniature, in small scale (e.g. Paris, Louvre; London, National) and on

the scale of life, and larger-scale mythological, allegorical and religious works for collectors and churches in Laon and Paris. Most of the latter disappeared during the French Revolution (but rediscovered mythologies now Orleans, Musée; Rheims, Musée; allegories, Paris, Louvre; chapel decoration, Paris, St Jacques du Haut-Pas, Louvre; Nevers, St Pierre, Saint-Sacrement; other religious subjects London, National; New York, Farkas Foundation; Paris, Louvre, Notre-Dame; Darmstadt).

It is with history painting (*see under* genres) that the Le Nains, trained under an unknown artist in Laon, first made their reputation, both in their native city and in Paris, and Mathieu is known to have continued to produce such works after his brothers' deaths in 1648. Recent scholarship also reverses the long-held notion that *genre* painting, and specifically rustic *genre*, was a prerogative of the provinces: on the contrary, it would appear that only in the capital was a wide clientele of collectors creating a demand for this type of painting. It is likely, therefore, that the Le Nains, began to produce their most characteristic works only after *c.*1629. Their *genre* pictures are typified by intense *realism, an absence of overtly comical, satirical or moralizing intent, and vigorous brushwork; particular attention is paid to the effects of natural or artificial light. Probably the most original and the best painted are the 'peasant meals' with figures grouped in an interior around a white tablecloth (e.g. Paris, Louvre; London, National and the exterior scenes with peasants, of which only eight are now known (Paris, Louvre; Leningrad, Hermitage; Karlsruhe, Kunsthalle; Hartford, Atheneum; San Francisco, Cal., Legion of Honor; Washington, National; London, Victoria and Albert). Equally noteworthy and often engraved, one of the works which assured the survival of the artists' name into the 19th century, is the remarkable *Forge* (Paris, Louvre). An unfinished *Portrait of Three Men* (London, National), recently restored, gives a precious insight into the artists' technique and may represent the three brothers, *c.*1645–8.

LEONARDO DA VINCI (1452–1519) Italian painter, sculptor, architect, civil and military engineer, student of the natural sciences seeking to discover the mathematical laws governing all observable phenomena, musician, designer of courtly entertainments: Leonardo is still revered as the very model of the 'universal genius'. The breadth of his mind is manifest in the numerous manuscripts – preparations for treatises never completed, working sketch- and note-books – now in libraries in London, Madrid, Milan, Paris, Rome, Turin and Windsor. Whilst Leonardo's brilliance remains unique, it should be pointed out that his range of activities was not, in itself, unprecedented – see, for example, Francesco di Giorgio, whom Leonardo knew and whose treatise on architecture he owned.

Leonardo's importance within the history of art stems from his mastery in representing natural effects, allied to a supreme ability to *idealize. He was the originator of the style we call the High *Renais-

sance (*see also* Michelangelo, Raphael). As a painter, he created some of the world's most potent and influential images. The *Last Supper* (c.1495–7, Milan, S. Maria delle Grazie, refectory) remains the best-known Christian *istoria* (*see under* genres); the so-called *Mona Lisa*, more properly *Portrait of a Lady on a Balcony* (*c*.1505–14, Paris, Louvre) established a long-lived portrait formula. Even Leonardo's lost or never completed works influenced the evolution of the genres they exemplify; the never-cast equestrian *Monument of Francesco Sforza* in Milan (*c*.1485–93, full-scale clay model destroyed) and its projected reprise, the *Trivulzio monument* (designs, *c*.1508–09); the never-finished mural of the *Battle of Anghiari* (1503–06, Florence, Palazzo della Signoria, Great Council Chamber, now Salone del Cinquecento; painted copies, Munich, Hoffman Coll.; Florence, Uffizi; drawing by *Rubens after an engraving, Paris, Louvre); the lost *Madonna and Child with the Yarnwinder* (*c*.1501, best copy, Scotland, Drumlanrig) and *Leda and the Swan* (*c*.1504–16, best copy, Wiltshire, Wilton Hall); the cartoon (*see under* fresco) of the *Madonna, Child, St Anne and St John* (*c*.1508, London, National and the related unfinished painting of the *Madonna, Child, St Anne and a Lamb* (*c*.1508, Paris, Louvre) – all these furnished contemporaries and later generations with an unendingly fascinating stock of pictorial compositions, poses, facial types and expressions. More general painterly problems were defined and resolved by Leonardo, notably the problem of tonal unity (*see under* colour) which ensures that all the forms represented within a single picture seem to be consistently lit from one or more predetermined light source, regardless of the local colour of any given area. To this end Leonardo evolved his famous *chiaroscuro, in which the tonal structure of the entire painting is established in monochrome, from deepest black shadows to light highlights, then coloured through the application of translucent glazes in varying hues. The early monochrome stages of this procedure can be seen in the unfinished *Adoration of the Magi* (1481, Florence, Uffizi). Leonardo's first use of chiaroscuro as a means of imposing tonal harmony is, however, already observable in the immature but completed painting of the *Annunciation* (*c*.1473, Florence, Uffizi) in which the black underpaint can be seen to 'tone down' the bright hues of the Virgin's garments. More obvious perhaps is the use of chiaroscuro to suggest three-dimensionality, 'relief': the dark 'shadowed' areas seem to recede, the highlights to come forward. The *Annunciation* also demonstrates Leonardo's early interest in the pictorial problem of *perspective. Two kinds of perspective are employed here: *linear*, in which the orthogonal edges of architecture and pavement are carefully inscribed to direct the eye to the vanishing point on the horizon, and *aerial*, in which colours fade gradually to a pale blue haze in the distance. Yet another pictorial device associated with Leonardo appears in a slightly later picture, the portrait of *Ginevra de'Benci* (1474?, Washington, National). This is *sfumato*, the blurring of transitions from dark to light or from one hue

to another. *Sfumato* is used strikingly throughout the *Madonna of the Rocks* (1483–c.6, Paris, Louvre) which is also the earliest completed painting by Leonardo fully to achieve tonal unity. The second version of this subject, an altarpiece of the *Immaculate Conception* (c.1495–1508, London, National), which is not fully complete and may not be autograph in every detail, is darker in tone, anticipating the *expressive mystical *tenebrism of the *St John the Baptist* (c.1509, Paris, Louvre).

Whilst no work of sculpture by Leonardo's own hand survives, *Rustici's bronze group over the north door of Florence Baptistry was executed to his design and under his close supervision.

The large number of unfinished works in Leonardo's *oeuvre*, and the comparatively small number known to have been completed, point to a complex of factors differentiating the artist from most of his contemporaries. Some works, it is true, were abandoned as a result of circumstances beyond Leonardo's control. Thus the *Sforza monument* was left uncast when, with the French invasion of 1494, the required bronze was despatched to be made into cannon. But Leonardo's ever-proliferating studies in other fields absorbed time which might have been devoted to painting or sculpture. Equally important, the evolution of each work, from preliminary ideas relating to the original commission, through to techniques, was at every stage experimental, thus time-consuming and not suitable to be left to assistants. Finally, Leonardo's ideal of finish was very high; the *Mona Lisa*, for example, is built up in innumerable, slow-drying layers of translucent glazes. These temperamental, intellectual and artistic factors were decisive in shaping Leonardo's career.

Born the illegitimate albeit welcomed son of a notary from Vinci near Florence, Leonardo was raised in his father's house and apprenticed, sometime after 1464 (1469?), to Andrea del *Verrocchio. He stayed in his master's workshop after the termination of his apprenticeship, until at least 1476. Verrocchio's influence can be seen to have been immense; most of the motifs of Leonardo's art, and his technical interests, can be traced to his studio. Yet, whilst Leonardo's artistic aims were deeply rooted in Florentine tradition – which he himself traced proudly back through *Masaccio to *Giotto – his disposition ill-suited him to the commercial and competitive practice of art in Florence in the 1480s. Abandoning unfinished the commissioned *Adoration of the Magi*, he left the city c.1482 to enter the service of Duke Ludovico Sforza in Milan. A salaried appointment, varied employment and the intellectual stimulus of a court which drew into its orbit distinguished mathematicians, philosophers, musicians and writers, proved congenial. Leonardo spent 18 highly creative years in Milan, leaving only with the final collapse of Ludovico's reign in 1499. After visits to Mantua (portrait drawing of Isabella d'Este, Paris, Louvre) and Venice, he returned to Florence in 1500. He was to remain there, with lengthy interruptions, until 1508. Despite these interruptions, the Florentine years also

proved remarkably fertile. The overthrow of the Medici in 1494 had resulted in the establishment of a vigorous Republic, unchecked by the execution of Savonarola in 1498, and the broadening of the base of government led to the construction of the huge Great Council Hall and the awarding of the *Battle* commissions to Leonardo and Michelangelo. Although finished paintings were few, Leonardo's compositions attracted interest and excitement from the general public as well as other artists, and his work of these years played a formative role in the evolution of Raphael's style, as well as that of *Fra Bartolommeo and *Andrea del Sarto. Nevertheless, recalled to Milan by a lawsuit over the non-completion of the *Madonna of the Rocks*, Leonardo was persuaded to remain there in the service of the French, hoping to redeem the failure of the *Sforza monument* with an equestrian statue commissioned by Ludovic Sforza's enemy, the mercenary general of the French forces, Trivulzio. In 1513, the French having lost control of Milan to Ludovico's son Massimiliano Sforza, Leonardo had to forsake this project also. Accompanied by his pupils – one of whom, the well-born and educated Francesco Melzi, was to become his literary executor, preserving the precious notebooks – Leonardo now found refuge in Rome under the protection of Giuliano de'Medici, the brother of the newly elected Medici pope, Leo X. After Giuliano's death in 1516 Leonardo accepted the invitation of the French king, Francis I, to join his court at the Château of Cloux near Amboise, where he remained from 1517 until his death two years later. Tradition has it, wrongly, that he died in the King's arms – but it is true that he was fully appreciated, not only for his artistic and technical gifts but as 'a very great philosopher'.

LEONI, Leone (c.1509–90) Tuscan sculptor, active mainly in northern Italy. Like his rival *Cellini he trained as a goldsmith and gained a reputation as a medallist whilst aspiring to execute large-scale works. He was engraver at the papal mint in Rome (1537–40) but was condemned to the galleys for assaulting and disfiguring the Pope's jeweller. Freed in 1541/2 through the intervention of Andrea Doria, admiral of the imperial fleet, Leoni became master of the imperial mint in Milan (1542–5; 1550–89). In 1548 he entered the service of Charles V as a sculptor, executing, mainly in bronze, many portrait sculptures of members of the Habsburg family (Madrid, Prado; Vienna, Kunsthistorisches). His *oeuvre* includes two allegorical portrait groups: *Charles V restraining Fury* (1549–64, Madrid, Prado) and *Ferrante Gonzaga Triumphant over Envy* (1557–94; Guastalla, Piazza Roma). Leoni is the most prolific court portraitist of the Renaissance; his most innovative work, however, is the sculptural decoration of his own house in Milan (Via Omenoni).

His son Pompeo Leoni (c.1533–1608), with whom Leone collaborated on the high altar of the Escorial, executed the bronze portrait statues of Charles V and Philip II and their families for their monuments in the Escorial (1591–8).

LEOPARDI, Alessandro (active after 1482–1522/3). Bronze sculptor, active mainly in Venice, where between 1488–96 he completed the Colleoni monument left unfinished by *Verrocchio, for which he designed the base. His principal independent works are the bases of three flagstaffs in the Piazza San Marco.

LE SUEUR, Eustache (1616–55) French painter, much admired in his day and in the 18th century for combining tender sentiment with the severe *classicism of *Poussin, notably in his series on the *Life of St Bruno* painted 1648–c.50 for the Charterhouse of Paris (now Paris, Louvre). Trained from c.1632 by *Vouet, he imitated his manner until the early 1640s (e.g. Leningrad, Hermitage), turning, however, to Poussin and to *Raphael – whose works he knew only through engravings (*see under* intaglio prints) – in his decorative panels for the Cabinet de l'Amour (c.1646–7) and the Cabinet des Muses (c.1647–9) in the Hôtel Lambert (now Louvre). From c.1650 he modelled his work increasingly on prints after Raphael's tapestry cartoons (*see under* fresco), imitating their fullness of form to the point of caricature (e.g. Paris, Louvre; La Rochelle, Musée; Marseilles, Musée; Tours, Musée).

LEYDEN, Lucas van *See* Lucas van Leyden.

LEYSTER, Judith (1609–60) Precocious Dutch painter; she may have been a pupil of Frans *Hals in Haarlem, and is one of his closest followers. She painted mostly *genre* scenes, but she also did some portraits and *still-lifes. In 1636 she married the *genre* painter Jan Miensz Molenaer (c.1609–1668) and from the 1630s she began to paint small pictures in his manner. There are no works by her dated later than 1652. (Amsterdam, Rijksmuseum; Stockholm, Museum; London, National; etc.)

LIEVENS, Jan (1607–74) Dutch painter, etcher (*see under* intaglio prints) and designer of woodcuts (*see under* relief prints). His reputation has been eclipsed by that of his friend *Rembrandt, but Lievens was a more precocious artist. After two years working in Amsterdam with Pieter *Lastman (c.1617–19, or perhaps c.1619–21) he returned to his native Leiden as an independent artist; the influence of Lastman is evident in his work of the early 1620s (e.g. *The Feast of Esther*, c.1625, Raleigh, North Carolina, Museum). From c.1625–31 he may have shared a studio with Rembrandt; the two young men worked on each other's pictures, and their hands occasionally were, and still are, confused. Lievens' work from this period relies more than before on *chiaroscuro (*Raising of Lazarus*, 1631, Brighton, Gallery; *Prince Charles Ludwig of the Palatinate and his governor as Alexander and Aristotle* (?), 1631, Malibu, Ca., Getty). In 1630 Lievens was adjudged superior to Rembrandt in grandeur of invention and boldness, whilst Rembrandt surpassed Lievens in the expression of inner life. About the time that Rembrandt went to Amsterdam, 1631/2, Lievens departed for England, where he worked as a portrait painter before settling in Antwerp, 1635–44. Having absorbed the influence of *Van Dyck and *Rubens,

he continued to paint in the light, elegant Flemish manner after his return to the Netherlands in 1644. In addition to fashionable portraits, he executed large-scale narrative decorations for the residence of the Princes of Orange, the Huis ten Bosch; for the new town hall of Amsterdam, and for the Rijnlandhuis in Leiden.

LIMBOURG, Pol, Herman and Jean or Jehanequin (recorded from 1399 – all three dead by or in 1416) The Limbourg brothers were apprenticed to a goldsmith, but became illuminators, first for the Duke of Burgundy, 1402–4 (moralized Bible, Paris, Bibliothèque Nationale), and after his death for the Duke of Berry. They illustrated at least part of three *Books of Hours for this patron, including all of the sumptuous *Très Riches Heures* now at Chantilly, Musée (1413–16). It is the first Book of Hours of which the calendar received elaborate full-page illustrations, one for each month, showing the typical activities of the peasants and the seasonal recreations of the nobles. In their mixture of decorative elegance, Italian *idealization (notably in many of the figure poses derived from Italian art), and sharp observation of natural phenomena and social reality, the illuminations of the Limbourg brothers are amongst the most accomplished examples of the International *Gothic style.

LIOTARD, Jean-Etienne (1702–89) Much-travelled painter and pastellist. Born in Geneva, where he settled again in 1758, he studied and worked in Paris, 1723–36. Probably influenced by the success of Rosalba *Carriera on her Parisian visit 1620–1, he specialized in pastel portraits. In 1736 he set out on extensive travels; in Rome he met Englishmen who took him with them to Constantinople, where his stay resulted in *genre* studies of Turkish life and costume. He also worked in Vienna, London and Holland. Within the pastel medium, Liotard achieved remarkably *realistic effects of texture, lustre and reflection – as in the *Maid Carrying Chocolate* (Dresden, Gemäldegalerie). His portraits, too, were sharply realistic, earning from Walpole the exclamation that they were 'too like to please'. There are works by him in Geneva, Musée; London, Victoria and Albert; Amsterdam, Rijksmuseum; Vienna, Akademie.

LIPPI, Fra Filippo (1406/07–69) and his son Filippino (1457–1504) Leading Florentine painters. Filippo, author of many panel paintings and two important *fresco cycles (Prato, cathedral, 1452–64; Spoleto, cathedral, largely executed by assistants, 1467–9) was esteemed by contemporaries for the charm and lively grace of his work, qualities which earned him the patronage and support of the Medici family. Earlier 20th-century critics dismissed him as an ingratiating 'illustrator'. Current opinion sees him as a complex artist, experimental in attempting to reconcile conflicting trends in contemporary art. In his growing interest in aerial *perspective and tonal painting he is viewed as a direct precursor of *Leonardo da Vinci. He was probably the teacher of *Botticelli.

An orphan placed in the friary as a child, Filippo took his vows as a Carmelite in 1421 in S. Maria del Carmine in Florence, where c.1427 *Masaccio and *Masolino were to paint the Brancacci chapel. His earliest work was clearly based on Masaccio (*Reform of the Carmelite Rule*, 1432, fresco fragments from Carmine cloister). He left the Carmine in 1432. Paintings on panel from the 1430s through the early 1450s demonstrate his departure from Masaccio's severe unadorned manner without, however, abandoning its spatial and volumetric implications (*Tarquini Madonna*, 1437, Rome, Nazionale; *Barbadori altarpiece*, 1438, Paris, Louvre; other works Florence, S. Lorenzo, Pitti, Uffizi; Munich, Alte Pinakothek; London, National). Influenced by Fra *Angelico and Netherlandish art, he strove to counteract the pictorially disruptive tendency of single-vanishing-point perspective through colour, used to create a vibrant pattern across the picture surface, and a decorative use of line. In the later 1450s the balance thus achieved was fragmented towards greater decorative fantasy (e.g. *Adoration*, Florence, Uffizi). Finally, late scenes in the Prato frescoes announce the new more monumental style of the 1460s in which deep space is once again emphasized and dualities between *realism and decoration exploited to dramatic ends.

Filippo is notorious for having induced a nun, Lucrezia Buti, to elope with him in 1456; he was then chaplain to her order in Prato. From this union, which was regularized – after years of conflict with the ecclesiastical authorities – through the intercession of the Medici, issued their son, Filippino ('little Filippo'). In Spoleto with his father from 1467-9, the boy returned to Florence after Filippo's death; by 1472 he was working with Botticelli. A number of pictures once attributed to the anonymous 'Amico di Sandro' (friend of Sandro Botticelli) are now assigned to him in the years 1475-80 (e.g. London, National). Between 1481-3 he completed the lower tier of frescoes left unfinished by Masaccio and Masolino in the Brancacci chapel. It was to be the only time he painted in a Masaccio-esque manner; his works, for most of the religious and civic institutions of Florence, are closer to the manner of Botticelli and the young Leonardo da Vinci in their restless play of ornamental lines and planes, and use of Netherlandish colour (e.g. *Vision of St Bernard*, Florence, Badia; *Adoration of the Magi*, Uffizi; other panel paintings in Florence, Pitti; Paris, Louvre; Copenhagen, Museum; Bologna, S. Domenico; Genoa, Palazzo Bianco; etc.). In 1487 he was commissioned to fresco the Strozzi chapel in S. Maria Novella; the work was interrupted in 1488 by a call to Rome to decorate Cardinal Carafa's chapel in S. Maria sopra Minerva (1488-93). The Roman experience was of great importance to the evolution of Filippino's style. The full impact of Rome on the artist can best be appreciated in the Strozzi chapel in Florence, completed in 1502, where Filippino's interest in archeology and his detailed study of *classical sarcophagi and other ancient relief sculptures is fully apparent, especially in the

famous details of musical instruments. The Strozzi chapel decoration, ordered in lunettes and large square pictorial fields instead of the hereto more usual tiers, is poised visibly at a point of transition in Florentine art between the Early and the High *Renaissance.

LISS, or LYS, Johann or Jan or Giovanni (c.1597–1629/30) Eclectic German-born painter who had a great influence on subsequent Venetian artists, particularly in the 18th century (see especially *Piazzetta, *Pittoni, Sebastiano *Ricci). He settled in Venice in 1629, shortly before the advent of the plague which killed him, and after a brief preliminary visit in 1621. His late style, anticipating the *Rococo, is best seen in his much-copied altarpiece of the Vision of St Jerome (c.1628, Venice, S. Nicolò da Tolentino); it was preceded by a variety of other styles reflecting his earlier travels. From c.1615–19 he had worked in Haarlem, Amsterdam and Antwerp, coming into contact especially with *Hals and *Jordaens. On his first stay in Venice he was most affected by Domenico *Fetti, who showed him how to translate into Italian terms his small-scale Dutch-inspired *genre pictures. A stay in Rome c.1622-mid-to-late 1620s introduced him to the work of *Caravaggio, Annibale *Carracci, and northern artists such as *Elsheimer and the brothers *Brill. By the time of his second stay in Venice his idiom was more truly *Baroque than that of any other artist who had worked there, and, as we have seen, he quickly moved towards that even greater freedom of handling and disintegration of form characteristic of the Rococo. There are only a few paintings by Liss, some in Venetian private collections; Berlin-Dahlem, Museen; London, National.

LOCHNER, Stephan (active from c.1430–51) The outstanding painter in Cologne, where he is first recorded in 1442. In the course of his career he succumbed increasingly to Netherlandish influences, modifying his own decorative International *Gothic style towards greater naturalism (see under realism) but without ever compromising the soft and luminous prettiness of his work, even in scenes of martyrdom and the torments of the damned (Last Judgement altarpiece, c.1435–40, central panel Cologne, Wallraf Richartz, wings Frankfurt, Kunstinstitut; Munich, Alte Pinakothek). His major painting, which Albrecht *Dürer paid to be shown in 1520, is the Adoration of the Magi, combining the *iconography of an Adoration with that of a *maestà (c.1440, Cologne, cathedral). But he is perhaps best known for the sweetness of his Madonna pictures, notably the Madonna in the Rose Bower (c.1438–40, Cologne, Cathedral). (Other works in Cologne, Archiepiscopal; Lisbon, Gulbenkian Coll.; and London, National). His one dated picture, a Presentation in the Temple, 1447, is in Darmstadt, Museum.

LOMBARDO or LOMBARDI, Pietro, Antonio and Tullio See Pietro Solari.

LONGHI, Pietro (1702–85) Venetian painter of aristocratic and bourgeois *genre, somewhat flattering recorder of the life and

entertainments of polite society, always in a small format. (Venice, Querini-Stampalia, etc.). His son, Alessandro (1733–1813), was a well-known portrait specialist, and the author of a book on contemporary Venetian painters (*Compendio delle Vite . . ., 1762*).

Loo, van A dynasty of successful painters, of whom the most important is Carle van Loo or Vanloo, as he was known in France (*see below*). The eldest, Jacob van Loo (*c.*1615–70) was a Flemish-born Amsterdam painter of aristocratic *genre and small-scale biblical and mythological pictures (Leningrad, Hermitage; Glasgow, Gallery). He settled successfully in Paris in 1661. His son, Louis Abraham (*d.*1712) in turn had two sons trained as painters: Jean-Baptiste (1684–1745) and Charles-André, called Carle (1705–65).

After training as a history painter (*see under* genres) in Rome and Genoa, Jean-Baptiste van Loo worked as a court painter in Turin, 1712–19. From 1719–37 he was employed in Paris, painting pictures for churches and achieving fashionable success with an equestrian portrait of the youthful King Louis XV, 1723. In 1737, however, he moved to London, quickly establishing himself as a leading portrait painter, patronized by the Prince of Wales and the Prime Minister, Sir Robert Walpole (Rousham, Oxon; Leningrad, Hermitage; London, National Portrait; Paris, Louvre and various churches; Versailles; etc.). In 1742 he retired through ill-health, returning to his birthplace, Aix-en-Provence, where he died. Jean-Baptiste taught his much younger brother Carle, as well as his own sons, Louis-Michel (1707–71; *see below*), François, who was killed in an accident in Italy while still a student, and Charles-Amédée-Philippe (1715–95), who became rector at the French Royal *Academy and later served at Berlin as court painter to Frederick the Great.

Carle van Loo, only fourteen on his brother's return to France in 1719, was enrolled at the Academy, winning a medal for drawing and first prize for painting in 1724. These successes were repeated at the French Academy in Rome (first prize, 1727). Carle, precocious, industrious and amiable, if by all accounts stupid and uncultivated, quickly rose to be one of the most admired painters of his day. He modelled himself on *Raphael, the *Carracci, *Domenichino, and *Maratta, forging a rather bland and dry version of the Grand Manner. In view of his untiring production of decorative paintings for public spaces (Turin, 1732–4; Paris, Hôtel de Soubise, 1737), solemn, enormous altarpieces and cycles of paintings for Paris and other French churches (Paris, Saint-Sulpice, 1739; Saint-Eustache, 1742; Notre-Dame-des-Victoires, 1746, 1753–5; Besançon, Cathedral, Chapelle du Saint-Suaire, 1740–50), large-scale history paintings on *Classical themes (such as his self-chosen reception piece at the Academy, *Apollo flaying Marsyas*, 1735, Paris, Ecole des Beaux Arts; *Augustus closing the Doors of the Temple of Janus*, *c.*1750; *Sacrifice of Iphigenia*, painted for Frederick the Great, 1757, Potsdam, Neues Palais), and his etchings of academy

nudes, c.1743, it is ironic that by the end of the century Carle van Loo
should have been reviled as the arch-exponent of effeminate *Rococo.
In addition to his works in serious modes, however, Carle also pro-
duced more typically Rococo pictures: exotic hunts for the King's
private apartments at Versailles (1738/9, now Amiens, Musée; *Bou-
cher was also employed on this decoration); modern dress *fêtes galantes
(e.g. Rest during the Hunt, 1737, for the King's private dining room at
Fontainebleau, now Paris, Louvre); elegant genre with exotic costumes,
Spanish (Leningrad, Hermitage) and Turkish (London, Wallace) and
even decorative landscapes.

In 1762 Carle was made Premier Peintre to the King, and became
Director of the Academy in 1763. Although he had showed full-length
portraits of the Queen (1747) and King (1750; Versailles) and a self-
portrait (1753) at the official Academy exhibitions, Carle was later to
eschew portraiture, perhaps because it had become the exclusive
speciality of his talented nephew Louis-Michel. An equally successful
student at the Academy, Louis-Michel had accompanied his uncle to
Rome, and spent the years 1727–33 in Italy. From 1737–52, he was
portrait painter to the Spanish court of Philip V at Madrid, where he
was instrumental in the founding of the Spanish Academy of San
Fernando (1752). There are royal portraits by him in the Prado,
Madrid, and a likeness of Philip of Bourbon, Duke of Parma (c.1739) in
Mexico (F. Gonzales de la Fuente). After his return to Paris, he execut-
ed formal state portraits of Louis XV (c.1761; one of many versions is in
London, Wallace) but was also capable of spirited studies of character,
such as his half-length likeness of the philosopher, essayist and critic
Diderot (1767, Louvre). He painted a large-scale group portrait of the
family of his uncle Carle (Paris, Arts Décoratifs), and succeeded Carle
as governor of the Academy School.

LORENZETTI, Ambrogio (active 1319–48?) and his brother Pietro
(recorded from 1320–48?) Sienese painters, contemporaries of
Simone *Martini and like him influenced by *Duccio. They were even
more affected by Duccio's experiments in descriptive *realism than by
his decorative effects, although Ambrogio's Madonna and Child
pictures in particular demonstrate his supreme sensitivity to two-
dimensional patterning as well as his acute powers of observation (see
e.g. the Madonna del Latte, mid-1320s? Siena, Seminary). Both brothers
formed connections with Florence, and, responding to the art of
*Giotto, they in turn influenced his Florentine followers, notably Tad-
deo *Gaddi and Bernardo *Daddi. Like Duccio and Giotto before them
they looked closely also at the work of Giovanni *Pisano. Their own
daring experiments in representation were cut short by the Black Death
of 1348.

Ambrogio was probably the younger and the more innovative of
the two. His evocations of antique prototypes remained famous even
during the *Renaissance, the best-known being the personification of

Peace in the fresco of *Good Government*, (Sala de'Nove, Siena Town Hall). Here the political ideals and effects of *Tyranny* and of a Sienese-type of *Good Government* are contrasted (1338–9). Scholastic allegory is combined with panoramic views of city and countryside, renowned both for their poeticized naturalism of detail and their system of synthetic *perspective, in which diminution proceeds in all directions from a focal point in the centre. Ambrogio's interest in landscape is manifested also in the two small panels (mid-1320s? Siena, Pinacoteca) which are the earliest surviving pure landscape paintings in Italian art.

Less well known than the Town Hall murals but equally astonishing are two frescoes in S. Francesco, Siena, removed from the now-destroyed chapter house. The *Franciscan Martyrdom* demonstrates complex *foreshortenings, and the *Reception of St Louis of Toulouse* accommodates a superbly individuated crowd into an ample architectural interior whose spatial clarity is unprecedented. The same can be said for Ambrogio's last surviving dated picture, the panel of the *Annunciation* (1344, Siena, Pinacoteca) in which a true vanishing-point perspective is approximated.

Pietro's most important surviving works are the frescoes in the lower church of S. Francesco, Assisi (mid-1320s-early 1340s), combining Ducciesque *iconography with Giotto's dramatic economy. The triptych of the *Birth of the Virgin* (1342, Siena, Cathedral Museum) exploits the frame of its separate pictorial fields to represent a unified, complex architectural space, elaborating notions already embodied in Pietro's Arezzo polyptych (1320, Arezzo, Pieve). The brothers collaborated in 1335 on frescoes for the façade of the hospital of S. Maria della Scala, Siena, now lost, and it is apparent that despite stylistic differences they shared ideas and exchanged designs throughout their working lives, anticipating many developments of 15th- and 16th-century art, and unsurpassed in any period for originality and profundity.

LORENZO DI CREDI *See* Credi, Lorenzo di.

LORENZO MONACO (*c.*1370–1424) Possibly Sienese-born Florentine painter, a Camaldolese monk in the monastery of S. Maria degli Angeli, Florence, by 1391. He was to transmute the sober, monumental style of Agnolo *Gaddi, *Spinello Aretino and other late 14th-century Florentine artists into a graceful, sophisticated calligraphic idiom which was related both to earlier Sienese painting (e.g. *Duccio, Simone *Martini) and contemporary International *Gothic, and was influential on later Florentine art, e.g. *Masolino. There are panels by him in Florence, Accademia, Uffizi; Monte San Savino, S. Maria delle Vertighe. His only sizeable extant work in *fresco is the Bartolini Salimbeni Chapel, Florence, S. Trinità (*c.*1423), for which he also executed the panel altarpiece.

LORRAINE or LE LORRAIN *See* Claude Gellée.

LOTTI, Lorenzo *See* Lorenzetto.

LOTTO, Lorenzo (*c*.1480–1556/7) Peripatetic and eclectic Venetian-born painter. Widely cultured but intensely pious and disquiet, he was unable to compete successfully with his more urbane Venetian contemporaries (*see* Giorgione, Titian) and worked mainly in provincial centres. The originality and high quality of his *oeuvre*, dispersed and various in style, have been appreciated only since the late 19th century.

Lotto is first documented at Treviso, 1503–06, then in the Marche (*polyptych for Recanati, S. Domenico, 1506–08, now in Pinacoteca Comunale). In 1509 he was paid for work in the **stanze* in the Vatican, alongside *Raphael; his role in Rome has not been identified, but mutual influences are acknowledged. By 1512 he was once again in the Marche, but from 1513–25 he settled in Bergamo, where he executed major altarpieces, portraits and devotional pictures for private houses (Bergamo, S. Bartolomeo, S. Spirito, S. Bernardino, Accademia; Madrid, Prado; Leningrad, Hermitage; Rome, Nazionale; London, National; etc.). Towards the end of his stay in Bergamo he also began supplying the designs for the marquetry of the choir stalls in S. Maria Maggiore, 1524–33. In 1524 he frescoed the oratory of the Suardi family at Trescore, in the Alpine foothills near Bergamo. For purposes of popular religious instruction, this astonishing decoration employs an archaicizing 'vernacular' idiom, executed, however, with sophisticated pictorial means.

In 1526 Lotto moved to Venice (Venice, Carmine, Accademia) continuing to supply works also to provincial patrons. Prolonged visits to the Marche (1534–9; e.g. Jesi, Biblioteca) and Treviso (1542–5) testify to his lack of success in his native town. In 1550 he tried but failed to raise money with a public auction of his paintings in Ancona. Finally, in 1552, the impoverished and tragic old man sought refuge in the Holy House at Loreto, where he became a lay brother, continuing, however, to paint (Loreto, Pinacoteca, Palazzo Apostolico). His last work, the probably unfinished *Presentation in the Temple*, is one of the most personal and moving pictures of the century.

During his long career, Lotto absorbed many diverse influences, forging them into a variable but intensely individual idiom. His basic vocabulary, derived from Giovanni *Bellini, was enriched through the experience of northern European art, to which his long stay in the sub-alpine Lombardo-Venetian provinces made him receptive. The direct influences of *Grünewald, *Altdorfer, *Dürer and *Holbein have all been detected in his work, as well as those of northern Italian mediators between German and Italian modes, such as *Pordenone. Perhaps his deep and highly emotional religious convictions also predisposed him to the Christian *expressivity of German art, as they made him attend to the vernacular art of provincial craftsmen-artists. At the same time, he was well aware of central Italian *Renaissance developments. His final stay in Venice exposed him to the mature works of Titian. But his own pictorial intelligence and originality radiate through

all his works – from the great altarpieces to the psychologically search-ing portraits of which he is one of the finest masters. In addition to the works already cited, there are paintings by him in Paris, Louvre; Vienna, Kunsthistorisches; Naples, Capodimonte; Hampton Court; Rome, Borghese; Milan, Brera; Philadelphia, Museum; Cambridge, Mass., Fogg; etc.

LOUTHERBOURG, Philip James de (1740–1812) Alsatian-born painter of battle scenes, shipwrecks and landscapes, a member of the French *Academy from 1767. In 1771 he came to London, and from 1773–81 was stage and scene designer at the Drury Lane Theatre. He made many technical innovations increasing the range and credi-bility of natural effects on stage; in 1778/9 he staged a pantomime, *The Wonders of Derbyshire*, which concentrated exclusively on landscape as a form of theatrical representation, and for which he studied well-known Derbyshire views. The idea was further developed in his own pano-ramic moving peepshow, the *Eidophusikon* (1781) in which landscape painting, combined with artful lighting and sound effects, simulated a wide range of natural phenomena, from the cheerful to the *Pictur-esque and the *Sublime. He also depicted the dramatic new landscape of the Industrial Revolution. In 1805 he published *The Romantic and Picturesque Scenery of England and Wales*. De Loutherbourg's work, whilst not perhaps itself 'high' art, was an important influence on Romantic painting (*see* especially Turner, Volume Two); his *Eidophusikon* inspired the Showbox, with its paintings on glass, of *Gainsborough.

LUCAS VAN LEYDEN (*c.*1489–1533) Dutch painter, draughtsman and engraver, one of the most important artists of the 16th century. A pioneer of *genre* painting, he was innovative also in landscape and generally in spatial and narrative construction. Originally influenced by *Dürer, *Gossart, Jacopo de' *Barbari and by direct contact with Italian prints and paintings, he in turn exercised great influence, notably on Italian artists, through his 172 engravings (*see under* intaglio prints). The engraver Marcantonio Raimondi (*see under* Raphael), the Florent-ine painters *Andrea del Sarto and *Pontormo, and others, borrowed motifs from his prints; *Vasari proclaimed him to have been an even better artist than Dürer. *Rembrandt was to be inspired by his engraving of the *Ecce Homo*, 1510.

A youthful prodigy, Lucas studied first with his father, the Leiden painter Hugo Jacobsz.; after the latter's early death he entered the workshop of Cornelis Engelbrechtsz. Soon, however, he was working independently; the first dated work is the accomplished engraving of *Mohammed and the Monk Sergius*, 1508. His early paintings, such as the *Adoration of the Magi* (*c.*1500–10, Merion Station, Pa., Barnes Coll.) already show an interest in deep space contrary to the emphasis on surface ornamentation of his teacher, and this interest is combined with one in Italianate *Renaissance architecture and *perspective in the *Ecce Homo* already mentioned. The earliest known *genre* scenes date from

c.1510 (*Chess Players*, Berlin-Dahlem, Museen; also *The Card Players*, *c*.1514, Salisbury, Wilton House; *Gambling Scene*, *c*.1520, Washington, National). These paintings of half-length figures grouped around a gaming board or table were probably meant to convey moral overtones. The suggestion is given additional weight by their later full-length transformation in the small but monumental *triptych *Worship of the Golden Calf* (*c*.1525, Amsterdam, Rijksmuseum), where the moral message is unambiguous.

There are other paintings by Lucas in Leiden, Museum; Leningrad, Hermitage; London, National; Munich, Alte Pinakothek; Boston, Museum; Amsterdam, Rijksmuseum; Paris, Louvre. A small self-portrait, *c*.1525(?) is in Brunswick, Museum. Most important print collections have copies of his engravings, which combine northern and Italianate modes of hatching.

LUINI, Bernardino (*c*.1480–1532) The Milanese painter most obviously influenced by *Leonardo da Vinci, albeit only in superficial traits such as facial types and expressions, and, in easel works, an exaggerated *chiaroscuro. Where he did not copy Leonardo's designs he remained an old-fashioned Lombard artist, and was consequently very popular with his conservative provincial patrons, especially as an executant of decorative narrative *fresco cycles (e.g. Chapel of S. Giuseppe, formerly Milan, S. Maria della Pace, now Brera; decorations for Robia family houses, now Washington, National; Berlin-Dahlem, Museen; etc.; Saronno, S. Maria dei Miracoli – *see also* Gaudenzio Ferrari). Other paintings are in London, National; Cambridge, Mass., Fogg; Paris, Louvre; etc.

LYS, Jan *See* Liss, Johann.

MABUSE *See* Gossart, Jan.

MADERNO, Stefano (*c.*1576–1636) Lombard-born *classicizing sculptor working in Rome, initially as a restorer of antiques, then making terracotta reductions of classical statues (e.g. Venice, Ca d'Oro; Leningrad, Hermitage), many of which were also cast in bronze. He is celebrated for his recumbent life-size statue of *St Cecilia* (1599–1600, Rome, St Cecilia in Trastevere), which commemorates the discovery of the martyred saint's body in 1599 and is supposedly based on direct study, although it actually reflects a Hellenistic sculpture.

MAES, Nicolaes (1634–93) Dutch painter, best known for his *genre* pictures of the domestic life of women and children, painted between *c.*1654–60. He was a pupil of *Rembrandt, whose *chiaroscuro he adopted in these paintings, and whose Holy Family motifs he secularized. After 1660, however, Maes abandoned *genre* painting and became a portrait specialist, lightening and brightening his colours in accordance with Flemish and French fashion. There are paintings by him in Amsterdam, Rijksmuseum; in his native Dordrecht, Museum; and in many major collections outside Holland.

MAESTÀ In Italian art, a large-scale representation of the Madonna as Queen of Heaven, enthroned in majesty amongst saints and angels with the Christ child on her lap. The term is usually reserved for 13th- and 14th-century examples, such as *Duccio's *Maestà*, formerly the high altarpiece of Siena cathedral (completed 1311). Later and more intimate versions of the theme are called *sacre conversazioni* (sing. *sacra conversazione*).

MAGNASCO, Alessandro (often called Lissandrino) (1667–1749) Genoese specialist in macabre and fantastical *cabinet pictures. His rapidly darting, flickering brushstroke can be traced to the late studies of *Castiglione; the disquieting content of his pictures, however, owes more to *Callot or *Rosa's scenes of witchcraft. Magnasco went as a youth to Milan, where, excepting for a stay in Florence *c.*1709–11, he remained until 1735. There are paintings by him in Milan, Castello, Poldi Pezzoli; Genoa, Palazzo Bianco; Cleveland, Ohio, Museum; etc.

MAINARDI, Sebastiano *See under* Ghirlandaio.

MAINO, Juan Bautista *See* Mayno, Juan Bautista.

MAITANI, Lorenzo (*c.*1270–1330) Sienese architect and sculptor. He was master of works for Orvieto Cathedral from 1310 until his death, and designed the façade with its unique marble reliefs, the finest of which are attributed to him. French *Gothic ivory carvings may have influenced his sculptural style, and he in turn may be an influence on Andrea *Pisano.

MAJANO, Benedetto and Giuliano da *See* Benedetto da Majano.

MANDER, Karel van (1548–1606) Flemish-born painter, poet and theoretician of art. His stay in Italy from 1573–7 inspired his important treatise on painting, *Het Schilderboek* (1604). This contains the first extensive account of the lives of the major northern European artists of the 15th and 16th centuries, for which it remains a principal source; a condensed Dutch translation of *Vasari's *Lives of the [Italian] Artists* (1568), with original additions of later material; and a long poem, 'The Fundamentals of the Noble and Liberal Art of Painting', which adapts current Italian art theory and the social aspirations of Italian artists to the northern context. In 1583 van Mander fled his native land for Haarlem in the northern Netherlands to escape the effects of the war with Spain. With *Cornelis van Haarlem and *Goltzius he is one of the originators of the Italianate style known as Haarlem *Mannerism. His own paintings, however, by no means all conform to his own precepts, but include also rustic **genre* (Leningrad, Hermitage).

MANFREDI, Bartolomeo (1582–after 1622) Mantuan-born Roman painter, imitator of *Caravaggio, the low-life aspects of whose art he exaggerated to the detriment of spiritual qualities. He executed Caravaggesque **genre* subjects, which had been characteristic of Caravaggio's early, light-hued phase, in the *tenebrist manner of Caravaggio's later style. His work, known only from *c.*1610, has sometimes been confused with that of *Valentin. It is Manfredi, more than Caravaggio himself, who influenced the northern *Caravaggisti* in Rome (*see* e.g. Honthorst; Terbrugghen). (Rome, Nazionale; Vienna, Kunsthistorisches; Brussels, Musées; etc.)

MANNERISM A style label applied to certain types of art produced *c.*1520–*c.*1580, mainly in central Italy, and diffused thence to France, the Netherlands, Spain and the imperial courts in Prague and Vienna. Mannerism is interposed in the history of styles between High *Renaissance and *Baroque art. There is little consensus, however, amongst historians as to the canon, the distinguishing formal characteristics, and the significance of Mannerist art. The word derives from the Italian *maniera*, which has a long history of usage in the literature of manners and the arts before being incorporated into a visual style label (by Luigi Lanzi in 1792). *Maniera* has neutral, favourable and pejorative meanings. It can signify 'style' in the sense of 'stylish' or as a style associated with a place, a period or an individual. It can denote knowledge of the 'rules', as for example the *Classical orders of architecture. It can mean technical facility and, by extension, excessive facility deployed at the expense of study either of nature or of the problems of representation: reliance on stereotype.

This critical polyvalance persists in modern definitions of Mannerism, which in turn colour our perceptions of the works of art to which they are attached. Mannerist art has been variously defined as decadent; as a conscious rebellion against the *classicizing ideals of the

High Renaissance, symptomatic of 'anguish', either of 'the age' or of 'neurotic' individuals, or of 'higher spirituality'. More recently, Mannerism has been viewed as an art of courtly artifice, refinement and elegance, *expressive works being excluded from the canon. Each of these definitions may apply with greater or lesser truth to some work of art of the 16th century. They err, as do all essentialist definitions of style, in postulating a single descriptive and explanatory principle. Mannerism is not a coherent movement on the 20th-century model of an association of artists pursuing a joint programme. Insofar as the term has general applicability, however, this depends on the following. Mannerist artists and their courtly or metropolitan audiences shared a certain sophistication, the knowledge of various artistic modes transcending local schools. In particular, they shared a reverence for High Renaissance art, notably the work of *Michelangelo: his almost exclusive concentration on the human figure, his ideals of youthful grace or mature musculature, his formulae of *contrapposto, etc. His use of the antique relief style for painting (Battle of Cascina), as well as sculpture, was widely emulated (by *Pontormo, *Rosso Fiorentino, *Bronzino amongst others). With this precondition, Mannerism embraces different kinds of art, and Mannerist artists sought out influences to suit their needs and the task in hand. *Polidoro's monochrome façades for Roman town houses (1520s) are painted with antique motifs in the antique relief style, but his 1534 altarpiece of Christ Carrying the Cross for a Spanish congregation in Sicily (now Naples, Capodimonte) mingles Flemish references with a schema derived from a *Raphael prototype itself based on a *Dürer print. The visionary and expressive religious paintings of Pontormo, and to a lesser extent those of the young Rosso, also depend on Dürer prints. *Parmigianino emulates the suavity of Raphael, joined to the colourism of his great compatriot from Parma, *Correggio, and occasionally conflated with Michelangelesque echoes. The decorative schemes for state apartments invented (1540s–70s) by *Vasari, *Perino del Vaga, *Salviati, Pellegrino *Tibaldi and others, draw their inspiration from princely festival entries and masques as much as from Raphael's *Stanze and Michelangelo's Sistine Chapel ceiling, whilst *Giulio Romano's Mantuan decorations assimilate antique motifs and style (and sometimes – as in the Sala dei Giganti in the Palazzo del Tè, 1537 – a nearly style-less *illusionism). The Grand Ducal sponsorship of Giovanni *Bologna's Florentine bronze workshop, and the use of his small bronzes as diplomatic gifts, account in great measure for their complex, unfeeling, preciosity; his religious works and large equestrian statues are far simpler and more direct of address. If High Renaissance art at its most characteristic is a harmonious balance of illusionism, *idealization, and expression, Mannerism is less a single style than a willingness by artists to tip that balance in one direction or another, their ability to differentiate between representation and stylization.

MANTEGNA, Andrea (1430/1–1506) Outstanding northern Italian painter, engraver (*see under* intaglio prints) and occasional sculptor; influenced by his friend *Alberti, he also practised as an architect. From 1460 until his death – except for 1488–90 when he was allowed to work in Rome on a papal chapel (destroyed in the 18th century) – he served as court painter to the Gonzaga at Mantua. Conservative in certain technical respects – he continued to work meticulously in tempera at a time when most artists were experimenting with oils – he was innovative in *perspective and in recovering the detailed appearance of Graeco–Roman antiquity, the remains of which he studied and collected. He was the first artist of the *Renaissance to clothe *classical and mythological scenes in (nearly) accurate antique costume and appurtenances. Although 16th-century artists and critics had reservations about his dry, precise pictorial style, they continued to praise his skill in devising *illusionistic schemes, notably the *frescoes of the so-called Camera degli Sposi completed in 1474 in the ducal palace at Mantua (*see below*). Cosmè *Tura, *Crivelli and Gentile and Giovanni *Bellini – whose sister he married in 1453 – are amongst the artists most directly influenced by Mantegna's style as a whole; *Correggio's dome paintings in Parma, on the other hand, owe only their illusionistic perspective to him. Although Mantegna's works in reproduction look, and are often said to be, linear, many of his easel paintings (as well as the *Triumphs of Caesar* discussed below) are executed on coarse canvas which blurs and softens the hard edges. Thus the linearity of his imitators, including the youthful Giovanni Bellini, in fact often exceeds his own.

Between 1441–5 Mantegna trained under his 'adoptive father', the mediocre Paduan tailor-turned-painter Francesco Squarcione (1397–1468). Squarcione's importance as a teacher may have been exaggerated, but he trained able students (*see* e.g. Vivarini), and had accumulated a large collection of casts after ancient sculpture, recent 'advanced' works of painting, and drawings. His own style, influenced by Filippo *Lippi, is known now only through two works (Padua, Museo; Berlin-Dahlem Museen). It demonstrates a romantic, excitable attitude *vis-à-vis* the antique and an *expressive use of line – traits which left their mark on Mantegna. Probably more influential, however, on the precocious young artist (who was to be locked in lawsuits with his former teacher from 1448–57) were the Paduan works of *Donatello and the Venetian works of *Uccello and *Andrea del Castagno; he must have also known the now-lost paintings of *Piero della Francesca in Ferrara.

In 1448 Mantegna, not yet of age, was contracted for part of the decoration of the Ovetari Chapel in the church of the Eremitani in Padua, along with Antonio *Vivarini and Giovanni d'Alemagna. In the event, Mantegna executed most of the frescoes, including scenes from the *Lives of Sts James and Christopher* (completed by 1457). Most of the

cycle was destroyed in an air raid in 1944. Surviving remnants and earlier photographs demonstrate, however, the striking novelty of Mantegna's rigorous application of perspective to the various tiers of the cycle and his almost obsessive recreation of the material culture of ancient Rome.

The next most important work initiated by the artist before his removal to Mantua in 1460 was the *San Zeno* altarpiece for S. Zeno in Verona (main panels *in situ*, original *predella panels now Paris, Louvre and Tours, Musée). Technically a *triptych, the altar daringly creates spatial unity between its painted portions and the wooden architecture of the frame, designed by Mantegna. It reflects the bronze structure erected by Donatello on the high altar of the Santo in Padua.

Of the many works executed during Mantegna's long tenure at the Gonzaga court, which included portraits (e.g. Naples, Capodimonte), small devotional pictures, both with full-length figures and in half-length (e.g. Florence, Uffizi; Milan, Brera; Vienna, Kunsthistorisches) altarpieces and allegories (see below), the most important are the frescoes of the *camera picta*, the painted room now known, inaccurately, as the Camera degli Sposi or 'bridal chamber', and the nine large canvases of the *Triumphs of Caesar* (now Hampton Court). The decoration of the *camera picta*, a square tower room in the oldest part of the ducal palace complex in Mantua, was executed in 1465–74, partly *a secco* on dry plaster and with an oil varnish (which accounts for its poor state of preservation but probably also for the glowing, festive colours). It consists of a vaulted ceiling painted illusionistically to resemble white stucco reliefs of Roman emperors and mythological scenes set against a gold mosaic background. In the centre an equally fictive *oculus*, or round opening (like the real one in the Roman-built Pantheon in Rome) 'opens' to the sky. Ladies of the court, servants, a peacock, playful winged *putti look down, leaning against the simulated marble balustrade, on which a potted orange shrub balances precariously – all in masterful *foreshortening. The actual architecture of the room, once an audience chamber, has been transformed in paint into an open loggia. On two walls, painted brocade curtains are drawn between fictive pillars; on the other two, the curtains are 'pulled back' and looped to reveal a *Court Scene* above the fireplace and *The Meeting* on the wall left of it. Both include portraits of members of the Gonzaga family and court (including Ludovico Gonzaga's much-loved old dog, Rubino, lying under his master's chair). Two illustrious visitors, never actually present in Italy at the same time, the Emperor Frederick III and King Christian of Denmark, are inserted into the *Meeting* scene. The unaffected naturalism (*see under* realism) of the portraits and their vivid immediacy have tempted scholars to identify the particular occasions represented, but no allusion to specific events may be intended. What is stressed is the continuity of the dynasty and its secular and ecclesiastical standing and the affectionate, self-assured ambience at court. All are

depicted in contemporary dress, but the Roman allusions of the fictive architecture hint at ancient lineage and feudal allegiance to the Holy Roman empire; *putti*, horses and dogs animate the scenes, touches of tenderness and informality humanize them. The ideological value of naturalism has never been more apparent: Mantegna's 'unflattering' art makes us believe in the innate dignity of his sitters, the harmony of their relations with servants and dependants, their natural right to rule.

In contrast, the *Triumphs of Caesar* (in fact only the Gallic Triumph as described in ancient and contemporary texts), painted for no known permanent location probably between *c.*1484–*c.*1506, makes no overt reference to the Gonzaga. The theme was an accepted one for the decoration of princely palaces and may have been selected as congenial to the artist, who was therefore likely to exploit his talents to the full, and thus reflect glory on his patrons – as indeed became the case. No other work shows better his empathy with the culture of ancient Rome, and his ability to deploy archeological material in an intensely poetic way. All but one of the tempera paintings have recently been cleaned of the disastrous paraffin-wax impregnation inflicted by an earlier restorer and are once again visible in something approaching to their original state.

Of Mantegna's other works mention must be made of the *Madonna della Vittoria*, commissioned in 1495 to commemorate Francesco Gonzaga's inconclusive victory over the French at Fornovo (now Paris, Louvre). Mantegna's interest in Flemish painting (*see especially* van Eyck) can be deduced from the meticulous depiction of surface textures. In 1497 he completed the first of his two allegorical paintings for the *studiolo* of Francesco's wife , Isabella d'Este: the *Parnassus*; the second, *Minerva expelling the Vices*, was finished in 1504; a third, *Myth of the God Comus*, was completed after Mantegna's death by Lorenzo *Costa (all now Paris, Louvre). Finally, the National Gallery in London now owns a remarkable *Introduction of the Cult of Cybele to Rome* (1505–06) painted for Francesco Cornaro, a Venetian tracing his lineage to one of the ancient Roman protagonists in this event. Mantegna has painted the scene in a kind of multi-coloured **grisaille* to resemble a large agate cameo. The work not only brings to life an episode of Roman history, in a medium recalling the ancient art forms of stone relief and cameo gems – it also defies the angry criticism of his first teacher and exploiter, Squarcione: 'Andrea [should] have painted his figures ... as if they were of marble seeing that [they] resembled ancient statues ... rather than living creatures.' The magic of the painting, and of Mantegna's art, is that its figures resemble *both* ancient statues *and* living creatures, the most perfect 15th-century evocation of antiquity.

MANUELINE STYLE Portugese style of sculptural decoration flourishing from 1450–1540. It is named after King Manuel, and includes motifs from Portugal's overseas enterprises of navigation and exploration: crocodiles, exotic plants, African angels, seashells, etc., as

well as figures from the medieval bestiary and Italianate *Renaissance ornaments. Its chief exponent was Diogo Pires the Younger (active 1511–35).

MARATTA or MARATTI, Carlo (1625–1713) Roman painter born in the Marche; the chief pupil of Andrea *Sacchi, whose studio he joined at the age of 12 and remained connected with until Sacchi's death in 1661. An artist of great distinction if not striking originality, he forged an individual style reconciling his master's *classicism (with its strong debt to *Raphael) with certain *Baroque tendencies. The resultant grand manner, sometimes dramatic, always clear and dignified, had by 1700 replaced the *Baroque style of *Pietro da Cortona and *Bernini (see also Gaulli). By 1680 Maratta had acquired international fame as the greatest painter of his age. His reputation has been devalued since, however, largely because later generations judge him through studio works and the innumerable copies and replicas of his many small Madonna and Child pictures. There are altarpieces by him in Roman and Sienese churches. He also worked in *fresco (1676 onwards, Rome, Palazzo Altieri) and was an admirable official portraitist (e.g. Vatican, Pinacoteca). His many pupils contributed to the success of Maratta's manner in Rome and throughout European courts (but see the counter-vailing influence of *Pozzo in Austria and Germany).

MARINUS van Reymerswaele (active c.1509–after 1567) A Nether-landish painter whose identity and biography have not been decisively established from documentary evidence. Reymerswaele or Roymerswaele was a place in Zeeland. The name appears as a signature on a group of pictures portraying half-length figures of St Jerome; Two Tax Gatherers; and a Banker (or money-changer) and his Wife; these images are repeated in many variants. All are painted in brightly lit and extravagant detail, and all (with the partial exception of St Jerome) are grotesque, probably satirizing different types of human folly, such as pedantry, greed, avarice, etc. The formula of the grotesque half-length secular representation may be related to Metsys, but the format and the subjects themselves are not rare in Netherlandish art, and half-length grotesque figures are depicted in a religious context, the Mocking of Christ, by Hieronymus *Bosch. It is now usually said that the purpose of Marinus' works is unclear, but that may be because we no longer relish the combination of elaborate execution with humour and satire, which we can accept best on a reduced scale in drawings or prints. Yet in the Late Middle Ages, the *Renaissance and even the 17th century, humour and satire were as much appreciated in all forms of the visual arts as they were in literature, especially in northern Europe. At any rate, not only were Marinus' pictures popular enough for him to replicate, but they were much imitated by other, anonymous, artists. Probably the best example of Marinus' Tax Gatherers is in London, National; other works by him are in Antwerp, Musées; Madrid, Prado; Vienna, Kunsthistorisches; etc.

MARTINI, Simone (recorded from 1315–44) Italian painter, praised by Petrarch (Sonnets 57, 58), for whom he executed a portrait of Laura, now lost, and decorated a manuscript of Servius' *Commentary on Virgil* (1340–4, Milan, Ambrosiana). A subtle, sophisticated artist and one of the great Sienese followers of *Duccio (*see also* Ambrogio and Pietro Lorenzetti), Simone moved freely between descriptive *realism and abstract decoration, and was a master of public propaganda as of intimate small-scale panels, like his *Christ Returning To His Parents* (1342, Liverpool, Walker). The former mode is evident in his earliest known work, the *Maestà* of 1315 and 1321, painted on the end wall of the Council Chamber, Siena Town Hall. Executed largely *a *secco*, and with the addition of gold-leaf and three-dimensional embossing, it is a commentary on *Duccio's *Maestà* for the High Altar of Siena Cathedral; but its function is not purely religious. The Virgin as Governor of Siena addresses her counsellors, urging political and social unity whilst proclaiming the city's magnificence.

Even more striking is the pictorial formula arrived at in the altarpiece of *St Louis of Toulouse* (1317, Naples, Capodimonte). Here the dynastic claims of Robert of Anjou are conjoined with the transcendental ones made on behalf of his brother Louis, ascetic Franciscan friar and reluctant bishop of Toulouse, who renounced the crown of Naples in favour of Robert. The grandeur of a large-scale cult image is combined with the preciousness of a courtly *objet d'art* and, in the likeness of Robert, with the naturalism of a portrait from life. The *predella scenes are the earliest surviving examples of separate scenes grouped around a clearly defined central axis. A coherently organized *perspective scheme similarly characterizes the undated decoration of the Chapel of St Martin in the lower church of S. Francesco, Assissi (*c.*1317? or *c.*1339?). Simone's contribution is agreed to include not only the frescoes but also the design of the stained-glass windows.

It is generally agreed, despite recent controversy, that in 1328 Simone returned to Siena to paint, on the other end wall of the Town Hall Council Chamber, facing his own *Maestà*, the fresco of *Guidoriccio da Fogliano*. The fresco's authorship and dating are, however, under debate.

Simone and his brother-in-law, Lippo *Memmi, together signed the *Annunciation* (1333; Florence, Uffizi). The frame is not original. A less well-known altarpiece, to the Blessed Agostino Novello (Siena, Cathedral Museum) reverts to an older format: a large *iconic figure flanked by evocative smaller narratives of his miracles.

From *c.*1340 to his death in 1344 Simone was at the Papal court in Avignon. His most important *iconographic invention, the *Madonna of Humility*, a Virgin seated on the ground with her Child, dates from this period. The original is lost, but it is reflected in countless Italian and French examples of which the earliest known (1346) is in Palermo. Simone's influence on French illumination is incalculable.

MARVILLE, Jean de *See under* Sluter, Claus.

M ASACCIO, Tommaso di Ser Giovanni di Mone called (1401–28?) The greatest Italian painter of the Early *Renaissance. His grave, monumental style, dramatically intense but stripped of all flourish and ornament, combining naturalism (*see under* realism) with geometric abstraction, became influential only long after his death when his famous *frescoes in the Brancacci chapel, Florence, S. Maria del Carmine, served as a school to leading Florentine artists. Perhaps the most important of those who studied his work was *Michelangelo (drawing, Munich, Graphische Sammlung). Traces of his influence may be discerned also in the work of *Leonardo da Vinci and *Raphael; *Vasari considered Masaccio the founder, with his predecessor *Giotto, of the Florentine school.

Born in Castel San Giovanni, the modern San Giovanni Valdarno not far from Florence, Masaccio (the nickname means Large, or Clumsy, Tom) matriculated in the Florentine guild in 1422, although we do not know where, or under whom, he trained. His earliest known work, discovered in the 1960s, is also dated 1422 and comes from Cascia, a tiny town in the Valdarno (*S. Giovenale triptych* (*see* polyptych) now Florence, Uffizi). Albeit traditional in most respects, the painting already demonstrates certain features of Masaccio's mature style, notably the spatial unity conveyed by the converging floor boards of the triptych's ground plane; the space-defining role of the Madonna's throne in the centre panel; the triangular shape formed by the Madonna and her attendant angels on the picture plane; the angels' heads in lost profile (i.e. turned away from the viewer so that little of the profile is seen); the strongly modelled, athletic nudity of the Child; and the general breadth of the body and drapery painting, represented as if in real daylight sharing the viewer's space. Like the handling of space and volume, the use of colour is sober and economical. Although the work recalls both earlier Giottesque painting and the contemporary sculpture of *Donatello, it is boldly individualistic and innovative.

Masaccio's next known work, the *Madonna and Child with St Anne and Angels* for the Florentine church of S. Ambrogio (*c.*1423, now Florence, Uffizi) probably marks his entry into the Florentine art market. Under now unknown circumstances the picture was painted in collaboration with, or finished by, *Masolino da Panicale, who was responsible for the angels and the cloth of honour. There is no evidence to support the supposition that Masolino was Masaccio's teacher, or even that he was noticeably older, and his own style, indebted to *Lorenzo Monaco, seems to have made no impact on Masaccio. The style of the S. Ambrogio altarpiece is even more vigorous than that of the S. Giovenale triptych, and further breaks down the barriers between the world of the spectator and the painted image.

In 1426 Masaccio executed his only documented work, the great polyptych for the Carmine in Pisa, now dismembered (central panel,

London, National; *predella panels and flanking saints, Berlin-Dahlem, Museen; pinnacle *Crucifixion*, Naples, Capodimonte; half-length saints from pinnacles? Pisa, Museo). The tendencies already noted in the S. Giovenale triptych are more boldly advanced in the central panel of the *Madonna and Child* in London. Especially note-worthy are the *all'antica architecture of the Virgin's throne and the geometrically correct *foreshortening of the lutes played by the musical angels. The lighting throughout, but especially on these objects, has been studied from life, and falls naturalistically from a single source on the upper left of the viewer's space, casting graduated shadows unprecedented in Florentine painting.

Masaccio's greatest surviving works, however, are not on panel but in fresco: the cycle from the *Life of St Peter* executed with Masolino in Florence, S. Maria del Carmine, Brancacci chapel, *c.*1427 and finished later in the century by Filippino *Lippi (lower register only), and the 'funerary chapel' fresco known as *The Trinity* in S. Maria Novella, before 1428, to which *Brunelleschi probably contributed the design of the scientifically foreshortened architecture.

A short entry precludes even a summary discussion of the striking novelties of Masaccio's contribution to the Brancacci chapel, from the *perspectival scheme of the whole to the dramatically *expressive and anatomically convincing nudes of the Adam and Eve in the *Expulsion from the Garden of Eden* and of the youths in the *Baptism of the Neophytes*, to the breakdown of spatial and psychological barriers between viewer and painted event of the large *Tribute Money* and of the *Miracle of the Shadow Healing*. The chapel was damaged by fire in the 18th century and the vault repainted; the window above the altar was enlarged earlier and the altar itself remodelled, cutting into and covering part of the painted wall. A recent restoration has used as a guide the colours uncovered under the altar moulding, and reveals a fresher, brighter palette than hitherto suspected, as well as additional details.

The Brancacci frescoes demonstrate Masaccio's supreme gifts as a narrative artist; like Giotto he employs bodily posture to reveal emotional states. His mastery of perspective and lighting is put to the service both of religious symbolism and of what has been called the 'eye-witness principle', by which the viewer seems to witness, and even participate in, the events depicted.

An equal control of pictorial means is demonstrated in the *Trinity* fresco – an unprecedented image, both complex and accessible. Covered over and partly destroyed in Vasari's remodelling of S. Maria Novella, it has only recently become visible again, in its original location.

Masaccio's ill-documented and brief working life left a legacy of paintings which, like the sculpture of Donatello and the cathedral dome of Brunelleschi – his contemporaries and friends – remain powerfully eloquent: rooted in Giottesque tradition, they were a

leavening agent for the subsequent evolution of the Florentine school, yet are timeless in their profound humanity.

MASO DI BANCO (recorded from 1341–50) No factual information about his *oeuvre* has reached us, and there are a number of contested attributions (e.g. *Pietà di S. Remigio*, Florence, Uffizi) but the tradition that he painted the frescoes and window in the Bardi di Vernio Chapel, Florence, S. Croce (late 1330s?) has never been challenged. The decoration of this chapel demonstrates originality both of narrative mode and formal characteristics, assimilating the lessons of *Giotto and the *Lorenzetti in a total personal way.

MASOLINO DA PANICALE (1383/?c.1400?–1447?) Famous but poorly documented Florentine painter from Panicale. He matriculated in the Florentine guild in 1423, the year of his only dated work (*Madonna of Humility*, Bremen, Kunsthalle) which shows the influence of the refined style of *Lorenzo Monaco. At about the same date he probably collaborated with *Masaccio on the S. Ambrogio altarpiece, *Madonna and Child with St Anne and Angels* (now Florence, Uffizi). The two definitely collaborated on the famous *frescoes of the Brancacci chapel, Florence, S. Maria del Carmine, *c.*1427, although under circumstances which are still imperfectly understood. In 1424 Masolino was paid for a cycle of frescoes on the *Story of the True Cross* in Empoli (fragments from entrance only, Empoli, S. Agostino). Sometime in the second half of the 1420s he worked in Hungary. By the end of the decade, leaving the Brancacci chapel unfinished, he left Florence for Rome (*c.*1430, frescoes of the *Life of St Catherine of Alexandria*, S. Clemente; S. Maria Maggiore, altar fragments now Naples, Capodimonte.) Perhaps in the mid-1430s he painted a cycle of the *Life of St John the Baptist* in the baptistry of the Collegiata, Castiglione Olona, not far from Milan.

Although Masolino briefly fell under Masaccio's influence, his style always remained distinct from the latter's. Extravagant use of single-vanishing point *perspective in his work serves to frame, punctuate or interrupt the narrative rather than to focus the viewer's attention on significant figures or episodes. Greater use is made of decorative detail. Finally, although his control of anatomy and modelling almost conforms to Masaccio's new naturalistic (*see under* realism) canon, his figure style retains the delicate charm of Lorenzo Monaco's, albeit in less mannered, attenuated form.

MASSYS, Quentin *See* Metsys, Quentin.

MASTER OF THE AMSTERDAM CABINET *See* Housebook Master.

MASTER OF FLÉMALLE A name invented by art historians in the late 19th century to identify the painter of an important group of Early Netherlandish pictures, evidently by the same hand but neither signed nor documented. He is now frequently thought to have been Robert *Campin, an older contemporary of Jan van *Eyck and the master of Rogier van der *Weyden. Since there is no absolute proof, however, both names are used.

MASTER OF THE ST FRANCIS CYCLE So called after the *fresco cycle of the legend of St Francis in the nave of the upper church of S. Francesco, Assissi (probably c.1290). A now-unknown painter, sometimes identified with *Giotto, responsible for the overall plan and the execution of some of the frescoes of the cycle, which followed upon *Cimabue's frescoes in the choir and transepts.

MATSYS, Quentin See Metsys, Quentin.

MAULBERTSCH, Franz Anton (1724–96) Leading Austrian painter, mainly of ceiling *frescoes but also in oils. At a time when the Vienna *Academy, where he studied 1741–51, had adopted the *classicism of *Donner, he continued to work in a visionary and agitated Late *Baroque or *Rococo manner, indebted to Cosmas Damian *Asam, *Rubens, *Rembrandt and *Tiepolo. Never in favour at the imperial court, he worked for private and ecclesiastical patrons in Austria (e.g. Vienna, Piaristenkirche, 1752; Old University, divinity school, 1766), Hungary in the 1770–80s, and Bohemia (Prague, Strahov, 1794 – the *classicizing touch of this fresco is due to Maulbertsch's sketches having been interpreted by assistants). There are oil paintings by him in Vienna, Barockmuseum, and oil sketches for frescoes Vienna, Albertina.

MAYNO or MAINO, Juan Bautista (1578–1649) Outstanding pupil of El *Greco in Toledo (see also Pedro Orrente, Luis Tristán). The son of a Milanese father and a Spanish mother, he visited Italy in his youth, returning to Toledo by 1611. In 1613 he professed as a Dominican in the friary of S. Pedro Martír where he had been painting the main altarpiece since 1612. Around 1620 he was transferred to Madrid, becoming drawing master to the future Philip IV. An outstanding portraitist, perhaps influenced by *Velázquez (e.g. Madrid, Prado; Oxford, Ashmolean) he also executed landscapes in the manner of Annibale *Carracci and *Domenichino (Madrid, Prado) and shows evidence of having known at first hand the work of *Caravaggio and his Roman followers. In 1627 he helped Velázquez win favour at court by adjudging him the victor in a painting competition. His excellent, large narrative painting, the Recapture of Bahía (1635, Prado) once formed part of the decoration of the Hall of Realms in the royal palace of Buen Retiro, alongside, amongst others, Velázquez' Surrender of Breda and canvases by *Zurbarán and Vincencio *Carducho.

MAZO, Juan Bautista Martínez del See under Velázquez.

MAZZONI, Guido (recorded from 1473–1508) Northern Italian sculptor born in Modena. He specialized in life-size *polychrome groups modelled in terracotta, of pious subjects such as the Nativity, the Lamentation and the Entombment of Christ, sometimes for funerary monuments. Less frenetic than the famous group by *Nicolò dell'Arca, they are marked by extreme naturalism (see under realism) *genre details derived from northern *Gothic sources. In 1489 he moved to Naples, and in 1495 accompanied King Charles VIII to

France, where he remained – with the exception of a brief return home in 1507 – until 1516. He died in Modena. His marble tomb of Charles VIII at Saint-Denis was destroyed in 1793. Terracotta groups, or single-figure fragments, can be found in Modena, cathedral and Museo; Crema, S. Lorenzo; Padua, Museo; Ferrara, S. Maria della Rosa; Naples, S. Anna dei Lombardi.

MEDINA, Sir John Baptist (c.1679–1710) The most successful Edinburgh portrait painter of his time, he has been called '*Kneller's equivalent in Scotland'. His style, albeit not his colour harmonies, is based on Kneller's, and was carried on by his son well into the 18th century. Of Spanish family, Medina was born in Brussels and trained there. He came to London in 1686; in 1688/9 he settled in Edinburgh, and was knighted in 1706. A series of oval portraits, including his finest work, a self-portrait (1708), hangs in the Surgeons' Hall, Edinburgh. There are also works by him in the Scottish National Portrait and in many Scottish collections. He taught the most distinguished Scottish portraitist of the next generation, William *Aikman.

MELDOLLA, Andrea See Schiavone, Andrea Meldolla.

MELÉNDEZ OR MENÉNDEZ, Luis (1716–80) Spanish painter, mainly known for his still-lifes but the author also of two striking self-portraits (1746, Paris, Louvre; c.1770, Madrid, Private Coll.). Forty-five of his monumental yet sober paintings of foodstuffs were placed in the dining room of the royal palace at Aranjuez; 44 of these are still known. There are works by him in Madrid, Prado; New York, Metropolitan; London, National; etc.

MELOZZO DA FORLÌ (1438–94) Painter and perhaps architect from Forlì in Romagna, active also in Urbino, 1465–75; Rome, c.1469–70, 1475–c.1484, c.1489; and Loreto, c.1484. He was celebrated by contemporaries for his skill in *illusionistic *perspective. Traditionally a disciple of *Piero della Francesca, he would have known the latter's works in Urbino, as well as those of that other researcher in perspective, *Uccello. His own painting, however, is more vigorously *realistic than that of either of these masters. Although he may have helped design the famous studiolo in the ducal palace at Urbino, his major commissions were executed for Pope Sixtus IV and his relations: the *fresco of Sixtus IV ordering Platina to reorganize the Vatican library (1475–77, detached c.1820, now Vatican, Pinacoteca) with its illusionistic architecture and life-like portraits; the apse fresco of SS. Apostoli, Rome (1478–80; apse demolished 1711; fresco fragments Vatican, Pinacoteca; Quirinale; drawing for the head of an apostle, London, British.) Melozzo's vault fresco at Loreto, S. Casa, was largely executed by his best-known pupil and assistant, Marco Palmezzano (1459/63–1539). Its scheme of painted architecture and foreshortened seated prophets may have influenced *Michelangelo's early designs for the Sistine Chapel ceiling.

MELZI, Francesco See under Leonardo da Vinci.

MEMLINC or MEMLING, Hans (*c.*1440–94) Prolific and eclectic German-born Netherlandish painter, the main artist in Bruges – where he settled in 1465 – in the last quarter of the century. Although he was the chief follower of Rogier van der *Weyden, in whose workshop he may have spent some time, and re-used Rogier's figure poses and compositions, he lacked this master's intensity and pathos. The gentle charm of Memlinc's work made him the favoured Early Netherlandish painter of 19th-century art lovers. He is, however, a stronger painter than appears at first sight: experimental in his naturalistic (*see under* realism) handling of space, in his revival of pictorial modes pioneered by Jan van *Eyck and Hugo van der *Goes, and in his search for rational order, clarity and monumentality. His eclecticism is evident not only in the freedom with which he adapts earlier pictorial inventions to his own uses, but also in the flexibility he demonstrates in resolving the varying problems of different artistic tasks. Thus his famous reliquary casket, the three-feet-long *Chasse of St Ursula* (1489, Bruges, Hospital of St John) employs delicate colour and decorative undulating pattern to stress both the narrative and the jewel-like effect of painted panels inserted into a miniature *Gothic shrine, whilst the *St Christopher Altarpiece* (1484, Bruges, Museum) unifies monumental figures and landscape, continuous across three panels, through *chiaroscuro and the rhythmic repetition of strong colours on simplified surfaces.

Many portraits by Memlinc survive, some derived from diptychs or triptychs (*see under* polyptych) whose companion panels have not survived, others painted as independent works. Albeit dignified and elegant, they are more individuated than portraits by Rogier; like his other works, they demonstrate Memlinc's willingness to experiment with different formats and by changing the relationship of figure to background. There are works by Memlinc in many European and American collections, but the largest and most significant portion of his work remains in Bruges, Hospital of St John.

MEMMI, Lippo (recorded from 1317–57) Sienese painter, brother-in-law of the much greater artist Simone *Martini, with whom he signed the *Annunciation* now in the Uffizi, Florence (1333). In 1317 he frescoed, with his father Memmo di Filipuccio, a *Maestà* in the new town hall in S. Gimignano, which reworks Simone's Siena Town Hall *Maestà* of 1315. There are *Madonnas* on panel in Orvieto, Siena, Altenburg and Berlin.

MENGS, Anton Raffael (1728–79) Portraitist and one of the most important painters of *Classical, allegorical and religious subjects of the second half of the 18th century. He espoused the theories of J. J. Winckelmann, the celebrated author of *Reflections on the Imitation of Greek Art in Painting and Sculpture*, whom he met in Rome in 1755 (portrait, New York, Metropolitan), and sought out models in the excavations at Herculaneum and Pompeii. He is a precursor of the Neo-Classicism of *David.

His father and first teacher, Ismael Mengs, was court painter at Dresden, and had him christened after Antonio *Correggio and *Raphael. In 1740 he left for Rome, where he studied under Benefial and from the masters of the High *Renaissance. Appointed court painter upon his return to Dresden in 1746, he soon departed once more for Rome, where in 1748 he converted to Catholicism and married. His first major works were the ceiling *frescoes of the Villa Albani (1761) which first fully reveal his allegiance to Winckelmann and the Antique, and eschew all *Baroque *illusionism or *Rococo frivolity. After completing the *Parnassus*, Mengs left for Madrid, where he had been appointed court painter, and began decorating the ceilings of the Royal Palace. These are markedly less austere than those of the Villa Albani, possibly under the pressure of competition from *Tiepolo. Back in Rome in 1769, Mengs was elected *Principe* of the Academy of St Luke, and painted the decoration of the Camera dei Papiri in the Vatican (1772–3). In 1775 he returned to Madrid, completing the two ceilings begun a decade earlier and painting a third. Illness overtook him in 1776, and he left Madrid for Rome, where he died. In addition to the works *in situ*, there are paintings by Mengs in Dresden; Madrid, Prado; London, Victoria and Albert, National Portrait; Wellington; etc.

MERCIER, Philip (1689?–1760) A peripatetic artist, son of a French Huguenot exile in Berlin, Mercier is mainly remembered as one of the significant French influences on the formation of British painting (*see* especially Hogarth, Hayman, Morland, Gainsborough). He was trained by a Frenchman, Pesne, at the Berlin *Academy; in Italy, and in Paris; in the early 1720s he was making etchings (*see under* intaglio prints) after *Watteau. In 1725/6 he introduced a new genre, the *Conversation Piece, to England (*Viscount Tyrconnel and his family*, Belton House). After working from 1728/9–36/7 as Painter to the Prince of Wales (*Portrait of Frederick, Prince of Wales*; *Frederick, Prince of Wales, and his Sisters at Concert*, 1733; London, National Portrait) he created yet another new genre, the *Fancy Picture on a large scale. Many of these works were widely diffused in popular engravings (e.g. *Girl with Kitten*, engraved 1756; Edinburgh, National). By 1740 Mercier was working in Yorkshire (York, Gallery; Temple Newsam; Burton Agnes), travelling to Scotland, Ireland and London. In 1752 he all but settled in Portugal, but throughout his travels he never lost the French cast of his art, its most consistent characteristic.

MERRY COMPANY *See under* Buytewech, Willem.

MESSERSCHMIDT, Franz Xaver (1736–83) Sculptor, born at Württemberg and educated mainly at the Vienna *Academy, where he became Professor in 1769. Forced to resign in 1774 because of mental illness, he is now chiefly known for a series of 69 grimacing heads in alabaster and lead, of which 49 survive (1770–83; mainly Vienna, Osterreichische). Called *Charakterköpfe*, they are less studies in physiognomy or pathognomy than attempts to exorcise the private

demons of his illness. Despite their pathological causality, they demonstrate Messerschmidt's characteristic ability to combine *realism with *classicizing stylization.

METSU, Gabriel (1629–67) Eclectic Dutch painter, son of a painter of Flemish origin, Jacques Metsu (d.1629). He was born in Leiden, and was instrumental in forming the painters' guild there (1648); he may also have spent some time in Utrecht (c.1650). In these early years he executed a number of history paintings (see under genres), including biblical scenes and allegorical subjects (Leiden, Museum; The Hague, Mauritshuis). After settling in Amsterdam in 1657, he turned exclusively to smaller scale genre and *Conversation Pieces (Berlin-Dahlem, Museen; Leningrad, Hermitage; London, National, Wallace). His best-known work is the poignant Sick Child (Amsterdam, Rijksmuseum).

METSYS, Quinten or Quentin Massys or Matsys (c.1465/6–1530) The leading painter in Antwerp from c.1510 until his death, and an important influence for change in northern European art. An eclectic and perhaps self-taught artist born in Louvain, he borrowed freely from the Italians, notably *Leonardo, but also from *Dürer, and from past Netherlandish masters such as Jan van *Eyck, Rogier van der *Weyden and Hugo van der *Goes. All these influences he fused and assimilated, without, however, finding a consistent style of his own. Metsys' variousness is especially evident in his portraits. The famous profile Portrait of a Man (1513, Paris, Jacquemart-André) may be based on a Leonardo *caricature, while the likenesses of Erasmus and Petrus Aegidius painted for Sir Thomas More in 1517 (Rome, Nazionale and Longford Castle, Radnor Coll. respectively) utilize 15th-century northern scholar-portrait formulae. For this reason undated portraits – as indeed all his undated paintings – are difficult to place in his oeuvre (e.g. portraits in Chicago, Institute; New York, Metropolitan; Vaduz, Liechtenstein Coll.).

Metsys' early work has been grouped with reference to the earliest dateable painting, the 1507–09 St Anne Altarpiece (now Brussels, Musées). This astonishing triptych (see under polyptych) combines northern *iconography and composition with Italianate architecture, set against a mountainous landscape painted in Leonardesque aerial *perspective; *Gothic figure types and faces are *idealized and softened with *sfumato *chiaroscuro, clearly also indebted to Leonardo. Similar effects are observable in works now in Lyons, Musée; Brussels, Musées, and a trip to northern Italy has been suggested.

The next great commission, the Deposition Altarpiece for Antwerp cathedral, 1508–11 (now Musée) demonstrates another feature which characterizes some of Metsys' work: his ability to juxtapose elegance and the grotesque (see also Madrid, Prado; New York, Metropolitan). Metsys's friendship with Erasmus may have influenced him to put his talent for the grotesque at the service of satirical or moralizing *genre,

which was to influence later artists, notably *Marinus van Reymerswaele. The best-known satirical work is the *Unequal Pair* (Washington, National). Typically, Metsys' pictures in this vein fuse the influence of *Bosch with that of Leonardo's caricatures.

MEZZOTINT A special type of *intaglio print, invented in the 17th century, but widely practised in the 18th, notably for the reproduction of paintings. The technique is especially suitable to this end, because it facilitates the controlled engraving of tone rather than of line, as in traditional copper engraving with the use of a burin. A toothed chisel, the 'rocker', is held upright and pushed while being rocked back and forth with its edge pressing on the metal plate. This makes it possible to lay an even, close mesh of burred pits all over the surface of the plates. Tints are then scraped or burnished into this even tone. Sharp edges can be pointed up by engraving or etching lines.

MICHELANGELO Buonarroti (1475–1564) The towering genius of Italian 16th-century art and the first artist whom contemporaries viewed in this light. A sculptor, painter and architect, and important in the history of Italian literature for his poems, he is probably the single most influential European artist, with the possible exception of his rival, *Raphael, a paradigm of the *expressive and self-willed artist despite the fact that he worked virtually throughout his life on commission and his career was beset with frustration and compromise. Some of his best-known works were left incomplete (e.g. the Medici Chapel, Florence, S. Lorenzo, 1520–34) or went through successive abortive stages before being completed largely by others (notably the tomb of Pope Julius II, 1505–45, Rome, S. Pietro in Vincoli).

A member of a minor noble Florentine family, he successfully resisted social definition as an artisan-artist, never running a workshop in the normal sense and suppressing the facts of his training. It is known that he spent 1488–9 of a projected three-year apprenticeship with *Ghirlandaio, and his sculptural training is ascribed to *Bertoldo, curator of Lorenzo de'Medici's collection of antique sculpture. He lived in the Medici palace from 1490 until Lorenzo's death in 1492. Since Bertoldo seems to have worked exclusively in bronze, some scholars have suggested a period in the studio of *Benedetto da Majano. Whatever the facts of his training, Michelangelo acquired a good grounding in the techniques of panel painting – as revealed in the 1986 cleaning of the *Doni* tondo or roundel (*c.*1504, Florence, Uffizi) – of *fresco – demonstrated in the recent restoration of his most extensive fresco work, the Sistine chapel ceiling (1508–12, Rome, Vatican) – and of marble carving. At the same time, however, his relative independence of workshop routines enabled him to innovate technically, for example in the use of claw chisels and by his way of blocking out a projected statue in the round from one dominant face, as in relief sculpture, thus keeping as long as possible the chance of revision and change (e.g. *St Matthew*, 1506, Florence, Accademia). In painting, too, he seems to have

been the first artist fully to exploit the effect of chromatic, as opposed to tonal, modelling (*see* colour), as is now apparent in the cleaned Sistine chapel vault.

Despite the radical break with Florentine workshop practice Michelangelo was deeply imbued with the traditions of Florentine art. As a youth, *c.*1490, he drew after figures in frescoes by *Giotto and *Masaccio (Paris, Louvre; Munich, Alte Pinakothek; Vienna, Albertina). He looked long at *Donatello (*Madonna of the Stairs, c.*1491, Florence, Casa Buonarroti). Despite its *classicizing style and classical subject, the relief of the *Battle of the Centaurs* (1492, Casa Buonarroti) follows 15th-century Florentine practice (e.g. *Ghiberti's east door, Florence, baptistry) in jutting forward from top ('background') to bottom ('foreground'). Equally contrary to ancient practice, but in accord with Florentine ideals of the statue in the round, the *Bacchus* (Florence, Bargello) made during Michelangelo's first stay in Rome, 1496–1501, is carved as a serpentine figure with no single predominant view. (The *figura serpentinata*, so important in Michelangelo's two-figure groups – e.g. the *Victory* originally for the tomb of Julius II, *c.*1521–3, now Florence, Palazzo Vecchio – like so much of his formal language, became one of the hallmarks of *Mannerist style.) He drew variations after *Leonardo da Vinci's cartoon of *St Anne with the Virgin and Child* (e.g. Oxford, Ashmolean). Most significantly, however, he identified the highest goals of art with Florentine *disegno*. In so doing, however, he redefined the notion. He did not, for example, engage in the Florentine tradition of perspectival experiment – despite demonstrating his understanding of *perspective in the painted architectural framework of the Sistine Chapel ceiling. He embraced only that aspect of the tradition which defined high art as the representation of the human figure in action. Through his example, *disegno*, as later taught in the *academies of art throughout Europe, became virtually synonymous with the representation of the nude, especially the male nude, and *composition* with the complex manner in which active figures relate to each other and to their pictorial or architectonic space. Thus a typically sculptural ideal came to dominate even pictorial notions of the Grand Manner.

In October 1494, as Florence was threatened by the advance of the French army of Charles VIII, Michelangelo fled to Venice and from there to Bologna, where he completed the tomb of S. Dominic (*see* Niccolò dell'Arca) and studied Jacopo della *Quercia's reliefs on the portal of S. Petronio. In Florence again in 1495/6 he carved a sleeping *Cupid* (lost) which was purchased from a dealer in Rome as a genuine ancient work. Between 1496–1501 he was in Rome, where he made the *Bacchus* already discussed, and the *Pietà* in St Peter's for a French cardinal. The *iconography was probably suggested by French examples, but the execution, both highly naturalistic (*see under* realism) in its handling of anatomy and highly *idealized in physiognomy, was totally Italianate.

The years 1501–05 in Florence, now declared a republic, were perhaps the most prolific in Michelangelo's life. He carved the gigantic *David* (now Florence, Accademia) from a block quarried in 1466 but spoiled in the blocking out; the *Bruges Madonna* (Bruges, Notre Dame); figures for the Piccolomini altar by Andrea *Bregno (Siena, cathedral); the (unfinished) *Pitti* and *Taddei Madonnas* (Florence, Bargello and London, Royal Academy respectively) and painted the *Doni* tondo. He received at this time a commission for 12 Apostles for Florence cathedral, of which only the *St Matthew* was begun, and for a mural of the *Battle of Cascina* to decorate the Grand Council chamber of the Palazzo della Signoria along with Leonardo's *Battle of Anghiari*. Only the cartoon was prepared when Michelangelo was summoned to Rome by Pope Julius II to begin work on what should have been the most magnificent sculptural work of the age, a gigantic free-standing tomb for St Peter's, but which turned into the virtually life-long torment of his career – the 'tragedy of the tomb' in the words of his protégé and biographer Condivi. As noted above, the existing monument is a sad compromise between original hopes, overweening patronal and artistic ambition, the demands of a career dominated by the will of successive popes, changing artistic ideals and political and religious circumstances. The monument underwent six distinct phases. The first project of 1505 was abandoned by the Pope for the construction of Bramante's new St Peter's, and replaced by a bronze statue of Julius for Bologna (destroyed) and the fresco decoration of the Sistine Chapel ceiling, 1508–12. A second project dates from after Pope Julius' death in 1513, and is recorded in a contract with his executors. The pieces of the tomb carved at this time include the so-called *Dying and Rebellious Slaves* (Paris, Louvre) and the *Moses*, now on the wall tomb in S. Pietro Vincoli. Work on this project was interrupted by the wish of the newly elected pope, Leo X (Giovanni de'Medici) to erect a façade for the Medici parish church of S. Lorenzo; the contract for this was given to Michelangelo in 1516/17 (cancelled 1520) and preceded by a new, reduced contract for the tomb in which the·latter was redesigned as a true wall monument. Four unfinished figures of *Slaves* in Florence, Accademia, probably date from this time. From 1520 Michelangelo was busied on work for the new chapel in S. Lorenzo, which replaced the commission for the façade and was to include tombs of Leo's father, uncle, nephew and younger brother. After Leo's death in 1521 pressure from the new pope, Adrian VI, and Julius' heirs, forced Michelangelo to return to work also on the tomb. The elderly Adrian, however, having died in 1523, was succeeded by Leo's cousin, Giulio de'Medici, as Pope Clement VII and Julius' tomb was once again set aside in favour of the Medici chapel and a new library for S. Lorenzo (after 1524). Embittered discussions on a new, further reduced project for the tomb were underway in 1525–6 but were interrupted by the Sack of Rome in 1527 and the re-installation of a republican government in Florence. Despite his

long association with the Medici, Michelangelo was an ardent republican and was charged with fortifying the city against the pope's return (drawings, Casa Buonarroti). The city, however, capitulated. In 1530 Michelangelo was pardoned by Clement and returned to work on the Medici commissions. A new project for the Julius tomb dates from 1532, at the instance of the pope to include figures sculpted by others. The monument was now to be erected, not at St Peter's, but in Julius' titular church whilst cardinal, S. Pietro in Vincoli. By this time unfinished statues for the tomb were both in Florence and Rome; it has been suggested that the *Virgin and Child* in the Medici chapel had been carved originally for the Julius tomb. The final instalment in the tangled and increasingly unhappy saga of the tomb – in which Julius's heirs accused Michelangelo of fraud – dates from after Clement's death in 1542. His successor, Paul III, appointed Michelangelo supreme architect, sculptor and painter to the papal court. For Paul III 'the tomb was no more than an obstacle to the execution of papal commissions', the first of which, already planned by Clement, was the *Last Judgement* in the Sistine chapel (1535–41). By putting pressure on Julius's heirs Pope Paul was able to arrange in 1542 for a new final contract, the results of which are to be seen today. The only statues by Michelangelo dating from this period and thus to scale with the much-reduced monument are the *Contemplative Life, Rachel*, and the *Active Life, Leah*. They contrast both in scale and in style with the much earlier *Moses*, who in turn has been placed inappropriately in a niche on the lower storey rather than a corner of the first storey as originally planned. Other figures were executed by Raffaello da Montelupo. For a work which overshadowed so much of the artist's life the final result is disjointed and visually disappointing, yet, when studied with a knowledge of the tomb's history and of the dispersed statues which were carved at various stages of the project, it provides a matchless resumé of Michelangelo's creative impulses. In the same way, the exuberance and formal beauty of the Sistine Chapel ceiling of the first decade of the century can be contrasted with the sombre penitential grandeur of the *Last Judgement* of the mid-century, the first great artistic project in Rome after the Sack. The Medici chapel in Florence, having been abandoned unfinished when Michelangelo moved definitively to Rome in 1534, was systematized in its present state under the direction of *Vasari. The result is more stark than originally intended, and the wall monument for Lorenzo and Giuliano de'Medici remains incomplete.

After finishing the *Last Judgement* Michelangelo was set to work on the frescoes for the Pope's private chapel in the Vatican, the *Conversion of St Paul* and the *Crucifixion of St Peter* (1542–50), which developed further the apocalyptic style of the *Judgement*. His conversion from the humanist and Neo-Platonic aestheticism of his youth to the deeply religious and meditative spirituality of these years in which the Church, under threat from the Lutheran Reformation, was itself reforming, is

attested not only by these great papal frescoes but also in drawings (many in London, British) and in his last sculptural groups of the *Pietà* (1552 onwards, Florence, Opera del Duomo; Milan, Castello). Michelangelo's friendship with the intellectual and pious Vittoria Colonna, celebrated in many of his poems, was deeply instrumental in this conversion.

In 1547 Michelangelo became chief architect of St Peter's; his old age was largely occupied with architectural projects beyond the scope of this entry, albeit it has often been said, rightly, that his building design relies on the same principles of motion, light and shade and organic form as his sculptural practice.

MICHELOZZO DI BARTOLOMMEO (1396–1472) Florentine architect and sculptor in metal, marble, terracotta and stucco. He worked with *Ghiberti, 1417–24, on the latter's first doors for Florence Baptistry and the *St Matthew* for Or San Michele, and in 1437–42 on the cleaning and chasing of the Doors of Paradise. He ran a studio in partnership with *Donatello from 1425–33; the main commissions undertaken by the firm were the monument to the anti-pope *John XXIII Coscia* in Florence baptistry, for which Michelozzo executed the greater part of the marble figure sculpture; the monument of *Cardinal Brancaccio* for S. Angelo a Nilo, Naples, executed in Pisa; the Aragazzi monument for the parish church of S. Maria, now cathedral, for Montepulciano – this monument, now disassembled (two reliefs, London, Victoria and Albert), seems to have been largely Michelozzo's work – and the exterior pulpit at Prato cathedral, for which Donatello executed the marble reliefs. From 1445–7 and again 1463–4 Michelozzo was associated with Luca della *Robbia on the bronze doors of the north sacristy of Florence cathedral. The silver figure of *St John The Baptist* surmounting the altar of Florence baptistry (1452; now Cathedral Museum) is Michelozzo's, as are the *Madonna* reliefs in marble in Florence, SS. Annunziata and Bargello, in terracotta in Budapest, Museum, and in stucco at Ortignano, S. Michele a Raggiolo. These non-collaborative works confirm the individuality of his strongly *classical style. The reader should recall, however, that Michelozzo is known primarily as an architect, his most famous building being the Medici palace, Florence.

MIEL, Jan *See under* Laer, Pieter van.

MIERIS, Frans van, the Elder (1635–81) Gerrit *Dou's best student and, after his death, the chief representative of the Leiden school of Fijnschilders, popular with princely collectors. His small *genre* paintings were imitated by his sons Jan (1660–90) and Willem (1662–1747) and by Willem's son, Frans Mieris the Younger (1689–1763). There are paintings by him in Leningrad, Hermitage; London, National; Schwerin, Museum; Vienna, Kunsthistorisches; etc.

MIGNARD, Pierre (1612–95) French painter, the chief rival of *Lebrun whom he succeeded in 1690 as First Painter to the

King and Director of the *Academy. Having studied for some time in
Paris under *Vouet, Mignard lived in Rome from 1636–57, visiting
Venice and other north Italian towns in 1654–5 (altarpieces, Rome, S.
Carlo alle Quattro Fontane). His style was formed on Annibale *Car-
racci, *Domenichino and *Poussin, although he pretended allegiance
with the Venetian colourists in the quarrel between the *Poussinistes* and
the *Rubénistes* (*see under disegno*), mainly to oppose Lebrun. In 1657 he
was summoned back to France by Louis XIV, achieving success in the
decoration of private houses and churches (e.g. Paris, Val-de-Grâce,
dome, 1663), but mainly as a portraitist, the only field in which he
showed any originality, giving life to the tired tradition of the *portrait
historié* (e.g. *Comte de Toulouse as Cupid asleep*, Versailles; *Marquise de
Seignelay as Thetis*, 1691, London, National; *Louis XIV at the Siege of
Maastricht as a Roman Emperor*, 1673, Turin, Galleria).

MIJTENS, Daniel *See* Mytens.

MINO DA FIESOLE (1429–84) Florentine sculptor, now chiefly
remembered as the author of the earliest surviving portrait bust
of the *Renaissance (*Piero de'Medici*, 1453, Florence, Bargello) and
other busts of Florentine personalities (Florence, as above; also
Washington, National; Berlin-Dahlem, Museen; Paris, Louvre). But he
was active also on church sculpture: funerary monuments, tabernacles
and pulpits for Roman and Tuscan churches. Many of these works were
undertaken in collaboration with other sculptors.

MITELLI, Agostino *See under* Colonna, Angelo Michele.

MOCHI, Francesco (1580–1654) Talented Tuscan sculptor, the
son of the Florentine sculptor Orazio Mochi, who worked on
the bronze doors of Pisa cathedral. Francesco was exceptional in being
able to undertake his own casting, and is best known for his bronze
equestrian statues of *Ranuccio and Alessandro Farnese* (1612–25,
Piacenza, Piazza Cavalli) and the colossal marble *Veronica* in one of the
piers of St Peter's, Rome (1629–40; *see also* Bernini, François Duques-
noy). Like his first independent work, an *Annunciation* for Orvieto
cathedral (1603, now Orvieto, Museo), these sculptures are remarkable
for their concern with movement; the *Veronica* was criticized by contem-
poraries for 'running'.

MOLENAER, Jan Miensz (*c.*1609–68) *See under* Leyster, Judith.

MOLIJN or MOLYN, Pieter de (1595–1661) One of the originators
of the 'tonal' phase of Dutch landscape art, in which the topo-
graphy and humid atmosphere of the Dutch coast dominate the repre-
sentation of human activities (*see also* Salomon van Ruysdael, Jan van
Goyen). He was born in London; in 1616 he joined the painters' guild at
Haarlem, where he remained for most of his life. There are paintings
by him in Brunswick, Museum; New York, Metropolitan; Prague,
Gallery.

MOMPER, Joos or Jodocus de (1564–1635) Prolific Flemish land-
scape painter, perhaps a pupil of Lodewijk Toeput. He

specialized in decorative and fantastical mountain scenes, painted in a
technique of translucent glazes and bold brushstrokes indebted to
Pieter *Bruegel the Elder. A journey across the Alps has been post-
ulated but is not documented. Received in the Antwerp painters' guild
in 1581 and made its Dean in 1611, he ran a busy workshop in the city,
in which he was probably succeeded by sons who continued producing
pictures in his style. A younger member of the family, however, Frans
de Momper (1603–60), who became master in Antwerp in 1629,
worked in Holland from 1645–50, largely adopting there the technique
and compositions of Jan van *Goyen, although his earlier style relies on
the elder de Momper. His work from 1650–60 is influenced by *Ten-
iers (Leipzig, Museum; Brussels, Musées). The elder de Momper is
known to have been in contact with Jan Brueghel the Elder and his son
Jan the Younger, who furnished the figures in some of his landscapes,
and whose village views and open vistas he occasionally emulated (e.g.
Oxford, Ashmolean). He or his workshop furnished decorative land-
scapes for the Castles of Rosenborg at Copenhagen and Frederiksborg
at Hillerød; there are also paintings by him in Vienna, Kunst-
historisches; Dresden, Gemäldegalerie; Kassel, Gemäldegalerie; Chi-
cago, Institute.

MONACO, Lorenzo *See* Lorenzo Monaco.

MONE, or MONET, Jean (*c.*1480–*c.*1550) Lorraine-born sculptor,
trained probably in France and Italy, and practising mainly in
the Netherlands (1524/5–50), although he is also recorded at Aix-en-
Provence (1512–13) and in Spain (1516–17). In 1522 Charles V confer-
red on him the title of 'artist of the emperor' (alabaster relief portrait of
Charles V and his consort, 1526, Gaesbeck, castle). Mone's chief works
were alabaster altarpieces, the first *classicizing *Renaissance altars in
the Netherlands (1533 Halle, St Martin; 1538–41, Brussels, Sainte-
Gudule).

MONOTYPE *See under* Castiglione, Giovanni Benedetto.

MONSÙ DESIDERIO *See* Barra, Didier and Nomé, François de.

MONTAÑÉS, Juan Martínez (1568–1649) Pehaps Spain's greatest
sculptor, called 'the God of Wood' by contemporaries. Trained
in Granada, by 1588 he was established in Seville, where he studied the
ancient statues in the collection of the Duke of Alcalá and the works of
*Torrigiani and Juan Bautista *Vázquez. He accomplished the transi-
tion from *Mannerism to *Baroque and influenced not only other
sculptors but the leading painters in Seville 1600–25: *Pacheco – who
carried out the *polychromy on his figures after 1604 – *Zurbarán,
*Velázquez, and above all his follower Alonso *Cano, who was both
sculptor and painter.

Montañés supplied churches and other religious establishments
throughout Andalusia and the overseas colonies, notably Chile (e.g.
altar, 1607/22, Lima, Concepción). He conformed to the demands of
the austere Spanish form of the Counter Reformation in the didactic

content and popular *realism of his figures – although the latter was always tempered with a strong residue of *Renaissance *idealization. Carving figures relating to the cult of the Virgin, Christ and various saints, he was instrumental in establishing *iconographic novelties: the *Christ of Clemency* (1603–06) is one of the first images in Spain showing the crucified Saviour alive, '. . . looking at any person who might be praying at his feet' as the contract specified, and the *Immaculate Conception* (1629–31, both Seville, cathedral), albeit not the first, is one of the most influential embodiments of the doctrine. His range within such figures was wide, from the ingenuous *Christ Child lifting his Arms* (1606, Seville, cathedral) to the tautly nervous *St Francis Borgia* (1610, Seville, University Chapel) and the pathetic processional figure of the *Christ of the Passion* (c.1618, Seville, S. Salvador).

MONTORSOLI, Giovanni Angelo (c.1507–63). Peripatetic Florentine sculptor associated with *Michelangelo in the Medici Chapel and recommended by him to Pope Clement VII as restorer of the antique group of the *Laocoön*, 1532. His most important independent works were executed in Genoa, 1543–7 (S. Matteo; *Pietà* and statues; crypt tomb of Andrea Doria) and in Messina, where he became master of works of the cathedral in 1547 (*Fountain of Orion*, 1550; *Altar of the Apostles*, cathedral, c.1552; *Fountain of Neptune*, 1557, also Museo). When it was erected, the *Orion* fountain was the largest, tallest and sculpturally most elaborate fountain in Italy; it inspired the construction of *Ammanati's fountain in Florence. Montorsoli became a member of the Servite religious order whilst still in Florence, 1530–1, and executed a number of works for the Servite church of SS. Annunziata.

MOR VAN DASHORST, Anthonis (also known as Antonio, or Antonius, Moro) (1517/21–76/7). Utrecht-born portrait painter, a pupil of the Italianate Jan van *Scorel. As portraitist to the Habsburg courts in the Netherlands and in Spain, Mor forged a highly polished style of state portraiture, fusing meticulous technique and sober Dutch *realism with the grandeur of pose and mood, and the tonal refinement, of *Titian's portraits. His influence on Spanish art was lasting, transmitted through his pupil Sanchez *Coello, to the latter's pupil *Pantoja, and perceptible still in the early court portraits of *Velázquez. He is said to have revived portrait painting in the Netherlands. The label *Mannerist which is sometimes attached to Mor's work is misleading, and refers to its international status rather than to any over-refinement of proportions or exaggerated complexity of pose.

By 1549 Mor was working in Brussels for the Emperor Charles V's minister Granvelle and for Mary of Hungary, the Regent of the Netherlands. The latter dispatched him to Lisbon to paint the Portuguese royal family, 1552. Around this time he also visited Rome. In 1554 he painted Mary Tudor on behalf of her bridegroom, Philip II of Spain, presumably in London although the visit is not documented and must have been brief (three versions by Mor: Castle Ashby; Boston,

Gardner; Escorial). Brought to Spain by Philip, whose portrait he painted after the battle of St Quentin, 1557 (Escorial), Mor took fright at accusations of Protestantism and fled back to the Netherlands in 1558. There he continued, however, to work for Philip. Other portraits by Mor can be found in Madrid, Prado; London, National, National Portrait; Kassel, Gemäldegalerie; New York, Metropolitan; a self-portrait, Florence, Uffizi.

MORALES, Luisa de *See under* Valdés Leal, Juan de.

MORAZZONE; Pier Francesco Mazzucchelli called (1573–1626) With *Cerano and Giulio Cesare *Procaccini, one of the three foremost painters of Milan in the early 1600s. Their pre-eminence is commemorated in the unusual joint commission of an altarpiece, the *Martyrdom of SS. Rufina and Seconda*, called the 'Tre Mani' ('three-hander'), early 1620s, now Milan, Brera. Unlike Cerano and G. C. Procaccini, however, Morazzone avoided competing for work within the city of Milan itself. Having established his family in his native village of Morazzone, he travelled throughout Lombardy, and to a lesser extent Piedmont and Liguria, painting *frescoes and large altarpieces *in situ*. His style was formed by contact with contemporary Roman *Mannerism during a youthful stay in Rome, *c.*1592–8, perhaps in the studio of the Cavaliere d'*Arpino (partly destroyed frescoes, Rome, S. Silvestro in Capite), through study of Venetian painting, notably that of *Tintoretto, and by local traditions. Fundamental to these was the work in the 1520s of his great predecessor at the *Sacro Monte of Varallo, Gaudenzio *Ferrari, whose 'hand' Morazzone was contracted to imitate in his own contributions to the pilgrimage site, 1605–14.

MORETTO; Alessandro Buonvicino, called (*c.*1498–1554) Veneto-Lombard painter from Brescia, associated mainly with Catholic Reform patrons in his native city, for whom he executed religious paintings with explicit doctrinal content or in everyday settings (Brescia, Pinacoteca and churches). He was a prominent member of the Confraternity of the Sacrament, for whose chapel in S. Giovanni Evangelista he painted, with *Romanino, important decorations on canvas, later to affect *Caravaggio (*see also* Savoldo). He executed, too, a few portraits, which are fundamental to the development of Lombard portraiture and influential on his probable apprentice *Moroni (e.g. New York, Metropolitan; London, National; Brescia, Salvadego Coll.).

MORLAND, George (1763–1804) English painter of landscape and rustic *genre*. Although he began, *c.*1785, with portraits and sentimental vignettes of rural life, in the 1790s he produced unvar-nished representations of rural poverty (London, Tate; Edinburgh, National). These works were bowdlerized in the many engravings, executed by his brother-in-law William Ward, which popularized his *oeuvre*, so that the paintings' contemporary significance has, until very recently, been overlooked. The son of a minor artist and restorer, Henry Robert Morland (*c.*1730–97), Morland was trained by his

father and employed by him to restore and fake the Dutch Old Masters, who influenced him. Upon reaching independence, he dissociated himself from polite society, living amongst the urban and rural proletariat; he became an alcoholic; was arrested as a French spy whilst fleeing his creditors in 1799 and afterwards imprisoned for debt. He lived out most of his last years within the rules of the King's Bench; his later production is largely hack work to pay off his debts. Even at the time of his greatest success, however, Morland refused to work for individual patrons or dealers, preferring to sell through an agent and maintain his independence, in defiance of the norms of 18th-century art production. There is a remarkably unflinching self-portrait of *c*.1802–03, *The Artist in his Studio with Mr Gibbs frying up* (Nottingham, Castle), which shows the bleak consequences of Morland's personal and professional rebellion.

MORO Antonio *See* Mor van Dashorst, Anthonis.

MORONI, Giovanni Battista (1520/24–78) One of the greatest portrait painters of his century. Born near Bergamo (where *Lotto had worked *c*.1513–25) he was apprenticed to *Moretto in Brescia (*see also* Romanino, Savoldo) and has been called a stylistic link between these two Veneto-Lombard centres: rooted in Lombard *realism but affected by Venetian colourism (*see under disegno*; *also* Giorgione, Titian). He remained close to Moretto, sharing his Catholic Reformation outlook and basing his relatively few religious paintings on those by his master (e.g. Trento, S. Chiara, S. Maria Maggiore; Milan, Brera). His dependence on Moretto's portraits was, however, soon outgrown.

Moroni's portraits encompass a wide social range of sitters – ecclesiastics at the Council of Trent, Bergamasque nobles and professional men, and the famous *Tailor* (*c*.1570, London, National) and *Sculptor* (Vienna, Kunsthistorisches). As is usual for the period, men far outnumber women, the exceptions being noblewomen, depicted perhaps on the occasion of their marriage and/or as pendants to the portraits of their husbands (e.g. Bergamo, Accademia; London, National). Moroni painted on canvas, coarsely woven at first, finer later, when the paint itself came to be more thinly and fluidly applied. All but one of the known likenesses engage the spectator's gaze (*Canon Ludovico di Terzi*, London, National is the exception) although in other respects there are unusually many variations of pose, format (from full-length to bust) and viewpoint (level with the sitter's eyes to high above or low beneath). Scholars have divided his portrait *oeuvre* into mainly two groups: a 'rose' or 'red' period, lasting until *c*.1560, so-called from the prevalent warm tone of the paintings and the colour of the sitters' costumes, and a 'grey' period late in his life, in which cool black, white and grey tones predominate, echoing the Spanish influence on dress as in art. The apparent directness and intimacy of these works are far removed from the courtly portraiture of, e.g. *Van Dyck.

Moroni's example was to influence Bergamasque painters through the 18th century (*see* Giuseppe Ghislandi). For a long time he was a favourite of English collectors and remains particularly well represented in the National Gallery, London, although many paintings in private hands were sold to American museums (e.g. Washington, National ; Boston, Gardner; Chicago, Institute).

MORTIMER, John Hamilton (1740–79) With *Wright of Derby he was a pupil of *Hudson (1756/7), and in the 1760s practised as a portraitist and painter of *Conversation Pieces in the style of *Zoffany. His reputation, however, rests on scenes of bandits and 'horrible imaginings' in the manner of Salvator *Rosa, and on romantic literary subjects which anticipate the work of Fuseli (*see* Volume Two). In 1775 he exhibited four companion pictures, *The Progress of Virtue* (London, Tate), slightly disingenuous 'moral subjects' which have been compared with similar works by *Greuze.

MOSTAERT, Gillis *See under* Bruegel.

MOSTAERT, Jan (*c*.1472–after 1554) Ill-documented Haarlem painter; much of the information about his life and work comes from Karel van *Mander. Active in the painters' guild of his native city, he also served intermittently at the court – in Brussels and Malines – of the Regent of the Netherlands, Margaret of Austria (probably from before 1519–after 1521). Despite his early dependence on the older Haarlem painter *Geertgen tot Sint Jans, he introduced elements of the more modern and sophisticated southern Netherlandish art, of *Gossart and *Patinir in particular, into the background of his later portraits and altarpieces. There are works attributed to him in Brussels, Musées; Amsterdam, Rijksmuseum; Liverpool, Gallery; Würzburg, Museum; London, National; etc. An imaginary 'West Indian landscape with many nude people, a fantastic cliff and exotic houses and huts' has been identified from van Mander's description as a picture now in Haarlem, Hals, or perhaps an unknown replica.

MUDÉJAR Spanish term used to describe an Iberian style of architectural or sculptural ornament evolved by Moorish artists working under Christian rule, distinguished by a proliferation of geometric star-patterns or interweaving organic forms. In the *Renaissance, a similar flattened ornamental style, with Italianate elements such as *grotesques, was called Plateresque, because of its resemblance to the work of silversmiths (from *plata*, silver).

MULTSCHER, Hans (first recorded 1427–1459/67) German stone and limewood sculptor, whose workshop in Ulm produced much of the best sculpture of its period in southern Germany and influenced later artists (*see* Michael Erhart). He had direct experience of the Burgundian sculpture of Claus *Sluter's followers. In 1433 he signed a *retable altarpiece for Ulm Minster; in 1456–9 he worked at Sterzing (now Vipiteno) on a retable for the Pfarrkirche. Many fragments of this dismantled alterpiece have been identified (Sterzing,

Museum, Pfarrkirche; Innsbruck, Ferdinandeum; Munich, Museum).
Multscher's workshop also produced paintings, but it is not clear
whether he himself was a practising painter.

MURILLO, Bartolomé Esteban (1618–82) With *Zurbarán, whom
he displaced in public esteem, the foremost painter active in
Seville; one of the greatest and most prolific Spanish *Baroque artists.
Throughout the 18th and 19th centuries his international fame out-
ranked that of *Velázquez and rivalled that of *Raphael. Works by him,
in English collections by 1729, directly inspired *Hogarth, *Reynolds
and *Gainsborough. But the mild and suave temper and 'vaporous
style' of his mature and late religious paintings, and their wholesale
reproduction as pious images and for the 'chocolate-box' market, pro-
duced a reaction which led to his dismissal, c.1900, as a mere purveyor
of sickly sentimentality. Only since the comprehensive exhibition of his
works on the occasion of the tercentenary of his death in 1982 have
Murillo's qualities as an artist, at once highly sophisticated and gen-
uinely popular, come, once again, to be recognized outside his native
country.

The youngest of 14 children of a prosperous barber-surgeon, he was
brought up after his parents' deaths in 1627 and 1628 by his older sister
and her surgeon husband, and trained as a painter with a relative of his
mother's. Shortly after his marriage in 1645 he began the series of
major works that were to occupy him in Seville until the end of his life,
which was precipitated by a fall from scaffolding whilst engaged on a
painting for the high altar of the Capuchin church in Cádiz (completed
by his disciple Meneses Osorio, d.1721). He never remarried after his
wife's death in 1663; of their nine children only four survived their
mother, and only three their father. The family's piety is indicated by
the religious vocations of the painter's only daughter, who became a
Dominican nun, his oldest son, a subdeacon, and his youngest son, a
canon of Seville cathedral. Murillo himself belonged to several religious
confraternities. The artist's increasing loneliness has often been cited as
a factor compensated for in his paintings, increasingly populated with
smiling children, frolicsome cherubs and warmly affectionate
Madonnas.

Murillo's earliest known work, *The Virgin Presenting the Rosary to St
Dominic* (c.1638–40, now Seville, Archbishop's palace) shows the
influence on him of earlier Sevillan painters: his master, Juan del
Castillo, but above all the luminous colourism of *Roelas in the celestial
apparition and the tight modelling of Zurbarán in St Dominic's habit.
These contrasting modes continue to coexist in his first major commis-
sion, the series of scenes from the lives of Franciscan saints – stressing
the virtues of the love of God and one's neighbour and including no
scenes of martyrdoms – which Murillo painted 1645–8 for the small
cloister of the Friary of S. Francisco. In 'low-life' scenes such as *S. Diego
Giving Food to the Poor* (now Madrid, Academia) the earth tones, hard

modelling and naturalistic (*see under* realism) details of Zurbarán pre-
dominate, whilst Roelas' golden glow envelops the heavenly cortège in
scenes such as the *Death of St Clare* (Dresden, Gemäldegalerie; other
paintings from the series now Paris, Louvre; Madrid, Academia;
Raleigh, North Carolina, Museum; Williamstown, Mass., Clark
Institute; Ottawa, National; Toulouse, Musée des Augustins).

In the group of large-scale Madonnas painted *c.*1650–5, Murillo
abandoned Zurbarán's *tenebrism and sculptural monumentality for
more translucent and elegant effects, influenced by the work of *Van
Dyck, known in Seville (e.g. *Virgin of the Rosary*, Madrid, Prado; *Virgin
and Child*, Florence, Pitti). The compositions of these and later
Madonna and Child pictures, of which he was to become the greatest
Spanish exponent, were indebted to prints after *Raphael. Zurbarán's
manner was to persist longer, however, in the secular *genre* paintings
of vagrant and mendicant children which, perhaps on the suggestion of
Dutch and Flemish merchants resident in Seville, and almost certainly
for a foreign market, Murillo began to paint *c.*1645–50 (e.g. *Boy Killing
a Flea*, Paris, Louvre). Some 25 such pictures, which in turn became
lighter in colour and more ingratiating in mode, made his reputation
abroad and are the source of Reynolds' and Gainsborough's *Fancy
Pictures. The best are now to be found in Munich, Alte Pinakothek;
Dulwich, Gallery; Paris, Louvre. Whilst certain groups – such as the
several depicting an older woman searching for fleas in a child's hair –
are clearly indebted to Dutch prints, others are amongst the most
pictorially inventive and spontaneous 17th-century compositions, pre-
cursors of, and influential on, the *Rococo. As in Dutch *genre* paint-
ings, moralizing symbolism cannot be excluded in reading these
pictures.

The great Sevillan church, monastic and charitable institution series
begun at S. Francisco continue with the four large paintings for S.
Maria la Blanca, a medieval synagogue newly converted into a church
(1662–5; Madrid, Prado; Paris, Louvre; Faringdon, Buscot Park). The
technique, increasingly fluid, translucent and animated, now heralds
Murillo's later, renowned 'vaporous style', but is held in check with firm
draughtsmanship and architectonic compositions; these works are cer-
tainly amongst his highest achievements. There follow important cycles
and series for the Capuchins (*c.*1665–6; 1668) and the Agostinians
(after 1666), now mainly hung in Seville, Museo. Between 1668–74 he
executed six very large and two smaller paintings illustrating, with the
altar, the *Seven Works of Mercy*, for the church of the Hospital de la
Caridad, to which charitable confraternity he had been admitted in
1665 (four *in situ*; others London, National; Leningrad, Hermitage;
Washington, National; Ottawa, National; *see also* Valdés Leal). Cele-
brated in Murillo's lifetime, these remained the most famous works of
art in Seville until their partial dispersal in 1810. In 1675, for the
church of the Hospital de los Venerables Sacerdotes, he executed,

together with other paintings, a famous *Immaculate Conception* (now Madrid, Prado), painted in his most mature style. The theme is one with which, as with that of the Virgin and Child, Murillo is especially identified (but *see also* Pacheco).

For a private patron, the Marqués de Villanmanrique, Murillo executed, *c.*1665, a series of landscapes illustrating Old Testament scenes from the *Life of Jacob*; the masterly landscape backgrounds, influenced by *Momper, are amongst the finest of the century (now Dallas, Meadows Museum; Cleveland, Ohio, Museum; Detroit, Institute; El Paso, Museum).

Although only a few portraits by him are known, they rank amongst the best in Spanish art. Perhaps the most exceptional is the portrait of *Don Antonio Hurtado de Salcedo in Hunting Dress* (*c.*1664, Spain, private coll.). Probably inspired by Velázquez' royal portraits for the hunting lodge of the Torre de la Parada – Hurtado was Philip IV's Secretary of State – it introduces a landscape background, a dog-keeper and three dogs in naturalistic contrast to the commanding Hurtado. Less grandiose but no less impressive are the portraits of ecclesiastics, the *Canon Justino de Neve* (*c.*1660–5, London, National) and *Canon Juan Antonio de Miranda* (1680, Madrid, Duke of Alba). The likenesses of the Dutch merchant *Josua van Belle* (1670, Dublin, National) and the Flemish poet and merchant, Murillo's friend *Nicolás de Omazur* (1672, Madrid, Prado), both resident in Seville, are closely modelled on Dutch portraits. A pendant portrait of Omazur's wife is known today only through a copy. Of the two known autograph self-portraits, the one now in London, National (*c.*1670) inspired Hogarth's *Self-Portrait* in the Tate.

In 1660 Murillo co-founded the Art *Academy of Seville, of which he served as first President together with Francisco *Herrera the Younger. His belief in Italianate academic precepts is borne out by his extant graphic *oeuvre*, which includes many excellent drawings from the life and compositional studies.

MUSSCHER, Michiel van (1645–1705) *See under* Hooch, Pieter de.

MUZIANO, Girolamo (1532–92) From *c.*1575 the leading painter at the Papal court, the author of many Counter-Reformation altarpieces in Roman churches. Born in Brescia and trained in Padua and Venice, he never forsook Venetian colourism (*see under disegno*), especially in the conspicuous landscape backgrounds of his religious compositions; his sober figure style, however, was modelled on *Sebastiano del Piombo. Outside Rome he is now probably best remembered as the author of pioneering landscape drawings made before his arrival in the city, *c.*1549 (Florence, Uffizi), some of them executed during a bout of fever which caused him longingly to recall 'limpid rivulets and vivacious fountains ... flowering meadows and verdant landscapes' seen on his travels. Between 1573–6 similar drawings by him were used for a series of six engravings (*see under* intaglio prints) by the northerner

Cornelis Cort, depicting hermit saints in landscape. Muziano supervised the decoration with *fresco landscapes of the Villa d'Este at Tivoli, 1563–6.

MYTENS or MIJTENS, Daniel (*c.*1590–before 1647) Chief of the precursors of *Van Dyck in England. Born at Delft and trained at The Hague, he was introduced into England before 1618 by the great patron of the arts, Thomas Howard, Earl of Arundel. In 1621/2 he succeeded van *Somer as court painter, being particularly favoured by Charles, Prince of Wales. On Charles' accession to the throne, Mytens was appointed Painter of the King's Chamber, and sent back to the Low Countries to study the latest fashions in Flemish portraiture. He returned to execute a continuous series of royal portraits until after the arrival of Van Dyck in 1632. By 1637 Mytens was once again living in The Hague, where he acted as agent for Lord Arundel's collection. Mytens' portraits lack the elegance and nobility of Van Dyck's, but at their best (e.g. *First Duke of Hamilton*, 1629, Edinburgh, National) they combine sympathetic interpretation of character with a wonderful sense of colour and atmosphere.

NANNI di Banco (*c.*1374–1421) One of the most gifted Florentine sculptors of his generation. He was three times associated with *Donatello on the sculpture of Florence Cathedral: in 1407–08 they executed companion figures of *Prophets* for the Porta della Mandorla; in 1408 Nanni carved an *Isaiah* for the northern tribune, and Donatello a companion marble *David*; and in 1410–13 Nanni completed his *St Luke* for the façade (Cathedral Museum) which antedates by two years Donatello's companion *St John*. The *St Luke* anticipates many of Donatello's stylistic innovations, particularly the sense of a bulky body beneath the drapery, and the figure's autonomy of movement, but lacks the energy which infuses the *St John*. Nanni's study of antique sculpture is even more evident in his group of the *Quattro Santi Coronati* for Or San Michele (*c.*1413). The four life-size figures are grouped together like the half-length figures on Roman grave altars. Nanni executed also a *St Philip* and a *St Eligius* for Or San Michele. His last major work, the relief of the *Assumption of the Virgin* above the Porta della Mandorla, abandons this *classicizing mode, however, to return to *Gothic forms, especially in the figure of the Virgin.

NANNI di Bartolo (called Rosso) (active 1419–51) Florentine sculptor, employed on the façade of Florence cathedral in 1419, and on statues for the bell tower from 1421 (*Abdias*, Florence, Cathedral Museum). By 1424 he had left Florence for Venice, and the rest of his career was pursued there and throughout northern Italy (doorway, Tolentino, S. Nicola, 1432–5; Brenzoni monument, Verona, S. Fermo Maggiore).

NATOIRE, Charles-Joseph (1700–77) French painter, and student, like his far more talented contemporary *Boucher, of François *Lemoyne. Although chiefly remembered for his *Rococo decorations in Paris, Hôtel de Soubise, 1737–8, he is more historically significant as the author of the earliest French decorative scheme based on a national-patriotic theme (*History of Clovis*, 1736–7, Troyes, Musée). Appointed Director of the French *Academy in Rome in 1751, he was forced to resign in 1774 through administrative incompetence and as his style fell out of favour. He never returned to France, but retired to Castel Gandolfo, where he turned to landscape – a genre in which his work anticipates that of Hubert *Robert and *Fragonard. He was the teacher of *Vien.

NATTIER, Jean-Marc (1685–1766) French painter, best known for his work as a portraitist, in which speciality he followed his father, Marc Nattier (1642–1705). Although a master of the decorative *Rococo style fostered at court by Louis XV and Mme de Pompadour, he was also capable of simplicity and directness, as in his portrait of the queen, *Marie Leczinska* (Versailles) or of one of her daughters, *Madame*

Adélaïde, (Paris, Louvre). He occasionally allegorized his sitters, as in the *Duchesse d'Orléans as Hebe* (Stockholm, Museum) or included allegorical figures with their likenesses, as in the *Maréchal de Saxe crowned by Time* (Dresden, Gemäldegalerie). Having been very popular at court, his work fell out of favour in the last years of his life and he died in neglect and poverty. (Other works London, National, Wallace; New York, Metropolitan, Frick; and in French provincial museums.)

NATURALISM *See under* realism.

NEEFS, Pieter the Elder and Pieter the Younger *See under* Steenwijck, Hendrick van.

NEER, Aernout or Aert van der (1603/04–77) Dutch specialist of the 'tonal' phase of landscape painting (*see also* Jan van Goyen, Salomon van Ruysdael, Pieter de Molijn). Leaving behind the greybrown-green tonality of other practitioners of this mode, and of his own earlier paintings, he turned to the representation of snowy winter landscapes, nocturnal, and especially moonlight, scenes, for which he has become famous. The treatment of coloured light characteristic of these pictures may have been inspired by certain late landscapes of *Rubens. Van der Neer settled in Amsterdam in the early 1630s; opened an inn there in 1659, and was bankrupt in 1662. There is some falling-off in the quality of his work from that date, although the nocturnes with burning towns produced in his late period anticipate, and may have influenced, effects exploited by Turner (*see* Volume Two).

Aert's son, Eglon Hendrick van der Neer (1634–1703), practised mainly as a painter of aristocratic *genre, but there are some landscapes by him demonstrating a deliberate return to *Elsheimer. There are works by both artists in London, National, Wallace; New York, Metropolitan; and in many galleries on the Continent.

NEITHART, Mathis Gothard *See* Grünewald, Matthias.

NETSCHER, Caspar (1635/6?–84) Dutch painter, born in either Prague or Heidelberg, the son of Johannes Netscher, a sculptor from Stuttgart. He studied with *Ter Borch at Deventer *c.*1655–*c.*8, and specialized at first mainly in *genre, with the occasional religious or classical subject. In 1662 he settled at The Hague, giving up *genre* scenes for small-scale half-length portraits of the aristocracy, widely respected for their fastidious attention to the texture and details of costly costume. He was much imitated, most closely by his sons Theodorus (1661–1732) and Constantijn (1668–1723). There are paintings by Netscher in London, National, Wallace; The Hague, Mauritshuis; etc.

NICCOLÒ dell'Arca (*c.*1435–94) Eclectic sculptor of south Italian origin, active in Bologna from 1462 as a carver in marble and a modeller in terracotta. His 'surname' is derived from the tomb – *arca* – of St Dominic by Nicola *Pisano, Bologna, San Domenica Maggiore, for which Niccolò carved a lid decorated with marble statuettes, 1469–

73 (later completed by *Michelangelo). His style here, as in his large *Madonna di Piazza* (1478, Bologna) demonstrates knowledge of both Burgundian and Tuscan sculpture. Niccolò's masterpiece is universally acknowledged to be his dramatically *expressive terracotta group of the *Lamentation*, originally *polychrome (1463, Bologna, S. Maria della Vita), anticipating the more placid terracotta groups of Guido *Mazzoni.

NICOLAES Eliasz. *See* Pickenoy.

NICOLÒ dell'Abate. *See* Abate, Nicolò dell'.

NIGRETI, Antonio. *See under* Palma Giovane.

NIGRETI, Jacopo. *See* Palma Vecchio.

NOMÉ, François de (1593–*c.*1640). Born in Metz but working from *c.*1610 mainly in Naples, de Nomé specialized in small pictures of fantastical architecture, in which the figures were inserted by other artists. His identity has, until recently, been combined with that of his compatriot Didier *Barra under the name of Monsù (corruption of Monsieur) Desiderio.

NOORT, Adam van (1562–1641) Flemish painter, teacher of *Rubens, 1592–6, and of Jacob *Jordaens, whose father-in-law he also became. Many paintings formerly attributed to him have been discovered to be youthful works by Jordaens. He is recorded as being a portraitist is well as a history painter (*see under* genres), but none of his portraits is known. Like his near-contemporary Otto van *Veen, Rubens' teacher after 1596, Noort seems to have evolved from a belated dependence on the manner of Frans *Floris, through a *Mannerist phase, to a form of *classicism. His late work, however, is influenced by the spirited brushwork of Jordaens. There are drawings by van Noort in Antwerp, Moretus; Rotterdam, Boymans-van Beuningen; and paintings by him in Antwerp, Rubenshuis; Brussels, Musées; Mainz, Museum.

NORTHCOTE, James (1746–1831) Portraitist, painter of *Fancy Pictures, and one of the first artists to contribute to Boydell's Shakespeare Gallery. He also attempted to emulate *Hogarth with some series of 'modern moral subjects'. From 1771–5 he lived as a pupil and assistant in *Reynolds' house; from 1777–81 he studied in Rome. His works are studded with quotations from ancient and Italian art. There are paintings by him in Dulwich, Gallery; London, Victoria and Albert; Glasgow, University; but he is probably best remembered today for his biography of Reynolds.

NOTKE, Bernt (*d.* after 1509) One of the greatest sculptors of north-west Germany, active in Lübeck (Stockholm, St Nicholas, *St George and the Dragon*, 1489; Lübeck, St Mary's, *tomb of Hermen Hutterock*, *c.*1508–09).

NUDE A form of representation which is of special importance in the history of Western art, having become in Graeco–Roman antiquity a prime vehicle of *idealization. A nude differs from the

representation of a naked human being in that it suppresses individual resemblance and particular circumstances in favour of harmonious, or abstract, design and timeless generalization.

O

OESER, Adam Friedrich *See under* Donner, Georg Raphael.

OLIVER, Isaac (before 1568–1617) Born in Rouen, Oliver came to England as a child in 1568. He is best known as a miniaturist, although he also painted portraits on the scale of life (*Frances, Countess of Essex*, Welbeck Abbey). Where his master *Hilliard's style relates to that of the French court, Oliver's is influenced by Dutch and Italian painting; he may have visited Holland in 1588, and was in Venice in 1596. Unlike Hilliard, he modelled his sitters' likenesses in light and shade. Not as jewel-like as Hilliard's, some of Oliver's full-length minia-tures resemble large-scale state portraits in format, pose and attributes, as well as style (*Third Earl of Dorset*, 1616, London, Victoria and Albert). Oliver was made 'limner' or miniature painter to Queen Anne of Denmark in 1604, and had the monopoly of her and of Prince Henry's portraits in miniature. He also made some religious and narrative drawings, and copies after Italian compositions.

OOSTSANEN, Jacob Cornelisz van (1470–1533) Dutch portraitist and designer of woodcuts (*see under* relief prints), he is the first important artist working in Amsterdam. His early work is indebted to the Haarlem painter *Geertgen tot Sint Jans, but he later came under the influence of *Dürer, especially in his woodcuts. His paintings, crowded with elaborately costumed figures and surface movement, have been characterized as Late-*Gothic *Mannerist (Amsterdam, Rijksmuseum; Enschede, Rijksmuseum; Berlin-Dahlem, Museen; Kassel, Museum). He may have been the second teacher of Jan van *Scorel.

OPIE, John (1761–1807) British painter, whose work marked a return to Dutch and Flemish 17th-century art as a source of inspiration. The precocious son of a Cornish carpenter, he was taken up at the age of 14 by John Wolcot, a former pupil of Richard *Wilson, who was practising medicine in Cornwall. Having noted Opie's natural talent for *realistic representation and *chiaroscuro effects, Wolcot trained him, secretly, on prints by, and after, *Rembrandt and other *tenebrists. In 1781 Wolcot launched Opie in London as an untaught prodigy, 'the Cornish Wonder'; he became a successful society port-raitist, albeit always at his best in the portrayal of unaffected old people (*Mrs Delaney*, 1782, London, National Portrait) and children (*Children of the Duke of Argyll*, c.1784, Inveraray). His first multi-figured subject picture, *The School*, exhibited at the *Academy in 1784 (Lockinge, Loyd Coll.) was much praised. From 1786 he began to paint seven pictures for Boydell's Shakespeare Gallery, and other costume pieces, some for Bowyer's Historic Gallery (1790s), which influenced the development of the historic costume piece of the 19th century. But his talent declined as the literary content of his pictures increased, and his early, naturalistic,

work is his best. There are paintings by Opie in many British museums, including London, Tate.

ORCAGNA, Andrea; Andrea di Cione, called (active 1343–68) Florentine painter, sculptor and architect. His one surviving authenticated painting is the altarpiece in the Strozzi chapel, S. Maria Novella, Florence (1357), which was of an unprecedented subject in Tuscan altarpieces, an adult *Christ in Majesty with Saints*. Stressing the transcendental and hieratic aspects of its theme, this work rejects *Giotto's innovations for a deliberately archaicizing stylization. The chapel itself was decorated (1350s) with huge crowded frescoes of *The Last Judgement, Paradise* and *Hell* by Andrea's brother Nardo di Cione (active 1343–65/6), whose major works they are. In 1355 Andrea became master of works of the guild church, Or San Michele, for which he designed and carved the ciborium-like tabernacle enshrining *Daddi's painting of the *Virgin and Child*. A younger brother, Jacopo di Cione (active 1362–98) completed the altarpiece of *St Matthew* (Florence, Uffizi) left unfinished at Andrea's death.

ORDÓÑEZ, Bartolomé (c.1490–1520) One of the founders of Spanish *Renaissance sculpture (*see also* Diego de Siloe). A wealthy gentleman from Burgos, he probably studied in Florence under Andrea *Sansovino, and knew the youthful reliefs of *Michelangelo. His 1514–15 marble relief of the *Adoration of the Magi* (Naples, S. Giovanni a Carbonara) demonstrates his mastery of *rilievo schiacciato* and Florentine compositional principles. He died at Carrara whilst working on the (incomplete) monument to the parents of Charles V, Joan the Mad and Philip the Handsome, set up in Granada in 1603 (Royal Chapel). Other works by him are the end panels of the choir stalls in Barcelona cathedral 1517–19.

ORLEY, Bernard or Barend van (1491/2–1541) Leading Brussels painter, he became court artist, first to the Regent Margaret of Austria, 1518, then to her successor, Mary of Hungary, 1532. Trained by his father, Valentin van Orley, he was influenced by Italian art mediated through engravings (*see under* relief prints) and the cartoons (*see under* fresco) by *Raphael which he studied from 1517, as supervisor of the tapestries woven from them in Brussels. His mature style is also indebted to *Gossart. Although he never achieved a convincing fusion between Netherlandish naturalism (*see under* realism) and Italianate *idealization, he is one of the major exponents of Flemish *Mannerism, both in portraiture and altarpieces (Brussels, Musées; Antwerp, Musée) and in designs for tapestries and stained glass (the latter for Brussels, Ste-Gudule). A portrait drawing of him by *Dürer is still preserved; he invited the German master to an elaborate dinner during Dürer's trip to the Netherlands, 1520–1.

ORRENTE, Pedro (c.1570–1645) Called 'the Spanish *Bassano', he was the oldest of *El Greco's pupils (*see also* Luis Tristán, Juan Bautista Mayno). During his travels across Spain he executed many

nocturnal bucolic scenes on Old Testament themes, some until recently falsely attributed to Jacopo Bassano (e.g. Lisbon, Museu), as well as large narratives from the New Testament and the lives of saints. Sometime between 1600–10 he adopted the *tenebrist style of *Caravaggio (1616, Valencia, cathedral; 1617, Toledo, cathedral) which, during Orrente's first stay in Valencia in 1616, influenced Francisco *Ribalta.

OSTADE, Adriaen van (1610–85) and his brother Isaack (1621–49) Adriaen was a painter and etcher resident in Haarlem, a prolific specialist in peasant scenes. He is supposed to have been a student of Frans *Hals and may have known *Brouwer; the influence of *Rembrandt is also detectable in his work. By the middle of the century his boisterous, disorderly subjects gave way to more 'respectable' figures, in keeping with the greater prosperity of Holland in general, and of Ostade, who married well, in particular. More than 800 of his paintings, and some 50 etchings (see intaglio prints) are known. He was much in demand by princely collectors in the 18th century, and his work is to be found in most well-established galleries. He probably taught Jan *Steen, but his principal pupil was his younger brother, Isaack, who, after an initial period of emulating his brother's peasant interiors, went on to specialize in exterior scenes, often combining winter or summer landscape and *genre, especially the activity in front of a country cottage or a roadside inn (Haarlem, Hals; Basel, Kunstsammlung; Berlin-Dahlem, Museen; London, National; etc.). During the last years of Adriaen van Ostade's life, Cornelis Dusart (1660–1704) entered his studio, assisting Adriaen in completing his pictures. After Adriaen's death Dusart inherited unfinished paintings by both Adriaen and Isaack, completing them for the market in his coarser, more caricatural style.

OUDRY, Jean-Baptiste (1686–1755) French painter, the leading *Rococo specialist of aristocratic *still-life and hunting pieces, close to the decorative manner of the two *Weenix brothers. Trained by *Largillière, he was capable of great tonal finesse (see under colour): the White Duck (1753, Coll. Dowager Marchioness of Cholmondeley) is a virtuoso piece composed almost entirely in shades of white and silver. Whilst most of Oudry's paintings combine still-life, living animals, plants and architecture against a background of decorative landscape (e.g. London, Wallace), he also executed a major cycle of panoramic hunting scenes in topographical landscapes (e.g. Fontainebleau, Château). These Royal Hunts document the expeditions of Louis XV, and were intended as cartoons (see under fresco) for tapestries to be made at the Beauvais tapestry works, where Oudry had been appointed official painter in 1726; in 1734 he was made Director, becoming Inspector of the Gobelins tapestry works in 1738, and in 1748 Chief Inspector. He also worked for private patrons and foreign collectors, the most devoted of whom was the Duke of Mecklenburg-Schwerin (Schwerin, Museum).

OUWATER, Albert See under Geertgen tot Sin Jans.

PACHECO, Francisco (1564–1654) Sevillan painter and scholar, the director of an artistic and literary *academy; from 1618 chief censor of the Inquisition in Seville. He was the author of the important treatise *El arte de la pintura, su antiguedad y grandeza* (*The art of painting, its antiquity and greatness*), published in 1649. An excellent teacher, he was the master of *Herrera the Elder, Alonso *Cano and *Velázquez, who married his daughter in 1618. He executed the *polychromy on the sculptures of Juan Martinez *Montañés.

Despite praising in his treatise the naturalistic (*see under* realism) *bodegones* of Velázquez, Pacheco remained a *classicizing *Mannerist working largely from prints after Italian and Netherlandish masters and in a dry, hard technique dependent on Flemish painting (e.g. Seville, Count Ibarra). As censor for the Inquisition, he showed particular interest in religious *iconography, most notably in the new doctrine of the Immaculate Conception, which was propagated with particular fervour in Seville (cathedral; S. Lorenzo). Only as a portraitist did Pacheco show pictorial – as opposed to verbal – understanding of the new style (e.g. Williamstown, Mass., Museum). His unfinished *Book Describing the True Portraits of Illustrious and Noteworthy Gentlemen* contains excellent portrait drawings (mostly preserved, Madrid, Lázaro Galdiano).

PACHER, Michael (active from *c.*1462–98) German painter and sculptor (or perhaps only designer of sculpture produced in his workshop) based in the south Tyrol. The sculpture is northern in style, a synthesis of *Multscher's later manner and the new grand figure type of *Gerhaert; Pacher's painting, however, demonstrates first-hand knowledge of Paduan art and especially the work of *Mantegna. The most complete extant work is the high altarpiece, St Wolfgang, Pfarr-kirche (1471–81, restored in 1861).

PAJOU, Augustin (1730–1809) French sculptor, whose career, like that of his older contemporary, the painter *Vien, successfully survived the most extreme political upheavals: he worked for Mme du Barry, and received crown commissions under Louis XV and Louis XVI, but later also served on official committees during the Revolution and under the Directoire, and was still exhibiting officially commis-sioned works in 1802 and 1803 under the Consulat of Napoleon (Paris, Palais du Sénat, Chambre des Députés). His style is characterized by a slightly sentimentalized *classicism, and although he produced many portrait busts, including one of his teacher Jean-Baptiste *Lemoyne (terracotta, 1758, Nantes, Musée; bronze, Paris, Louvre) the best examples of his work are his reliefs (e.g. Leningrad, Hermitage). From 1772–92 he served as designer for the medals of the Académie des Inscriptions, and added relief figures to *Goujon's famous *Fontaine des Innocents*, Paris. His best-known works are the gilded wooden reliefs in

the opera house at Versailles, 1768–70. (Other works Paris, Institut; Ecole des Beaux-Arts; many fine drawings, some at Princeton.) He became the father-in-law of *Clodion.

PALMA Giovane or the Younger, Jacopo Nigreti, called (c.1548–1628) Eclectic and prolific Venetian painter, whose long stay in central Italy, first in Pesaro, then, 1567–c.75 in Rome, converted him to a *Mannerist idiom. On his return to Venice he also adopted formulae from *Veronese and *Tintoretto, and occasionally the naturalistic (see under realism) vein of Jacopo *Bassano. He soon found favour with the Venetian government (Doge's Palace, Great Council Hall, c.1578) and with the Counter-Reformation clergy (e.g. S. Giacomo dell'Orio, c.1584; Oratorio dei Crociferi, 1583–96), as well as with princely patrons throughout Italy and abroad. After the death of Tintoretto in 1594 he became the leading artist in Venice. He was the great-nephew of *Palma Vecchio, and the son of the painter Antonio Nigreti (1510/15–after 1575). There are works by him in many Venetian churches, and in museums in Italy and abroad.

PALMA Vecchio or the Elder; Jacopo Nigreti, called (c.1480–1528) Venetian painter born near Bergamo, possibly trained by *Carpaccio, but soon influenced by *Giorgione and *Titian. Although he executed portraits (e.g. London, National) and some altarpieces (Venice, S. Maria Formosa, c.1522–3; Vicenza, S. Stefano, c.1523) he is best known for two domestic genres which he developed: *sacre conversazioni of horizontal format, in which the figures are disposed in front of an extensive landscape (e.g. London, National; Vienna, Kunsthistorisches; Florence, Uffizi; Munich, Alte Pinakothek) and half-length quasi-portraits of beautiful women, perhaps Venetian courtesans (e.g. Lugano, Thyssen-Bornemisza Coll.; Vienna, Kunsthistorisches; cf. Titian, Flora; Woman in Blue Dress). He was the great-uncle of *Palma Giovane.

PALMEZZANO, Marco See under Melozzo da Forlì.

PALOMINO, Antonio (1655–1726) Spanish painter, scholar and writer on art. A native of Cordova, he had studied briefly with *Valdés Leal before moving to Madrid in 1680; he became court painter to Charles II in 1688. After 1699 he specialized in large allegorical *fresco decorations for churches in various cities throughout Spain. His main importance, however, resides in his writings: the third volume of his treatise on painting, the Parnaso español pintoresco laureado (1724), modelled on *Vasari's Lives . . ., is our most valuable source for the history of Spanish painting in the 16th and 17th centuries. Summaries in English and French were published in 1739 and 1749/1762 respectively.

PANINI or PANNINI, Gian Paolo (1691/2–1765) Painter specializing, from c.1735, in celebrated views of Roman architecture and ruins. He depicted real topography as well as imaginary views, but was not, as is sometimes said, the originator of *vedute ideate, having been

anticipated by Giovanni *Ghisolfi. Born at Piacenza and probably trained in architectural drawing, he moved to Rome in 1711. His reputation was established with his *fresco decorations of the Villa Patrizi (1718–25, destroyed) and in the Quirinal Palace (c.1722). Commissioned by Cardinal de Polignac for a series of paintings recording celebrations on the birth of the heir to the French crown in 1729, and married to a Frenchwoman, Panini forged close relations with the French *Academy in Rome, influencing many French artists, including the more poetical Hubert *Robert. His architectural fantasies also affected *Piranesi. There are many variants of compositions by Panini which are found in numerous collections in Rome and abroad.

PANTOJA DE LA CRUZ, Juan (1553–1608) Spanish court portraitist, a pupil and follower of *Sánchez Coello. He was particularly in demand after the death of Philip II in 1597; between 1600–07 he executed 66 royal portraits, of which at least nine are of Philip III (best versions Vienna, Kunsthistorisches; Hampton Court; Escorial; Madrid, Prado; Cambridge, Mass., Fogg) and eight of Queen Margarita (best versions, Buckingham Palace; Houston, Museum). After the disastrous fire of 1604 at the Pardo Palace, Pantoja restored mutilated portraits by Sánchez Coello, confusing later attributions. Pantoja also executed religious works, some of them incorporating portraits of the royal family (e.g. Madrid, Prado; Toledo, Cathedral). The poses of Pantoja's sitters were influential on later court portraitists, including *Velázquez.

PAOLO VENEZIANO (active 1321–before 1362) Founder of the Venetian school of painting and the first to modify Byzantine schemata by elements derived mainly from *Giotto. There are works in the Cathedral at Dignano; in Vicenza, Gallery; Carpinetta, parish church; Venice, Accademia, and others. His sons Luca and Giovanni collaborated with him on the panels of the covering of the Pala d'Oro, S. Marco, Venice (1345), and he painted the *Coronation* (New York, Frick) with his son Giovanni in 1358.

PARMIGIANINO; Girolamo Francesco Maria Mazzoli, called (1503–40) Precocious painter and etcher from Parma – hence his nickname. Assimilating the influences of *Correggio, *Raphael and *Michelangelo, he forged an original and extremely elegant form of *Mannerism which was widely influential throughout Europe, especially as it spread by means of his etchings (*see under* intaglio prints; *also* Primaticcio; Nicolò dell'Abate and, especially, Bartolomeus Spranger).

Trained by his uncles, the painters Michele and Pier Ilario Mazzola, after the death of his father in 1506, he was painting independently from the age of 18 (*Mystical Marriage of St Catherine*, 1521, Bardi, S. Maria). In 1522–3 he executed the *fresco decoration of side chapels in Parma, S. Giovanni Evangelista, where Correggio had been painting the dome (1520–3). Around 1523 he decorated the ceiling of a small room in the Sanvitale castle at Fontanellata; the episodes from the tale

of *Diana and Acteon*, drawn from Ovid's *Metamorphoses*, unfold in an
*illusionistic arbour inspired by Correggio's ceiling in the Convent of S.
Paolo, Parma. In 1524 Parmigianino also painted his patron at Fon-
tanellata, Galeazzo Sanvitale (Naples, Capodimonte) – one of the ear-
liest of many highly refined yet *expressive portraits (e.g. London,
National; York, Gallery; Copenhagen, Museum; Rome, Borghese;
Parma, Galleria; Madrid, Prado). Later that year the young artist
travelled to Rome to gain an entry to the papal court, bringing with
him, as a demonstration of his talents, one of the great virtuoso pieces
in the history of art: the *Self-Portrait in a Mirror* (now Vienna, Kunst-
historisches), a prime instance of optical *realism.

Parmigianino's main Roman work was the large altarpiece, *The
Madonna and Child with Sts John the Baptist and Jerome* (1526–7, London,
National), which demonstrates his study of Raphael and Michelangelo
along with his continuing allegiance to Correggio.

After leaving Rome following the Sack of 1527, Parmigianino settled
in Bologna (1527–31), where a series of major religious works testifies
to his continuing search for refinement and complexity (Bologna,
Pinacoteca, S. Petronio; Dresden, Gemäldegalerie; Florence, Uffizi). In
1531 he returned to Parma, signing a contract for the decoration of the
apse and vaults of the church of the Steccata. Although this commission
gave him great difficulty – to the point where the overseers had him
imprisoned in 1589 for breach of contract – the east vault, the only part
completed, is one of the most beautiful decorative works of the century.
In combining painted with carved areas, it anticipates the *Baroque
vault effects of *Gaulli.

The best-known easel painting of these years is the unfinished
Madonna of the Long Neck (*c*.1535, Florence, Uffizi), the culmination of
Parmigianino's synthesis of religious meaning with artificial grace.

Taking refuge from the overseers of the Steccata at Casalmaggiore,
where he was to die, Parmigianino completed his last work, *Madonna
and Child with Sts Stephen and John the Baptist* (now Dresden, Gemälde-
galerie) in a newly grave manner. Great beauty of colour is combined
with near-abstraction of form, more brittle and austere than in the
Uffizi Madonna.

*Vasari records that Parmigianino's last years were devoted to
alchemy, although this may be a rumour caused by his interest in the
chemical procedures of etching. The artist seems certainly to have
undergone a period of severe depression. The change in style of the
Dresden picture has given rise to conjectures of a religious conversion
in the year following his imprisonment.

PASSAROTTI or PASSEROTTI, Bartolommeo (1529–92) Bolognese
*Mannerist painter, a pupil of Taddeo *Zuccaro in Rome *c*.1551–
65 and himself a teacher of the *Carracci in Bologna. Although he
executed many altarpieces for Bolognese churches, in which he experi-
mented with a variety of styles derived from *Correggio (1565, S.

Giocomo Maggiore) to *Tibaldi (c.1575, S. Maria del Borgo), he is now best remembered for his stridently naturalistic (see under realism) low-life *genre pieces (from c.1575, e.g. Butcher's Shop, Rome, Nazionale). Inspired by the Flemish paintings of Pieter *Aertsen and Joachim Beuckelar, and Vincenzo *Campi's Italian derivations, these works combine near-*caricature with illusionistic *still-life and, despite their very different temper, influenced Annibale Carracci's more solemn genre pieces.

PASTI, Matteo de' (c.1420–67/8) Illuminator and medallist, he became court artist to Sigismondo Malatesta in Rimini, and worked as an architect on the reconstruction of the interior of the Tempio Malatestiano (1447–c.60). He is thought to have been responsible for the finest of the carvings in the building, the most richly sculptured *Renaissance edifice in Italy. (See also Agostino di Duccio; Alberti; Piero della Francesca).

PATER, Jean-Baptiste See under Watteau, Jean-Antoine.

PATINIR, PATINIER or PATENIER, Joachim (c.1475/80–1524) A native of the Meuse river valley, master in the Antwerp painters' guild in 1515, he is the first known landscape specialist in European art. Although not himself the inventor of the panoramic landscape, he established the type in Flemish painting; signed or documented works are very few, but a host of contemporary imitations are still attributed to him.

Two basic forms of landscape construction are associated with Patinir. In one, the landscape, depicted as if from a high viewpoint, recedes without a break 'as far as the eye can see' to a distant horizon high on the picture plane (Passage to the Infernal Regions, c.1520–4, Madrid, Prado). In the other, the painting is divided in two along a diagonal; in one half the view is unimpeded to the high horizon, but in the other it is blocked by a tall rock formation, itself usually enlivened by paths winding into the distance (Flight into Egypt, c.1515–20, Antwerp, Musée). In both, a system of reddish-brown foreground, green middle ground and blue background simulates the effects of aerial *perspective. Narrative incidents with human figures and/or architectural forms are inserted into both landscape types with no account taken of the height of the viewpoint, thus creating a dual perspective. The foreground figures may be represented as if at a considerable distance from the viewer – this is the case in the two paintings cited – or they may loom large in the foreground, as in the Baptism of Christ (c.1515–20, Vienna, Kunsthistorisches) or in the Temptation of St Anthony (c.1520–4, Madrid, Prado). In the latter picture the figures were executed by Quinten *Metsys, who became the guardian of two of Patinir's three daughters after the artist's death. Earlier examples of collaboration with Joos van *Cleve and other, unnamed artists are recorded by van *Mander.

Although Patinir's landscapes always contain narrative, their real

theme is the grandeur of nature. This is apparent despite the fact that the works themselves are small and made up of miniature elements: the very rock masses are painted from stones brought into the workshop, as advocated in Cennino Cennini's (*see under* Gaddi) *Book of the (Painter's) Craft* and practised both south and north of the Alps. Later followers – the chief of them Patinir's nephew Herri met de *Bles – were to stress more the elements of *genre* and of the landscape as a setting for human action.

PELLEGRINI, Giovanni Antonio (1675–1741) One of the earliest Venetian painters of light-hearted *Rococo decoration to have an international career; a charming and influential precursor of *Tiepolo. Trained first in Milan, he was formed mainly through study of the work of Sebastiano *Ricci and Luca *Giordano. He married one of the sisters of Rosalba *Carriera. Brought to England in 1708 by the then British Ambassador to Venice, Pellegrini painted decorations at Kimbolton Castle, at Castle Howard, and at Narford, where most of his surviving work in Britain is now to be found. He was also involved, with *Kneller, in the foundation of the *Academy in London in 1711. In 1713 he left for Düsseldorf (Bensburg Castle, decorated 1713–14), returning to England only briefly in 1718/19. He painted the ceiling of the Bank of France in Paris in 1720 (destroyed) and worked in the Castle at Mannheim (1736–7) and elsewhere. There are easel paintings by him in London, National; Paris, Louvre; Vienna, Kunsthistorisches; etc.

PENCZ, Georg (*c.*1500–50) As a young man he called himself Jörg Bencz. Nuremberg painter and printmaker, a master both of large-scale mural painting and tiny engravings (*see under* intaglio prints). He was in *Dürer's workshop in the early 1520s, and painted murals in Nuremberg town hall after Dürer's designs. In 1525, he, along with Sebald and Bartel *Beham, was temporarily expelled from the city for anarchism and atheism. He went to Northern Italy *c.*1530, and to Florence and Rome in 1539. The Venetian influence transmitted to him in Dürer's shop was strengthened by his first trip (e.g. Krakow, Jagiellon Chapel; East Berlin, Staatliche Museen) and after the second the imprint of Tuscan and Roman *Mannerism (e.g. *Bronzino) becomes apparent in his portraits (e.g. Nuremberg, Museum; Karlsruhe, Kunsthalle; Darmstadt, Museum), in his mural paintings (Nuremberg, Hirschvogel House; Landshut, palace) and in his prints (series of the *Planets*). After Bartel Beham's death in 1540 Pencz was summoned to Landshut to work for the Duke of Bavaria; he died shortly after taking up an appointment as court painter to the Duke of Prussia.

PENNI, Giovanni Francesco *See under* Raphael.

PENTIMENTO (pl. *pentimenti*, Italian, repentance, qualm) *See under alla prima.*

PERINO DEL VAGA; Piero Buonaccorsi, called (*c.*1500–47) One of the most influential decorative artists of the 16th century; his stylish version of *Mannerism found many followers, especially in

Genoa and Rome. Born in Florence, Perino arrived in Rome c.1516 in the company of a painter called Vaga, whose name he adopted. In 1518 he joined *Raphael's workshop, becoming one of the chief executants on the Vatican Logge. He left Rome after the Sack of 1527, settling in Genoa (1528–36/7), where he was in charge of the remodelling and redecoration of the Palazzo del Principe for Andrea Doria, and founded a long-enduring local school (*Basadonne* altarpiece, 1534, now Washington, National). From 1537 he worked again in Rome (1539, SS. Trinità dei Monti; detached *fresco now London, Victoria and Albert), becoming the chief decorator of Pope Paul III Farnese, for whom he executed his greatest surviving project: the Pauline apartments in the Castel S. Angelo, consisting of the Sala Paolina (completed after his death, mainly by Pellegrino *Tibaldi) and the adjoining smaller rooms, the Sala of Psyche and of Perseus.

PERMOSER, Balthasar (1651–1732) Outstanding Austrian-born Late *Baroque sculptor, the dominant artistic personality in Dresden in the early 18th century. After an unfruitful apprenticeship in Salzburg, Permoser went to Italy, where he remained c.1675–89, working in Venice, in Rome – in the studio of *Bernini –and in Florence (S. Gaetano). Italian records speak of him variously as 'Baldassare Fiammingo' – 'Baldassare the Fleming'– or as 'Belmosel' and 'Delmosel'. In 1689 he was summoned to Dresden by Johann Georg III of Saxony; he remained there for the rest of his life, executing and designing sculpture in marble, alabaster and sandstone, and training numerous pupils, among them *Roubiliac. His style in sculpture, influenced by Bernini, is highly painterly, and, like Pierre *Legros the Younger in Rome, he experimented with the *polychrome effects of different coloured marbles within a single work (e.g. *Scourging of Christ*, Dresden, Moritzburg, Hofkirche; Leipzig, Museum). His most extensive work, however, is for the Zwinger, a court surrounded by arcades and pavilions, for a projected but never completed palace in Dresden, 1709–17. Other works in various Dresden churches; Bautsen, Stadtmuseum, etc.

PERRIER, François *See under* Lebrun, Charles.

PERSPECTIVE A method of representing three dimensions on a two-dimensional surface, as in drawing, painting and shallow relief. The term originates in optics rather than art, and the *Renaissance invention of precisely calculated recession and diminution is indebted to a study of medieval optics. All types of *linear perspective* depend on the illusion of parallel lines at right angles to the picture plane (orthogonals) meeting at a 'vanishing' point in the distance. In ancient scenography, and the mural painting it inspired, the effect is imperfectly approximated, no systematic vanishing-point or points governing the convergence of all receding orthogonals. The great Florentine innovator *Giotto (d.1337) used two distinct methods of perspective construction. In his earlier work he set buildings at an angle to the

spectator, the receding orthogonals converging rather imprecisely out-
side the side edges of the picture field. Later, he tended to set buildings
parallel to the picture plane, with the orthogonals above the horizon
line sloping downwards, and those below sloping upwards. The Sienese
Ambrogio *Lorenzetti (d.1348), and some northern European artists of
the 15th century, evolved empirical methods of representing recession
and diminution based on the notional curvature of the visual field:
objects diminish in scale from the centre to the periphery, as well as
from front to rear. *Brunelleschi's pioneering demonstration of mathe-
matically constructed perspective employed a peephole and a mirror,
and probably involved two vanishing-points at the sides of the demon-
stration panel (see also under Bibiena). *Alberti evolved a simpler
method, which could be used to represent not only actual buildings (as
was the case with Brunelleschi's construction) but also imagined ones.
Described in his treatise On Painting (1435 and 1436), later elaborated
by other artists, this so-called costruzione legittima employs a single van-
ishing point on the horizon, usually but not necessarily in the centre of
the composition, corresponding to the spectator's viewpoint in front of
the picture. An intersection of the 'visual pyramid' enables the artist to
calculate the precise scale of objects diminishing in the distance. The
Albertian costruzione legittima has several advantages. It allows the depic-
tion of a measurable environment. It serves to clarify narrative, to help
focus the viewer's attention, and to mobilize his or her empathy by
making the viewer an eye-witness to the event or scene depicted. It can
also be used to make symbolic points, either through application or by
disruption of the laws of optics (as, respectively, in Masaccio's Tribute
Money, Brancacci Chapel, and Holy Trinity, S. Maria Novella, both in
Florence).

Linear perspective is utilized in such specialized illusionistic forms as
quadratura painting (see under illusionism). Aerial and colour perspective
deal with the diminution through distance of colour intensity and
definition. They were first studied systematically by *Leonardo da
Vinci. The perspectival representation of irregular objects, whilst
obviously related to the representation of space and regular volumes,
requires much more complex calculations. This branch of perspective
study was of particular interest to *Uccello, but treated also by Leon-
ardo, *Mantegna, *Piero della Francesca and *Dürer.

PERUGINO; Pietro Vanucci called (c.1450–1523) Influential
Umbrian painter, born near Perugia, the principal centre of his
activity – hence his nickname. Although it now appears that *Raphael
was his assistant, rather than a pupil, the latter's early works bear the
unmistakable imprint of Perugino's mature style: gently pious, grace-
fully posed and clearly positioned figures set against sunlit landscapes,
perhaps inspired by Netherlandish art (see especially Rogier van der
Weyden). Perugino's workshop procedure of drawings from the life
was taken over by Raphael, along with many actual compositions.

Indeed, the years 1482–91 saw the general diffusion of Perugino's style and imagery throughout central Italy. After about the first decade of the 16th century, however, Perugino's nearly unchanging manner came to be seen as old-fashioned and provincial.

The artist's early formation is not documented; he is thought to have been a pupil of *Piero della Francesca c.1465, and from c.1470 to have worked in Florence in the ambient of *Verrocchio; there are signs also of the influence of *Botticelli. He probably worked in Perugia, Palazzo dei Priori, 1475, and fragments still exist of his first securely dated commission, the 1478 *frescoes in Cerqueto, S. Maria Maddalena. In 1479 he was in Rome, painting the chapel of the Conception in St Peter's (destroyed 1609), and in 1480/1–2 he was in charge of the mural decoration of the Sistine Chapel, working with *Ghirlandaio, Botticelli and Cosimo *Rosselli. His fresco altarpiece and two flanking scenes were later to be destroyed by *Michelangelo to accommodate the *Last Judgment*.

From 1482–95 Perugino worked mainly in Florence; outstanding works in that city are his *Last Supper* in the ex-convent of S. Onofrio, c.1495 and the *Crucifixion* in the chapter house of S. Maria Madalena dei Pazzi, 1493–6. Easel paintings from this period are mainly to be found in Florence, Uffizi, Pitti, Accademia; also Vatican, Pinacoteca.

Perhaps in 1496–7, but probably closer to 1500–07, Perugino and his shop painted the vault and walls of the Collegio del Cambio in Perugia. This important decoration, consisting of *grotesques and pagan divinities in the vault, and allegorical figures of the cardinal virtues enthroned above their historical exemplars on the walls, influenced Raphael's frescoes in the Stanza della Segnatura.

Sometime c.1499, Perugino was also at work on a *polyptych for the Charterhouse in Pavia (London, National, fragments). The *Marriage of the Virgin* (Caen, Musée), commissioned for Perugia cathedral in 1499, was also begun, but only after some delay, and completed c.1505. It was later copied, and 'corrected', by Raphael. From about the same date is the *Battle of Love and Chastity*, a laboured allegorical composition for Isabella d'Este's *studiolo* in Mantua (*see also* Mantegna; Costa). Around 1507, Perugino was at work once more in the Vatican, painting the vault in the Stanza dell'Incendio; the recent restoration reveals that his workshop methods were as inventive as ever in the efficient use of cartoons (*see under* fresco) for the grotesque ornament.

PERUZZI, Baldassare (1481–1536) Sienese-born painter and architect, mainly active in Rome from c.1503 until the Sack in 1527, and again in 1530–1 and from 1535 until his death. Some of his most important and influential pictorial work has been lost to us: for example, his *all'antica* façade decorations, which influenced those of *Polidoro da Caravaggio, and his scenery for the theatre, the main arena for his researches in *perspective and perspectival *illusionism. His interest both in archaeology and in perspective is well illustrated,

however, in his decoration for the Villa Farnesina in Rome (ceiling fresco, Sala di Galatea, *c.*1510; frieze, Sala del Fregio, *c.*1511; Sala delle Prospettive, or delle Colonne, *c.*1516). Despite his debt to *Raphael, Peruzzi retains a Tuscan and 15th-century ideal of grace, witty, precise, slightly precious and less monumental. This may be observed also in his *frescoes for S. Maria della Pace (1516 and *c.*1518) and in his decorations in the loggia of the Villa Madama (1521). The reader should be aware, however, that Peruzzi's present stature in the history of *Renaissance art derives mainly from his architectural practice in Rome and in his native Siena.

Piazzetta, Giovanni Battista (1683–1754) Outstanding Venetian painter. Trained partly in Bologna under Giuseppe Maria *Crespi, he remained faithful to the latter's *chiaroscuro, stressing the sculptural monumentality of figures – in almost total contrast to the prevalent *Rococo style (e.g. Venice, Gesuati; Milan, Brera). Notoriously slow and deliberate in execution – in especial contrast to *Tiepolo, who as a young man was nonetheless influenced by him – he was atypical also in remaining in Venice after his return from Bologna, 1711, whilst most Venetian artists worked extensively abroad (*see* e.g. Sebastiano and Marco Ricci). Despite his relative unproductivity, he was appointed the first Director of the newly created Venetian *Academy, 1750; he spent the last few years of his life teaching rather than painting and left his widow virtually destitute. His altarpieces were in great demand not only in his native city but also abroad, especially in Germany, as were his rather enigmatic, poetic *genre* works (e.g. Dresden, Gemäldegalerie; Cologne, Wallraf-Richartz). Even his history paintings (*see under* genres) had certain plebeian overtones, a lack of social pretensions reminiscent of *Caravaggio. Other works London, National; Lille, Musée; Venice, Accademia, and in various Venetian churches.

Picturesque 'worthy of a picture' An aesthetic category, between the *Sublime and the Beautiful, formulated in the 18th century with special reference to landscape and landscape art. Its foremost exponents were English, notably the Rev. William Gilpin (1724–1804) and Sir Uvedale Price (1747–1829). 'The two opposite qualities of roughness and of sudden variation, joined to that of irregularity, are the most efficient causes of the picturesque' (Price). It has been said, justly, that Picturesque theory was a socio-political response as much as an aesthetic one: it enabled the squirearchy to view distressing or threatening aspects of country life as pictorial themes rather than practical or ethical problems. Price again: 'In our own species, objects merely picturesque are to be found among the wandering tribes of gypsies and beggars; who in all the qualities which give them that character, bear a close analogy to the wild forester and the worn-out cart-horse, again to old mills, hovels, and other inanimate objects of the same kind.'

Pierino da Vinci (1520/1 or 1531–54) Precocious and sensitive Florentine sculptor in marble. After a stay in Rome in 1548, he returned to Tuscany imbued with the sculptural ideals of *Michelangelo and learned in his techniques; his two-figure group of *Samson Slaying a Philistine* (1549, Florence, Palazzo Vecchio) is based on sketches by the older master, and the relief of *Cosimo I as Patron of Pisa* (1549, Rome, Museo Vaticano) attempts to transcribe the painting style of the Sistine Chapel into marble.

Piero di Cosimo (1462–1521) Idiosyncratic Florentine painter, a long-time pupil of Cosimo *Rosselli, whose name he adopted and whom he assisted in the Sistine Chapel in Rome, 1481–2. Renowned for his fantastical imagination, Piero was in demand as a designer of processional floats and costumes, and made a particularly deep impression with his macabre Triumphal Chariot of Death for the Carnival of 1511. The same imagination is evident in the mythological panels, now dispersed in various museums, which formed part of one or more room decorations on the theme of prehistory or the early history of humankind (Hartford, Connecticut, Atheneum; London, National; New York, Metropolitan; Ottawa, National; Oxford, Ashmolean). Another such panel, the *Liberation of Andromeda* (c.1510, Florence, Uffizi) maintains the same fairy-tale charm whilst demonstrating, notably in its use of *sfumato*, Piero's growing debt to *Leonardo da Vinci. Even his large altarpieces incorporate, especially in the background landscapes, fantastical details (e.g. *Immaculate Conception*, c.1505, Florence, Uffizi) which are perhaps indebted as much to northern European prints as to the Florentine *cassone* tradition. Although Piero had pupils and disciples – the most notable being *Andrea del Sarto – he became increasingly reclusive and eccentric.

Piero della Francesca or dei Franceschi (c.1415/20–92) Painter and mathematical theorist from Borgo San Sepolcro (the modern Sansepolcro) near Arezzo. Albeit not as neglected in his day as sometimes supposed, and indeed influential on central and northern Italian artists (*see*, e.g. Bramantino and Melozzo da Forlì), he has gained particular fame in the modern period for his generally light palette (*see under* colour), his interest in geometry (including *perspective) and his monumental, architectonic sense of form and pictorial composition.

Piero's life is badly documented. We do not know by whom or where he was trained. Scholars disagree on the chronology of his extant works, on the causes for the delays between commissioning and completion of major projects (e.g. *Misericordia* *polyptch; *True Cross* *frescoes, *see below*), on the order of execution of the various portions of such works and on the degree of collaboration by assistants. Much of his *oeuvre* is lost, notably important frescoes in Ferrara and the Vatican. Other works have been dismembered and partly destroyed (*St Augustine* polyptych; central panel lost; flanking and *predella figures now Lisbon, Museu; London, National; New York, Frick; J. D. Rockefeller

Coll.; Milan, Poldi Pezzoli; Washington, National); others have been cut down (*Madonna and Saints with Federico II da Montefeltro*, Milan, Brera; *St Antony* polyptych, Perugia, Galleria), reassembled in modern frames (*Misericordia* polyptych, *Urbino* diptych, *see below*), or damaged through overcleaning (e.g. *The Nativity, see below*). Finally, a small, now celebrated picture, *The Flagellation* (Urbino, Galleria) presents an *iconographic puzzle: the identity of three figures in the foreground. All these factors impede our reading of Piero. Yet, except for *The Flagellation* which must have had special significance for a private patron, his work is unexceptional in content. Other than portraits (*see below*) only one secular painting by him is known: a fresco fragment depicting *Hercules* (Boston, Gardner). Even the famous impassivity of his figures is not markedly greater than that of Fra *Angelico's, who may have influenced him. Piero's fascination resides neither in a rejection of narrative and symbolism nor in complex *iconography, but in his pictorial methods: the way in which he reconciles abstract geometry with naturalism (*see under* realism) – an interest fuelled through contact with Netherlandish art, mainly in Urbino (*see* Joos van Ghent) – and the old-fashioned requirements of provincial patrons with the newest optical advances of Florentine art-science. What little is documented of his biography suggests that he was civic-minded and conventionally devout. There is some disagreement in the sources about whether or not he went blind sometime before his death; in either case he seems to have stopped painting by the 1480s and concentrated on writing mathematical treatises.

Piero is first recorded in 1439, assisting *Domenico Veneziano on frescoes in S. Egidio, Florence (destroyed). By 1442 he was back in Borgo San Sepolcro where in 1445 the Confraternity of the Misericordia commissioned from him the gold-grounded polyptych now reassembled in a modern frame (Sansepolcro, Pinacoteca). In defiance of the contract, the work was completed only in 1462 and not all 23 panels are by Piero. The influence of *Masaccio is evident throughout. Although the altarpiece of the *Baptism of Christ* (wings lost, London, National) may date from 1448–50, and the lost Ferrara frescoes *c.*1450, the next secure landmark in Piero's career is the fresco of *Sigismondo Malatesta Kneeling before St Sigismondo*, dated 1451 (Rimini, Tempio Malatestiano). Here, the demands of state portraiture, religious *icon, heraldry, architectural decoration and the realistic depiction of a fortress are all reconciled. In 1452, after the death of the Florentine Bicci di Lorenzo, Piero took over the decoration of the choir of S. Francesco in Arezzo. The frescoes of *The Legend of the True Cross* (completed 1459?1466?) are generally considered his masterpiece. They combine miracle stories, history, Old and New Testament and the celebration of two feasts of the Church, the Exaltation of the Cross and the Rediscovery of the True Cross. The cycle, however, which has undergone several restorations, is badly damaged.

Of Piero's other works in fresco, the best-known are the *Madonna del Parto* (1450?–5? 1460? Monterchi, votive chapel, now cemetery) and the *Resurrection of Christ* (1463–5, Sansepolcro, Pinacoteca). The pregnant Madonna is a rare but not unknown subject in Italian art. The reader is cautioned not to believe the fiction, perpetuated even by scholars, that the painting marks the burial place of Piero's mother: the chapel and its fresco altarpiece long pre-date the cemetery. The hieratic symmetry of the *Resurrection* recalls that the image, originally in the town hall, realistically represents the heraldic emblem of Borgo San Sepolcro: the Town of the Holy Sepulchre, founded by pilgrims returning from the Holy Land.

Piero's debt to Netherlandish art is especially noticeable in his panel paintings, in which he makes use of oil glazes laid over tempera (*see under* colour). It is perhaps most marked in the diptych portraying the Count, later Duke, of Urbino, Federico da Montefeltro and his wife Battista Sforza (1460? 1465? 1473? Florence, Uffizi). On the reverse of each portrait Federico and Battista are shown riding 'in triumph' on a pageantry chariot peopled with appropriate allegorical figures. Although the couple are depicted in profile, as on *classical medals and their contemporary emulations (*see* Pisanello), they are placed high above a luminous panoramic landscape, continuous across both panels and comparable with the landscapes in the background of many Netherlandish paintings (e.g. van *Eyck's *Rolin Madonna*). The showy frame which now interrupts the landscape dates from the 19th century. Although the iconography of *The Nativity* (*c.*1470–5? London, National) may have been borrowed from Filippo *Lippi, the motif of the naked Christ Child lying on the ground, adored by the kneeling Virgin, ultimately also derives from Netherlandish art. The unfinished appearance of this work probably results from its radical overcleaning in the 19th century.

The last major work thought to have been executed by Piero is the so-called *Brera* altarpiece, showing Federico da Montefeltro kneeling before the Virgin and Child surrounded by saints (before 1474, Milan, Brera). The famous ostrich egg suspended over the Virgin was, in fact, an object suspended in the apses of some Byzantine and Abyssinian churches, where it symbolized Creation and the four elements. Before the painting was cut down on all sides it must have shown much more of the painted architecture: the composition, situating the Virgin and her holy companions in the apse of a church, had a profound influence on Venetian altarpieces (e.g. Giovanni *Bellini).

According to tradition, Piero was the teacher of Luca *Signorelli.

PIETÀ (Italian, pity) A pictorial type abstracted from the narrative of the Passion of Christ, not so much intended to represent a specific moment in that narrative but to serve as a timeless focus of pious meditation and prayer. It is a representation of the dead Christ, carried down from the cross prior to burial, supported on his mother's lap. A

pictorial parallel is often drawn between the grieving older Madonna holding the dead adult Christ, and the youthful Madonna with a sleeping infant Jesus. Strictly speaking, a *Pietà* comprises only the two figures of Christ and Mary; where other mourners are depicted, and the scene is thus closer to narrative, the imagery is known as a *Lamentation*. This difference, however, is not observed in Italian and, by extension, by many writers in other languages. Like most other meditative devotional imagery (*see also andachtsbild*), the *Pietà* was a Late Medieval northern European development.

PIETERSZ., Pieter *See under* Pieter Aertsen.

PIETRO DA CORTONA (1596–1669) Architect, painter, decorator and designer of sculptural monuments. His real name was Pietro Berrettini. Born at Cortona in Tuscany to a family of stonemasons, he became, with *Bernini and the architect Borromini, the third great creator and exponent of Roman High *Baroque. His later work, however, heralds the end of the Baroque in its avoidance of extreme *illusionism and insistence on clear divisions between painting and three-dimensional enframement. It gave rise to a sumptuous kind of decorative *classicism which became the international ornamental style throughout Europe and particularly in France (*see* Lebrun). Nonetheless, Pietro da Cortona is identified with the anti-classicist faction of the *Academy of St Luke in Rome (*see* Andrea Sacchi) of which he was elected 'prince' from 1634–8. Although as an easel painter he lacked the moral seriousness of Sacchi and *Poussin (e.g. Rome, Capitoline; S. Maria della Concezione; S. Lorenzo in Miranda; Cortona, S. Agostino; Paris, Louvre) he was unmatched as a master of large-scale mural painting in Rome from the 1630s. Whilst this entry is limited to his achievements as a painter and decorative artist, the reader should be aware that as a brilliant architect Pietro da Cortona influenced even Bernini (e.g. Rome, S. Maria della Pace).

Apprenticed to a mediocre Florentine painter, he followed him to Rome in 1612/13. His early studies were mainly of *Raphael and a copy of the latter's *Galatea* won him the influential patronage of the Sacchetti family from 1623. At the Palazzo Sacchetti, he met Cardinal Francesco Barberini, the nephew of Pope Urban VIII, who became his lifelong patron, and the cardinal's learned secretary, Cassiano dal Pozzo. The latter employed him, as he did other young artists, including Poussin, to compile a corpus of ancient works of art remaining in Rome – the source of Pietro da Cortona's antiquarian interests. Fittingly, his most famous pictorial work was executed in the Palazzo Barberini, 1633–9: the ceiling decoration of the Gran Salone, a landmark of Baroque ceiling painting. This famous *fresco combines, in a wonderfully exuberant yet disciplined whole, several traditions of *illusionistic vault and ceiling painting. (*See* Annibale Carracci; Correggio; Veronese.)

Whilst passing through Florence in 1637, Pietro da Cortona was persuaded by Ferdinand II de'Medici to fresco a small room in the Pitti

Palace (Camera della Stufa). From 1640–7 he was to decorate ceilings of a suite of rooms. This time a real stucco enframement, some of it in very high relief, in pure white and pure gold, separated the painted areas. This is the decoration, at once stately and festive, which was adopted internationally and gave rise to the 'style Louis XIV'. Upon his return to Rome in 1647 he began his most extensive church decoration: the frescoes in S. Maria in Vallicella, 1647–51, 1655–60, where the separation of painted areas and decorative enframement was once again observed, although the frescoes themselves look back to *Lanfranco and Correggio. Between 1651–4, however, he painted for Pope Innocent X the ceiling of the long gallery of the Palazzo Pamphili, Rome; its luminous colour range anticipates the work of Luca *Giordano and the 18th century, and, unlike the public frescoes of S. Maria in Vallicella, the decoration appealed to the refined taste of connoisseurs by recalling High *Renaissance and antique design. In 1652 he published, together with the Jesuit Ottonelli, a *Treatise on Painting* in which he upheld the traditional Renaissance ideals of *decorum and the moral function of art.

Pietro Solari, called Pietro Lombardo (c.1435–1515) and his sons Tullio (c.1455/60–1532) and Antonio (c.1458–c.1516) With Antonio *Rizzo, the first fully *classicizing sculptor in Venice, where Pietro worked from c.1467, after a probable visit to Florence prior to 1462 and periods of activity in Bologna (1462–3, S. Petronio) and Padua (1464–7, S. Antonio). In addition to running a sculpture workshop, Pietro practised as an architect; after the flight of Rizzo in 1498, he became master of works in the Doge's palace. Member of a branch of the *Solari family, he was called Lombardo after his native region, Lombardy. To a greater extent than Rizzo, whose work remained eclectic, the Lombardi workshop evolved an autonomous Venetian *Renaissance sculptural style, first discernible in the *Mocenigo monument* (1476–80/1) and even more clearly in the *Marcello monument* (after 1480; both in Venice, SS. Giovanni e Paolo). This technical and stylistic advance is even more marked in the *Zanetti* (after 1485) and *Onigo* (after 1490) *monuments*, in which Tullio and Antonio played a more important part (Treviso, cathedral, S. Nicolò, respectively). Other major funerary monuments by the workshop are to be found in Venice, S. Suriano; S. Maria dei Frari, and include the *Tomb of Dante* in Ravenna (1482). Pietro also designed the lower part of the new façade of the Scuola di S. Marco, Venice (1488–90) with *perspectivized reliefs executed by Tullio and Antonio; he is also known to have worked on the choir screen of S. Maria dei Frari.

Tullio Lombardo had a more consuming interest in the antique than his father. He is known to have collected classical statuary, and many of his own works copy or adapt Graeco-Roman prototypes. The *Vendramin monument* which he probably designed and largely executed (compl. 1494, originally Venice, S. Maria dei Servi, now SS. Giovanni e

Paolo; figure of *Adam*, New York, Metropolitan) has been called 'a manifesto of Venetian classicism'. Tullio's reputation as a 'humanist sculptor' is particularly sustained in his lyrical portrait-like reliefs, inspired by Roman grave portraits (Vienna, Kunsthistorisches; Venice, Correr). Amongst his other important works are the marble relief altarpiece for Venice, S. Giovanni Crisostomo (1499–1502) and two reliefs for the Chapel of St Anthony of Padua (1501–20, Padua, S. Antonio), a complex to which Antonio Lombardo also contributed a relief (1505). From *c*.1515–28 Tullio worked on commissions outside Venice: in Ravenna cathedral; at Belluno; for Isabella d'Este in the ducal palace at Mantua, and at Feltre.

Antonio Lombardo's career is the least well documented. In addition to his presumed participation in the Lombardi workshop monuments from *c*.1475, and his authorship of the relief in Padua mentioned above, his main activity whilst in Venice relates to the Zen chapel in St Mark's (bronze *Virgin and Child*, model 1506, date of casting unknown). After 1506 he moved to Ferrara, where he was employed by Alfonso d'Este on the mythological reliefs for the Camerini d'Alabastro in the Castello (*see also* Titian; Dossi Dossi). The greater part of these dispersed reliefs is now in Leningrad, Hermitage; Florence, Bargello. Antonio's style has been characterized as more pictorial than either his father's or brother's.

PIGALLE, Jean-Baptiste (1714–85) Leading French sculptor. Like *Falconet Pigalle was of humble origins, a student of Jean-Baptiste *Lemoyne and an individualist, but unlike him he rose to high honours, receiving many major commissions from the crown and becoming, exceptionally for a sculptor, Chancellor of the *Academy. His work is distinguished by its vigour and naturalism (*see under* realism) – most startlingly evident in his full-length statue of *Voltaire nu* (1770–6, Paris, Institut) in which the philosopher's body is depicted with the sagging muscles, stiff joints and wrinkles of old age – in other words, 'naked' rather than *classically 'nude', and was posed for by an old soldier.

Despite not having won first prize at the Academy School in Paris, Pigalle was allowed to work at the French Academy in Rome, 1736–9. Although demonstrably familiar with both antique and *Baroque sculpture in Rome, he seems to have been influenced relatively little by either. Before returning to Paris in 1741, he spent two years in Lyons, where he may have executed the terracotta model for his successful reception piece for the Academy, the *Mercury* (exhibited 1742, now New York, Metropolitan; marble version, 1744, Paris, Louvre; *see also under* Chardin). In the years following he was to be employed by Mme de Pompadour and the French crown (e.g. bust of *Mme De Pompadour*, 1748–51, New York, Metropolitan; the allegorical *Love and Friendship Embracing*, 1758, Paris, Louvre). His greatest work, the funerary monument to the Maréchal de Saxe (Strasbourg, St Thomas) was commissioned and designed in 1753 but completed only in 1776. The

commission itself led to his being selected by the city of Reims to execute a large monument to Louis XV, of which only the allegorical figures at the base remain (compl. 1765, Reims, Place Royale), and the success of this prompted *Bouchardon to name him as his successor on the monument to Louis XV in Paris (destroyed).

In addition to large-scale works Pigalle executed some portrait busts, chiefly of professional men who were his friends (e.g. Orléans, Musée). His self-portrait of 1780 is at the Louvre. One of his best-known early works is the nude *Enfant à la Cage* (1750, Paris, Louvre), ostensibly a *putto *all'antica* but actually the portrait of the one-year-old son of a patron.

PIJNACKER or PYNACKER, Adam (1621–73) Italianate Dutch painter of landscapes in the manner of Jan *Both (e.g. Munich, Gemäldesammlungen) and harbour scenes indebted to Jan *Asselijn (Amsterdam, Rijksmuseum; Leningrad, Hermitage; Hartford Conn., Atheneum; Vienna, Akademie). He is said to have spent three years in Italy, although there is no documented record of the presumed voyage. After working at Delft (1649) and Schiedam (1658) he settled in Amsterdam, producing huge decorative wall hangings for patrician houses.

PILGRAM, Anton (c.1450/60–after 1515) Architect and sculptor, born in Brünn. From 1511–15 he was in Vienna as master mason of St Stephen's cathedral; at this period he executed also his first sculpture (organ-bracket with self-portrait, pulpit with busts of the Fathers of the Church).

PILO, Carl Gustaf (1721/13–92) Swedish painter, best-known member of an artistic dynasty which included his father, the Polish painter Olof Pijhlow (1668–1753) and his brother Jöns (1707–after 1750). Fleeing an affiliation case at home, he became First Portrait Painter to the Royal Court of Denmark (Copenhagen, Museum).

PILON, Germain (c.1525–90) Leading French sculptor in marble and bronze; the successor of *Goujon in Paris, although a more *expressive and naturalistic (*see under* realism) artist. Probably trained in the workshop of his father, the sculptor André Pilon, he is first recorded in 1558 as sculptor on the tomb of Francis I designed by the distinguished architect Philibert de l'Orme (lost); in 1560 he was working for *Primaticcio on the *Monument for the heart of Henry III* (Paris, Louvre). His early manner, influenced by Primaticcio, gives way to greater naturalism in the bronze kneeling figures of the King and Queen, and their marble recumbent nude effigies, on the *tomb of Henry II and Catherine de'Medici* executed to Primaticcio's design (1563–70, Paris, St Denis). During the 1570s he was active making portrait busts in both marble and bronze (Paris, Louvre; London, Wallace) and medals; both types of work suggest familiarity with contemporary Italian sculpture, notably that of Leone *Leoni, briefly in Paris in 1549 and in touch with Primaticcio in 1550. Pilon's main projects in the 1580s were

groups for the Valois Chapel at St Denis, commissioned by Catherine de'Medici (c.1580–5, fragments now Paris, Louvre, St Paul-St Louis, St Jean-St François) and tombs for the Birague family in Paris, Ste. Catherine du Val-des-Ecoliers (fragments, Paris, Louvre). These last works are increasingly dramatic. The same expressivity is evident in the related bronze relief of the *Deposition*, showing traces of the influence of *Michelangelo and his school. Most of Pilon's successors, however, eschewed his last, emotional manner, in favour of the more elegant style of his early works. The chief of these followers is Barthélemy Prieur (active from 1573 to 1611) but statues deriving from Pilon's were executed in France well into the 17th century.

PINTORICCHIO; Bernardino di Betto, called (c.1454–1513) Painter and miniaturist from Perugia. His nickname, 'rich painter', derives from the lavish use of gold leaf and expensive pigments with which he delighted his wealthy clients, and for which he was to be criticized by *Vasari. An abundance of small-scale detail and ornament detracts from monumentality in most of his large-scale *frescoes. From c.1473 until 1481 when he was inscribed in the painters' guild in Perugia, he was an assistant to *Perugino, whom he may have followed to Rome to work in the Sistine Chapel. Perugino's poetic style still prevails in Pintoricchio's first major work, the frescoes of the Bufalini chapel, Rome, S. Maria Aracoeli, c.1486. Other works in Rome from the 1480s are mainly lost (e.g. Palazzo Colonna), with the exception of frescoes in S. Maria del Popolo, where between 1485–9 Pintoricchio and his assistants decorated at least four chapels (della Rovere chapel still extant). He was to return to this church in 1508–09 to execute the spectacular ceiling decoration of the extended apse. His best-known works in Rome, however, are the luxurious decorations of the Borgia apartments in the Vatican, executed 1492–4 for Pope Alexander VI Borgia. Progress on these was interrupted in 1492 whilst Pintoricchio painted in the cathedral at Orvieto, and they were completed by assistants. By 1495 the artist was back in Perugia (Galleria). There followed a series of private devotional *Virgin and Child* pictures (now, e.g. Washington, National; Warsaw, Museum; S. Mariano, Calif., Huntington; Cambridge, Mass., Fogg). In 1500–01 Pintoricchio was working in Spello, S. Maria Maggiore, Baglioni chapel where he left a self-portrait in the guise of a fictive panel painting, modelled on that of Perugino painted in 1500 in the Cambio in Perugia. The first contract for his second-most famous work, the decoration of the Piccolomini Library, Siena cathedral, dates from 1502, but the frescoes were not executed until 1505–07. *Raphael may have contributed designs for several of the episodes from the life of Pius II Piccolomini. Meanwhile, 1504–06, Pintoricchio painted frescoes in the chapel of St John the Baptist in the cathedral. On his return from S. Maria del Popolo in Rome in 1509 (*see above*) he contributed to the scenes from the *Odyssey* of a room in the Petrucci palace

(or Palazzo del Magnifico), Siena (now London, National; *see also* Signorelli).

PIOMBO, Sebastiano del *See* Sebastiano Veneziano.

PIPPI, Giulio *See* Giulio Romano.

PIRANESI, Giovanni Battista (1720–78) Venetian architect, etcher (*see under* intaglio prints), designer, archaeologist, restorer and dealer in antiquities, champion of Roman versus Greek art and architecture, Piranesi had an electrifying effect on contemporary taste, architecture and the decorative arts, nowhere more than in Britain. He is the greatest single influence on the architect Robert Adam. His visionary, melodramatic etchings of *Prisons*, growing out of his early training in scenography, captured the imagination of a younger generation; their impact belongs to the history of Romantic art (*see* Volume Two; in this volume *see* Sublime). Born on the Venetian *terra firma* to a family of master builders and hydraulic engineers, Piranesi was trained in architecture and stage design. He first went to Rome as a draughtsman in the retinue of the Venetian ambassador. Unable to find work as an architect, and influenced by the Venetian tradition of *vedute and *capricci as much as by the lucrative Roman practice of *Panini, he entered the studio of a Sicilian engraver of Roman scenes, Guiseppe Vasi, from whom he learned the rudiments of etching. From 1741 he was producing small etched *vedute* of Rome which were incorporated in guidebooks and published in a collection, *Varie Vedute di Roma Antica e Moderna* in 1743. The larger-scale *Vedute di Roma* in 135 plates were produced from the late 1740s until his death, and posthumously by the family firm headed by his son Francesco. In 1743 he published 12 plates of architectural fantasies, ideal structures and imaginary scenes of ruins, intended to reprove the mediocrity of contemporary architecture. This *Prima Parte di Architetture e Prospettive* (the projected 'second part' was never published, but the 1750 *Opere Varie di Architettura, prospettiva, groteschi, Antichità* ... may be said to have taken its place) revealed the creative potential of antique ruins for contemporary design; Piranesi was to explore this theme throughout his career. Forced to return to Venice through lack of funds in 1744, Piranesi now encountered the works of his greatest contemporary compatriot in the visual arts: G.B. *Tiepolo. The contact transformed Piranesi's etching style from a dry and tight manner to the fluent, boldly dramatic *chiaroscuro style we now associate with his name. The four plates of *Grotteschi*, and the 14 plates of the first version of his celebrated *Imaginary Prisons* (*Invenzioni capric di Carceri*; published after his return to Rome *c.*1745, refashioned then reissued early in the 1760s) express both the change of style and the final fusion of Venetian and Roman preoccupations. In 1756, his growing concern with archaeology culminated in the four volumes of *Antichità Romana*; whilst his publications of the 1760s, beginning with *della Magnificenza ed Architettura de'Romani*, reflect his involvement in the Graeco-Roman controversy. Despite his

passionate championship of the Romans, however, his last work, completed after his death by his son Francesco, was a series of 20 plates of the Doric temples at Paestum.

Piranesi's contacts with practising architects, French and, above all, British, proliferated from the mid-1750s. Not until the 1760s, however, did he receive his first substantial architectural commissions, as well as commissions for decorative schemes and furniture, from the Venetian-born Pope Clement XIII Rezzonico and members of his family. The decorative schemes are recorded in the *Diverse Maniere d'Adornare i Cammini*, a compilation of chimney pieces, furniture and interior designs published in 1769. With the pope's death in the same year, the influence of the Rezzonico family inevitably waned, but their place was taken up by Piranesi's now numerous British patrons. His activity as a dealer and restorer, much of it with British *cognoscenti* and antiquaries such as Gavin *Hamilton, is recorded in the *Vasi, Candelabri, Cippi, Sarcofagi*, issued as single plates from *c.*1768, collected in two volumes in 1778. Despite considerable studio assistance, these plates achieved widespread popularity and influenced architectural and interior ornament throughout Europe, most especially in England.

PIRES, Diogo the Younger *See under* Manueline style.

PISANELLO; Antonio Pisano, called (*c.*1395–1455) Celebrated Italian painter, draughtsman and medallist in bronze and silver; with *Gentile da Fabriano, whom he succeeded in *fresco cycles in Venice and Rome (*see below*) the foremost International *Gothic artist. Born in Verona of a Pisan father, he spent most of his career as a peripatetic artist working at princely courts, notably for the Visconti in Pavia and Milan, the Gonzaga in Mantua, the Este in Ferrara, the Malatesta in Rimini, Alfonso of Aragon in Naples – as well as in the Doge's Palace in Venice and in the papal church of St John Lateran in Rome. Most of his frescoes are lost (*but see below*) and he is now best represented through his medals (various museums) and some panel paintings (e.g. London, National; Washington, National) and by numerous drawings, including studies of animals (e.g. Paris, Louvre), of costume (e.g. Chantilly, Musée; Oxford, Ashmolean), and a famous depiction of hanging men (London, British), used in the background of a fresco in Verona (S. Anastasia, *see below*). Pisanello excels both in the lifelike description of detail and in creating overall patterns of great ornamental beauty; contemporaries praised his poetic gifts as much as his naturalism (*see under* realism). He struck portrait medals of all the major personages of his day; the *verso* often depicts an *impresa* (*see under* emblem books) combining image and motto. His painted portraits (e.g. Paris, Louvre; Bergamo, Accademia) mainly follow the profile format of the medals.

Trained probably under a local artist, Stefano da Verona, Pisanello was summoned to Venice *c.*1415 to complete the fresco decoration of the Great Council Chamber begun by Gentile da Fabriano (*c.*1415–22,

destroyed by fire 1574). Around 1424 he was in Pavia decorating the Visconti Castle; his frescoes of animals, hunting scenes and jousts – themes current in his extant drawings – were destroyed by French artillery in 1527. Also from 1424–6 is his fresco of the *Annunciation*, part of the Brenzoni monument in Verona, S. Fermo Maggiore (sculptural portion by *Nanni di Bartolo). In the same years he is also recorded at the Gonzaga court in Mantua, although his major pictorial project in the ducal palace is thought to date from 1439–40 and 1443–4, or, according to others, 1446–7. This was a never-completed fresco decoration rediscovered only in 1969. Sinopie (*see under* fresco) and unfinished fresco depict a battle and other episodes from Arthurian romance. Daring *foreshortenings and vivid action scenes punctuate the overall pattern of the long wall – one of the most remarkable fresco remnants of the century.

From 1428–32 Pisanello was in Rome completing Gentile da Fabriano's fresco cycle at St John Lateran (destroyed); he inherited all Gentile's professional effects. Between 1429–30, however, Pisanello was in Verona, painting the fresco of *St George and the Princess* in the Pellegrini chapel of S. Anastasia – a much-reproduced image which combines courtly elegance, in the figures of the protagonists, with gruesome realism in the hanging men in the background and fairy-tale-like invention in the architecture.

In addition to the works mentioned above there are two well-known small panels by the artist: the *Vision of St Eustace*, and the (over-restored in the 19th century) *Apparition of the Madonna to Sts Anthony Abbot and George* (both London, National).

PISANO, Andrea; Andrea di Ugolino Nini da Pontedera, called (recorded 1330–48?) The most important sculptor active in Tuscany in the second quarter of the 14th century, associated almost exclusively with the first bronze doors of Florence baptistry (1330–6) and some of the reliefs and statues for the cathedral bell-tower (Florence, Opera del Duomo). A notary's son, he was probably trained as a goldsmith in Pisa. The principal sources for the bronze doors are the 12th-century doors by Bonanno in Pisa Cathedral, French *Gothic metalwork, and *Giotto's frescoes in the Peruzzi Chapel, S. Croce, Florence. The two artists must have worked closely together on the bell-tower, and the exact attribution of the relief designs is in some doubt.

His son Nino Pisano (documented 1349–68) was the first sculptor to utilize the pictorial motif of the Virgin suckling her Child (Pisa, Museo). He worked in Tuscany, Umbria and Venice (SS. Giovanni e Paolo, Cornaro Monument).

PISANO, Nicola (mentioned from 1258–*c*.84) and his son Giovanni (mentioned 1265–after 1314) Along with his one-time assistant, *Arnolfo di Cambio, Nicola and his son Giovanni were the dominant sculptors of late 13th-century Italy. Drawing both on *Classical and

*Gothic models, they began the slow process of freeing sculpture from its subservience to architecture, a process accomplished only in the *Renaissance (*see* e.g. Donatello; Verrocchio; Michelangelo). Investing sculpture with greater naturalism (*see under* realism) and *expressivity, and expanding its *iconography, the Pisani were instrumental also in the pictorial revolution of the early 14th century (*see* Giotto; Duccio).

Nicola had migrated to Pisa from Apulia in Southern Italy by 1250. His documented works include the pulpit of Pisa baptistry (1260), the pulpit in Siena Cathedral (1265–8) on which the young Giovanni was also employed, and the great fountain (*Fontana Maggiore*) in Perugia (1278). He and his workshop were also responsible for the *Tomb of St Dominic* (1264–7, Bologna, S. Domenico). His adaptation of a nude Hercules-type for the figure of Fortitude on the Pisa pulpit is probably the most celebrated example of pre-Renaissance classicism.

Giovanni, born in Pisa, is first recorded in 1265 in Nicola's contract for the Siena pulpit. By 1285 he had been granted Sienese citizenship and was working on the design for the façade of Siena Cathedral; this design subordinates architecture to sculpture. Giovanni's figures, distorted for optical and expressive ends, foreshadow Donatello's *Prophets* for the bell tower of Florence Cathedral. In 1301 Giovanni completed the pulpit in S. Andrea, Pistoia, a masterpiece of dramatic narrative realism, and from 1302–10 he was engaged on the pulpit for Pisa Cathedral, the largest and most sumptuous of the four Pisano pulpits. His last work, undocumented but securely attributed on stylistic grounds, is the *Virgin of the Holy Girdle* in the reliquary-shrine of the Cathedral at Prato.

PITOCCHETTO *See* Ceruti, Giacomo.

PITTONI, Giovanni Battista (1687–1767) Eclectic Venetian *Rococo painter; in 1758 he succeeded *Tiepolo as head of the Venetian *Academy. His light and vibrant colour has been variously described as 'sophisticated' and 'sugary'; although he was much in demand by contemporaries, notably from Germany, where he dispatched many altarpieces, his work on a large scale is inclined to sentimentality. There are paintings by him in Venice, Accademia, various churches; Edinburgh, National; London, National; Cambridge, Sidney Sussex College, Fitzwilliam; various museums in Germany; etc.

PLATERESQUE *See under mudéjar.*

POCCETTI, Bernardino (1548–1612) Florentine painter. After a probable period of study in Rome, he graduated *c.*1580 from being a decorative painter of *grotesques and façades to become one of the leading narrative *fresco artists in Florence, adapting his *Mannerist draughtsmanship to the demands of naturalist (*see under* realism) Counter-Reformatory church decoration. By the 1590s he had evolved a 'reformist', largely retrospective style echoing the idiom of both High and Early *Renaissance masters such as *Raphael, *Andrea del Sarto, *Ghirlandaio (1580s, Rome, main cloister of S. Maria Novella; cloister

of S. Pier Maggiore; 1590s, Val d'Ema, Charterhouse; 1599, Florence, S. Maria Maddalena dei Pazzi; 1602, S. Marco, Cloister of S. Antonio; 1610, Hospital of the Holy Innocents). His secular decoration, however, remained more wedded to the elegant complexities of *Mannerism (c.1585, Florence, Palazzo Capponi; 1603, Palazzo Usimbardi).

POELENBURGH, Cornelis van (c.1586–1667) A leading member of the first generation of Italianate Dutch painters. Born in Utrecht, he studied there with *Bloemaert before leaving for Italy where he remained c.1617–c.25. There, his painting style was formed after the works of *Elsheimer, and to a lesser extent Paul *Brill. After his return to Utrecht, his Arcadian landscapes, often with ruins and nude figures, sometimes with mythological scenes, proved very popular, especially in aristocratic circles. He also sometimes painted figures in landscapes by other artists. From 1637–c.9 he was in London at the invitation of Charles I. There are works by him in Utrecht, Centraal; Copenhagen, Museum; Florence, Uffizi; London, National; Toledo, Ohio, Museum; etc.

POINTING MACHINE A mechanical device for transferring precisely the design of a three-dimensional model, whether clay, wax or plaster cast, to a stone block. The method consists of establishing parallel points on the model and the block, which is then drilled to the desired depth. It was first developed by the Greeks, much used by the Romans, and assumed great importance again in the 18th and 19th centuries. By raising *modelling* above *carving*, which it reduces to a merely mechanical skill, pointing interposes studio assistance between the creative process and the finished product. A revulsion against the practice led to a revival of direct carving from the end of the 19th century. (*See also* John Bacon.)

POLIDORO DA CARAVAGGIO; Polidoro Caldara, called (c.1500–43) Important painter, whose most influential works, Roman monochrome façade decorations *all'antica*, are now known to us mainly through drawings and prints. They provided a readily visible source of antique motifs and compositions on which such major artists as Taddeo *Zuccaro, *Rubens and *Poussin were to draw. Although not conspicuously mannered, these works are an important example of, and influence on, *Mannerism.

Polidoro, born in Caravaggio in Lombardy (like the better-known Michelangelo Merisi, called *Caravaggio) came to Rome untrained in art. He worked from c.1518 as a plasterer at the Vatican Logge. Encouraged by the artists in *Raphael's workshop, he began to paint (dadoes, sala di Costantino; ceiling *fresco, Villa Lante, now Palazzo Zuccaro), soon forming a partnership with Maturino, a Florentine adept at drawing after the antique and a family friend of *Peruzzi. Inspired by Peruzzi's façade paintings, Polidoro and Maturino decorated the exteriors of a dozen palaces, between 1524 and the Sack of Rome in 1527, with friezes of Roman histories and architectural and decorative motifs in *grisaille.

Polidoro's side paintings in the Fetti chapel, S. Silvestro al Quirinale, *c*.1525, are an equally remarkable, if less immediately influential, adaptation of Roman models. Scenes from the *Lives of Mary Magdalen and St Catherine of Siena* are depicted in two nearly pure landscapes, in which the narrative figures are reduced to the scale of *staffage. Imitating the 'impressionism' of one type of ancient Roman wall painting, these works are also a highly personal response to nature. They anticipate, and may have influenced, the landscapes of Annibale *Carracci and his pupils (*see* especially Domenichino).

Polidoro left Rome after the Sack; after a brief stay in Naples, he settled in Messina in Sicily, where he seems to have undergone an intense religious conversion. His great altarpiece painted there, the *Road to Calvary* (before 1534, now Naples, Capodimonte), borrows simultaneously from the Flemish and German modes prevailing in Sicily, and from a composition by Raphael – itself inspired by *Dürer, and destined for a Sicilian church, but which Polidoro would have known in Rome. Despite these dual origins, it is a deeply personal and evocative work, as are the dark, thinly painted devotional panels executed for private collectors in Messina and only recently rediscovered (mainly Naples, Capodimonte).

A prolific draughtsman, Polidoro left many drawings, some of them autonomous works and not in preparation for paintings. A number recall *Michelangelo's lunettes in the Sistine Chapel; others are fantasies of landscapes or ruins.

Polidoro died, murdered by a thief, in Messina.

POLLAIUOLO, Antonio del (*c*.1431/2–98) and his brother Piero (*c*.1441–96) Florentine artists, Antonio primarily a goldsmith, sculptor in bronze and designer, Piero primarily a painter. Their surname derives from their father's occupation: *pollaiuolo*, Italian for 'poulterer'. Although they also ran separate workshops, the brothers operated as a team on most major commissions, in which Antonio was the senior partner and the more able artist. His innovativeness, technical expertise and love of experiment are exemplified in his most influential work, the large engraving (*see under* intaglio prints) called *The Battle of the Ten Nudes* (early 1470s), a pattern or model-sheet of anatomical studies of male bodies in vigorous action, which remained a prime artistic source, not only in Italy but throughout Europe, for centuries. Piero's more conventional talent is demonstrated in his independent altarpiece of *The Coronation of the Virgin* (1483, San Gimignano, Collegiata). His *Six Virtues* of 1469–70 for the Mercanzia – the Florentine merchants' court – now in Florence, Uffizi, have been heavily damaged and restored. The brothers' first joint commission, which is still extant, was their contribution of a wall painting and an altarpiece on panel to the Chapel of the Cardinal of Portugal in Florence, S. Miniato al Monte (1466–7; altarpiece now Uffizi; *see also* Rossellino; Baldovinetti; Luca della Robbia). But the partnership's espousal of *iconographic and formal novelty, coupled with

traditional craftsmanship, can best be observed in their most famous collaborative works: the altarpiece of *The Martyrdom of St Sebastian* (1475, London, National) and the free-standing bronze *tomb of Pope Sixtus IV* (*c.* 1484–93, Rome, St Peter's).

Other important works by the Pollaiuolo firm are the small bronze statuettes on mythological themes (Florence, Bargello; East Berlin, Bodemuseum; New York, Frick), although they are unclassical in their anatomical emphasis; and the bronze wall *Tomb of Pope Innocent VIII* (1492–8, Rome, St Peter's). Antonio Pollaiuolo also contributed to the silver altar for Florence baptistry and designed 27 embroideries with scenes from the life of St John the Baptist for the baptistry vestments (now Florence, Opera del Duomo). His drawings became quickly popular and are now difficult to distinguish from workshop copies, imitations by contemporaries and later copies (but *see* the designs for an equestrian monument to Francesco Sforza, Munich, Graphische Sammlung, and New York, Metropolitan).

POLYCHROME, POLYCHROMY From the Greek *polychromos*, manycoloured. Usually employed in art history with reference to sculpture painted in many colours to imitate natural appearances. Ancient polychromy on marble was translucent, whilst that on terracotta was opaque. The process was particularly common on the wood sculpture of pre-Reformation Germany and of Spain. Colours were applied over a gesso ground and, in places, over a ground of gold leaf for greater luminosity. The pigments could then be scratched out to create designs, as, for example, of gold brocade.

POLYPTYCH A painting or relief made up of separate pictorial fields, usually an altarpiece. The polyptych altarpiece evolved from the single-panelled *antependium and *dossal in the late 13th century. The fully developed polyptych (mid-14th to 15th century) consists of many separate panels of different sizes and shapes, some containing single figures, others narrative scenes, unified by an architectural and decorative system of framing. Some polyptych frames are hinged, allowing for different pictorial effects at different times. A diptych consists of two panels, a triptych of three; many such simple polyptychs were produced on a small scale for private devotions. (*See also* Bernardo Daddi; retable.)

PONTORMO; Jacopo Carucci, called (1494–1557) Perhaps the last great Florentine painter, chief exponent of Early Florentine *Mannerism (but *see also* Rosso). His nickname refers to the Tuscan village where he was born. Although solitary and eccentric, Pontormo is not adequately characterized as a 'neurotic' artist, and even less as an artistic rebel. On the contrary, his mature style, albeit profoundly original, is a logical summation of Florentine tradition, and assimilates into that tradition the latest researches of *Michelangelo's Roman *frescoes and the newly imported northern European prints, notably by *Lucas van Leyden and *Dürer. His only extant large-scale work of

secular decoration, the *Vertumnus and Pomona* fresco in the salone of the Medici villa at Poggio a Cajano, 1520–1, anticipates certain 18th-century developments in its daring but perfectly harmonized synthesis of naturalism (*see under* realism), *classicism and the pastoral.

We do not know precisely the facts of Pontormo's training. His earliest surviving work, the *Sacra Conversazione* of 1514 (Florence, SS. Annunziata, chapel of the Company of St Luke) demonstrates his dependence both on Fra *Bartolommeo and on *Andrea del Sarto, whose assistant he became briefly sometime *c.*1512. The *Visitation* (1515–16, SS. Annunziata forecourt) is more monumentally Sartesque. Only with the altarpiece in S. Michele Visdomini, 1518, is High *Renaissance equilibrium disrupted. Although this disruption of Renaissance canons seems to point forward to mid-16th century *Mannerism, its aims are different. The latter, as exemplified for example in the paintings of *Vasari, exploits superficially similar effects in order to enhance, not *expressivity but *idealization. Pontormo's communicative and expressive aims in the Visdomini altar link him, rather, with earlier Florentine artists, notably *Donatello. Different again, however, are the unnaturalistic devices of Pontormo's contributions to the Borgherini decoration of the *Story of Joseph* (*c.*1515, London, National; *see under* Andrea del Sarto). The non-classicism of these paintings is dictated primarily by ornamental and narrative requirements; they should be judged as a culmination of the *cassone*, or furniture-painting, tradition rather than as independent easel paintings. The decorative lessons learned here on a small scale were applied, however, to later large-scale works: not only the fresco at Poggio a Cajano (see above) but also the *Passion* cycle for the Charterhouse of Galluzzo outside Florence (1523–4; five frescoes in cloister, now detached). Albeit closely based in composition on prints of the *Passion* by Dürer, these now sadly damaged frescoes ally extreme pathos with the most refined elegance of form and colour. On the other hand, the oil painting of the *Supper at Emmaus*, once *illusionistically framed in an 'additional doorway' to the refectory in the guest wing at the Charterhouse (1525, now Florence, Uffizi) eschews formal beauty for naturalism and a darker tonality. The pilgrim-guests of the Charterhouse were thus invited to identify with the pilgrims of Emmaus, and found the living Christ breaking bread amongst them (the 'divine eye' above Christ's head is a later addition). This pictorial manner anticipates the naturalism of *Caravaggio and his followers.

In the decoration of the Capponi chapel in Florence, S. Felicità, 1525–8, which is partly lost and where he was assisted by his pupil *Bronzino, Pontormo turned once again to a brighter chromatic scale (*see* colour). Motivated perhaps by the natural darkness of the chapel, the colour testifies also to the influence of Michelangelo's lunettes in the Sistine Chapel as revealed in their recent cleaning. The particular accent of beauty in pathos, however, is specifically Pontormo's; his

range of feeling is different from, and perhaps more complex than, Michelangelo's. It may be found again in such easel paintings as the *Visitation* (*c*.1528, Carmignano, Pieve).

In addition to altarpieces and devotional easel paintings (e.g. Paris, Louvre; Leningrad, Hermitage; Florence, Uffizi, Pitti) Pontormo also executed portraits, unprecedented in their suggestion of inner feelings allied to outward elegance (Lucca, Pinacoteca; Philadelphia, Museum; Washington, National; Florence, Uffizi). These had their greatest influence on the more numerous, but shallower, portraits of Bronzino.

It has become axiomatic in art-historical literature that, with the fall of the Florentine Republic in 1530, Pontormo's emotionally communicative art ceased to please. He was certainly not personally suited to the climate of the princely Medici court, and Vasari has some harsh things to say of his late works. Nevertheless, historical judgement is probably skewed by the loss of his major commissions of these years. For the Medici continued steadily to employ him: in 1532 he made designs for the completion of the salone decoration at Poggio a Cajano, left unexecuted with the death of Clement VII de'Medici in 1534; in 1535–6 he decorated the Medicean villa at Careggi, and between 1537–43 a loggia in their villa at Castello. Both of these works were destroyed later, although drawings for all the late projects exist, mainly in Florence, Uffizi. Around 1545–9 he furnished cartoons (*see under* fresco), alongside Bronzino and *Salviati, for Cosimo I de'Medici's new tapestry works (tapestries now Rome, Quirinale). In 1546 he began the decoration of the choir of the Medici parish church of S. Lorenzo, left uncompleted at his death. These enormous frescoes, retelling stories from Genesis and a combined *Resurrection* and *Last Judgement*, influenced by but transforming Michelangelo's *Last Judgement*, were unhappily destroyed when the choir was rebuilt in 1742. Once again, only the poignant and eloquent drawings remain.

Porcellis, Jan (*c*.1584–1632) Recognized by contemporaries as the greatest marine painter of his time, Porcellis was born in Ghent, and worked in Rotterdam, Middleburg, London, Antwerp, Haarlem and Amsterdam before settling at Zoeterwoude in southern Holland. He accomplished the transition from the Early *Realist seascape with its emphasis on detailed, multicoloured ship portraiture (*see* Hendrick Vroom) to a tonal, monochromatic representation of skies, seas and atmosphere. His son, Julius Porcellis (*c*.1609–45), adopted his style and subject matter. There are works by Jan Porcellis in Berlin-Dahlem, Museen; Leiden, Museum; Munich, Gemäldesammlungen; etc.

Pordenone; Giovanni Antonio de Sacchis, called (*c*.1484–1539) Inventive painter from Pordenone in Friuli, north-east of Venice. From his experience of Venetian art (*Carpaccio, Giovanni *Bellini, *Giorgione and *Titian), of nearby Mantua (*Mantegna), central Italy (*Michelangelo, *Perino del Vaga) and northern Europe (e.g. *Dürer) he forged a violently *expressive idiom, at times stylish, at others

intentionally populist, using *illusionism to enforce the spectator's –
especially the provincial spectator's – involvement in the painted
drama. A precursor of the *Baroque, he is usually classified as a Man-
nerist artist, and certainly influenced the *Mannerism of, e.g. *Tin-
toretto. In important respects, however, he shares the theatrically
expressive *realism of the Lombard *Sacro Monte decoration.

Sometime between 1516 (*Madonna della Misericordia*, 1515–16, Por-
denone, cathedral) and 1520 (Treviso, cathedral, 1520; Cremona
cathedral, 1520–2) Pordenone encountered Roman *Renaissance art.
The Treviso dome (destroyed in World War Two), projected a drama-
tically foreshortened God the Father into the viewer's space (*cf.* the
nearly contemporary work of *Correggio). Complementing an altar-
piece by Titian below, Pordenone used the opportunity for a critique of
the latter's figure of God in the Frari *Assumption and Coronation of the
Virgin*, 1518, with references to Michelangelo's Sistine chapel and
*Raphael's Chigi chapel.

In the Cremona *frescoes Pordenone replaced *Romanino, con-
tinuing and exaggerating the latter's 'German' manner and aiming for
the coarse dramatic effects of popular miracle plays. The Spilimbergo
cathedral organ shutters (1523–4) are equally dramatic and illusionistic;
this mode is further explored, but with greater elegance, in the decora-
tion of the Pallavicini Chapel in the Franciscan church at Corte-
maggiore (1529–30; altarpiece now Naples, Capodimonte). From
*c.*1530 Pordenone worked mainly in Venice (S. Stefano, S. Maria
dell'Orto, S. Giovanni Elemosinario; Murano, S. Maria degli Angeli;
Doge's Palace) where he became the chief rival of Titian. His many
palace façade decorations, emulating those of *Peruzzi and *Polidoro
da Caravaggio in Rome, are mainly known through drawings (e.g.
London, Victoria and Albert). He died at Ferrara, where he had been
summoned to design tapestry cartoons (*see under* fresco). Other works
Budapest, Museum; London, National; Venice, Accademia; Piacenza,
Madonna di Campagna.

PORTA, Bartolommeo or Fra Bartolommeo della *See* Bartolommeo
or Baccio della Porta.

PORTRAIT HISTORIÉ (French, narrative portrait, always used in the
original language.) A portrait in which the sitter is depicted in the
guise of a figure from literature, history, mythology or the Bible.

PORTRAITURE *See under* genres.

POTTER, Paulus (1625–54) Precocious Dutch animal painter, the
son of Pieter Potter (1597/1600–52), painter and owner of a
factory for embossing and gilding leather, best known for his *vanitas*
still-lifes (Amsterdam, Rijksmuseum). Paulus's work is notable for his
sense of atmosphere and meticulously rendered lighting. He often set
his scenes of cattle and farmyard animals in clearly identifiable times of
day and weather conditions (London, National; Leningrad, Her-
mitage). Although most of his work is in a small format, he is famous

for the huge canvas depicting a life-size *Young Bull* (1647; The Hague, Mauritshuis). This monumental heroization of a single motif silhouetted against the sky has acquired symbolic connotations related to the Dutch national character (*see also* Asselijn). It is typical of the *'classical' phase of Dutch painting, perhaps best exemplified in the landscape painting of Potter's contemporary Jacob van *Ruisdael. Paulus Potter's work influenced later animal painters well into the 19th century.

POURBUS, Pieter (*c*.1510–84), his son Frans the Elder (1545–81) and the latter's son Frans the Younger (1569–1622) Dynasty of painters originating in Bruges and best known as portraitists, although Pieter did not begin to work in this genre until 1551. After an apprenticeship with Lancelot Blondeel he remained in Bruges, where his paintings for the municipality and in churches are characterized by traditional compositions, bright colouring and precise brushwork. Frans the Elder worked with Frans *Floris from 1562 and became master at Antwerp in 1569, specializing mainly in portraiture, somewhat more flexible in style than his father's and at times incorporating *genre* motifs (e.g. Brussels, Musées). The most accomplished member of the family was Frans the Younger. In the Antwerp guild from 1591, he was called to the court in Brussels to execute official portraits of the Archdukes Ernest and Albert and Infanta Isabella, of which many replicas and engraved copies exist. These works, and some bourgeois portraits of the same years (Leeds, Gallery; *Self-Portrait*, 1591, Florence, Uffizi) are, however, eclipsed by the portraits which he painted during his term as court artist at Mantua, 1600–*c*.09. These refined yet precise images of figures immobilized amongst the precious details of costume are some of the most striking examples of the *Mannerist portrait of status (*see also* Anthonis Mor), emulated – but quickly surpassed – by Pourbus's compatriot and colleague at the Mantuan court, *Rubens. Outstanding works from this period are in Rome, S. Carlo al Corso; Mantua, Palazzo d'Arco and private collections; Vienna, Kunsthistorisches; Madrid, Prado. From 1609 until his death Frans Pourbus the Younger served as court painter in France. Here he married a sober naturalism (*see under* realism), evident especially in his likenesses of non-royal personages (e.g. *The Duke of Chevreuse*, 1612, Northamptonshire, Althorp) to the formalism of his official portraiture. This style not only came to dominate French portraiture in the reign of Henry IV and the regency of Marie de'Medici but influenced later practitioners, notably *Philippe de Champaigne. Pourbus's *The Last Supper*, 1618, now Louvre, introduced an equally sober Venetian Grand Manner, learned in Mantua, to Parisian artists, and made a lasting impression on *Poussin, evident even in the latter's Roman works.

POUSSIN, Gaspar *See* Dughet, Gaspar.

POUSSIN, Nicolas (1594–1665) French-born painter active in Rome from 1624, with the exception of 1640–2 when he worked for

Louis XIII in Paris. He is, however, of decisive importance for the later evolution of French art, notably through the teaching in the Royal *Academy, and is the virtual founder of French *classicism. His name was adopted in France for the pro-*disegno faction in the long-lasting contest between *Poussinistes* and *Rubénistes* (*see also* Rubens). In the wider history of art, his importance consists in having elevated gallery-sized easel paintings of narrative subjects to the high seriousness and status of *istoria*, or history painting (*see under* genres), hitherto reserved for works on the scale of life.

Born of a peasant family near Les Andelys in Normandy, Poussin was first attracted to painting in 1611 through the activity at Les Andelys church of the minor Late *Mannerist Quentin Varin (*c*.1570–1634). In the following year he left to study painting, first in Rouen, then in Paris, where he trained for a while with a Flemish portraitist, Ferdinand Elle (*c*.1580–1649). The most important influence on him at this time, however, seems to have been his access to the Royal Library, where he studied engravings after *Raphael, Giulio *Romano and *Polidoro da Caravaggio, and the royal collection of sculpture, where he first saw Roman reliefs and statues. Sometime *c*.1616–17 and again *c*.1619–20 he tried to go to Rome, but had to turn back in Florence and Lyons respectively, on the first occasion because of some unspecified accident, on the second because his money was claimed by a creditor. In 1622 he was commissioned by the Jesuits in Paris for six large tempera paintings, now lost, for the celebrations of the canonization of Sts Ignatius Loyola and Francis Xavier. When these attracted attention, he gained employment at the Luxembourg Palace, and met the patron of his first extant works, the Italian poet Marino, protégé of the Queen Mother Marie de'Medici. The drawings illustrating The *Metamorphoses* of Ovid which he executed for Marino (Windsor, Royal Library) resemble in style the work of artists of the so-called Second School of Fontainebleau, notably *Dubreuil.

With Marino's help Poussin finally succeeded in reaching Rome. His early years there, from 1624–*c*.30, were ones of experiment, in which he adapted his style to suit his commissions. The two battle pieces now in Leningrad, Hermitage (*Victory of Joshua over the Amorites*, *Victory of Joshua over the Amalekites*, 1625–6) show his debt to Giulio Romano and Polidoro. Soon after his arrival, he worked in the studio of *Domenichino, and the latter's influence is visible in, e.g. *Apollo and the Muses on Mount Parnassus* (Madrid, Prado) whose general composition is based on Marcantonio Raimondi's (*see under* Raphael) engraving after Raphael's *fresco in the Stanza della Segnatura. Other paintings, such as the *Holy Family with St John* (*c*.1627, Karlsruhe, Kunsthalle) show the influence of *Titian in the handling of colour. The most accomplished painting of this period is *The Death of Germanicus* (1627, Minneapolis, Institute), which employs Titianesque colour for a composition inspired by ancient reliefs, of a type to which Poussin would often return in the

middle period of his life – a full-length-figure *istoria* under two metres in length and one and a half metres high.

In 1628–9 Poussin received two large-scale public commissions, which should have sealed his reputation: the altarpieces of *The Martyrdom of St Erasmus* for St Peter's (1628–9, now Vatican, Pinacoteca) and of *The Virgin appearing to St James* for a church in Valenciennes (1629–30, now Paris, Louvre). The former, which makes use of a design for the same altar by *Pietro de Cortona, remained the artist's only large-scale picture on public view in Rome, but it was slated by most critics as lacking in *naturalism, strength, richness and harmony of colour. The latter, the most *Baroque of Poussin's pictures, is close in feeling to the work of *Bernini, and is the only surviving painting by the artist to employ a detail identified with *Caravaggio: the dusty feet of the man kneeling in the foreground. It was later to enter the collection of Richelieu in France.

Whether because of the failure of the *Erasmus*, or the effects of a grave illness in 1629/30, or because of his own sense of his limitations when working on a large scale, Poussin was not afterwards to seek this type of commission. (When, during his stay in France 1640–2 commissions for altarpieces and the large decorative scheme of the Long Gallery in the Louvre were thrust upon him, he reacted with unease, and returned to his beloved Rome on a pretext as soon as possible.) Instead, in the 1630s, he retired from the public arena, to paint relatively small-scale pictures for a circle of connoisseurs clustered around the scholarly Cassiano dal Pozzo. Poussin participated in Cassiano's project of recording in drawings all the relics of ancient Rome (now Windsor, Royal Library). A series of paintings mainly on mythological themes, *Bacchanals*, *Triumphs* and scenes based on Ovid's *Metamorphoses*, testify both to the tastes of these scholarly patrons and to Poussin's growing familiarity with ancient literature and artefacts; formally, the paintings of *c.*1629–33 rely heavily on Titian's early mythologies for Alfonso d'Este, at that time visible in Rome; after that date Venetian colourism is gradually replaced by the clearer daylight, full modelling and classicizing compositions of Raphael and his 17th-century followers, Annibale *Carracci and *Domenichino (Paris, Louvre; London, National; Munich, Alte Pinakothek; Dresden, Gemäldegalerie; Detroit, Institute; Philadelphia, Museum; etc.). Even in the tales of love from Ovid, Poussin stresses allegorical significance over erotic appeal: Stoical notions of the cycles of nature – fertility and death – inform these works, as well as the small group devoted to scenes from Tasso's *Gerusalemme Liberata*, the only modern poem interpreted by Poussin (e.g. London, Dulwich; Moscow, Pushkin; East Berlin, Museen). The most elaborate of the *Bacchanals*, and the most elaborately archeological, were painted for Cardinal Richelieu, and helped to establish Poussin's French reputation.

Towards the end of the 1630s Poussin no longer concentrated on

poetical and mythological themes, beginning to interpret texts which allowed for more dramatic pageantry: from the Old Testament (e.g. London, National; Edinburgh, National; Vienna, Kunsthistorisches; Melbourne, National) or from ancient history (e.g. Paris, Louvre; New York, Metropolitan). The increasing seriousness of his work becomes especially apparent in the great first series of the *Seven Sacraments* commissioned by Cassiano dal Pozzo, of which the last, *The Baptism*, was taken by Poussin to Paris and not completed until 1642 (now Washington, National; others executed *c.*1638–40, five surviving now Belvoir Castle).

Poussin went to Paris reluctantly at the insistence of Richelieu and the King; as has been said, his sojourn at the court in Paris was not a success, and further complicated by the envious intrigues of rivals like *Vouet. But the visit had important and beneficial consequences. While in Paris he established contacts with a circle of intellectual bourgeois: minor civil servants, small bankers, merchants, who were to be his best patrons for the latter part of his life and to influence his whole outlook. The most important of them was Chantelou, for whom he had already painted the important *Fall of Manna* in Rome in 1639 (Paris, Louvre). It is through Poussin's letters to Chantelou especially, but also to his other French mail-order clients, that we gain the fullest insights into the painter's artistic ideals. It is also on this correspondence that some of the teachings of the Academy are based: Poussin's insistence, for example, that his paintings be *read*, figure by figure, or his theory of the Modes based on musical theories, which can best be related to notions of *decorum.

During 1642–*c.*52 Poussin produced his most monumental, most solemn and classicizing works for these patrons, who in general allowed him to choose his own subjects, now drawn from the New Testament more often than the Old, and from Stoic ancient historians (mainly Paris, Louvre; also Washington, National; Dublin, National; Leningrad, Hermitage; New York, Metropolitan; Copenhagen, Museum). For Chantelou, he painted a second series of *Seven Sacraments*, 1644–8 (Edinburgh, National). In the second half of the 1640s, perhaps inspired by his friend *Claude, he began to paint classicizing landscapes (e.g. Knowsley; Oxford, Ashmolean).

From *c.*1653, however, his style changed once more, becoming even more intense and personal. The figure compositions are increasingly understated (e.g. Leningrad, Hermitage). The landscapes, however, in which he returns to mythological subjects for allegorical ends, are less orderly and less subject to the laws of geometry. Nature assumes a grander and wilder aspect and is free from the intrusion of architecture, as it might have appeared at the dawn of time (e.g. New York, Metropolitan; Cambridge, Mass., Fogg; Moscow, Pushkin). In his last great commission, the four landscapes of the *Seasons* painted for the Duc de Richelieu 1660–4 (now Paris, Louvre) cosmic symbolism is

related to the earliest history of humankind as outlined in the Old Testament.

However alien Poussin's classicizing principles and, even more, his philosophical outlook may now seem, he is in certain important respects one of the first truly modern artists. Virtually self-taught, he was able to impose his ambitions, and his limitations, on his patrons. Choosing the scaler and format which best suited his gifts, he nonetheless escaped the stigma of being a painter of second-rank *genres; he chose his own themes; bullied his patrons into showing, viewing – and even framing – his pictures as he wished. He worked, at least after 1642, to his own tempo. Above all, he became accepted as his patrons' intellectual equal or even superior, a painter-philosopher. It is the image which he left to posterity in his second *Self-Portrait*, painted for Chantelou in 1649–50 (Paris, Louvre).

POUSSINISTES *See under disegno.*

Pozzo, Andrea, also called Fratel ('Brother') or Padre ('Father') Pozzo (1642–1709) Northern Italian painter and architect, from 1665 a Jesuit lay brother; a painter of altarpieces and a specialist in *perspective (e.g. 1676–7, Mondovi, Jesuit church). His best-known work is the *illusionistic ceiling decoration of the huge Jesuit church of S. Ignazio in Rome (c.1691–4); this combines a *quadratura* framework with figures arranged in loosely connected light and dark areas reminiscent of *Gaulli's *frescoes at the Gesù. The programme, combining a *Triumph of St Ignatius Loyola* with details of the missionary activities of the Jesuits throughout the world, was admired by the Austrian ambassador, Prince Liechtenstein, to whom Pozzo explained it in a letter published in the 19th century. In 1703 the artist settled in Vienna, where his major work, the secular *Triumph of Hercules* in the great salon of the Liechtenstein palace, did much to spread Gaulli's innovations to Austria and Germany. Pozzo was also the author of a much-translated treatise on perspective.

PREDELLA A box-like structure at the base of an altarpiece or *retable, acting as a support to the main panel as it rests on the altar table. The word is usually applied to the decorated front, which normally consists of a row of small paintings or reliefs. The earliest known predellas seem to have formed part of *Cimabuie's altarpiece for S. Chiara in Pisa, 1301, and *Duccio's *Maestà* for the Chapel of the Nine in Siena Town Hall, 1302, both no longer extant). Although, especially in northern Italy, the predella may consist of a strip of single bust-length figures of saints, it is most characteristically narrative, illustrating stories from the lives of saints, Christ or the Virgin Mary, under the *iconic representation of these personages on the main panel and wings, if any, of the altarpiece. Predella paintings were a favoured location for pictorial experimentation in 14th- and 15th-century Italy.

PRETI, Mattia (called the Cavaliere Calabrese) (1613–99) In 1630 he left his native Calabria for Rome, where he painted numerous

*Caravaggesque easel pictures of musicians and cardsharps (Rome, Doria; Oxford, Ashmolean; Leningrad, Hermitage; etc.). His *fresco style, however (Rome, S. Andrea della Valle, 1650/1; Modena, S. Biagio, 1653–6), derives from Emilian and Venetian examples, studied during his travels as well as through the Roman works of *Lanfranco, *Domenichino, and, above all, *Guercino. From 1656–60 he worked in Naples, and quickly became leader of the local school. There are many frescoes and altarpieces (e.g. in S. Domenico Soriano, Sant'Agostino degli Scalzi) and easel paintings for collectors (e.g. Capodimonte) from this period. He evolved a dramatic new style in which details emerge from shadows, and figures appear *à contre-jour (see, e.g. Almsgiving, Naples, De Vito Coll.). From 1661 until his death he spent most of his time in Malta, having gone there to paint the vault and apse of the Co-Cathedral of St John in Valetta; he was made a Knight of the Order of St John. His output in these years was immense, aided by a thriving workshop; a reliable chronology has not been established.

PRIEUR, Barthélemy. See under Pilon, Germain.

PRIMATICCIO, Francesco (1504–70) Painter, sculptor, designer, architect and art impresario from Bologna; the originator, with *Rosso, of the influential French School of Fontainebleau and chiefly responsible for the coldly elegant, yet erotic, form of *Mannerism associated with it. Primaticcio left Bologna in 1526 to work under *Giulio Romano at Mantua (*classical stucco frieze, Sala dei Stucchi, Palazzo del Tè, c.1530). In 1532 he joined Rosso at the château of Fontainebleau. Of the decorations he executed there before Rosso's death in 1540 all have perished except for a chimney piece for the Chambre de la Reine, but we know from drawings that his first work, for the Chambre du Roi, was based on a drawing by Giulio.

In 1540–1 Primaticcio went to Rome on behalf of King Francis I of France, to obtain moulds of the most famous ancient statues then known. The bronze casts made subsequently of the Laocoön, the Apollo Belvedere, the Marcus Aurelius and reliefs from Trajan's Column thus became available to French artists, with profound effects on the development of French art. Upon his return from Rome, Primaticcio began a new, even more important series of decorations for Fontainebleau. Although many of these are lost, what remains, and drawings and engravings of what has been destroyed, demonstrate that in the period 1540–50 Primaticcio gradually freed himself from the influence of Giulio. He now created, in stucco sculpture and in painting, that elongated and slender canon of figure drawing – influenced by *Parmigianino and reinforced by *Cellini – which was to become characteristic of French painting for the rest of the century, and of northern European Mannerism even longer (see, e.g. Wtewael). The most important example of the new style was the Galerie d'Ulysse, destroyed in the 18th century.

In 1546 Primaticcio undertook a second trip to Rome, returning

with a cast of *Michelangelo's Vatican *Pietà*, executed for a French cardinal and thus of special significance in France. His architectural activities began with works of decorative sculpture: the grottoes at Fontainebleau and at Meudon, influenced by Giulio's rusticated work and perhaps by the unfinished *Slaves* projected by Michelangelo for Julius II's tomb. There are drawings by Primaticcio in many collections, notably Paris, Louvre, Ecole des Beaux-Arts; Chantilly, Musée; London, British; and easel paintings, some of scenes from the Galerie d'Ulysse, in e.g., Toledo, Ohio, Museum; Barnard Castle.

PROCACCINI, Camillo (*c*.1561–1629) and his more gifted brother Giulio Cesare (1574–1625) Painters from a Bolognese artists' family; their careers evolved mainly in Milan, where they settled *c*.1587-8. From that date until *c*.1600 Camillo was the leading painter in the city, displaced after the return from Rome of Cardinal Federico Borromeo by the cardinal's protégé, *Cerano. After 1610, Giulio Cesare, trained initially as a sculptor and active as a painter only from *c*.1600, was, with Cerano and *Morazzone, one of the three foremost artists in Milan (the unusual joint commission of an altarpiece, the *Martyrdom of SS. Rufina and Seconda* known as the *'Tre Mani'* or *'Three-hander'*, early 1620s, now Milan, Brera, commemorates their predominance).

PRONKSTILLEVEN Dutch, 'still-life of ostentation' The painting of luxury wares (such as imported Chinese bowls and vases, silver vessels, Venetian glass, mounted nautilus shells) which is characteristic of the third, and final, phase of Dutch *still-life painting in the 17th century. *See also* Kalf, Willem.

PUGET, Pierre (1620–94) The greatest French *Baroque sculptor. Born in Marseilles, he spent most of his life there and in Toulon, except for 1640–3, when he worked in Florence and Rome under *Pietro da Cortona, and 1660–7, when he was in Carrara and Genoa (S. Maria di Carignano, Sauli family sculptures). His *expressive manner, best seen in the anguished *Atlantes* (1656, Toulon, Hotel de Ville portal) and the *Milo of Crotona devoured by a lion* (1671–82, Paris, Louvre) – taken to Versailles by his son François – is founded on the work of Pietro da Cortona, *Bernini and *Michelangelo. An intractable, even arrogant, individualist, he was unable to find favour at the French court until the death of Colbert in 1683 (*see also under* Lebrun; Mignard), and even then only briefly (*Perseus and Andromeda*, compl. 1684, now Louvre). His most important marble relief, *Alexander and Diogenes* (1671–93, Louvre) reached Versailles after the death of Louvois, Colbert's successor and Puget's patron, and was prevented by intrigue from ever reaching the King's eyes; his last work, the relief of *S. Carlo Borromeo in the Plague at Milan* (1694, Marseilles, Musée) was refused by the King. There are paintings by Puget in local churches in Toulon, where he was also employed designing the decoration of warships and executed architectural designs for the reconstruction of the arsenal; other works of sculpture are in the Louvre and in churches in Genoa.

PUTTO (pl. *putti* Italian for boy or child.) In art the word indicates a chubby, usually but not invariably naked, figure of a child, first used as a decorative motif in *Classical art and revived in the *Renaissance. *Putti* have the proportions of babies, but play games and perform tasks of which real babies would not be capable. They are related to *amorini*, 'little loves' (sing. *amorino*) or Cupids, who are equipped with wings and accompany Venus or signal scenes of love. From the Renaissance onwards, *putti* or *amorini* in a Christian context usually represent cherubs, although the Christ Child, the child John the Baptist, and the Holy Innocents all came to be depicted as *putti*.

Q

QUADRATURA *See under* illusionism.

QUELLIN, Quellinus Important dynasty of Flemish artists; their tangled family relationships are all the harder to unravel because different members of the clan used different forms of the family name. The patriarch of the family was the sculptor Erasmus Quellin the Elder (1548–1639) active in Antwerp (cathedral). Of his two sons, Erasmus Quellinus the Younger (1607–78) was a painter and draughtsman, an assistant to *Rubens in the 1630s. His painting style was much influenced by *Van Dyck (Antwerp, St Jacobskerk, Musée; Vaduz, Liechtenstein Coll.). His younger brother, the sculptor Artus I Quellin (1609–68) was an important figure in both Flemish and Dutch art. After a period of study in Rome under the Italo-Flemish sculptor François du *Quesnoy, he settled in Antwerp in 1639, executing works which are amongst the earliest *Baroque sculptures in the Netherlands (Antwerp, Plantin, St Pauluskerk; Brussels, Cathedral). In 1650 he was called to Amsterdam to provide the sculptural decoration for the new town hall, now the Royal Palace. He gathered around him a large workshop including his cousin(?) Artus II Quellin. Whilst working on the town hall he also carried out other commissions, mainly funerary monuments (Amsterdam, Rijksmuseum; Bokhoven on the Meuse, parish church; Antwerp, Musée, St Andreaskerk). He returned to Antwerp in 1664.

Artus II Quellin (1625–1700) has been called a sculptor in search of new forms. His independent works range from dramatic Baroque *illusionism (e.g. Antwerp, cathedral; St Jacobskerk; Bruges, cathedral) through *classicizing draped figures in the manner of François du Quesnoy (Tournai, cathedral) to a tender proto-*Rococo (Antwerp, St Pauluskerk). He was the master of Gabriel *Gruppello. His sons also became notable sculptors. The elder, Artus III Quellin (1653–86), also called Arnold by English writers and sometimes mistakenly identified as a son of Artus I, emigrated to England in the early 1680s. He executed some independent commissions for City patrons and at Court, and collaborated with Grinling *Gibbons on monumental statues (London, Trafalgar Square, Chelsea Hospital). The younger, Thomas Quellin (1661–1709) also worked for a while in England, but his main activity was in Denmark, where he executed many funerary monuments (e.g. Copenhagen, Frauenkirche).

The painter Jan Erasmus Quellinus (1634–1715) was a son of Erasmus Quellinus the Younger. He was in Rome by 1660; on his return to the Netherlands he became court painter to the Archdukes Leopold I, then Joseph I, at Malines. His large decorative landscapes, inspired by *Veronese, are typical of the classicizing Late Baroque in

the Netherlands. His older brother, the engraver (see under intaglio prints) Hubertus Quellinus (1619–87) was in Rome in 1650. He specialized in prints after the works of members of his family including a series on the decoration of the Amsterdam town hall.

QUERCIA, Jacopo della (c.1374–1438) Sienese sculptor, in 1401 one of the contestants in the competition for the second bronze doors of the baptistry, Florence. His trial relief has not survived (see Ghiberti, Brunelleschi). His earliest extant recorded work is a Virgin and Child for Ferrara Cathedral (1406; Ferrara, Opera del Duomo), but far better known is the slightly later Tomb of Ilaria del Carretto in Lucca Cathedral (c.1406; mutilated and incompletely reassembled, 1429). The effigy, Burgundian in type, is celebrated for its haunting beauty, but almost equally remarkable are the winged *putti with garlands decorating the sarcophagus, dependent on ancient Roman prototypes. The mixture of *Gothic and *Classical idioms is typical of Quercia. At Lucca he executed also tomb slabs and an altar for the Trenta family (1416–22; S. Frediano). His first major work in Siena is the Fonte Gaia, an architectural/sculptural fountain complex facing the Town Hall (commissioned 1409; executed 1414–19; marble sculptural fragments now in the Town Hall, replaced by casts in the original location). Between 1417 and 1431 he participated also on the Siena baptistry font (bronze relief of Zacharias in the Temple, marble upper section of font, 1428–30; see also Ghiberti, Donatello). Quercia's most accomplished work is the central doorway of S. Petronio, Bologna (1425–38), left incomplete at the artist's death. *Michelangelo admired the reliefs of the Genesis scenes. The development of Quercia's style is thought to demonstrate his familiarity with the work of *Sluter at Dijon as well as with *Classical remains.

QUESNOY, DU Family of Flemish sculptors, of whom the best-known is François du Quesnoy (see below), although his father Hieronymus I, or Jerome, du Quesnoy executed the tabernacle of the church of St Martin in Aalst in 1604, and was the author of the much-loved Manneken-Pis in Brussels (original destroyed in 1817; the present statue is a copy), a fountain in the form of a urinating *putto. Putti became the speciality of Hieronymus's brilliant oldest son, François, or Francesco, du Quesnoy or Duquesnoy, called Il Fiammingo, 'the Fleming' (1594–1643). Born in Brussels, in 1618 François received a government bursary to study in Rome, and spent the rest of his life there. He died in Leghorn, on his way, reluctantly, to take up a post offered him many years before at the French court.

Much of François du Quesnoy's work is lost, for during his first years in Rome he was employed on small-scale sculpture for collectors, on wooden reliquaries, and in restoring ancient marbles. His study of Roman antiquity was further deepened by his participation in the collection of drawings after all known Roman and Early Christian remains being compiled by young artists on behalf of Cassiano del

Pozzo. Upon *Poussin's arrival in 1624, *Il Fiammingo* became friendly with him, and they shared a house. He also came to know *Sacchi, and was generally drawn into a circle of serious-minded artists with antiquarian interests. Between 1627–8 he was employed by the sculptor *Bernini on the sculptural decoration of the Baldacchino, the giant bronze canopy over the high altar of St Peter's in the Vatican.

His reputation established, he was chosen to execute one of the four gigantic statues planned by Bernini for the piers supporting the dome of St Peter's (the other three are by Bernini himself, and by Francesco *Mochi and Andrea Bolgi). Du Quesnoy's *Saint Andrew* (1629–40) is one of only two monumental statues by him, the other being *Saint Susanna* (1629–33) in the church of S. Maria di Loreto, Rome. Although *St Andrew* successfully negotiates its enormous scale, it is the *Susanna* which became celebrated and widely influential. More or less disregarded today by all but specialists, *Susanna* seemed to contemporaries to have achieved the perfect synthesis of the study of nature and of antique ideals.

Like the *Susanna*, du Quesnoy's many reliefs and statues of *putti* (e.g. *Tombs of Andren Vryburch*, 1629, and *Ferdinand van den Eynde*, 1633–40, both in Rome, S. Maria dell'Anima; *putto* frieze, Naples, SS. Apostoli; London, Victoria and Albert; etc.) continued to exert their influence through the 18th century. Countless sculpted and painted *Baroque and *Rococo representations of children, cherubs and *putti* testify to the lasting importance of this facet of du Quesnoy's art. He was himself indebted, in addition to the direct study of the antique, to *Titian's painting of the *Worship of Venus*, or *Children's Bacchanal*, then in a Roman collection (1518–19, now Madrid, Prado). Towards the end of his life, however, he became increasingly attracted to the chubbier, even more vigorous *putti* of *Rubens, whose strain of Flemish *realism may have recalled to him his native roots. Du Quesnoy's brief career illustrates, amongst other things, the sometimes forgotten interdependence of painting and sculpture in the art of the past.

François' brother, Hieronymus II du Quesnoy (1602–54), was trained by him, and completed the commission given to François for the monument of Bishop Anton Triest in the cathedral of Ghent (c.1640–54). Hieronymus worked for several years in Spain, in Florence and in Rome, returning to the Netherlands after his brother's death in 1643. He was an eclectic sculptor, admired for a statue of *St Ursula* in Brussels, Notre Dame du Sablon, and three figures of apostles for the cathedral. He was condemned to death by strangling for having committed sodomy in a chapel where he was working.

Artus I *Quellin was also trained in François du Quesnoy's Rome workshop.

RAFFAELLINO DEL GARBO　*See under* Andrea del Sarto; Bronzino.
RAFFAELLO DA MONTELUPO　*See under* Michelangelo.
RAIMONDI, Marcantonio　*See under* Raphael.

RAMSAY, Allan (1713–84) Scottish-born portrait painter. Having worked in Rome with Imperali and in Naples with *Solimena (1736–8) he anticipated *Reynolds in wedding the Italian Grand Manner to British portraiture. His *Norman, Twenty-second Chief of Macleod* (1748, Skye, Dunvegan Castle) adapts the pose of the *Apollo Belvedere* to a contemporary subject some five years before Reynolds' *Commodore Keppel*. Ramsay further differed from other British portraitists in his extensive use of drawings to establish the pose, and in his special emphasis on *expressive gestures of the hands, for which many drawings exist (Edinburgh, National). From *c*.1739 Ramsay was settled in London, which was to remain his base, although many of his sitters were Scottish. In 1755–7, perhaps in reaction to the rising reputation of Reynolds, freshly come from Italy, Ramsay returned to Rome. This time, however, he drew at the French *Academy and studied the *classicizing frescoes of the Bolognese school; on his return, he accentuated the delicacy and gracefulness of his style, perhaps to distinguish his work further from that of Reynolds. His portrait of his second wife (1557?, Edinburgh, National) is a fine example of his silvery later manner, as are *Lady Mary Coke* (1762, Mount Stuart) and his portraits of Queen Charlotte. He was recognized to excel in portraits of women, unlike Reynolds, who began to imitate Ramsay in this respect. After 1760, although not officially appointed King's Painter, he was almost exclusively engaged on royal portraits, many of them studio repetitions, mainly the work of assistants. He refused a knighthood, was not connected with the Royal Academy, and virtually ceased to paint after 1769, possibly as a result of an accident to his arm. Son of the author of *The Gentle Shepherd*, he himself turned to literary production in later life. The best collection of his pictures is at Edinburgh, National and Portrait; but there are excellent examples also in London, Foundling Hospital; National Portrait; Tate; Victoria and Albert; Courtauld; and in other galleries and private collections throughout Britain.

RAPHAEL (Raffaello Santi) (1483–1520) Celebrated Italian artist. Younger than either *Leonardo or *Michelangelo, he was associated with them in the formation of what we now call the High *Renaissance style. Personable, ambitious, prolific and an excellent organizer, until his premature death he suffered none of the professional setbacks which marked the careers of these two men. One of the greatest draughtsmen in Western art, painter in *fresco, on canvas and panel, architect, designer of sculpture (*see* Lorenzetti) and of decorative

ensembles, the favourite of successive papal courts, Raphael came to be enshrined in art *academies as the author of images which fused truthful imitation with *idealization: a paragon of *classicism. His designs of late collaborative works verging on *Mannerism were attributed to members of his workshop (e.g. frescoes, Vatican, Stanza dell'Incendio, 1514–17) and even autograph paintings by him were modified in restoration, the better to conform to this notion of his *oeuvre* (e.g. *Canigiani Holy Family*, c.1505–07, Munich, Alte Pinakothek). A sentimental view of the artist was also propagated through 'chocolate-box' reproductions of some of his compositions (e.g. *Madonna della Sedia*, c.1514, Florence, Pitti) and paintings and prints purporting to represent episodes of his life (*see* e.g. Ingres, Volume Two). His outstanding success with contemporaries and the idolatry of posterity brought about a reaction amongst some 20th-century viewers. It is hoped, however, that the exhibitions marking the 1983 quincentenary of his birth, for which many works were successfully restored, will have once again revealed to the general public a truer Raphael: the vigorous and eclectic artist who dramatically changed direction several times during his short working life. Far from being mainly the saccharine master of 'dear Madonnas' (the theme of the series of collectors' pictures painted c.1500–c.1510, in which he assimilated the lessons of Florentine art – e.g. Berlin-Dahlem, Museen; Edinburgh, National; Florence, Uffizi, Pitti; Leningrad, Hermitage; Munich, Alte Pinakothek; Paris, Louvre; Vienna, Kunsthistorisches; Washington, National), Raphael was also a portraitist unsurpassed in lifelike representation (e.g. *Pope Julius II*, 1511–12, London, National; *Donna Velata, 'Woman with a Veil'*, c.1512–15, Florence, Pitti; *Baldassare Castiglione*, c.1514–15, Paris, Louvre; *Pope Leo X with Cardinals Giulio de'Medici and Luigi Rossi*, 1517–19, Florence, Uffizi). His mature altarpieces transformed static traditional schemata into new dynamic modes; the *Sistine Madonna* (c.1512–14, Dresden, Gemäldegalerie) anticipates *Baroque visionary effects. As a painter of mural-scale *istorie* (*see under* genres) he was unrivalled in invention, clarity of narration, richness of spatial, colouristic and light effects, and yielded little, in his mature works, to Michelangelo in dramatic power (e.g. Vatican, Stanza d'Eliodoro, c.1511–14; tapestries for Sistine Chapel, cartoons (*see under* fresco) 1515–16, London, Victoria and Albert). As a designer of secular decoration he demonstrated freshness and verve (*Loggia of Pysche*, Rome, Villa Farnesina, c.1517–18). Raphael's studies of the antique also resulted in workshop recreations of Roman *grotesque decorations (Vatican, Logge, 1518–19, Loggetta, 1519; Cardinal Bibbiena's bathroom, 1516).

The facts of Raphael's training are uncertain. His father Giovanni Santi, a minor but cultivated painter of Urbino, died in 1494. Sometime after that date Raphael left Urbino to join the studio of *Perugino. By 1500, the date of the first extant documentary record, he was already an

independent master. Although the earliest securely known Raphael paintings closely resemble Perugino's (e.g. *'Mond' Crucifixion*, 1503, London, National) they also demonstrate a superior ability to construct a *perspective scheme – as can be seen through comparing Perugino's *Marriage of the Virgin* (1499–c.1505, Caen, Musée) with Raphael's painting of the same subject (1504, Milan, Brera). Raphael must thus have learned his methods of pictorial construction elsewhere than in Perugino's studio, presumably in Urbino. Giovanni Santi had been a friend of *Melozzo da Forlì, admired *Mantegna and must have known the works painted in Urbino in the late 1460s and 1470s by *Uccello and *Piero della Francesca respectively. All of these artists were famous students of perspective. What Raphael had not already learned from his father by the time of the latter's death, he may have done later from some other member of the Santi workshop. It has been suggested that he remained in Urbino until as late as 1499, perhaps completing an apprenticeship with Timoteo Viti (1469–1523), an Urbinate artist who returned to the city in 1495 after studying with Francesco *Francia in Bologna. Raphael would then have joined Perugino as an independent artist to assist with specific commissions. In this capacity he would have been free to assist *Pintoricchio with designs for the latter's frescoes in the Piccolomini Library, Siena Cathedral, 1504 (drawings, Florence, Uffizi, Contini-Bonacossi Coll.; Oxford, Ashmolean). Whatever the facts of the years 1494–1500, documents and paintings reveal that the years 1500–08 were spent working throughout Umbria and Tuscany. The paintings of c.1504–08 – altarpieces, Madonna and Child pictures (*see above*) and portraits – increasingly demonstrate Florentine, and especially Leonardo's, influence. Notable examples are the *Colonna Altarpiece* (c.1504–05, New York, Metropolitan), the '*Madonna of the Meadow*' (1505, Vienna, Kunsthistorisches); pendant portraits of *Angelo and Maddalena Doni* (c.1505, c.1506 respectively, Florence, Pitti). By 1507, when Raphael completed *The Entombment* for a funerary chapel in Perugia (now Rome, Borghese) the influence of Michelangelo and the antique is clearly discernible. The stages through which this painting was created can fortunately be traced in extant drawings (Oxford, Ashmolean; London, British; Florence, Uffizi).

In 1508 the artist ws summoned to the court of Pope Julius II to help with the redecoration of the papal apartments, the suite of three interconnecting rooms in the Vatican palace known as the Stanze and the larger Sala di Costantino. The first artist to have been involved was Perugino (ceiling of the Stanza dell'Incendio); the second *Sodoma; other painters from Tuscany, Lombardy and the Veneto were also employed. By October 1509 Raphael had been appointed Writer of Papal Briefs and was in charge of the decoration of the Stanze. The first room to be decorated by him (the second in location) is now called the Stanza della Segnatura (1508–11); it contains the famous lunette-shaped wall frescoes known as the *Disputà* ('Disputation on the Holy

Eucharist'); *The School of Athens*; *Parnassus*; *The Three Cardinal Virtues*, with, below, *Pope Gregory IX Handing out the Decretals* and *Emperor Justinian Handing out the Pandects*. The ceiling paintings make clear that these subjects illustrate the practitioners and exemplars of *Theology*; *Philosophy*; *Poetry*; and *Justice* or canon and civil law. The *iconography of this room, animated through Raphael's impulse to increasingly dramatic narrative, in fact resembles the more static emblematic imagery of Perugino's decoration of the Collegio del Cambio, Perugia, in which Raphael participated. The second room in which Raphael worked (and the third in location within the apartments) was the Stanza d'Eliodoro or of Heliodorus (1511–14). Here the wall decorations are more properly narrative, illustrating miraculous interventions in human history, symbolically parallel to events in Julius's career. The scenes comprise *The Expulsion of Heliodorus from the Temple*, an Old Testament subject; *The Freeing of St Peter*, from the Acts of the Apostles; the *Mass at Bolsena*, which illustrates a medieval miracle; the *Repulse of Attila the Hun from the walls of Rome*, a chronicle of the Early Christian Church. A portrait of Julius as either witness or participant is incorporated in each fresco; at his death in 1513, the newly elected pope, Leo X, was aptly featured as Attila's adversary, Leo I.

On the death of the architect Bramante in 1514, Raphael was appointed architect in charge of the rebuilding of St Peter's and papal demands on his time increased continually (*see above* for some of the projects executed 1514–20). Thus his role as executant in the final room, the Stanza dell'Incendio (1514–17) is lesser than in the other two, although all the designs seem to have been his. The fresco of *The Fire in the Borgo*, chronicling a 9th-century miracle of Pope Leo IV, demonstrates Raphael's mounting interest in archaeology, his study of architecture, and a growing predilection for isolating expressive 'sculptural' figures and groups. Other scenes include *The Sea Victory at Ostia*; *The Coronation of Charlemagne* and *The Oath of Pope Leo III*. All refer to Leo X's Carolingian predecessors, whose example also motivated Leo's commission of the narrative tapestries for the Sistine Chapel (*see above*), where Raphael – and Leo – were to compete directly with Michelangelo and his patron Julius II.

It will be obvious that by now Raphael was obliged to employ many assistants. His studio practice, based on that of Perugino, involved a methodical approach to building up a composition step by step, from rough 'idea' sketches, studies for separate groups, studies from life of individual figures, with details of heads, hands, etc., to more finished compositional studies, squared enlargements and finally full-scale cartoons. Teams of assistants could intervene at various stages of the process under Raphael's guidance. Increasingly, they became executants of the finished painting, so that Raphael's drawings are a truer record of his intentions (as in the *Loggia of Pysche*, *see above*). The main exception is his mature portraiture, entirely, or nearly so, autograph

(*see above*). His best-known assistants and his heirs were Giovanni Francesco Penni (1488–1528) and *Giulio Romano, who completed the Sala di Costantino after Raphael's death. Two younger artists, *Perino del Vaga and *Polidoro da Caravaggio, began their careers working on the Logge (*see above*).

Raphael's early fame was partly the result of his having been the first artist whose work was widely reproduced. The Bolognese engraver (*see under* intaglio prints) Marcantonio Raimondi (*c.*1480–1534), who worked in Rome from 1510–*c.*27, is the most famous of his interpreters through the medium of prints. Although for the great part of the 16th century the Stanze were inaccessible to artists as well as to the general public, their decorations became known through Marcantonio's engravings after preliminary drawings, sometimes differing in detail from the finished frescoes.

Above all, however, Raphael's enduring popularity, at least until our own day, rests on his ability to formulate images of seemingly universal relevance. Sometimes intimate, at other times grand, his art at all times addresses itself to communication. Raphael, 'always imitating, and always original', in *Reynolds's phrase, makes manifest to us our own aspirations.

REALISM An important but slippery term; for Realism as a movement, *see* Volume Two. Most uses of the word in discussing earlier art hinge upon the notion of resemblance: a work of art is said to be realistic if it resembles the world of appearances as perceived by a viewer from a particular vantage-point and in specific light conditions. Difficulties arise from the fact that the term may be applied with a bias founded in its use in medieval philosophy. That is, realism in art may consist of representing 'universals' rather than 'particulars': the geometric forms and mathematic principles thought to underlie the ever-changing, 'accidental' world of appearances. In this usage, realism comes close to its seeming contrary, *idealization. The supreme example of an artist striving to reconcile both notions of realism is *Leonardo da Vinci. His work, however, hardly seems to the modern viewer to be realistic. The more commonsense usage, implying observation of, and resemblance to visible phenomena, has, from the 17th century, implied also a form of social realism (for Social Realism in the 20th century, *see* Volume Two). *Genre painting, depicting the behaviour of 'people like ourselves or worse than ourselves' in contemporary dress and settings, is said to be realistic. This usage may have a polemical edge. For example, portraying Jesus and the Apostles in their actual social milieu, as carpenter and fishermen etc, is a form of realism which may run counter to notions of *decorum (*see*, e.g. Caravaggio). Artists specializing in contemporary imagery, especially of the 'lower' classes, are thought of as realists. Naturalism, which denotes the optically convincing depiction of different surfaces under various conditions of illumination, is a particular kind of realism (*see*, e.g. van

Eyck). In Italianate art theory, it may denote 'slavish adherence' to observation of the model, lack of imagination or invention (*see under disegno*). The term may also imply social realism, and can be used to mean the refusal to idealize, the wish to present 'unvarnished truth', as in 'warts and all' portraiture.

RELIEF PRINTS These are made by cutting away from between lines drawn on a smooth surface; each side of the line has to be cut separately. Ink is then pounded or rolled on to the upstanding lines and printed on a sheet of smooth, or damp, paper laid face down on the inked surface. Originally, the back of the paper was rubbed to produce an impression; from *c.*1450 printing presses have been used. The height of the lines to be printed can be deliberately varied, so as to increase or decrease the pressure of the press, and thus the darkness of the lines printed, in particular places. The lines in a relief print, in contrast to those of an *intaglio print, are sunk into the paper.

Relief prints can be made from a wood block, usually one cut with the grain ('side wood'). Woodcuts are the oldest of the relief processes. Originally used for printing textiles, they have been applied to printing pictures since *c.*1400. Metal cuts have been used from the late 1400s. In these, engraver's tools (*see under* intaglio prints), or decorative punches may be used to remove the parts that are not to print. Many early metal cuts are thus highly patterned, after the manner of goldsmiths' work.

Chiaroscuro prints are relief prints, usually woodcuts, printed from several blocks: a line block is usually printed last; the effect resembles that of a wash drawing.

REMBRANDT HARMENSZ VAN RIJN (1606–69) The greatest Dutch painter and graphic artist and one of the leading European masters of the 17th century. Remaining all his life in his native Holland, he rivalled his older contemporary, the much-travelled Fleming *Rubens, in his grasp of the Italianate Grand Manner, and surpassed him in psychological profundity and originality. Whilst social and political circumstances deprived Rembrandt of monumental religious commissions, and he received only one commission for a large-scale public history painting (*see under* genres); (*Conspiracy of Julius Civilis*, 1661/2; fragment, Stockholm, Museum) he became one of the grandest interpreters of Biblical narrative in the history of art; his paintings of mythology and ancient history are equally dramatic, although fewer in number and sometimes obscure in significance (*Rape of Ganymede*, 1635, Dresden, Gemäldegalerie; *Danae*, 1636, Leningrad, Hermitage) and his group portraits are composed in the focused and psychologically compelling mode of heroic narrative (*The Anatomy Lesson of Dr Tulp*, 1632, The Hague, Mauritshuis; *The Night Watch*, 1642, and the *Syndics of the Cloth Drapers' Guild*, 1661/2, Amsterdam, Rijksmuseum).

The eighth of nine children of a miller, Rembrandt was intended by his parents for a learned profession, but after grammar school and some short time at the University of Leiden he was apprenticed, first to

an unknown painter, secondly to Jacob van Swanenburgh, whose effect on his *oeuvre* is undetectable. The most lasting influence on Rembrandt (with the exception of *Elsheimer and Rubens, who were never his masters) was his third teacher, the Italianate Amsterdam painter Peter *Lastman. After six months with Lastman c.1624, Rembrandt returned as an independent master to Leiden, where he worked closely with another former pupil of Lastman, Jan *Lievens. At this time he specialized in small but dramatic narrative paintings, many of them based on the Scriptures, which were admired for their emotional truthfulness and intensity (e.g. *Repentance of Judas*, 1629, private coll.). He took on the first of his many students, Gerrit *Dou, in 1628. At about this time Rembrandt also began to form his extensive collection of prints by 16th- and 17th-century northern and Italian masters, and began his own experiments with the comparatively new medium of etching (*see under* intaglio prints), in emulation of Hercules *Seghers and Elsheimer. Only from c.1631 did he begin to execute commissioned portraits, although he had painted portrait compositions of himself and of members of his family.

In 1631/2 Rembrandt moved from Leiden to Amsterdam, where he rapidly gained popularity as a portraitist and began to execute narrative paintings on a large scale, influenced by engravings after Rubens. Like his contemporaries, he experimented with sensational and violent scenes (e.g. *Blinding of Samson*, 1636, Frankfurt, Kunstinstitut). The most important commission of this first Amsterdam period, however, was a *Passion* series for Frederick Henry of Nassau, Prince of Orange. Whilst only under a metre high, these vertical lunettes intended for the decoration of Frederick Henry's new palace at The Hague were in a format, and of subjects, associated with monumental altarpieces, and in them Rembrandt was able both to acknowledge his debt to Rubens and to compete directly with the Flemish master (five *Passion* scenes, c.1633–45, Munich, Alte Pinakothek). In 1634 Rembrandt married Saskia van Uylenburgh, the daughter of a wealthy patrician family (*Saskia in Arcadian Costume*, Leningrad, Hermitage; London, National). In 1639, to mark his prosperity and rising social status, he bought a large house – the factor mainly responsible for his insolvency in the mid-1650s.

Rembrandt's popularity as a portraitist began to wane in the early 1640s – albeit not, as used to be thought, as a direct result of the supposed unfavourable reception of *The Night Watch*, more properly called *The Company of Captain Frans Banning Cocq and Lieutenant Willem van Ruytenburch*, which transforms the traditional full-length Amsterdam group portrait into a dynamic composition unified through a dramatic use of *chiaroscuro. Taste in Amsterdam now veered towards the lighter and brighter colour key of *Van Dyck, and most of Rembrandt's pupils adapted to the elegant new manner, whilst Rembrandt himself continued to exploit, although in a less exuberant, more *classical mode, extremes of light and dark tonality. In this decade, especially

after Saskia's death in 1642, Rembrandt turned to landscape – observed landscapes of the Dutch countryside in drawings and etchings, romantic fantasy landscapes in paintings. But commissioned works never actually ceased altogether, and some of his most moving and evocative portraits, etched or painted, date from the late 1640s and 1650s (*Jan Six*, 1647, etching, London, British, etc.; *Jan Six*, 1654, Amsterdam, Six Coll.). There was also demand for his work abroad: his etchings were collected internationally, and Don Antonio Ruffo, a Sicilian nobleman, ordered a painting of a philosopher in 1653 (*Aristotle with the bust of Homer*, New York, Metropolitan), of *Alexander the Great* in 1661 (unidentified) and a *Homer* in 1663 (The Hague, Mauritshuis). Double and group portraits were commissioned from him privately (*Jewish Bride*, c.1661, Amsterdam, Rijksmuseum; *Family Portrait*, c.1668, Brunswick, Museum) and for public institutions (*Anatomy Lesson of Dr Deyman*, 1656, fragment, Amsterdam, Rijksmuseum; the *Syndics*, see above).

Neither commissions nor the sale of etchings, nor the fees of pupils, sufficed in the 1650s to rescue Rembrandt from insolvency, aggravated by the general economic depression. His extensive collection of curios and works of art was sold in 1657. His and Saskia's only surviving child, Titus, b.1641, and Rembrandt's housekeeper and companion, Hendrickje Stoffels, formed a limited company employing him as painter, to evade the regulations of the artists' guild regarding insolvent members. His last years were embittered not only by poverty and litigation, but finally also by the death of Hendrickje in 1663 and of Titus in 1668. Rembrandt was left alone with his 15-year-old daughter by Hendrickje, Cornelia. But the tragedies of his life had no adverse effect on his art. From the 1620s he had used his own face as a model, at first to study expression and the effects of light, later probably to experiment with various modes of portraiture. In his last years these self-portraits became genuine portraits of self, confessional and introspective; they stand, together with one of his last narrative paintings, the *Prodigal Son* (c.1669, Leningrad, Hermitage), amongst the greatest monuments of European culture, as much spiritual statements as marvels of technical skill. Rembrandt's mastery of human expression encompassed in particular transitional emotional states (e.g. *Denial of St Peter*, 1660, Amsterdam, Rijksmuseum) and his evocation of the inner life of men and women has never been surpassed. There are paintings by this prolific artist in most major collections, and etchings and drypoints in most print cabinets.

RENAISSANCE (French, rebirth) The use of the term to denote a period in European history was introduced in 1855 by the French historian Jules Michelet. Art-historical usage reflects Michelet's chronological definition. Despite disagreement about precise dating, scholars agree that the term applies to art in Western Europe c.1300/ c.1400–c.1520/50/c.1600. The earlier dates encompass a time of rapid

urbanization, of change from a feudal and ecclesiastical society of status to a capitalist contract society in which secular institutions played an increasing role. The 16th century, in addition, witnessed the rise of the centralized state and national consciousness. Renaissance art thus comes to include a wider range of *genres than medieval art, evolving such secular forms as state and domestic portraiture and the forerunners of modern types like landscape and *still-life.

More contentiously, however, the word also functions as a style label, following its use in 1860 by the German-speaking Swiss scholar Jakob Burckhardt to describe Italian civilization in the early modern period. His usage popularized the notion of cultural rebirth, first formulated as long ago as the 9th century at the Carolingian court (*renovatio*) and applied by Italian writers of the 14th to the 16th centuries to the arts and letters of their own day (e.g. *Vasari, *rinascità*). The two main components of this idea are the 'return to Nature' and the 'revival of *classical antiquity'. Research has clearly demonstrated that in neither of these did Renaissance art break with its immediate past; that the northern European style known as *Gothic had had both naturalistic and classicizing modes, and that the classical tradition had survived in Italy without a radical break. Nonetheless, common parlance still defines Renaissance style as a new preoccupation with the representation of natural appearances and with the formulae of Graeco-Roman art and architecture. This definition, however, not only postulates a disjuncture between medieval and early modern art, but also presupposes that Italy took the lead in the 'rebirth' of art whilst northern Europe followed – an interpretation which has been, and continues to be, challenged.

In practice, most professional art historians now avoid the use of the term as a label denoting a single style or set of stylistic determinants. According to this more shaded interpretation, artists north and south of the Alps were responding to the new social functions required of art in the period characterized in the opening paragraph of this entry, whilst building on their respective medieval traditions. An interchange of influences between northern Europe and Italy is recognized. Scholars concede to 15th-century Netherlands the primacy in pictorial naturalism (*see under* realism) – notably the representation of light through space and reflected from different surfaces (Jan van *Eyck). To 14th- and 15th-century Tuscany they assign the main role in forging monumental narrative, in reconciling optical accuracy with formal order, *expression with *idealization (*Giotto, *Masaccio, *Ghiberti, *Donatello). New techniques (oil painting, monumental bronze casting, etc.) and new inventions (such as that of linear *perspective), as well as the adaptation of classical figures and poses, are viewed as instrumental to these ends. The term Renaissance itself tends to be modified to lend it some greater descriptive precision in this dual period and style-label sense. Thus Early Renaissance is usually understood to apply to Tuscan

art *c*.1400–*c*.80; High Renaissance to art in Florence and Rome *c*.1500–*c*.20, and in Venice *c*.1510–*c*.80; Northern Renaissance to art *c*.1400–*c*.1550 north of the Alps. *See also* Mannerism.

R ENI, Guido (1575–1642) One of the greatest Italian painters of the 17th century, a subtle colourist, a master of graceful line and composition. His unique synthesis of naturalism (*see under* realism) and *idealizing *classicism was an important influence. Although few, his portraits are notable for psychological penetration (*Papal Portrait*, Corsham court). From the 19th century until recently, his reputation was tarnished by the stereotypic, sentimental production of his studio, mostly the work of assistants, from the last 10 years of his life.

A Bolognese, trained mainly by Lodovico *Carracci, Reni followed Annibale Carracci to Rome shortly after 1600; he remained there from 1600–04; 1607–11; 1613–14; quickly gaining the status of an independent master. His early works fuse classical principles of composition with the dramatic power and use of light of *Caravaggio. Becoming the protégé of Cardinal Scipione Borghese, nephew of Pope Paul V and a rapacious art lover, Reni received important *fresco commissions (amongst them *St Andrew adoring the Cross*, S. Gregorio al Celio, 1608; Quirinal Palace, Chapel of the Annunciation – with Bolognese assistants – 1609–12; Palazzo Rospigliosi, Casino dell'Aurora, *Aurora* ceiling, 1613–14) which made him a leading exponent of the style sometimes known as Early *Baroque Classicism. In 1612 he was called to Naples; but in 1614 he renounced his southern Italian successes to return to his native Bologna, remaining there except for an abortive trip to Naples, in 1621/2, to decorate the Cappella del Tesoro in the cathedral. He abandoned the project when one of his assistants was assaulted; it was later completed by another Bolognese, *Domenichino.

Back in Bologna Reni executed masterful altarpieces (Bologna, Pinacoteca) and secular collectors' pictures (most leading galleries and many private coll.) and a series of influential pietistic images conforming to Counter-Reformation *iconography, and echoed in countless devotional prints. A new, lighter and cooler colour scheme pervades his work from *c*.1625. The last pictures have a curious chalky quality and may be unfinished.

R EPOUSSOIR (from French *repousser*, to push back). Any pictorial motif which enhances the sense of spatial recession. In landscape painting, for example, a tree or architectural form stretching from the bottom of the picture field to nearly the top, and painted dark against light in its upper portion, has the effect of 'pushing back' the sky and the other landscape incidents into the far distance. In portraiture, a similar though less extreme effect is achieved by a balustrade interposed between viewer and figure portrayed.

R ESTOUT, Jean the Younger (1692–1768) French painter, mainly known for his austere and deeply felt religious works, which form a link between the *Baroque altarpiece and the revival of moralizing

history painting (*see under* genres); (*see also* , e.g. David). He was the most important member of an artistic dynasty from Normandy, trained as a child by his father, Jean Restout the Elder (1663–1702); after *c*.1707 he studied in Paris under his maternal uncle, Jean Jouvenet (1644–1717). His son, Jean-Bernard Restout (1732–1797) was a painter and has left an uncompromisingly severe portrait of his father (Versailles, Musée).

Through Jouvenet, Restout looks back to the 17th-century French religious painting of *Le Sueur. Works such as the *Ecstasy of St Benedict* and its famous pendant, the *Death of St Scholastica* (1730, Tours, Musée), *St Vincent with St François de Sales* (1732, Paris, Ste Marguerite) or the *Martyrdom of St Andrew* (1749, Grenoble, Musée) combine rigour of composition, intensity and truthfulness of expression, with halluci- natory vividness and historical accuracy of detail. His few portraits and secular history paintings are equally sober but emotionally compelling (e.g. Stockholm, Museum; France, Véziers Coll. respectively). He became Director of the French *Academy in 1760 and was the teacher of, amongst others, the neo-Baroque painter Jean-Baptiste-Henri Deshays (1729–65) hailed by Diderot in 1761 for his moral grandeur.

RETABLE or REREDOS A *dossal or vertically proportioned altar- piece set above and behind the altar table. Retable and reredos are terms usually reserved for the elaborately carved *polyptychs pro- duced, e.g. in Spain and in pre-Reformation Germany, whilst dossal and altarpiece normally denote an altar decoration in which the painted elements predominate.

REYNOLDS, Sir Joshua (1723–92) Through his example as a painter, his position as first President of the Royal *Academy (1768–92), the 15 *Discourses on Art* he delivered there (1769–90), his intimacy with men of letters, and his knighthood in 1769, Joshua Reynolds is without doubt the artist who did most to raise the status of the visual arts in Britain and to draw the British school out of its lingering provincial isolation.

The son of a grammar-school headmaster and former fellow of Balliol, Reynolds was apprenticed at 17 to *Hudson, although roundly declaring that 'he would rather be an apothecary than an *ordinary* painter'. In search of the *extraordinary* dimension, after some years of independent practice as a portraitist in his native Devon and in London (1743–9) he set out for Italy with his friend Commodore, later Admiral and Viscount, Keppel, whose portrait was later to secure Reynolds's reputation (1753/4, Greenwich, Maritime). He was to define his goal most succinctly perhaps in his *Third Discourse* (1770): '. . . it is not the eye, it is the mind, which the painter of genius desires to address , . . . his great design [is] of speaking to the heart . . . [This] is that one great idea, which gives to painting its true dignity, which entitles it to the name of a Liberal Art, and ranks it as a sister of poetry.'

In Italy he strove to master the principles and not merely the devices

of the great artists of the *Renaissance and antiquity. Whilst believing that *Ideal Beauty and history painting (*see under* genres) were the highest manifestations of art, he was practical enough to recognize that the British painter could earn a living only through portraiture. Upon his return to London in 1752, therefore, he worked to elevate the British tradition of portraiture by marrying it to elements of the Grand Style – a task in which he had been anticipated in some measure by *Ramsay. Reynolds's portraits of the 1750s were, however, more vigorous and intellectually penetrating than Ramsay's and he enjoyed greater success, albeit not at Court. His citations of *Classical and Renaissance formulae, always at this period tactfully adapted to the individual sitter, extended the symbolic references of the paintings without compromising either likeness or intimacy (*see* e.g. *Georgiana, Countess Spencer and her daughter*, 1760/1, Althorp, which employs a Madonna and Child design to haunting effect). From the 1760s, however, Reynolds began to seek a more overt rhetoric and to combine portraiture yet more closely with history painting, particularly in those pictures intended for public exhibition. One of the earliest of such works is the portrait of his friend Garrick, the famous actor/manager: *Garrick between Tragedy and Comedy* (1762, private coll.) in which Comedy is painted in the style of *Correggio and Tragedy in that of Guido *Reni. From the 1760s he also experimented with a form of generalized classical dress, such as that advocated in his *Fourth Discourse* (1771). The series of portraits of ladies engaged in antique pursuits, dressed in 'timeless' gowns, albeit always intelligently conceived (none more so than *Three Ladies adorning a term of Hymen*, 1774, London, National) occasionally strike a note of the absurd (*see*, e.g. *Lady Sarah Bunbury sacrificing to the Graces*, 1765, Chicago, Institute). He exhibited also subject paintings; from the 1770s these began to include *Fancy Pictures, less unremittingly Italianate, more exercises in the style of Old Masters of other schools: *Murillo (*Shepherd Boy*, c.1772, Earl of Halifax), *Rembrandt (*Children with Cabbage Net*, 1775, Buscot). The earliest of these anticipate *Gainsborough's Fancy Pieces. In the 1770s he also combined the Fancy Picture with actual children's portraits, for which, perhaps surprisingly, he had a particular flair (*Master Crewe as Henry VIII*, 1776, private coll.; *Lady Caroline Scott as Winter*, 1777, Bowhill). Late in this decade he abandoned the classical draperies of his historiated portraits, now able to combine grandeur of concept and composition with specifically contemporary dress. The most monumental of British group portraits, *The Family of the Duke of Marlborough* (1778, Blenheim) is perhaps the greatest achievement of this phase.

A journey to Flanders and Holland in 1781 awakened a study of *Rubens, reflected in the more dramatic and livelier style of his last manner (*The Duchess of Devonshire and her daughter*, 1786, Chatsworth; *Lord Heathfield*, 1788, London, National). Although frequently compromised by technical shortcomings – the carmines of his flesh tones

have faded, and his reliance on the unstable pigment, bitumen, has caused darkening and lizard-like cracking of paint surfaces – Reynolds's portraits eminently deserve the high praise of contemporaries, not least that bestowed by his rival, Gainsborough: 'Damn him, how various he is!' His *Discourses* remain the clearest, the noblest, and at times most touching, statement of academic ideals in art ever written.

RIBALTA, Francisco (1565–1628) and his son Juan (c.1597–1628) Spanish painters active in Valencia, where Francisco settled in 1598 after working at the Escorial and in Madrid. A single work from his early period survives (1582, now Leningrad, Hermitage). Francisco's Valencian works until c.1611 are wildly eclectic and variable, borrowing from all available sources including prints by *Dürer. After 1612, however, he found a sober monumental style, *Caravaggesque in origin (Madrid, Prado and Valencia, Museum; various churches). Juan Ribalta was an able Caravaggesque painter technically dependent on his father (Valencia, Museum; Torrente).

RIBAS, Felipe de *See under* Montañés.

RIBERA, Juseppe or José de (called 'Il Spagnoletto', 'the Little Spaniard') (1591–1652) Influential *Baroque painter and etcher born near Valencia. Shortly after 1610 he travelled throughout northern Italy; c.1612 he settled in Rome, where he was influenced by *Raphael, the *Carracci, Guido *Reni and, above all, *Caravaggio, whose bohemian existence he is said to have emulated. In 1616 he transferred to Naples where he gained the protection of the Spanish Viceroys. He left a lasting imprint on the Neapolitan school and had a considerable influence also on Spanish art. A master of the exacting technique of painting *alla prima*, which he combined with precise drawing and masterful modelling, he achieved dramatic compositions by relating large, monumental forms to simple, airy backgrounds, lending dignity to even his most naturalistic (*see under* realism) low-life subjects – all traits which affected the art of *Velázquez, *Zurbarán, *Murillo and *Cano. His earliest securely known works, 1621–4, a series of etchings (*see under* intaglio prints) of saints, grotesque male heads and limbs in various poses, served as a source for artists until the 19th century, *Rembrandt and Goya (*see* Volume Two) amongst others.

Three periods are distinguished in his work: 1620–35, when he preferred dark backgrounds and violent contrasts of light and dark (e.g. *Drunken Silenus*, 1626, Naples, Capodimonte; *Martyrdom of St Andrew*, 1628, Budapest, Museum; *Christ Disputing with the Doctors*, c.1630, Vienna, Kunsthistorisches; the series of *Twelve Apostles and Christ*, c.1631–2, all but four now Madrid, Prado); 1635–9, when under the influence of *Van Dyck his backgrounds became lighter, shadows more transparent and *chiaroscuro less pronounced (e.g. *St Joseph and the Budding Rod*, c.1635, Brooklyn, New York, Museum; *Laughing Girl with a Tambourine*, 1637, London, Mr and Mrs R. E. A. Drey, one of

several *genre* subjects forming a series on the Five Senses, indebted to Flemish art; the *Trinity*, 1636–7, Prado); finally, 1640–52, characterized by an even looser, more liquid modelling and the predominance of airy, silvery tones (e.g. the famous *Club-Footed Boy*, 1642, Paris, Louvre; *St Jerome*, 1644, Prado; *Communion of the Apostles*, 1651, Naples, S. Martino).

Ribera, based as he was in Italy – hence his nickname – painted more mythological subjects than any other Spanish artist, albeit often with ironic, *genre*-like realism. He was also an accomplished portraitist, although few autograph likenesses by him are now known. He was the master of, amongst others, Luca *Giordano.

RICCI, Sebastiano (1659–1734) and his nephew and pupil Marco (1676–1729) Venetian decorative painters; Sebastiano was the originator of the Venetian *Rococo, whose most brilliant exponent was Giovanni Battista *Tiepolo. Trained in Bologna, Parma and Rome as well as Venice, Sebastiano Ricci synthesized the styles of the great 16th-century decorators, *Correggio and *Veronese, with those of the 17th-century masters of the genre, Annibale *Carracci, *Pietro da Cortona and Luca *Giordano. His own peripatetic career was one of the causes of the international success of the Venetian school from the 1710s. Even before 1710, he had worked in Milan, 1695–8; Vienna, 1701–03; Bergamo, 1704 and Florence, 1706–07, as well as in Venice. Around 1712–16 he was in England, brought there by his nephew Marco, with whom he sometimes collaborated (e.g. *Allegorical Tomb of the Duke of Devonshire*, Birmingham, Barber). His surviving independent masterpiece in England is the *fresco of *The Resurrection* (London, Chelsea Hospital, chapel). Disappointed at not receiving the commissions for Hampton Court and St Paul's, which went to the English *Thornhill, both Ricci returned to Venice via Paris, where Sebastiano copied some of *Watteau's drawings. In addition to altarpieces and decorations *in situ*, there are easel paintings and drawings by Sebastiano in the Royal Collection and in many continental galleries.

Marco Ricci was also a pioneer of the *capriccio*. Influenced by *Magnasco, through his ruin-pieces and romantic scenes, he in turn influenced *Canaletto and *Guardi. He was first brought to England by *Pellegrini in 1708. His later life is ill-documented. Perhaps under the impact of Netherlandish landscape, he began to paint sober yet poetical landscapes of fact, small *gouache pictures on kidskin anticipating 19th-century developments (e.g. Royal Coll.). His etched landscapes (*see under* intaglio prints) were published in Venice the year after his death.

RICCIO or CRISPUS; Andrea Briosco, called (*c.*1470/5–1532) Paduan sculptor, the greatest Italian master of the small bronze statuette or implement *all'antica*. His improvisations on the theme of the satyr are especially renowned (Florence, Bargello; Paris, Louvre; Oxford, Ashmolean). In contact with leading Paduan humanists, he also interpreted contemporary subjects and Christian symbols in

antique terms (Della Torre monument, Verona, S. Fermo Maggiore, before 1511; Paschal candlestick, Padua, S. Antonio, 1507–15).

RICHARDSON, Jonathan (1665–1745) A pupil of *Riley, he became a leading portrait painter in England in the generation after *Kneller. His writings, in which he expounds his theories of High Art and the Grand Manner, are more successful than his solemn but prosy pictures (e.g. London, National Portrait). These writings had a decisive influence on the young *Reynolds, whose first teacher, *Hudson, was Richardson's pupil. Richardson also owned an important collection of Old Master drawings. He retired from painting in 1740, continuing his literary work with his son, Jonathan Richardson the Younger (1694–1771), also a painter but better known as one of the new professional 'art experts'. In 1722 they published together *An Account of some of the Statues, Bas-reliefs, Drawings and Pictures in Italy*, widely used by collectors on the Grand Tour, and by British artists in Italy. There are portraits by the elder Richardson in London, National Portrait; Edinburgh, Portrait; at Oxford, Christ Church, Bodleian; Cambridge, St John's; at Firle Place; etc.

RICIARELLI, Daniele See Daniele da Volterra.

RIEMENSCHNEIDER, Tilman (active 1485–1531) Distinguished wood and stone carver, head of a large workshop in Würzburg. With *Stoss, he is the most fully documented German pre-Reformation sculptor. He became Burgomaster 1520–1, but in 1525 he was imprisoned, expelled from the Council and fined for refusing to support the Prince-Bishop against the peasants' revolt. There are no dated works from the last decade of his life, although we know that in 1527 he was employed to repair an altarpiece damaged in the Peasants' War.

Riemenschneider's early work is very eclectic. He was probably trained in alabaster sculpture in Thuringia, and in limewood carving in Ulm, perhaps with Michel *Erhart; he drew also on Netherlandish and Upper Rhenish patterns. He is the first of the limewood carvers to produce altarpieces finished not in *polychrome but with a brown glaze. Documented works *in situ* are to be found in Würzburg, cathedral; Rothenburg, St James; Bamberg, cathedral; Creglingen. There are fragments of sandstone sculpture in Würzburg, Museum; of limewood sculpture in Berlin-Dahlem, Museen; Munich, Museum; a drawing in Heidelberg, Museum.

RIGAUD, Hyacinthe (1659–1743) French portrait painter, *Baroque interpreter of the grandeur of absolutist monarchy (*Louis XIV*, 1701, Paris, Louvre) but simultaneously the first artist in France to emulate the naturalistic (*see under* realism) and intimate portraits of *Rembrandt, seven of whose paintings he owned (*The Artist's Mother*, 1695, Louvre). Born in Perpignan and trained in the south of France, he settled in Paris in 1681. After some years portraying Parisian bourgeois and fellow artists, he broke new ground in 1688 with a commission to paint the King's brother. From this time he became

almost exclusively a court painter, whilst his friendly rival, *Largillière, continued to specialize in bourgeois portraits. Rigaud's sitters included most members of the royal family, the great French generals and prelates, visiting foreign princes and diplomats (e.g. Paris, Louvre, Versailles; Madrid, Prado; London, Kenwood; Nottinghamshire, Welbeck Abbey; Perpignan, Musée). To depict them he evolved formulae dependent both on *Van Dyck and the more severe Philippe de *Champaigne. Ennobled in 1727, Rigaud became Director of the French *Academy in 1733.

RILEY, John (1646–91) British portraitist, chief painter to the King jointly with *Kneller after the Revolution of 1688. He had an established reputation, perhaps amongst the middle classes, even before *Lely's death in 1680. Of this early style, however, we know nothing. From 1680 until his death he painted the great figures of the day (e.g. Oxford, Ashmolean) but his diffidence made him less successful with aristocratic sitters than with persons from humbler walks of life. Two portraits of the latter type are amongst the most sympathetic of the period: *The Scullion* (Oxford, Christ Church) and *Bridget Holmes, housemaid to James II, in her ninety-sixth year* (1686, Windsor Castle). Riley was the teacher of some of the most important portrait painters of the next generation (see Jonathan Richardson).

RILIEVO SCHIACCIATO or (Tuscan) STIACCIATO Italian for 'flattened relief'. A form of shallow relief sculpture evolved by *Donatello and associated especially with Tuscan Early *Renaissance artists, notably, in addition to Donatello, *Ghiberti and *Desiderio da Settignano. More pictorial than high relief, *schiacciato* relief relies for its effects on gentle modulations of the surface combined with incised contours and accents. Where the perceived or notional depth of high or medium relief is always directly proportional to the actual depth of the carving, the notional depth of *schiacciato* relief, like that of a painting, is infinite. The technique thus lends itself particularly well to the representation of *perspective, and was utilized by Donatello in the first demonstration of a single-vanishing point perspective in a work of art, the relief at the base of his statue of St George in Florence, Or San Michele (original now Florence, Bargello).

RIZZO, Antonio (recorded from 1465–99/1500) With Pietro Lombardo (*see* Solari) the first fully *classicizing *Renaissance sculptor working in Venice, author of the celebrated statues of *Adam* and *Eve* (after 1483, now Doge's Palace). Their softness of modelling is thought to have been influenced by Rizzo's contacts with the painters Gentile and Giovanni *Bellini and *Antonello da Messina. A native of Verona, he is confused in older accounts with both Antonio *Bregno (with whom he collaborated on the Arco Foscari) and *Riccio. Of his several funerary monuments in Venice the foremost surviving is that of Niccolò Tron (1476–80s, S. Maria dei Frari). He also designed the Staircase of the Giants of the Doge's Palace (1491). Appointed master of works in

the palace in 1483, Rizzo was accused of embezzlement and fled Venice in 1498, travelling to Ancona, Cesena and Foligno, where he died.

ROBBIA, Luca della (1399/1400–82) Florentine sculptor. Although he executed outstanding works in bronze and marble, he is remembered most vividly for the glazed terracotta sculpture, predominantly in blue and white, which became the speciality of the della Robbia workshop inherited after Luca's death by his nephew Andrea (1435–1525) and the latter's sons, notably Giovanni (1469–1529) and Girolamo (1488–1566). Luca first springs to prominence in art-historical records with the commission for the *classicizing marble Singing Gallery, or Cantoria, for Florence Cathedral (1431–8; now reconstructed, Opera del Duomo). He must have been a well-established artist by this time, yet nothing is known of his earlier work or training, which was possibly under *Nanni di Banco. In 1436 he is mentioned by *Alberti in the prologue to the treatise On Painting as one of the outstanding innovators of Florentine art, along with *Brunelleschi, *Donatello, *Ghiberti and *Masaccio. His later reliefs were influenced by Donatello's competing organ gallery, begun 1433.

Luca first employed glazed terracotta as a decorative element in 1441–3 (Peretola); a similar combination of marble and *polychrome decoration was employed in the Federighi monument for S. Pancrazio (1454–7; reassembled Florence, S. Trinita). Luca's earliest bronze works are two angels from the Cantoria (Paris, Jacquemart-André); from 1445–7, and again 1464–9, he worked on the bronze doors for the sacristies of Florence cathedral (see also Michelozzo). Glazed terracotta as an independent sculptural medium was used by Luca in architectural settings; it is probable that he worked out the technique at *Brunelleschi's instance. The earliest documented work entirely in this medium was the predominantly white-and-blue Resurrection lunette over the entrance to the north sacristy of Florence cathedral (1442–5); this was matched by the lunette of the Ascension over the entrance to the south sacristy (1446–51). In the years 1440–50 he produced circular reliefs of the Apostles for Brunelleschi's Pazzi chapel. The glazed decoration of Michelozzo's Chapel of the Crucifix in S. Miniato was probably executed in 1447–8, and the ceiling decoration for the Chapel of the Cardinal of Portugal in the same church in 1461–2. The three guild emblems above niches at Or San Michele are usually also assigned to about this date. Two free-standing figures of angels bearing candlesticks were made for the cathedral, 1448–51. Luca's last major work in terracotta was an altarpiece now in the chapel of the episcopal palace at Pescia (after 1472), but throughout this period he and the shop collaborated on many smaller works for private devotion and decoration.

After Andrea assumed control of the shop, the quality of the glazed terracotta products declined. Andrea himself is primarily associated with the glazed terracotta roundels of the Florence foundling hospital, the Ospedale degli Innocenti (1487), and with a series of polychrome

altars in the principal church of the Franciscan shrine at La Verna, made in collaboration with his sons, of which replicas and variants were exported all over Tuscany.

ROBERT, Hubert (1733–1808) Painter, French exponent of the Italianate *capriccio* inspired by *Panini and *Piranesi. He was also a forerunner of Romantic responses to nature (*see* Volume Two), perhaps under the influence of *Fragonard, with whom he became friends during his stay in Rome, 1754–65. In addition to imaginary views with ruins, he was also capable of topographical accuracy. During the last years of the *ancien régime*, when he was keeper of Louis XVI's pictures, Robert executed vivid views of the construction and demolition of parts of Paris (Paris, Carnavalet; other works, Paris, Louvre; Leningrad, Hermitage; New York, Metropolitan; Cambridge, Fitzwilliam; etc.).

ROBERTI, Ercole *See under* Costa, Lorenzo.

ROCOCO, ROCOCO Style label coined, originally as a term of ridicule, at the end of the 18th century by Maurice Quai, a student of the Neo-*Classical French painter Jacques Louis *David. It is applied to aspects of 18th-century art in France and elsewhere under French influence, and is thought to derive from the French word *rocaille*, meaning rock- and shell-work for the incrustation of grottoes and fountains, and, by extension, a whimsical style of decoration associated with the reign of Louis XV (1715–74) and the taste of his mistress, Mme de Pompadour. In the rococo style all objects, including works of painting and sculpture, but also wall panelling, furniture, fabrics, silver and tableware, are subsumed to an ideal of elegant, sometimes frivolous, overall decorative harmony. The characteristic colour range of rococo includes white, gold, silver, rose-pink and sky-blue. Its line is the asymmetrical S-curve; *Hogarth's S-Line of Beauty is a rococo phenomenon. As this style became identified with the private apartments of aristocratic women, it assumed a political and even moral significance in the latter part of the century, being contrasted with 'masculine', 'severe and upright' classicism. Yet in its origins the *style rocaille* was also a reforming style, invoking the great past masters of colourism (*see under disegno*) – *Correggio, *Veronese, *Rubens – and seeking to add to the emulation of antiquity taught in the *Academy the study of nature in all its variety and spontaneity. Far from having begun as an expression of aristocratic licentiousness, rococo was initially patronized by the bourgeoisie and used to decorate small and unpretentious town houses. Rococo painters were also influenced by the 'little masters' – *genre* painters of 17th-century Holland and Flanders – for example *Teniers. And while the ebullient works of *Boucher, for instance, with their sprightly eroticism, can be said to devalue the traditional content of mythological and history painting (*see under* genres), rococo art is not necessarily shallow or licentious. *Watteau and frequently *Fragonard (who had studied

*Rembrandt as closely as the Dutch painters of *genre*) are far from being mere decorators, and their work is often tinged with introspective melancholy and sincere feelings, such as those cultivated in contemporary bourgeois theatre and literature.

Under French influence abroad the style was modified to embrace public art. In southern Germany and Austria rococo ensembles adorned churches and palaces. The grand decorative *frescoes of *Tiepolo (virtually the only major Italian practitioner of the style) – lighter, airier and more tender variations of *Baroque mural and ceiling painting – are typical of rococo public design.

ROELAS, Juan de (*c.*1558/60–1625) Pioneering Sevillan painter, a priest, perhaps born at Valladolid where he is recorded as working alongside Bartolomé *Carducho, 1598–1602. In his huge altarpieces, to be found only in Andalusia (e.g. Seville, University church, cathedral, S. Pedro, Museum; etc.), Roelas achieved an eloquent style combining *realism and vigour with delicacy of handling – the 'vaporous style' for which the far-better-known *Murillo was to be praised in the 1660s. Roelas's figure types, compositions, colour-range and open brushwork were also to influence Francisco *Herrera the Elder.

ROGIER VAN DER WEYDEN *See* Weyden, Rogier van der.

ROMANINO, Girolamo (1484/7–1562) Veneto-Lombard painter from Brescia, active in and near his native city and throughout northern Italy. His work, until *c.*1540 original and exuberantly free, combines in various admixtures Venetian colourism (*see under disegno*, *also* Giorgione, Titian), Lombard *realism and the influence of *Dürer's prints. He is best known for his religious *fresco cycles (Cremona, cathedral, 1519–20, *see also* Pordenone; Pisogne, S. Maria della Neve, *c.*1534; Breno, S. Antonio, *c.*1535; Bienno, S. Maria Annunziata, *c.*1540). The last three, in country churches near Brescia, show the influence of Pordenone's popular, 'rustic' manner. He also painted altarpieces (e.g. Padua, Museo; Brescia, S. Francesco; Salò, cathedral) and other religious easel pictures. From 1521–4 he participated with *Moretto in the decoration, on canvas, of the Chapel of the Sacrament, Brescia, S. Giovanni Evangelista, an important ensemble often cited to demonstrate these artists' influence on *Caravaggio (*see also* Savoldo). In 1531–2 Romanino joined *Dosso in the secular fresco decoration of the Castel Buonconsiglio in Trento. From *c.*1540 he collaborated with his son-in-law Lattanzio Gambara (1530–74).

There are works by Romanino in Brescia, Pinacoteca Tosio Martinengo, Congrega della Carità Apostolica; Duomo Nuovo; Venice, Accademia; London, National; Modena, S. Pietro; Memphis, Tennessee, Brooks Memorial; etc.

ROMANO, Gian Cristoforo *See under* Isaia da Pisa.

ROMANO, Giulio *See* Giulio Romano.

ROMNEY, George (1734–1802) Fashionable English portrait painter, usually ranked just below *Reynolds and *Gainsborough

amongst the late 18th-century portraitists before Lawrence (*see* Volume Two). Unlike these two masters, Romney neither penetrates into the character of his sitters nor poeticizes their sensibilities; his strength is in the telling disposition of the figures, the linear pattern of his designs, his fresh, clear colour. At its best, his work has a glossy poise, an authority, achieved in large measure through his study of *Classical statuary and *Raphael.

Romney was the son of a Lancashire cabinet maker, and apprenticed (1755–7) to a travelling portraitist, Christopher Steele. After some years of independent practice in Kendal, he established himself in London (1763) where, except for a visit to Paris in 1764 and a trip to Italy in 1773–5, he remained until retiring back to Kendal in 1798. His best period is generally reckoned to be the half-decade following his return from Rome (1775–80), but there are a few striking later works, including the imposing double portrait of *Sir Christopher and Lady Sykes* (1786, Sledmere) and the uncharacteristically thoughtful *Warren Hastings* (1795, London, India Office). In 1781 he came into contact with Emma Hart (who became Lady Hamilton in 1791) and began obsessively to depict her in over 50 pictures, some from direct sittings or drawings, some from memory. There are works by him in Kendal, Gallery; Cambridge, Fitzwilliam; Eton College; etc.

ROSA, Salvator (1615–73) The 17th-century Italian artist most collected by 18th-century English connoisseurs. Poet, actor, musician, satirist, letter-writer, self-professed Stoic philosopher and etcher as well as painter, Rosa was a highly individual and intransigent personality. He is the first Italian artist of stature to rebel against the prevailing system of patronage, by making exhibitions, not commissions, his principal means of attracting sales.

Born and trained in Naples, he was dubbed 'savage Rosa' by 18th-century admirers, who believed him, wrongly, to have spent his youth with bandits and joined Masaniello's revolt against the Spanish (1647–8), 'fighting by day and painting by night'. This view of the artist was supported by the subjects, and to a lesser extent the manner, of his most characteristic works: battle scenes, landscapes of rugged mountain scenery peopled with hermits or bandits, macabre scenes of witchcraft. The famous series of etchings (*see under* intaglio prints) the *Figurine*, seemed to hint at enigmatic narratives. But the bold brushstrokes and vivid lights of his landscapes, the portentousness of his self-portraits (London, National; New York, Metropolitan; Siena, Chigi-Saraceni), cannot disguise stereotypic compositions. Even the allegorical and philosophical pictures (*Humana Fragilitas*, Cambridge, Fitzwilliam) are more derivative and conventional than appears at first sight. In truth, Rosa, despite his intelligence and ambition, never completely outgrew his training as a painter of decorative *genres: battle scenes (he studied with the specialist Aniello Falcone), landscapes and coastal views.

Rosa left Naples for Rome in 1635; receiving one commission for an

altarpiece from a Neapolitan cardinal (*Incredulity of St Thomas*, Viterbo, Museo, 1638/9), he subsisted mainly by decorative pieces sold through dealers. But in nine years in Florence (1640–9) he broadened his work to include biblical, mythological and philosophical subjects, albeit usually within a landscape framework (*The Philosopher's Grove*, Florence, Pitti) and won a reputation with aristocratic Florentine collectors. Upon his return to Rome in 1649 he vied with *Poussin in the production of heroic narrative landscape (*Landscape with the Baptism of Christ, Landscape with St John the Baptist pointing out Christ*, Glasgow, Gallery; *Pythagoras emerging from the Underworld*, Fort Worth, Kimball). Whilst never rivalling Poussin's, these finally won him an international reputation and clientele, as did his technically accomplished etchings, many of them devoted to proclaiming the independence and intellectual eminence of the artist (*The Genius of Salvator Rosa, Alexander in the Studio of Appelles*).

ROSSELLI, Cosimo (1439–1506/07 Florentine painter, a pupil of Benozzo *Gozzoli or *Baldovinetti. Although he worked in the entrance cloister of Florence, SS. Annunziata (1476), S. Ambrogio (1485–6) and S. Maria Maddalena dei Pazzi (1505), his main claim to fame is having been commissioned to execute some of the mural *frescoes in the Sistine Chapel in Rome, with *Perugino, *Ghirlandaio and *Botticelli. He was the teacher of Fra *Bartolommeo and *Piero di Cosimo, who assumed his name. Other works are in Florence, Uffizi, Accademia; Paris, Louvre; Oxford, Ashmolean; etc.

ROSSELLINO, Bernardo (1409–64) and his brother and pupil Antonio (1427–79) Florentine sculptors from Settignano; Bernardo also practised as an architect, notably in Pope Pius II's model town of Pienza. He trained Antonio and his less well-known brothers Giovanni (*b.*1417), Domenico (*b.*1407) and Tommaso (*b.*1422), all of whom were members of the Rossellino workshop, and the sculptor *Desiderio da Settignano. Bernardo Rossellino, under *Brunelleschi's influence, is associated primarily with sculpture in which the figurative portions are subordinated to architecture: tabernacles (1450, Florence, S. Egidio) and wall tombs. His outstanding example of the latter is the monument for the humanist, historian and Chancellor of Florence, Leonardo Bruni (1444–7, Florence, S. Croce). It inaugurated a new type of funerary monument in which the sarcophagus and the effigy of the deceased are contained in a *classical triumphal arch, within whose lunette is carved a roundel with a half-figure of the Madonna holding the Child. This scheme derives from elements in *Donatello and *Michelozzo's Coscia monument in Florence baptistry, but gives greater emphasis to the architectural enframement. The form was adopted by other Tuscan sculptors, including Desiderio, Antonio Rossellino and *Mino da Fiesole.

Antonio Rossellino assisted his brother on several minor works, emulating – and surpassing – Bernardo's Bruni monument in his tomb for the Chapel of the Cardinal of Portugal in Florence, S. Miniato

(1461–6, *see also* Baldovinetti, Antonio and Piero Pollaiuolo, Luca della Robbia). The face of the Cardinal of Portugal's effigy was carved after a death mask, and Antonio Rossellino's influential portrait bust of *Giovanni Chellini*, Donatello's doctor (1456, London, Victoria and Albert) was unique in its day for being based on a life cast. Almost equally arresting in its evocation of character is the – now badly weathered – bust of *Matteo Palmieri* (1468, Florence, Bargello).

A number of Virgin and Child reliefs have been attributed to Antonio and a heterogenous assortment of youthful busts and reliefs representing the young St John the Baptist and Christ Child (e.g. New York, Metropolitan). Less formally severe than Bernardo's, Antonio's sculpture is notable for its sensitive vivacity (*Virgin with Laughing Child*, terracotta, London, Victoria and Albert).

Rosso; Giovanni Battista di Jacopo, called (1495–1540) Florentine painter and draughtsman, with *Pontormo the creator of Early Florentine *Mannerism. A less consistent and less profound artist than Pontormo, he never achieved a similar synthesis of feeling and form, oscillating throughout his career between extremes of *expressivity verging on *caricature and of over-refined elegance. His importance in the history of art stems mainly from his decorative work at Fontainebleau, which became known throughout Europe by means of engravings (*see under* intaglio prints). He also executed many drawings for reproduction in prints.

Like Pontormo, he first worked under the dominant influences of *Andrea del Sarto and Fra *Bartolommeo (*Assumption of the Virgin*, 1516–17, Florence, SS. Annunziata), later experimenting with effects reflecting 15th-century Florentine art, notably that of *Donatello (*Sacra Conversazione*, 1518, Florence, Uffizi). The famous *Deposition* (1521, now Volterra, Pinacoteca) also demonstrates his interest in northern European prints, especially those of *Dürer. His last major work of this period, the *Moses and the Daughters of Jethro* (1523–4, Florence, Uffizi) exploits the idiom of *Michelangelo's *Battle of Cascina* cartoon.

In 1524 Rosso followed the new Medici pope, Clement VII, to Rome (*frescoes, S. Maria della Pace). His attempt to synthesize the canon of Michelangelo with the grace of *Raphael is evident in the *Dead Christ Supported by Angels* (*c.*1525–6, Boston, Mass., Museum). Maltreated in the Sack of Rome, 1527, Rosso fled to Arezzo and its environs (*Pietà*, 1527–8, Borgo S. Sepolcro, Orfanello; *Resurrection*, 1528–30, Citta di Castello, cathedral). In 1530 he was summoned to France by Francis I, to work at Fontainebleau alongside *Primaticcio. His main achievement for the King was the complex decoration of the Grande Galerie, consisting of allegorical frescoes in sculptural stucco enframements. He is generally credited with the famous *strap-work elements of this enframement. His *Pietà* (1530–40, Paris, Louvre) returns to the religious expressivity of his early work in Florence.

ROTTENHAMMER, Hans (1564–1625) Bavarian painter. After 1588, he went to Italy, making the acquaintance in Rome of Jan *Brueghel and Paul *Brill, who were to paint the landscapes in some of his pictures, and spending 1596–1606 in Venice, where he was influenced by *Tintoretto and *Palma Giovane. From 1606 he worked in Augsburg in a Venetian High *Renaissance style, executing both large-scale altarpieces and decorative ceiling paintings (Munich, Residenz-Museum, various churches; Augsburg, town hall; Bückeburg castle) and small-scale *cabinet pictures, including paintings on copper, in which he anticipated *Elsheimer.

ROTTMAYR, Johann Michael (1654–1730) Austrian painter, the first major native exponent of the dome and ceiling *fresco decorations which were to become such an important feature of secular, but more especially ecclesiastic, Late *Baroque and *Rococo architecture in Austria and southern Germany (but see also Pozzo). From 1696 until his death he worked for the imperial court at Vienna as well as in churches, princely and civic buildings throughout Austria and Germany (Breslau, St Matthias, 1704–06; Salzburg, Residenz, 1710–11; Vienna, Peterskirche, 1715, Karlskirche, 1725; Pommersfelden, Marble Hall, 1717–18; Melk, abbey church, 1719). In addition to Italian influences, Rottmayr was increasingly indebted to *Rubens, many of whose paintings were housed in Viennese collections. His main follower was Paul *Troger.

ROUBILIAC, Louis François (1702/05–62) French Huguenot sculptor, trained by Balthasar *Permoser at Dresden and Nicolas *Coustou in Paris. From 1735 he is recorded in England, becoming perhaps the most accomplished sculptor to have worked there. His first commission was for a marble statue of Handel for Vauxhall Gardens (1738), but he made his reputation as a maker of portrait busts, evolving a new pattern for each (Birmingham, Museum; London, National Portrait; etc.). During the 1740s he began to obtain commissions for tombs outside London (Worcester, cathedral; Shropshire, Condover) and between 1745–9 he executed his first major London commission, the monument to John, Duke of Argyll (Westminster Abbey). In 1752 he journeyed to Italy with the painter Thomas *Hudson; the work executed after his return is more vigorous, even more dramatic, than before (London, Westminster Abbey, tombs of General Hargrave, 1757, Lady Elizabeth Nightingale; Handel, both 1761). His series of busts of distinguished members of Trinity College, Cambridge, 1751–7, all based on painted portraits, as well as his busts of famous men long dead (Milton; Shakespeare; Cromwell; Charles I, terracotta, London, British) demonstrate his ability to recreate imaginatively the semblance of life. Stylistically, his work plays an important part in the development of *Rococo in England.

ROWLANDSON, Thomas (1756–1827) English watercolourist and caricaturist. He was trained in figure drawing in Paris from

1771–3, and in London at the *Academy schools. In addition to his rollicking *caricatures of the life of the times, he came close to *Sandby in his landscape watercolours, which are notable for their sensitivity to atmospheric tone.

RUBÉNISTES *See under disegno.*

RUBENS, Peter Paul (1577–1640) Italianate Flemish painter, perhaps the greatest exponent of the *Baroque style which he pioneered; and the only northern European artist successfully to rival the Italians in history painting (*see under* genres). He was also an unmatched designer of altarpieces and large-scale mural and ceiling decoration, working, however, in oils and not *fresco. His portraits on the scale of life influenced, amongst others, his one-time assistant *Van Dyck, and his landscapes revolutionized the genre. His work, based on first-hand study of the antique, the Italian *Renaissance and his own native tradition, affected not only countless contemporaries but also successive generations of artists even into the 20th century (*see* Volume Two). The tag of 'learned painter', whilst more accurate than for almost any other artist, does not do justice to the intensely visual quality of his art, uniquely affirmative of the joys of life, albeit tempered with a philosophic moderation and reticence not immediately perceptible to a modern viewer. He is the brilliant colourist *par excellence*, so that 'Rubéniste' became the French *Academy's label for those painters favouring *coloris* (*colorito*) over *dessein* (**disegno*). Under the influence above all of *Titian, he evolved a type of chromatic modelling which virtually excludes shadows in flesh tones, suggesting translucence and vibrancy. His resplendent female nudes, his vigorous male figures, were criticized in the academies for lacking *idealization, yet they are generally based on *classical or Renaissance prototypes, according to his own precept for drawing after statuary: transforming marble into 'living flesh'.

Rubens was born in Siegen, Westphalia, where his patrician family, originally from Antwerp, were in temporary exile; most of his childhood was spent in Cologne. His father Jan, a learned lawyer, and his scholarly elder brother Philip fostered his considerable intellectual gifts. After the family's return to Antwerp following Jan Rubens's death in 1587, he attended a well-known grammar school, leaving in 1590 to become a page to the Countess de Ligne-Arenberg at Oudenarde. Rubens's abiding dislike of princely courts, as well as the roots of his later diplomatic career, may perhaps be traced to this brief episode. He soon persuaded his mother to let him study painting: first with a kinsman, the landscape artist Tobias Verhaecht (1561–1631); from 1592 with Adam van *Noort, and from *c.*1596 with the erudite Otto van *Veen, who of his three teachers most influenced him. The few securely identified works from this period show Rubens already drawing from prints after *Raphael (Antwerp, Rubenshuis; London, National). In 1600 he left for Italy, where he spent eight formative years. Nominally

in the service of the Duke of Mantua, he was able to travel widely, study and work in other Italian centres. In 1603 he was sent by the Duke to Spain with presents for Philip II (equestrian portrait of the *Duke of Lerma*, 1603, Madrid, Prado).

Eschewing the tasks of small-scale portraiture, landscape or **genre* normally relegated to Netherlandish artists in Italy, Rubens successfully imposed himself as a painter on the scale of life. At Mantua, he decorated a room with scenes after Virgil's *Aeneid* (1602, fragments only, Prague, castle museum; Fontainebleau, Château) and executed a group of three large paintings for the chancel of the new Jesuit church (1604–05; *Baptism of Christ*, Antwerp, Musée; *Transfiguration*, Nancy, Musée; *Gonzaga family adoring the Trinity*, fragments only, Mantua, Palazzo Ducale; Vienna, Kunsthistorisches). In Rome, he was commissioned twice for altarpieces, first for S. Croce in Gerusalemme (1601–02, now Grasse, cathedral) and then for S. Maria in Valicella (1607, first version Grenoble, Musée; 1608, second version *in situ*). In Genoa, he painted a series of portraits of the local aristocracy, which were to inspire Van Dyck on his visit to the city in 1621 (e.g. Washington, National). Paintings on classical themes dating from his Italian sojourn are now to be found in, e.g. Dresden, Gemäldegalerie; New Haven, Yale.

Rubens's real career as a painter of international stature begins, however, with his return to Flanders in 1609. Although he continued to execute autograph pictures – portraits of the Regents, of his family, friends and special patrons (e.g. Munich, Alte Pinakothek; Vaduz, Liechtenstein Coll., London, Courtauld) collectors' pictures on biblical or mythological themes (e.g. Dresden, Gemäldegalerie; Cologne, Wallraf-Richarts; Kassel, Kunstsammlungen; London, National) or of exotic animal hunts (e.g. Munich, Alte Pinakothek) – his studio, working from coloured oil sketches by the master, furnished pictures for numerous patrons, especially altarpieces for the many Antwerp churches despoiled by Calvinist iconoclasts in the 1560s and 1570s, and for newly-built churches (e.g. Antwerp, cathedral, St Michaelskerk, St Pauluskerk, St Augustinuskerk). For the new Jesuit church, which he may have helped design, Rubens created not only altarpieces (now Vienna, Kunsthistorishes) but an entire, and quite novel, lavish interior decoration, including ceiling paintings in the Venetian mode (1620–1; destroyed by fire, 1718). In 1622–5 he executed, again with studio aid, a large cycle of panegyric biography of the Queen Mother of France, Marie de'Medici, for her palace of the Luxembourg (now Paris, Louvre). This was to be paired with a series of paintings extolling Marie's late husband, Henry IV, never completed (e.g. Florence, Uffizi).

His classically based pictorial language of life-like allegory is demonstrated also in his designs for tapestries representing the *Triumph of the Eucharist* for the Regent Infanta's favoured convent in Madrid (1625–7;

tapestries, Madrid, Descalzas Reales; sketches, Chicago, Institute; Washington, National; etc.). Rubens's diplomatic work on behalf of the Regents, secret missions to promote the reunification of the Netherlands and peace in Europe, intensified after the death of his much-loved first wife, Isabella Brant, in 1626. His political ideals are evoked in two famous allegorical paintings, *Minerva protecting Peace from Mars* (1629–30, London, National) and *The Effects of War* (*c.*1637, Florence, Pitti). His missions to Spain, 1628, and to England, 1629–30, resulted not only in his being knighted by the art-loving monarchs of these countries, Philip IV and Charles I, but also in two more major decorative commissions: for the Whitehall Banqueting House ceiling (completed 1634, London, *in situ*), and, for Philip's hunting lodge near Madrid, the Torre de la Parada, a series of mythological paintings based on Ovid's *Metamorphoses* (completed, almost entirely by assistants, *c.*1636–8; ensemble destroyed; remaining paintings Madrid, Prado; autograph sketches, Brussels, Musées; Rotterdam, Boymans-van Beuningen; etc.).

The last major cycle on which he worked was undoubtedly more deeply felt than either of these projects. Not flattering a prince so much as pleading on behalf of his city's stricken economy, he designed the festival entry decorations for the arrival in Antwerp on 17 April 1635 of the Cardinal-Infante Ferdinand, the new Regent of the Netherlands (recorded in engravings published 1642).

In 1630 Rubens remarried, to the young Helene Fourment. When, in the last four years of his life, ill with gout, he went into quasi-retirement, it was as a noble to a newly purchased country manor, Het Steen. Here he painted for his own enjoyment a brilliant series of pictures. Especially remarkable are the landscapes, with their pioneering notation of fleeting weather and light conditions; rustic *genre* scenes on themes first popularized by Pieter *Bruegel; and fantasies on pastoral or courtly love, which were the source of the 18th-century *fête galante* (e.g. London, National, Wallace, Courtauld; Vienna, Kunsthistorisches; etc.).

Celebrated in his day as the 'Belgian Apelles', Rubens did not content himself with emulating Alexander the Great's famous painter. His diplomatic work has already been mentioned. But he was also genuinely scholarly, an insatiable reader and collector of books, antiques and other art; he was also occasionally a dealer. He corresponded on all manner of subjects with the most erudite people in Europe. The extant letters testify, as do the writings of his contemporaries, to his independence of spirit, his moral courage and his warm affections. In an age of violent sectarianism he was a champion of tolerance and internationalism. His support of monarchs and of the church should be understood as an expression of hope for a united Europe and an affirmation of the enduring values of civilization.

RUISDAEL, Jacob van (1628/9–82) The foremost exponent of the 'classical' phase of Dutch landscape painting, notable for its monumentality and the heroization, for symbolic as much as formal ends, of

single motifs: a windmill (*Windmill at Wijk*, *c.*1665, Amsterdam, Rijks-museum), a clump of trees (*Dunes*, *c.*1647, Paris, Louvre) or an animal (*see* Paulus Potter).

Ruisdael was born in Haarlem, the son of the painter Isaak van Ruisdael, of whose work little is known. An early influence was his uncle Salomon van *Ruysdael, a leading painter of the 'tonal' phase of Dutch landscape, in which the topography and humid atmosphere of the Dutch coast dominate over the representation of human activities. From the beginning, however, Ruisdael's work differed from that of his uncle by a denser, more opaque, use of paint, more vigorous accents of local colour and more energetic composition.

In the early 1650s Ruisdael left Haarlem for the border region between Holland and Germany (*Bentheim Castle*, 1653, Ireland, Blessington, Beit Coll.). Around 1656, he settled in Amsterdam, where he continued to paint the flat countryside near Haarlem as well as the rolling woodlands and streams of the Dutch–German borderland. Under the influence of *Everdingen he added, *c.*1660, the Scandi-navian themes of rocky mountains, fir forests and waterfalls to his repertoire. Although the former subjects are sometimes classified as 'realistic' and the latter 'romantic', there is as much *expressive power in the moisture-laden clouds and fitfully illuminated fields of his *View of Haarlem* (*c.*1670, Amsterdam, Rijksmuseum) as in the powerful animated trees of the *Marsh in the Woods* (*c.*1665, Leningrad, Her-mitage). Ruisdael's ability to create a poetic, even tragic, mood through landscape is best seen in the *Jewish Cemetery* (*c.*1660, Dresden, Gemälde-galerie; an earlier version, Detroit Institute), which seems to symbolize the transience of all earthly things.

RUOPPOLO, Giovanni Battista (1629–93) The foremost Neapolitan *still-life painter. His early work is both naturalistic (*see under* realism) and dramatic, setting illuminated flowers and vegetables against a dark background. The most important painting from this phase is in Oxford, Ashmolean. After the 1660s he veered towards a more decorative style, with lavish arrangements of flowers and fruit.

RUSTICI, Giovanni Francesco (1474–1554) Florentine sculptor, a pupil of *Verrocchio and later associated with *Leonardo da Vinci, who was closely involved in the *expressive bronze group of *St John the Baptist preaching to a Levite and a Pharisee* over the north door of Florence baptistry, 1506–11, competing with Andrea *Sansovino's *classicizing *Baptism of Christ* over the east door. Four terracotta groups of fighting horsemen also reflect Leonardo's ideas (Paris, Louvre; Florence, Bargello). In 1514 Rustici was employed on Verrocchio's Forteguerri monument in Pistoia cathedral. Having participated in the decorations for the 1515 festival entry of Pope Leo X (Giovanni de'Medici) into Florence, Rustici was commissioned by the Medici for a bronze fountain figure of Mercury (now private coll.). On the expulsion of the Medici in 1528, he left for France, where he worked mainly on an

equestrian statue for King Francis I, a project abandoned upon the King's death in 1547.

RUYSCH, Rachel (1663–1750) Amsterdam flower painter of international fame. The daughter of a distinguished botanist and anatomist, she studied with William van *Aelst, whose asymmetrical compositions she adopted. She also painted insects and reptiles. She was one of the artists patronized by the Elector Palatine, Johann Wilhelm (see also Adriaen van der Werff; Godfried Schalcken): her entire production in the years 1710–13 was contracted to him. Rachel Ruysch bore ten children, and perhaps for this reason only about 100 paintings by her are known (Munich, Alte Pinakothek; etc.).

RUYSDAEL, Salomon van (1600/03?–70) One of the originators of the 'tonal' phase of Dutch landscape, in which the topography and humid atmosphere of the Dutch coast dominate over the representation of human activities (see also Jan van Goyen; Pieter de Molijn). Born at Gooiland, hence his early appellation Salomon de Gooyer, he was settled in Haarlem by 1623. He is best known for the river scenes he began to paint in the 1630s. Around 1650, under the influence of his nephew, Jacob van *Ruisdael, he began to employ the forceful motif of a 'heroic' tree, often against a colourful sunset sky (e.g. Halt at an Inn, 1649, Budapest, Museum). At the beginning of the 1660s he painted some *still-lifes of objects arranged on a marble surface – perhaps the artificial marble which he is recorded as having invented (e.g. The Hague, Bredius).

His son, Jacob Salomonsz Ruysdael (1629/30–81), was also a landscape painter (e.g. London, National). There are paintings by Salomon in most art galleries in Europe and the United States.

RYSBRACK, Michael (1694–1770) The leading sculptor in England between 1720–40. Born in Antwerp, he was the son of the painter Peter Rysbrack and was almost certainly apprenticed to the distinguished Antwerp sculptor, Michael Vervoort, who had spent some ten years in Rome. From his arrival in England c.1720 he received important commissions: a large relief over a fireplace at Kensington Palace (A Roman Marriage, 1723), a tomb in Westminster Abbey (Monument to Matthew Prior, 1723), the monument of the painter Sir Godfrey *Kneller (intended for Whitton Church, set up 1730 in Westminster Abbey) and a bust of the Earl of Nottingham (1723, Rutland, Ayston Hall). The latter is a landmark in English sculpture: a deliberate attempt at portraiture *all'antica. By 1732 Rysbrack had executed over 60 portrait busts, many of which exist in two versions: a terracotta model, from the life if possible, and a marble cut from the model. Several of these are royal portraits (Windsor Castle; London, Wallace; Oxford, Christ Church), and there are many aristocratic portraits, as well as many of the leading professional men of the day (London, Victoria and Albert, British; etc.). He also executed many imaginary portraits of Great Men, much in demand for the adornment of gardens and libraries. At the

same time, he continued to practise as a tomb sculptor. In association with William *Kent he erected the *Monument to Newton* in Westminster Abbey (1731), and its companion, *Tomb of the Earl of Stanhope* (1733); whilst at Blenheim Palace the grander *Monument to the Duke of Marlborough* was erected in 1732. Stylistically, Rysbrack's art has been characterized as conflating *Baroque vigour and *classicizing pose; both tendencies are well illustrated in his bronze equestrian statue of William III (1735, Bristol). In his later years, he was influenced by the dramatic manner of *Roubiliac (e.g. *Monument of Admiral Vernon*, 1763, Westminster Abbey), probably in an attempt to regain the popularity of his earlier work.

SACCHI, Andrea (1599–1661) Roman painter, a pupil of *Albani both in Rome and in Bologna (see also Carracci). From c.1621 he had settled in his native city, where, after having painted major altarpieces in a *Baroque style (1622, Rome, S. Isidoro; 1625–7, Vatican, Pinacoteca) he evolved the sober, introspective *classicism for which he is best remembered (Vision of S. Romuald, c.1638, Vatican, Pinacoteca; cycle of the Life of St John the Baptist, 1639–45, Rome, S. Giovanni in Fonte). In contrast to *Poussin, whose development in these years presents striking parallels, he never lost, however, the rich and warm range of colours of his earliest work (e.g. Death of St Anne, 1649, Rome, S. Carlo ai Catinari).

Sacchi had worked under *Pietro da Cortona at Castel Fusano in 1627–9. Their views diverged markedly, however, from 1629–33, when Sacchi was employed painting the ceiling of a small room in the Palazzo Barberini. His fresco of Divine Wisdom avoids the *illusionism of Pietro da Cortona's ceiling decoration of Divine Providence, begun in 1633 in the Gran Salone of the same palace, and represents only a few figures, in tranquil poses, as on a quadro riportato – an easel painting hung up on the ceiling – albeit without a prominent painted frame. The differences between the two artists were voiced in disputes held at the *Academy of St Luke in the 1630s, centred on the number of figures desirable in a composition.

A slow, self-critical artist, Sacchi never achieved the worldly success later attained by his chief pupil, Carlo *Maratta.

SACRA CONVERSAZIONE, (Italian pl. sacre conversazioni, holy conversation; more accurately, holy communing) A representation, normally an altarpiece, of the Virgin and Child attended by saints and sometimes angels. The figures need not be shown conversing, but appear in an architecturally unified space, as opposed to the separately framed pictorial fields of the *polyptych. Unlike its predecessor, the *maestà, the sacra conversazione evokes an intimate mood of meditation and contemplation. The form evolved in mid-15th-century Florence (*Domenico Veneziano, St Lucy Altar, c.1445, Florence, Uffizi), was transmitted to northern Italy via *Donatello's sculptural altar for Sant'Antonio, Padua (1443–53, dismantled, partially resassembled), and is particularly associated with the later Venetian altarpieces of Giovanni *Bellini, which in turn influenced, via Fra *Bartolommeo, the 16th-century altarpieces of the Florentine School.

SACRO MONTE (pl. Sacri Monti; Italian for Holy Mountain(s)) Sites of popular pilgrimage in Lombardy and Piedmont, all but one of which are situated in the foothills of the Àlps. The first and most influential was founded at Varallo in 1486. The intention was to reconstruct exactly the Holy Places in Palestine and recreate, as an aid to

piety, scenes from the life of Christ. Each Sacro Monte thus consists of a series of separate chapels enclosing 'tableaux vivants' of *realistic, life-size *polychrome sculptures, usually of terracotta (compare with Guido *Mazzoni), many with real hair and glass eyes, arranged against a background of *illusionistic frescoes, rather like the modern exhibits of animals or prehistoric people in a natural science museum.

The construction of the Sacro Monte at Varallo continued until 1765, when 43 chapels had been completed; the end of the 16th century and the 1600s saw an acceleration in the founding of other Sacri Monti, as important tools of Counter-Reformation propaganda amongst the northern Italian populations most vulnerable to Waldensian and Lutheran heresy. The original conception was expanded to include, e.g. the *Life of St Francis* (Orta, 1592–1795) and the *Mysteries of the Rosary* (Crea, 1589–1615 or after; Varese, 1604–80). Some of the most notable northern Italian artists participated in their construction and decoration, including the painters Gaudenzio *Ferrari, at Varallo from c.1517–30; *Morazzone, at Varese in 1605–09, at Varallo in 1609–12 and 1615–16, at Orta 1611–20; *Tanzio da Varallo, at Varallo in 1616 and 1628. More importantly for the history of European art, the *expressive naturalism (*see under* realism) of the Sacri Monti, edging over into *caricature in the representation of cruel or low-life characters – in much the same way as medieval miracle plays or Late *Gothic Netherlandish and German art – affected all northern Italian artists, including *Caravaggio, whose influence in turn spread across all Europe.

SAENREDAM, Pieter Jansz. (1597–1665) Dutch painter, resident for most of his life in Haarlem. He specialized in the faithful representation of public buildings and churches, travelling to towns throughout Holland to make careful sketches, which he then worked up into construction drawings used as the basis for meticulously detailed, yet poetic, oil paintings (Amsterdam, Rijksmuseum; London, National; Rotterdam, Boyman-Van Beuningen; etc.). Virtually his only paintings not drawn from first-hand observation were his views of Rome, based on sketches from Maerten van *Heemskerck's Roman sketch-book, which he owned (e.g. Kettwig-Ruhr, H. Girardet Coll.).

SALVIATI; Francesco de'Rossi, called (1510–63) Florentine-born *Mannerist painter, mainly of outstanding secular *fresco cycles but also of altarpieces, tapestry designs and portraits. His style was formed less during his Florentine training (*Bandinelli, *Andrea del Sarto) than through his enthusiastic studies, part of the time with his friend and chronicler *Vasari, of High *Renaissance and earlier Mannerist art in Rome (*Raphael, *Michelangelo, *Perino del Vaga). He was to work in Rome 1532–8/9; 1541–3; 1548–63, taking on the name, Salviati, of a cardinal who was an early patron and protector (Rome, S. Francesco a Ripa; S. Giovanni Decollato, Palazzo della Cancelleria, S. Maria dell'Anima, Palazzo Sacchetti, Palazzo Farnese, S. Maria del

Popolo, S. Marcello al Corso). Between 1543–8 he was active at the Florentine court of Duke Cosimo I de'Medici (Florence, Palazzo Vecchio, Sala dell'Udienza; designs for tapestries, Florence Uffizi, S. Croce). A visit to Venice via Bologna (1539–41) further affected his style, especially through exposure to the work of *Parmigianino. A stay in France (1554–6; Château de Dampierre, destroyed) enhanced, through the influence of *Primaticcio, his own elegance of form and line.

Salviati's brand of Mannerism is far more than a formula for ordering pictorial composition and aestheticizing the human form. It is apparent also in his attitude to partitioning the wall surface of his mural decorations: no painter is more inventive or revels more in playful alternations of levels of reality, perceptual puzzles and witty allusions to earlier art. Clarity of narrative and *expressivity are subsumed to such artful ends, albeit less in his Florentine works than in Rome, where mural decoration of secular spaces was more highly evolved.

SÁNCHEZ COELLO, Alonso (1531/2–88) Spanish painter, brought up in Portugal and trained in Flanders under Anthonis *Mor. Soon after 1552 he became, with Mor and *Titian, the court portraitist of Philip II of Spain, working in a precise, austere but sensitive manner well attuned to Spanish court etiquette. His state portraits were sent as dynastic and diplomatic presents as far afield as the court of the Emperor of China, although due to the disastrous fires which swept the Spanish royal palaces in 1604 and 1734, authentic works by him are now rare. There are, however, four notable portraits by him, 1552–7, in Buckingham Palace; others, Dublin, National; Madrid, Prado. Sánchez Coello was the teacher of Juan *Pantoja de la Cruz.

SANDBY, Paul (1730–1809) Watercolourist painter of landscapes. With his brother Thomas (1721–98), the architect and draughtsman, he was trained in topographical drawing and cartography, but learned to ally meticulous accuracy with a lively feeling for nature. It was through him that the medium of watercolour acquired status, and he was the only watercolourist founder-member of the Royal *Academy. He was one of the first to draw directly in watercolour, as opposed to tinting drawings made first in pencil. Many of his large exhibition paintings were executed in *gouache; he was also the first major artist in England to reproduce his drawings in *aquatint.

The brothers came to London from Nottingham to take up appointments in the Drawing Office to the Tower. In 1746–c.51 Paul served as a draughtsman with the Ordnance Survey party sent to the Highlands of Scotland after the rebellion of 1745. This period was formative for his art, resulting not only in paintings of *picturesque scenery but also figure studies. After 1751 he returned to London, often staying with his brother, who had become deputy Ranger of Windsor Forest, carrying out major landscaping schemes, including Virginia Water, which Paul depicted in a series of prints and drawings (Windsor Castle, Coll. HM

the Queen). His loving portraiture of individual trees anticipates Constable (*see* Volume Two). In the 1770s he published series of views of Wales. Influential through these and other works on a younger generation of painters, Sandby also influenced military draughtsmen through his employment as chief drawing master at the Royal Military Academy, Woolwich (1768–96).

SANDRART, Joachim von (1606–88) Much-travelled German painter and writer on art. He journeyed to Prague *c*.1621–2. Apprenticed in Utrecht under Gerrit van *Honthorst, he accompanied his master to the court of Charles I in London. From 1629–35 he worked in Rome, and he has left us precious recollections of northern European artists resident in the city – notably *Claude, *Poussin, Pieter van *Laer and du *Quesnoy. In 1637 he settled in Amsterdam, where he made a name as a portraitist, and in 1640 received a commission for one of the six large paintings of militia companies for the banqueting hall of the Arquebusiers' Civic Guard, the Kloveniersdoelen, the most ambitious decorative project in the Netherlands until the decoration of the Oranjezaal in the late 1640s (*Civic Guard Company of Captain Cornelis Bicker, c.*1642, Amsterdam, Rijksmuseum). In 1674/5 Sandrart founded the earliest art *academy in Germany, at Nuremberg, and it is for this body that he wrote his major work, which includes his Roman reminiscences and accounts of the lives of artists, the *Deutsche Akademie der edlen Bau-, Bild- und Mahlerey-Kunste,* 1st ed. Nuremberg, 1675.

SANGALLO, da Florentine dynasty – so called after their native district – mainly important in the history of architecture but of some significance also for sculpture. Giuliano Giamberti, called da Sangallo (1445/52–1516) although above all an architect, influenced decorative sculpture in Florence in the late 1480s and 1490s upon his return from a stay in Rome (Florence, Palazzo Gondi; S. Trinita, Sassetti chapel; Medici palace, chapel, stalls). His *classicizing style has been compared to that of *Bertoldo. His son, Francesco da Sangallo (1494–1576) practised mainly as a sculptor. His earliest dated work is a *St Anne with the Virgin and Child* (1522–6, Florence, Or San Michele) whose composition depends on *Leonardo da Vinci's cartoon for an altarpiece on the same subject, exhibited publicly in Florence in 1501. In 1531–3 Francesco worked at Loreto for the Holy House (*see also* Andrea Sansovino). In the 1540s he was active in Rome as well as in Tuscany, where in 1543 he was appointed architect and master of works of Florence cathedral, and was commissioned also for monuments in Naples (Monteoliveto, S. Severino e Sosio). In addition to his *St Anne* his main works in Florence are the *Marzi monument* (1546, Ss. Annunziata) and the *Giovio monument* (1560, SS. Lorenzo, cloister). He also executed portrait medals and at least one portrait bust (Florence, Bargello). Albeit a dominant figure in the artistic life of Tuscany in the first half of the 16th century, he has been described as a heavy and insensitive sculptor.

SANSOVINO; Andrea Contucci, called (c.1467–1529) Born at Monte San Savino, he was the principal *classicizing Tuscan sculptor of the turn of the century; his style is transitional between Early and High *Renaissance. More than any other major sculptor of the time he specialized in relief. *Vasari relates that he spent nine years in Portugal between c.1490–9, but this is now doubted by many scholars. Having made his reputation in Florence with the *Corbinelli Altar* in S. Spirito (c.1485–90) and two statues he was carving for Genoa cathedral (1501–03) he was entrusted in 1502 with the major commission for a marble group of the *Baptism of Christ* over the eastern door of Florence baptistry (*see also* Rustici). This was left unfinished in 1505 with his departure for Rome, and may have been completed by Vincenzo *Danti. To Sansovino's Roman period belong the *Sforza* and *Basso monuments* in S. Maria del Popolo (1505; 1507 respectively); the pedimental group on Giuliano da *Sangallo's façade of S. Maria dell'Anima (1507?) and a group of *St Anne with the Virgin and Child* (1512, S. Agostino) inspired by *Leonardo da Vinci's cartoon of the same subject exhibited in Florence in 1501 (*see also* Sangallo, Francesco da), and associated with a fresco by *Raphael. In 1513 he was appointed by Pope Julius II to take charge of the greatest relief commission of the High Renaissance, the casing of the Holy House in Loreto Basilica, designed by Bramante, for which he carved a number of reliefs and designed others (installed 1530s), although he was demoted in 1517 from master of works and left in charge of the sculpture alone. His narrative scenes, especially that of the *Annunciation*, were of the greatest importance for Florentine art in the third quarter of the century. Andrea Sansovino was the teacher of Jacopo Tatti *Sansovino, who assumed his name, and probably of the Spaniard Bartolomé *Ordóñez.

SANSOVINO; Jacopo Tatti, called (1486–1570) Important *classicizing Florentine sculptor, pupil of Andrea *Sansovino, whose name he assumed. He is of great significance also for the history of architecture, which he practised in Venice after the Sack of Rome in 1527. As a sculptor, he was much affected stylistically and technically by his first stay in Rome, 1505–11, when he may have assisted Andrea at S. Maria del Popolo, but principally worked on the restoration of antiques. He came to the notice of the architect Bramante and of *Raphael, joining, as it were, the anti-*Michelangelo party. He competed directly with Michelangelo in his celebrated *Bacchus*, executed after his return to Florence in 1511 and more authentically *all'antica* than Michelangelo's statue of the same subject, and in his *St James* (1511) for Florence cathedral, originally part of the commission for which Michelangelo executed his unfinished *St Matthew*. During this period in Florence he shared a studio with the painter *Andrea del Sarto, for whom he executed small-scale models. Having participated in the decorations for the entry of Pope Leo X (Giovanni de'Medici) in 1515, he was promised a share in the sculptural decoration of the façade of the Medici parish

church, S. Lorenzo, but was rejected by Michelangelo. He returned to Rome in 1518 (*Virgin and Child*, 1518–19, S. Agostino; other statues and monuments, S. Maria di Monserrato; S. Marcello). Before engaging on his Venetian career (see above) he executed the Nichesola monument for Verona cathedral, and the *Virgin and Child* from this tomb was reproduced as a bronze statuette in his workshop (Oxford, Ashmolean; Leningrad, Hermitage; etc.). In Venice he was responsible also for sculptural commissions, the most important of which were the tribune reliefs and bronze sacristy door for S. Marco; the Loggetta – which combines relief with architecture – and marble reliefs for Padua, S. Antonio; the *Venier monument* in S. Salvatore (1556–61); the *Rangone monument* in S. Giuliano; and the *Neptune* and *Mars* for the Giants' staircase of the Doge's Palace. Throughout his residence in Venice, as in Rome and Florence, Sansovino was in friendly contact with painters – he became the intimate of *Titian, *Tintoretto and *Lotto. Despite his classicism, his tribune reliefs for S. Marco narrate the saint's life with a passion ultimately dependent on *Donatello's reliefs for the altar of S. Antonio, Padua; their vehement diagonal accents particularly influenced Tintoretto.

Santi di Tito (1536–1603) Outstanding though understated Florentine painter from Borgo San Sepolcro. After a stay in Rome 1558–64, where he succumbed to the influence of Taddeo *Zuccaro, he returned to Florence, becoming the first artist to challenge the dominant *Mannerism of Florentine painting in the 1560s (*see*, e.g. Bronzino, Vasari). Santi's naturalism (*see under* realism) was tempered with *classicizing recollections of Roman and Florentine High *Renaissance art (e.g. *Raphael, *Andrea del Sarto). The gentleness and lack of rhetoric of his many Counter-Reformatory altarpieces should not obscure the radical nature of his accomplishment (Florence, Ognissanti, S. Croce, S. Maria Novella, S. Marco, Uffizi Gallery; Borgo S. Sepolcro, cathedral; Colazzo, Villa Chierichetti; etc.).

Saraceni, Carlo (1579–1620) Venetian painter resident in Rome from 1598 until 1613, when he moved to Mantua, working at the ducal court until his return to Venice in 1619. At first closely linked with *Elsheimer, whose precious small-scale pictures on copper he emulated (e.g. London, National; Naples, Capodimonte), he became interested in the work of *Caravaggio (e.g. altarpieces, etc. Rome, Chiesa Argentina, S. Lorenzo in Lucina, S. Maria dell'Anima). Saraceni had contacts with France and the Lorraine and a group of pictures brought together under the pseudonym 'Pensionante del Saraceni' ('Saraceni's boarder') may have been executed by an anonymous French artist. During the last year of his life he was assisted by Jean Le Clerc from Nancy (*c*.1590–*c*.1633), who completed the large *Oath of Doge Enrico Dandolo* for the Doge's Palace before returning in 1622 to the Lorraine, where he may have influenced the early works of Georges de *La Tour.

SARRAZIN, Jacques (1588–1660) Influential French sculptor; late in life he evolved the style which was to dominate sculpture at Versailles for over 20 years, anticipating, in stone or bronze, the pictorial style of *Lebrun and of the court of Louix XIV: a particularly French blend of the *classicizing and the *Baroque (*Tomb of Henri de Bourbon, Prince de Condé*, 1648–63, finished by Sarrazin's assistants; originally Paris, St Paul-St Louis, rearranged in Chantilly, château).

After training in France, Sarrazin worked in Rome, 1610–c.27. On his return, he hesitated for some time between a Baroque manner influenced by the youthful work of *Bernini (e.g. *Enfants à la Chevre*, c.1640, Paris, Louvre) and a fully classical style, indebted to his study of *Domenichino and of ancient Roman sculpture (*Caryatids* for the Pavillon de l'Horloge, 1641, Paris, Louvre; executed after Sarrazin's models by his pupil Gilles Guérin). Between 1642–50 Sarrazin directed the sculptural decoration of the château at Maisons, executed by Guérin (1606–78), Philippe de Buyster (1595-1688) and Gerard van Obstal (c.1594–1668), the most outstanding of his many pupils.

SARTO, Andrea del *See* Andrea del Sarto.

SASSETTA; Stefano di Giovanni, called (c.1400–1450) The leading Sienese painter of the 15th century, notable for his poetic, calligraphic style. His work, albeit always dependent on his great 14th-century predecessors the *Lorenzetti and Simone *Martini, can be divided into three distinct phases. Around 1426–32, he came into contact with Florentine art, absorbing the *perspectival advances of *Masaccio and their more decorative interpretation by Filippo *Lippi (e.g. *Madonna of the Snow*, 1430–32, Siena, Contini-Bonacossi Coll.). From c.1432–6 scholars distinguish a 're-*Gothicizing' or International Gothic tendency; due largely to political events in Siena, Sassetta became acquainted with northern Italian and French miniatures and panels (e.g. *polyptych for his parents' birthplace of Cortona, 1433–4, now Cortona, Museo). In the last period of his life, exemplified through the polyptych for S. Francesco, Borgo San Sepolcro, of 1437–44 (dismembered 1752, fragments in various collections, including London, National; Chantilly, Musée), Sassetta adopted the light colours of *Domenico Veneziano.

Sassetta's first recorded work was a polyptych of 1423 for the Sienese guild of wool merchants (fragments now Siena, Pinacoteca; Barnard Castle, Bowes; Vatican, Pinacoteca; Budapest, Museum). Fragments from other dismembered altarpieces, such as the one of the *Life of St Anthony Abbot* for Asciano, are in various other museums, e.g. New York, Metropolitan; New Haven, Yale. He died as a result of contracting pneumonia whilst working on a *fresco for the Porta Romana, Siena, begun in 1447.

SASSOFERRATO; Giovanni Battista Salvi, called (1609–85) Painter from Sassoferrato in the Marche, working in Rome, where he may have studied with *Domenichino. His highly finished stereotyped

images of the Virgin and Child, popular in devotional circles, are so anachronistic that they have been taken for a follower's of *Raphael or even *Perugino. He occasionally derived his compositions from designs by *Reni. There are works by him in Rome, S. Sabina, Doria; London, National; Munich, Alte Pinakothek; Genoa, Palazzo Bianco; Naples, Capodimonte; etc. He also executed portraits of ecclesiastics (e.g. Rome, Nazionale).

SAVERY, Roelant (1576–1639) Flemish émigré, a pioneer of Dutch landscape painting, but famous also for his representations of flowers and animals. In Amsterdam c.1591, he was called c.1604 to Prague by the Emperor Rudolph II, who commissioned him to make sketches in the Tyrolean Alps as a basis for decorative paintings. After Rudolph's death Savery worked for his successor, Matthias, in Vienna (1614). In 1619 he settled in Utrecht, specializing in Alpine scenery and in fantastical landscapes with exotic animals (Vienna, Kunsthistorishes; etc.)

SAVOLDO, Giovanni Girolamo (1480/5–after 1548) Veneto– Lombard painter. Born in Brescia, he is recorded in Florence in 1508 and in Venice from c.1520; he may have worked in Milan c.1532–5. Not a prolific artist, he specialized in paintings of a single figure, normally in half- or knee-length against a distant landscape background. The most striking and accomplished feature of his work is the drapery painting, usually in large blocks of a single local colour minutely modified to depict the effects of different kinds of illumination on reflective materials. Savoldo's selective *illusionism is indebted to a study of Flemish art, although his subjects and their poetic tone bespeak the influence of *Giorgione. Some of his pictures are known in several versions (e.g. St Mary Magdalen approaching the Sepulchre, London, National; Florence, Contini-Bonacossi Coll., Berlin-Dahlem, Museen). Other works can be found in Rome, Capitolina, Borghese; New York, Metropolitan; etc. Savoldo's historical importance resides in his probable influence on *Caravaggio (but see more especially Romanino, Moretto).

SCHALCKEN, Godfried (1643–1706) Dordrecht painter, a pupil first of *Hoogstraeten, then of Gerrit *Dou of Leiden, whose technique of 'fine' painting (fijnschilder) he emulated (e.g. Candlelight Scene, London, National). Around 1675 Schalcken began to paint more *classicizing and elegant subjects, allegorical and mythological themes and scenes based on antique literary texts (e.g. Lesbia weighing her Sparrow against her Jewels, from a poem by Catullus, London, National), both on the near-miniature scale of Dou, like the picture cited above, and of somewhat larger size (e.g. Venus at her Toilet, Kassel, Kunstsammlungen). Towards the end of his life, Schalcken worked at The Hague, London and Düsseldorf, where he was court painter to the Elector Palatine, Johann Wilhelm, the patron also of Adriaen van der *Werff and Rachel *Ruysch. His work was eagerly

collected during the 18th century, and he influenced a number of lesser painters.

SCHEEMAKERS, Peter (1691–1781) Flemish sculptor working in England from c.1721. In 1728–c.30 he undertook a study trip to Rome, returning with many clay models after the antique. Some of these he later repeated in stone (Rousham, Oxfordshire), whilst others were cast by him in plaster to be sold as sets. He is an important influence in forming the English taste for *Classical sculpture, and in the education of younger sculptors. Scheemaker's classicism, however, predates his Italian voyage, as is demonstrated by the *Monument to the Earl of Rockingham* (1726, Rockingham, Northamptonshire) executed with Laurent *Delvaux. During the 1730s, Scheemakers competed with *Rysbrack; at the end of the decade, probably under the latter's influence, he began to move away from his dependence on the antique towards a more naturalistic (*see under* realism) and animated mode (*Monument to William Shakespeare*, 1740, London, Westminster Abbey). By the end of the 1740s, both he and Rysbrack were overtaken in popularity by *Roubiliac, although Scheemakers continued to take on apprentices, and to receive commissions for monuments in Westminster Abbey and in other parts of the country (*Mr and Mrs Tothill*, after 1753, Urchfont, Wiltshire; *Lord Shelburne*, 1754, High Wycombe, Buckinghamshire; etc.). The practice was carried on by his son, Thomas Scheemakers (1740–1808).

SCHIACCIATO or STIACCIATO *See rilievo schiacciato*.

SCHIAVONE; Andrea Meldolla, called (c.1510/15–63) Pioneering Venetian painter and etcher (*see* intaglio prints) largely responsible for the formation of Venetian *Mannerism (*see* e.g. Tintoretto) and influential on the late style of *Titian. His nickname refers to his origins in Zara, an Adriatic outpost of the Venetian empire, although he was not of Slavonic stock; it is responsible for the long-standing confusion between him and another 'Andrea Schiavone', one Andrea di Nicolo da Curzola (1522–82), a lowly furniture painter from Sebenico.

The facts of Andrea's early training are unknown. The greatest influence on him was *Parmigianino, whose elongated figure canon and rhythmic grace he adopted. His mature style, from c.1540, amalgamates these elements with Venetian colourism (*see under disegno*, also Giorgione) and monumental Central Italian Mannerism (e.g. *Salviati, *Vasari). His major contribution, however, consisted of exaggerating the painterly qualities of the Venetian idiom, virtually submerging representation under an *expressive web of pigment. Originally applied to small-scale, possibly furniture paintings, in which such freedom was more acceptable, the technique came to dominate even large-scale works (*Adoration of the Magi*, c.1547, Milan, Ambrosiana). In the mid-1550s Schiavone experimented with dark over-all tonalities (e.g. *Sacra Conversazione*, c.1553, Rome, British Embassy; *Annunciation*, c.1555, organ shutters, Belluno, S. Pietro) which also found an echo in

Titian's work. The relationship between the two artists seems to have been close and reciprocal: Titian nominated Schiavone to paint three roundels in the Marciana library, 1556, and in 1559 he permitted Schiavone to execute variants after his own *Diana and Acteon* (Vienna, Kunsthistorisches; Hampton Court).

There are paintings both in oils and *fresco by Schiavone in Venetian churches and the Accademia, but many of his works were executed for private collectors. Of these, perhaps the most astonishing is the *Christ Before Herod* (c.1558–62, Naples, Capodimonte), which simultaneously looks back to Giorgione and forward to *Rembrandt, who may indeed have seen Schiavone's paintings in the sale rooms of Amsterdam. Other works are in Dresden, Gemäldegalerie; Wellesley, Mass., Wellesley College; Prague, Hradcany Castle; New York, Metropolitan; London, National; Florence, Pitti, Strozzi; etc.

SCHILDERSBENT Flemish, Dutch, for band of painters. A fraternal association of Netherlandish artists, founded in Rome in 1623 for purposes of mutual assistance and general hilarity, and dissolved by papal decree in 1720 for mocking the sacrament of baptism. Members were given Bentnamen (pseudonyms) at a baptism in wine and in ceremonies which mocked the initiation of members of the Order of the Golden Fleece. They called themselves Bentvueghels, 'birds of a flock'. Paulus *Bor was a founding member; *Poelenburgh and *Breenbergh also belonged, and Pieter van *Laer, *il Bamboccio*, was a leader of the *Bent* during his sojourn in Rome c.1625–38.

SCHMIDT, Martin Johann (1718–1801) Popular Austrian *Rococo painter and etcher (*see under* intaglio prints) known as Kremser-Schmidt from his native region of Krems, the centre of his activity. The son of a sculptor father, with whom he worked at Dürnstein Abbey, he is remembered for his *expressive church *frescoes and altarpieces and the many small devotional paintings in whose execution his busy workshop had a major part from c.1786. Influenced by the prints of *Rembrandt in local collections, he took up etching in 1764 to reproduce his own painted compositions. There are works by him throughout local churches and, e.g. Vienna, Melkerhof.

SCHONGAUER, Martin (c.1435–91) Engraver and painter, the most widely influential German artist of the 15th century and the greatest engraver before *Dürer (*see* intaglio prints). As a young man, the latter was sent to work under him in Colmar, but – having travelled first throughout Germany – arrived only after Schongauer's death.

Born probably in Augsburg, Martin was taken to Colmar as a child by his father, the goldsmith Caspar Schongauer. One of his brothers, Paul, practised as a goldsmith in Leipzig, and a document of 1465 attests to Martin's matriculation from the University of Leipzig – in which precise capacity it is not known, since he is also recorded working as a painter in a convent near Ulm in 1462. A trip to the Netherlands is usually postulated on *iconographic and stylistic grounds.

The only certified painting by his hand is the *Virgin of the Rose Bower* (1473, Colmar, St Martin) on the basis of which other pictures have been attributed to his busy workshop (e.g. Colmar, Musée; Munich, Alte Pinakothek; Berlin-Dahlem, Museen; Vienna, Kunsthistorisches). Of greater importance in the history of art are the 115 engravings signed with his initials, MS, on either side of a cross and crescent – although some of these are no doubt imitations by other engravers. None is dated. The pictorial effects of his line engravings, and his re-interpretations of Netherlandish compositions, affected painters and printmakers throughout Europe.

SCOREL, Jan van (1495–1562) Eclectic and much-travelled Dutch painter. His first-hand experience of art in Venice and Rome caused him to formulate a unique pictorial blend of northern European and Italian modes; he has been called a 'northern Raphael'.

The son of a priest, later legitimized by the Emperor Charles V, van Scorel took his name from his native village of Schoorl, near Alkmaar. His first teacher was said to have been Cornelius Buys, tentatively identified with the 'Master of Alkmaar', author of a panel of the *Seven Acts of Mercy*, 1504, now in Amsterdam, Rijksmuseum. He may also have studied under Jacob Cornelisz van Oostsanen in Amsterdam, and gone to Utrecht to meet *Gossart. In 1518/19 he travelled to Venice via Basel and Nuremberg, where he may have assisted in *Dürer's workshop. These, at any rate, are the various influences which have been discerned in the *Holy Kinship Altarpiece* (1520, Obervellach, parish church). Later in the same year van Scorel joined a pilgrimage to the Holy Land – an experience reflected in a drawing of Bethlehem (London, British), the topographic cityscape in the background of the *Entry of Christ into Jerusalem* (1527, Utrecht, Museum) and in the group portrait of the *Pilgrims to Jerusalem* (1527–30, Haarlem, Museum) as well as in the *Portrait of a Jerusalem Pilgrim* (Bloomfield Hills, Michigan, Cranbrook). His return to Venice in 1521 resulted in his adoption of *Giorgionesque elements (e.g. *Death of Cleopatra*, c.1522, Amsterdam, Rijksmuseum).

In 1522 van Scorel was appointed by the Dutch pope, Adrian VI, to supervise the antique collections of the Belvedere (*Adrian VI*, Louvain, University). A predecessor in this post had been *Raphael, and van Scorel employed his time at the Vatican to study his works and those of *Michelangelo, the architecture of Bramante (*see*, e.g. the architectural background of the *Presentation of Christ in the Temple* c.1530–5, Vienna, Kunsthistorisches) and the antique. When the pope died in 1523 van Scorel returned to Holland. After working in Alkmaar and Haarlem he finally settled in Utrecht, where he was made a canon – a clerical ✎ appointment which did not prevent him from taking the sister of another canon as his mistress (*Agatha van Schoonhoven*, 1529, Rome, Doria) and fathering six children. In 1550, famous throughout the Netherlands, he was called to Ghent to restore Jan van *Eyck's *Ghent*

Altarpiece. Other works are in Washington, National; Rotterdam, Boymans-van Beuningen; Berlin-Dahlem, Museen; Brussels, Musées. His most important pupils were *Heemskerck and *Mor.

SCROTS, Guillim (recorded from 1537–53) Netherlandish portrait painter. In 1545/6 he succeeded *Holbein as King's Painter at the court of Henry VIII (*Edward VI as Prince of Wales; Princess Elizabeth*, 1546/7, Windsor Castle).

SEBASTIANO VENEZIANO or DEL PIOMBO (c.1485–1547) Venetian-born painter, possibly a pupil of Giovanni *Bellini and certainly associated with *Giorgione. From 1511 he resided in Rome, where he became a protégé of *Michelangelo and an instrument of the latter's rivalry with *Raphael. He achieved a fusion of Venetian colourism with central Italian *disegno* and Roman monumentality. After Raphael's death in 1520 he was recognized as the leading portrait painter in central Italy (e.g. Dublin, National; Washington, National; Leningrad, Hermitage; Naples, Capodimonte; Parma, Pinacoteca; Rome, Doria; Los Angeles, Norton Simon Coll.; etc.). In 1531 he was appointed keeper of the papal seal or *piombo* (whence his second nickname). After this date he painted much less. Some of his later works are executed on stone supports (e.g. Rome, S. Maria del Popolo).

Two major Venetian commissions date from before Sebastiano's departure for Rome: the organ shutters for S. Bartolomeo a Rialto, and the high altar of S. Giovanni Crisostomo. A famous unfinished painting, one of the most important early 16th-century works of the Venetian school, *The Judgement of Solomon* (Kingston Lacy) was acquired in 1820 as a work by Giorgione but is now widely attributed to Sebastiano.

His first Roman activity was in the Villa Farnesina (*see also* Peruzzi, Raphael). Early easel paintings of his Roman stay show his gradual synthesis of Venetian and Roman styles (now Cambridge, Fitzwilliam; Florence, Uffizi). After c.1515 he was supplied with design ideas, and some working sketches, by Michelangelo, and his work became graver and more monumental (*Pietà, c.1515*, Viterbo, Museo). The Sebastiano/Michelangelo rivalry with Raphael was made explicit when in 1516 Cardinal Giulio de'Medici commissioned Sebastiano and Raphael to paint companion altarpieces for his titular church, the cathedral at Narbonne. Sebastiano's *Raising of Lazarus*, 1518–19, for portions of which Michelangelo supplied drawings, is now in London, National (Raphael's *Transfiguration*, posthumously completed by pupils, is in the Vatican Pinacoteca). Sebastiano took refuge from the Sack of Rome, 1527, in his native Venice, whence he returned in 1529. His sombre final style, evolving during the heyday of Roman *Mannerism, anticipates the austere, legible *Classicism of the Counter-Reformation.

SECCO, A SECCO (Italian, dry.) A method of wall painting, rather like distemper, in which the pigments are not chemically united with the plaster, as in *fresco. The results resemble true fresco initially but are far less durable. Many so-called frescoes are combinations of true,

or *buon*, fresco and *a secco*, which is the method used for certain colours, for retouching or accentuating details, or, since it is easier than buon fresco, for large subsidiary areas. As *a secco* portions of a mural flake off in time, our perception of these mixed frescoes is affected, sometimes more than we realize if the *buon* fresco extends over most of the picture area.

SEGHERS, Daniel (1590–1661) One of the most illustrious Flemish flower painters. Converted to Catholicism through the influence of his teacher, Jan 'Velvet' *Brueghel, Seghers became a Jesuit lay brother. He specialized in garlands or bouquets of flowers surrounding fictive reliefs in *grisaille of religious images, usually executed by other artists. Some of the greatest collectors of the age came to call on Seghers, and sent magnificent offerings in return for his flower pieces. Examples of his work can be seen in Dulwich, Gallery; Oxford, Ashmolean.

SEGHERS, Hercules (*c.*1589/90–after 1635) Dutch painter and etcher (*see under* intaglio prints) of landscapes, mainly imaginary, often fantastical or romantic in mood. A pupil of *Coninxloo, indebted also to *Elsheimer and *Savery, he had a profound influence on the landscape art of *Rembrandt, who owned eight of his paintings and one of his etched plates, which he reworked (*Tobias and the Angel*, altered into a *Flight into Egypt*). Only about 15 paintings can be attributed to him today (Amsterdam, Rijksmuseum; Berlin-Dahlem, Museen; Florence, Uffizi; Rotterdam, Boymans-van Beuningen). Seghers experimented with making colour prints from single etched plates, either by printing on coloured paper or linen or by touching up the print with oils or watercolours. The etchings are almost as rare as the paintings: there are only about 165 impressions of some 50 prints, of which almost one third are in the Print Room of the Rijksmuseum, Amsterdam.

SEISENEGGER, Jakob (1505–67) Court painter to the Habsburg emperor Ferdinand I; he journeyed with the court to Bologna, Madrid and the Netherlands, but was active mainly in Vienna. His best-known work is the portrait of *Charles V with his dog* (Vienna, Kunsthistorisches), a drawing of which served as a model to *Titian; it is one of his many official Habsburg portraits adopting the formula of the life-size full-length likeness evolved by Lucas *Cranach the Elder. There are works by him also in The Hague, Mauritshuis, and Innsbruck, Ferdinandeum.

SETTIGNANO, Desiderio da *See* Desiderio da Settignano.

SFUMATO (Italian, 'vanished gradually', from the word *fumo*, smoke.) Used in painting to mean the gradual transition from one hue or tone to another (*see* colour); shadowy, rather than hard, contours. *Leonardo da Vinci advocated *sfumato*, using it to soften the transitions from darkest shadow to brightest highlight, and counteract the danger of harshness inherent in his *chiaroscuro. But it was left to others influenced by him, (notably *Giorgione and *Correggio), to perfect *sfumato* from one hue to another, sometimes within a narrow tonal

range. By enabling artists to build up through layers of translucent glazes (that is, suspensions of pigment in a drying medium) like veils of colour, painting in oils is supremely suited to achieving these effects.

SIBERECHTS, Jan (1627–1700/03) Landscape painter from Antwerp. He may have spent some years in Italy, returning home by 1648/9. His earliest-known paintings, 1653, are close to the Italianate Dutch artists *Both, *Dujardin and especially *Pijnacker, whose bluish tints he emulated (e.g. Berlin-Dahlem, Museen). Around 1660 Siberechts evolved a type of majestic landscape in which the representation of roads and trees justified the use of converging *perspective, and that of water allowed the use of a strong blue throughout the painting (e.g. London, National). A few *genre paintings by him are known (e.g. Copenhagen, Museum). In 1672/4 he settled in England, where he was active until his death. Among his landscape paintings are a group of bird's-eye views of aristocratic country houses – Longleat, Nannau Hall, Wollaton Hall, etc. – 'country house portraits', of which he seems to have been the first specialist.

SIGNORELLI, Luca (c.1450–1523) Painter from Cortona, a much older relative of *Vasari. His vigorous style is marked by clear outlines, bold relief and, in figure drawing, a stress on movement and daring musculature, often in *foreshortening – possibly the consequence of a period of study in the *Pollaiuolo workshop in Florence after his presumed training under *Piero della Francesca. His best-known work, the *frescoes of the chapel of S. Brizio, Orvieto cathedral, 1499–1502, on the theme of the end of the world as predicted in the Apocalypse and the Epistles of St John, influenced the Last Judgement of *Michelangelo. They complete a decoration begun by Fra *Angelico.

A peripatetic artist, Signorelli is documented in Cortona in 1470 and in Arezzo in 1472. Around 1480 he executed the vault and mural decoration of the sacristy, Loreto, Basilica of the Holy House; in 1481 he may have contributed a design for one of the wall paintings in the Sistine Chapel in Rome (see also *Perugino; *Ghirlandaio; *Botticelli; Cosimo *Rosselli). In 1484 he was working on the high altarpiece for Perugia cathedral (now Museo Capitolare). For executing a processional standard, he was made honorary citizen of Città di Castello, 1488, the date also of his remarkable mythological fantasy of Pan enthroned, formerly Berlin, Kaiser Friedrich Museum (destroyed, World War Two). In Volterra 1491, Urbino 1494, he executed, 1497–8, nine vividly detailed frescoes from the Life of St Benedict in the cloister of the abbey of Monteoliveto; the cycle was later completed – albeit with chronologically earlier episodes in the saint's life – by *Sodoma. In Cortona in 1502, he worked in Siena on a design for the pavement of the cathedral in 1506; c.1509 he collaborated with *Pintoricchio on the decoration of a room in the Sienese Palazzo del Magnifico, now dispersed between London, National, and Siena, Pinacoteca. In 1508 and 1513 he was in Rome, but his linear and hard 15th-century style was

now eclipsed by Michelangelo and *Raphael, and he retired to Cortona, continuing to work for Umbrian churches.

SILOE, Gil de (active c.1480–c.1505) and his son Diego (c.1495–1563) Spanish sculptors; Diego was also an architect. Gil de Siloe, who may have come from Orléans, was an outstanding Late *Gothic artist active at Burgos; here he executed grandiose tomb monuments commissioned by Queen Isabella the Catholic, and collaborated as a wood carver on *retables (respectively Burgos, Cortuja de Miraflores, Museo, cathedral). Diego de Siloe, one of the two founders of Spanish *Renaissance sculpture (see also Bartolomé Ordóñez) was active principally in Burgos cathedral (1519, monument to Bishop Acuña; 1519–23 Escalera Dorada, 'Golden Staircase'; 1523–6, Chapel of the Constable, high altar) and in Granada from 1528 until his death. He left many pupils in both cities and his Italianate style in sculpture and architecture persisted in Granada until the 17th century.

Diego served his apprenticeship in Florence, perhaps under Andrea *Sansovino; his early work in Naples (c.1514–15, S. Giovanni a Carbonara, Caraccioli altar, with Ordóñez; Cathedral, Tocco Chapel, relief of Virgin and Child) demonstrates his understanding of *Donatello and the Florentine works of *Michelangelo. In Granada he evolved a style of architectural sculpture which combined clear, monumental Michelangelesque figures with elaborate insertions of exuberant *grotesque surface decoration (1530s, stone portals, cathedral; see also Plateresque). His work as a sculptor ranges across most media: stone, alabaster, *polychrome wood and polished oak (choir stalls, 1528, Valladolid, Museum; 1528–30, Granada, S. Jeronimo) and monuments in marble (c.1528, Mercado monument, Guipúzcoa, Oñate, S. Miguel).

SINOPIA, SINOPIE See under fresco.

SLODTZ, René-Michel (called Michel-Ange) (1705–64) French sculptor, resident in Rome 1728–46 and the most distinguished practitioner of the French neo-*Baroque style derived from *Bernini (see also the Adam brothers). One of the five sons of the Flemish-born sculptor Sébastien Slodtz (1655–1726), and a pupil of *Girardon, Michel-Ange was to produce his finest works in Italy, although his masterpiece, the Montmorin tomb, 1740–4, was executed in Rome for Vienne cathedral in France. Of the works for Roman churches, the best-known is the *expressive St Bruno, 1744, for St Peter's. After his return to Paris, Slodtz was to receive only one further important commission, the Longuet de Gergy monument, 1753, St Sulpice, the last allegorical-narrative funerary monument to be produced in 18th-century France.

SLUTER, Claus or Klaas (recorded from 1379–1405/06) Dutch-born sculptor working for Philip the Bold, Duke of Burgundy; the first great master of monumental stone sculpture in northern Europe. His work, in its dramatic force, can be compared favourably with the early sculpture of *Donatello.

First recorded in Brussels in 1379, Sluter joined the workshop of the Flemish sculptor Jean de Merville, in the service of Duke Philip in 1385. After Jean's death in 1389 Sluter was put in charge. In this capacity he designed and carved his great works for the Carthusian monastery founded by the Duke at Champmol near Dijon: the sculptural decoration of the church portal (completed 1397); the monumental *Calvary* in the cloisters, usually called the *Moses Fountain* (1395–1403; carved base, Champmol, other fragments Dijon, Musée Archéologique); a funerary monument of the Duke, commissioned from Jean de Merville in 1384 and completed after Sluter's death by his nephew and successor Claus de Werve (dispersed and partly destroyed; autograph fragments Paris, Cluny; Dijon, Musée).

Sluter's style, albeit founded in late 14th-century monumental sculpture in the southern Netherlands, is characterized by a new attitude to the relationship between architecture and sculpture. Sculpted figures project from their architectural setting with great emphasis on their three-dimensionality. This new *realism of form is further emphasized by realism of portrayal. Not only the actual portraits of the donors on the portal at Champmol, but also the prophets on the *Moses Fountain*, are fully individualized. The ample draperies suggest the body underneath and also accentuate the dramatic power of poise and gesture. Perhaps the best-known example is the hooded monk from the mourning cortège of Philip the Bold's funerary monument (Dijon, Musée). Restoration has brought to light remnants of *polychromy on the figures of the *Moses Fountain*.

Sluter's influence on later stone sculpture in Burgundy, France, the Netherlands and Germany is incalculable.

SMIBERT, John (1688–1751) Edinburgh painter, he studied in Rome 1717–20 before establishing himself in London as a portraitist. In 1728 he joined Dean, later Bishop, Berkely on an expedition to Bermuda to found a university in the New World; Smibert was to teach drawing, painting and architecture. In the event, the party was stranded in Rhode Island; rather than return to Britain with the others, Smibert settled in Boston (1729), the first fully-trained painter in colonial America. A public showing of his works, including the influential *Bermuda Group* (1729; New Haven, Yale University) was the first recorded art exhibition in America. Smibert's collection of engravings (*see under* intaglio prints), copies after the Old Masters, and plaster casts of antique statuary, in effect provided colonial artists with their first *academic training. Through his partnership with the engraver Peter Pelham, who reproduced for sale his portraits of public figures, Smibert had a direct influence on the greatest of the New England painters, Pelham's step-son and pupil, John Singleton *Copley.

SNYDERS or SNIJDERS, Frans (1579–1657) First and greatest Flemish specialist of large-scale *still-life and animal and hunt pictures; sometime collaborator of *Rubens (e.g. Philadelphia,

Museum; Leningrad, Hermitage; Malines, Notre-Dame au delà de la Dyle; Rennes, Musée). He was a pupil of Pieter *Bruegel the Younger and of Hendrick van Balen, the teacher of *Van Dyck. Some time after matriculating in the painters' guild in Antwerp in 1602, he travelled to Italy; in 1608 Jan Brueghel recommended him to his patron, Cardinal Federigo Borromeo, in Milan. He returned to Antwerp in 1609; in 1611 he married the sister of Cornelis and Paul de *Vos.

Snyders's early pictures reflect the manner of *Aertsen and Beuckelaer (e.g. 1603, Brussels, Willems; Karlsruhe, Kunsthalle). Around 1615 he imposed a greater coherence on his large compositions of fruit, vegetables, game or fish, perhaps under the influence of the *classicist Abraham *Janssens, with whom he worked. A good example of his painting at this time is the series of four markets, 1615–20, now in Leningrad, Hermitage, in which the picture surface is divided into rectangular compartments. Later, under the influence of Rubens, he was to use a characteristically *Baroque scheme of diagonal construction; he also widened the space of his hunting scenes into broad landscapes (e.g. Poznań, Muzeum). His work is robust, colourful, yet stately. His most important pupil was Jan *Fyt.

S ODOMA; Giovanni Antonio Bazzi, called (1477–1549) Eclectic and prolific painter, mainly active in Siena, but also Rome (1508; c.1516– 18). He came from Piedmont, and by the time of his arrival in Siena before 1503 had become acquainted with the works of *Leonardo da Vinci in Milan, from which he retained, throughout his career, superficial characteristics, notably the famous 'Leonardesque smile'.

In Siena Sodoma was influenced by *Pintoricchio, who from 1503–08 was at work on the Piccolomini library. His first major commission, 1505–08, was to complete the cycle of 31 frescoes on the Life of St Benedict begun in 1497 by *Signorelli at the monastery of Monteoliveto. Called to Rome by the Sienese papal banker Agostino Chigi, Sodoma was lent to Pope Julius II to begin work on the ceiling of the Stanza della Segnatura – but was soon displaced by *Raphael. His major Roman works, the decoration of Chigi's bedroom in the Farnesina (Marriage of Alexander and Roxane, 1516–17; Alexander and the Family of Darius, 1518) demonstrate his superficial assimilation of Raphael's High *Renaissance style. After c.1518 he worked almost wholly in Siena, where with *Beccafumi he became the leading painter of the third and fourth decades of the 16th century.

Other works by Sodoma are found in various museums, including London, National; Florence, Pitti; Paris, Louvre. His art is a curious amalgam of the provincial and the metropolitan. All his influences remain visible and ill-digested in his work, which nevertheless exercises a good deal of charm through a certain vernacular copiousness and vigour.

S OLARI or SOLARIO, Cristoforo; called Il Gobbo, 'the hunchback' (recorded from 1489–1527) and his brother Andrea (1450–c.1520)

Cristoforo was the best-known member of a large dynasty of Lombard architects and sculptors active in Milan and Pavia from *c*.1428 (but *see also* Pietro Solari, called Lombardo). His earliest known work was in Venice (S. Maria della Carita, *c*.1489, destroyed; S. Panteleon). In 1495 he was recalled to Lombardy to work on the façade of the Charterhouse of Pavia (*see also* Amadeo), but in 1497 the untimely death of the Duchess Beatrice d'Este caused him to be commissioned with the effigies of Beatrice and her husband Lodovico 'il Moro' Sforza for Milan, S. Maria delle Grazie (now Pavia, Charterhouse). These effigies are characterized by extreme *realism and polished detail, and remain Il Gobbo's best-known works. From 1501–6 he was employed both as architect and sculptor on Milan cathedral, where his statues of *Adam* and *Eve* (1502) and *Christ at the Column* reflect an entirely different, softened *classicism influenced by *Leonardo da Vinci, court painter at Milan until 1499. His last years were spent mainly as an architect, although sculptural commissions for Ferrara and Mantua, *c*.1516, now lost, demonstrate that his reputation extended beyond Lombardy. He is known to have visited Rome *c*.1514, and was popularly supposed to have been the author of *Michelangelo's *Pietà* at St Peter's when it was first exhibited.

Andrea Solari, apparently trained by Cristoforo, was a painter. Accompanying his brother to Venice, he was deeply influenced by *Antonello da Messina and Giovanni *Bellini (*Holy Family with St Jerome*, 1495, Milan, Brera). In 1507–10, he worked in France at the Château de Gaillon; his *frescoes there have been destroyed. On his return to Milan, he, too, reshaped his style to that of Leonardo; he was one of the very few Milanese painters to understand its underlying principles (*Virgin with the Green Cushion*, 1510–15, Paris, Louvre). Other works Nantes, Musée; Brescia, Pinacoteca; Rome, Borghese; etc.

SOLIMENA, Francesco (1657–1747) Trained in the provincial southern Italian workshop of his father Angelo, Solimena was heir-apparent to Luca *Giordano as head of the Neapolitan school. He acquired an international reputation as a painter of altarpieces and grand *fresco decorations, his *Academy becoming the centre of Neapolitan artistic life. Amongst his pupils was Allan *Ramsey, who nonetheless went on to practise solely as a portrait painter. Solimena combined *Baroque exuberance with *classicizing elements borrowed from, e.g. *Raphael. This academic tendency was reinforced by direct contact with *Maratta in 1700. There are easel paintings in Naples and in many collections, and frescoes in Naples, Salerno, Nocera, etc. *See also* Corrado Giaquinto, Sebastiano Conca.

SOMER, Paul van (*c*.1577/8–1621/2) Antwerp-born painter, he is recorded working in Amsterdam with his elder brother, Bernard (1604), in Leyden (1612, 1614), at The Hague (1615) and in Brussels (1616). By December 1616 he had settled in London, where he died. From the beginning of his stay in England he was employed at court. A

precursor of *Van Dyck, he modified the schematic English 'Costume Piece' to a grander, more life-like portrait-type closer to Continental portraits of the period (*Queen Anne of Denmark*, Coll. HM the Queen).

SPAGNOLETTO *See* Crespi, Giuseppe Maria; Ribera, Juseppe or José de.

SPINELLO, Aretino (recorded 1373–1411) Painter from Arezzo, working throughout Tuscany, with artistic connections both with the Sienese followers of *Duccio and the Florentine followers of *Giotto. In his major surviving works, the frescoes of the sacristy of S. Miniato al Monte, Florence (1387), he looks back beyond his immediate predecessors to the paintings of Giotto himself, thus anticipating their reinterpretation by *Masaccio. His son Parri Spinelli assisted him in the vigorous frescoes of the *Life of Alexander III*, 1408, in a room in Siena town hall.

SPRANGER, Bartolomeus (1546–1611) Antwerp-born painter, one of the most influential practitioners of international *Mannerism. In 1565 he went to Italy, working for some time in Parma, where the example of *Correggio and *Parmigianino taught him *sfumato* and a particularly supple and elegant mode of figure drawing. In 1570 he was appointed painter to Pope Pius V in Rome. On the recommendation of his compatriot, Giovanni *Bologna, Spranger entered the service of the Habsburg emperor, Maximilian II, in Vienna (1575). When Maximilian died only a few months after his arrival, Spranger was taken into the employ of his successor, Rudolph II, and moved (1581) with the imperial court to Prague (*see also* Savery; Arcimboldo). Rudolph was one of the great collectors of curiosities and rarities in the arts and in the natural and occult sciences. He patronized an overwhelmingly secular, refined and often erotic art, favouring representations of the female nude. Thus Spranger's *oeuvre*, little of which is to be found outside what were formerly the imperial collections, consists largely of mythological or allegorical images, some of them imperial panegyrics showing Rudolph bringing the arts to Bohemia, all or nearly all of them featuring female nudes in ever-more complex poses and from suggestive viewpoints (mainly Vienna, Kunsthistorisches).

Whilst in Rome, Spranger had made the acquaintance of his countryman, Karel van *Mander. In 1577 Spranger invited van Mander to Vienna to assist him in preparing decorations for Rudolph's investiture; in thanks, he gave van Mander drawings, which the latter took with him when he emigrated in 1583 to Haarlem. There, van Mander showed the drawings to his new friend and associate *Goltzius, whom they influenced profoundly. Goltzius's engravings after Spranger's designs are the fountainhead not only of Haarlem Mannerism (*see also* Cornelis Cornelisz van Haarlem) but of an international vogue, influencing artists throughout northern Europe, Italy and the Iberian peninsula.

SQUARCIONE, Francesco *See under* Mantegna, Andrea.

STAFFAGE A pseudo-French word, pronounced as in French, introduced into English from German. It is formed by the addition of the French suffix *-age* to the root of the German verb *staffiren*: to garnish. Staffage denotes that which is accessory, not integral to the main theme of a work of art. The term is normally but not exclusively employed for the anonymous human figures introduced into landscape pictures to provide colouristic accents and clues to scale, distance and mood. In the 17th century, many northern European landscape and *vedute* specialists collaborated with figure painters who furnished the staffage of their landscapes.

STANZE (Italian, rooms.) The suite of rooms in the Vatican palace decorated by *Raphael for Pope Julius II and his successor Leo X.

STEEN, Jan (1625/6–79) Prolific Dutch painter of *genre*, history pictures (*see under* genres), and some portraits. After a stay at the University of Leiden, he studied painting in Utrecht, then with Adriaen van *Ostade in Haarlem, finally with Jan van *Goyen, whose daughter he married in 1649, at The Hague. He is documented as an independent painter in all three towns; his father, a brewer, leased a brewery for him in Delft, but there is no evidence of his having settled there for any length of time. In 1672 he received a licence to operate a tavern in Leiden.

Steen was as eclectic as he was peripatetic. He is the most spirited of all Dutch painters, and his wit, which cuts across social class and economic condition, is charged with proverbial, aphoristic, emblematic and literary content, as well as demonstrating his close connections with the theatre. But above all it relies on the copiousness of visual detail: the variety of vessels used to collect and distribute the life-giving waters in *Moses striking the Rock* (*c*.1671, Philadelphia, Museum), the varieties of human expressions in nearly all his paintings (e.g. *The Schoolmaster*, Dublin, National; *The Feast of St Nicholas, c*.1667, Amsterdam, Rijksmuseum). His repeated use of stock characters and costumes from the Italian *commedia dell'arte*, sometimes ironically (*The Doctor's Visit*, London, Apsley House; *Self-Portrait*, Lugano, Thyssen-Bornemisza Coll.), later poetically (*Two Men and a Young Woman Making Music on a Terrace*, London, National; *Nocturnal Serenade*, Prague, Gallery) anticipates *Rococo art. A Catholic, Steen painted over 60 biblical narratives. Most embody comic or burlesque elements. Those which do not, reveal an original and tender vision of Divine grace and human frailty (*Adoration of the Shepherds; Christ at Emmaus*, Amsterdam, Rijksmuseum). An uneven painter, at his best Steen achieves a sparkle which is pictorial as well as intellectual, and has not often been equalled.

STEENWIJCK, Harmen (1612–after 1664) The leading exponent of the Dutch *vanitas* *still-life, a speciality of Leiden. Objects are depicted as symbols of transience and the vanity of earthly life, and motifs such as skulls are introduced to make the intended meaning plain (e.g. London, National). His younger brother Pieter (*c*.1615–after

1654) also specialized in this genre. Both brothers studied with David *Bailly, often credited with the invention of this type of painting.

STEFANO DI GIOVANNI See Sassetta, Stefano di Giovanni.

STIACCIATO See rilievo schiacciato.

STILL-LIFE (See also genres.) The representation, usually in painting, of objects such as flowers, fruit, foodstuffs and kitchen and table implements, etc., as the main focus of interest. Live animals may be included, as in hunting-trophy pictures or in market and kitchen pieces, where human figures may also be portrayed. The word derives from the Dutch stilleven, in use from c.1650; before that each type of still-life was categorized separately, and to this day Dutch still-lifes may be termed 'breakfast pieces', 'banquets', 'flowerpieces', etc. Spanish also preserves the early distinction between bodegon (from bodega, cellar or low-life eating-place) and florero, flowerpiece. We speak of the bodegones, of e.g. *Velázquez, in which equal attention is focused on kitchen implements and human figures. The vanitas still-life is a particular type evolved in the Dutch city of Leiden in the 17th-century. Overtly symbolic of the transience of life, it includes emblematic objects such as skulls, snuffed candles, watches, to remind the viewer of mortality and the passage of time. The name is derived from the passage in Ecclesiastes (12:8): 'Vanitas vanitatum . . .' 'Vanity of vanities, saith the preacher, all is vanity' (see, e.g. Harmen Steenwijck).

STIMMER, Tobias (1539–84) Versatile German artist – portrait painter (e.g. Basel, Kunstmuseum); decorative painter of *frescoes on the façades of houses (Schaffhausen, Haus zum Ritter, 1568–70, now Schaffhausen Museum) and of ceiling paintings on canvas in the Venetian manner (Baden-Baden, castle, 1578–9); designer and decorator of clocks (Strasbourg, minster, 1571–4) and of small-scale stained-glass panels. Stimmer's fame, however, rests above all on his enormous output of reproductive and illustrative prints (reproductions of portraits of famous men from the humanist Paolo Giovio's Museum at Como, 1575, drawn while visiting Italy; illustrations of Bible stories; illustrations of the ancient historians Livy and Flavius Josephus; the Ages of Man and Woman, etc.). At a time when engraving (see intaglio prints) was the preferred medium for illustration, Stimmer, inspired by *Dürer, revived woodcut (see relief prints) as a serious vehicle for artistic expression.

STONE, Nicholas (c.1587–1647) Leading English sculptor. He was taken on as a journeyman by the Dutch sculptor and architect Hendrik de *Keyser (1606–13). After his return to England he built up a large practice in tomb sculpture. Charles I's purchase of the Mantuan collection, 1628/9, had a considerable impact on his style, by introducing him to *Classical sculpture; the outstanding example of his new manner is the wall-monument to John and Thomas Lyttelton (1634; Oxford, Magdalen College). In the late 1630s he also made a number of classicizing statues, the first by a native English sculptor

(Northamptonshire, Kirby Hall; Norfolk, Blickling Hall). His son Nicholas (1618–47), also a sculptor, was sent with his brother Henry, a painter, for a four-year tour abroad; he is the first English artist to have kept a detailed travel diary, which includes an account of his meeting with *Bernini.

STOSS, Veit, (Polish: Wyt Stwosz) (c.1450?–1533) With *Riemenschneider, the most fully documented German pre-Reformation sculptor; a distinctive artist, famous especially for the monochrome wood sculpture of his later years (e.g. *St Andrew*, c.1510–20, Nuremberg, St Sebalduskirche; *St Roch*, c.1510–20, Florence, SS. Annunziata; *Raphael and Tobias*, 1516, Nuremberg, Museum). Earlier in his career he carved also in marble and sandstone and executed monuments in *polychromed wood. Despite the documentation, neither his birthdate nor native town are certain. He is first recorded in 1477 giving up his citizenship in Nuremberg to move to the then-capital of Poland, Cracow. There, between 1477–96, he was employed both by the resident German merchants and the Polish crown, his main sculptural commissions being the polychrome wood *retable for the high altar of St Mary's, 1477–89, and the red marble tomb of King Casimir IV Jagiello in Wawel cathedral. Much of the exaggerated *foreshortening and contorted *expressiveness of the altarpiece is explained by difficult viewing conditions for which Stoss tried to compensate. The style is indebted to that of *Gerhaert, as is that of the effigy of King Casimir. Stoss may also have practised as an architect, an engraver and a designer for goldsmiths and bronze casters. He almost certainly speculated in commercial ventures.

In 1496 Stoss returned to Nuremberg a rich man. Cheated out of a large sum of money, he forged a document to recoup his losses. Between 1503–06 he was tried, convicted, branded on the face and confined to the city, whence he fled. Not until 1507, after an audience with the Emperor, was Stoss able again to take up residence legally in Nuremberg. Stylistically, this period forms a transitional phase between the Cracow exuberance and the mature Nuremberg pieces; the key surviving work is the *Volckamer Monument* of 1499, with monochrome oak figures and sandstone reliefs, (Nuremberg, St Sebalduskirche). From 1507, Stoss worked in a seemingly more simplified mode, but with distinctive, daringly carved drapery. Deeply excavated lozenge and arc shapes, stressing the linear edge of the folds, constitute a virtual signature. In addition to the works mentioned, there are examples of his sculpture in Langenzenn, Pfarrkirche; Bamberg, cathedral; Nuremberg, St Lorenz; London, Victoria and Albert.

Stoss's Cracow *oeuvre* influenced much Eastern European sculpture.

STRAP-WORK A form of ornamental design resembling leather rolled, folded and cut into fantastic shapes. Although probably first appearing in Italian engravings (*see under* intaglio prints), and used c.1515 by Andrea di Cosimo Feltrini in the decoration of the chapel of

Leo X in S. Maria Novella, Florence, it was popularized through the stucco decoration of the Grande Galerie at Fontainebleau, designed by *Rosso *c*.1533–40. The motif, transmitted through prints, was copied all over Europe, becoming an important theme of *Mannerist decoration.

STROZZI, Bernardo (1581–1644) One of the leading Italian 17th-century painters. Born in Genoa, he settled in Venice in 1631; much of the subsequent development of Venetian painting was influenced by his style, which was formed from the variety of sources available to him during his training in his native city: *Rubens, in Genoa in 1607; *Van Dyck, in 1621; *Barocci, whose huge *Crucifixion* altarpiece had been installed in Genoa cathedral in 1597; the Milanese *Cerano and, in particular, Giulio Cesare *Procaccini, who visited Genoa in 1618. In Venice he looked especially at *Veronese. The modern viewer of his vigorous, painterly and colourful religious and *genre* pictures, and his swaggering portraits, may be startled to learn that Strozzi became a Capuchin – that is, a strictly observant Franciscan friar, *c*.1597; he is thus also called 'Il Cappucino' and 'Il Prete Genovese', 'the Genovese priest'.

It is difficult to establish a chronology for Strozzi's easel paintings, which can be found in many collections in Italy and abroad, including London, National; Berlin-Dahlem, Museen; Dublin, National.

STUBBS, George (1724–1806) Classified in his lifetime as a 'sporting painter', Stubbs transcends this category, as he does even those to which he aspired: portraiture and history painting (*see under* genres). Even more than his younger contemporary, *Wright of Derby, he combined a passionate interest in natural science with a poetic, painterly imagination. His pictorial variations on the theme of *Mares and Foals* (nine known, 1760–70; 1773; Grosvenor Estate; Duke of Grafton; Viscountess Ward of Witley; London, Tate; Milton Park; Ascott; USA, Jack R. Dick) have been said to express most intensely Stubbs's identity as a painter: his absorption in anatomical studies of the horse, his profound yet reticent empathy with animals, his fastidious, musical, sense of design.

Born in Liverpool, the son of a currier and leatherseller, Stubbs was an impassioned draughtsman, albeit obliged to work at his father's trade until he was 15 or 16. After his father's death in 1741, he was able briefly to assist an artist copying the Earl of Derby's pictures at Knowsley Hall near Liverpool. With his mother's help, he spent the next four years at home teaching himself to paint, and pursuing his earliest and most enduring passion, anatomy, by dissecting horses and dogs.

In 1746 he lectured privately on human anatomy at York Hospital and drew and etched the human embryo for a book on midwifery (publ. 1751). During this time he supported himself by portraiture. In 1754 he visited Italy; claiming to have done so 'to convince himself that Nature is superior to all art', he seems nonetheless to have looked

closely at Roman and Hellenistic animal sculpture. Certainly the famous theme of a lion attacking a horse or other animal, to which he returned several times, which was supposedly inspired by an incident he witnessed in Morocco, is anticipated in the same dramatic form in ancient art. After his return from abroad he retired to Lincolnshire, where, in 1758–9, he prepared the dissections and drawings for his great work, *The Anatomy of the Horse* (publ. 1766). From c.1759 he settled in London and practised as a painter of *Conversation Pieces, with or without horses and dogs; of landscapes with figures; of studies of wild animals; and of large horse portraits (London, National, Goodwood House; Manchester, Gallery; New Haven, Yale; etc.). As a 'sporting painter' he was excluded from the Royal *Academy at its foundation, and continued to exhibit at the Society of Arts, along with *Zoffany and Wright of Derby. From the 1770s Stubbs was associated with Wedgwood in the production of paintings in enamel on copper or china plaques (e.g. Barlaston, Museum). Some of these were repeated on canvas. In 1780 he was made Associate of the Royal Academy. In the 1790s he was patronized by the Prince of Wales, for whom he painted some of his most poetic compositions of horses and men (Windsor Castle). From 1802 onwards he was engaged on *A comparative anatomical exposition of the structure of the Human Body with that of a Tiger and Common Fowls*, which was never completed.

STWOSZ, Wyt *See* Stoss, Veit.

SUBLEYRAS, Pierre (1699–1749) Born in southern France and educated at Toulouse and at the Royal *Academy in Paris, where in 1727 he gained first prize for painting, he settled in Rome in 1728. Here he specialized in sober, deeply-felt religious pictures and portraits (e.g. Rome, S. Maria degli Angeli, S. Francesca Romana; Accademia di S. Luca), painted in a subtly graduated light tonality with much use of areas of white (*see under* colour). A picture of his own studio (after 1740, Vienna, Akademie) reproduces many of his best-known compositions.

SUBLIME An aesthetic category, originally formulated in Late Antiquity, refashioned in the 18th century by the Anglo-Irish statesman Edmund Burke. 'Longinus', an unknown author of the first century AD, defined the sublime as that which, expressing the grandeur of the Divine Intellect, 'irresistibly uplifts the souls' of all men at all times. Burke's theory, set out in the *Philosophical Enquiry into the Origin of our Ideas of the Sublime and the Beautiful* (1757), is more grounded in psychology than in metaphysics. Whilst a sense of beauty is aroused by that which attracts, the repellent and disturbing arouse feelings of the Sublime. Infinite extension, excessive size, darkness, are qualities leading to a perception of sublimity; in art, exaggeration and excess. Burke's theory provided a vocabulary for describing such works as the archeological and architectural fantasies of *Piranesi, and influenced the art and art theories of Romanticism (*see* Volume Two; *see also*, in this volume, Picturesque).

SUSTERMANS, Justus (1597–1681) Prolific Flemish-born portraitist of the Medici court in Florence, where he went *c*.1620 after three years in Paris in the studio of François *Pourbus the Younger. His reputation, dulled by the many poor copies after his originals, has recently been revived as a result of a series of exhibitions in which newly cleaned paintings have revealed his gifts as a draughtsman and colourist; he was admired by *Rubens, a life-long friend, and *Van Dyck. At its best, his work bears comparison with their portraits and those of *Velázquez (Florence, Uffizi, Pitti). He also painted some narrative pictures, including the huge canvas of *The Senators of Florence swearing Allegiance to Ferdinand II de'Medici* (1626, Florence, Uffizi; oil sketch, Oxford, Ashmolean), a few *genre* scenes and portraits of animals (e.g. Florence, Poggio Imperiale, Uffizi, respectively). The Print Cabinet at the Uffizi has a series of landscape drawings by him, much influenced by those of Florentine artists.

SUSTRIS, Lambert (*c*.1515–after 1568) and his son Federico or Friedrich (*c*.1540–99) Italo–Netherlandish painters. Lambert, recorded also as 'Alberthus de Olandis', was born in Amsterdam and probably trained in Utrecht under van *Scorel. By the late 1530s he was in the Veneto, perhaps following a stay in Rome; he worked in Venice in *Titian's studio and independently in Padua. He accompanied Titian to Augsburg in 1548 and 1550, returning alone in 1552; during his visits he executed portraits (Augsburg, Gallery; Munich, Alte Pinakothek; Zeil, castle). On his return to Italy, perhaps through direct contact with *Schiavone, and under the influence of the prints of *Parmigianino, he revised his style to arrive at a personal variant of Venetian *Mannerism, particularly successful in narratives in extensive landscape. There are works by him in Amsterdam, Rijksmuseum; Paris, Louvre; Caen, Musée; Lille, Palais; Madrid, Prado; Leningrad, Hermitage; Oxford, Christ Church; etc.

Lambert's son and pupil Federico may have been born in Padua. Between 1563–7 he worked in Florence with *Vasari, executing cartoons for tapestries for the Palazzo Vecchio, 1564. Summoned to Augsburg to decorate interiors in the Fugger mansion, 1569–73, he was recommended by Hans Fugger to Duke Wilhelm V, for whom he worked at and near Landshut 1573–9. In 1580 he moved to Munich, becoming an architect and supervisor of all artistic projects at court.

SWEERTS, Michiel (1618–62/4) Flemish painter, born in Brussels. From *c*.1646–*c*.54 he was resident in Rome, where he was impressed by Pieter van *Laer's pictures of Roman street life, and by *Caravaggio's religious paintings. In 1656 he obtained permission from the city of Brussels to open a drawing *academy. In 1659/60 he was in Amsterdam. A successful portraitist, a grave and lyrical recorder of the life of women and children, of artists' studios and of Roman low-life, he was a profoundly religious man. In 1661, after joining a missionary society, he is recorded as fasting almost daily, taking communion three

or four times a day, and giving away his possessions to the poor. His compassionate interest in social problems is recorded in paintings of the *Acts of Mercy* (Amsterdam, Rijksmuseum; New York, Metropolitan). In 1662 he set out with the mission of Bishop François Pallu for Persia, but, 'not the master of his own mind', he was dismissed in Isfahan. He made his own way from Iran to India to join the Portuguese Jesuits, and died in Goa.

Sweerts's clarity of form, purity of colour, and poetic intensity have led to comparisons with the works of *Vermeer's classic period, but his particular synthesis of northern *realism and Italianate eloquence, especially in his paintings of half-length figures, bears comparison with *Rembrandt. There is a self-portrait in Oberlin, Ohio, College; and other works in Hartford, Conn., Atheneum; London, Wallace; etc.

TACCA, Pietro (1577–1640) Florentine sculptor. Born at Carrara, the site of the great marble quarries of Tuscany, into a family of marble merchants, he disliked marble carving and specialized in bronze. In 1592 he entered the workshop of Giovanni *Bologna, becoming his principal assistant. Before Giovanni Bologna's death in 1608 Tacca carried out the project for the equestrian *monument of Ferdinando I de'Medici* (1601–07/8), Florence, Piazza SS. Annunziata), and worked on the early stage of the monuments to Henry IV of France (c.1604–14, formerly Paris, Pont Neuf, destroyed 1792, fragments Louvre) and *Philip III of Spain* (1606–16, Madrid, Plaza de Oriente). In 1617 Tacca became Giovanni Bologna's successor as grand-ducal sculptor. The major projects carried out in the workshop under him were the four *Slaves* at the base of the monument to Ferdinando I in Leghorn (1615–24); two bronze fountains (1627) intended for Leghorn but ultimately installed in Florence, Piazza SS. Annunziata; the bronze *Boar* for Florence, Mercato Nuovo, after an antique marble; the bronze *Turtles* for the bases of the obelisks in Piazza Sta Maria Novella; and the colossal bronze statues for the tombs in the Capella dei Principi, the grand-ducal mausoleum in San Lorenzo. Between 1634 and his death Tacca worked on the great equestrian *Monument to Philip IV of Spain* (Madrid), the first completed monument of a rider on a rearing horse in the history of equestrian statuary, although Tacca had already projected the type in two statuettes, the *Louis XIII of France* (Florence, Bargello) and *Carlo Emmanuele of Savoy* (1619–21, Kassel).

TANZIO DA VARALLO (c.1575/80–1635) Lombard painter from a German-speaking community in the Valsesia; he was first known as Antonio d'Enrico. A trip to Rome for the Papal Jubilee, 1600, acquainted him at first hand with the work of *Caravaggio, whom he may have followed to Naples. Caravaggesque influences reinforced local Lombard traditions, notably those derived from Gaudenzio *Ferrari, in Tanzio's best-known work, the *illusionistic and highly *expressive *frescoes in the *Sacro Monte at Varallo, painted upon his return to northern Italy, 1616–26. Other works can be found in Varallo, Pinacoteca; Novara, S. Gaudenzio; Milan, Brera.

TASSI, Agostino *See under* Guercino; Claude Gelée; Gentileschi.

TENEBRISM, TENEBRIST (from Italian *tenebroso*, dark, obscure, gloomy) A type of painting which relies for its effects on overall darkness, from which highlights pick out significant details, notably gestures and facial expressions. Generally applied to the later paintings of *Caravaggio and his imitators, the term may also imply emotional gloom, lack of ornamentation, even squalor. *See also* chiaroscuro.

TENIERS, David the Younger (1610–90) Prolific Flemish painter, mainly of *genre scenes and landscape; also an etcher (*see under*

intaglio prints), art historian and dealer. He was the pupil of his father, David Teniers the Elder (1582–1649), a history painter (*see under* genres) whose *oeuvre* has not been satisfactorily established, although works in Antwerp, Pauluskerk, and Dendermonde, Onze Lieve Vrouwekerk, provide a touchstone. The most obvious influences on Teniers the Younger, however, were his father-in-law, Jan *Brueghel, and Dutch painting, notably works by Jan Davidsz. de *Heem and *Kalf, which inspired the meticulous still-lifes in many of his pictures (e.g. Karlsruhe, Kunsthalle; Brussels, Musées; The Hague, Mauritshuis), by Pieter *Codde and Willem *Duyster, whose barrack-room subjects he revived (e.g. Leningrad, Hermitage), by *Terborch, whose portraits he emulated in his Civil Guards' procession paintings (e.g. Leningrad, Hermitage) and, most of all, by Adriaen *Brouwer. Teniers imitated Brouwer's peasant scenes, recasting them into his own less vigorous but more refined pictorial idiom (e.g. Kassel, Gemäldegalerie; Leipzig, Museum; London, National, Wallace; Madrid, Prado; Paris, Louvre; Budapest, Museum). Gradually, the earthy subjects inspired by Brouwer gave way to scenes from fashionable life (e.g. London, Edmund de Rothschild). He also depicted apes and cats in human guise; Witches' Sabbaths and other demonic and fantastical subjects in the tradition of Jan Brueghel and Frans *Francken the Younger.

Shortly after his election as Dean of the Antwerp painters' guild, 1645, Teniers moved to Brussels where he became court artist to the Archduke Leopold Wilhelm and his successor. In Brussels he evolved a version of a Flemish theme traceable back to Jan Brueghel: the depiction of a picture gallery (e.g. Madrid, Prado). Miniature portraits of the artist himself, as custodian and cataloguer of Leopold's treasures, of the Archduke and other visitors, vie in interest with the accurately copied pictures-within-the-picture; the whole providing an invaluable historical record of picture collecting, framing and hanging practice. In addition, Teniers painted small-scale copies of the collection's prime holdings, especially the Venetian pictures, to serve as the basis for engravings, a selection of which was published in 1660 (e.g. London, Courtauld). Teniers's landscapes, related to those by Paul *Brill and Jodocus de *Momper, also formed the setting for the activities of the court (e.g. Vienna, Kunsthistorisches). After 1662, they often include in the background views of the château of The Three Towers near Perck, bought by Teniers in that year from the second husband of *Rubens's widow, Hélène Fourment (e.g. London, National). Also in 1662 the artist was one of the prime movers in the establishment of the Royal *Academy in Antwerp, finally founded in 1663. In 1680 he obtained a long-sought patent of nobility.

Teniers also practised as an art dealer, travelling to England between 1650–5 to buy paintings for an aristocratic client, and selling pictures to his archducal patron. With the exception of his landscapes the quality of his work deteriorated from *c*.1650; there are no dated works from

1680–90. His son, David Teniers III (1638–85), continued painting in his manner.

TER BORCH or TERBORCH, Gerard (1617–81) Much-travelled Dutch painter based in Deventer after 1654, notable for the pictorial and psychological refinement of his small paintings, mainly *genre scenes with two or three figures in an interior, and portraits. He began his training under his father, Gerard Ter Borch the Elder (1584–1662), who had lived in Italy in his youth; his earliest known drawing, made when he was eight years old, represents the rear view of a figure, a motif he was to continue exploring throughout his life, focusing attention on the exquisitely painted sheen of satin stuffs (*The Parental Admonition*, c.1654/5; *The Concert*, c.1675; Berlin-Dahlem, Museen). Like de *Hooch, Ter Borch began as a painter of barrack-room scenes (*see also* Duyster, Codde). In the 1640s he added to his repertoire small full-length portraits (*Helena van der Schalke as a Child*, c.1644, Amsterdam, Rijksmuseum). In 1635 Ter Borch was in England; in 1640/41 probably in Rome; he travelled also in France, Spain and throughout the Netherlands. In 1648 he was at Münster, where he painted individual portraits of delegates to the peace negotiations, and his most famous work: *The Swearing of the Oath of Ratification of the Treaty of Münster* (London, National). In this tiny (46cm×58cm) painting on copper, Ter Borch recorded faithfully the interior of the Ratskammer adorned for the ceremony, and portrayed 77 persons attending, including himself. Having demanded the enormous sum of 6,000 guilders for the work, and not received it, the artist kept the picture, and it remained in his family throughout the 18th century. Ter Borch's most important student (c.1655–c.58) was Caspar *Netscher.

TERBRUGGHEN, Henrick (1588–1629) A pupil of *Bloemaert, he is one of a group of painters known as the Dutch Caravaggisti (*see also* Honthorst, Baburen). He is supposed to have spent c.1604–14 in Italy, where he may have met *Caravaggio. Upon his return to Utrecht he began to paint pictures combining deliberate Netherlandish archaicisms – such as motifs derived from Lucas van *Leyden, and grotesque types inspired by Quentin *Metsys – with Caravaggesque elements. After 1620, with the return of other Dutch Caravaggisti from Rome, the Caravaggesque begins to predominate. His dependence on the Italian painter is never slavish, however: he evolved entirely new, shimmering colour harmonies, a silvery tonality, and a method of painting dark figures against light backgrounds, which anticipates, and may have influenced, the Delft School (*see* Vermeer, Fabritius). There are pictures by him mainly of Biblical subjects and *genre, in many major galleries, including Copenhagen, Museum; Kassel, Gemäldgalerie; London, National; New York, Metropolitan; Rome, Nazionale. His masterpiece, *St Sebastian tended by the Holy Women* (1625), is in Oberlin, Ohio, College.

THEOTOCOPULOS, Domenico *See* Greco, El.

THORNHILL, Sir James (1675/6–1734) By far the most successful native painter of *Baroque decoration in Britain. We know little of his early training, which may have been in architecture; of painting, he learned much from *Laguerre, whom he displaced in popularity. He was a vigorous self-publicist and political manoeuvrer, who achieved his pre-eminence not only through considerable ability but also by exploiting xenophobic prejudice to the detriment of his foreign competitors. Xenophobia recurs as a motif in the career of his son-in-law, *Hogarth.

Thornhill's first major commission seems to have been the decoration of the Painted Hall at Greenwich (1708–27), and it remains his greatest achievement. In it he translates episodes of contemporary history into the *idealizing idiom of the Grand Manner (London, British, annotated drawing for *The Landing of George I*). In 1715 Thornhill triumphed over his foreign rivals Laguerre and Sebastiano *Ricci to receive the commission for the decorations of St Paul's (1716–19). These he worked on concurrently with other decorative schemes, not only at Greenwich but also at Blenheim and at Charborough Park. In 1716 he succeeded *Kneller as head of the first, short-lived, *Academy. He was made 'History Painter to His Majesty' in 1718, and Sergeant Painter in 1720, the year also in which he became Master of the Painter Stainers' Company, and received his knighthood. In 1722 he was elected MP for Melcombe Regis. With the death of his patron, the Earl of Sunderland, and the ascendancy of Lord Burlington, his fortunes began to falter; in 1723 he lost the commission of the decoration of Kensington Palace to William *Kent.

Thornhill practised other *genres as well as grand decoration: there are early portraits by him at Trinity College, Cambridge, and All Souls', Oxford. The sketchbook of his journey to Holland and Belgium in 1711 demonstrates his interest in architecture.

TIBALDI, Pellegrino (1527–96) Precocious *Mannerist painter and architect from Bologna. Following his debut at 15 (*Marriage of St Catherine*, c.1542, Bologna, Pinacoteca), he left in 1545/6 for Rome, where he first assisted then succeeded *Perino del Vaga in the *fresco decoration of the Sala Paolina in the Castel Sant'Angelo (completed 1549). It is here that he evolved the *Michelangelesque idiom of his mature style, and *illusionistic elaborations. He continued to work in Rome (with *Daniele da Volterra c.1550, SS. Trinità; S. Luigi dei Francesi; Vatican, Belvedere, S. Andrea; 1549, *Adoration of the Shepherds*, Borghese) moving in 1553 to Loreto (fresco in the Holy House, part-destroyed, part-detached). Sometime during 1553–5 he returned to Bologna, succeeding Nicolò dell'*Abate in the Palazzo Poggi. From 1558–61 he worked mostly in Ancona, in an increasingly ponderous, over-blown style (Palazzo Ferretti, Pinacoteca). From 1586–94/5, he replaced Federico *Zuccaro at the Escorial in Spain, where his fresco cycles and altar paintings temper *Mannerism with a

Counter-Reformatory, *academicizing clarity – a pious naturalism (*see under* realism) which was to influence later Spanish artists.

TIEPOLO, Giovanni Battista (1696–1770) The towering figure of 18th-century Venetian art, a brilliant virtuoso of vast *fresco schemes and large altarpieces, as well as a draughtsman and etcher (*see under* intaglio prints). The greatest Italian *Rococo painter, he is also the last great master of the Italian Grand Manner founded in the High *Renaissance. Whilst his links to *Veronese are especially close, his works betray knowledge, too, of *Titian, *Raphael, *Michelangelo and the masters of the *Baroque, notably *Rubens. His etchings, produced from c.1740, show reminiscences of *Rembrandt, *Castiglione, *Rosa and even *Dürer. Although, until the very last years of his life, his career was meteoric, he never worked in Rome, France or England – the centres of the new *Academic *classicism. His decorative frescoes, shimmering with light and air, are superior to his oil paintings – except for sketches and models for larger works (e.g. London, Courtauld, National).

A precocious pupil of the mediocre Gregorio Lazzarini (1665–1730) he soon broke away from his master. In view of his later dependence on Veronese, the greatest influence on his earliest work was, surprisingly, not the Veronesque Sebastiano *Ricci but *Piazzetta (e.g. *Sacrifice of Isaac*, c.1716, Venice, Ospedaletto; *Madonna del Carmelo*, c.1721, Milan, Brera; *Glory of St Teresa*, c.1725, Venice, Scalzi).

In 1726 Tiepolo's characteristically light-hued and translucent painting style first appeared in his earliest important fresco cycle outside Venice (Udine, cathedral and archiepiscopal palace). After its completion, he received other commissions in northern Italy outside Venice, followed by the triumphant Venetian decorations: 1737–9, ceiling, Chiesa dei Gesuati; 1740–7, Scuola dei Carmini, Scalzi (destroyed); c.1744–5, salon of the Palazzo Labia. In 1750 he set out for Würzburg, the capital of Franconia, where he was commissioned to decorate the newly built Residenz of the Prince-Bishop (Kaisersaal and Grand Staircase, 1750–3), assisted by his two sons, Giovanni Domenico (1727–1804) and the 14-year-old Lorenzo (1736–76) (see below). The pedantic programme proposed for this decoration was transformed by Tiepolo into one of his grandest and most imaginative masterpieces. As is usual in his work, historical personages – even in the 12th-century German scenes of the Kaisersaal – are presented in the colourful dress of 16th-century Venice.

On his return, Tiepolo continued his work for Venetian churches (1754–5, Chiesa della Pietà). The family firm also undertook the decoration of several villas in the Veneto; the most outstanding is the Villa Valmarana near Vicenza (1757). Four reception rooms of the main house are each dedicated to one of the great epic poems – two ancient, two modern – Homer's *Iliad*, Virgil's *Aeneid*, Ariosto's *Orlando Furioso* and Tasso's *Gerusalemme Liberata*. All but one of the seven rooms

of the guest house, however, were designed and executed by Giovanni Domenico Tiepolo, and here his individual talent was at last given free rein. Less grandly eloquent than his father's, his decorations are, in their very different way, as resonant: of pastoral; of exotic Chinoiserie; of the bourgeois Venetian theatre of Goldoni (a theme to which he would return with even greater vigour and wit in the decorations of the Tiepolos' own villa at Zianigo, 1790s, now Venice, Ca' Rezzonico). Sadly, Giovanni Domenico's talent for lyrical *genre had no other commissioned outlet.

Giovanni Battista's fertile imagination in design and speedy execution are further manifested in two ceilings of the Ca' Rezzonico, Venice, 1758; the fresco of the *Assumption* at Udine, Chiesa della Purità, painted in a single month in 1759; decorations in the Palazzo Canossa, Verona, 1761 and at the Villa Pisani at Stra, 1761–2. In between these commissions Tiepolo was also completing canvases for dispatch to the Russian court and to S. Marco, the Venetian church in Rome.

In the summer of 1762 at the invitation of King Charles III, the Tiepolo firm settled in Madrid. Here Giovanni Battista was to spend the last eight years of his life, electing not to return to Italy after the completion of the original commissions: the huge ceiling *Apotheosis of Spain*, in the throne room of the newly built royal palace, and two lesser ceilings. Yet even in Spain fashion was turning against him. Seven altarpieces, commissioned after some delay for Aranjuez, were soon removed at the instance of the king's confessor to be replaced by works by Anton Raffael *Mengs.

At their father's death Lorenzo and Giovanni Domenico separated, the former to remain in Spain, the latter returning to the Veneto. Although his independent painting output was limited (in addition to the decorations of the Villa Valmarana and his own villa at Zianigo, already mentioned, we can cite his youthful *Stations of the Cross*, 1749, Venice, S. Polo), Giovanni Domenico was a prolific etcher, reproducing his own and his father's works but also originating his own designs. The Punchinelli, which were a half-melancholy, half-satirical Tiepolo print motif, recur in painted form in the Zianigo frescoes.

TILLEMANS, Peter (*d.*1734) Antwerp painter settled in England in 1708, best remembered as a topographical painter and one of the 'Old Masters' of sporting pictures. (*See also* Wootton.)

TINO DI CAMAINO (active from *c.*1306–37) Sculptor and architect, son of a master of works at Siena Cathedral, Camaino di Crescentino, and the most gifted follower of Giovanni *Pisano. He was associated with *Giotto at the Angevin court in Naples, where he was summoned in 1323/4, and at his death Pietro *Lorenzetti became guardian to his children. His modern reputation rests on his funerary monuments, of which many are now dismembered and partly destroyed: the *Tomb of the Emperor Henry VIII*, 1315, Pisa, cathedral and Camposanto; the *Petroni monument*, 1318, Siena cathedral; *Della Torre*

monument, Florence, S. Croce, and *Orso monument*, Florence cathedral, 1321–3; the Neapolitan tombs of *Mary of Hungary* (St Maria Donna Regina), *Catherine of Austria* (S. Lorenzo), *Charles of Calabria* and *Mary of Valois* (S. Chiara) 1323/4–37. His sculpture is marked by the lyrical interplay between a smoothly flowing incised line and massive block-like forms, but the austere effect today, so evocative of 20th-century experiments, is not the effect intended or indeed achieved in the 14th century, since most of the original *polychromy of many of the statues has been lost.

TINTORETTO; Jacopo Robusti, called (1518–94) Prolific and influential Venetian painter, who converted the city's patrons and artists to a belated acceptance of a non-*naturalistic and anti-*classical form of *Mannerism. His nickname derives from his father's occupation of dyer (*tintore*). His virtuoso style, supposedly derived from *Michelangelo's *disegno* and *Titian's colourism, was actually arrived at during a long period of experimentation in the 1540s under the influence of Andrea *Schiavone, *Pordenone, *Lotto and the prints of *Parmigianino. It is characterized by violent energy, arbitrary use of colour and *chiaroscuro, asymmetrical and exaggerated *perspective in which the vanishing point, raised high, creates funnelling effects. His compositions were evidently worked out with the aid of miniature stages on which draped wax figures were disposed and sharply lit.

Tintoretto's reputation was established with the large painting of the *Miracle of St Mark or of the Slave*, 1548 (Venice, Accademia). Three later paintings complete a virtual St Mark cycle (after 1562, Venice, Accademia; Milan, Brera). From 1565–87 he worked recurrently on his major project, the pictorial decoration of the Scuola di S. Rocco, the most lavish ensemble of confraternity imagery extant in Venice and the largest to have been designed by a single artist (*see also* Carpaccio, Gentile Bellini). It has been said, justly, that Tintoretto can be fully appreciated only when viewed *in situ* here. The enormous lower hall (*Life of the Virgin*), the upper hall with its sombre painted ceiling compartments framed in heavy carved gilt (*Old Testament* scenes; on the walls, *Life of Christ*) and the adjoining room with its enormous *Crucifixion* (*Passion* scenes) reveal him to be one of the greatest decorative painters of all time. The flickering lights and eccentric foreshortenings which can look melodramatic in a gallery, are shown here to have been supremely effective devices, conveying at one and the same time religious fervour and worldly opulence.

With the aid of his extensive workshop, which included his sons Domenico (*c.*1560–1635) and Marco (*d.*1637) and his daughter Marietta (*c.*1556–*c.*90), as well as Andrea Vicentino (1539–*c.*1617) and the Greek-born Antonio Vasilacchi (1556–1629), Tintoretto worked extensively for the Doge's Palace in Venice. Perhaps the best-known of his vast canvases there is the *Paradiso*, 1588, in the Great Council Hall. A smaller anteroom in the palace contains four of his relatively infrequent

mythologies (1578; another, London, National). Earlier in his career he had also been a prolific, if not particularly inventive, portraitist; the most successful portraits seem to be those of old men (e.g. Florence, Pitti, Uffizi; Paris, Louvre). His best work, and the kind which engaged him most, was religious in content; in addition to the Scuola di S. Rocco, it can be seen to advantage in various Venetian churches, notably S. Giorgio Maggiore, S. Maria dell'Orto, and at the Accademia.

TITIAN (Tiziano Vecellio) (c.1480/5–1576) The most celebrated Venetian painter, and the first to acquire a mainly international clientele, despite remaining in Venice for most of his life. A master of local genres, such as the anonymous 'courtesan' portrait (*Flora*, c.1520; *Girl in Blue Dress*, 1536, Florence, Uffizi, Pitti respectively), the recumbent female nude (e.g. *Venus of Urbino*, 1538, Florence, Uffizi) the large narrative *scuola* painting on canvas (*Presentation of the Virgin*, 1534–8, Venice, Accademia; *see also* Gentile Bellini, Carpaccio), he was also prolific and innovatory in all the traditional pictorial categories. His altarpieces revived the venerable form, bringing to it new movement, drama and optical complexity. His portraits established the long-lasting conventions of aristocratic and princely European portraiture. His mythological paintings virtually codified the semblance of pagan antiquity in the European imagination – not by recreating the forms of *classical art, but by seeming to bring the world of ancient myth to life. Albeit not the originator of the most extreme form of Venetian colourism (*see under disegno*; *also* colour) he remains its most famous and influential exponent.

Born in Pieve di Cadore, Titian trained in Venice under the *Bellini, before joining *Giorgione c.1507. His first recorded commission, 1508, was the side façade of the Fondaco dei Tedeschi, the German merchants' warehouse whose main façade was assigned to Giorgione (fragments, Venice, Ca' d'Oro). Titian was to complete Giorgione's *Venus* (1510, Dresden, Gemäldegalerie). Their styles were then so close that several works from about this date have been attributed to either artist, although they may be the work of neither (e.g. *Concert Champêtre*, Paris, Louvre). As Titian's own manner becomes distinct from that of Giorgione, however, it can be seen to be more outgoing (e.g. *Gipsy Madonna*, c.1510, Vienna, Kunsthistorisches). This is evident even in his most poetic, 'Giorgionesque' secular subjects (*Three Ages of Man*, c.1509, Edinburgh, National), and in his works of private devotion (*Noli me tangere*, c.1508, London, National), and is confirmed in his first large-scale narrative works, the documented 1511 *frescoes for the Scuola di S. Antonio, Padua. It is most striking in his monumental early half-length portraits on the scale of life (*Man with Blue Sleeve*; *Woman called 'La Schiavona'*; both c.1511, London, National), which boldly engage the viewer's eye, breaking decisively with the introverted portrait type of Giovanni Bellini and Giorgione, and perhaps also signalling Titian's interest in the latest developments of central Italian High *Renaissance

art, known in Venice through prints and drawings (*see also* his design for a woodcut of the *Triumph of Christ*, 1508, which quotes a figure from *Michelangelo).

Titian's altarpieces were even more revolutionary. The *Assumption and Coronation of the Virgin* (1516–18, Venice, S. Maria Gloriosa dei Frari) was unprecedented in the city in its large scale, dazzling colour, optical *realism, movement and introduction of central Italian *contrapposto*. It was followed in 1519–26 with the *Pesaro Madonna* for the same Franciscan church. The brilliant series of altarpieces inaugurated here culminated *c.*1526–30 in the rival Dominican church of SS. Giovanni e Paolo, with the *Death of St Peter Martyr* depicted in an atmospheric, agitated landscape. Although this picture was destroyed by fire in 1867, copies, painted and engraved, attest to its appearance. Perhaps only two of Titian's many later altarpieces rival these in colouristic realism and drama: the nocturnal *Martyrdom of St Lawrence* (*c.*1548–57, Venice, Gesuiti) and its even more extraordinary and powerful variant of 1564–7 in the Escorial, Iglesia Vieja.

In 1513 Titian, after much intrigue against older artists, obtained the sinecure of painting for the Great Council Chamber in the Doge's Palace. Although he continued to draw his salary, Titian only completed one scene, *The Battle of Spoleto* (compl. 1538), a rival of the famous never-finished battle scenes by *Leonardo da Vinci and Michelangelo in an analogous room in Florence. Titian's most elaborate composition, and one of his most influential, it, too, was destroyed by fire (in 1577).

In 1516 Titian began his international career through his association with his first princely patron, Alfonso d'Este of Ferrara, for whom he painted his first series of large mythological narratives, the genre in which, after the death of *Raphael, he was to have no rivals (*The Worship of Venus*, 1518–19, Madrid, Prado; *Bacchus and Ariadne*, 1520–3, London, National; *The Andrians*, 1523–5, Madrid, Prado). Based on ancient literary texts, these works have no known visual precedents.

Later in life Titian was to paint another series of mythological narratives, whose principal source was Ovid's *Metamorphoses*, but whose underlying themes were the celebration of the female nude and the power of erotic passion. Painted for Titian's most discerning and appreciative patron, Philip II of Spain, these *poesie* (as Titian called them) demonstrate, as they were intended to, the ability of painting to rival poetry. The choice of subject was left to the artist (*Danae*, *c.*1549–50; *Venus and Adonis*, 1551–4, both Madrid, Prado; *Perseus and Andromeda*, 1554–6, London, Wallace; *Diana and Acteon, Diana and Callisto*, both 1556–9, Edinburgh, National; *Rape of Europa*, 1559–62, Boston, Mass., Gardner). (The unfinished *Death of Acteon*, *c.*1555, London, National, was probably begun for the series but was never sent to Spain. *Tarquin and Lucretia*, 1568–71, Cambridge, Fitzwilliam, Titian's last narrative work on an antique theme, was sent to Philip but does not

form part of this series.) These works differ from the mythologies for Alfonso d'Este not only in their heightened eroticism but also in style. From the 1540s Titian painted with a more open, looser brush work, in a complex, time-consuming system of glazes, fluid strokes and even finger smears, intended to give the finished surface the freshness and sparkle of a spontaneous sketch. Although often credited with the invention of this colouristic technique, Titian was almost certainly influenced by the earlier experiments of Andrea *Schiavone and Jacopo *Tintoretto. In the *Diana* paintings he had also changed his figure canon, in response to the *Mannerist engravings of the School of Fontainebleau (*see* Primaticcio).

Titian's lengthy and fruitful relationship with Philip, begun before the latter ascended to the throne of Spain (e.g. *Portrait of Prince Philip of Spain*, 1549, Madrid, Prado) had its origins in his patronage by Philip's father, the Habsburg Emperor Charles V. Introduced to Charles in 1532, Titian was to execute for him works which virtually created the canon for all later royal portraiture (*Charles V with a dog*, *c.*1532–6, Madrid, Prado, after the painting by Jacob *Seisenegger, and one of the first full-length Italian portraits; *Charles V on Horseback*, 1548, Madrid, Prado; *Charles V Seated*, 1548, Munich, Alte Pinakothek). So many commissions flowed from all the Habsburgs and their courts that from the 1550s Titian hardly executed any pictures for Venetian clients.

In the same years that he was portraying Europe's mightiest secular ruler, however, Titian was also prevailed upon to paint the pope, Paul III Farnese, in Rome (*Paul III with his grandsons Cardinal Alessandro and Ottaviano Farnese*, 1545–6, Naples, Capodimonte). Left unfinished, this remarkable picture reflects to some extent the schema of Raphael's portrait of Leo X with his nephews – although in other respects Titian's visit to Rome had little impact on the artist, who had assimilated ancient and central Italian influences, through drawings and prints, many years before.

This entry perforce omits perhaps the majority of the works in Titian's enormous *oeuvre*, augmented by the output of his studio. His son Orazio Vecellio (1525–76) ran the workshop in his father's old age, when few original autograph compositions were produced, except for Philip of Spain. It is still disputed whether Titian's last few years saw the emergence of an even broader and looser painting style, or whether this is an effect produced by the dispersal of unfinished works from the studio after Titian's and Orazio's deaths. Titian's methods of painting in maturity are recorded in the transcript of an eye-witness account by his one-time pupil, *Palma Giovane.

TORRIGIANO, Pietro (1472–1528) Florentine sculptor, a pupil of *Bertoldo. He is remembered for having assaulted *Michelangelo and broken his nose, for which he was exiled from Florence (before 1492). After a stay in Rome (stucco decorations of the Torre Borgia) he served in the armies of Cesare Borgia in the Romagna (after 1498);

leaving Italy sometime after 1500, he worked in the Netherlands for the Regent Margaret of Austria (1509–10), and in London from 1511. His main extant work is the marble and gilt bronze *tomb of Henry VII and Elizabeth of York* (1512–19, London, Westminster Abbey), influenced in form by *Pollaiuolo's tomb of Sixtus IV. He also executed the terracotta monument of Dr John Young (after 1516, now London, Public Records office) and a bronze relief portrait of Sir Thomas Lovell (*c.*1518, London, Westminster Abbey). Around 1522 Torrigiano moved to Spain (terracotta statues, now Seville, Museum), where he died at the hands of the Inquisition.

TRIPTYCH *See under* polyptych.

TRISTÁN, Luis (*c.*1586–1624) The best-known pupil of El *Greco, working in his Toledo studio 1603–08 (*see also* Pedro Orrente, Juan Bautista Mayno). Probably between 1606–13 he went to Italy, returning to settle permanently in Toledo in 1613. He is one of the earliest Spanish artists to evolve a naturalistic (*see under* realism) *Caravagesque style. His works for Seville (Alcazar; cathedral) are thought to have been a decisive influence on *Velázquez. He also executed outstanding portraits (e.g. Madrid, Prado).

TROGER, Paul (1698–1762) Influential Late *Baroque Austrian painter, mainly of dome and ceiling *frescoes. A follower of *Rottmayr, he was influenced also by a period of study and independent activity in Italy: by *Piazzetta in Venice, *Solimena in Naples, Luca *Giordano in Rome and *Correggio in Parma. After his return home before 1728 he worked in churches throughout Austria and in Bohemia. In 1751 he became Professor at the Vienna *Academy, and its President 1754–7.

TROMPE L'OEIL *See under* illusionism.

TROOST, Cornelis (1696–1750) Amsterdam painter of portraits and *genre*, the foremost Dutch portraitist of the 18th century. Working both in oils and in pastels, he introduced a note of informality and wit into the traditions of group and individual portraiture established in the previous century, painting both on the scale of life and in the small format of the *Conversation Piece. A master also of comic *genre* and theatrical pieces, he has been called a 'Dutch *Hogarth', although he lacks the moralizing bite of his English contemporary (The Hague, Mauritshuis; Amsterdam, Rijksmuseum; Dublin, National).

TROY, Jean-François de (1679–1752) With his rival *Lemoyne, the leading painter in France *c.*1725; bested by Lemoyne for the post of *Premier Peintre du Roi*, he became Director of the French *Academy in Rome, 1738–52. Trained by his father François de Troy (1645–1730), a Toulouse-born painter best known for his portraits in the Flemish tradition of *Van Dyck, Jean-François travelled to Italy 1699–1707, and was received at the Academy in Paris in 1708, the year in which his father became Director (reception piece *Niobe and her Children*, Montpellier, Musée). An able executant of large religious works

(e.g. *St Geneviève and the Aldermen of Paris*, 1726, Paris, St Etienne-du-Mont), mythological and history paintings (*see under* genres; e.g. Nancy, Musée; Neuchatel, Musée) and cartoons for Gobelins tapestries (*Story of Esther*, 1738–42, Paris, Louvre; Musée des Arts Decoratifs; *Jason and Medea*, 1743–6, museums of Angers; Brest; Clermont-Ferrand; Le Puy; Toulouse; sketch, Birmingham, Barber), he was most prized by connoisseurs for his topical *genre* pictures (e.g. *The Reading from Molière*, *c*.1728, coll. Dowager Marchioness of Cholmondeley). In these smaller '*tableaux de mode*', more prosaic than the **fêtes galantes* of *Watteau which may have influenced them, de Troy's gifts for *realistic observation of contemporary fashions of dress, behaviour and setting are most fully displayed.

TULLIO LOMBARDO *See under* Pietro Solari.

TURA, Cosmè or Cosimo (*c*.1430–95) The first important Ferrarese painter, influential on all his successors at the Este court, where he was employed *c*.1451–86 (*see also* Cossa, Costa). His harsh yet decorative style can be understood as a re-working of the International *Gothic mode in the light of 'modern' researches as mediated through the idioms of *Mantegna, *Piero della Francesca and the Venetian works of *Andrea del Castagno. Major projects by Tura have been destroyed or dismantled. Allegorical figures (now London, National; Berlin-Dahlem, Museen) may be all that remain of his decorations for the *studiolo* at Belfiore, 1458–63. The great Roverella *polyptych, *c*.1480, has been dispersed to London, National; Rome, Colonna; Paris, Louvre; San Diego, Calif., Museum; New York, Metropolitan; Boston, Mass., Gardner and Cambridge, Mass., Fogg. Badly damaged organ shutters for Ferrara cathedral, 1469, are now in the Museo del Duomo. Other works Bergamo, Accademia; Florence, Uffizi; etc.

U

Uccello, Paolo (1397–1475) Florentine painter, a pioneer of studies in linear *perspective (e.g. drawings, Florence, Uffizi). Unlike his younger contemporary *Masaccio, however, he was preoccupied with the ornamental possibilities of this technique. His training under *Ghiberti c.1407–1415, and his stay in Venice 1425–30, predisposed him to adopt the linear rhythms and empirical *realism of detail of International *Gothic (see also Pisanello; Gentile da Fabriano). His style throughout his working life thus reconciled – albeit imperfectly – two incompatible traditions and attitudes: that of the decorator-artificer with that of the artist-scientist. Where the former devalues *expressivity in favour of elegance, the latter explores the world of appearances and of human emotions. The two extremes of these tendencies in Uccello's art can be observed, on the one hand, in the small St George and the Dragon, part of a room decoration (c.1460, London, National) and, on the other, in the *fresco of the Flood and the Recession of the Flood (after 1447? transferred to canvas, Florence, S. Maria Novella, Chiostro Verde or Green Cloister).

Much of Uccello's life is ill documented and a number of works are lost, such as the mosaic of St Peter set up in 1425 on the façade of S. Marco. His early style upon his return to Florence may be deduced from his first badly damaged frescoes on the east wall of the Green Cloister at S. Maria Novella, The Creation of the Animals and the Creation of Adam, The Creation of Eve and the Fall (1430–6?, transferred to canvas, in situ). Executed largely in the terra verde, 'green earth', which gives the cloister its name, these frescoes, like their minor Gothic predecessors on the south and west walls, are enlivened by touches of other colours. The design of major figures depends on Ghiberti, that of the many realistic animals on northern Italian sketch-books. The landscape is conventional and there is as yet no use of linear perspective.

Uccello's next major Florentine commission, however, although also executed in terra verde, is very different. His monumental effigy of Sir John Hawkwood (d.1394), English mercenary captain of Florence's armies, replaced an earlier image painted in 1395 by Agnolo *Gaddi in lieu of the originally projected marble monument. Uccello's famous fresco, in the event, was designed to simulate a bronze equestrian monument atop a marble sarcophagus; the effect is now weakened by the loss of the original fictive cast shadow, the addition in the 16th century of a decorative border, and the transferral of the fresco to canvas hung at a different height from the floor. Enough of the original remains, however, to demonstrate Uccello's procedures. The fictive sarcophagus is painted in accurate sharp recession from a low viewpoint, giving even now the illusion of a three-dimensional object

on the wall. To avoid distortion, however, neither horse nor rider is foreshortened, although the viewer is not immediately aware of the implied dual viewpoint.

The exact date of the badly damaged *Flood* fresco at S. Maria Novella is not known. From its appearance it is plausible to suppose it was painted *c.*1447, after Uccello's visit to Padua where he would have seen *Donatello's reliefs for the high altar of S. Antonio. *The Flood* is the work of Uccello's which most nearly complies with *Alberti's prescription for painting an *istoria* (*see under* genres); *Vasari writes that he represented in it '. . . the dead, the tempest, the fury of the winds, the flashes of lightning, the rooting up of trees, and the terror of men . . .'. The vertiginous recession to the vanishing point, however, whilst it adds a surreal grandeur to our sense of scale of the Ark, does not help us see that two separate episodes are here linked in a single visual scheme; even in its original state the fresco could not have been easily read.

Of Uccello's surviving major works, perhaps the one which best exploited his curious talents is the now-dismembered decoration for a room in the Medici palace in Florence, *The Rout of San Romano* (*c.*1456? three panels now distributed between London, National; Florence, Uffizi; Paris, Louvre). Originally placed with their lower edges seven or more feet from the ground, these large panels display a non-*illusionistic system of perspective, in which the broken lances and bodies of the fallen are arranged to indicate the orthogonals and transversals of the perspective scheme, limited to a fairly narrow strip in the foreground. The background landscape bears no spatial relationship to the foreground, and unity of the three scenes, *Nicolò da Tolentino directing the Battle* (London), *The Unhorsing of Bernardino della Carda* (Florence) and *Micheletto da Cotignola attacking the Sienese rear* (Paris), is imposed by recurrent forms and colours. As *The Flood* explores a range of human actions and emotions, so the *Rout* depicts the fullest range of postures of horses – a theme of great interest in the *Renaissance and one later exploited by *Leonardo da Vinci. The realism of battle, however, is sacrificed to the decorative qualities of costume details (notably the ceremonial head-dress of Nicolò da Tolentino) and other appurtenances, and the patterns created by the lances, cross-bows, plumed helmets, men and horses. The glowing oranges on the trees, and the roses on the shrubs against which the episodes of battle unfold, clearly show the relationship of these painted panels to tapestries, and recall that this record of a historical event was intended for a private room rather than a public hall. Part propaganda, part decoration and part exhibition of perspectival skill, the *Rout* remains Uccello's most congenial large-scale work.

In 1465 Uccello was at Urbino, where he painted for the Confraternity of Corpus Domini a narrative *predella in six panels, *The Profanation of the Host*, to an altarpiece of the *Institution of the Eucharist* (later

executed by *Joos van Ghent). The romantic little *Hunt* now in Oxford, Ashmolean, was perhaps originally part of a *cassone*. Recession is established through the diminution of tree forms, hunters, stags and hounds (a repertory of whose poses is furnished analogous to that of horses in the large *Rout*). The tapestry-like flowers of the forest floor and foliage of the tree tops conspire with the bright little figures, seen in profile or from the rear, to lure the viewer into an enchanted world, where even the arduous study of perspective is reduced to dreamlike playfulness.

UYTEWAEL, Joachim *See* Wtewael, Joachim.

VAGA, Perino del *See* Perino del Vaga.

VALDÉS LEAL, Juan de (1622–90) After *Murillo, to whose artistic temperament and ideals he was diametrically opposed, the leading Sevillan painter of the second half of the 17th century. He is best remembered for the two gruesomely *expressive – yet *realistic in detail – *vanitas* *still-life allegories painted to complement Murillo's cycle in the church of the Caridad: *Finis Gloriae Mundi* and *Triumph of Death (In Ictu Oculi)* (1672, *in situ*). Smaller, but similar in their use of still-life elements for religious instruction are the now-separated pair, *A Jesuit Conversion* – an illustration of Christian repentence – and *Vanitas* (1660; now York, Gallery and Hartford, Conn., Atheneum, respectively).

The son of a Portuguese father, Valdés Leal was born in Seville but educated in Cordova where he worked until *c.*1654 (e.g. S. Francisco). By 1656 he had settled in Seville, where he became one of the founders, with Murillo and Francisco *Herrera the Younger, of the Seville *Academy, and served as its president, 1664–6. In addition to the works already mentioned he executed cycles for various convents (now Seville, Museo; Mairena, Bonsor Coll.; Madrid, Prado; Barnard Castle, Bowes; Dresden, Gemäldegalerie; Grenoble, Musée; Le Mans, Musée). Other works now in London, National; New York, Hispanic Society, Kress Foundation; etc.

VALENTIN (1594–1632) Also called Valentin de Boulogne or Le Valentin; his first name is not known. Roman painter born in France of an Italian father, settled in Rome *c.*1612. He was an imitator of *Caravaggio; most of his known work dates from after 1620 and he followed Caravaggio's *tenebrist manner longer than any artist in Rome (but *see*, e.g. Honthorst and Terbrugghen in Utrecht). Although his paintings have sometimes been confused with *Manfredi's, he was a more disciplined artist with a wider emotional range. A neighbour of *Poussin's in the latter's early years in Rome, he competed with him in painting the *Martyrdom of SS. Processus and Martinianus* (1628–30, Vatican, Pinacoteca) as a pendant to Poussin's *Martyrdom of St Erasmus*. There are works attributed to him in Cambridge, Fitzwilliam; London, National; Rome, Nazionale; Vienna, Kunsthistorisches etc.

VALLAYER-COSTER, Anne (1744–1818) One of the most accomplished French *still-life specialists of the 18th century. Her subjects were influenced by *Chardin, but her colours are brighter and more vivid than his and her *illusionistic detail more insistent (e.g. Cleveland, Ohio, Museum; Toledo, Ohio, Museum).

VAN CLEEF, JOOS *See* Cleve, Joos van.

VANDERBANK, John (1694–1739) English painter, son of a Huguenot tapestry weaver. He founded the second London

painting *academy (1720) in which *Hogarth trained, and was himself a vivid portraitist in the painterly style associated with Hogarth. His masterpiece, the portrait of *Queen Caroline*, 1736, is at Goodwood. He is now best known, however, for 20 small scenes illustrating *Don Quixote* (1731–6), which are amongst the earliest examples in England of paintings based on a literary text.

VAN DYCK, Sir Anthony (1599–1641) Supreme portraitist of the Stuart court of Charles I, Van Dyck was born in Antwerp, the seventh child of a rich textile merchant. A precocious talent, he was apprenticed at 10 to Hendrik van Balen (1575–1632), a painter of elegant small-scale mythological scenes for middle-class collectors, of whose manner little is discernible even in Van Dyck's earliest-known works. He was an independent master before the age of 19. Drawn into the orbit of *Rubens, it was as an assistant in the latter's studio that he came to the notice of England's premier connoisseur, the Earl of Arundel (portrait, 1620/1, USA, Logan Coll.; *Arundel with his grandson Thomas*, *c*.1635–6; with *Aletheia, Countess of Arundel*, *c*.1639, both Arundel Castle; drawing for never-completed family group portrait, *c*.1643, London, British). At the Earl's instigation Van Dyck came to London in 1620. He entered the service of James I in 1621, and also painted pictures for the principal collectors at Court (e.g. *Continence of Scipio*, Oxford, Christ Church), studying in their collections works by Venetian *Renaissance painters already influential on him in Antwerp. Thus the influence of Rubens was diluted by that of *Veronese and, above all, *Titian, with a corresponding loosening of brushwork, an increased emphasis on the paint surface deployed on canvas rather than panel, and a certain devaluation of spatial and volumetric definition. In 1621 he received leave to study in Italy, but returned first to Antwerp, then, absconding from the King's service, remained in Italy until 1627; in 1628 he had re-established his studio in Antwerp, and did not return to London until 1632, to the court of Charles I and Queen Henrietta Maria.

In Italy, Van Dyck, quite lacking Rubens's intellectual and archeological interests, sketched mainly pictures he admired; amongst these works by Titian predominate. He travelled everywhere, cutting an aristocratic figure. Although his altarpiece for Palermo (*Madonna of the Rosary*, 1624–7, Palermo, Madonna del Rosario) had an influence on the Neapolitan school, his main impact was in Genoa. There he executed a brilliant series of aristocratic portraits, which were indebted to Rubens's Genoese portraits of nearly two decades before, but which also developed the full range of Van Dyck's later portrait repertory: equestrian portraits (e.g. *Anton Giulio Brignole Sale*, Genoa, Palazzo Rosso), a monumental family group (*The Lomellini Family*, Edinburgh, National), full-length seated and standing single figures (e.g. *Cardinal Bentivoglio*, Florence, Pitti; *Marchesa Doria*, Paris, Louvre), and standing figures accompanied by children or attendants (*Marchesa Brignole Sale and her Son*, Washington, National).

Back in Antwerp, Van Dyck embarked on a period of intense activity (1628–32) which saw his finest achievements as a painter of large altarpieces (e.g. *Vision of St Augustine*, 1628, Antwerp, Augustijnenkerk; *Crucifixion*, Lille, Musée), smaller works for private devotion (e.g. *Rest on the Flight to Egypt*, Munich, Alte Pinakothek), mythological or poetic subjects (*Rinaldo and Armida*, Baltimore, Museum), as well as portraits. He also became court painter to the Regent of the Netherlands, Archduchess Isabella. Despite a wealth of commissions and great success, however, Van Dyck responded to solicitations from the English court; in 1632 he began the *oeuvre* for which he is best known today, and which transformed, and cast a lasting influence over, the British school. Perhaps a desire to emulate or outshine Rubens had a part in this decision; but it must be said that Van Dyck's removal to London, where he was knighted in 1632, virtually put a stop to his development as a painter of narrative and religious subjects in the greatest tradition of European art, and robbed that tradition of one of its most sensitive exponents. This is not to deprecate his achievements in England, where his finest royal portraits in particular outdo Titian in the poetic and imaginative conflation of the public and the intimate, and the depiction of social status with the illusion of natural nobility (*Le roi à la chasse*, Paris, Louvre). The great equestrian portrait of *Charles I with M. de St Antoine* (1633, Coll. HM the Queen) brilliantly combines the imagery of imperial tradition with a lyricism entirely Van Dyck's own. It is this lyrical gift which transfigures even the most arrogant aristocratic icon (*Lord John Stuart with his brother Lord Bernard Stuart*, c.1639, London, National) into a romantic ideal. Not all the innumerable English portraits are autograph throughout, and quality varies; sure touchstones are the earlier portraits of the royal children (1635, Turin, Galleria; 1637, Coll. HM the Queen) and the multiple views of the King (1635) and Queen (1638, both Coll. HM the Queen) furnished to the sculptor *Bernini.

Never intending to settle permanently in London, Van Dyck returned twice to the Netherlands (1633–5; 1640). The first period resulted in some of his finest compositions (e.g. *The Abbé Scaglia*, Viscount Camrose; *The Abbé Scaglia Adoring the Virgin and Child*, London, National; *Equestrian portrait of Prince Thomas of Savoy*, Turin, Galleria; *Lamentation*, Munich, Alte Pinakothek; etc.). On the second occasion he travelled to Paris, in the hope of receiving the commission for the Grande Galerie of the Louvre which went to *Poussin. Nor was he able to conclude a grand decorative scheme for Whitehall, of which the sketch of the *Garter Procession* (c.1638, Belvoir Castle) is the only remaining visual evidence. He died in London; a marvellous late self-portrait (the Earl of Jersey) records the appearance, disquieted and worn, of the artist who won the highest distinctions but never fulfilled his ambitions.

VANITAS *See under* still-life, and Steenwijck, Harmen.

VANLOO *See* Loo, van.

VARALLO, Tanzio da *See* Tanzio da Varallo.

VARIN, Quentin *See under* Poussin, Nicolas.

VASARI, Giorgio (1511–74) Painter, architect and art impresario, born in Arezzo but Florentine by adoption, he was the most important contemporary writer on the art of the Italian *Renaissance and *Mannerism. His *Vite de' Piu Eccellenti Pittori, Scultori ed Architettori* (*Lives of the Most Excellant Painters, Sculptors and Architects*, 1st. ed. 1550, 2nd revised ed. 1568) with their prefatory 'Introduction to the Three Arts of Design (**disegno*): Architecture, Sculpture and Painting'; the *Ragionamenti sopra le invenzioni da lui dipinte in Firenze nel palazzo di loro altezze serenissime* ... (*Dialogues on the Inventions painted by himself in Florence in the Palazzo Vecchio*, 1557, 1563), his *Descrizione dell' Apparato fatto in Firenze per le nozze ... di Don Francesco de' Medici* ... (*Description of the Festival decorations for the Wedding of Francesco de' Medici*, 1566) and his letters are unparalleled sources for the biographies of Italian artists, the techniques of art, and modes of thinking by artists about art, in the mid-16th century. In addition, the *Lives* are our primary source of knowledge about earlier Tuscan artists from *Cimabue onwards. Unlike the older Cennino Cennini (*see under* Gaddi) and *Ghiberti, and later *Cellini, whose more limited writings are also important for an understanding of techniques and artistic ideals, Vasari undertook extensive research throughout Italy and adopted for the *Lives* a historical framework whose influence is still enshrined in most scholarly accounts of art. For Vasari, his fellow Tuscan *Michelangelo stands at the apex of an organic evolution of post-antique art, accomplished in three periods corresponding to infancy, youth and maturity.

Vasari's practice of art has until recently been eclipsed by his work as a writer. It was, however, both extensive and important, especially his decorative *fresco cycles (see below) and the works of architecture undertaken during Vasari's tenure, from 1555, as Cosimo I de'Medici's art impresario. It was also in his capacity as Cosimo's artistic adviser that in 1562 Vasari inaugurated the first modern art *academy.

Vasari's intellectual predilections, fostered through his humanist education alongside the young Medici heirs and his artistic training under *Bandinelli, manifest themselves in the complex *iconography and dry abstracting handling of his portraits and altarpieces (e.g. *Duke Alessandro de'Medici*, 1534, Florence, Museo Medici; Camaldoli, Arcicenobio; Florence, SS. Apostoli; Rimini, S. Fortunato; Ravenna, Accademia; Rome, S. Pietro in Montorio). These qualities are a greater asset in his large decorative ensembles, where the execution is in any case largely the work of assistants. The first such commission is the great salone in Rome, Palazzo della Cancelleria (*Sala dei Cento Giorni*, 1546; extensively restored in 1943 after damage by fire). Most striking is Vasari's use here of Michelangelo's designs for the staircase of the vestibule to the Laurentian Library in Florence. From 1556 Vasari

designed and oversaw the refurbishment and decoration of the Palazzo Vecchio in Florence, the most extensive *Mannerist decoration in the city expounded in the *Ragionamenti*, which includes the tiny *studiolo* of Francesco I de'Medici, the most perfect Italian example of a *Kunstkammer*.

VECCHIETTA; Lorenzo di Pietro, called (1410–80) Sienese painter and sculptor, active also as an architect and metal-worker. His paintings in *fresco and on panel in the hospital and church of S. Maria della Scala are some of the most important produced in Siena in the 15th century. He carved in wood throughout his career (Florence, Bargello; Horne Museum) and worked also in marble, but it is for his bronze sculpture, produced after contact with *Donatello's Sienese studio, that he is best known (*Foscari effigy*, 1463–4, Rome, S. Maria del Popolo; *Sozzini effigy*, 1467, Florence, Bargello; tabernacle, 1467–72, Siena, cathedral; New York, Frick).

VECCHIO, Palma *See* Palma Vecchio.

VECELLIO, Tiziano and Orazio *See* Titian.

VEDUTA (pl. *vedute*) Topographical view, a type of painting which became important in the second half of the 17th century. It combined landscape elements with the work of the architectural designer and the *quadraturista*, or scene painter. The *veduta esatta* was a precise rendering of a topographical situation; the *veduta ideata*, or *di fantasia*, an imaginary view. Gian Paolo *Panini was the great master of *vedute* of Rome; his *vedute ideate* showed scenic arrangements of antique ruins, and influenced, amongst others, *Piranesi. *Canaletto specialized in Venetian *vedute*, and his nephew *Bellotto migrated north of the Alps, practising *vedute* painting in Dresden, Vienna, Munich and Warsaw. *See also capriccio*. A *vedutista* is a painter of *vedute*.

VEEN, Otto van (also known as Octavius Vaenius) (1556–1629) Distinguished Italianate Flemish painter and humanist, teacher of *Rubens. Of patrician birth in Leiden, Holland, he first studied with Isaac Nicolai van Swanenburgh; by 1572 he was in Antwerp and Liège in the southern Netherlands, continuing his training in the eclectic Italianate style of Frans *Floris. In 1575–80 he studied in Rome under the *Mannerist painter Federico *Zuccaro. He worked also in Cologne. In 1585 he entered the service of Alessandro Farnese in Brussels. Finally, *c*.1590, he settled at Antwerp, although preserving his connections with the court in Brussels. Rubens was in his studio from *c*.1596–8, and continued to work with him until he left for Italy in 1600, and perhaps even later.

Van Veen's work immediately after his return to the Netherlands in 1585 reflects his schooling under Zuccaro and his enthusiasm for the school of Parma (*Correggio, *Parmigianino) (Brussels, Musées; Potsdam, Sanssouci; Berne, Museum). But his style began to change in the late 1590s (Antwerp, Openbare Onderstand, Andreaskerk) and by 1610 he had abandoned Mannerist complexities for a clear, rational

*Classicism. In this style he executed a number of religious works of Counter-Reformatory propaganda (Munich, Gemäldesammlungen; Ghent, St Bavo).

Van Veen knew Latin and was part of the intellectual life of Antwerp. His importance to the visual arts is not exhausted by his own painted *oeuvre* and his tutelage of Rubens: he was also the author and designer of important *emblem books, both secular and religious, which sparked off the vogue for emblematic literature throughout the Netherlands.

VELÁZQUEZ, Diego Rodríguez de Silva (1599–1660) The greatest Spanish painter and one of the greatest figures in European art – recognized as such in his own lifetime and again since the 19th century, despite the loss of many of his works and the fact that none can be seen in its original context. His early *realistic and tightly painted portrait manner inspired by *Caravaggio, decried as 'melancholy and severe' by an Italian contemporary but praised by *Rubens for its *'modestia'*, was gradually transformed under the latter's influence and that of *Titian's works in the Spanish Royal Collections into the more colourful, airier 'distant blobs' with which, said an admirer, Velázquez achieved 'truth rather than likeness'. It is this supremely optical mode which characterizes his great masterpieces: the monumental *genre* and mythology painting of *The Fable of Arachne* (*Las Hilanderas*) with its streaking after-image of a spinning wheel, and *The Maids of Honour* (*Las Meninas*), the sublime court group and self-portrait, with its dim mirror reflection of the King and Queen of Spain seemingly standing beside the viewer (c.1656–8, 1656 respectively, both Madrid, Prado).

He was born in Seville; his paternal grandparents had come from Portugal and were said to have been of noble birth – a fact which was crucial to the artist's strivings, successful in 1659, to be received into the military order of Santiago. Possibly after a brief period with Francisco de *Herrera the Elder, he was apprenticed to Francisco *Pacheco, whose daughter he would marry in 1618, a year after matriculating as master. Like all Sevillan painters of his time, including his fellow-pupil *Zurbarán, he was trained as a painter of religious subjects (*Adoration of the Magi*, 1619, Madrid, Prado; *Immaculate Conception* and *St John the Evangelist on Patmos*, 1617–18, London, National). The artist's treatment of these owes more to the *polychrome sculpture of Juan Martínez *Montañés than to his master Pacheco, and the former's influence is still discernible in the *Christ on the Cross* of c.1631–2 (Prado). More exceptional were Velázquez's *bodegones* (*see under* still-life), of which he was an early exponent in Spain and remains the most celebrated. These paintings were singled out for praise by his early biographers, Pacheco and *Palomino. His earliest surviving dated works are amongst the finest in this genre, combining 'low-life' figures and kitchen still-lifes: *Old Woman Cooking Eggs* (1618, Edinburgh, National) and *Christ in the House of Martha and Mary* (1618, London, National). Of about the same

date is one of the first paintings by him seen at court in Madrid, *The Water Seller of Seville*, as well as the *Two Young Men at Table* (both London, Apsley House). Pacheco's claim that Velázquez studied from the life is confirmed by the reappearance in these and other *bodegones* of the same models and the same kitchen utensils. Of these works only two include religious themes: the *Christ in the House of Martha and Mary* already cited, and *Tavern Scene with Christ at Emmaus* (Blessington, Beit Coll.). These compositions, in which the religious scene is relegated to the background, derive from the works of Pieter *Aertsen and Joachim Beuckelaer, which Velázquez could have known from engravings. The *bodegones* in general reflect an interest in Caravaggio and his Spanish follower in Naples, *Ribera – although the precise transmission of these models to Seville before 1620 is not clear.

In 1622 Velázquez undertook his first journey to Madrid (portrait of the poet *Luis de Góngora*, Boston, Museum), being summoned again in the following year to paint the King, Philip IV; in 1623 he was appointed the 18-year-old Philip's painter. From that time he would undertake many additional official duties in the palace, rising to onerous posts which curtailed his production as a painter and incurred the envy of others. His relationship with Philip was close and genuinely friendly – perhaps unique in the history of royal patrons and artists. To it we owe a series of the most intimate state portraits ever painted, in which artist and sitter mature together (e.g. Madrid, Prado; London, National; New York, Frick). Velázquez's portraits of the royal children by Philip's first wife, Isabel of Bourbon, and his second, his niece Mariana of Austria, are probably the subtlest children's likenesses in European art, playing off the grace and vulnerability of childhood against the formality of court apparel and official pose (mainly Madrid, Prado and Vienna, Kunsthistorisches). Equally perceptive and moving are the famous portraits of court dwarfs and buffoons of the 1630s and 1640s (Madrid, Prado).

Accused by rivals of being able to paint 'only faces', Velázquez was commissioned in 1626 to execute his first history picture (*see under* genre), *The Expulsion of the Moriscos* (destroyed 1734), in competition against Vincencio *Carducho and two other artists; Juan Bautista *Mayno was one of the judges who awarded him the prize. The visit at the Spanish court in 1628–9 of the great narrative painter Rubens not only influenced Velázquez's technique (*see above*) but also inspired the commission and execution of his first mythological subject, *Bacchus and his Companions* (*Los Borrachos, The Drinkers*, c.1628, Madrid, Prado). Rubens, and their joint study of the Venetian works in the royal collection, revived the Spanish artist's desire to go to Italy; he finally received permission in 1629, returning in 1631. The success at court of two narrative works executed in Italy, *Apollo in the Forge of Vulcan* (Prado) and *Joseph's Blood-Stained Coat Brought to Jacob* (Escorial) resulted in further commissions for narrative pictures, of which the most

important is *The Surrender of Breda* (1634–5, Madrid, Prado), one of the works commemorating Spanish victories and decorating the Hall of Realms in the Buen Retiro palace (*see also* Zurbarán; Mayno; Carducho). Velázquez was also to contribute a series of royal equestrian portraits to this important ensemble (now Madrid, Prado). *The Christian Soul Contemplating Christ after the Flagellation* (London, National) was probably painted shortly after his return from Italy. Two very different altarpieces, *Sts Anthony Abbot and Paul the Hermit*, with an extensive landscape, and the sumptuous *Coronation of the Virgin* for the Queen's oratory (both Madrid, Prado) date from *c*.1633 and *c*.1640 respectively.

In addition to royal portraits in hunting dress (Prado), other works were also commissioned from the artist for the hunting lodge, the Torre de la Parada, for which Rubens's workshop was painting mythological scenes: the large landscape *Philip IV Hunting Wild Boar* (*c*.1635–7, London, National), *Mars at Rest*; *Menippus* and *Aesop* (all *c*.1636–40, Madrid, Prado). The only surviving female nude by Velázquez, the *Toilet of Venus*, also called the *Rokeby Venus* (1649–51, London, National) was, however, not a royal commission – albeit influenced by Venetian mythologies in the royal collection – but executed for a young nobleman. Like other works of these years the composition was influenced by Velázquez's study of ancient sculpture during his Italian trip.

In 1649–51 Velázquez was allowed to re-visit Italy. Two small but exceptional paintings resulted from this second trip: his only known autograph pure landscapes, in which the artist anticipates the *plein air* effects of 19th-century painting (*Villa Medici Gardens, Rome, Pavilion of Cleopatra* and *Grotto-Loggia Façade*, both Madrid, Prado). More publicly renowned were the two portraits executed in Rome: that of *Pope Innocent X* (1649–50, Rome, Doria), which earned Velázquez admission to the *Academy of St Luke and was described by *Reynolds as 'one of the first portraits in the world', and the 'preparatory' likeness of Velázquez's mulatto servant, *Juan de Pareja* (New York, Metropolitan).

Upon his return to Spain Velázquez designed and supervised the decoration of rooms in the Alcazar palace which were to house the paintings, sculptures, casts and *objects d'art* he had purchased in Italy on the king's behalf, notably the Hall of Mirrors for which *Mitelli and Colonna executed the ornate *quadratura* ceiling. The ensemble was destroyed by fire in 1734, and with it three of the four paintings of mythological subjects by Velázquez which were hung between the windows; only the *Mercury and Argus* survives (*c*.1659, Madrid, Prado). In the airy, impressionist technique of his late maturity, the artist here returns to the low-life, picaresque mode of his early works. Similarly, the *genre* character of the foreground of *The Fable of Arachne* (*c*.1656–8, Madrid, Prado) served to obscure this great work's mythological subject; recognized in Velázquez's own time, it became known merely

as *Las Hilanderas, The Spinners*, until its recent re-identification. Formally and in the allusive mode of reference to the 'higher' subject in the background, this work resembles the early religious *bodegones*.

Velázquez's last great royal commission resulted in his most illustrious work. *Las Meninas* is a group portrait on the scale of life, unprecedented in conception and unequalled in execution. Ten figures, including the five-year-old Infanta Margarita and her maids of honour, dwarfs and dog, pose as if captured in a single moment of time in a vast airy room hung with pictures – Velázquez's studio in the royal palace. Amongst this cast of characters drawn from virtually the whole of the artist's portrait repertory, Velázquez has included his only secure self-likeness, in the act of painting. Only the back of his enormous canvas is visible to the viewer, but the subject of this painting-within-the-painting can be deduced from the 'reflections' in a mirror on the back wall of the room: the King and Queen of Spain are posing for their portrait. The spatial scheme makes it evident that they must be standing amongst us, the viewers of *Las Meninas*; to put it another way, we the viewers have been invited into the artist's spacious studio. Through the magic of this mysterious composition – perhaps inspired by van *Eyck's *Arnolfini Marriage*, then in the Spanish royal collection – we are enabled to enter the world of Velázquez's art, the very heart of the art of painting. Not surprisingly, *Las Meninas* has proved an abiding inspiration to later painters.

Chief of the artists inspired by Velázquez in his own lifetime, however, is his son-in-law and successor at court, Juan Bautista Martínez del Mazo (1612/16–67). His best-known work, a free improvisation on the theme of *Las Meninas*, is *The Artist's Family* (c.1664–5, Vienna, Kunsthistorisches).

VELDE, Esaias van de (c.1591–1630) Oldest member of a family of distinguished Dutch artists. Draughtsman, etcher (*see under* intaglio prints) (Amsterdam, Rijksprentenkabinet) and painter, he is best known as a pioneer of the *realistic Dutch landscape, which he began to paint especially after settling in The Hague in 1618 (*The Cattle Ferry*, 1622, Amsterdam, Rijksmuseum; *Winter Landscape*, 1629, Kassel, Kunstsammlungen; Oberlin, Ohio, college). Some of his earlier paintings, notably his scenes of outdoor banquets, show the influence of the Flemish émigré *Vinckboons, who is believed to have been his teacher in his native Amsterdam (Amsterdam, Rijksmuseum). Between 1610–18 he worked in Haarlem, where in 1617 he taught Jan van *Goyen. His cousin, Jan van de Velde II (1593–1641), a distinguished Haarlem engraver, imitated his landscape prints. The latter's son, Jan Jansz. van de Velde (c.1619–63 or after), although born and probably trained in Haarlem, is considered primarily as an Amsterdam painter of *still-life (Amsterdam, Rijksmuseum).

VELDE, Willem van de the Elder (1611–93) and Willem the Younger (1633–1707) Marine painters born in Leiden. From

1652, Willem the Elder was the official Dutch war artist, recording the sea fights between the Dutch and English navies. He evolved a *grisaille painting technique which enabled him to render these engagements in more permanent form than drawing but with maximum speed and historical fidelity. He also painted shipping pieces in oil. In 1673, to escape the effects of the French invasion and a tumultuous marriage, he changed sides and settled in England with his son, Willem the Younger. In 1674 they were officially appointed naval war artists under the English Crown, with a studio in the Queen's House at Greenwich. Willem the Younger, who was also taught by the marine artist Simon de *Vlieger, painted not only portraits of sea battles and individual ships but also atmospheric seascapes. He is the originator of the English tradition of marine painting. There is a large collection of works by both van de Veldes in the Maritime Museum, Greenwich, and also in London (National, Wallace, Kenwood, Ham House; Coll. HM the Queen). Willem the Younger's famous and monumental *The Cannon Shot*, c.1660, is in the Rijksmuseum, Amsterdam.

VENEZIANO, Domenico *See* Domenico Veneziano.

VENEZIANO, Sebastiano *See* Sebastiano Veneziano.

VERHAECHT or VERHAEGHT, Tobias *See under* Rubens, Peter Paul.

VERHULST, Marie *See under* Bruegel.

VERHULST, Rombout (1624/5–96) Flemish sculptor, active mainly in Holland. Albeit not a formal innovator, he is notable for the delicacy of his modelling, and the sensitivity of his portraits, and has been called 'the aristocrat of Flemish sculptors'. From c.1647 he was employed on the Amsterdam Town Hall (now Royal Palace) in the workshop of Artus I *Quellin; the figure of *Venus* (1650/7) and two allegorical reliefs in the galleries are signed by him. After leaving the workshop long before the completion of the town hall, Verhulst executed a whole series of funerary monuments in churches throughout the United Provinces – in Amsterdam, Delft, Leiden, Katwijk, Utrecht, and in remote villages of Groningen and Zeeland – beginning with monuments in the Nieuwe Kerk at Amsterdam and the Oude Kerk in Delft in 1654 and ending with the elaborate monument to Admiral de Ruyter in the Nieuwe Kerk, Amsterdam, in 1681.

VERMEER, Jan or Johannes (1632–75) The greatest painter of the third, and last, generation of the Golden Age of Dutch art. He was born and lived in Delft, where he is recorded as the worthy successor of Carel *Fabritius, killed in 1654. He is unlikely, however, to have been Fabritius's pupil, although he owned three of the latter's paintings, possibly in his capacity as an art dealer.

Vermeer's total output was small, totalling some 40-odd pictures. The earliest of these, c.1654–c.56, are large-scale figure compositions influenced by the Utrecht *Caravaggisti (*see* Terbrugghen, Honthorst, Baburen). They include his only extant religious and mythological narratives: *Diana and her Companions* (The Hague, Mauritshuis) and

Christ in the House of Martha and Mary (Edinburgh, National) and his first known essay in *genre*, *The Procuress* (1656, Dresden, Gemäldegalerie), one of only two dated pictures. In the late 1650s Vermeer changed direction, perhaps under the influence of his Delft contemporary, Pieter de *Hooch: now one, two or three figures, usually in contemporary dress, pursue their tranquil occupations in harmoniously composed Dutch interiors. The interest in anecdote, still conspicuous in the *Soldier and Laughing Girl* (*c.*1657, New York, Frick) wanes as the spatial clarity increases, and cool colour harmony replaces the earlier *chiaroscuro. Yet even a typical example of Vermeer's middle period, the *Woman Weighing Pearls* (*c.*1665, Washington, National) conveys a narrative or allegorical significance: the contrast between wordly treasures being weighed, and the weighing of souls in the painting of the Last Judgement depicted on the wall behind the woman. Like Fabritius, Vermeer came increasingly to silhouette a darker figure against a light ground, and, also like Fabritius, he used a *camera obscura*, approximating in paint the blurred edges of forms projected in this apparatus. To this end he made use of thick dots of bright paint as highlights over a dark area. Two cityscapes by him are known: *Street in Delft* ('Straatje', *c.*1660, Amsterdam, Rijksmuseum) and the slightly later, larger, *View of Delft* (The Hague, Mauritshuis), one of the most accomplished studies of atmospheric and light effects in European painting.

In his late works Vermeer abandoned some of the simplicity of the middle period. Around 1670, the contrasts in illumination increase, perspectival effects become more laboured, accessories more opulent – in line with general developments in Dutch art of this period – and the paint finish harder and more enamel-like (e.g. *The Letter*, Amsterdam, Rijksmuseum; *A Girl with a Guitar*, London, Kenwood; *Young Woman Standing at a Virginal*, *Young Woman Seated at a Virginal*, London, National). To this same period belong two openly allegorical works: *Allegory of the Art of Painting* (Vienna, Kunsthistorisches) and the *Allegory of the Catholic Faith* (New York, Metropolitan).

Vermeer was elected an official of the Guild at Delft four times. Despite his fellow painters' esteem, however, and the high prices his pictures fetched, he was in constant debt. His slow rate of production, his 11 children, the effects of the war with France, must all have played their share in this.

His reputation remained purely local, until the French art critic, Thoré-Burger, published the articles in 1866 which earned Vermeer his present international renown.

VERNET, Claude-Joseph (1714–89) The leading French 18th-century landscape – and especially seascape – painter; his works, based on studies after nature, were seen as the naturalistic alternative (*see under* realism) to the more artificial *Rococo landscapes of *Boucher. He achieved an international reputation for his atmospheric

coastal pictures, sometimes calm and sometimes stormy, depicted at various times of day or night. Being able to combine the *picturesque with topographical exactitude, he was commissioned by the crown in the 1750s to paint the ports of France (Paris, Musée de la Marine).

Born in Avignon, he was sent in 1734 by a local patron to Rome, where he settled and married an English wife; many of his clients were English Grand Tourists. Recalled to France in 1751, he did not make Paris his home until the 1760s. The main influences on his art were *Claude, Gaspard *Dughet, Salvator *Rosa and their 18th-century followers in Rome; his lively figure style, examples of which are in Paris, Louvre; Leningrad, Hermitage; London, National; and many private collections, was influenced by *Panini. Amongst his many followers and imitators were his probable pupil Charles de Lacroix (d.1782) and Pierre-Jacques de Volaire (1729–1802), who after working with Vernet at Toulon on the *Ports of France* commission went to Rome in 1764 and settled in Naples in 1769, where he specialized in painting eruptions of Vesuvius (e.g. Nantes, Musée). But Vernet's influence was also felt by non-French artists, notably *Wright of Derby and *Wilson. His son Carle Vernet (1758–1836) and the latter's son Horace Vernet (1789–1863) also became painters, specializing in horse and battle scenes.

VERONESE; Paolo Caliari, called (1528–88) Born in Verona, he became one of the most prolific and successful painters in Venice where he moved c.1550. Master of *fresco mural decoration (e.g. façades, now lost; Venice, S. Sebastiano, 1558; Maser, Villa Barbaro, 1560); of altarpieces; of ceiling paintings (Doge's Palace, 1553, before 1585; S. Sebastiano, 1556; Marciana Library, 1556–7); of enormous feast-scenes on canvas for refectories (e.g. Paris, Louvre, 1562–3; Vicenza, Monte Berico, 1572; Venice, Accademia, 1573); and portraits, he also evolved a modern variant of the old Venetian *telero* or *scuola* pictures (*see* e.g. Carpaccio). As in the brilliant *The Family of Darius before Alexander* (late 1550s, London, National) the mood of these and Veronese's other paintings through the 1550s and early 1560s is characteristically grand, dignified and elegant but not tragic or even overtly emotional. These sumptuous parades were revived – even to particulars of costume and physiognomy – some two centuries later by *Tiepolo.

Veronese, at first drawn to *Mannerism, developed a personal style ultimately counter to it: adapting *Titian's colourism (*see also under disegno*) to central Italian monumentality and plasticity. One or more trips to Rome are probable in 1555, 1560 or 1566. His luminous and brilliant colours do not fuse forms – as in Titian's late manner – but serve to pick them out, to enhance *illusionism and a kind of *classicizing *realism. Around 1565, under the influence of *Tintoretto, Veronese began to introduce a darker tonality and *chiaroscuro; the temper of his paintings also became graver and increasingly full of pathos (e.g. *Pietà*, c.1565, Leningrad, Hermitage; *Crucifixion*, c.1571, Paris, Louvre; *Agony in the Garden*, c.1580, Milan, Brera; *Lucretia*,

1580–5, Vienna, Kunsthistorisches; *Dead Christ appearing to Sts. Mark, James and Jerome*, by 1584, Venice, S. Giuliano; *S. Pantaleone Healing a Child*, 1587, Venice, S. Pantaleon).

Through the later 1560s–84 Veronese painted mythological pictures for an international clientele as well as for Venetian clients (now New York, Frick, Metropolitan; Cambridge, Fitzwilliam; London, National; Augsburg, Maximilianmuseum). Two mythologies painted in or just before 1584 were bought for the Spanish Royal Collection by *Veláz-quez on his trip to Italy in 1650 (*Venus and Adonis*; *Cephalus and Procris*; now Madrid, Prado and Strasbourg, Musée respectively).

In 1573 there occurred in Veronese's life an incident of great art- and socio-historical interest. He was called to appear before the tribunal of the Inquisition to answer charges of having introduced unseemly secular elements into a painting (now in the Accademia) for the refectory of the convent of SS. Giovanni e Paolo: 'The Last Supper in the House of Simon' (*sic*; the confusion is Veronese's own as recorded by the tribunal). Veronese pleaded artistic licence – such as that accorded to 'poets and jesters' – and custom to introduce 'ornament', 'enrich spare space', and 'decorate the picture'. In the event, although decree-ing that Veronese should 'improve and change' the painting, the Inquisitors were satisfied with a change in title to *The Feast in the house of Levi*.

Veronese ran a large workshop, which continued to produce works 'by the heirs of Veronese' after his death. It included his brother Benedetto (1538–98) and his sons Gabriele (1568–1631) and Car-letto (1570–96), the latter apprenticed to Jacopo *Bassano, as well as his nephew Alvise Benfatto, called del Frisco (*c*.1544–1609). The painter Giovanni Battista Zelotti (1526–81) shared early decorative commissions with Veronese, and continued to work in his manner in fresco in great country houses in the Veneto and on façades in Vicenza.

VERRIO, Antonio (*c*.1639–1707) Mediocre Neapolitan painter, whose mythological and emblematic *fresco decorations gained him enormous wealth and reputation at the English court. Admitted as a member of the Paris *Academy in 1671, after some years' residence in Toulouse, Verrio arrived in England in 1671/2. From 1676 to the Revolution of 1688, he was in continuous employment for the crown, succeeding *Lely as the King's Painter in 1684. He refused to work for William III, and from 1688–99 he mainly painted at Chatsworth and at Burghley House, covering enormous ceiling and wall spaces with his characteristically ill-drawn, ill-coloured, pretentious confections. From 1699–1702 he worked once more under royal patronage, largely at Hampton Court.

VERROCCHIO, Andrea del (1435–1488) The leading Florentine artist of the 1470s. As an executant he specialized in sculpture, in bronze, marble and terracotta; he was, however, also the head of an active and innovative studio designing and supervising the production

of works in other media, including panel painting (*see*, e.g. the *Ruskin Madonna*, *c.*1470–3, Edinburgh, National; *Baptism of Christ*, *c.*1476, Florence, Uffizi; also Pistoia, cathedral; London, National; Berlin-Dahlem, Museen). His workshop included, amongst others, *Perugino and *Leonardo da Vinci. It is Verrocchio's historical position as a 'hyphen' between *Donatello and Leonardo which has unfairly obscured his originality and achievements. Many of the abiding themes of Leonardo's art originated in Verrocchio's studio and found their first expression in his work.

Trained originally as a goldsmith, Verocchio may have spent some time in the studio of Antonio *Rossellino, as is suggested by the style of his earliest marble sculpture, the highly ornamental lavabo in the Old Sacristy of San Lorenzo, Florence (*c.*1465–6). Better-known are the bronze works in which the sculptor measured himself against Donatello: the *David* executed for the Medici *c.*1471–3 (Florence, Bargello); the *Christ and St Thomas*, for a niche designed by Donatello and which originally contained Donatello's *St Louis of Toulouse* (1465–83, Florence, Or San Michele), which brilliantly resolves the problem of staging an interaction between two figures in a space intended for one; and the *Putto with a Fish*, a free-standing fountain figure originally for Lorenzo de'Medici's villa at Carreggi (*c.*1470), later moved to Florence, Palazzo della Signoria, which is the source of the *figura serpentinata* of 16th-century sculpture (*see* e.g. Michelangelo, Giovanni Bologna). Finally, Verrocchio's equestrian *Colleoni monument* (1480–96, Venice, Campo SS. Giovanni e Paolo; *see also* Leopardi) explicitly competes with Donatello's *Gattamelata* in Padua, increasing the figures' *contrapposto* and sense of unstable motion. Clothed, unlike the *Gattamelata*, in purely contemporary armour, Verrocchio's *Colleoni* divorces the equestrian monument from its *Classical origins and prefigures its *Baroque descendants.

A mature marble work, the *Lady Holding Primroses* (*c.*1475–*c.*80) is the first bust in which the sitter's hands are shown, and is thought to be the source for Leonardo's portrait of Ginevra dei Benci and thus, ultimately, the *Mona Lisa*. The marble *Forteguerri Monument* (begun 1476) in Pistoia cathedral was, like the *Colleoni*, left unfinished at the sculptor's death and was further modified in the 18th century. A terracotta model for the monument (London, Victoria and Albert) suggests that it would have been 'the most richly figurated monument of the whole century', in contrast to Verrocchio's only other tomb, the *Monument to Piero and Giovanni de'Medici* in S. Lorenzo, Florence (1469). This superb work in bronze, marble and red and green porphyry relies for its effect on an inventive use of the decorative vocabulary of the Rossellino workshop and on matchless craftsmanship. Verrocchio's engineering skill and the craftsmanship of his studio are, finally, demonstrated in the enormous copper orb placed on top of the lantern of *Brunelleschi's dome for Florence cathedral (1467–71; destroyed 1600).

VERSCHAFFELT, Pieter Antoon (1710–93) Flemish-born sculptor. He worked in Paris with *Bouchardon; then spent some 10 years in Rome, where he executed a portrait bust of *Pope Benedict XIV* (1749, Rome, Pinacoteca Capitolina) and the bronze statue of the *Archangel Michael* atop the Castel Sant'Angelo, the fortress of Rome (1753), replacing an earlier marble sculpture by Raffaele da Montelupo. He then became court sculptor to the Elector Charles Theodore at Mannheim, in Germany, although returning to his native city, Ghent, to erect the *Monument to Bishop van der Noot* in the cathedral (1778).

VIEN, Joseph-Marie (1715–1809) Like that of his younger contemporary the sculptor *Pajou, this French painter's career spanned successfully the most extreme political changes. Head of the royal school of Elèves Protégés; Director of the French *Academy in Rome 1775–81; the last *Premier Peintre du Roi*, 1789, he survived the French Revolution to be made a senator, and finally a Count of the Empire by Napoleon.

Born at Montpellier, he became a pupil of *Natoire in Paris; in 1744–50 he was at the French Academy in Rome, where he was drawn to the Early *Baroque *Classicism of the *Carracci, *Reni and *Guercino. These were the models which he was later to hold up to his pupil *David, with far more dramatic results than those observable in Vien's own paintings (e.g. cycle of the *Life of St Martha*, 1746–7, Tarascon, Collégiale de Ste Marthe). In the 1760s he played a part in the revival of large-scale religious painting in Paris (Paris, St Roch). Encouraged by fashionable antiquarian interest sparked off by the discovery of Herculaneum in 1719 and Pompeii in 1748, and the wall paintings uncovered there, he evolved a rather limp, sentimental form of decorative Neo-Classicism (*see also* Volume Two). His work in this style was preferred by Mme du Barry for her lodge at Louveciennes over the far superior, but still *Rococo, panels by *Fragonard (Vien's panels now Paris, Louvre; other paintings in this chastely erotic *manière grecque*, Ponce, Museum; Montpellier, Musée).

VIGÉE-LEBRUN, Marie-Louise-Elizabeth (1755–1842) French portraitist, an attractive and charming woman specializing in the attractive and charming depiction of women and children. She was particularly associated with Queen Marie-Antoinette, whose portrait she painted several times from 1779 (Versailles). After her flight from France during the Revolution she became an international success in most of the capitals of Europe. She returned to France after the Restoration in 1814.

There is an element of paradox in comparing Vigée-Lebrun with her rival Mme *Labille-Guiard, who was received in to the French *Academy on the same day in 1783. The latter, a Republican sympathizer, is best remembered for official court portraiture in a style which harks back to *Nattier. Vigée-Lebrun, a socialite who under the *ancien régime* gave famous parties *à la grecque*, that is, in simplified dress

harking back to the ancient Greeks, introduced this type of costume into her portraits. Influenced by *Greuze and reproductive prints after English painters, she strove for graceful spontaneity in her work. Thus it was she, and not her Revolutionary rival, who first introduced into French portraiture a Neo-*Classical simplicity anticipating that of *David's portraits. The naturalness and intimacy of her best work – tending towards archness or sentimentality in her lesser paintings – also anticipate Romanticism (see Volume Two). Late in life she wrote her *Memoirs* (1835). There are paintings by her in Paris, Louvre; Leningrad, Hermitage; London, Wallace, Coll. HM the Queen; Geneva, Musée; Toledo, Ohio, Museum; etc.

VINCI, Leonardo da See Leonardo da Vinci.

VINCKBOONS or VINCKEBOONS, David (1576–1632/3) Flemish-born, he emigrated with his family to Amsterdam, becoming one of the most prolific and popular painters and print designers in Holland. Himself influenced by Pieter *Bruegel the Elder, he helped to forge the new *realistic style of Dutch *genre and landscape painting. There are pictures by him in Dresden, Gemäldegalerie; Vienna, Akademie, as well as in Dutch collections.

VISCHER, Peter the Elder (c.1460–1529), Hermann the Younger (before 1486–1517) and Peter the Younger (1487–1528) Nuremberg bronze founders and sculptors. Peter the Elder inherited his father Hermann Vischer's bronze foundry and made it famous throughout Germany. He was assisted by his two sons, one of whom certainly, and both of whom probably, visited Italy. Their work combines *Gothic forms and motifs with features inspired by Italian *Renaissance art and perhaps also by antique pieces in the collection of Peter the Elder. The firm produced many funerary monuments, their last important works being the statues of *Theodoric* and *Arthur* for the *Monument of Emperor Maximilian* (Innsbruck, Hofkirche, 1513). But their most ambitious production was the tomb and shrine of *St Sebald* (Nuremberg, St Sebald, 1507–19; first design, 1488), a large free-standing bronze structure combining reliefs, statuettes, architectural forms and ornaments, and reflecting Italianate humanist subject matter.

VITI, Timoteo See under Raphael.

VITTORIA, Alessandro (1525–1608) Unequal but versatile and innovative sculptor from Trent, active mainly in Venice, where he settled in 1543. Having joined the workshop of Jacopo *Sansovino, he fell out with him over his preference for the *expressive sculpture of *Michelangelo above the *classicizing style Sansovino owed to *Raphael. He adapted motifs from Michelangelo – which he knew only from reproductions – in monuments and statues for Venice, the Doge's Palace and various churches. More accomplished as a modeller than a carver in marble, he executed highly effective stucco statues. From 1553, he worked also as a medallist, and from c.1560 he was the

dominant Venetian portrait sculptor; there are bronze, marble and terracotta portrait busts by him in Venice and elsewhere. As a maker of small bronze statues, he executed at least one major work, the *Neptune* (*c.*1580–5, London, Victoria and Albert), which in its dynamic sweep anticipates the *Baroque style of *Bernini.

VIVARINI, Antonio (before 1430–after 1476), his brother Bartolomeo (*c.*1430–after 1491) and Antonio's son Alvise (1446/53–1505) Dynasty of Venetian painters second in importance only to the *Bellini. From *c.*1450–*c.*70 Antonio and Bartolomeo together held a near-monopoly of providing altarpieces to the provincial churches in the Venetian empire. This market had been opened up by Antonio; except for a brief period *c.*1450–8 the two brothers ran separate workshops, working together, however, on major commissions. After *c.*1470, when Antonio ceased to paint, to 1482, Bartolomeo became the more dominant figure, executing many altarpieces in Venice itself. From 1488 Alvise became the only artist to work on equal terms with Giovanni Bellini on the decoration of the Great Council hall in the Doge's Palace (*see also* Carpaccio; Titian). His three canvasses, never finished, were destroyed with the rest in the fire of 1577, but the prestigious commission earned him other major Venetian work in the 1490s (e.g. altarpieces for S. Giovanni in Bragora; S. Maria Gloriosa dei Frari; Il Redentore). After 1500 his capacity for work was impaired by illness; the Frari altarpiece was completed by his assistant *Basaiti.

Antonio and Bartolomeo Vivarini came from a family of Paduan glass painters established in Murano in the 14th century; Antonio signed himself Antonio da Murano. We do not know the facts of his training; he certainly looked closely at the work of *Gentile da Fabriano and of the Tuscan artists who worked in the Veneto at various times between 1424–42: *Masolino; *Ghiberti; Paolo *Uccello; *Donatello; *Michelozzo; Filippo *Lippi; *Andrea del Castagno. His first known work is dated 1440 (Parenzo, Basilica Eufrasina). From the early 1440s until 1450 he often worked in collaboration with his brother-in-law, the German-born Giovanni d'Alemagna (*d.*1450), who may have been responsible for the more *Gothic features of their altarpieces and *fresco decorations (e.g. *Ancona of S. Sabina*, 1443, Venice, S. Zaccaria; *Madonna with Saints*, 1446, Accademia; vault, Padua, Eremitani chapel, destroyed in World War Two). Antonio's style hardly evolved, and a good example is the 1446 altarpiece, an early instance in Venice of a *triptych composition pictured within a single spatial construction – a device later to be employed by *Mantegna for the S. Zeno altar in Verona (but *see also* Domenico Veneziano in Florence). Other works by Antonio can be found in Venice, S. Pantaleon; Ca d'Oro; Houston, Texas, Museum; London, National; Prague, Norodny; Rome, Vatican Pinacoteca; etc.

In 1450 Antonio collaborated with Bartolomeo, who had joined him in Padua, on an altarpiece now in Bologna, Pinacoteca. The brothers'

firm was dissolved after 1458, although they continued informal collaboration. Bartolomeo's style is in some respects more advanced than his brother's, marked by a greater, albeit superficial, dependence on Giovanni Bellini's treatment of light. This was coupled, however, with an exaggerated linearity and hardness of surface acquired in the workshop of the Paduan Squarcione (see under Mantegna). Bartolomeo further developed the theme of the *sacra conversazione, often uniting it with a motif developed by Giovanni Bellini but which the Vivarini brothers made their own: the adoration by the Madonna of the sleeping Christ Child prefiguring the dead adult Christ (e.g. Naples, Capodimonte). Other works, Paris, Louvre; Venice, S. Maria Gloriosa dei Frari and other churches, Accademia; London, National, Westminster Abbey; Padua, Museo; etc.

Alvise, probably trained in his uncle's studio, acquired a better understanding of *Antonello da Messina and Giovanni Bellini's use of light as a record of actual optical experience and a unifying element in pictorial composition. He softened the colours of his paintings, perhaps also under the influence of *Perugino, who was in Venice between 1494–6. In addition to altarpieces in the family tradition, his work in the Doge's Palace also brought him a few portrait commissions, derived from Flemish prototypes through the agency of Antonello (1497, London, National; Washington, National; Philadelphia, Johnson Coll.; Padua, Museo). More vigorous and dramatic in movement than the late work of Bellini, his religious compositions attracted the interest of the young *Giorgione and Titian and influenced *Lotto and Paris *Bordone. His last completed work (1500, Amiens, Musée de Picardie) was once attributed to Basaiti.

VLIEGER, Simon de (1601–53) One of the most prized Dutch painters of seascapes. Born in Rotterdam, he worked in Delft from 1633/4–8, and in Amsterdam thereafter. A versatile artist, he made cartoons for tapestries (see under fresco), painted the doors of the organ in the Grote Kerk in Rotterdam and designed stained-glass windows for the Nieuwe Kerk in Amsterdam. He also made etchings (see under intaglio prints) of landscape and animal studies. But his greatest contribution is to marine painting. Beginning in a style close to that of the Early *Realist *Vroom, he soon came to be primarily interested (perhaps under the influence of *Porcellis) in the atmospheric depiction of sea, sky and clouds. There are works by de Vlieger in most major galleries, including The Hague, Mauritshuis; Prague, Norodny; Greenwich, Maritime; Budapest, Museum.

VOLAIRE, Pierre-Jacques de See under Vernet, Claude-Joseph.

VOS, Cornelis de (1584–1651) Antwerp portraitist and history painter (see under genres), influenced by *Rubens and the young *Van Dyck. He is perhaps the earliest exponent in Flanders of the group *portrait historié, hitherto a Dutch genre. There are works by him in Antwerp, Musée, St Pauluskerk; Brunswick, Anton-Ulrich; Vienna,

Kunsthistorisches; Graz, Landesmuseum. His brother Paul de Vos (1596–1678) specialized in hunting and animal scenes (e.g. Madrid, Prado), much influenced by Frans *Synders, the husband of Cornelis's and Paul's sister Margaretha.

Vos, Maerten de (1532–1603) Italianate Flemish painter, who was a pupil of Frans *Floris. He was directly influenced also by *Tintoretto, whose studio assistant he became during his Italian sojourn, from the early 1550s until 1558. Upon his return to Antwerp, de Vos became one of the leading artists of the city, inheriting Floris's primacy upon the latter's death in 1570. He combined Floris's eclecticism of design with Venetian colourism (*see under diregno*) , evolving a highly decorative manner which anticipates the Flemish *Baroque of the 17th century. Many altarpieces and mythological paintings by him are known (Antwerp, cathedral, Musées; Brussels, Musées; Florence, Uffizi; Seville, Museum; etc.).

Vouet, Simon (1590–1649) French painter, born in Paris, who spent 15 years in Italy (1612–27), mainly in Rome, where he emerged as leader of the French colony; he was elected head of the *Academy of St Luke in 1624. On his return to France he gained a virtual monopoly in the production of altarpieces for Parisian churches and of decorative schemes (some carried out in conjunction with the sculptor Jacques *Sarrazin) for great houses and royal palaces. This monopoly was threatened with the arrival of *Poussin in 1640, but with the latter's return to Rome in 1642 Vouet once again regained ascendancy.

During his first years in Rome Vouet copied the style of *Caravaggio, but by the time he returned to Paris he had adopted a 'compromise' manner, a *Baroque style tempered by *classicism. His decorative French commissions are indebted to Venetian painting, especially *Veronese, whose work he studied during his visits to Venice at various times between 1612–27. There are paintings by Vouet in churches in Paris, Rome, Naples, Genoa, and in Paris, Louvre; Naples, Capodimonte; Chatsworth; London, National.

Vredeman de Vries, Hans (1527–c.1606) and his son Paul (1567–c.1630) Hans Vredeman was a Dutch architect, painter and draughtsman active throughout the Netherlands and in Germany. A pupil of Cornelis *Floris, he was the first Dutch artist to specialize in pictures of imaginary architecture (e.g. Amsterdam, Rijksmuseum; Vienna, Kunsthistorisches). His multilingual treatise on *Perspective, that is, the Celebrated Art . . . (1604) was of great importance to Dutch artists, whilst engravings (*see under* intaglio prints) after his architectural designs influenced buildings and the design of *retables, etc. throughout the Netherlands, Germany, Scandinavia, England, Spain and Latin America.

Born in Antwerp, Paul Vredeman de Vries followed his father in painting fantasy pictures of churches, palaces and interiors; the figures

in these paintings were often done by other artists, e.g. Frans
*Francken (Vienna, Kunsthistorisches). Sometime after 1604 he
departed for Prague, where he worked at the court of the Emperor
Rudolf II.

VRIES (rightly Fries), Adrian or Adriaen de (c.1545–1626) Dutch-
born *Mannerist sculptor trained under Giovanni *Bologna. He
was a friend of Hubert *Gerhard, and his two monumental fountains in
Augsburg, the *Mercury* (1596–9) and the *Hercules* (compl. 1602), form a
series with Gerhard's *Augustus Fountain*. Although he received the com-
missions on a trip to Germany in 1596, de Vries made the models,
which were cast locally by others, in Rome, where he had already
executed two monumental multiple-figure groups, indebted to
Giovanni Bologna, for the Emperor Rudolf II (1592, now Stockholm,
Nationalmuseum; Paris, Louvre). In 1601 de Vries was appointed
sculptor to the Emperor in Prague (busts of *Rudolf II* 1603, 1607,
Vienna, Kunsthistorisches; of *Elector Christian II of Saxony*, 1603, Dres-
den, Albertinum; and allegorical reliefs of *Rudolf II*, 1609, Windsor
Castle; Vienna, Kunsthistorisches). After Rudolf's death in 1612 de
Vries was employed by Count Ernst of Schaumberg (Bückeburg, parish
church, font, 1616; Stadthagen mausoleum sculpture, 1618–20) and
Christian IV of Denmark (*Neptune Fountain*, 1617–23, now in Drott-
ningholm, Sweden). From c.1622, he worked again in Prague, in the
palace of Duke Albrecht of Wallenstein (figures now in Drott-
ningholm). In time, his style departed from the vigorous precision of
Giovanni Bologna towards an increasingly more intricate and restless
modelling.

VROOM, Hendrick Cornelisz. (1566–1640) The first European
artist to specialize in marine painting. After extensive travels as a
painter on pottery, Vroom returned to his native Haarlem c.1590, to
paint large detailed pictures of ships, fleets and sea battles, usually
celebrating Dutch marine power (Amsterdam, Rijksmuseum; Haarlem,
Hals; etc.). He also designed tapestries, his most famous being a set of
10, *Defeat of the Spanish Armada by the English fleet*, which hung in the
House of Lords, Westminster, until destroyed by the fire of 1834. His
son, Cornelis Hendricksz. Vroom (c.1590/1–1661), was a landscapist
best known for his forest views, which anticipate later works by Jacob
van *Ruisdael (London, National; Rotterdam, Boymans-Van Beu-
ningen) and were themselves influenced by *Elsheimer.

WALS, Goffredo *See under* Claude Gelée.

WANDERJAHRE (German, travelling years) In the guild statutes governing the professional activities of artists in most German (and other northern European) cities in the Middle Ages and the *Renaissance, the years of compulsory educational travel outside one's own city between the completion of formal apprenticeship and entry into the guild as a master. During this time the young painter or sculptor would work as a *journeyman. The *Wanderjahre* were also, in effect, a 'bachelor's journey' before marriage. *See*, e.g. Dürer, Cranach, Breu.

WASSENHOVE, Joos van *See* Joos van Ghent.

WATTEAU, Jean-Antoine (1684–1721) French painter, born in the formerly Flemish town of Valenciennes. One of the originators of the *Rococo style, he remains its most individualistic exponent. A wilful, independent spirit, his caustic, restless and melancholy temperament was no doubt accentuated by the tuberculosis which killed him. He sought no commissions and was most at ease painting *cabinet pictures for a small circle of friends, mainly dealers, antiquaries and enlightened collectors. His last two works, however, the enigmatic *Gilles* (*c*.1719, Paris, Louvre) and *Gersaint's Shopsign* (1721, Berlin-Dahlem, Museen), indicate that he was taking a new direction, grander in scale and more monumental, yet at the same time, at least in the latter painting, more *realist. Watteau's independence – and his outstanding talent – were recognized by the French *Academy, which allowed him, exceptionally, to choose the subject of his reception piece (*Pilgrimage to the Isle of Cythera*, 1717, Paris, Louvre) and enrolled him in a category of his own invention, the ***fête galante*. Two factors raise Watteau above his predecessors and imitators: his constant reference to nature, specifically human nature, through the medium of drawing, in which he built up a large stock of poses and expressions studied from the life (on which he relied in composing his paintings), and the underlying seriousness of his exploration of human psychology. Unusually in the history of art, albeit not in the context of the social history of 18th-century Paris, Watteau does not seek empathy mainly from the male spectator, depicting men and women as equally active partners in subtle emotional transactions.

Arriving in Paris *c*.1702, steeped in the Flemish–Dutch tradition of small-scale rustic, fairground and military scenes (*see especially* Brouwer, Teniers the Younger; Dou) Watteau first found work as a copyist in a sort of picture factory, then entered the studio of Claude Gillot (1673–1722). Originally a decorative painter, now known primarily as an etcher (*see under* intaglio prints) and book designer, Gillot revived the subject of the *commedia dell'arte* or Italian comedy, with its

stock characters of Harlequin, Pierrot or Gilles, Columbine, Pantaloon, etc., which was first introduced in French painting in the late 16th century – a theme of which Watteau was the first to realize the full pictorial and emotional potential (e.g. Washington, National; New York, Metropolitan, Frick; London, Wallace; *see also Gilles*, above). Probably by 1708 Watteau had quarrelled with Gillot and moved to the workshop of Claude III Audran (1658–1734), who was mainly employed as a decorator and designer and, crucially for Watteau, Keeper of the Luxembourg palace. Audran may have introduced Watteau to the arabesque curve and decoration in the newly-fashionable 'Chinese' style (a few decorative panels by Watteau are known, and others engraved). More importantly, however, he allowed the young painter entry to the Luxembourg to study the *Marie de'Medicis* cycle by *Rubens, whose painterly technique was fully assimilated by Watteau (*see also under disegno*). Rubens's example also inspired Watteau to study Italian, and specifically Venetian, art. With this in mind he presented himself to the Academy in 1709 and again in 1712, hoping to win a bursary to the French Academy in Rome. Although unsuccessful, he was later able to study works by *Veronese and *Titian in the collection of Crozat, and to meet Sebastiano *Ricci and Rosalba *Carriera on their visits to Paris; a romantic, nostalgic view of Italy, akin to that associated with *Giorgione, permeates many of his works.

From *c.*1709 Watteau emerges as an independent artist, first achieving sales with military scenes, then in a wider range of subjects. The *fête galante*, as we have seen, is identified with him, and was to be continued, in more trivial form, by Lancret (1690–1743) and Watteau's only pupil, Pater (1695–1736). In 1720 Watteau visited London, perhaps to consult the collector and famous physician, Dr Mead. He died *en route* to his native Valenciennes, convinced that he would be cured there.

Watteau's influence was enormous, both during his lifetime, when he achieved international fame despite seeking no official commissions, courtly patronage or even great commercial success, and largely after his death, when his total *oeuvre* was engraved on the initiative of his friend, the collector Jean de Julienne. The young *Boucher was one of the engravers at work on the four volumes; Gian Domenico *Tiepolo owned at least some of the prints, and *Gainsborough a copy of the whole collection. In England Watteau's influence was also mediated through *Mercier, and is perceptible in such artists as *Hogarth and *Hayman (*see also* Conversation Piece). In France, perhaps the artist who best assimilated his spirit was *Fragonard, who, like Watteau, cultivated personal and artistic freedom.

WEENIX, Jan Baptist or Giovanni Battista (1621–60/1) Italian-ate Dutch painter, best known for his *genre*-like views of the Roman Campagna and exotic harbour scenes (Detroit, Institute; London, Wallace; etc.). He also painted portraits, indoor *genre* scenes, and *still-lifes with dead game, influenced by the Flemish painter

*Snyders (Amsterdam, Rijksmuseum). In 1642/3 he was in Rome; probably after his return from Italy to Holland, 1646/7, he came to know *Berchem, whom he influenced, and whose influence is also occasionally visible in his work (Cleveland, Ohio, Coll. Millikin). His son, Jan Weenix (1640–1710), specialized in pictures of hunting trophies, some designed to decorate entire walls (Bensberg, Gemälde-sammlungen).

WERFF, Adriaen van der (1659–1722) Dutch painter and architect resident mainly in Rotterdam, even after becoming painter to the Elector Palatine, Johann Wilhelm, at Dusseldorf from 1696. (*See also* Godfried Schalcken, Rachel Ruysch.) Van der Werff obtained a hereditary knighthood in 1703 and must be reckoned one of the most successful Dutch artists of all time, although few would now agree with those of his contemporaries who considered him the greatest of all Dutch painters. This judgement must be understood in the light of the *academic theories then fashionable not only in the Dutch Republic but throughout Europe, largely under French influence (*see also* Gerard de Lairesse).

Van der Werff trained mainly under Eglon van der Neer (*see* Arnout van der Neer). He perfected the technique of 'fine painting', *fijnschilder*, evolved in Leiden (*see* Gerrit Dou). But his international reputation was acquired when, *c.*1685, he abandoned the *genre subjects of the Leiden school, to produce elegant *classicizing pictures on religious and mythological themes. These *cabinet pictures were much prized for their adherence to academic doctrine, but they appealed also through their covert or overt sensuality and occasional sentimentality. His religious pictures for the Elector (including a series of 15 *Mysteries of the Rosary*, 1703–16) were compared, to their advantage, with the *Passion* series by *Rembrandt, then in the electoral gallery. After the Elector's death in 1716, van der Werff continued to be patronized by princely and wealthy collectors in Russia, France, Germany and England. There are works by him in the major national collections in these countries. A few elegant portraits by van der Werff are also known, including a *Self-Portrait Painting his Wife and Child* (1699, Amsterdam, Rijks-museum). He decorated his house in Rotterdam with large panels of pastoral scenes, partly preserved in Kassel, Gemäldegalerie. His brother, Pieter van der Werff (1661–1722), was his only pupil and collaborator, and an extant notebook records their precise contributions to various paintings.

WEST, Benjamin (1738–1820) Pennsylvania-born painter of Quaker parentage, who set up a studio in London after a study trip to Italy 1760–3. He enjoyed a long association with the British crown from 1769, beginning with the commission for *The Final Departure of Regulus from Rome* (London, Kensington Palace), pioneered modern-dress history painting (*see under* genres; *Death of General Wolfe*, 1771, Ottawa, National; five other versions), and having been a founder

member of the Royal *Academy, succeeded *Reynolds as President, 1792.

In Rome West had become a protégé of *Mengs and friend of Gavin *Hamilton, and was confirmed in his ambition to relinquish portraiture for *Classical subjects (*Agrippina Landing at Brundisium with the Ashes of Germanicus*, 1768, New Haven, Conn., Yale). Over the years he executed some 75 paintings and designs of paintings for the crown. The most grandiose of the royal schemes was for a series of 36 huge paintings on the theme of *Revealed Religion* to decorate a new chapel in Windsor Castle. Only seven were completed before George III's madness forced the abandonment of the project; they were returned to West (now Brooklyn; Greenville, South Carolina, Bob Jones University; Philadelphia). They are composed in what has been called West's 'Dread Manner': a proto-Romantic (*see* Volume Two) reworking of *Baroque principles. Despite this innovatory late style, West is mainly remembered for his modern-day, modern-dress subjects in the Grand Manner; the chief, in addition to the *Death of Wolfe*, being *Penn's Treaty with the Indians* (1771, Philadelphia, Academy) and *The Battle of La Hogue* (1779, Washington, National). As early as 1773, as a companion to the *Death of Wolfe*, West also treated a 'medieval' subject, the *Death of Bayard*, in a 'medievalizing' mode actually copied from Salvator *Rosa, anticipating the 'troubadour' style of the 19th century (*see* Volume Two).

WEYDEN, Rogier van der (*c.*1339–1464) Netherlandish painter, one of the most influential artists of the 15th century, internationally famed for the naturalism of detail (*see under* realism) and the *expressive pathos and piety which characterize his work. He created a range of pictorial types – for religious subjects such as the *Descent from the Cross* or the *Pietà, and for portraits – which entered the repertory of Netherlandish art, and affected artists throughout northern Europe, the Iberian peninsula, and even Italy. These compositions were repeated in quantities in his own prolific workshop, remaining in use in Brussels and Antwerp until the mid-16th century in the workshops of his son Pieter, his grandson Gossen and his great-grandson Rogier.

Born at Tournai, Roger de la Pasture, as he then was, was apprenticed to Robert *Campin, who was to prove the strongest influence on his work. He moved to Flemish-speaking Brussels by 1435, when his name was translated into Flemish. It is thus as Rogier van der Weyden that he became official painter to the city of Brussels, also receiving commissions from Philip the Good, Duke of Burgundy, and members of his court, from foreign princes, and from church authorities. He probably went on pilgrimage to Rome in the jubilee year of 1450, accepting Italian commissions *en route* or on his return (*Entombment*, formerly in the collection of Lionello d'Este, Marquisse of Ferrara, now Florence, Uffizi; *Madonna with Four Saints*, formerly in the Medici collection, Florence, now Frankfurt, Institute).

Rogier's *oeuvre* is poorly documented and has been reconstructed by comparison with a handful of paintings recorded in his lifetime and in the 16th century. A celebrated secular work, 1439–before 1450, was destroyed in the bombardment of Brussels in 1695. It consisted of four large panels, representing *The Justice of the Roman Emperor Trajan* and *The Justice of Herkinbald*, a legendary Duke of Brabant, for the courtroom of Brussels Town Hall. The only extant work attributed to him in a contemporary source is in fact a workshop replica: *The Altar of the Virgin* (before 1445, Berlin-Dahlem, Museen). But the original altarpiece by Rogier exists as separate fragments (*Holy Family* and *Pietà*, Granada, Capilla Real; *Christ Appearing to the Virgin*, New York, Metropolitan). Two further paintings are ascribed to him in 16th-century sources: *The Descent from the Cross* (before 1443, Madrid, Prado) and *The Crucifixion* (1454–60, Escorial).

These works from early and late in Rogier's career reveal that, unlike Robert Campin, he increasingly came to sacrifice both realism and decorative values to the demands of expressivity, albeit of a particular kind. More or less ignoring the logic of scale and of spatial recession, he confined himself to a selective naturalism of detail, and made little or no attempt to differentiate between the emotional reactions of his painted figures, imposing on them a restrained and generalized air of piety or grief. The expressivity which is such a hallmark of his later work comes instead from the powerful tension produced through purely pictorial means. Campin's sinuous and decorative line becomes more angular and broken; limbs and features are elongated, poses subtly distorted; seemingly stable compositions are built up of individually unstable figures. By contrast with Jan van *Eyck, some of whose compositions he adapted, Rogier treats the painting as a flat surface upon which he inscribes abstracting contours.

With the exception of the more outgoing *Portrait of a Young Woman* in Berlin-Dahlem, Museen, the five independent portraits attributed to Rogier share these abstracting tendencies (Lugano, Thyssen-Bornemisza Coll.; Brussels, Musées; New York, Metropolitan; Washington, National). Other, equally austere and aristocratic portraits have been identified as the donor half of devotional diptychs (*see* polyptych).

In addition to the paintings mentioned above, works attributed to Rogier can be found in London, National; Madrid, Prado; Boston, Mass., Museum; Vienna, Kunsthistorisches; Antwerp, Musée; Beaune, Hôtel-Dieu; Paris, Louvre; Munich, Alte Pinakothek.

The ablest of Rogier's immediate followers was the German-born painter Hans *Memlinc, who was probably his pupil.

WHEATLEY, Francis (1747–1801) Possibly a pupil of *Zoffany, he began his career with small-scale portraits and *Conversation Pieces, but with a broader and more sensitive touch, especially for landscape. From 1779–83/4 he worked in Dublin (*The Irish House of*

Commons, 1780, Coll. A. D. F. Gasgoigne). Some years after his return to London he took up the sentimental bourgeois *genre made popular by the French painter *Greuze (*Mr Howard offering Relief to Prisoners*, 1787, Sandon) and he is best remembered for his pictures in this vein, and of country life and the rural side of city life (*Cries of London*, 1792/3, Upton House; engraved 1795).

WILSON, Richard (1713–82) Welsh-born painter, the first British artist to specialize in landscape in the *classical tradition, neither topographical record nor simple decoration, but an intellectually rigorous work evocative both of a love of nature and nostalgia for the Classical past. His application of this tradition to British – especially Welsh – scenes is his most innovative contribution to landscape painting (*see*, e.g. *Snowdon*, Liverpool, Walker). He produced also poetic views of the Roman Campagna (e.g. *Ego fui in Arcadia*, Abbots Worth), dramatic mythological narratives set in landscape and *picturesque or romantic versions of the country-house portrait (e.g. five *Views of Wilton*, Wilton). Although esteemed by some of his fellow artists, being a founder member of the Royal *Academy and its Librarian from 1776, Wilson gained little general recognition in his lifetime and retired to Wales, embittered and impoverished, a year before his death.

The well-educated son of a clergyman, Wilson was apprenticed to a portrait painter in London and in the 1740s produced portraits of some distinction (London, National Portrait, Tate; Greenwich, Maritime). Temperamentally unsuited to fashionable portraiture, however, he was already drawn to landscape painting (London, Foundling Hospital, roundels; *View of Dover*, engraved 1747; possible country house portraits). In 1750 he left for Venice, where in 1751 he met *Zuccarelli, who probably influenced him to specialize in landscape, a decision finally settled by meeting *Vernet in Rome in 1752; from 1753 Wilson painted only in this genre. His major influences were *Claude, Gaspard *Dughet, and the Italianate Dutch artist *Cuyp, but his best works show an unmistakable originality; his deep feeling for mountain scenery has been compared with Wordsworth's. Perhaps ironically, this sharply outspoken man, no respecter of social forms, brought the commissioned country house portrait to its finest perfection, establishing the models which his successors followed (*see* e.g. Turner, Volume Two). There are works by him in private collections throughout England and in most English galleries, as well as in American museums, but the largest collection is in the National Museum of Wales, Cardiff.

WIT, Jacob de (1695–1754) Leading Dutch decorative painter, best known for his *illusionistic ceilings (e.g. Heemstede, Huis Boschbeek) and *grisaille imitations of marble reliefs (e.g. Amsterdam, former town hall, now royal palace). He was also, however, the first artist since the 16th century to receive commissions for religious pictures in Dutch Catholic places of worship.

WITTE, Emanuel de (1616/18–92) Born in Alkmaar, active in Rotterdam, c.1639–40, Delft, c.1641–51, and Amsterdam by 1652. He was recognized in his own time and since as the greatest architectural painter of the Netherlands, famous especially for his real and imaginary views of the interiors of churches, always the scene of human action and probably intended to arouse solemn meditations on the significance of human life (Edinburgh, National; London, National; Rotterdam, Boymans-Van Beuningen; etc.). He turned to architectural subjects only c.1650; domestic interiors, harbour and marine views by him are also known, and after 1660 he specialized as well in market scenes, some with portraits (London; Rotterdam, as above). He ended his life by suicide, c.1660, after attempting to solve his financial problems by indenturing himself to a notary. Although his teacher is not known, he may have been in contact with Carel *Fabritius in Delft.

WITZ, Konrad (c.1410–before or in 1446) Outstanding Swiss painter, a native of the German town of Rottweil who settled in Basel in 1434. His innovative art is related to that of the Burgundian school (see Robert Campin). His last known work, the signed and dated Altarpiece of St Peter (1444, central panel lost, wings only in Geneva, Musée) included his now most famous painting, the Miraculous Draft of Fishes. Not only does the landscape realistically represent part of Lake Geneva, but Witz has portrayed the different effects of reflected and refracted light in depicting the half-submerged rocky foreground – perhaps the first artist to do so. Equally, the Freeing of St Peter in the other wing of the altarpiece uses cast shadows to represent one of the earliest night scenes in northern European art.

Witz's earliest known work is the dismembered Heilspiegel Altarpiece (Basel, Kunstmuseum; Dijon, Musée; Berlin-Dahlem, Museen). As in the Altar of St Peter, the central panel has been lost. Surviving panels from another destroyed altar are now in Basel, as above; Strasbourg, Musée de l'Oeuvre Notre-Dame; Nuremberg, Museum.

WOLGEMUT, Michael (1434–1519) The major artist and art entrepreneur in Nuremberg before *Dürer, whose teacher he was. He worked on the Zwickau Altarpiece (1479, Zwickau, Marien-kirche) but his importance rests less on his activities as a painter than on his running a workshop of quasi-independent groups of artists, on whose behalf he imported the latest Italian and German prints – notably the engravings (see under intaglio prints) – of Martin *Schongauer to serve as models. Most significantly, he designed and published books illustrated with woodcuts (Schatzbehalter, 1491; Nurem-berg Chronicle, 1493), hitherto the province of publishers and their craftsmen employees. His elevation of the *relief print into an artistic medium and his underwriting of publications were imitated by Dürer, who improved on Wolgemut's example by himself publishing the woodcut Apocalypse in 1498.

WOODCUT See under relief prints.

WOOTTON, John (d.1756) Best known as one of the originators of English sporting painting, but even more important as a landscape artist. He was a pupil of Jan Wyck (1652–1700), with whom he collaborated on some battle-pieces. In the 1720s the Duke of Beaufort paid for him to travel to Rome, where he discovered Gaspard *Dughet and *Claude; on his return, Wootton introduced *classicizing Gaspardesque landscape to British painting, sometimes including it as a backdrop in his sporting pictures and horse portraits. There are works by him at Welbeck; Longleat; Althorp, and London, Tate.

WOUWERMAN, Philips (1619–68) A specialist in small-scale *genre scenes and landscapes with horses, he is esteemed as the most, perhaps the only, successful Dutch painter of horseflesh. In the 18th century no princely collection was without examples of his work (the Hermitage, Leningrad, owns more than 50; Dresden Gallery, over 60). He lived and worked in Haarlem, where he may have studied with Frans *Hals, but was decisively influenced by Pieter van *Laer.

WRIGHT, Joseph (called Wright of Derby) (1734–97) The first professional painter to share and depict the scientific interests of the Industrial Revolution; two of his principal patrons were Wedgwood and Arkwright, and he was in contact with Erasmus Darwin and the Lunar Society. Trained as a portraitist under *Hudson (1751–3; 1756–7) he practised portraiture, mainly in his native Derby, whilst developing an absorbing interest in *chiaroscuro effects, possibly stimulated by having seen works of the Utrecht Caravaggisti (see Caravaggio; Baburen; Honthorst; Terbrugghen). During his 'candlelight period' before 1769 he produced three masterpieces: Three Persons viewing 'The Gladiator' by Candlelight (1765, private coll.); The Orrery (1766, Derby, Gallery) and An Experiment on a Bird in the Air Pump (1768, London, National). In addition to portraying – on a large scale and without either the comedy of genre or the bombast of history painting (see under genres) – the preoccupations of a newly emergent educated class, and the effects of artificial light, the pictures depict a range of sympathetically observed, 'natural' emotional responses.

In 1772, Wright exhibited his first literary narrative, Miravan Opening the Tomb of his Ancestors (Derby), a genre which he was to exploit more fully after his return from a study tour of Italy, 1773–5. This trip also influenced him to paint landscape in the mode of *Vernet, and to a study of nocturnal light effects: moonlight, Vesuvius erupting, a fireworks display at Castel S. Angelo, the glow of an iron forge (Derby; Leningrad, Hermitage; etc.). After his return to England, he hoped to establish himself as a fashionable portraitist in Bath, which *Gainsborough had left in 1774; failing, he returned for good to Derby. His best portraits date from c.1781 (Sir Brooke Boothby, 1781; London, Tate). Some of the narrative pictures of the 1780s demonstrate his allegiance to international Neo-*Classicism (see Volume Two): e.g. The Maid of Corinth, 1782–4; Mellon Coll. He has been compared, to his

advantage, with the French painter *Greuze, and his interests and sensibilities with those of the French Encyclopedists.

WTEWAEL, WTTEWAEL or UYTEWAEL, Joachim (1566–1638) Dutch painter, one of the so-called Utrecht *Mannerists. The main components of his sophisticated and artificial style were formed during his voyages to Italy, 1586–88, and France, 1588–90, where he encountered the elegant French version of Italian Mannerism evolved at Fontainebleau (*see* Primaticcio). Known chiefly for his bright, precious small-scale collectors' pictures, mainly of mythological and allegorical subjects (e.g. London, National; Paris, Louvre), he also painted portraits and kitchen scenes. A staunch Dutch Calvinist and patriot, he designed the stained-glass window of Gouda cathedral, depicting *Holland's Chariot of Freedom of Conscience Victorious over Spain and Idolatry* (1595). A series of drawings, never engraved and now dispersed (six in Vienna, Albertina), portray in allegorical form his political ideals for the Netherlands. His son Peter was also a painter.

WYCK, Jan *See under* Wootton, John.

YÁÑEZ DE LA ALMEDINA, Fernando (recorded in Spain from 1506–31) Foremost Spanish painter of the High *Renaissance, trained, with his collaborator Fernando de los Llanos, in Florence under *Leonardo da Vinci. One of them must have been the 'Fernando spagnolo' who assisted Leonardo in 1505 on the *Battle of Anghiari*. Yáñez's extant works are distinguished by their forceful illusion of space and monumental figures (Valencia, cathedral; Madrid, Prado).

ZAUFFALY, Johannes *See* Zoffany, Johann.
ZELOTTI, Giovanni Battista *See under* Veronese.

ZOFFANY (born Zauffaly or Zauffelij, Johann(es) (Josephus)) (1733–1810) Painter mainly remembered for his minutely detailed, richly-coloured, English *Conversation Pieces and theatre pictures. He was in fact a cultured, complex and versatile artist, the full range of whose accomplishments and interests has only recently come to be appreciated. Born near Frankfurt, the son of a court cabinet maker and architect, Zoffany also painted religious and mythological works, and large-scale *fresco and oil decorations in the German *Rococo style (1758–60; Regensburg, Alte Kapelle, Museum; Würzburg, Museum; Coblenz, Museum; Bordeaux, Musée; Manchester, Gallery. Decorations in palaces in Coblenz and Trier destroyed; preparatory drawings, London, British; Coll. HM the Queen). In Florence and Parma (1770s) he painted *Baroque court portraits on the scale of life for the Grand Duke of Tuscany (Vienna, Kunsthistorisches), one of which earned him the title of Baron of the Holy Empire. In the same years, for his own pleasure, he painted highly finished *genre pictures of Italian low-life and peasant festivals (Parma, Galleria; London, Tate). During his first visit to Rome after his apprenticeship in Regensburg, 1750, he had been a protégé of the Neo-*Classical painter *Mengs and befriended by *Piranesi. His interest in *Classical sculpture can be gauged by the picture he painted of, and for, his friend Townley: *Charles Towneley's Library in Park Street* (1781–3; Burnley, Gallery). In 1794, after a lifetime of tolerant scepticism, in reaction to the massacres of 1792 he painted savage satires on the horrors of the French Revolution. His stay in India (1783–9) produced not only portraits and Conversation Pieces of Anglo–Indian and Indian society, (London, India Office; Calcutta, Victoria Hall) but also drawings reflecting his serious interest in Hindu customs (New Haven, Conn., Yale; London, British, Courtauld; Oxford, Ashmolean). He became a member of the scholarly Asiatic society, as he was a member of several Italian academies and of the Royal *Academy in London (*The Academicians of the Royal Academy*, 1771–2, Coll. HM the Queen). A series of self-portraits, notably those painted at a difficult personal time in the 1770s (Florence, Uffizi), testify to a reflective, conflicted nature as much as to his knowledge of the 17th-century emblematic tradition.

Zoffany came to England in 1760. Speaking no English, he was employed in hack work, until rescued by his earliest major English patron, the actor-manager David Garrick. His English reputation was made first through Conversation Pieces of Garrick and his familiars (Coll. Lord Lambton; Lord Egremont) and theatrical pictures of Garrick in various roles (London, National Portrait, etc.). Introduced to

Queen Charlotte, he painted for her two works which inaugurate the informal royal Conversation Piece as a genre (1764; Coll. HM the Queen). In 1772 he was commissioned by the Queen to go to Florence to paint *The Tribuna of the Uffizi* (1772–7/8; Coll. HM the Queen); it was at this time that he worked at the Grand Ducal court (*see above*). But the years after his return to England (1779–83) were disappointing; he had lost his following as a fashionable portraitist, and the *Tribuna*, possibly the most famous picture of a gallery of works of art, was adversely criticized; it was at this time that he decided to go to India, where he repaired his fortunes, but lost his health. He seems to have stopped painting after 1800.

ZUCCARELLI, Francesco (1702–88) Florentine-born painter of Italianate *Rococo landscapes, active mainly in Venice and England, where he worked between 1752–62 and 1765–72. In 1751 he met Richard *Wilson in Venice and may have influenced him to take up landscape painting. Zuccarelli was enormously successful in England, enjoying royal patronage, which Wilson never did, and becoming a founder member of the Royal *Academy. From the mid-19th century his work has been denigrated as vapid and artificial, but it should be remembered that his pictures were never intended as serious studies of nature, but merely to embellish a room, as decorative features set into a wall or over a fireplace. There are innumerable works in the royal collection, in private collections, and in public galleries throughout Britain.

ZUCCARO, Taddeo (1529–66) and his brother Federico (1542/3–1609) Important Roman painters born near Urbino, working in a chastened *Mannerist idiom. Taddeo, the more naturally gifted of the two, came to Rome at the age of 14. Virtually self-taught through the study mainly of *Raphael and his school, he first made his reputation *c*.1548 as a painter of façades, none of which survives (*see also* Polidoro da Caravaggio). Virtually all of his major commissions were finished after his death by Federico (S. Marcello al Corso, Cappella Frangipane, the *Conversion of St Paul*, *c*.1563; Caprarola, Farnese palace, begun 1559; *Dead Christ supported by Angels*, 1564–5, Urbino, Galleria; Vatican, Sala Regia). Taddeo's style is tempered both by a retrospective *classicism and by *realism; at times he anticipates the 'reforming' mode of Annibale *Carracci. He is nonetheless one of the most formally inventive decorative artists of his day, mingling – as for example in the Sala dei Fasti Farnesiani at Caprarola – *illusionism of various types in a sophisticated but thematically apt and visually clear way.

Federico, trained by his brother, began to paint on his own account before the age of 20 (Casino of Pope Pius IV, partly destroyed). He was a widely travelled artist and was in Venice in 1563–4 (S. Francesco della Vigna, Grimani chapel), Florence in 1565 (ceremonial entry for Giovanna d'Austria) and Orvieto in 1570 (cathedral). In 1574 he went abroad, to Lorraine, Holland and also England, where Elizabeth I gave

him a sitting for a portrait (drawing only, London, British). Returning to Italy in the same year, he spent the next five years in Florence completing the *frescoes of the cathedral dome left unfinished by *Vasari. On his return to Rome in 1579 he was assigned to complete the decoration of *Michelangelo's Cappella Paolina in the Vatican (finished 1583–4). The task was interrupted by temporary banishment from the city, 1581–3, resulting from the public exhibition of a satirical allegorical painting, the *Porta Virtutis* (Gate of Virtue), in which Federico caricatured the detractors of his altarpiece for the church of S. Maria del Barracano in Bologna (painting lost, preparatory drawing Frankfurt, Institut). During his exile he worked for the Duke of Urbino (S. Maria di Loreto, 1582–3) and again in Venice, where he received the prestigious commission for one of the large historical canvases in the Great Council Chamber of the Doge's Palace (*see also* Giovanni Bellini; Alvise Vivarini; Carpaccio; Titian). In all these schemes Federico attempted to 'correct' local traditions towards greater classicism as this was understood in Rome; in Venice, his particular animus was directed at *Tintoretto, whom he was to pillory in his treatise *Lamento della Pittura*, published in Milan in 1605. From 1586–8 he worked for King Philip II of Spain, where his work was much disliked. In the early 1590s he was largely involved in founding in Rome the *Academy of St Luke, which was meant to implement the principles of the Florentine Accademia del *Disegno. He was to publish his theoretical writings in 1607 in Turin, whilst working mainly in Lombardy and Piedmont; the *Idea de'scultori, pittori et architetti* is one of the most systematic expositions in Italian of the tenets of late *Mannerism and academic doctrine. Some of his notions are expressed pictorially in the allegorical decoration of his own house in Rome, where he held meetings of the Academy.

Federico's late works approach the counter-Mannerist naturalism of, e.g. *Santi di Tito (e.g. *Adoration of the Magi*, 1594, Lucca, cathedral), although he continued to deploy Mannerist conceits in decorative contexts. His tendency to academic schemata made him an easy model, and he became widely imitated amongst contemporaries and even by older artists.

ZURBARÁN, Francisco de (1598–1664) One of the greatest Spanish painters, despite a somewhat limited technique, and the one most closely identified with the *tenebrist naturalism (*see under* realism) and unquestioning piety of Spanish devotional art; rediscovered by the French in the 19th century.

Born in a small town in Estramadura, he was apprenticed in Seville to an obscure painter of religious images, returning to his native region in 1617 to work in Llerena, where in 1626 he received a decisive commission: 21 paintings for the newly built Dominican friary of San Pablo el Real in Seville (five extant). In 1627 he completed the *Christ on the Cross* for the sacristy of San Pablo (now Chicago, Institute) and this painting seems to have been instrumental in Zurbarán being invited to

settle in Seville without first being examined for membership of the
*Academy of St Luke. Throughout the late 1620s and 1630s Zurbarán
was almost exclusively employed painting cycles, series and altarpieces
for Sevillan monastic patrons: the Trinitarians, Hieronymites, Mer-
cedarians, Franciscans, Carthusians. These ensembles, on which his
reputation is founded, have been largely dispersed and partly lost,
individual canvases finding their way to various galleries and collections
(e.g. Cádiz, Museo; Seville, Museo; Madrid, Prado, Academy; New
York, Metropolitan, Hispanic Society; Paris, Louvre; Grenoble, Musée;
London, National; Dublin, National; Strasbourg, Musée). Whilst his
altarpieces abound in rich colour and decorative detail, as do some of
his single figures of female saints, the majority of the narratives of the
lives of monastic saints and the single figures of such saints show the
qualities most closely identified with the artist: the graduated depiction
of brown, black, grey and especially white habits; monumentality and a
dramatic stillness. The narratives, often based on Flemish and other
prints and frequently clumsy in their representation of action, are
constructed with geometrical simplicity in shallow box-like spaces,
almost like sculpted high reliefs. Indeed, his figures show a debt to the
work of Sevillan *polychrome-wood sculptors, notably *Montañés.

In 1634, possibly at the instance of his acquaintance *Velázquez,
Zurbarán participated in the decoration of the Hall of Realms in the
Buen Retiro palace, executing, with assistants, 10 emblematic *Labours of
Hercules* and two battle scenes, of which only the *Defence of Cádiz* sur-
vives (all Madrid, Prado; *see also* Mayno).

By the 1640s Zurbarán's severe and static style fell out of favour,
displaced by the more animated and suave manner of *Murillo.
Although he attempted to adapt to the new fashion (e.g. 1658, Madrid,
S. Francisco el Grande, Prado) Zurbarán never regained his former
domestic market and began to paint large numbers of pictures on
speculation to be sold in the Spanish colonies in the Americas. He
moved to Madrid in 1658.

Despite the fact that all the faces in Zurbarán's religious paintings
are individualized, he painted only a few independent portraits. Whilst
still-life accessories in all his works are depicted with almost surreal
concreteness, only one documented *still-life is known (now Los
Angeles, Norton Simon Foundation). On the basis of this others have
been attributed to him (Florence, Contini-Bonacossi; Madrid, Prado).
His son, Juan de Zurbarán, became a still-life specialist.

All these books are available at your local bookshop or newsagent, or can be ordered direct from the publisher. Indicate the number of copies required and fill in the form below.

Send to: **CS Department, Pan Books Ltd., PO Box 40, Basingstoke, Hants. RG21 2YT**

or phone: 0256 469551 (Ansaphone), quoting title, author and Credit Card number.

Please enclose remittance* to the value of the cover price plus: 60p for the first book plus 30p per copy for each additional book ordered to a maximum charge of £2.40 to cover postage and packing.

*Payment may be made in sterling by UK personal cheque, postal order, sterling draft or international money order, made payable to Pan Books Ltd.

Alternatively by Barclaycard/Access:

Card No.

Signature:

Applicable only in the UK and Republic of Ireland.

While every effort is made to keep prices low, it is sometimes necessary to increase prices at short notice. Pan Books reserve the right to show on covers and charge new retail prices which may differ from those advertised in the text or elsewhere

NAME AND ADDRESS IN BLOCK LETTERS PLEASE:

..

Name

Address

3/87